ART IN HISTORY

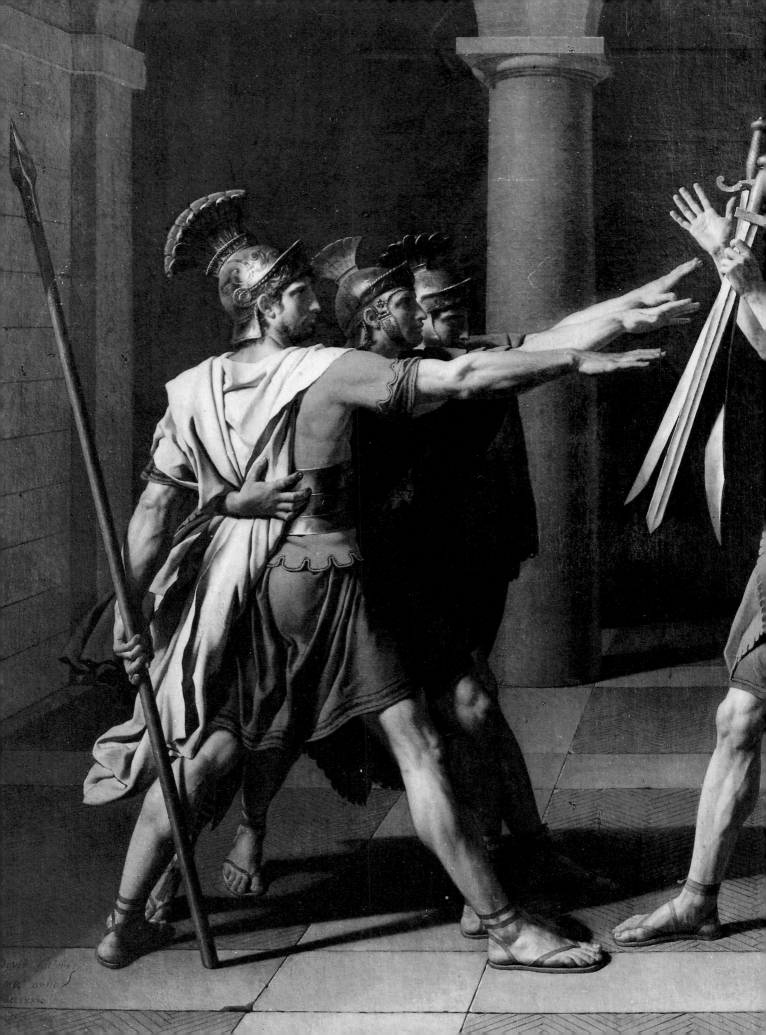

ART IN HISTORY

Larry Silver
Northwestern University

Abbeville Press • Publishers
New York • London • Paris

ISBN 1–55859–605–4

This book was designed and produced by
CALMANN AND KING LTD
71 Great Russell Street, London WC1B 3BN

Designer: Richard Foenander
Picture Researcher: Kate Duffy
Printed and bound in Hong Kong

Cover: Detail of Ambrogio Lorenzetti, *Effects of Good Government*,
Sala della Pace, Palazzo Pubblico, Siena, 1337–40. Fresco. See pages
158–59.

Frontispiece: Jacques-Louis David, *Oath of the Horatii*, 1784–85.
Oil on canvas, 14 × 11 feet (4.27 × 3.35 meters). Louvre, Paris.
Photo RMN.

CONTENTS

5. LATER RENAISSANCE IN ITALY

6. AGE OF ABSOLUTISM

PREFACE

Any book should state its purposes and should limit its liabilities at the outset, the more so if it purports to introduce its readers to the entire history of art. As a single volume, *Art in History* has, of course, its limits of scale. Nonetheless, it was written with a specific goal in mind: to present works of art with a greater depth of treatment and a more historical and contextual view of their audiences and cultures than most survey volumes. As a result, discussion of the artists mentioned is more elaborate than the paragraph or two that most surveys – by necessity – provide, although the overall total of artists may be fewer. This book will offer multiple works by individual artists or multiple views and aspects of ensemble monuments, such as the presentation of Chartres cathedral through its architecture, portal sculpture, and stained glass.

While the need for selectivity imposes restraints on the quantity of works and artists considered in the pages that follow, that selectivity has been relaxed somewhat in the pages on more recent art, particularly the segments on the twentieth century. There the account will more closely resemble other standard introductions, with more artists discussed in terms of fewer works – in part because the sheer number of familiar artists seems to require greater attention. This viewpoint seems to accord metaphorically with actual practice in paintings: the convention of atmospheric perspective, which embodies the premise that the greatest number of details and most vivid distinctions can be made in the area closest to the viewer. Moreover, this approach signals the (at times bewildering) diversity of artworks and movements from the past three decades and indicates that the roster of major monuments has by no means distilled itself out from a general welter.

Nor should the smaller roster of artists in the earlier chapters be taken to indicate that the author is wedded to a "canon" of what used to be called "key monuments in the history of art." Quite the contrary. But textbooks do need to introduce prevailing traditions, and this one has chosen to concentrate on major political and economic centers from ancient Egypt to modern New York. Power attracts artists and in turn promotes the artists who succeed within that power structure. The cliché tells us that there is a reason why tourist attractions get to be tourist attractions; in similar fashion, canonical Western artists got their omnipresence and cultural status for a reason, although here such a reason will more often be tied to considerations of their patrons and their audiences at centers of power. (This is *not* a book that will ever couch such a canon in terms of "quality" or universal appeal.)

There have been some conscious omissions and deletions – and some deliberate substitutions. For example, the soft-ground etchings of Mary Cassatt appear here as surrogates for a larger field of later nineteenth-century experimental prints, including the etchings of Degas and the lithographs of Toulouse-Lautrec. Space would not permit more than one of these talented printmakers, and Cassatt was both a technical innovator and a sensitive representative of the *Japoniste* influences important to so many artists of her time. Furthermore, as a woman artist her prints have been unjustly neglected. For such substitutions, one makes no apology.

Further remarks on the organizing principles of this book need to be made. Quite consciously, this book is addressed to a contemporary audience in America and Europe. Hence, it centers on Europe, like most books of its type, because the artistic tradition that dominates even American museums and American art production stems in general from Europe. However, it is equally conscious that this modern world is a global village and that the remarkable diversity of American (and, increasingly, European) citizens comes from a variety of traditions and artistic cultures. Hence, there are deliberate interruptions in the smooth-flowing narrative to historicize and discuss some major moments of cultures outside the "mainstream" of Europe that dominates art history in museums and academies today.

These "Views from Outside" do not purport to be comprehensive. It is insulting and token to find single chapters on "Far Eastern Art" or "Primitive Alternatives" inserted into most survey volumes, as if those cultures could still be covered comprehensively in a single chapter, even in a similar volume that lumped them all together like those chapters. Here the solution to this impossible problem derives from the same principles as the text on European art: to concentrate on a more limited historical moment important to the overall tradition, but not to claim inclusiveness. Just as this book as a whole hopes to undermine any illusion of comprehensiveness through its lengthier expositions and more limited examples, so do its "case studies" from other cultural traditions (including Soviet Russia and America as well as Africa, Asia, and Central America) attempt to provide a strong period flavor. They also invite any cross-cultural comparisons as well as contrasts that the reader might deem to be appropriate. These "non-Western" case studies remain quite specific. By limiting the focus, the few pages that are reserved for each account of non-European art can go into greater depth on their objects of study than any other conventional survey text. For example, the Renaissance era turns its attention to Aztec Mexico and to ancient Nigeria, Ife and Benin. Those two accounts in particular will be picked up again in the twentieth-century period, because the more recent tradition of Mexican muralists and Yoruba carvers has had an appreciable cultural effect, not only in its own region, but also in modern America (the United

States as part of the larger Americas, Hispanic as well as Creole).

Whereas the author has striven to incorporate decorative (or applied) arts (still pejorative-sounding terms but better than the former derisive phrase "minor arts") as well as printmaking and photography within the overall narrative, current museum bias in favor of easel painting and sculpture has nonetheless dictated the predominance of those two media throughout this text. There have been modifications according to specific cultures, however, especially older ones. In this text, architecture often appears in its encompassing role as a comprehensive cultural program, as in the case of the Acropolis in Athens or Chartres cathedral or St. Peter's in Rome – or Todai-ji in Nara.

This text will focus on centers of power and wealth. Hence important artists in provincial regions relative to political power may not always receive attention proportional to their merits, because at this point the narrative attends to London and Paris (and to a lesser extent Berlin) during the modern era, or Florence and Rome (and to a lesser extent Venice) during the Italian Renaissance. Kings and popes as well as the great urban centers inevitably loom large in a book devoted to a contextual study of public art. (This does not mean that important regional or pre-urban cultures do not deserve study. The glories of prehistoric caves or Scythian gold or Hiberno-Saxon manuscripts immediately evoke justified attention, but they do not figure here.)

Attentive readers of this book will perhaps note a disproportionate number of objects from the Art Institute of Chicago. The reasons are simple. The author lives and works in Chicago, and the Art Institute is a great museum, particularly for works after 1800. Such familiar and local works form the backbone of any author's experience of the history of art, and it is to be hoped that an instructor using this text to teach will also localize some of its Chicago-based observations with examples available to students on a first-hand basis. There can be no substitute for the actual experience of the size, the texture, the very materiality of an artwork; no slides or reproductions in this book (or even digitized simulacra) should obscure that basic fact. So the Art Institute and all other institutions and collections that own these objects should be thanked, not only for permission to reproduce them, but also for their custodianship, and their permission to readers to visit and view. A conscious effort has been made by the author to support such public institutions by choosing works from their collections rather than objects in private hands.

Writing such a book, especially with an interest in culture and context rather than formal description, is a demanding task; it has been instructive in its own right. As one learns when attempting to practice an art rather than analyzing and criticizing it, doing something yourself is much tougher than kibbitzing about it. Thus chastened, the author now has much greater respect for all of his predecessors in this endeavour than he did before attempting to improve on their precedents. That admiration is all the greater for the finest practitioners of this difficult, often thankless task. Like classics of other kinds, even artworks, classic introductions to art history like those of Janson and Gombrich have become classics for a reason, and the recent achievements of authors such as Hartt, Honour and Fleming, and Wilkins and Schultz provide worthy competition to them.

This volume aims to provide an introduction to the means by which art functions in and for its culture, while providing a visual primer of images saturated in the significance of their distinctive epochs. It also aims to retain a balance between the Eurocentric heritage of the modern art world, while acknowledging the power and the inherent interest of other contributors to that heritage – from Africa, from Mexico, and from Asia. Even the small section on Islamic Asia is offered in the hope of understanding – instead of the traditional, unfamiliar, demonic adversary usually offered, from the Crusades to Desert Storm. But every project has its limits, and this Preface should observe some limits, too.

Larry Silver

ACKNOWLEDGMENTS

No book could be written without the assistance of colleagues, readers, and producers. This one is certainly no exception. First thanks are due to the publishers at Prentice Hall, headed by Norwell ("Bud") Therien. Bud's consistent belief in this project and his moral support at dispiriting moments was subsequently backed up by his implementation of its text into printed reality. He also found the astute if acerbic readers of preliminary (many preliminary) drafts of the chapters who subsequently shaped the current form of the text. Their comments and efforts were much appreciated, even if they did make more of a "textbook" out of this project than the initial ambition would have warranted. For sympathetic assistance in the actual production of this tome, the author is deeply grateful to the overall supervision of Rosemary Bradley, as well as the editorial intervention of Liz Thussu, the photographic sleuthing of Kate Duffy and the designs of Richard Foenander, all of Calmann and King in London. The handsome appearance of the final product is the result of their assiduous labours.

Colleagues, too, offered indispensable advice on details, careful reading of chapters, and both intellectual and spiritual guidance at crucial moments. No one could be more blessed with talent in colleagues than an art historian at Northwestern University, and many of these scholars have had a hand in shaping the chapters that follow: Otto Karl Werckmeister, Whitney Davis, Sandra Hindman, Olan Rand, Leonard Barkan, Richard Wendorf, Hollis Clayson, David Van Zanten, Nancy Troy, Michael Leja, Betty Monroe, James Yood. Distinguished former Northwestern graduate students also greatly aided work on topics, especially modern ones: Jonathan Katz, John Hutton, Nancy Ring. And colleagues in other universities have graciously contributed critiques of chapters, especially modern ones, from a distance: Craig Adcock of Notre Dame, Jonathan Fineberg of the University of Illinois, and Archie Rand of Brooklyn, USA.

Finally, I wish to thank my students (from primary school pupils to advanced graduate students) and also my teachers. While most cannot be named specifically, the following exercised formative pedagogical influence on the text that follows (although they cannot be blamed for its deficiencies): Karl J. Weintraub, Herbert Kessler, Seymour Slive, Oleg Grabar, T.J. Clark, Harry Rand. For particular chapters on non-Western subjects, the following have provided direct and indirect inspiration: Harry Vanderstappen and James Cahill (China), John Rosenfield and Yoshiaki Shimizu (Japan), Richard Townsend, Cecilia Klein, and Elizabeth Boone (Mexico), and Suzanne Blier and Eli Bentor (Africa).

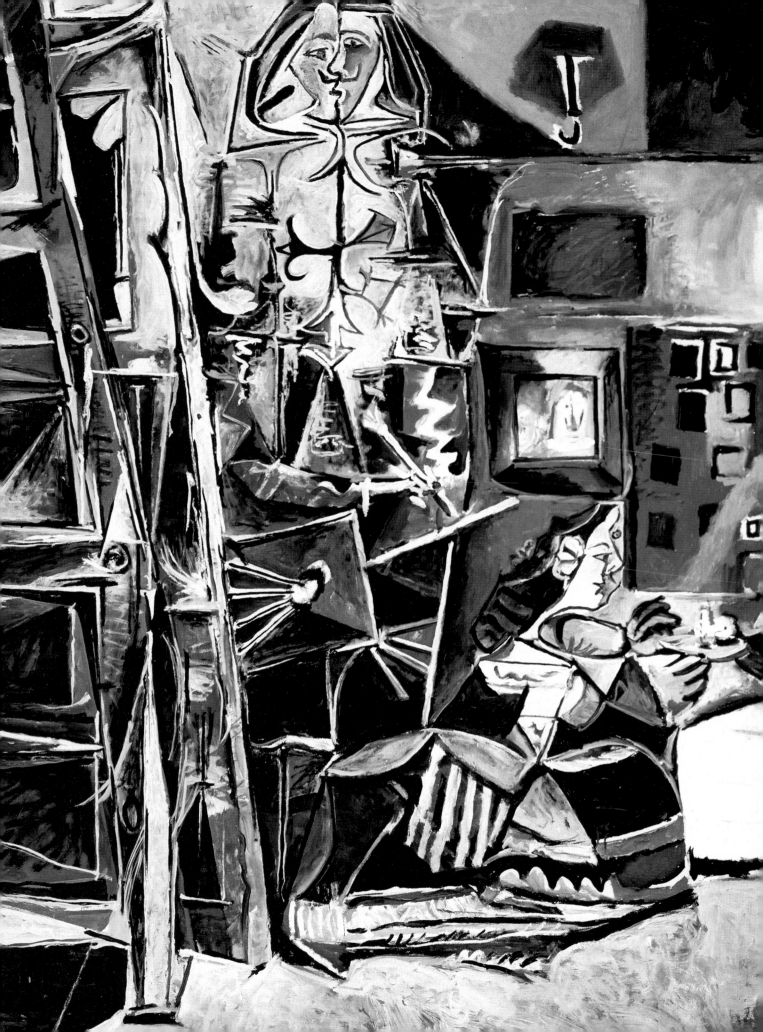

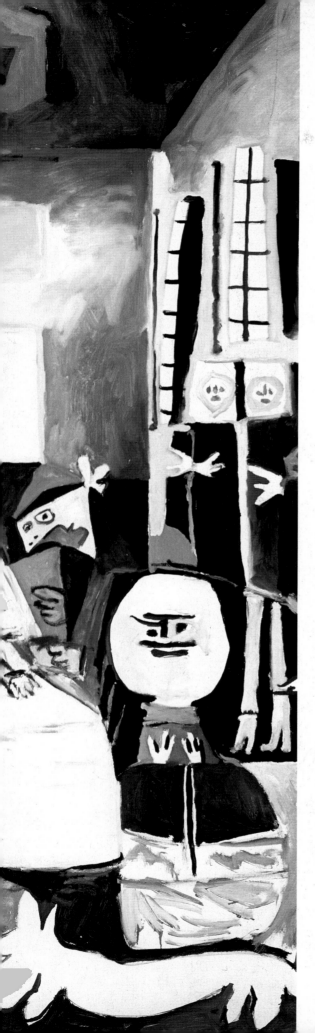

INTRODUCTION:

THE ROLES OF THE ARTIST

Artworks, of course, are made by artists. But we may be surprised to learn that artists have only represented themselves at work in their art-making for about five centuries now. And if we contrast two self images of artists at work on their craft, we can see just how varied their chosen profession has been over this period, in which their self conception shifts from a model of medieval craftsman to one of modern, experimental independence.

St. Luke Drawing the Virgin (ca. 1440; Fig. **1.1**, p. 19) painted by the official civic artist of Brussels, Rogier van der Weyden (ca. 1400–64), presents the artist not as a distinct personality (though the vivid, portraitlike features suggest that van der Weyden may have offered a disguised self-portrait here) but rather in the guise of the patron saint of all artists, Saint Luke, whose legend records that he painted a portrait from life of the Virgin Mary. This painting establishes the high status of the painter in his prevailing role as producer of religious artworks. Current painters derive their legitimacy, this picture implies, from having such a saintly role model. In all likelihood van der Weyden painted it for the guild of painters in Brussels. (The painting was frequently copied.) But it is not the identity of the particular painter himself that is celebrated here (indeed, the work is unsigned, and other contemporary works are often anonymous); instead it is the general aura of sanctity that all Flemish artists derive from the prototype of their saintly painter-patron.

Pablo Picasso (1881–1973) also defined the role of the artist in relation to the prevailing tasks of contemporary art in *Painter and Model* (1928; Fig. **1.2**, p. 19). This artist, however, no longer has any prescriptive subjects or even forms. Each painting can be a fresh creation of harmonies of

Detail of Fig. 1.13, Pablo Picasso, *Ladies in Waiting*, p. 28.

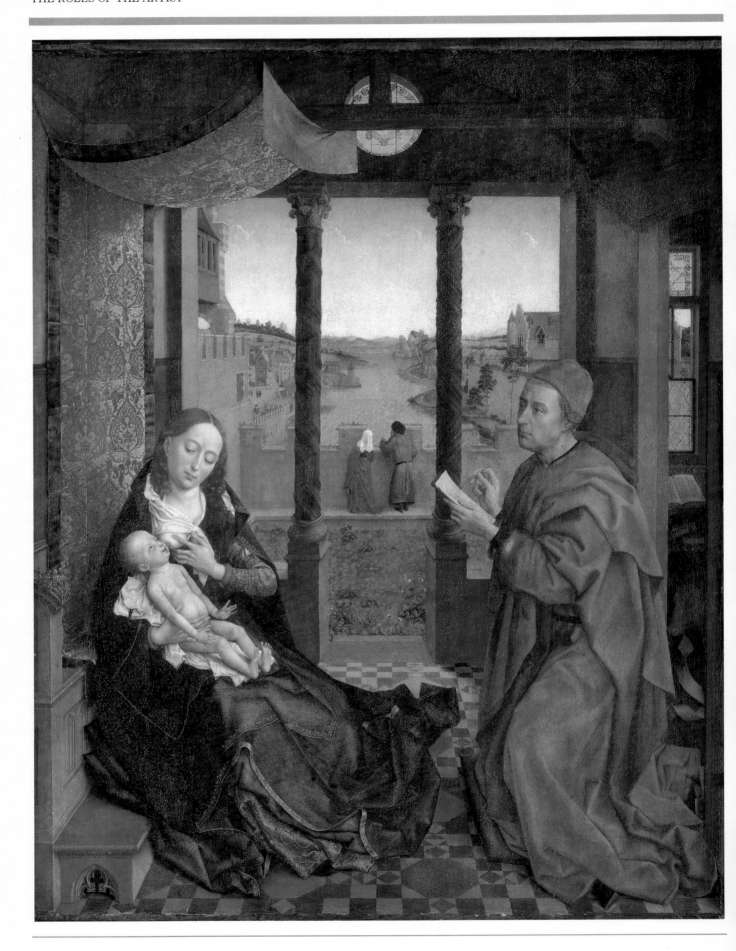

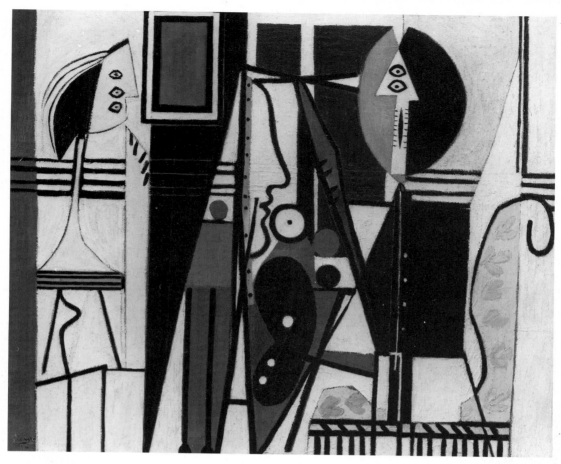

1.1 (Left) Rogier van der Weyden, *St. Luke Drawing the Virgin*, ca. 1440. Oil on panel, 54⅛ × 43⅝ ins (137.5 × 110.8 cm). Gift of Mr and Mrs Henry Lee Higginson, Courtesy Museum of Fine Arts, Boston.

1.2 Pablo Picasso, *Painter and Model*, 1928. Oil on canvas, 51⅝ × 63⅞ ins (129 × 163 cm). Collection, The Museum of Modern Art, New York. The Sidney and Harriet Janis Collection.

color and shape, with only the most symbolic of clues – such as the title of this work or its delineation of palette and canvas shapes – to lead a viewer to associate the image with a heritage of earlier pictures (including van der Weyden's drawing artist from a live model). Picasso asserts the uncompromising truth that all paintings are two-dimensional symbolic structures and that painters are free to invent whatever forms they wish, even when they acknowledge their ties to traditional imagery. Arbitrary artifice constructs the elements of this canvas, though Picasso concedes to legibility by using a simple profile outline of a face on the depicted canvas, despite the abstract forms of the painter and the model elsewhere in the studio. Painting need never conform to perceived reality, he implies, and utilizes symbolic pictorial conventions, such as this elegant silhouette, even when it seems "representational."

What both of these images reveal is that the personality or the biography of an artist can be fully irrelevant to the kinds of depictions he (or she) presents. Even when producing images of an artist at work, these two painters depend upon their understanding of what constitutes "art" in their communities, what their audiences expect to see and are accustomed to decipher as viewers. The modern myth of the artist as a

powerfully sensitive soul, pouring his or her anxieties onto a blank surface and waiting to be discovered or appreciated by an elite of fellow sensitive souls, is the legacy of the heroic creativity espoused by the Romantic movement of the early nineteenth century. In other ages and cultures, artistic roles have been much more integrated with their respective societies.

Ancient Greek myths include the story of Pygmalion, a supreme sculptor whose ivory statue of the most beautiful of women was so compelling that he fell in love with it himself. (Fortunately, Aphrodite, the goddess of love, brought the statue to life!) And ancient Greek writers celebrated their most famous artists, such as Apelles, who alone was allowed to paint portraits of Alexander the Great (d. 323 BC). With some rare earlier exceptions, Greek painters and sculptors were the first to sign their images, proudly proclaiming both their own individual accomplishments as well as their aspirations to immortality through their works. To the Greeks, then, (and the Roman writers who came after them, especially the naturalist, Pliny the Elder) can be traced the notion, still dominant in today's art market, that art has a history, punctuated by the creative inventions of great individual artists. This idea of

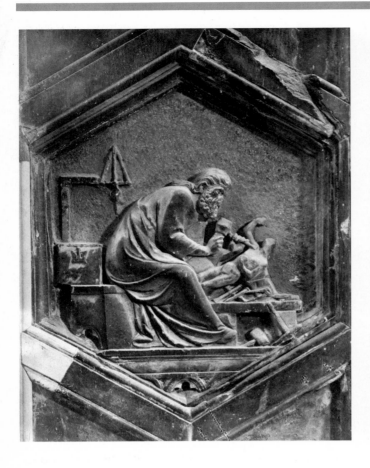

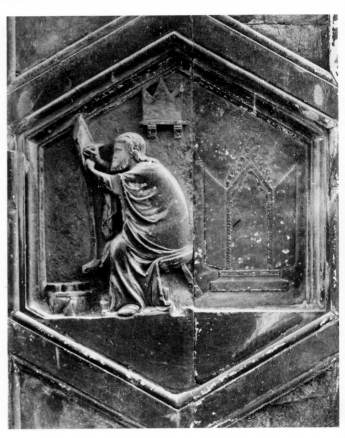

1.3 Andrea Pisano, *Sculpture*, *Painting*, 1334/48. Marble reliefs. Cathedral Campanile (bell tower), Florence.

art-as-history was rediscovered in Renaissance Italy, where ancient Greek and Roman texts were studied and ancient artworks avidly collected, as soon as they were excavated.

However, this celebration of art and the artist was unusual in Western art history for the many centuries in between. Artworks were integral to important social or religious functions, ornamenting the centers of politics and spirituality. Artists were seen less as creators than as craftsmen (or craftswomen, for women artists have suffered even greater anonymity than men artists throughout the history of art). Artists and their artworks served a higher purpose in society and received little separate glorification, despite the splendors they produced in, for example, medieval cathedrals. Most artists who worked on cathedrals from the twelfth century onward organized themselves into migrating lodges of architects and carvers. Later, in more permanent urban residences they formed guilds for mutual aid and quality control. But within these guild activities, craftsmanship was prized far more than originality, and artists often freely copied the admired works of their colleagues. This collaborative, workshop process of art-making can be seen in stained-glass images and sculpted reliefs of sculptors, painters, and architects at work. Such images appear within the overall context of pictorial programs that are part of the decorations of cathedrals, but have a very different context from the fine arts of the modern era. Instead, these creative activities emerge within a framework of the mechanical arts and crafts, along with medicine, weaving, agriculture, and navigation.

A characteristic example is the series of reliefs carved by Andrea Pisano for the bell tower (*campanile*) of Florence Cathedral (Fig. **1.3**). Significantly, these reliefs appear on the lowermost zone of the bell tower, alongside scenes illustrating the beginnings of humankind from Genesis. Above them, representations of the traditional liberal arts appear amid cycles of the planets, the virtues, and the sacraments, clearly conceived as a higher level of intellectual understanding. In the background of the relief of *Painting* are the characteristic profiles of standard religious pictures, organized as multi-paneled wood supports in elaborate gilded frames. The variety of such frames suggests a response by painters to the demand for religious images as well as the collaborative production of many such works at once. *Sculpture* shows the carver with his tools, sitting on his stone blocks and carving a figure on the diagonal in his workshop. In both representations, the work of artists appears as a practiced skill, produced in specialized workshops with the tools of their trade. Even where these single figures are made to personify an entire group, they suggest the collaborative and anonymous activity of painting and sculpture within lodges or urban guilds. Van der Weyden's St. Luke characteristically labors in front of a city view while engaged in an anonymous yet religious task.

STATUS OF THE ARTIST: CRAFTSMAN OR GENTLEMAN?

After religious painting, represented by van der Weyden in the guise of St. Luke, the depiction of a purely mercantile transaction between a painter and his middle-class patron may come as a shock. But that is precisely the exchange that Pieter Bruegel (ca. 1525–69) humorously represents in a drawing (ca. 1565; Fig. **1.4**), in which a bespectacled client reaches for his coinpurse while admiring the handiwork of a scruffy artist (almost surely *not* a self-portrait of Bruegel) on an easel. Spectacles are an obvious sign of shortsightedness, so here Bruegel undercuts the sensitivity of this buyer, who already sees the picture as something of a commodity or collector's item rather than as some kind of essential imagery. At the same time, Bruegel pokes fun at the unkempt craftsman-painter, intent on his work and pursuing his own vision, inaccessible to the patron he is obliged to humor. This artist lacks entirely the hard-won social status and dignity of guild members, even though Bruegel himself was a member of the painters' guild in the city of Antwerp. Instead, he seems to pursue an independent career, however close to subsistence, in the cut-throat world of the free market.

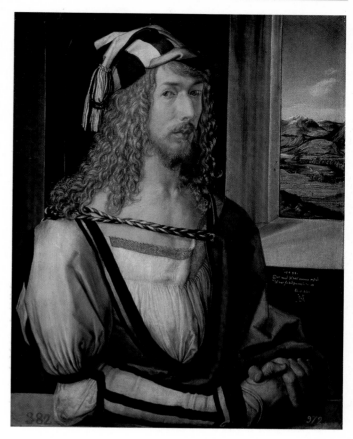

1.5 Albrecht Dürer, *Self-Portrait*, 1498. Oil on panel, 20½ × 16 ins (52 × 40 cm). Prado, Madrid.

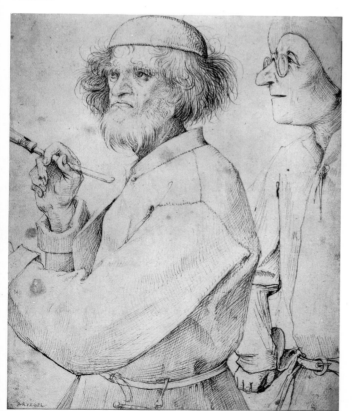

1.4 Pieter Bruegel, *Artist and his Client*, ca. 1565. Brown ink on paper, 9⅝ × 8½ ins (24.4 × 21.6 cm). Albertina, Vienna.

Despite its obvious level of accomplishment, this kind of art-making still was considered as a highly developed manual skill, stigmatized as physical labor. Even in Renaissance Italy, noblemen were forbidden by law from making art, because such manual labor was considered unseemly for gentlemen of leisure and learning. As a result, many of the artists who were glorified for their works during the Renaissance expended considerable effort on defending their activity not for its manual skills but rather for its intellectual attainments. During the sixteenth century, learned debates considered whether the visual arts could be considered superior to verbal, literary creations (the traditional center of the liberal arts). Visual artists usually based their claims on the arguments that sight is a sense superior to hearing. Moreover, painters, including Leonardo da Vinci (see p. 187), asserted that their medium was superior to sculpture, since it involved no physical exertion and could produce illusion through the mastery of scientific principles of perspective and optics. When famous Renaissance artists were portrayed by their colleagues or even by themselves, they usually appeared as gentlemen, well-dressed and dignified, and without a trace of the tools of their trade.

An exemplary image, proudly proclaiming his lordly clothes and pose as well as his mastery of the illusion of landscape, was produced and proudly signed by the German artist Albrecht Dürer in 1498 (Fig. **1.5**). Dürer was one of the

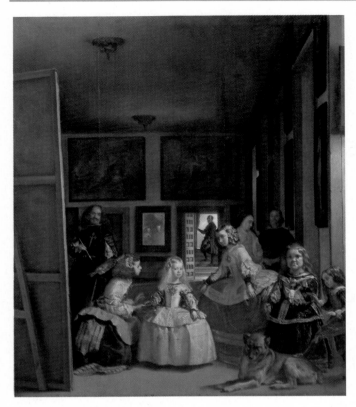

1.6 Diego Velázquez, *Ladies in Waiting*, 1656. Oil on panel, 127 × 108½ ins (322.6 × 275.6 cm). Prado, Madrid.

1.7 (Opposite) Detail of Fig. 6. Artist, mirror, and princess.

first artists to note the contrast between his own Nuremberg crafts organization and the Italian celebration of artistic individuality and originality. Writing to a friend from a visit to Venice in 1506, he noted, "Here I am a gentleman, at home only a parasite."

A breakthrough fusion of the two roles of gentleman and practicing artist was achieved only slowly. Stories from the sixteenth century about artists who worked for powerful princes marked the new esteem accorded to art in association with royalty or nobility. It was said in the mid-sixteenth century of the Venetian painter Titian (see p. 212) that even the Holy Roman Emperor and King of Spain, Charles V, stooped to pick up the fallen paintbrush of his esteemed court artist. Titian was also called the living Apelles to Charles V in the role of Alexander. He even received the singular honor of a knighthood bestowed by his grateful patron, a precedent that would be repeated in the subsequent century for artists at court, such as Peter Paul Rubens and Anthony van Dyck (see p. 243). However, no surviving images of Titian represent him at his painter's vocation.

Visually, the breakthrough of the gentleman-artist was attained a century later by Titian's great successor at the royal court of Spain, Diego Velázquez (1599–1660), who worked for Philip IV, the great-grandson of Charles V. The triumphant Velázquez image of himself as courtier-painter has come down

to us with the popular title, the *Ladies in Waiting* (Las Meninas, 1656; Fig. **1.6**). An enormous canvas shows the painter at work, facing the viewer from behind another enormous canvas (giving rise to numerous interpretations that he is painting the very picture that the viewer now beholds). The depicted setting is an actual room in the Spanish royal palace, the former quarters of the crown prince, now converted into an artist's studio for Velázquez. Early biographers of the artist have identified all of the figures in the picture, but their costume suffices to demonstrate that they, too, are courtiers of the Spanish royal house. Those same biographers reveal that both Velázquez and the man silhouetted in the doorway of his painting held high official court positions – as head attendants on the king and queen, respectively. His duties meant that Velázquez was in charge of court ceremonies for the king at audiences and festivals as well as the arrangement and adornment of the royal palace.

Like Apelles of Alexander (or more recently Titian of Charles V), Velázquez was the favored portraitist of his sovereign, Philip IV. But he was also a court servant like the attendants and dwarves who surrounded the central figure of the Spanish princess, Margarita, in the foreground of the painting. The mirror on the back wall reveals what is on the giant easel before the painter: a double image of Philip IV and Queen Mariana. Thus Velázquez portrays his role as artist as a double function of service to the monarch, both as attendant and as portraitist. For this kind of service he was rewarded with a noble title and membership in the exclusive Spanish chivalric society, the Order of Santiago. Velázquez proudly displays this membership in the cross emblazoned on his breast. He only received this in 1659 and then after rigorous cross-examination concerning his ancestry and his lack of compensation for his paintings, that is, his indifference to monetary gain through manual labor.

Velázquez, however, proudly proclaims his visual abilities as fully as his noble title and court office. By carefully constructing his interior space, filled with light, with such painstaking exactitude, he demonstrates his mastery of the prized intellectual accomplishments of Renaissance art theory: perspective and optics. By including recognizable pictures from the royal collection on the dark back wall, he clearly suggests his own ability to emulate the masterpieces of his predecessors; in this case Rubens, whose works were about rivalry in the arts between gods or gods and mortals. They were based on myths taken from the Roman writer, Ovid, who is in his turn now emulated in paint by the learned artist.

The uniqueness of Velázquez's skill also lies in his distinctive painterly touch, which produced a shorthand, sketchy vitality of brushwork yet nonetheless managed to create the illusion of likeness, enhanced by energy. Moreover, Velázquez has also challenged Nature herself in his portrait representation, by painting the mirror reflection of his own easel painting on the back wall. By doing so, he proclaims that painting can fully capture the living likeness of a human subject like a mirror (Fig. **1.7**). Yet painting can do more than merely capture a likeness. Painting can preserve that likeness for

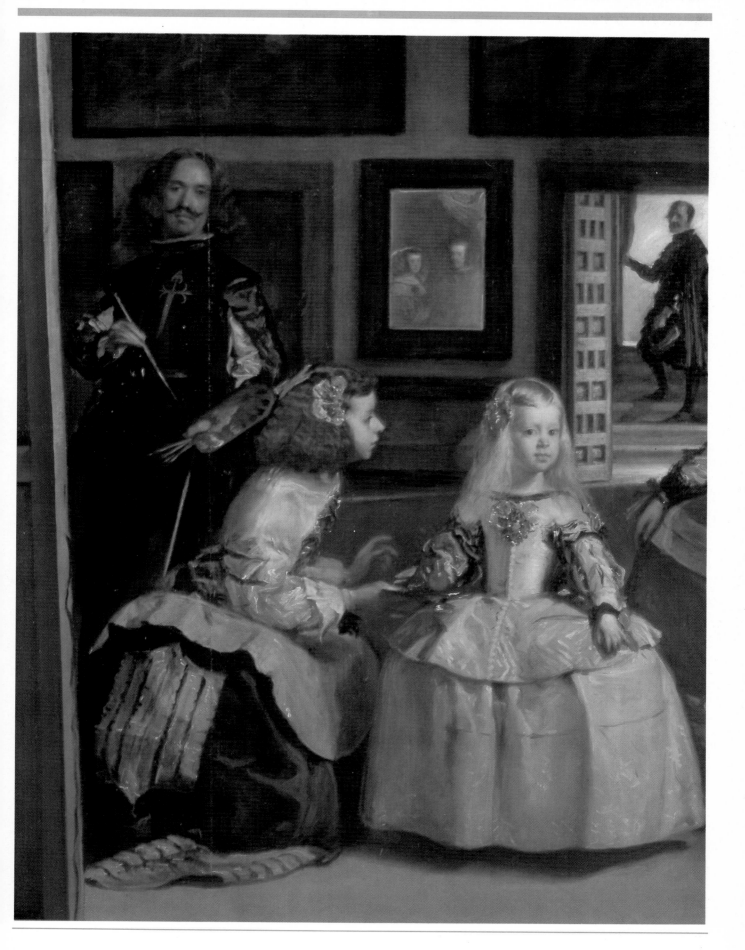

posterity and can further ennoble its subject, capturing through pose and composition the essential and permanent greatness of both the king and the skill of his portraitist. This message was not lost on Velázquez's early biographer, Palomino, who compares the artist to Phidias, the ancient Greek sculptor of the goddess Athena at the Parthenon, as well as to Titian (who is said to have produced a self-portrait showing the artist holding a portrait of King Philip II). Thus as long as the Greek gods or the Spanish kings are celebrated, their artistic creators – Phidias, Titian, and now Velázquez – can also bask in their reflected glory.

It should be noted that Velázquez's masterwork was not on public view; instead, it was the treasured possession of the king who commissioned it. The king is also implied as the privileged viewer, as if he sits with his queen to have his portrait taken by the artist and as if all the figures within the picture orient their gazes and actions toward his majesty. Later artists were taken as guests of the royal house to inspect this picture, which did take its place in the historical sequence of great artists working in Spain, from Titian to Rubens to Velázquez. Thus Velázquez demonstrated in his own works that painting can be the noblest of arts and the fitting adornment of the noblest of patrons.

1.8 Artemisia Gentileschi, *Self-Portrait as 'Painting'*, 1630. Oil on canvas, 38 × 29 ins (96.6 × 73.6 cm). Royal Collection, St James's Palace. © Her Majesty the Queen.

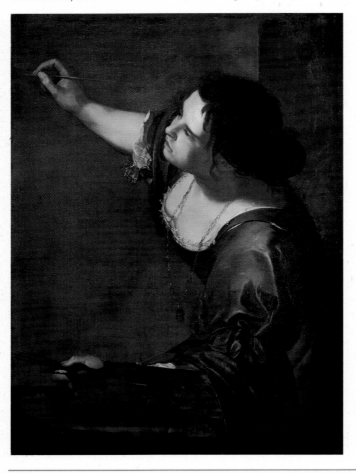

THE ART OF PAINTING

Some of the significance of Velázquez's image and of his own courtly position can be measured through comparison with his contemporaries in other countries. The case of two women painters suggests the alternative conventions of self-depiction as a professional artist as well as the more limited roles available both to women and to other painters in cities.

Artemisia Gentileschi (1593–ca. 1652), daughter of a Florentine painter, represented herself simultaneously as hard at work in the act of painting yet endowed with all of the attributes of the personification of Painting herself (1630; Fig. **1.8**). Since ancient Greece, allegories of abstract qualities had been portrayed by full-length females bearing distinctive identifying items. Rather than using the painter's activity alone as the basis of an image of the craft, Gentileschi based her more theoretical concept on contemporary handbooks for painters, summarizing their pictorial vocabulary. Gentileschi's self-portrait includes appropriate symbols of Painting: a golden chain with a pendant mask (imitation) and unruly locks of hair (poetic frenzy of creativity). At the same time, the artist has exploited her own female identity to fuse her own features onto the traditional female personification; she has also included her initials on the table as a signature. And she has shown herself as actively engaged in her profession, absorbed and thoughtful as she begins her work on a large, blank canvas.

Thus, Gentileschi, like Velázquez, can advance the elevation of the profession of the artist through claims to learning as well as to imitation and creativity. (It is even possible that Velázquez saw Gentileschi's self-portrait during his visit to the court at Naples where Artemisia then worked, so her masterwork may well have inspired his own.) At the same time she can also demonstrate her own ability to capture a likeness with a deft touch. This self-portrait integrates artistic theory and practice, learning and craft. By implication, as both model and painter, Gentileschi also asserts that the female artist is in a unique position to perceive and to transmit visual beauty.

Artemisia Gentileschi successfully found work for herself in a variety of Italian courts of her day, and her self-portrait was soon acquired by the King of England, Charles I. However, her sister painter, Judith Leyster (1609-60), remained a member (like van der Weyden and Bruegel before her) of a painters' guild in her native Dutch city of Haarlem. Leyster's self-portrait also depicts her at the easel, where she is painting her favorite subject, a merry youth in clownlike costume (ca. 1633; Fig. **1.9**). Like Velázquez and some earlier examples of high-status artists at work, Leyster portrays herself in elegant attire, with a starched collar and lace cuffs. Her relaxed pose and easy smile suggest a confidence and nonchalance, the expression of her professional assurance. The picture also directly places Leyster-as-sitter in dialogue with the viewer, as a "speaking likeness." Her portrayal of speech, as well as the depicted music of the fiddler on her canvas, rival the sister arts of literature and music in paint, as if in response to the theoretical arguments of Italian artists. Thus, even

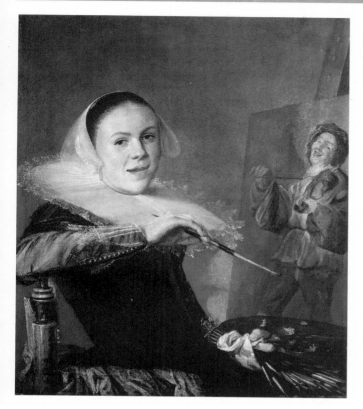

1.9 Judith Leyster, *Self-Portrait*, ca. 1633. Oil on canvas, 29⅜ × 25⅝ ins (74.6 × 65 cm). Gift of Mr and Mrs Robert Woods Bliss. © 1992 National Gallery of Art, Washington.

consciously set out to rival other art forms, specifically literature, drama, and music (although the mask has also been linked to the painter's goal of imitation, as conveyed on Gentileschi's pendant). Painting, it is claimed, is a superior art.

In Vermeer's image, the imitative or naturalistic aspects of painting seem to work in tension with its commemorative or idealizing functions. If the painter desires to express his learning or to convey an image of History, he still must do so through the literal rendering of a posed, live model. At the same time, his own historical costume and the outdated map of the Netherlands on the wall of his studio (another form of learning through imaging) point out that Vermeer does not simply mirror his own surroundings, but alludes instead to the Netherlands of the previous century, in line with the presence of the personification of History herself. In presenting all of these visual suggestions as lifelike illusion, Vermeer reminds his viewer that *all* art is illusion, capable of simulating familiar reality as well as referring to learned or historically distant concepts. Like Velázquez, Vermeer is a consummate master of pictorial techniques, including the suggestion of space and light. Yet at the same time, Vermeer's studio, filled with stage properties and populated by an anonymous painter and model, provides the inversion of Velázquez's ennobling interaction of art with royalty as practiced by a self-assertive court painter.

1.10 Jan Vermeer, *The Art of Painting*, ca. 1665. Oil on canvas, 47¼ × 39⅜ ins (120 × 100 cm). Kunsthistorisches Museum, Vienna.

outside the courtly world of Gentileschi and Velázquez, guild artists still concerned themselves with displaying their mastery of their craft as well as with proclaiming the status of painting as equivalent to other arts.

A final example from the seventeenth century of the newly acquired status and ambition of the profession of painting is *The Art of Painting* (ca. 1665) by Jan Vermeer (1632-75) from the nearby Dutch city of Delft (Fig. **1.10**). Recent research suggests that Vermeer did not have to work for the open Dutch art market like Judith Leyster; instead, he produced many of his exquisitely finished pictures for a single patron, an urban patrician who kept him "on retainer." This painting, however, remained in the painter's own family after his death and seems to have held special significance for Vermeer.

Unlike previous examples, Vermeer's image does not offer a self-portrait; indeed, the painter in the picture appears dressed in archaic costume from the previous century and is seen only from behind. He is working hard at his easel, painstakingly beginning a painting of a model, who poses before him. The model is dressed as an allegory, holding attributes – laurel wreath and trumpet of fame – derived from artists' handbooks. Vermeer used these elements to identify her as the muse of History, Clio, just as Artemisia Gentileschi had used the characteristics of Painting in her self-portrait. On the table on the left appear a book, a mask, and an open booklet, probably music. Once more the painter has self-

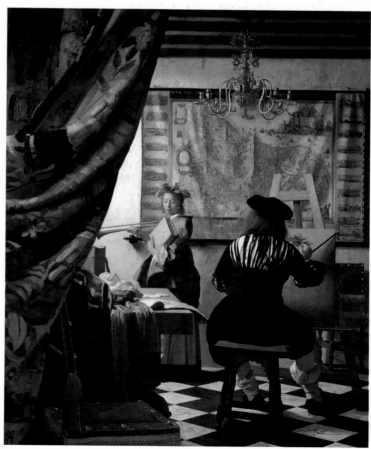

THE ARTIST AS CRITIC

Artworks have many sources of inspiration. Velázquez sought his place in the history of art by rivaling his famous predecessors as portraitists at the court of Spain. Vermeer, in turn, utilized the attributes of abstract concepts from thematic handbooks for his own personal meditation on his craft and its relationship to other art forms. But artworks need not be such original and personal creations. They can often be stimulated by other artworks, even be painted within the seemingly confining burden of tradition. After the completion of Velázquez's masterwork, his own picture as well as his other portraits of the king became in their turn standards of excellence for all successive painters of the Spanish monarchy. Yet from such a model another imaginative artist could produce his own impressive variation on a theme. Such an achievement was accomplished by the last great Spanish court painter,

Francisco Goya, in his *Family of Charles IV* of 1800 (Fig. **1.11**). Goya does not merely borrow from Velázquez; instead, his family portrait of Spanish royalty offers an updated reprise of the earlier masterpiece together with a barbed commentary, suggesting the decline of the monarchy from Velázquez's day to his own. The references to Velázquez are obvious: the central placement of a dazzlingly dressed royal personage, in this case Queen Maria Luisa; the insistent staring out of the picture by the entire royal group; plus the presence of the painter before a canvas at the left edge of the composition. Modern viewers can only express astonishment that the royal family did not perceive itself to be the objects of vicious, intentional parody. Goya's unblinking eye cruelly captures their coarse features atop their absurdly extravagant costumes.

1.11 Francisco Goya, *Family of Charles IV*, 1800. Oil on canvas, 110 × 132 ins (279.4 × 335.3 cm). Prado, Madrid.

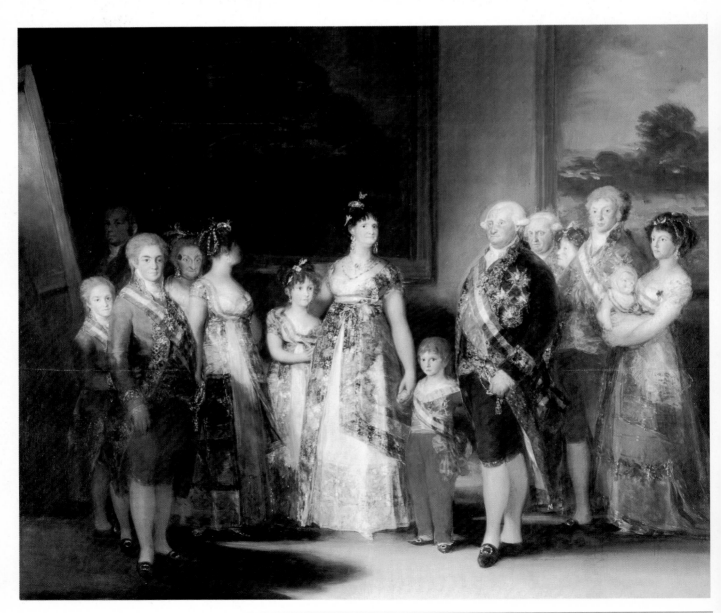

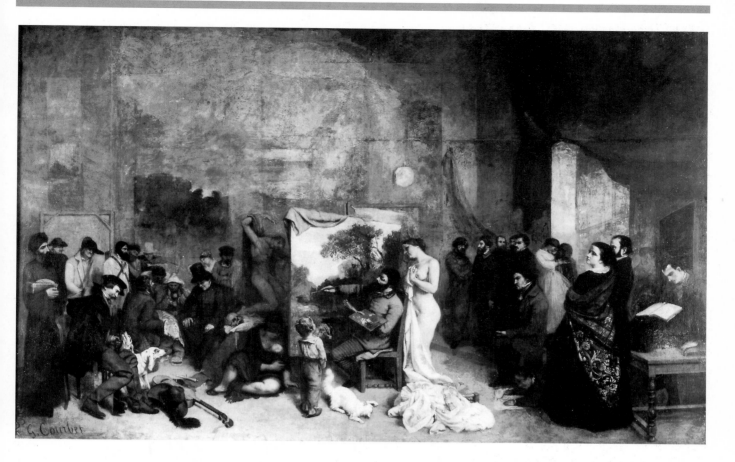

1.12 Gustave Courbet, *The Studio, A Real Allegory ...*, 1855. Oil on canvas, 142 × 235¾ ins (360.6 × 599 cm). Musée d'Orsay, Paris.

Goya has superficially emulated Velázquez's deft brushwork and his dazzling capacity to capture the surface glitter of silks and gilded decorations. However, instead of the mirror with the viewing king and queen, which holds the key to Velázquez's *Ladies in Waiting* and appears near the center of that composition, Goya includes the king and queen and all of the royal family fully within his group portrait. He even editorializes subtly by placing the queen rather than the king at the center of his image, occupying the place Velázquez had reserved for the princess and the ultimate controlling presence of the picture, the king in the mirror. In fact, during Goya's era Queen Maria Luisa was the unofficial ruler of Spain together with her lover, the prime minister. But what Goya also achieves with the removal of the mirror from within the painting is a totally new suggestion: the stares of the sitters, as well as that of the painter himself, face the canvas on which they are memorialized. The canvas, then, has *become a mirror,* and the unwavering assertiveness of these harsh portraits receives enduring credibility, even if art has lost the ennobling purpose that it held for Velázquez. However, in this case, grim banality replaces dignified majesty for both the royal sitters and their portrait artist.

Presumably Goya remains the privileged eye that takes in the reflection of the mirror in his group portrait, so we cannot say that he has truly removed himself from the transmitted image. Nor is this entirely the neutral reflection that one might expect at first from its equation with the surface of a mirror. Goya, after all, painted his royal portrait in the decade following the regicide of Louis XVI of France, together with all the other consequences that followed from the French Revolution. Like many other liberals in Spain, he saw clearly the follies and inequities of the repressive Spanish system of kingship and noble privileges. So his shadowy removal to the corner of the royal portrait is not a signal of his modesty in the presence of his august patrons; neither is it a declaration of his own pride at being in their company. Instead Goya presents his own isolation, despite his worldly rank, an isolation that is the very product of his sharp-sighted vision of the absurdity of that world around him.

THE INDEPENDENT ARTIST

Half a century later, in an imagined studio, the Parisian painter Gustave Courbet (1819–77) shows himself not only busy at work on a large canvas, but in contrast to the heritage of Velázquez and Goya he also insistently presents himself as an independent artist, surrounded by a world of his own making (Fig. **1.12**). The very title of this Courbet picture points to its ambitions and to its personalized quality: *The Studio, A Real Allegory of the Last Seven Years of my Life* (1855). Courbet does show his patrons in this image, but they are hardly

monarchs; instead, they appear among the shadows to his right side alongside his friends and other supporters, including members of the new profession of art critic. Now it is the artist who holds center stage, and Courbet makes it clear that his artwork flows from his internal imaginings and stored images, for he paints a landscape of a tree-lined brook from memory while within the confines of his studio. Also populating the artist's memory are the figures who appear among the shadows to his left. These comprise an almost random assortment of "picturesque" characters in costumes of poverty, rural provinciality, or those of a bygone era. Several of them had already inspired related figures in Courbet paintings during the previous seven years of his career, alluded to in the title of the picture.

Courbet, however, insists with Goya on the uncompromising naturalism of his figures. In this respect, he seems to relish and exploit the same tensions that stimulated Vermeer in his *Studio,* tensions that are summarized in the paradoxical title, a "real allegory." The nude who stands behind him at the easel, gazing longingly at the canvas, is the heritage of allegorical personifications from earlier centuries of art-making, when such a nude usually symbolized Nature herself or naked Truth.

Courbet makes her physical presence dominant by showing her as having discarded a bright pink contemporary dress, thereby reminding the viewer that this figure did not step out of the history of art so much as she has stepped out of her ordinary clothing. Courbet liked to insist that he was an unflagging realist, and he even christened his personal style of painting Realism with a capital "R." He is famous for having scoffingly challenged someone to show him an angel before he would paint it.

Despite the imagined landscape on his easel, Courbet prided himself on the directness and simplicity of his painterly transcription; that landscape, in fact, closely resembles the paintings from his native homeland in the Jura Mountains of eastern France, near his birthplace, the village of Ornans. In keeping with his Realist credo, Courbet includes two lifelike witnesses to his own activity as a painter: a little boy and a playful kitten. The little boy, simply dressed like the artist, stares intently at the canvas, while the cat attacks the pile of

1.13 Pablo Picasso, *Ladies in Waiting*, from a series of 14 canvases based upon Velázquez, 1957. Oil on canvas. Museo Picasso, Barcelona.

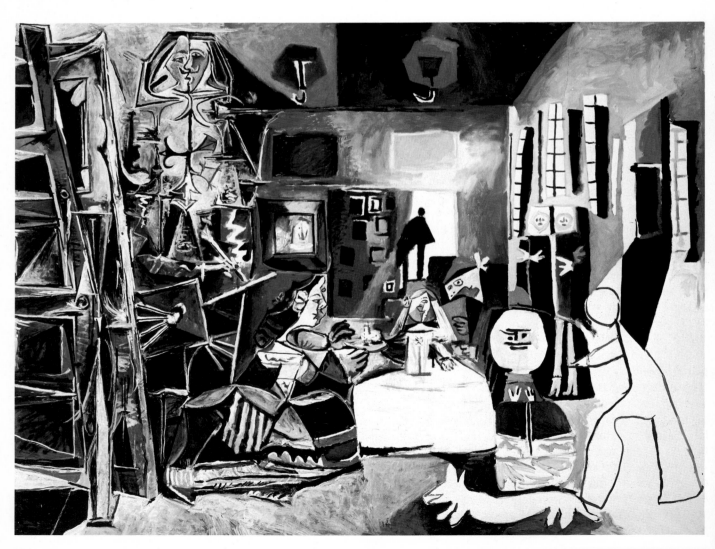

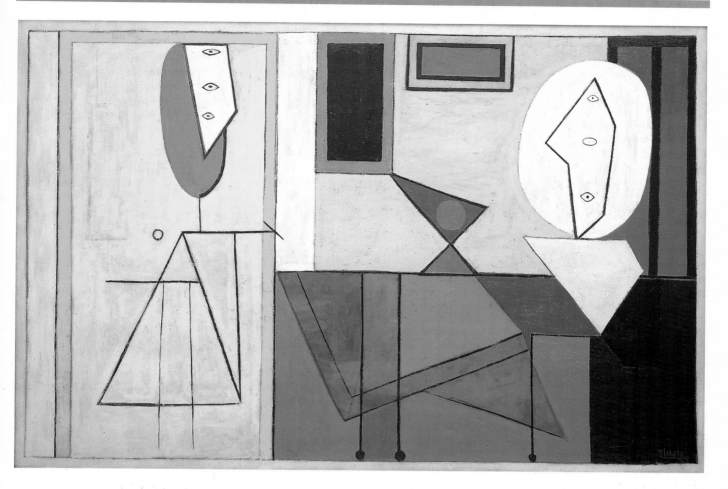

1.14 Pablo Picasso, *The Studio*, 1927–28. Oil on canvas, 59 × 91 ins (149.9 × 231.2 cm). Collection, The Museum of Modern Art, New York. Gift of Walter P. Chrysler, Jr.

drapery discarded by the nude model. In both cases, the activities on his studio floor provide analogies to the artist's own craft – derived from protracted, innocent gazing, yet at the same time born out of the playful use of imagination and the creation of subjective illusion for a viewer.

In this sense, the massive canvas by Courbet is a projection of the entire visual and subjective history of the heroic artist himself, now composed and arranged by him in his studio. Courbet even seems to suggest in this picture that he, like Velázquez, is in the very process of composing a summation of his life's work. However, now it is the artist alone – not the Church or some princely patron – who sets the agenda for the huge canvas that will be his distinctive contribution to the history of art.

If the artist can no longer depend upon the support of a patron, neither is he any longer responsible to anyone for his subjects or the character of his work. In the modern market situation where an artist sells his works to an often anonymous public through the mediating system of art dealers, the artist is left much more to his own devices and develops a recognizable trademark style much more as a form of self-promotion. Small wonder, then, that Courbet places himself alone at the center of his canvas. Indeed, Courbet displayed his *Studio* as the central work of his own daring self-exposition, a one-man Pavilion of Realism (funded by a private collector, who is pictured in the *Studio*) just outside the gates of the 1855

world's fair art exposition in Paris. Whether through public salons and expositions or through the private middlemen of dealers in their art galleries, artists of the modern era now had to rely on self-publicity to achieve personal renown and artistic success.

Autobiography and self-portraiture continued to lie close to the heart of many twentieth-century artists as well, none more than Pablo Picasso. Throughout his long and varied career Picasso frequently returned to the pictorial theme of the artist at work. Conscious of his position in the history of art, Picasso often utilized the masterworks of his predecessors, as if engaging them in visual dialogue. Picasso, a native Spaniard working in Paris, returned like Goya and Courbet to Velázquez, reworking the subject of the *Ladies in Waiting* (Fig. **1.13**). In many respects, the Velázquez model itself is about the identity of the artist and his vocation, and its authority provides a further challenge to Picasso. His translation of Velázquez is often quite literal, retaining all of the cast of characters of the original or singling out the princess for isolated attention. He employs muted gray tones in some canvases, brilliant colors in others. Picasso shows himself particularly responsive to the spatial complexities of Velázquez

and, within that great space, to the problems of figural proportions, which he exaggeratedly varies from picture to picture, sometimes ominously. In one of the pictures, Picasso extends the artist at his easel to the very ceiling, and throughout his series each of the elements of the original receives its own eccentric visual identity, making the reworked variant a hodgepodge of accumulated details. Some of Picasso's distortions have a character of irreverent bantering about the masterpiece in an act of defiance by the modern artist of his great predecessor. Other reworkings, however, especially the close-up facial studies of the princess, probe searchingly for a creative level of fantasy and innocence, often through bright new colors. Picasso uses his model not so much for parody as for an exercise on the dialogue – inevitable and essential in all painting – between copying and inventing, between illusion and virtuoso artistry, between the inherited traditions of art-making and the novelty of personal expression. By means of copying and varying it in his own terms, Picasso comes to possess the Velázquez, to subdue its power over him as a model yet at the same time to offer his own mature work as its modern successor within the chain of artistic tradition.

Earlier in his career Picasso had created his own, highly abstract versions of the artist at work in his studio (Fig. **1.14**, p. 29). With no dependence upon his predecessors, this image insistently reminds the viewer that painting is a two-dimensional medium and that illusion is a subjective state, created by an individual's perception of surface forms. Like *Painter and Model, The Studio* presents a painter before still-life objects on a table, a highly traditional subject that facilitates a reading of the painting. In this case a goblet with green circular fruit and a white bust sit on a table; on the wall behind hang two pictures in frames. The head of the painter and his own easel form a pictorial echo of the items in the room.

We can no longer identify the depicted artist in Picasso's studios with the painter himself, in the sense of a self-portrait, as we could with Velázquez, Goya, and Courbet. Yet these difficult readings of abstract linear forms as an artist at work suffice to establish just how much the painter has now become emancipated from any external demands on his image-making, either in the form of constraints by a patron or in the traditional urge toward convincing likeness or suggestions of naturalism. Even the personal aspect of an artist's self-conception, so important to Goya and Courbet, has been expunged from Picasso's abstract interiors, though other modern artists have often suffused their own self-presentations with intense passion or visionary overlays. One artist, Robert Rauschenberg, dispassionately replicated his own x-rays as the basis of an image (*Booster*, 1967), while other artists, led by Salvador Dali and Andy Warhol, managed to make their public personas into celebrities as dominant as any of the images they created.

For the most part, the depiction of artists at work on their craft remains confined to a limited period in the Western art tradition, a period when the profession of artist essentially defined itself. Between the sixteenth and the twentieth centuries, the concept of "fine art" grew out of a craft tradition, and the celebration of creativity and personal fame eclipsed guild anonymity. Today artists enjoy such total freedom to invent, such a compulsion to be original, that the depiction of men and women at work before an easel would actually be far too confining an image of art-making. In this respect, the aged Picasso recognized the modern climate of total invention, and he almost predicted the extinction of the very pictorial subject, the artist in his studio, that he brought to its contemporary conclusion: "Freedom, one must be careful of that. In painting as in everything else . . . Freedom not to do one thing requires that you do another, imperatively."

EARLIEST ARTISTS

Twentieth-century archaeologists have also explored the earliest pictorial ensembles: large-scale wall and ceiling paintings deep in the recesses of caves in northern Spain and south central France. Beginning around 25,000–20,000 BC, incised outlines of animals appeared, followed by pigmented animal images around 18,000 BC, and climaxing with the remarkable likenesses of diverse fauna in such caves as Lascaux (ca. 15,000 BC) and Altamira (ca. 14,000–10,000 BC). The roster of animals rarely includes the chief food and staples supply, reindeer, emphasizing instead bison and horses as well as a few other rarer creatures, almost all of them presented in the convention of profile. Consistent, nonrepresentational symbols and further unexplained markings also appear on cave walls alongside the lifelike animals. Reinforcement of pigment suggests that paintings were recreated, possibly in conjunction with some repeated ritual or activity, but of course the nature of that activity cannot be recovered in the absence of any other evidence (markings on stone surfaces, however, do show a sophisticated marking of calendrical time). That the spaces of the paintings lie so deep in their caves and require such effort to reach, let alone to light and to decorate, reinforces our intuition that these images held great social importance.

Within this communal and social gathering-place, however, artistic assertion also emerges. Recently scholars have theorized that subtle distinctions in choice or use of pigment could serve to distinguish individual painters, almost like modern artistic personalities, though we cannot be certain whether cave artists desired to have their personalized contributions singled out in this way (or whether such differences are inevitable in any case, with the scholars anachronistically assigning importance to such differences from their modern concepts).

However, one indisputable sign of artistic self-consciousness does appear on the walls of some prominent cave ensembles in the form of pigmented hand stencils. In one cave, Gargas, a group of some 160 traced hands, painted in the principal pigments of red ocher and black manganese oxide, appear on the walls in various combinations of raised and lowered fingers (thought by some scholars to be mutilations); these hands cluster as sets in different segments of the cave halls. At Peche-Merle, in addition to finger tracings of animals

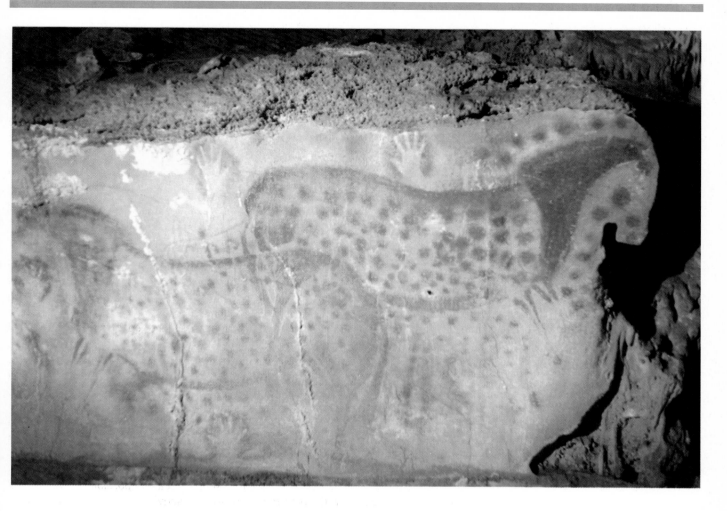

1.15 *Spotted Horses and Negative Hand Prints*, Pech-Merle cave, near Lot, France, ca. 15,000–13,000 BC. Murals, approx. 11 feet (3.35 meters) high.

(as well as women with pendulous breasts) in wet clay, undistorted hands appear in smaller numbers but in close conjunction with painted animals, including distinctive spotted horses (Fig. **1.15**). Repetitions at Gargas of identical hands, including the hands of younger persons, often combining hand signs with specific animal images, point to a ritual function of these images within their specific cave spaces. Hence the hands suggest symbolic hunter gestures, unspecifiable as to exact meaning, but clearly signaling the presence of their art makers as fully informed initiates within the complex system of animal paintings in Pyrenees cave art.

Of course, it is not fruitful to be concerned with the biography or the personal expression of the anonymous, if assertive, hand painters of European Paleolithic caves. Even without richer knowledge of the purpose(s) of such images, the ritual or other repeated use of this art clearly depends upon its social context. An examination of all subsequent cultures further confirms this interdependence of art and society, even in so permissive a society for artists as Picasso's Paris. And if we turn to ancient societies, such as Egypt and the cultures of Mesopotamia, we can readily observe the fundamental role or artworks in the display of centralized power and cultural authority, especially when reinforced by religion.

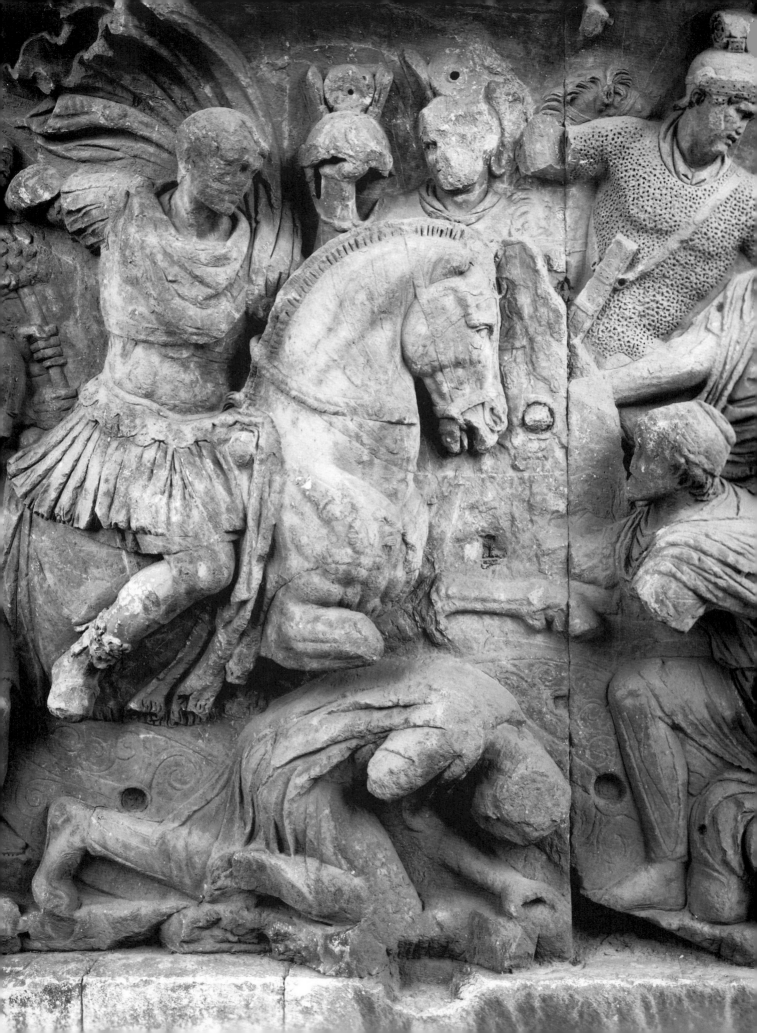

2

ANCIENT ANCESTORS

Production of art objects usually stems from surplus in society, although the images on the walls of Paleolithic caves (from as early as around 15,000 BC) cannot be assigned to any group other than hunter-gatherers. Even those caves works imply a system of symbolic communication that organizes imagery into spatial clusters and the repetition of associated figures (possibly in connection with rituals). Cave paintings also reveal self-conscious production on the part of their creators (the handprints of Gargas and Peche-Merle; see p. 31, Fig. 1.15.

When large urban settlements consolidated, usually along the banks of large rivers for both irrigation and transport, organized art production became possible. By the end of the fifth millennium BC, such urban centers had emerged in the area between the Tigris and Euphrates Rivers (Mesopotamia) and in the Middle Eastern region known as Sumer. Later, Asian civilizations grew up during the third millennium along the Indus River (modern Pakistan) and Yellow River (modern China). Archaeological evidence from the "Harappan" Indus culture even reveals some trade with Sumerian Mesopotamia, but none of the massive temples and palaces characteristic of Sumer have survived. In China, by contrast, in the centrally planned capital cities of the second millennium (Zhengzhou, established ca. 1600 BC; Anyang, ca. 1300 BC) decorated ritual vessels made of cast bronze in a variety of complex shapes and sizes were produced for the tombs of authoritarian rulers, the Shang dynasty (to 1027 BC). Such vessels, as well as elements of their decoration (and a basic calligraphy still used in modern Chinese writing) survived in elaborate variants for almost 800 years in China under the Zhou dynasty.

Sculpted reliefs on The Arch of Constantine, Rome, reused part of the "Great Trajanic Frieze"). See p. 81.

EGYPT AND ASSYRIA

ANCIENT EGYPT

Compared with such impressive early cities and states, the degree of centralized power and consolidated wealth of Egypt is astonishing and occurred extraordinarily early. When Narmer successfully united the Nile River regions of Upper Egypt with the delta of Lower Egypt (ca. 3200 BC) to found the first dynasty in a nearly 3,000-year royal rule, he established an unprecedented political unity (perhaps abetted by the protection of seas and desert). With the advent of the fourth dynasty in 2680 BC, the full majesty of the Old Kingdom asserted itself in Egypt, chiefly in the form of imposing buildings and their decorations.

THE PYRAMIDS At Giza, just outside modern Cairo, the kings of the fourth dynasty constructed their own permanent monuments: the pyramids (Fig. **2.1**). Purity of design and permanence of materials were fundamental to Egyptian thought, inasmuch as the rulers headed an elaborate cult of the dead, believing in the continuation of the spirit (*ka*) after life. Elaborate tombs for rulers and public officials began

in the Old Kingdom and continued throughout Egyptian civilization. Tombs were supplied with paintings and reliefs, often depicting the provision of amenities and pleasures for the deceased, and statues in the tomb of a dead man offered havens for the permanent residence of his soul, even while his mortal remains were mummified and carefully stored in stone coffins, or *sarcophagi*. Kings, in particular, were understood to take their place among the gods after death, notably the sun god, Ra, or the younger chief god of the sky, Osiris, within a complicated pantheon of divinities. Pyramids and the tombs constructed in their shadows at Giza for the royal family and courtiers signaled both the personal importance of the individual ruler and the unalterable stability of the kingdom of Egypt.

According to Egyptian tradition, the first builder in stone (later revered as a god in his own right) was named Imhotep, a priest and chancellor under King Zoser (ca. 2780 BC). Indeed Zoser's Step Pyramid at Saqqara, built by Imhotep, provides the model in stone for the great pyramids of Giza. The pyramids themselves were not tomb structures (although they did contain a simple sarcophagus) but rather markers of the ceremonial tomb precinct and temples for each ruler (the

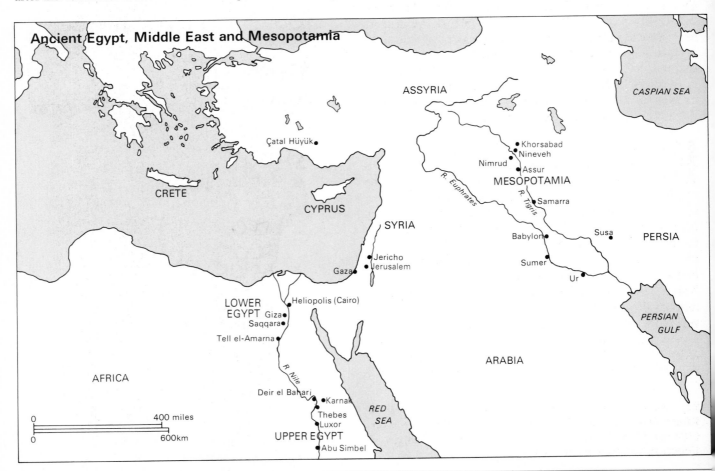

Ancient Egypt, Middle East and Mesopotamia

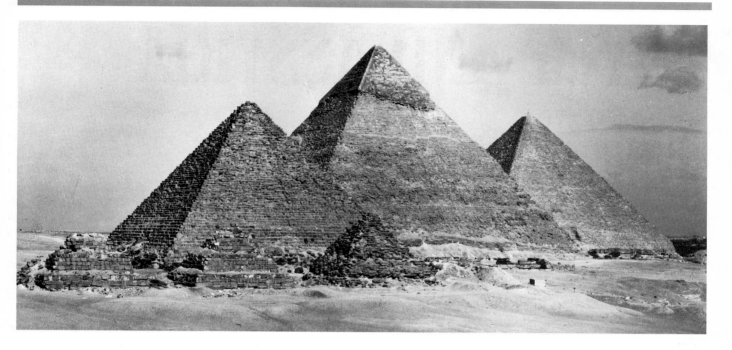

2.1 View of pyramids, Giza. Built by Mycerinus, Chephren, and Cheops, Dynasty IV, ca. 2650–2570 BC. Limestone, Chephren pyramid with sides of 755 feet (230 meters), 480 feet (146 meters) high.

smaller pyramids in front of them commemorate the three queens of Mycerinus). Their pure geometry derived from the cult of the sun god, Ra, whose own obelisk monuments terminated in a pyramid summit. The smaller size of the latest pyramid and the absence of any comparable monuments in later dynasties point to the drain on resources, both human and material, after Mycerinus. Thereafter the grandest monuments were consecrated to Ra, honoring the sun god as divine father of the ruling kings after the fifth dynasty.

EGYPTIAN SCULPTURE Within the temple precinct, permanence dictated the materials and forms of royal memorial sculptures. Slate, one of the hardest stone substances, was used for those of Mycerinus and Queen Khamerer-nebty (Fig. **2.2**). Shaped through abrasion and polishing (though unfinished in its lower portions and originally painted), the slate retains the outlines of its basic block. The pose is restrained and balanced, arranged to be seen from a strictly frontal viewpoint. Egyptian sculpture conformed to a strict "canon," or body of rules, in this case a proportional grid of relations between the various parts of the body, which was superimposed over carved blocks, relief carvings, and painted figures. Like the uniform striding poses adopted for figures in order to show body parts and costume in the most characteristic aspect, the canon reproduces in visual terms the powerful

2.2 *Mycerinus and Queen Kha-merer-nebty II*, slate from King's Valley Temple, Giza, Dynasty IV, ca. 2570 BC. 48⅞ ins (124 cm) high. Harvard University – MFA Expedition, Courtesy Museum of Fine Arts, Boston.

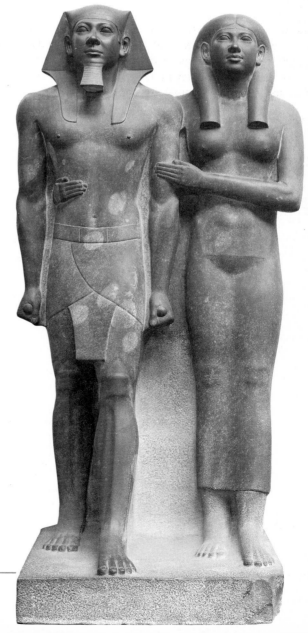

2.3 **Bust of Prince Ankh-af, from Giza, Dynasty IV, ca. 2630 BC. Limestone with paint on plaster, 22⅛ ins (56 cm) high. Courtesy Museum of Fine Arts, Boston.**

authority of consistency and permanence (lesser figures and foreigners, in contrast, could be shown as smaller in size and even distorted in details). The solid authority of Mycerinus, subtly supported yet complemented by his queen, emerges from his costume essentials, his frontal and immobile pose, and his powerful figure.

Egyptian sculpture could also emphasize more naturalistic details, as the keenly observed portrait likenesses of "reserve heads" from the Giza tombs reveal. A similar verisimilitude marks the face of a prince, Ankh-af, shown in Fig. **2.3**. An uncle of Chefren, he served as vizier and Overseer of the King's Works and was buried in his own turn in the tomb complex of Chefren. Its lifelike presence is enhanced by red pigment on plaster, and, originally, a short, painted beard would have completed the effect.

THE NEW KINGDOM The conformity of Egypt's traditions and canons is striking, but over the course of centuries even the most conservative inclinations reveal a discernible drift toward new forms. By the time of the New Kingdom (1570–1085 BC), beginning with the eighteenth dynasty and the zenith of Egyptian territory and power, a major new emphasis on visual display found expression. Early in the dynasty the powerful reign of a female pharaoh, Hatshepsut (1504–1483 BC), set a powerful example of imperial grandeur in building, particularly at the new national center at Thebes. On the west side of the river, the Valley of the Kings contained burial temples for rulers, while on the eastern shore the capital city featured the massive temple shrines of Luxor and Karnak, dedicated to the god Amun (fused with Ra as a sun deity), as a national cult. Inside the royal tombs the plaster walls are covered with painted figures; the principal

scenes feature worldly pleasures, such as feasting, fowling, or entertainments. In general, however, the power of the gods – and the high priests of their cults, especially of Theban Amun – dominated, rather than the cult of the pharaoh himself (or herself), as in the Old Kingdom.

As a result, during the New Kingdom, especially under Amenhotep III of the eighteenth dynasty (1410–1372 BC), the definitive shape of the Egyptian temple crystallized into a progression of spaces, with new segments added to Luxor or Karnak by successive rulers (Fig. **2.**4). Typically, the entrance, restricted to a small elite, was reached after an avenue of sphinxes, stone effigies of reclining lions with human or animal heads. Marked by a pair of massive mural *pylons* (flanking towers), often aligned westward to face the setting sun, the gateway typically featured colossal statues of the king. Within the temple a large court surrounded by *columns* was followed by a *hypostyle* hall, distinguished by its many columns, sometimes with the central rows higher to emphasize the main *axis*. Each of these repeatable spaces, characterized by towering *axial* forests of columns with papyrus stalk shapes and palm-leaf *capitals*, were alternated with open courts with heavy slab roofs. The temple procession culminated in a triad of chapels, each one housing cult statues of the god in a small, dark space available only to the high priests and the inner circle of the royal court.

2.4 **Luxor, Temple of Amun, gateway, begun by Amenhotep III and completed by Rameses II, Dynasties XVIII-XIX, 1417–1237 BC.**

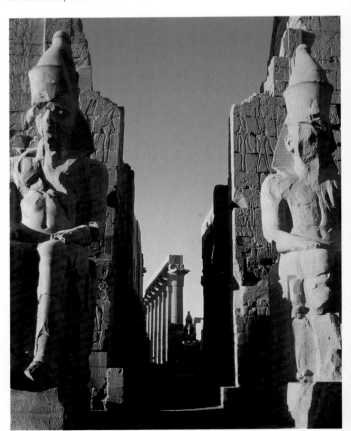

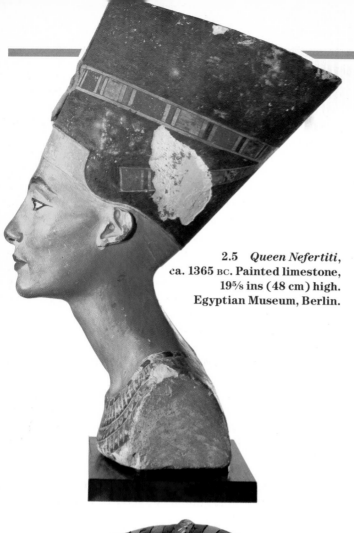

Within the framework of the New Kingdom under King Akhenaten (Amenhotep IV, 1372–1355 BC) a new capital at Amarna and a new monotheistic cult of the sun-disk, Aten, were established, only to revert to earlier traditions and the restoration of Thebes as capital city after his death. Artistically this "Amarna Revolution" introduced a new delicacy and aestheticized refinement as well as an emphatic, uncanonical naturalism into Egyptian art, even where it maintained contact with some earlier tradition, as in the painted limestone model portrait of Akhenaten's queen, Nefertiti (Fig. 2.5). Even allowing for their gender differences, in comparison to the ruddy and rounded forms of Ankh-af or the simpler symmetries of Queen Kha-merer-nebty, this likeness emphasizes the queen's elegant beauty of svelte neck and fine features with its subtle modeling of her distinctive age and appearance.

2.5 Queen Nefertiti, ca. 1365 BC. Painted limestone, 19⅝ ins (48 cm) high. Egyptian Museum, Berlin.

TUT-ANKH-AMEN Akhenaten's son-in-law and successor was a minor, short-lived king, Tut-ankh-amen (ca. 1355–1342 BC), a compromiser who began the restorations to Egyptian traditional orthodoxies (hence the significant name change from a stem with Aten to a stem with Amen). But "King Tut" is one of the best-known rulers of Egypt, after the spectacular discovery in the Valley of the Kings of his undisturbed tomb in 1922. The splendors lost over centuries

2.6 King Tut-ankh-amen, mask from tomb in Valley of Kings, ca. 1352 BC. Gold inlaid with enamel and semi-precious stones, 21¼ ins (54 cm) high. Egyptian Museum, Cairo.

2.7 Back rest of throne from tomb of King Tut-ankh-amen, ca. 1352 BC. Carved wood with gold inlay, glass paste, semi-precious stones, silver; 41 ins (104 cm) high. Egyptian Museum, Cairo.

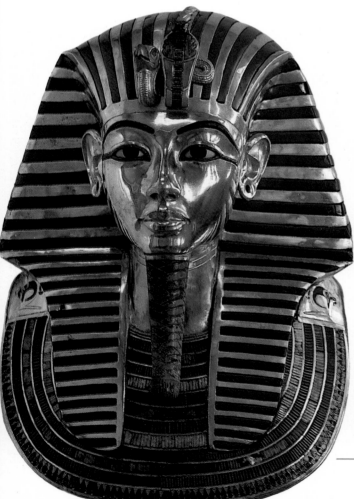

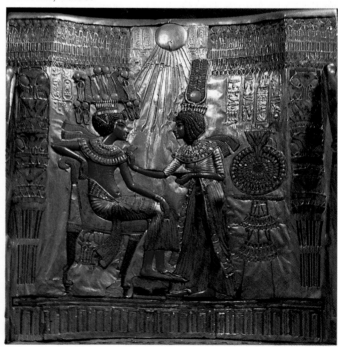

to grave robbers are best understood through the precious materials and exquisite workmanship of the mummy-case mask, showing the divine beard and animal symbols of the two regions of Egypt (serpent of Lower Egypt, vulture of Upper Egypt; Fig. **2.6**, p. 37). Much of the elegance of the Amarna forms has been retained here, yet the solemnity and symmetry of this boyish face reach back to the imagery of Mycerinus and the Old Kingdom, at the same moment that the royal and priestly traditions were being reestablished at Thebes. Closer to the Amarna visual idiom is the more personal monument of Tut-ankh-amen, his tomb throne, again embellished with gold, silver, semiprecious stones, and enamal-like glass paste (Fig. **2.7**, p. 37). Here the previous cult of the solar disk still appears above both king and queen, whose poses of royal ease and elongated proportions defy the formality of traditional canons.

With the death of Tut-ankh-amen, the New Kingdom passed to the new nineteenth dynasty, which reacted strongly against the reforms of its predecessors, often imitating Old Kingdom forms and canons. Conservative yet grandiose, these final monuments of the New Kingdom included the addition of new temple precincts at Luxor and Karnak as well as self-aggrandizing monuments, such as colossal statues and reliefs of military conquests, often set before public pylons. By this point Egypt more closely resembled the succession of neighboring city-states in Mesopotamia, whose increasing size and power eventually led to her conquest, first by the Assyrians in 670–664 BC, then later by the Persians (525 BC) and Alexander the Great of Macedonia (332 BC; see pp. 58–61).

2.8 *King Assurnasirpal II Killing Lions*, from Palace at Nimrud, ca. 883–859 BC. Alabaster relief, 39 × 100 ins (99 × 254 cm). British Museum, London.

ASSYRIA

The Assyrians took their name from the Tigris city of Assur, once a smaller Sumerian state. Their prominence in Mesopotamia followed the decline of a series of post-Sumerian empires, highlighted by the domination of Babylon (especially under King Hammurabi, 1792–1750 BC) during the second millennium until about 1350 BC. Eventually the Assyrians developed control over the entire region of greater Mesopotamia and threatened the boundaries of Egypt (Assurbanipal sacked Thebes in 663 BC) until their own defeat in 612 BC. Their great conqueror was King Assurnasirpal II (883–859 BC), whose lavish palace set the tone for subsequent Assyrian rulers.

Assurnasirpal moved his capital from Assur to Nimrud and introduced the tradition of ornamenting his palace with carved *reliefs*, a new medium for Mesopotamia. Running in a continuous narrative frieze, these alabaster reliefs focus entirely on the glory of the ruler, showing a chronicle of his military exploits, as well as his skills as a hunter, or else making him the object of homage from subjects and conquered peoples. Protective monster figures appear in palace reliefs, but otherwise there is no explicit Assyrian reference to religion. Unlike the Egyptian use of enhanced size to show social importance, King Assurnasirpal appears among his courtiers on the same scale, exposed to the same dangers (Fig. **2.8**). One of the most striking elements of these shallow Assyrian reliefs is the naturalism of their animal renderings, whether in the form of chariot horses or lion quarry. As in Egyptian reliefs, possibly known to Assyrian carvers, the favorable poses of both humans and animals in profile provided both animation and restraint for these unfolding actions. But the scenes of power and the cruel subjugation of captive cities

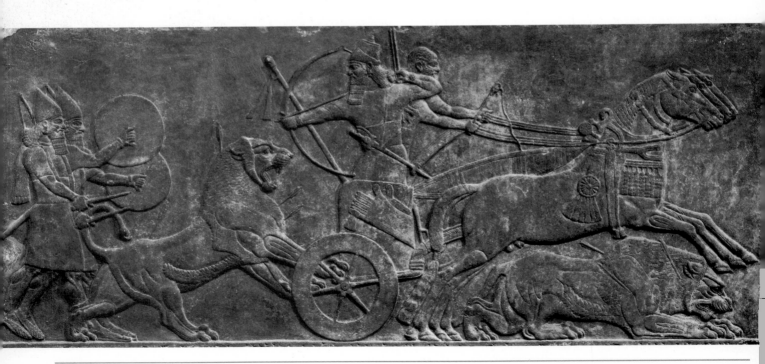

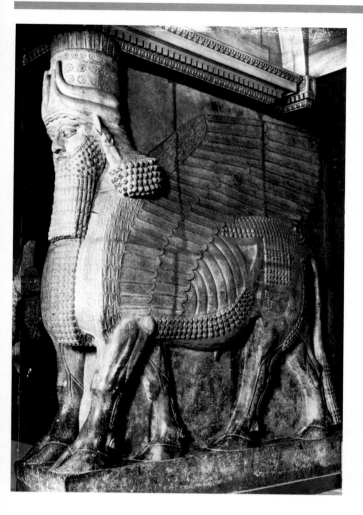

2.9 Winged Bull, Palace of King Sargon II at Dur Sharrukin (modern Khorsabad), late eighth century BC. Limestone, 166 ins (421 cm) high. Louvre, Paris.

Assyrian artistic vocabulary was incorporated into the new capital of Babylon. The reconstructed Ishtar Gate of the palace retains decorative profile reliefs of dragons and bulls (as well as lions elsewhere) found for two millennia in Mesopotamian seals and other reliefs, now reproduced on brilliantly colored glazed bricks for the processional entryway to the temple precinct (Fig. **2.10**). The terraced Hanging Gardens, celebrated as one of the wonders of the ancient world, and the towering ziggurat, a stepped temple mount incorporated into biblical legend as the Tower of Babel, have long since disappeared from Babylon in the wake of its devastations by conquests and erosion. Like most Mesopotamian states, Babylon was an unstable entity, continually pressured by rival neighbors, including her eventual captor, Persia. Persia, in turn, developed her own ambitions to overrun a rival civilization of related city-states based in Asia Minor and around the Aegean Sea. Her setback in the Persian Wars at the outset of the fifth century would lead instead to the ascendancy of Athens and the launching of a Greco-Roman culture which shaped the Western artistic tradition that will be the main subject of this book.

2.10 Ishtar Gate from Babylon, ca. 575 BC. Glazed brick. Staatliche Museen, Berlin.

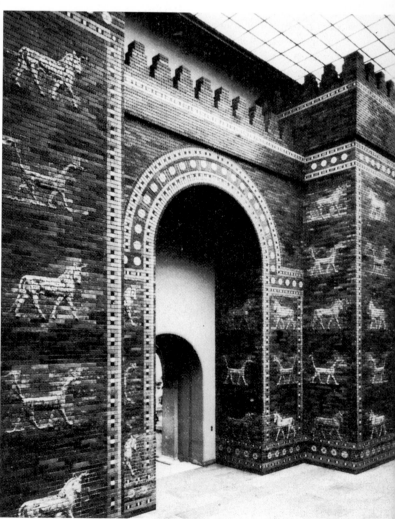

or animals served primarily to impress palace visitors with the power of their royal host.

To date, few of the great palaces of the Assyrians have been excavated, and their mud-brick construction enabled later conquerors as well as time to work considerable destruction. However, the massive palace of Sargon II at his new, short-lived capital of Dur Sharrukin (late eighth century BC, near modern Khorsabad) did reveal massive portal figures: winged bulls with human faces and divine headdresses in a kind of double relief, seen in most favorable aspect from both the front and flank (Fig. **2.9**). Like the sphinxes of Egypt, these are guardian figures, muscular and imposing, symbols of the royal power within. After the Khorsabad palace, later Assyrian rulers, chiefly Sennacherib (705–681 BC) and Assurbanipal (669–626 BC), established their centers at Nineveh (modern Kuyunjik), which eventually fell in its turn to new rulers, centered briefly again in Babylon.

ISHTAR GATE, BABYLON Under Nabopolassar and his son Nebuchadnezzar (a name known from biblical accounts of his capture of Judea), some of the same

GRECIAN GLORIES

According to Greek myth, the goddess of wisdom, Athena, sprang fully-grown from the head of her father, the king of the gods, Zeus. For Athens, the city of Athena, however, historical reality was considerably more complex. The Greek city-states were relative latecomers to political and artistic prominence in their Mediterranean region, preceded by a series of dynasties in Egypt that extend as far back as 3100 BC and by successive empires in Mesopotamia, the Fertile Crescent between the Tigris and Euphrates Rivers. By 2000 BC Minoan civilization flourished on the island of Crete and extended its dominions to the Greek mainland before falling prey to invaders, the first people eventually known as the Greeks, around the year 1450 BC.

Economic and military consolidation on the mainland led to the eventual formation of the Greek city-state, or *polis*, in which citizenship, usually implying some degree of land ownership, substituted for kinship as the basis of the political unit.

Each *polis* commanded the loyalty of its residents in judicial, religious, economic, and military matters. However, only a small percentage of residents were citizens of a *polis*; strangers and slaves made up a large laboring class of non-citizens. By the end of the eighth century BC (and up to about 550 BC) Greek cities were already establishing colonial settlements in such areas as Sicily and Asia Minor as extensions to their flourishing commerce. Some Greek cities formed political and military alliances, led by the Peloponnesian League, a federation headed by Sparta. And the oral literature of Homer was written down in the Greek letters that have given the name to our modern alphabet. The use of writing led to the development of a rich tradition of poetry and drama.

Greek religion, though diverse, included a number of rituals and celebrations that were taken part in by all the Greeks (and hence known as "Panhellenic"). Events such as these encompassed the entire peninsula and promoted the

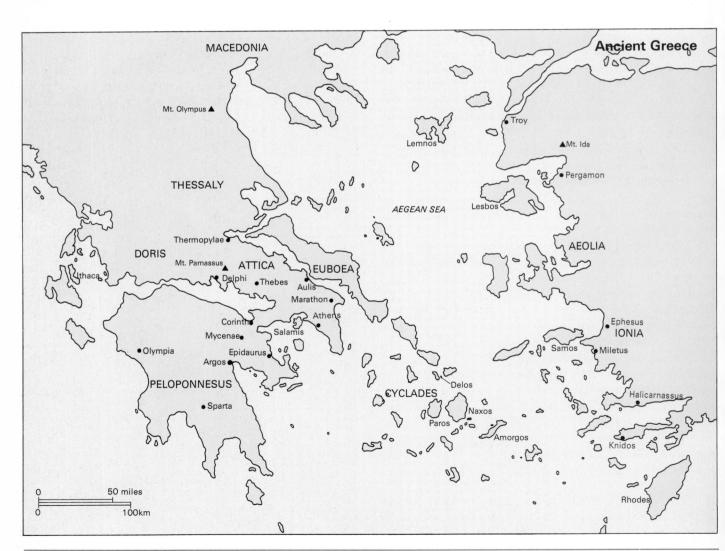

The Greek Temple

Well before the turn of the sixth century, BC, Ancient Greece had developed its two principal forms of architecture: the mainland Doric, exemplified at Olympia and Athens, and the Asia Minor Ionic. The principal construction of Greek architects remained the cult temple, housing the statue of the venerated deity and hence designed along the lines of a simple house structure, while public worship took place at a detached, open-air altar, usually to the east of the temple. Greek temples are dominated by a surrounding row of columns, or colonnade, supporting a roof space, or portico; the entire ensemble is called a peristyle. Such porticos could also be adapted for independent use as public buildings, or stoas. Columns, composed of tapering segments, or drums, were typically fluted, that is decorated with continuous running grooves. Inside the peristyle, the cult statue resided within its own room space, the cella or naos, entered through a forecourt, or pronaos.

On its exterior, the temple columns supported a roof slab, or entablature, culminating in a triangular gable, or pediment, the very image of stability atop the sturdy physicality of the colonnade. Sculpted decoration of lifesized figures ornamented the pediment, while relief carvings also filled the frieze level below the pediment, although the use of carvings in space varied between the Doric and Ionic models. Originally painted, these sculpted upper zones offered a bright figural climax to the temple façade.

Typically the chief difference between Doric and Ionic architecture types, or orders, consists of different column types and different decoration above the column at the frieze level. Doric columns typically had no base (added later by the Romans), tapered sharply, and their capital consisted of a flat slab (abacus) atop a cushion shape (echinus). Doric friezes consist of two parts. The first element presents a vertical grooved block, or triglyph, which echoes the vertical strength of the columnar shafts below and derives from the original beam ends of wooden buildings, such as the Temple of Hera at Olympia; alternating with triglyphs are metopes, the slabs between beams, suitable for sculpted relief ornament. Ancient writers contrasted the starker "masculine" Doric with the "feminine" ornateness of Ionic.

Ionic temples, such as the celebrated Temple of Artemis at Ephesus, one of the wonders of the ancient world, featured a full, running frieze of carved figures, uninterrupted by triglyphs. Ionic columns atop a molded base showed taller, more slender, nearly cylindrical shafts with narrower flutes, culminating in a more ornate capital composed of curving scroll forms (volutes). Occasionally Ionic temples use carved support figures, atlantes (male) or caryatids (female) in place of columns.

Doric and Ionic orders.

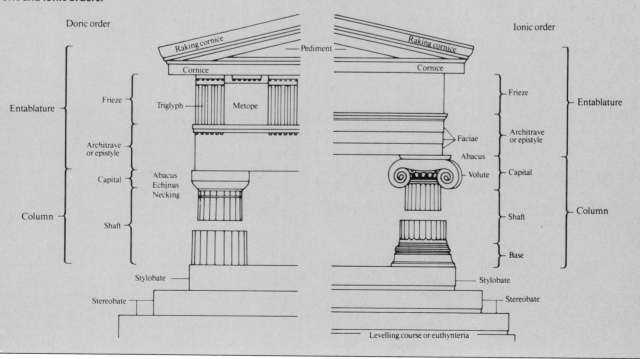

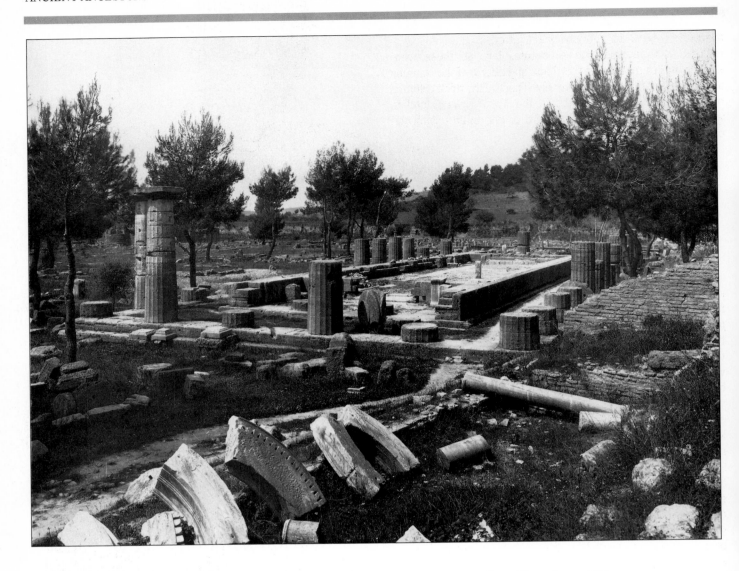

settlement of conflicts between city-states. One sacred site was Delphi, site of the oracle of Apollo (god of light and reason), whose priests were believed to be able to answer questions put to the god. Celebrations every four years at the oracle of Zeus, king of the gods, at Olympia featured gymnastic competitions and horse races besides religious ceremonies.

DORIC TEMPLES: OLYMPIA AND DELPHI

OLYMPIA features some of the earliest important remains of a Greek temple precinct. Early temples, housing the cult of a god or goddess, presumably were constructed in wood, giving rise to the trunklike columns supporting a flat *entablature* (between the columns and the eaves) in the building system known as post-and-lintel. The Temple of Hera (Roman: Juno), goddess of the hearth and wife of Zeus (Roman: Jupiter), was built at Olympia about 600 BC on a stepped terrace with wooden columns on the foundations of two earlier temples; the roof area was faced in fired clay, or

2.11 Temple of Hera, Olympia, ca. 600 BC.

2.12 Temple of Zeus, Olympia, 470–456 BC. Reconstruction.

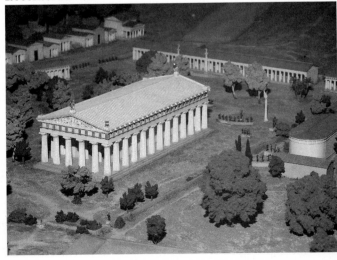

terracotta (Fig. **2.11**). As the wood rotted, each column was replaced with a limestone substitute, but, as these were erected at different times, the shape and fluting of the columns and their *capitals* vary considerably. The sturdy, thick columns of the Temple of Hera exemplify the *Doric order*, standing without a base and tapering upward to end in an unadorned capital.

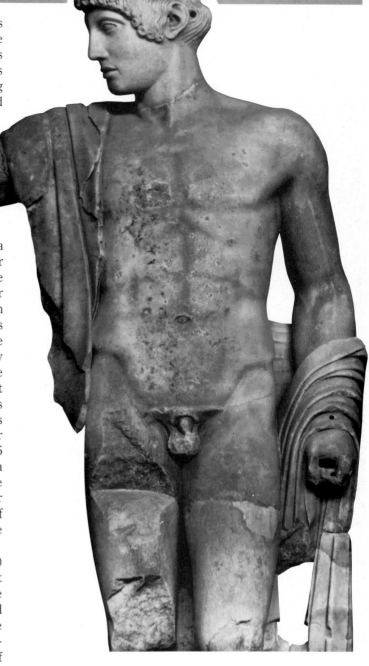

An example of the later form of a Doric temple at Olympia is the Temple of Zeus (470–456 BC; Fig. **2.12**). The triangular roofline of the façade was ornamented with full-size stone figures; here carved metopes were reserved for the interior *porticoes* so as not to compete with the larger scale statues. In the inner sanctuary, or *naos*, the cult statue (destroyed) was the most famous in ancient Greece, regarded as one of the wonders of the ancient world: a colossal Zeus of gold and ivory by the renowned sculptor, Pheidias. The god, wearing the olive wreath also bestowed on the victors in the Olympic games, sat enthroned with a golden scepter and eagle of rulership in his left hand and a golden image of personified Victory, *Nike*, in his right hand. The scale of the Temple of Zeus was far grander (65 feet/20 meters) than that of the Temple of Hera nearby (25 feet/7.8 metres). A second level for the sanctuary permitted a gallery above ground level for a closer view of the god. The outside of the temple was faced in painted plaster, or *stucco*, rather than marble (not available locally), in the form of blue *triglyphs* punctuated by donated golden shields on the external *metopes*.

The subjects of its pediment narratives (470–456 BC) relate to the activities at the site of Olympia. On the prominent east front, beneath a gilded statue of Nike, stood Zeus in the central, highest, and most prominent frontal position. Around him can be seen preparations for the chariot race – a prototype of the contests in the Olympic games – between King Oinomaos and Pelops, suitor for the king's daughter and devotee of Zeus. (The story has additional local significance, for Pelops gave his name to the Peloponnesus region that includes Olympia.) The matching west pediment (Figs **2.13** and **2.14**) features Apollo presiding over the conflict of the Lapith people against the bestial centaurs (half-man, half-horse) – a symbol of the victory of rationality over passion (as well as of the civilizing effects of the Olympic games, which occasioned a

2.13 *Apollo*, **west pediment, Temple of Zeus, Olympia, ca. 470–456 BC. Marble, 122 ins (310 cm) high. Archaeological Museum, Olympia.**

2.14 *Battle of Lapiths and Centaurs*, **west pediment, Temple of Zeus, Olympia, ca. 470–456 BC. Reconstruction (after G. Treu).**

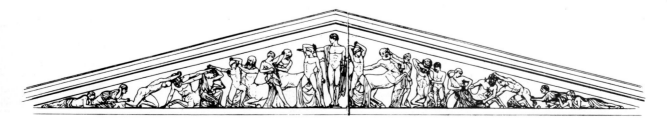

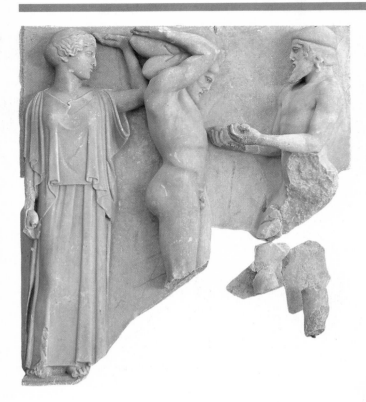

2.15 *Herakles and Atlas*, metope, Temple of Zeus, Olympia, ca. 470–456 BC. Marble relief, 63 ins (160 cm) high. Archaeological Museum, Olympia.

truce among warring city-states). Like Zeus on the opposite pediment, the god stands at the peak of the triangular pediment, arm outstretched as he presides over the outcome of a violent struggle of interacting figures. The figure itself is a consummate early instance of the Greek capacity to render volumes and muscles of the human body with perfect proportions and smooth outlines to mark it as the image of divinity. This athletic ideal, in turn, was transferred to the statues commemorating victors in the Olympic games in a "hall of fame" at the sacred grove of Olympia.

The metope decorations for the porches of the sanctuary feature the labors of Herakles (Roman: Hercules), the son of Zeus by a mortal woman. As a hero and a mortal, Herakles intervenes between divinity and humanity, much in the manner of a Christian saint. As the strongest of men, he serves as the model for the striving athletes of Olympia. The Labors of Herakles illustrate the cycle of the hero's struggles against monstrous enemies, personifying the brute forces of untamed nature. However, the most beautiful and well-preserved of the Olympia Herakles metopes shows another moment of repose and physical beauty. The Atlas metope records the moment where the giant Atlas procured for Herakles the golden apples of the Hesperides but asked the hero to take over his own burden of supporting the world on his shoulders (Fig. **2.15**). Here the sculptor has symbolically used the supporting role of the metope in his image, as if Herakles, here assisted by the goddess Athena (Roman: Minerva), supports the very roof of

the temple. The goddess, relaxed in her efforts, turns to face the viewer as she aids the struggling yet impassive hero. The metopes attest to the limits of even the strongest human achievements without the assistance of the gods and the central role of temple sites in Greek life.

Though almost all traces of their bright pigments have been lost through weathering, Greek sculptures like these were painted, not the unadorned stone we usually see today. Moreover, many Greek sculptures were made of polished

2.16 *Kleobis and Biton*, Sanctuary of Apollo, Delphi, ca. 615–600 BC. Marble 77½ ins (197 cm) high. Archaeological Museum, Delphi.

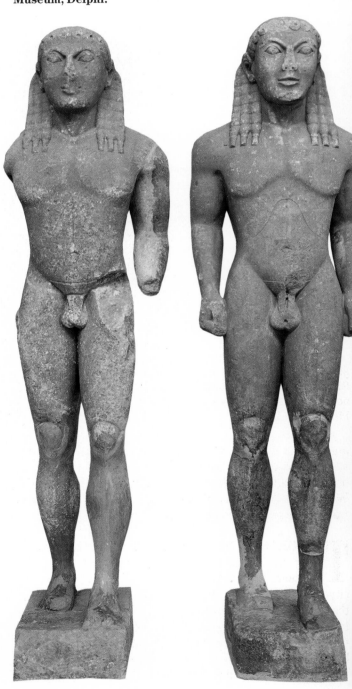

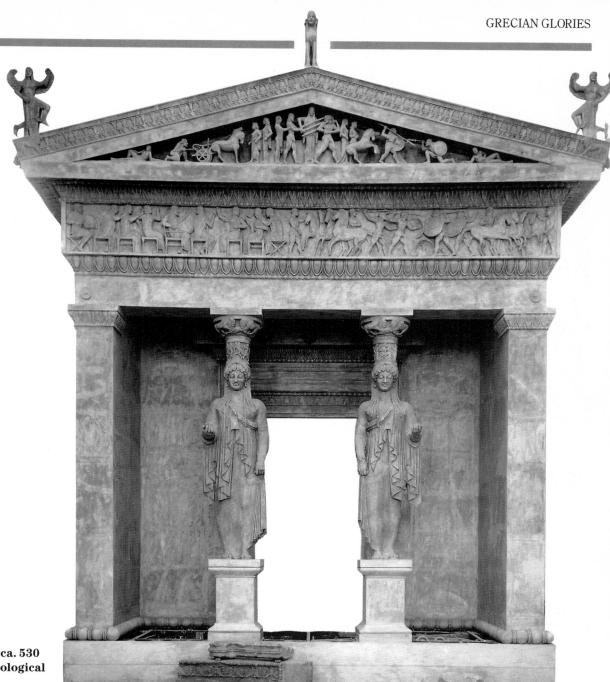

2.17 Treasury of Siphnians, Delphi, ca. 530 BC. Marble. Archaeological Museum, Delphi.

bronze, later melted down for their metal. Many of the marble statues that survive today are Roman copies after Greek originals, testifying to their abiding inspiration (to be echoed in Western art during various important revival periods of what would come to be called the "Classical" period of Greek art).

THE ORACLE OF APOLLO AT DELPHI was the other chief religious center of Panhellenic Greece. The sanctuary received donations and gifts from the leading city-states, and its surviving monuments document some of the earliest important surviving Greek sculptures, such as the twin statues of Kleobis and Biton (ca. 600 BC; Fig. 2.16) from the city of Argos. Their heroic story is recounted by the Greek historian, Herodotus.

These frontal standing male nudes, or *kouroi*, have been compared, in their symmetry and blocklike shape, to Egyptian statues, such as Mycerinus (Fig. 2.2); their role as enduring monuments doubtless depends upon earlier Egyptian carving of stone memorial images. Uncertainty often remains about whether such *kouroi* donations depicted the standing god Apollo himself or specific youthful individuals, like grave memorials or idealized commemorative images made during the bloom of life. These carvings are also among the first to be signed by a named sculptor (a fragment survives: "... medes").

Delphi was the site of building dedications as well, such as the lavish small treasury established ca. 525 BC by the islanders of Siphnos (Fig. 2.17). Such treasuries are small, single-room structures, usually with columnar porches. At Delphi they housed offerings from each city-state and flanked

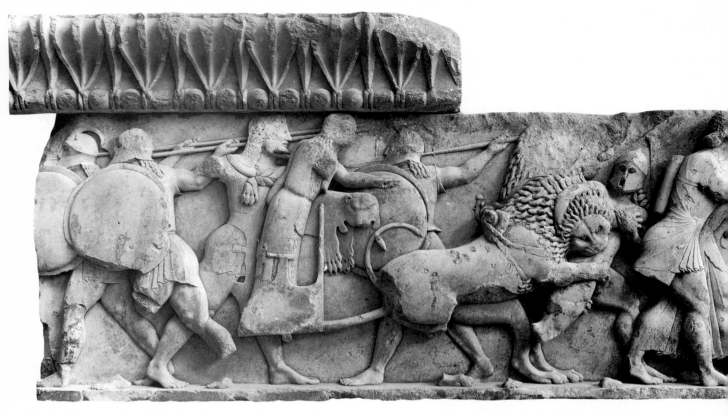

2.18 *Battle of Gods and Giants*, Treasury of Siphnians, Delphi, ca. 530 BC. Marble relief, 26 ins (66 cm) high. Archaeological Museum, Delphi.

2.19 *Charioteer of Delphi*, ca. 470 BC. Bronze, 71 ins (180.3 cm). Archaeological Museum, Delphi.

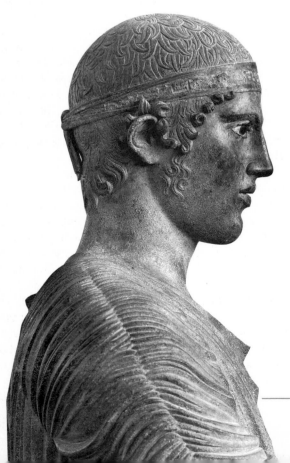

the sacred way to the oracle. The Siphnian Treasury porch was supported by two female figures, or *caryatids*, in the place of columns. A sculpted frieze band ornamented the perimeter of the building, presenting the dual themes of the gods of Olympus and the Trojan War (Fig. **2.18**). High-relief carving animates the figures of armed warriors and horses, which resemble the multiple-profile poses and overlaps of painted figures on surviving contemporary late sixth-century Athenian *red-figure* vase paintings. Again, we must remember that the figures and the surfaces would have been brightly painted (including additional images, such as the chariot behind the carved horses), and that the figures often held weapons or jewelry. Nearby, an Athenian treasury (ca. 500 BC) featured the metope carvings of heroic actions of both Herakles and Theseus.

Among the rare early surviving Greek bronzes, Fig. **2.19** celebrates the victory in a chariot race of the tyrant Polyzalos (of Gela in Sicily) at the Pythian games (ca. 475 BC). Greek sculptors learned to cast bronze around a hollow clay core about the mid-sixth century, where molten bronze substitutes for wax of equal thickness in a mold, the *"lost-wax process."* The *Charioteer* was cast in sections; its attached left arm is lost. Originally, it formed part of a much larger ensemble: a team of four horses, the image of the tyrant behind the charioteer, and probably a groom as well. The refined, minute details of hair curls, hands, and drapery folds are modeled with a precision rare in stone carvings, and the vivid presence of this otherwise columnar, if slightly asymmetrical, figure is enhanced by the addition of silver on the headband of victory, copper on the lips, and inset eyes of colored glass.

GREEK PAINTING

Paintings from ancient Greece have almost all been lost, though the names of celebrated painters have survived in ancient texts. Aside from text descriptions, much of our awareness of the conventions and accomplishments of Greek painters comes from the wealth of surviving painted vases, particularly from Athens (preserved in part because they were exported and utilized in burials by non-Greeks). Before the end of the seventh century BC, Athenian painters developed a convention of painting black figures on the natural earth-toned grounds of their vases. One of the most celebrated – and assertive – of these painters (and the proud potter as well), Exekias, signed several of his works, including a double-sided wine *amphora* (Fig. **2.20**). The image derives from Homer's

2.20 Exekias, *Ajax and Achilles Playing Draughts*, ca. 540 BC. Painted terracotta amphora, 24 ins (60.7 cm) high. Vatican Museums, Rome.

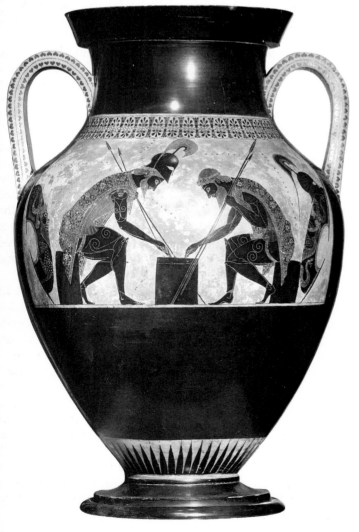

heroic tales of the Trojan War and shows the Greek interest in figural interaction across space, with the concentration on body poses and gestures already encountered in relief sculpture, such as the near-contemporary Treasury of the Siphnians.

Such signatures by Greek painters and sculptors remained unique in the ancient world and a rarity in Western art until the Renaissance era, despite the fact that, as craftsmen, artists were not accorded high status by the ruling aristocratic leisure class. In addition to expressions of pride, signatures might also have been a visible form of advertising.

Greek history was irrevocably altered at the turn of the fifth century BC by the invasion from Asia Minor of the dominant empire of the Fertile Crescent, Persia. Led by Darius the Great, the Persians first attacked the colonies of Athens, the most powerful city-state in Greece, and then advanced to the Greek mainland, where Athens won a great battle at Marathon in 490 BC. Ten years later, Darius's son, Xerxes, mounted a full-force invasion, resisted by both Athens and Sparta. A decisive Athenian sea victory at Salamis sealed the eventual victory of the Greek allies over their foes and propelled Athens into political leadership, military power, and eventual empire (the Delian League) over her fellow Greeks. The confident if turbulent fifth century that followed, dominated artistically by Athens, has been called by subsequent eras the Classical period of Greek art.

Internally, Athens underwent tremendous political change prior to the Persian invasions, beginning with legal reforms and the constitution introduced by Solon (594 BC). This was followed by a military tyranny and the establishment by Peisistratus (560–510 BC) of a thriving economy based on imports from the colonies. Beginning in the mid-sixth century, Athens became a center for art in the form of her painted pottery (used in the exports of wine and oil), and the monuments of architecture and sculpture erected on the Acropolis, site of Panathenaic civic festivals. Popular revolts against the tyrants established a definitively democratic constitution with assembly votes for citizens of the Athenian *polis*. Successes after the Persian Wars permitted vast expansion of the city's ceremonial precincts and buildings – the sacred shrines, government buildings, and shops of the public square, the Agora, as well as the fortress rock and sanctuary that towered above the Agora, the Acropolis.

Athenian art prior to the Classical period does not survive in great quantities apart from the painted pottery because of the destructions of the Persian Wars. Excavations on the Acropolis have unearthed a few statues of beautiful young women, *korai*, whose gentle smiles are framed by curving ringlets, jeweled ornaments, and pleated drapery. One *kore* (ca. 520–510 BC) still bears traces of color on her blue dress with red patterning; the carver seems to have come from Chios, a colony of Athens in Asia Minor (Fig. **2.21**, p.48). As in the case of the *kouroi* (male nudes), ambiguity concerning their identity surrounds such *korai* – whether they represent the image of the goddess Athena, patron of Athens, or the ideal visage of her female devotee, whether priestess or worshiper.

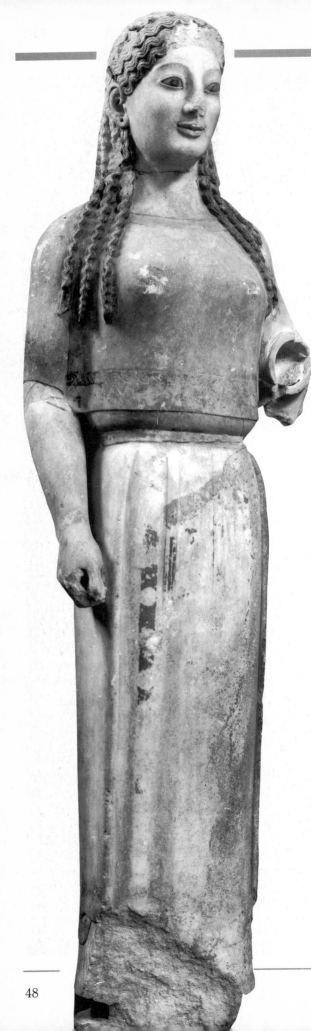

2.21 *Kore*, Acropolis, Athens, ca. 530 BC. Marble, 21½ ins (54.6 cm) high. Acropolis Museum, Athens.

POLYGNOTOS Ancient writers described the wall paintings, long lost, of Polygnotos, who worked in Athens after the victory over the Persians. His painted image of the Battle of Marathon decorated wooden panels in the Poikile Stoa in Athens (ca. 460 BC, along with the related subjects of the Sack of Troy and Battle against the Amazons) and commemorated the great victory visually at the same time as the prose history of Herodotus. According to descriptions, the figures of Polygnotos appear at varying elevations in the field of the picture, suggesting recession in space with minimal settings, as the battle unfolded from left to right. Quiet contemplation or gestures reveal character and suffering in each figure. Such qualities have been discerned in an anonymous red-figure vase painting that situates Athena and Herakles amid several warriors, presumably in the underworld (Fig. **2.22**). The fine nuances of these figures, turning in space, recall the dignity and gracefulness of the Olympia statues and metope reliefs, carved at about the same time. Even if we can only guess at the degree to which they are representative of the achievements of lost Greek wall paintings, these heroic figures in the natural red color of the fired terracotta vases achieve a volumetric effect of physical movement in space through their internal linear modeling and their newfound freedom from the restrictions of the silhouetted profiles of earlier black-figure vases.

2.22 Niobid Painter, *Athena, Herakles, and Heroes*, ca. 455–450 BC. Painted terracotta calyx-krater, 21¼ ins (54 cm) high. Louvre, Paris.

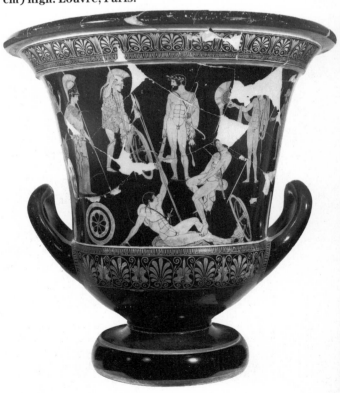

GREEK SCULPTURE AND ARCHITECTURE

Sculpture picked up the pictorial interest in human motions and gestures pioneered by Polygnotos. After the relative calm, sometimes referred to as the Severe Style, of Olympia, the Athenian sculptor Myron imparted a new patterned movement to his figures, exemplified by the famous *Diskobolos* or "Discus-Thrower" of ca. 460 BC (Fig. **2.23**). The bronze original is lost. Here, stillness in the midst of intense activity implies the remainder of the action to follow, a principle also employed in Greek tragedy, where most of the violent action occurs offstage. The subject remains tied to the ethos of athletic competition so basic at Olympia as well as at Delphi. Another famous sculpted group by Myron at the Acropolis of Athens portrayed the encounter of Athena with the half-human, half-goat satyr Marsyas, pointing a contrast between the beauty of reason and the grotesqueness of animal passion, in the tradition of the Battle between Lapiths and Centaurs.

POLYKLEITOS OF ARGOS was one of the most famous fifth-century Greek sculptors along with Pheidias and Myron. Working in bronze, his specialty was images of athletic victors, many of them imitated in surviving Roman marble copies. His most famous image, preserved in numerous copies, was the *Doryphoros*, "Youth Bearing Lance" (Fig. **2.24**). Polykleitos was celebrated for his intellectual approach to sculpture, and this image expressed his system of ideal proportions for the human body, upon which he wrote a treatise (lost), entitled *Canon* (from the Greek word for "rule"), a name also given to the *Doryphoros*. Numerical

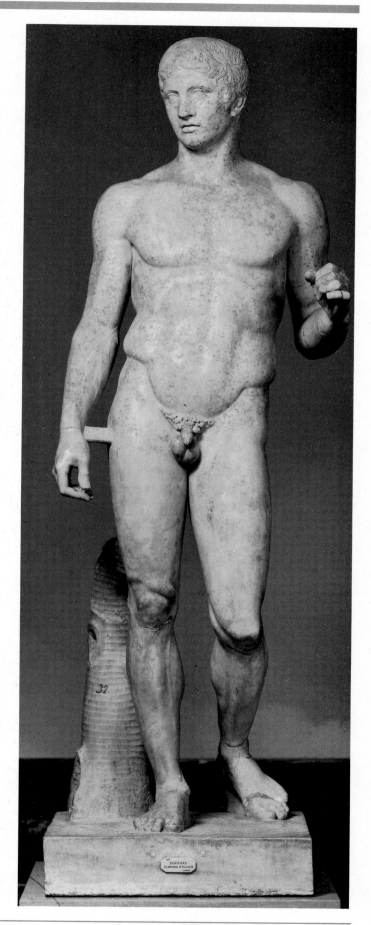

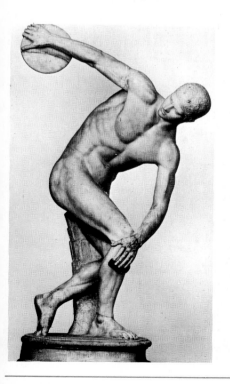

2.23 Myron, *Diskobolus* ("Discus-Thrower"), ca. 450 BC. Roman marble copy of bronze original, lifesize. Museo Nazionale Romano, Rome.

2.24 Polykleitos, *Doryphorus* ("Youth Bearing Lance"), ca. 450–440 BC. Roman marble copy of bronze original, lifesize. Museo Archeologico Nazionale, Naples.

harmonies of ratios between the parts of the body defined this muscular figure, yet its relaxed stance, known by its later Italian name of *contrapposto*, balances oppositions of tension against slackness to overcome the stiffness or stillness of perfect symmetry. The overall effect remains one of animation, as if the figure was interrupted in the process of walking rather than standing still, employing a subtler version of the same pregnant pause as Myron's discus-thrower. However, within this figural specificity, Polykleitos strove to express through his relation of the parts to the whole (*symmetria*) an image of perfection and beauty.

The concept of numerical rule through ratios also governed Greek architecture, whose measure was considered to be proportional to that of the human body. Greek veneration for number harmonies in art as well as music stems from the philosophical contemplation of mathematics by Pythagoras (late sixth century BC). Greek geometers, led by Euclid (ca. 300 BC), eventually codified the principles of plane surface designs. Such principles survived in a form that was later systematized for architecture by the Roman writer Vitruvius. Within this building system, regular ratios govern the relation between the diameter and the height of Greek columns or between the width and length of Greek temples, just as similar numerical ratios pertain between the head and the height of the human body.

THE ACROPOLIS The consummate achievement in Athens in the Classical period was the cluster of buildings erected on the Acropolis during the second half of the fifth century. The funding of such lavish monuments of civic pride and identity was made possible by Athens's aggressive imperial policy, led by Pericles from 461 to 429 BC with the support of the democratic assembly. Eventually Athens and other democracies quarreled with Sparta and the Peloponnesian League, which were governed by oligarchies, where power was held by a very small group. The resulting Peloponnesian War (431–404 BC; chronicled by Thucydides) exhausted both parties and resulted in the eventual surrender of Athens.

During the halcyon moment when Periclean Athens was prosperous and peaceful between the Persian Wars and the ruinous Peloponnesian War, the city basked in self-confidence and in a belief in the human capacity to create an ideal society on earth. Initially, Athenians vowed to leave their temples in ruins as a memorial to the destructions of the Persians, called barbarians, or uncivilized, by the Greeks; therefore, there was no new building during the period of Olympia, 479–450 BC. It was Pericles who set about rebuilding the Acropolis and other public buildings as a symbol of the Greek triumph as well as a signal of Athens's new cultural supremacy (appropriating the treasury of the Delian League). The rationale and idealistic declaration of Athens's democratic principles can be found in the celebrated Funeral Oration of Pericles to the fallen soldiers made during the first year of the Peloponnesian War (Thucydides II. 34–6).

THE PARTHENON Crowning the Acropolis was the Parthenon, temple of Athena Parthenos, warrior-maiden as well as goddess of wisdom and patron of the city (Figs 2.25 and 2.26). Designed by the architects Kallikrates and Iktinos (447–438 BC), in plan the building conforms fully to the Doric temple pattern: raised platform, colonnade, architrave, and pediment. More generous in scale, the dimensions of the building are carefully calibrated to the numerical proportions mentioned above, with a ratio of 8 columns by 17 (Olympia is 6 by 13) and a basic 4:9 ratio in its dimensions. At the same time subtle practical modifications have been made. A slight bowing curve raises the central section of each horizontal curve as an optional refinement (as well as a design for runoff), while thicker corner columns tilt slightly inward to emphasize the

2.25 Plan of Acropolis, Athens.

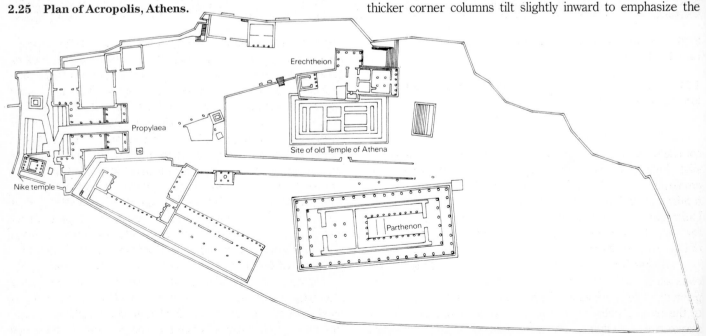

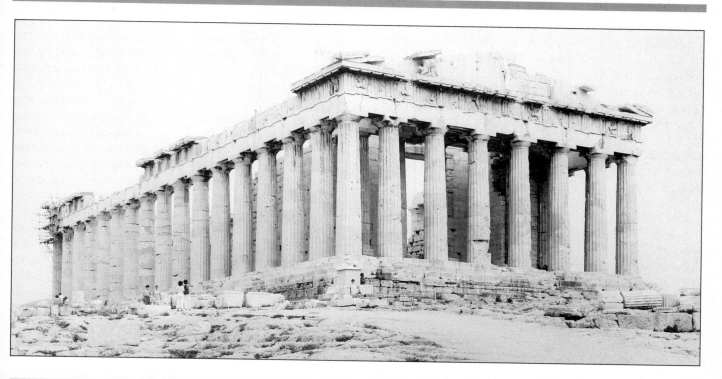

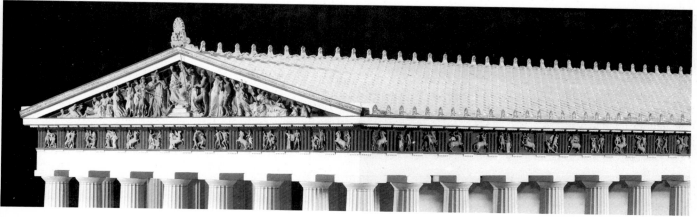

2.26 Iktinos and Kallikrates, Parthenon, Athens, ca. 447–438 BC.

2.27 Parthenon, reconstruction model. Metropolitan Museum, New York.

compactness of the building. Such adjustments, including a slight bulging (*entasis*) in the taper of the column shafts, were employed elsewhere in Greek temples but rarely with the refinement of detail and craftsmanship seen at the Parthenon. Unfortunately, the building was gravely damaged in 1687, so the overall effects of its rich marble (in contrast to the stucco of Olympia) and its original coloring have been lost.

The Parthenon was adorned with sculptures (Fig. **2.27**), completed in 432 BC by Pheidias and his workshop, general planners of the Periclean building program. In the central *naos* of the temple Pheidias produced his other most famous cult statue after the Olympian Zeus: a colossal standing frontal gold and ivory Athena, now lost (Fig. **2.28**, p.52). The size of this figure (around 33 feet/10 meters) necessitated the greater scale of the Parthenon, and Pheidias surely dictated some aspects of the design of Iktinos (by contrast, Zeus must have appeared cramped in his earlier temple home at Olympia). The entire body was built on a wooden framework, or *armature*, dimly lit yet glowing from the precious materials of her gilded costume and ivory skin. In her right hand the goddess held a Victory figure; her left hand held a shield with relief carving of the battle of the Greeks *vs* the Amazons (a female warrior tribe), enhanced by reliefs on her sandals of the battle against the centaurs. Once more the theme of the struggle of order and reason against passion and chaos informs Greek thought, but Pheidias's choice of the myth of Pandora for the base of his great statue disturbingly associates discord with cultural gifts.

More sculpture adorned the Parthenon than any other Greek temple. Figures in the pediment and 92 carved metopes filled the entire exterior, rare for larger Doric buildings, while the inner porch, unique in Doric buildings, bore a continuous

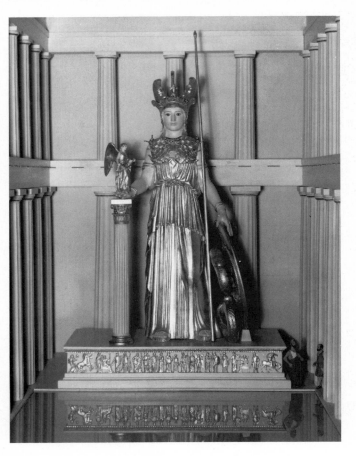

2.28 Pheidias, *Athena*, 447–432 BC, reconstruction model. Wood covered with gold and ivory. Courtesy of the Royal Ontario Museum, Toronto.

frieze. Surviving works show some variation in execution (especially in the metopes, presumably begun first) but a surprising consistency of quality in the Pheidian workshop. The Parthenon metopes repeat the subject of Olympia, Lapiths against centaurs, as well as other subjects akin to the decorations of the cult statue inside: the battle against the Amazons, Greeks against Trojans, gods against giants – all essentially symbolic of the recent glorious victory over the Persians. Many of the metopes were defaced by later possessors of the Parthenon, but the surviving images of the killing of the centaurs reveal a figural grace and poise that animates the sturdy, muscular forms already seen at Olympia, like the contemporary isolated figure by Polykleitos.

THE PARTHENON FRIEZE, three feet (one meter) high but running the entire perimeter of the inner porch (525 feet/160 meters long), was designed as a procession, moving along both sides of the temple before converging at the eastern front. Taking into account the actual approach of a visitor, the frieze begins with horsemen preparing to ride and continues around the corner to the north flank of the building (Fig. **2.29**). At the climax of the procession, the eastern frieze features central deities as well as maidens presenting

offering bowls. The entire frieze represents the Panathenaea, the annual Athenian festival in honor of Athena, which every fourth year featured the dedication of a luxurious woven cloak, or *peplos*, to a venerable cult statue (not the Pheidian image) of the goddess. This very festival unfolded alongside the Parthenon friezes representing it, just as the frieze progresses in time from the back of the building to its front with the passage of every visitor. In a striking display of confidence and pride, the Athenians have substituted themselves for the gods, the traditional subject of their most important temple precinct decoration. Of course, the modern viewer must make an imaginative attempt to restore the effects of painted settings and colored figures in place of the unadorned white of the surviving marble. The procession might well be commemorative or even symbolic; for example, the youthful equestrians of the carved frieze total 192, the number of martyrs slain at the Battle of Marathon. Whatever the specifics of the meaning, the Parthenon frieze underscores the close connection between Athenian glory, exemplified by the Parthenon itself, and the city's pious links with its protecting gods. The youths and maidens from the frieze display a remarkable, lifelike grace and figural interaction that enhance their beauty. Such figures were first seen in the isolated standing *koros* and *kore* figures of the previous century. Like those figures, these eternally young participants in the procession transcend earthly shortcomings, despite their lifelike rendering, as they offer their votive gifts to the divine protectors of the city and Greek civilization.

Pediments at the Parthenon had an unusually broad expanse to fill owing to the ample dimensions of the building, and the figures were carved almost in the round. Unfortunately, the pediments were the most severely damaged images in the explosion that destroyed the roof of the building. Drawings suggest more of the original composition than can surviving sculptures (Fig. **2.30**). The birth of the fully-grown Athena on the east pediment is complemented on the west by Athena's contest for the land of Athens with Poseidon, god of the sea (her gift, the olive tree, won her the city's undying gratitude for the chief item in its export trade). In a marked departure from the upright axial standing pediment figures of Zeus and Apollo at Olympia, Athena and Poseidon at the Parthenon form a V-shaped dynamic of movement and reaction, generated by the miraculous appearance of the olive tree of the narrative. Surviving, over-lifesize figures of goddesses from the east pediment reveal the sculptors' inventive solution to site problems of the steep slope of the gable (Fig. **2.31**, p.54). The gradual turn of the group from the corners to the center of the pediment composition underscores the central

2.29 Panathenaic frieze riders, Parthenon, 442–438 BC. Marble relief, 43 ins (109.2 cm) high. British Museum, London.

2.30 *Contest between Athena and Poseidon*, west pediment, Parthenon, Athens. Drawing by Jacques Carrey, 1673. Bibliothèque Nationale, Paris.

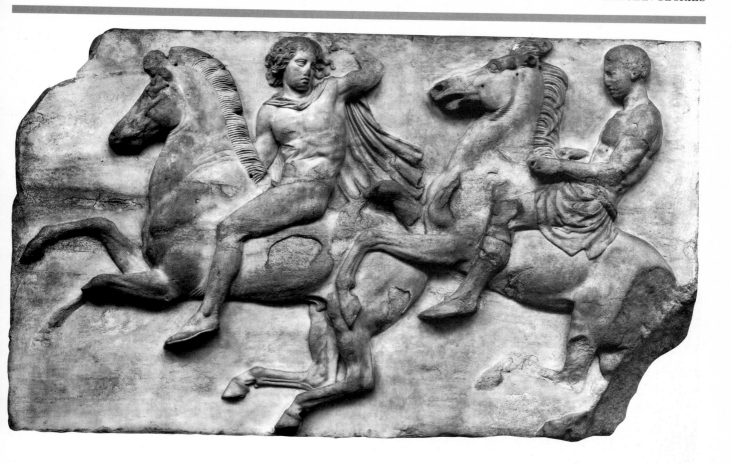

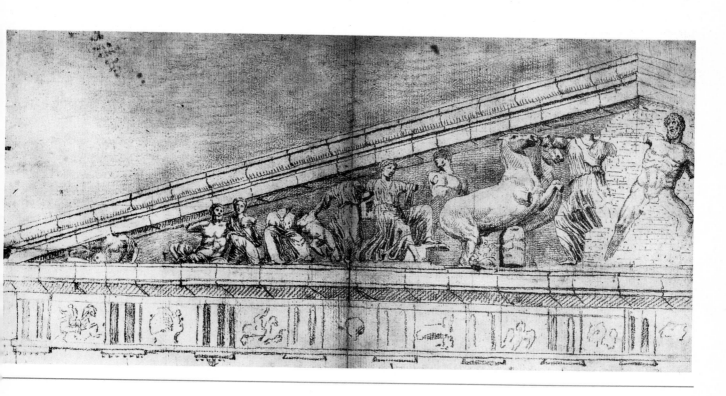

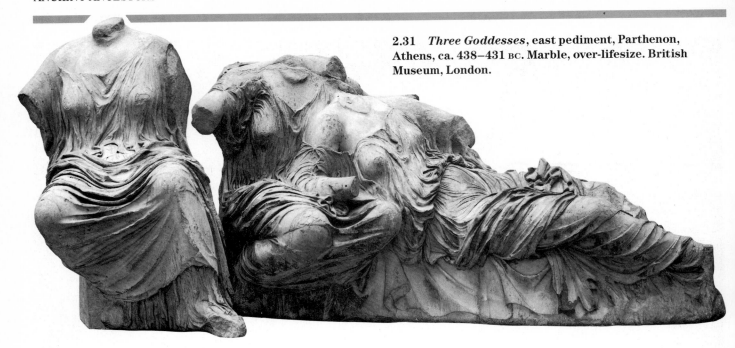

2.31 *Three Goddesses*, east pediment, Parthenon, Athens, ca. 438–431 BC. Marble, over-lifesize. British Museum, London.

importance of the birth of the goddess at the apex. In the meantime the organic solidity of these ample bodies, visible beneath rich cascades of clinging drapery, suggests the powerful presence of the missing central figures, easily visible even at a great distance from the pediment. Light and shade emphasize these deep-cut folds, which now serve as animating elements in their own right as they show volume and torsion for their figures. Balancing this triad of goddesses on the opposite end of the pediment sits a reclining and relaxed male nude, possibly Herakles, the bridge between humanity and divinity, and a perfect metaphor for the divine potential for strength and beauty in the ideal human figure (Fig. **2.32**).

THE ERECHTHEION Some of the powerful effects of carved folds reappear on the caryatids, supporting columnar sculpted female figures, on the porch of another building erected after the Parthenon on the Acropolis of Athens: the Erechtheion (421–409 BC; Fig. **2.33**). Though the specific religious function of this porch remains unknown, the sculptor surely intended his maidens to echo those on the nearby Parthenon frieze. Possibly the connection lay with the four-yearly (quadrennial) festivity, because this irregular

temple on a steep slope housed the wooden cult statue of Athena that received the *peplos* at the climax of that Panathenaic procession. Once more, the *kore* tradition of maidens clad in *peploi* reasserts itself after centuries on the Acropolis. The Erechtheion also housed the cult of Athena's olive tree as well as ancient cults of additional gods and local heroes, including the legendary king, Erechtheus, after whom it is named. In form this small temple is *Ionic*, derived from Asia Minor, the new focus of Athens replacing the Doric Peloponnese, wartime enemies of the city. Scrolled capitals, or *volutes*, rest on more slender columns with rich bases, which support an entablature with frieze, instead of the Doric triglyphs and metopes.

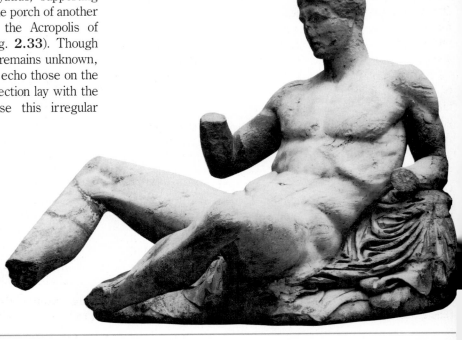

2.32 *Reclining Nude (Herakles?)*, east pediment, Parthenon, Athens. 438–432 BC. Marble, over-lifesize. British Museum, London.

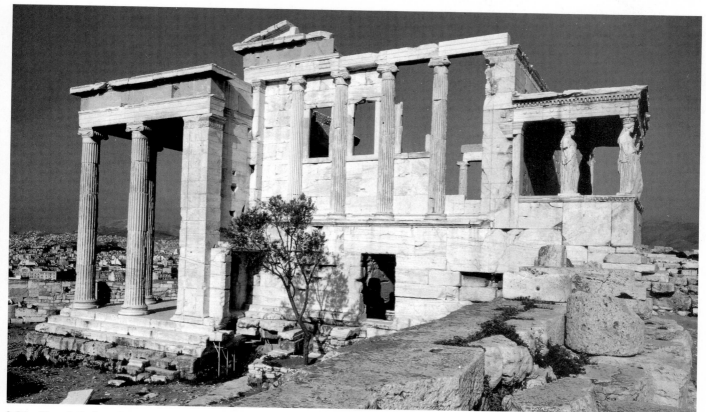

2.33 Erechtheion, Athens, ca. 421–405 BC.

Work on the Acropolis ensemble continued until the definitive defeat of Athens by Sparta and her allies in 404 BC. The ceremonial entrance gate, the Propylaia (designed by the architect Mnesicles), interrupted by the outbreak of war, was never completed. Thereafter Athens lost its dominance over other city-states, though its cultural influence remained high in subsequent years, especially through copies of famous artworks of the city and in the form of language and literature for both learning and international trade. The deaths at the end of the century of the historian Thucydides (ca. 400 BC) and of the philosopher Socrates (399 BC), condemned to death for his "corrupting" influence in asserting a new, antidemocratic, ethical autonomy, mark a cultural watershed in Athenian history. It seems appropriate that one of the chief activities of sculptors, alongside the great monuments of the Acropolis in Athens, consisted of the production of figured tombstones, *stelai*, now a question of expense rather than of noble origins. One of the late fifth-century examples of this tombstone carving, showing the influence of Pheidian carving in its graceful poses and drapery, is the Stele of Hegeso (ca. 400 BC; Fig. **2.34**). This modest yet elegant monument exudes a dignified air of gentle melancholy between an older and younger woman, whether a daughter or a servant. Their activity, looking into a small casket, remains serious yet subdued. Its epitaph function can serve here to mark the contemporary end of the democratic ideal of the *polis*, which reached its climax in Periclean Athens.

2.34 Stele of Hegeso, ca. 410–400 BC. Marble relief, 59 ins (150 cm) high. National Archaeological Museum, Athens.

HELLENISM

Despite the shift of political dominance from Athens to her rivals in Sparta and Thebes, Greek civilization in the fourth century BC did not see a decline in artistic accomplishment. On the contrary, most scholars consider the sculptures and paintings of this era to be "late Classical," inventive variants of the fifth-century precedents. The most momentous political change in Greek culture after a century of continual internecine warfare was the conquest from the north of the mainland as well as most of the known Eurasian world (chiefly Persia) by Alexander the Great of Macedonia (d. 323 BC). However, a new attention to the autonomous, subjective experience of the individual or to the truly universal – rather than the traditional public interaction of gods, heroes, or citizens in community – dominates not only the philosophy of the new era, beginning with Plato, but also its artworks.

Ancient descriptions tell us that the most famous of all Greek painters flourished during the fourth century. Their works are lost to us, but their names become a roll call of glory that later eras would evoke as the touchstones for their own emulations of what they considered to be "Classical" art: Agatharcos, Zeuxis, Parrhasios, and eventually Apelles, the exclusive painter of Alexander the Great. These artists are credited with such momentous pictorial discoveries as the rendering of shading and highlights, or *chiaroscuro* (Zeuxis), and the illusion of depth, or *perspective* (Agatharchos). Moreover, they figure as the subjects of anecdotes pointing to the naturalism of their renderings, such as the account that grapes painted by Zeuxis successfully deceived birds, which tried to eat them, while a curtain painted by Parrhasios in turn deceived Zeuxis himself. In another account, Zeuxis, in an effort to create a nude female figure of Helen, studied the best features of five separate living models and produced a composite ideal.

SKOPAS OF PAROS Surviving fourth-century sculptures often express emotional states of either suffering or tenderness in their figures in place of the calm, even severity, of the previous century. The sculptor singled out as the leading master at representing emotional states, especially through facial expression, was Skopas of Paros, both a marble sculptor and an architect. His name, along with those of other leading sculptors of the day, has been connected with the sculptures adorning the greatest individual monument of the fourth century: the *Mausoleum* at Halicarnassus in Asia Minor, considered one of the wonders of the ancient world. The Mausoleum was an Ionic temple-tomb erected (and named) for King Mausolus (d. 353 BC) by his wife, Artemisia. The building formed a stepped pyramid, faced with friezes and

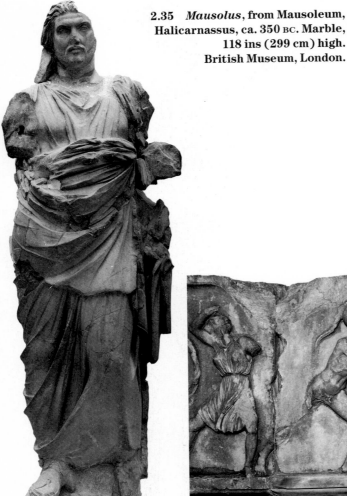

2.35 *Mausolus*, from Mausoleum, Halicarnassus, ca. 350 BC. Marble, 118 ins (299 cm) high. British Museum, London.

2.36 Attributed to Workshop of Skopas, *Greeks vs Amazons*, frieze from Mausoleum, Halicarnassus, ca. 350 BC. Marble relief, 35 ins (89 cm) high. British Museum, London.

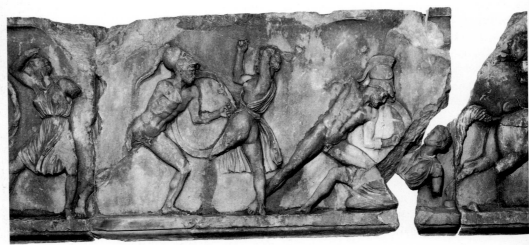

2.37 Attributed to Praxiteles, *Hermes and Dionysus*, Olympia, ca. 350–340 BC. Marble, possibly original or Roman copy, 84 ins (213.4 cm) high. Archaeological Museum, Olympia.

PRAXITELES If Skopas offered a new pathos in his carvings, his Athenian contemporary Praxiteles (active ca. 370–330 BC; son of a famous sculptor, Kephisodotos) presented naturalness in the form of a new lyrical tenderness. One marble work that once passed as an original of Praxiteles (now thought to be a superior copy) shows his creations at their best: *Hermes* from the Temple of Hera at Olympia (Fig. **2.37**). The overall pose of the standing god shows a new slenderness and leaning languor compared to the athletic figures of Polykleitos a century earlier. A unified composition communicates intimacy through the tender gaze of the god for the infant he cares for, and Hermes even injects a note of playful humor, as he teasingly dangles a cluster of grapes (lost) before a baby Bacchus, god of wine. Clearly this image no longer maintains any of the majesty of a cult object, although the transcendent beauty of Hermes clearly removes him from a human context, far from the practical concerns and imperfections of ordinary Greeks.

Praxiteles worked chiefly in bronze, and in that medium one fine work survives, excavated at sea off the coast of Marathon (Fig. **2.38**). This slender boy seems to have been

topped by colossal figures and a chariot. One of the colossal standing figures from between the columns survives in good condition; it has been called "Mausolus" but probably represents one of his ancestors, since Mausolus surely drove the chariot atop his monument (Fig. **2.35**). The thick, clustered drapery of the standing figure moves beyond any affinity with Parthenon sculptures toward animated, expressive folds. Its head still harks back to bearded divinities in the overall regularity of its features, yet the face shows a new individuation in the thick lips, flowing locks, and trimmed beard, or steady gaze of deep-set eyes. Surviving slabs from the frieze of the Mausoleum depict the battle between Greeks and Amazons with a new energy and tautness of gesture as well as with an intensity of gaze in the figures (Fig. **2.36**). These contrast with the measured calm of the Parthenon metopes to reveal a heightened sense of drama, emotion, and excitement.

2.38 Circle of Praxiteles, *Marathon Boy*, ca. 340–300 BC. Bronze original, 51¼ ins (130.2 cm) high. Archaeological Museum, Athens.

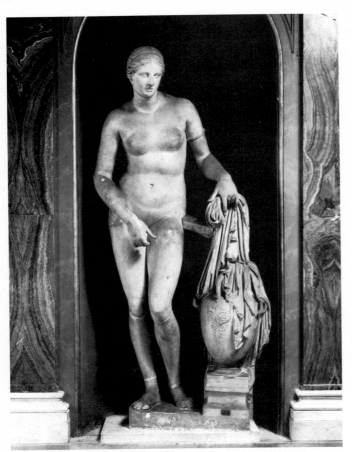

2.39 Praxiteles, *Aphrodite of Knidos*, ca. 350 BC. Roman marble copy of marble original, 80 ins (203.2 cm) high. Vatican Museums, Rome.

pouring wine across his body, and his smooth, youthful body contrasts with the sturdy athleticism of earlier male nudes. His pose mirrors a renowned early bronze by Praxiteles: a youthful *Apollo with a Lizard*, resting his raised arm against a tree.

The most famous and most frequently copied ancient sculpture was a nude Aphrodite of Knidos by Praxiteles (Fig. **2.39**), originally carved ca. 362 BC for Kos but rejected in favor of a clothed goddess by the same sculptor. This daring work was the first major image of a nude goddess, despite all of the nude male gods and athletes that went before her. Because of this unconventional subject, a justification was included by Praxiteles, as Aphrodite discards her garments on an urn (that also serves to support the figure) and uncovers her nudity. The mediocre copies of this celebrated work in marble make it impossible to ascertain the mood of this image or whether the figure gazed directly at the viewer or averted her gaze; however, one fervent admirer is reported to have been so overcome by love as to embrace this statue. Like his reinterpretations and projection of human sensibilities on other gods, such as Apollo and Hermes, this erotic Aphrodite of Praxiteles offers both sophistication and novelty, and bears the powerful stamp of the sculptor as an individual virtuoso. In similar fashion, the painter Apelles was celebrated for his sensuous image of Aphrodite rising from the sea (*Anadyomene*).

ART FOR ALEXANDER

The tendency toward cosmopolitan Panhellenism was consolidated after the conquest of Greece by Alexander the Great (ruled 336–323 BC). Despite a career of almost uninterrupted warfare, Alexander was keenly interested in using the finest Greek artists to portray his likeness, and he named the painter Apelles and the sculptor Lysippos (active ca. 360–306 BC) as his official and exclusive court artists. Painted likenesses of Alexander stressed his divine aspects; one famous image by Apelles in the Temple of Artemis at Ephesos showed the conqueror enthroned with the thunderbolt attribute of Zeus, an individualized echo of Pheidias's cult statue at Olympia.

LYSIPPOS In his carved portraits of Alexander, Lysippos is credited with emphasizing the heroic personality of the dynamic young ruler through the portrayal of his leonine locks and melting gaze. A second-century copy of a life-sized Alexander image from Pergamon (Fig. **2.40**) still retains some of the characteristic elements described in Lysippos's portraits, including the emphatic eyes, a slightly open mouth, high brow, and a distinct turn of the head (the hair of the original would have been gilded). The undulating

2.40 Portrait of Alexander the Great from Pergamon, second century BC. Marble, 16⅛ ins (40.9 cm) high. Archaeological Museum, Istanbul.

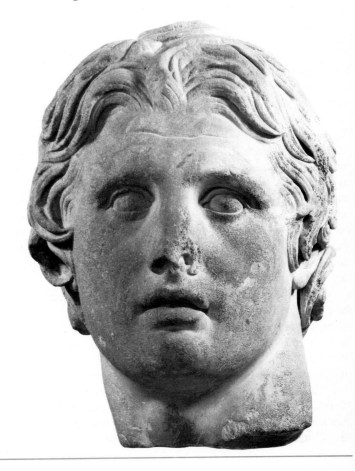

surface of cheeks and neck seems to be more characteristic of subsequent Pergamene sculpture. While still distinctive likenesses, Alexander's portraits became official public representations of the ruler in his ideal role, akin to the modern notion of propaganda.

Lysippos was also renowned for his interest in sculpture in the round and for his projections of limbs into viewer space as well as for his skills as a bronze-caster, sometimes on a colossal scale. His early images of athletes depart from the model of Polykleitos but with the new canon of slenderness characteristic of Praxiteles and the fourth century, again demonstrating the degree to which fourth-century Greek sculpture can be seen as an extension and variation on the "Classical" fifth century. At times, however, Lysippos deliberately set out to compete with his contemporary, Praxiteles, for instance, making bronze versions of the same subject as a Praxiteles marble.

A resting posture and heavy figural slackness inform one of the most famous of Lysippos's compositions: a resting *Herakles* (Fig. **2.41**). Twice life-size (though the scale of the numerous copies varies considerably), this image shows the hero as preternaturally muscular yet entirely exhausted, leaning heavily on his massive club. This powerful image, carved fully in the round, suggests an ironic relation to the athletic and heroic nudes of the previous century. Herakles's fatigue results from his holding up the heavens for Atlas, inasmuch as the hero holds behind him (implying a viewing of the sculpture in the round) the apples of the Hesperides in his hand; yet how much grace and confidence have been lost with this heightened physicality and weary subjectivity since the quiet dignity of the Olympia metope (Fig. 2.15). Lysippos also executed for Tarentum, in Southern Italy, another resting Herakles, head in hand, in bronze on a colossal scale, as well as a Zeus 59 feet (18 meters) high; the largest antique statue until it was surpassed in turn by the Colossus of Rhodes (177 feet/54 meters), an Apollo Helios by Chares of Lindos, a pupil of Lysippos.

In works such as these, the human qualities and capabilities of fifth-century ensembles have been abandoned completely in favor of an effect on the viewer of overpowering awe – in scale, in pathos, and in physical prowess. Lysippos also expanded the capacity of a sculptural workshop; however exaggerated the claims, he is credited by ancient writers with having produced over 1,500 works, so his role as a designer for a vast enterprise must have satisfied an enormous demand for the works of so famous a master.

Lysippos's most famous creation for Alexander other than his portraits was the "Granikos Monument," a figure group of some twenty-five equestrian statues in bronze, set up at Dion in Macedonia as a memorial to soldiers slain in Alexander's first victory over the Persians. Included among the other figures was a mounted portrait of Alexander himself. Even more than the Mausoleum, this aggrandizement of an individual marks the distance between this era of Hellenism and the corporate ideal of the fifth-century *polis*. The closest approximation to the Granikos Monument is the "Alexander Sarcophagus," a

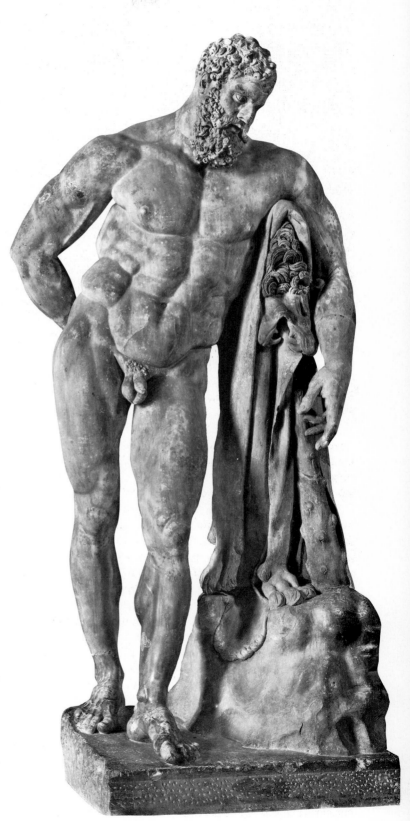

2.41 *Herakles Resting* ("Farnese Hercules"), Roman copy after Lysippos by Glykon of Athens, ca. 320 BC. Marble, over-lifesize. Archaeological Museum, Naples.

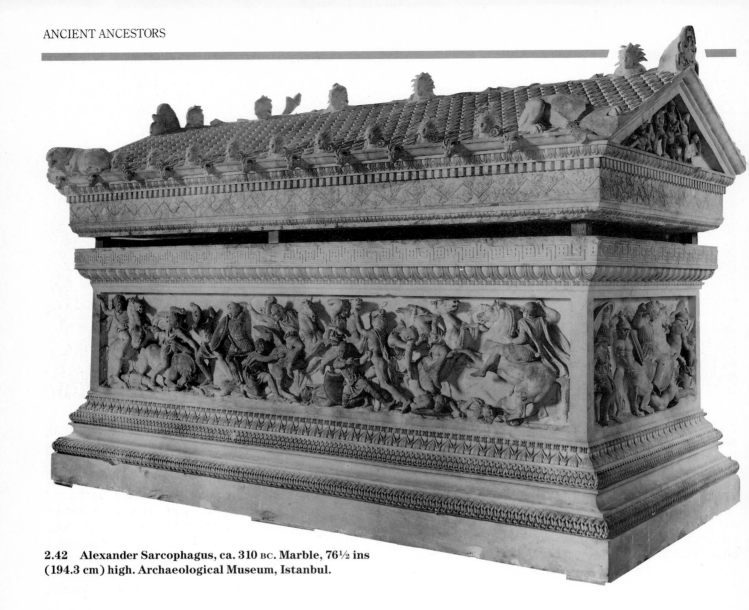

2.42 Alexander Sarcophagus, ca. 310 BC. Marble, 76½ ins (194.3 cm) high. Archaeological Museum, Istanbul.

late fourth-century burial piece (Fig. **2.42**), created for a regent of Alexander in Sidon, whose splendor and size contrast with the earlier Greek tomb monuments, such as the modest Stele of Hegeso (Fig. 2.34). Instead of the single relief, this sarcophagus offers a full temple-like structure ornamented on all sides with carvings in high relief. The chief scene on the sarcophagus features a battle between the Greek army, led by Alexander on horseback at the far left wearing a Heraklean lion helmet, and Persians, in distinctive costumes. In place of the quiet procession of the Parthenon frieze, this private monument glorifies royal combat (including a lion hunt on the opposite side) by the quasi-divine conqueror. Its vividness was enhanced by paint (traces of which remain), including different skin tones for Greeks and Persians and even details like eye color.

BATTLE OF ISSUS Even though the famous monuments of Greek painting of the fourth century do not survive (though royal tomb paintings at Verginia in Macedonia, ca. 330 BC, have recently been unearthed in damaged condition), Roman copies help to suggest some of its

pictorial innovations outlined above. One image, commemorating Alexander's victory over Darius at the Battle of Issus (333 BC), is preserved in a Roman mosaic copy at Pompeii, in the House of the Faun (Fig. **2.43**). The technique of tile *mosaic*, while adopted and developed by Roman craftsmen into one of the great art forms of the ancient world, was actually a major innovation of the third century at the Macedonian capital of Pella, where colored cube tiles of glass or stone, called *tesserae*, replaced pebbles as the elements of constructed images. Through the mosaic copy the refined qualities of characterization and narrative as well as pictorial forms can be discerned in the battle scene. The original painting must have derived from earlier battle scenes, such as the Athenian portico, or *stoà*, image of Marathon of the early fifth century. Alexander appears again on horseback on the left, as in the Alexander Sarcophagus. Despite spearing a vanquished Persian, the valiant conqueror's gaze meets that of his foe, the panic-stricken Darius, elevated in his chariot on the right. Even in the mosaic copy the differences of costume and facial expressions are evident, particularly in the wide eyes of the Persian leader. Space is created largely by the overlapping

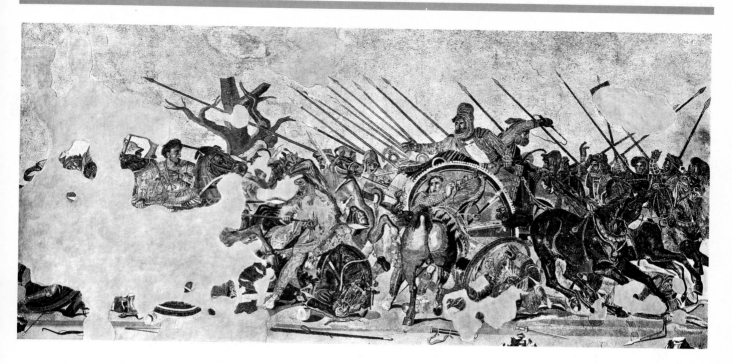

2.43 *Victory of Alexander the Great over Darius, Battle of Issus*, Roman mosaic copy of Greek painting, ca. 300 BC. Pompeii, House of the Faun, second century AD. 107 × 201½ ins (271.8 × 511.8 cm). Archaeological Museum, Naples.

of figures and by the accomplished foreshortening of horses and human limbs within the relief-like ensemble of the clashing armies. One virtuoso passage shows a fallen warrior beneath the chariot of Darius, with his face reflected in the polished shield beside it. Alongside evident cast shadows, subtle highlights and shading can be seen in all faces, despite the different medium and the intervention of a copyist. In short, as well as being an important visual testimonial of what Greek painted battles looked like, the Alexander mosaic bears witness to the representational accomplishments in perspective and *chiaroscuro* ascribed to renowned fourth-century painters.

PERGAMON: THE LEGACY OF ALEXANDER

Alexander died young and left no direct heir. His descendants split up his vast empire and ruled as absolute monarchs of a triad of kingdoms. Over the course of the next three centuries, the blending of Asian elements with the Greek foundations of Mediterranean culture resulted in a hybrid culture called "Hellenistic." Massive new cities were constructed, based on Greek models but on a much larger scale, led by Alexandria, named after the conqueror and founded by him in Egypt (332 BC). Alexandria was the site of the greatest library of ancient texts, the storehouse of Greek literature and learning. International trade in luxury goods fueled a period of prosperity and a

conversion of the political boundaries of Alexander's original empire into a trade network. In the new, Hellenized Asian centers a rectangular grid plan with broad, uniform streets shaped most of the new cities, including Alexandria, rather than the traditional defensive sitings dependent on an elevated acropolis. New individual religions largely replaced the traditional public Greek religion. Not only did Hellenistic rulers claim divinity for themselves in the tradition of Asian monarchs, but local Asian cults, called mystery religions, developed large personal followings around the figures of Isis or the Great Mother Goddess or even the Greek Tyche, goddess of fortune, as bestowers of salvation.

One of the new leading centers of Hellenism was Pergamon, located in Asia Minor, a provincial capital that aspired to the mantle of preservers and patrons of Greek culture. After its king, Attalos I, defeated an invasion from the north by Gauls (233–223 BC), he commemorated his victory with a series of bronze statues of dying Gauls, preserved in Roman marble copies (Fig. **2.44**). In these images, originally installed

2.44 *Dying Gaul*, Pergamon, ca. 230–220 BC. Roman marble copy after bronze original, lifesize. Capitoline Museum, Rome.

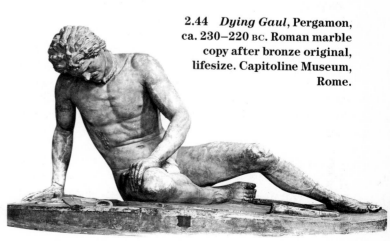

at Delphi, Delos, and Athens as well as Pergamon, the mustachioed features of a foreign foe, marked with a neck torque, nonetheless display great dignity under physical duress. Body details, including bleeding wounds and taut muscles, are carved in the vivid naturalist style adumbrated ever since Lysippos in the fourth century. Another vivid standing group shows a Gallic chieftain with a sword in his right hand, stabbing his own neck, while supporting the slumping figure of his bride in his left hand; they have clearly chosen suicide over dishonorable defeat.

ALTAR OF ZEUS

When the son of Attalos I, Eumenes II (reigned 197–159 BC), emerged as a regional leader through a combination of military victories and the momentary eclipse of rival powers (in part the result of the emergence of Roman power in the Mediterranean), he founded a new Panhellenic festival in honor of Athena on the acropolis at Pergamon, the Nikephoria. Near the site of the new festival was the Altar of Zeus, begun ca. 180 BC (Fig. **2.45**). The building that housed the altar, now reconstructed in Berlin, rests on a high platform with steps, introduced by an Ionic gateway of columns. Beneath the gateway and along the steps a life-sized frieze of the *Battle between Gods and Giants* symbolically celebrates the Pergamene victories and the triumph of Greek culture by depicting the conquest of warring giants by Zeus and the other Olympian gods (Fig. **2.46**). This is the most extensive sculptural ensemble since the Parthenon frieze at 390 feet (120 meters) long, though it is carved with much larger figures (7½ feet/2.3 meters high) and much higher relief. The figures in combat actually seem to emerge from the walls onto the very steps climbed by the visitor, spilling this cosmic clash into the world of experience. Violent action and struggle dominate these enormous, tightly intertwined figure groups. Each shows exaggerated muscle definition (the legacy of Lysippos) and deeply carved brows and shadowy eyes (seemingly derived from Skopas) to emphasize both physical strife and mental suffering. Pictorial invention leads to independence from description; for example, the wavy hair of the giants in conflict with Athena writhes with a life of its own, echoing the biting serpent of the goddess. Thick drapery sweeps in deep-cut folds while simultaneously rendering the limbs of the body visible. Nonetheless, in deliberate Pergamene evocation of the Classical heritage, echoes of the Athenian Parthenon still remain, particularly in the figures of Athena and Zeus, whose dynamic central vertical position and animated stride derive from the west pediment. A colossal marble copy after the Pheidias Athena cult statue adorned the library on the acropolis at Pergamon, further advancing its

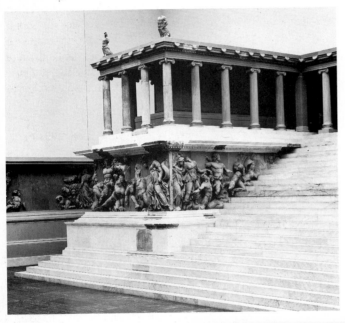

2.45 Altar of Zeus, Pergamon, ca. 181–159 BC. Staatliche Museen, Berlin.

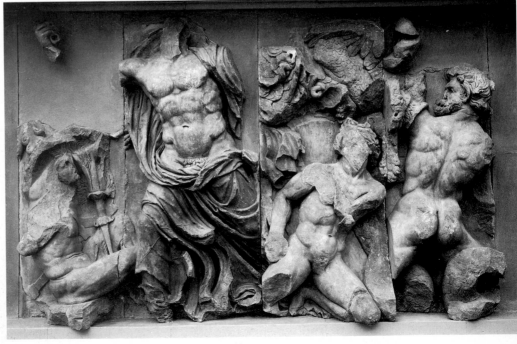

2.46 *Zeus Fighting Three Giants*, Altar of Zeus, Pergamon, ca. 181–159 BC. Marble relief, 90 ins (228.6 cm) high. Staatliche Museen, Berlin.

The general theme at Pergamon of the triumph of order over chaos, civilization over barbarism, still conforms closely to the programs at Olympia and Athens during the fifth century. However, Hellenistic art increasingly attended to more physical, less spiritual characters as its subjects, whose need of rational rule causes them to receive violent, even horrific punishment. One famous example from Rhodes (ca. 150 BC, the "Farnese Bull") depicted a cruel queen being tied to a bull. Another figure group, evoking comparison to the pathos of the giants on the Pergamon Altar of Zeus, showed the satyr Marsyas hanging, to be flayed alive for his presumptuousness in challenging Apollo to a contest of music. Inferior beings, too, such as ugly old women or men, amorous satyrs and cupids, or the slumping stupor of a large drunken *Faun*, a bestial half-goat (ca. 200 BC; Fig. **2.48**), evoke the descriptive naturalism of Hellenistic sculpture in the service of moral censure against the frailties of the flesh. The erotic frankness and insensate torpor of this large, strong yet languid body reveal a comic inversion of the high drama of the Altar of Zeus, the embodiment of Dionysian passion rather than Apollonian rationality.

2.47 *Herakles and his Infant Son, Telephos,* **Roman fresco copy of Pergamon painting, ca. 200 BC, Herculaneum, second century AD. Archaeological Museum, Naples.**

2.48 *"Barberini Faun"*, **restored original of ca. 200 BC. Marble, over-life size. Glyptothek, Munich.**

claim to be the New Athens. This change of location, however, suggests the degree to which the Hellenistic world already viewed its Classical predecessors as "artworks" and inherited culture rather than as functional elements of religion – analogous to the incorporation of earlier religious creations in our modern art museums.

One final Pergamon monument may be glimpsed through its copy: a painting from Herculaneum, near Pompeii. The subject, *Herakles in Arcadia, Finding his Son, Telephos, Suckled by a Hind,* had particular local significance for Pergamon, inasmuch as legend claimed that Telephos became king of the Pergamene region, and a version of the story appeared in a wall relief within the colonnade of the Altar of Zeus (Fig. **2.47**). Here again, the pictorial emphasis on figural foreshortening and careful modeling of light and shadow in color tones accords with the impression given by the Alexander mosaic. The naturalistic description found in the anatomy of Hellenistic sculptures is repeated in the bronzed body of Herakles but echoed as well by the still-life basket of fruit and various animals. The seated female with garlands is a personification of the region of *Arcadia*. Such personifications, already encountered in the figure of Nike (Victory), also figured in complex visual allegories, such as the celebrated Calumny composition by Apelles, preserved in ancient literary descriptions.

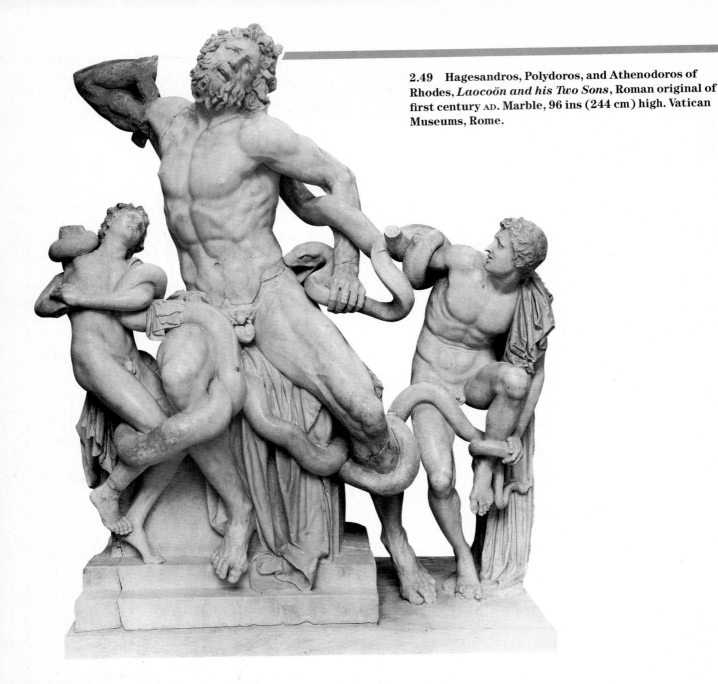

2.49 Hagesandros, Polydoros, and Athenodoros of Rhodes, *Laocoön and his Two Sons*, Roman original of first century AD. Marble, 96 ins (244 cm) high. Vatican Museums, Rome.

LAOCOÖN In this same vein of creativity comes the *Laocoön* (Fig. **2.49**), perhaps the most famous of all ancient sculpted groups after its excavation in the Renaissance Rome of Michelangelo in 1506. This work was extolled by the ancient Roman writer, Pliny, who recorded the identity of its sculptors: Hagesandros, Polydoros, and Athenodoros of Rhodes. Its story tells of a Trojan priest who tried to warn his countrymen against the Greek deception of the Trojan horse but was strangled with his sons by serpents sent by the gods who protected the Greeks. Physical suffering and pain register in the taut musculature, drawn brows, and crying mouths of these figures. Despite its obvious resemblance to the struggling giants of the Pergamon Zeus Altar, however, recent scholarship based on comparable new finds (at the imperial Roman resort grotto at Sperlonga) suggests that this ensemble may date from a Roman revival of Hellenistic forms (the *Laocoön* sculpture was found in excavations of the home

of Emperor Titus).

Such arguments reveal the ongoing exploration of archaeologists to uncover and contextualize monuments of the ancient world. But they also serve to remind us of how many of the images we have examined as evidence of Greek accomplishment are actually Roman copies of a later date. The ascendancy of Roman might in the Mediterranean in the third and second centuries BC in no way minimized the dependence of the new power on the venerable older culture of Greece, just as Pergamon herself had emulated the visual accomplishments of Periclean Athens. Hellenism spread the Athenian language and culture to the ends of the known Eurasian world, including the Alexandrian overlay to the ancient civilization of Egypt. We now need to turn to Rome to evaluate how much that greatest of ancient empires owed in her art and architecture to her Greek models and how much she contributed in her own right.

ROME: FROM REPUBLIC TO EMPIRE

Rome's sudden rise to power in the Mediterranean during the third century BC and the wholesale incorporation of artworks as part of the spoils of war resulted in a considerable blurring of the already fluid boundaries between the heritage of Athens, neo-Attic art, and Hellenistic art in general. In general, Roman adoption of Greek artforms parallels her absorption of Greek political entities, beginning with the conquest of Greek Sicily and the sack of Syracuse in 211 BC. Prime examples include the colossal sculptures of Zeus and Herakles by Lysippos at Tarentum, which were carried off in

conquest to the Capitol at Rome in 209 BC as trophies of the Punic Wars against her rival, Carthage. The Roman historian Plutarch describes one such triumphal procession (167 BC) and its rich plunder in his biography of Aemilius Paulus, conqueror of Macedonia: "The first day was just barely sufficient for seeing the statues which had been seized and the paintings, and the colossal images." Corinth was sacked in 146 BC, Athens in 87 BC.

Her definitive victory over Carthage in the Second Punic War (218–201 BC) enabled Rome to turn against Macedonia,

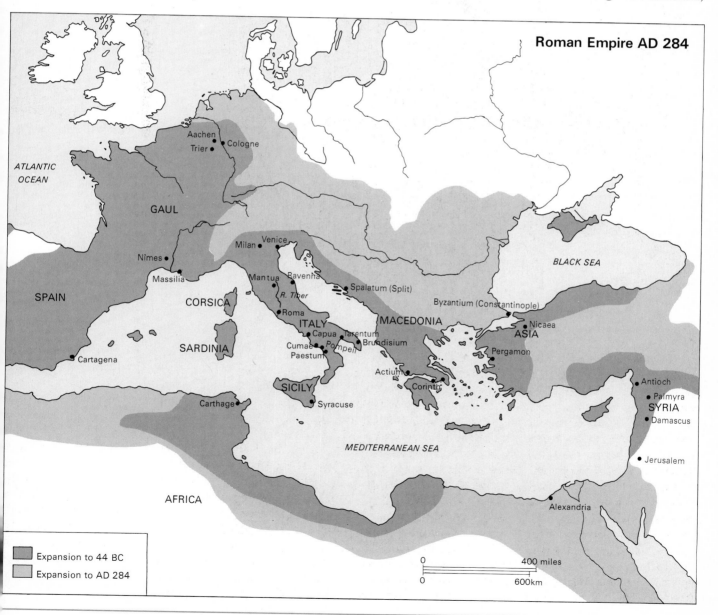

Roman Empire AD 284

Expansion to 44 BC
Expansion to AD 284

0 400 miles
0 600km

an ally of Carthage, and (with her own allies from both Pergamon and Rhodes) to subdue the heirs of Alexander the Great on battlefields in both Greece and Asia Minor during the early second century (200–189 BC). After an extended period of pro-Roman local rulers in Greek regions, independence gradually gave way to political incorporation by Rome in the form of provinces that would form the eventual empire. For example, in 133 BC, the last Pergamene royal ruler died, willing his kingdom to Rome. The city-state on the Tiber had become the undisputed champion of the entire Mediterranean and heir to the bulk of Alexander's vast empire.

GREEK AND ETRUSCAN SOURCES

With increasing prosperity, Rome became a center for collectors of Greek art in all media, and conditions approximating the modern art market arose to meet the new collecting demand (whose pervasiveness we discern behind the complaints of some "old Romans" against such interests as decadent extravagance). Scholars debate, therefore, whether or not Roman art is just a later extension of Greek art, based on the emulation of plundered originals. Many of the "surviving" monuments of Greek sculpture are in fact Roman marble copies after lost Greek bronze originals; moreover, our only fragmentary knowledge of the appearance of Greek paintings comes from later Roman versions, such as the Alexander mosaic and the Telephos painting. By adopting and then adapting Greek art for their own purposes, including a religion that renamed the same Olympian gods, Romans continued a cultural dependence already invested in Attic models by the Pergamenes and other contemporary Hellenistic city-states. Hence the uncertainty arises about whether the named Greek artists who carved the *Laocoön* (Fig. 2.49) were actually on site in Rome as late as the first century AD, carving within the framework of a collecting boom and a taste for Pergamene figures. The sculpture would otherwise have been a collector's item from a few centuries past, part of the intense Roman taste for both collecting and copying Greek models.

Just as the Greek world succeeded previous cultures on Crete and the mainland, Rome, too, supplanted a major artistic culture in the central Italian peninsula: that of the Etruscans, whose works survive in abundance but without much historical information about the society at large. Roman independence from the Etruscans – and the founding date for the Roman republic under the rule of two elected consuls rather than a king – is traditionally dated as early as 509 BC, though the two clashed for supremacy in Italy well into the third century until Rome finally consolidated power. In addition, Greek art became extremely important to the Etruscans from the late sixth century BC. Though the Etruscans were territorial rivals of Greek colonies, many of the finest extant painted Greek vases owe their survival to having been placed in Etruscan tombs. Hence Rome, like many other city-states of the Hellenistic era,

took her chief inspiration directly from the Greek heritage as well as indirectly from her local rival, Etruria.

TEMPLE OF FORTUNA VIRILIS A measure of the dependency on Greek and Etruscan precedents as well as the innovative potential of early Roman architecture can be seen in one of the oldest surviving temples in Rome itself, the Temple of "Fortuna Virilis," whose original dedication is unknown (Fig. **2.50**). Built on a sturdy platform with an overhanging portico, a formula borrowed from the Etruscans, this temple is approached by a single front flight of steps. Such an arrangement enforces axial frontality rather than imparting the overall continuity of a Greek temple. Its base, or *podium*, assures height relative to the temple's surroundings, while slender attached columns with Ionian capitals incorporate the emphasis on height and elegance seen in much contemporary Greek architecture. However, the *cella* structure is firmly enclosed behind its porch and within its screen of attached columns, asserting the visible solidity, even the permanence, of the temple building. Even in its modest dimensions, the Temple of "Fortuna Virilis" imparts some of the solidity and control that would characterize much of the Roman contribution to ancient art.

2.50 Temple of "Fortuna Virilis," (Temple of Portunus), Rome, late second century BC.

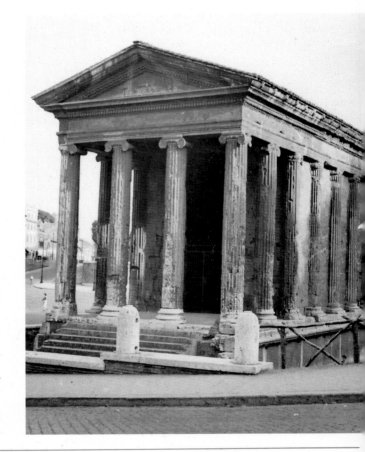

Roman Republican Portraits

Portraiture as the lifelike representation of features, rather than idealized or generalized images, such as the portraits of Alexander the Great, had already flourished in the Hellenistic world, especially in Athens, and not only for political rulers but also for renowned philosophers. Greek artists usually made full-length portraits rather than busts, using the body gestures of the sitter for rhetorical purposes to convey his role. However, Roman portraitists, beginning as early as the second century BC, went further in emphasizing the distinctive imperfections of individual likeness (especially the wrinkles of age in their aristocratic sitters), in order to convey a suggestion of venerable seriousness. Through such means, they identified their patrons with prized republican virtues of severity, gravity, and constancy. These same Roman aristocratic patrons also displayed the wax death masks of their ancestors in their homes, as well as at public sacrifices. Some were even worn like masks in funeral ceremonies as a measure of respect and as models for the younger members of the family.

From such customs the preference for bust portraits, carved in marble, emerged as a principal Roman republican artform, exemplified by a life-sized first-century group, *Patrician Carrying Two Portrait Heads* (Fig. **2.51**). The toga of the standing figure indicates that he was a Roman citizen, obviously wealthy to be able to afford such a portrait. Yet his features and those of his ancestors do not disguise his age – quite the contrary, they emphasize it, and the details of his gaunt baldness. This, too, is a "role portrait," despite its particularities, for this patrician enacts his veneration for distinguished family ancestors (whose number he will join shortly and in turn be recalled through this portrait). Such aristocrats, or patricians, formed the backbone of Roman republican rule, as they were the principal members of the Roman Senate and the guardians of the economic and political well-being of their vast networks of client-followers.

Portraiture remained a staple of Roman imperial art, providing a surrogate presence of the emperor in the provinces, a long-term consequence of the veneration of ancestor portrait images. While later portraits of Roman emperors almost invariably involved an idealizing quality, chiefly youthfulness, the distinctively individual features of each ruler remained a key ingredient of the power of these state commissions.

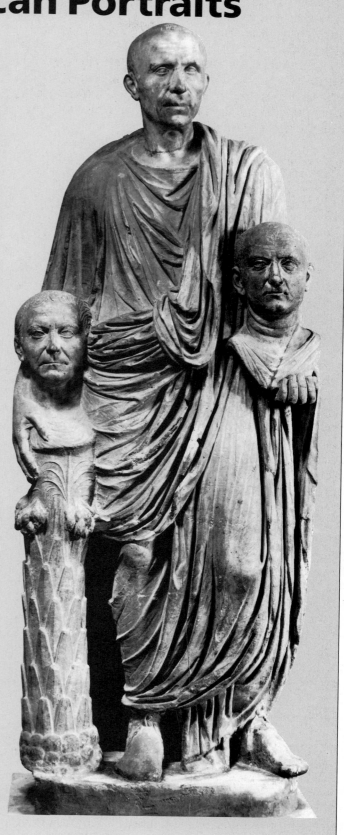

2.51 Patrician with two portrait heads, early first century, AD 15. Marble, lifesize. Capitoline Museum, Rome.

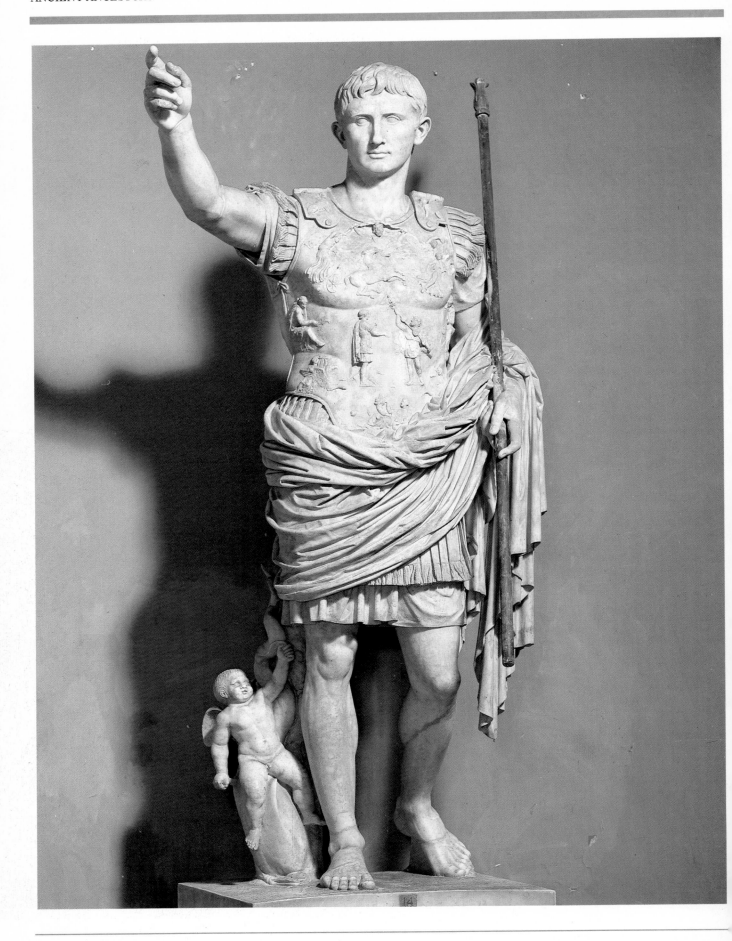

THE EMPIRE OF AUGUSTUS

The enormous expansion of Roman dominions and the resulting wealth that poured into the city as tribute brought dislocation to society and politics during the century after 133 BC. Conflicts between advocates of land and wealth redistribution (*Populares*) and their conservative adversaries in the Senate (*Optimates*) produced an ongoing struggle for control of the Republic, usually punctuated by a strong military leader and temporary dictatorial domination over Senate rule. This state of civil war climaxed with the united efforts of Pompey and Julius Caesar to overthrow the Senatorial tradition, led by Cicero. Eventually, Caesar emerged supreme, again as a reformer, only to be assassinated in turn by a Senatorial conspiracy (44 BC). The eventual resolution of this complete social breakdown was achieved through military victory (31 BC) by Caesar's adopted son, Octavian, later Augustus Caesar, over Caesar's former lieutenant, Antony. With the establishment of the empire under a single leader, Augustus, both the power and culture of Rome were at last consolidated, and the arts flourished.

Symbol of the new empire is the over-lifesized standing figure of Emperor Augustus (Fig. **2.52**). The wavy locks and features of this youthful warrior clearly distinguish him as Augustus, here dressed as a commanding general in parade armor with an officer's cloak. He gestures outward in a conventional Roman expression of command (*adlocutio*), with a weapon (perhaps a sword originally) in his left hand. Reliefs on his breastplate signal a surrender, Parthians submitting to Romans; allegories of the solar chariot above and the reclining earth below join flanking personifications of the captured provinces to frame the scene of submission. Comparing this statue of Augustus to the *Doryphoros* of Polykleitos (Fig. 2.24) shows how the new Roman specificity of identity and dress is grafted onto the idealized striding nude figure of the victorious athlete with spear. The martial Augustus can also be seen as the heir to the idealized general portrait of the victorious Alexander. In fact, suggestions of the divine nature of Augustus emerge from the playful Cupid on the support beside his leg. Cupid is the child of Venus, who, as mother of Aeneas, was also credited as the founder of Rome, commemorated in Vergil's contemporary epic, the *Aeneid*. This entire image is a summary of the claims to political power – and to the restoration of world peace – by Augustus with his new, quasi-divine authority.

Most surviving Roman art dates from the imperial centuries rather than the preceding republican period, in part due to the gradual increase in wealth and the eventual centralization of power from the time of Augustus onward. Prior to the aggrandizement of the city of Rome as capital of the empire, Romans had already developed their own distinctive grid plan,

based on axial cross-roads for towns, with the civic center, or forum, at the crossing. Under Julius Caesar, the Forum Romanum of Rome became a showpiece for his expanded powers, and he added his own Forum Julium in an adjacent space (Fig. **2.53**).

Augustus presented himself with deliberate restraint during his lifetime, though he was deified by his successors. His own record of his deeds as emperor characterizes him as "First Citizen," acting within the constitution to save the Roman state and restore peace to the world. Augustus is reported as having said, privately, that he had found Rome a city of brick and left it a city of marble.

A RA PACIS The memorial monument by Augustus to his accomplishments in the city of Rome was the Altar of Augustan Peace, or Ara Pacis (13–9 BC), established by a vote of the Senate and placed in the Field of Mars, god of war, as a site for annual sacrifices to celebrate the end of the civil wars (Fig. **2.54**, p.70). Utilizing an earlier Greek altar prototype (emulated expansively in the Pergamon Altar), this

2.53 Roman and Imperial Fora, fourth century AD. Reconstruction model. Museum of Roman Civilization, Rome.

2.52 *Augustus of Prima Porta*, early first century AD. Marble, 80 ins (203 cm) high. Vatican Museums, Rome.

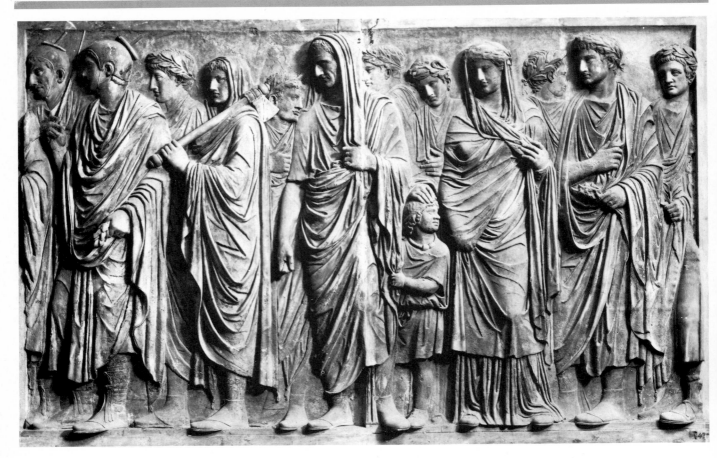

2.54a Altar of Peace ("Ara Pacis"), Rome, 13–9 BC. *Below*, general view. Marble, 35 feet (10.5 meters) wide, 23 feet (7 meters) high. Museum of the Ara Pacis, Rome. *Above*, detail of Imperial Procession frieze. Marble relief, 63 ins (160 cm) high.

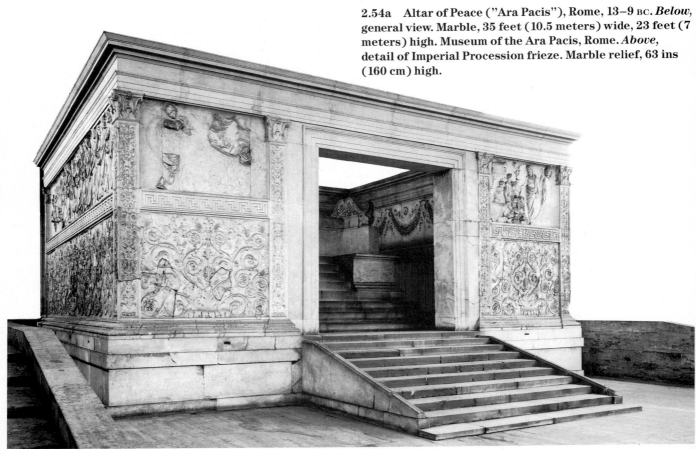

modest yet fully decorated temple exterior uses sculpted relief to promote a vision of pure civic harmony. Floral scroll ornament on a lower level suggests the fecundity of earthly peace, while panels with figures above allude to the city. Next to the entrance appear Rome's founding myths with the twins Romulus and Remus and the god Mars on one side and Aeneas, alleged ancestor and prototype of Augustus and his family, sacrificing on the other. Along both sides of the temple, moving toward the entrance, appears a procession frieze with representatives of the Senate and the populace of Rome. While this ritual file might – probably intentionally – recall the Parthenon in Athens, the Roman procession is not a general and recurring urban event; rather, with the inclusion of the specific figure of the emperor himself, head veiled in piety, the frieze records the founding act of sacrifice for this very edifice. Augustus as the new Aeneas is shown sacrificing at the climax of the procession (damaged; not illustrated); his dress remains consonant with that of his companions, again asserting his role as citizen rather than ruler. Here the Roman interest in portraiture and the specifics even of toga drapery imposes upon the striving for a classical dignity and restraint of figure movement. The effect of the entire ensemble is to suggest that the specifics of the Augustan era embody a new Golden Age of piety, peace, and prosperity.

More elaborate private creations became an important part of Roman luxury arts, including gems. One remarkable gem, a cameo (Fig. **2.55**), commemorates the reign of Augustus in completely different terms, presumably with the emphasis on the divinity accorded him after his death. Documents record that Augustus had his own signet ring carved by a Greek gem-cutter named Dioscurides, who may well have produced this work. Some of the triumphal elements on the breastplate of the statue of Augustus reappear here, as Roman soldiers erect a trophy pole with captured barbarian armor and prisoners (who resemble the Pergamene Gauls down to their neck torques) in the lower zone, while allegories fill the top. However, seated amid the allegories, Augustus himself appears as a new Jupiter, with an idealized body redolent of the Pheidian cult statue, flanked by the personification of Rome. A wreath crown above the head of Augustus is held by the figure of Oikoumene, the civilized Hellenic world, above the allegories of both earth and sea. At the left a youth in a toga stands in a chariot with winged Victory; presumably this is Tiberius, successor to Augustus as emperor, and the probable client for this imperial gem.

2.55 *Gemma Augustea*, **early first century** AD. **Onyx cameo, 7½ × 9 ins (19 × 23 cm). Kunsthistorisches Museum, Vienna.**

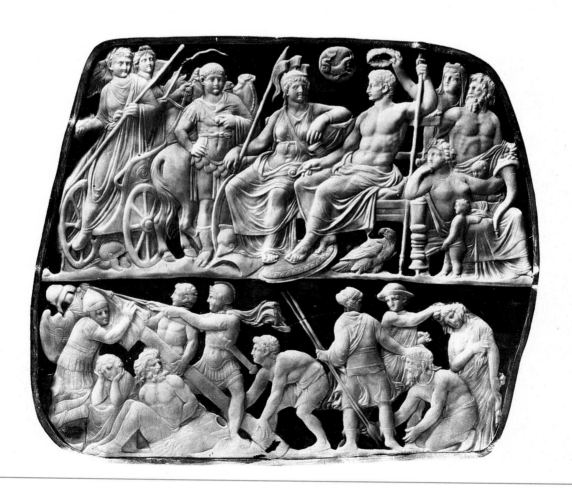

2.56 Ixion Room, House of the Vettii, Pompeii, AD 63–79. Frescoes.

2.57 *Dionysiac (Bacchic) Mystery Cult*, Villa of the Mysteries, Pompeii, ca. 50 BC. Frescoes, 63¾ ins (162 cm) high.

ROMAN DOMESTIC ART

Such gems, as well as the growing importance of collecting Greek artworks, point to the unprecedented importance of the private sector as an aspect of Roman art production and consumption. Nowhere is this private world of luxury more evident than in the preserved whole resort city of Pompeii, near modern Naples, buried by the eruption of Mount Vesuvius in AD 79. Its vast urban complex includes the basic elements of any standard Roman city, such as a central forum (here unified by a perimeter colonnade), temples, public baths, and *amphitheater* for public spectacles. Yet the homes of all kinds preserved at Pompeii suggest the importance of the private living unit as a special preserve for wealthy Romans away from the official grandeur of their public buildings. A set of rooms are arranged around an open, roofless central courtyard, or *atrium*, providing a focal, private space. Sometimes a Greek columnar *peristyle* (including at times a second storey) and a garden enhanced the luxury and space of the buildings surrounding the pool-cistern of the atrium.

Decoration of the domestic interior included both wall paintings and floor mosaics. Paintings were made directly on the walls as well as on panels. They not only included figural scenes, such as that of Herakles and Telephos (Fig. 2.47), but also elaborate decorative schemes. These ranged from illusionistic scenery of buildings and landscapes, which seem to dissolve the walls in fastidious geometrical intricacies of either repeated patterns or delicate inventive caprices, to deceptive depictions of still-life objects or even fictive spaces or gardens. An elaborate example of the range of such wall decorations appears in the House of the Vettii at Pompeii (Fig. **2.56**). Here the full vocabulary of wall decoration appears: mythological scenes of fully-modeled figures, perhaps directly copied or at least modeled upon famous Greek pictures; simulated marble inlay; fine decorative garlands, scrolls, and borders; and illusionistic window frames giving way to views of elaborate, open, multi-storeyed buildings.

Beyond their opulent display of wealth and status or sophisticated reference to Greek knowledge and culture, some paintings clearly remained private and personal images of great religious significance. One series of wall paintings, at the Pompeii "Villa of the Mysteries," seems to reveal the most intimate and spiritual aspects of one of the numerous mystery cults that abounded in the ancient world (Fig. **2.57**). The subject of this life-sized set of figures is an initiation, including a ritual flagellation, of a woman into an unknown sect, presumably connected with Dionysus (Roman: Bacchus), god of wine and ecstasy, who appears reclining on the breast of his beloved Ariadne at the center of the composition. The frieze ensemble includes both mortal women, including the initiate and a nude dancing bacchic *maenad*, at the sides, with gods, especially the nature gods of Bacchus and Pan, and satyrs, at the front. Owing to the secret aspects of a mystery cult, the meaning of these scenes cannot be fully explained. Scholars also debate whether this imagery derives from a famous Greek prototype or else was painted by a talented Greek painter for a Roman, presumably female, patron.

IMPERIAL GRANDEUR

At the time of the destruction of Pompeii at the end of the first century, the classicizing imperial art formulated by Augustus, as well as the rule established for his Julian dynasty, was giving way to a new taste for the colossal in public art, in the service of an aggrandized imperial rule under a new family dynasty, the Flavians, founded by Emperor Vespasian after the suicide of Nero (AD 68). A fire (AD 64) during the reign of Nero had cleared vast tracts of the city of Rome, and the city rose again on a new scale, coordinated by a system of building codes and zoning laws.

THE COLOSSEUM Grandest of all the Flavian buildings, even in its ruinous modern condition (it was used as a stone quarry by centuries of Renaissance Roman architects) is the huge amphitheater, aptly nicknamed the "Colosseum" (Fig. **2.58**) though the source of the name was

2.58 Flavian Ampitheater ("Colosseum"), AD 72–80.

not the grand scale of this building but the nearby colossus of Nero, a bronze statue some 120 feet (36.5 meters) high! As a symbol of the new public orientation of the emperors, Vespasian destroyed the gardens and lake of Nero's self-indulgent palace, the Golden House, in order to create the site for the Colosseum. Here, entertainment for the expanding population of Rome, already numbering around a million, featured gladiatorial contests, animal combats, and naval battles for some 50,000 spectators. The structural technique of the building represented one of Rome's great contributions to the history of architecture: arched passages and deep, rounded *barrel vaults*, constructed with concrete and brick masonry. These tunnel vaults radiate to facilitate the circulation of men and animals, as well as spectators above. At junctions between barrel vaults, sturdy *groin vaults* permitted concentric rings around each level of the amphitheater. Attached half-columns and limestone facing decorated the exterior of the building, forming an anthology of Greek styles, rising from sturdy Doric through graceful Ionic to ornate foliate *Corinthian* capitals. Henceforth, the structural principles were in place for future colossal structures to embody the power of the empire in Rome as well as its provinces. However, even in its ruined

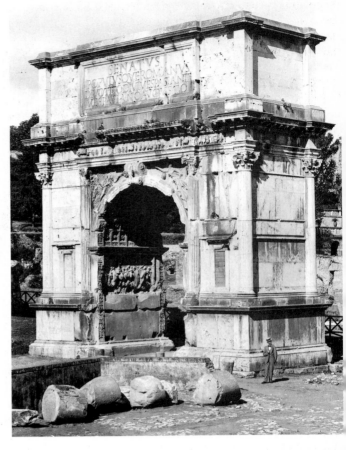

2.59 Arch of Titus, Rome AD **81. General view.** *Below,* **detail of Spoils of Temple of Jerusalem, Rome,** AD **81. Marble relief, 79 ins (200 cm) high.**

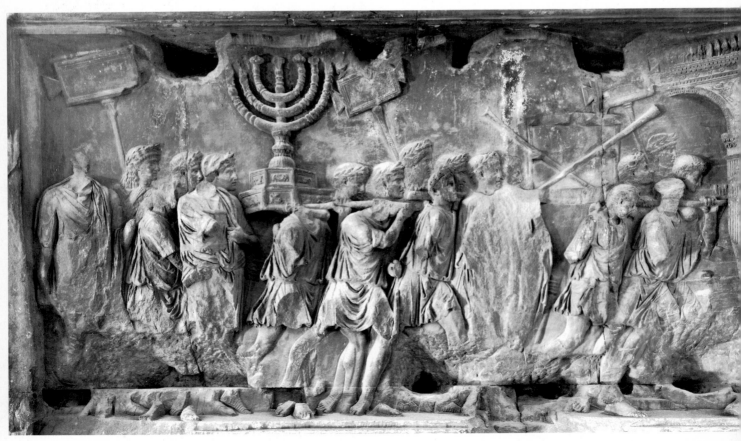

state, the Colosseum remained emblematic of Roman grandeur and in its ruinous condition even came to stand for the fallen splendor of the ancient empire, an inspiration for artists and writers visiting Rome ever afterward.

THE ARCH OF TITUS Near the Colosseum at the head of the Sacred Way (Via Sacra) leading into the Forum, a public monument (Fig. **2.59**) celebrates the military victory at Jerusalem in the Jewish Wars (AD 66–70) by Titus, son and brief successor of Vespasian. In form, the massive arch with attached *Composite* (a mixture of Corinthian and Ionic) half-columns and blocky attic storey conforms to the precedent set by the adjacent Colosseum. Although this is the first major permanent monument to military triumphs in Rome, its carved reliefs display the actual events, described by Plutarch and others, of ceremonial triumphal entry into the city with spoils by returning victorious commanders. Crowned with laurels, a lively procession of soldiers bears the massive candelabra (*menorah*) and silver trumpets from the Jerusalem temple, just as earlier armies had borne the sacred artworks of Greece. As in the Ara Pacis, this procession commemorates its dedication. The arch depicted on the relief includes a missing feature from the surviving structure in Rome – a bronze *quadriga* (four-horse chariot) on its summit. On the opposite site, the climax of the procession, appears the relief figure of Titus standing above his army in just such a decorated quadriga. A winged Victory crowns him, and he is escorted by a seminude Genius of the People, while led by Valor. Both reliefs have been celebrated for their remarkably pictorial evocation of motion by means of overlapping figures across space – a notably dynamic contrast to the stateliness of the Ara Pacis procession a century earlier.

The brief Flavian line of emperors ended with the assassination of the despot Domitian, Vespasian's son, in AD 96. The succeeding century saw the new imperial procedure of "adopting" a successor rather than depending on heredity in the form of a natural son. The "Five Good Emperors" who dominated the second century AD made important political and economic consolidations, particularly in the integration of the provinces of the empire. Typical of the new style of ruler was Trajan (ruled AD 98–117), born in Spain and active as a victorious military commander on the frontiers of the empire (Dacia and Parthia). Trajan (with his celebrated architect, Apollodorus of Damascus) left his mark distinctly in the center of Rome, building a massive Forum of Trajan at right angles to the Forum of Augustus. Organized along an axial plan and complemented by an adjacent, massive concrete vaulted market area for public use, the Forum of Trajan was entered through a triumphal arch, with an equestrian statue of the emperor in the center. It reached its climax in the Temple of the Divine Trajan. With this building complex, the monumentalization of the emperor and of Rome as the center of Empire was complete. Moreover, the principle of grand scale, vaulted concrete structures, and planned spatial sequences along an axis flourished as a model for later imperial structures, such as palaces and baths.

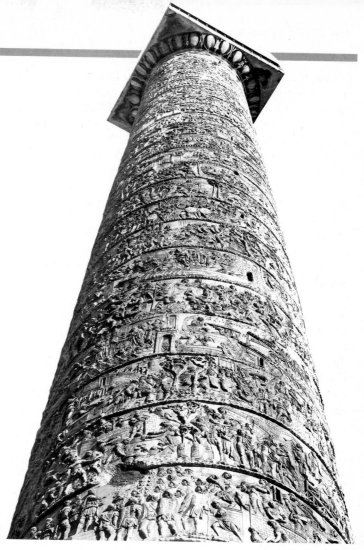

2.60 Column of Trajan, Rome, ca. 110 AD. Marble, 125 feet (38 meters) high, reliefs 36 ins (91 cm) high.

TRAJAN'S COLUMN displays the emperor's taste for magnificence and was his grandest sculpted addition to Rome's traditional center. Towering at 100 feet (30.5 meters) high, the column was originally surmounted by a gilded statue (Fig. **2.60**). Like the triumphal arch, the column served as a symbol of imperial victory, and it was adorned with a long spiral frieze of reliefs (625 feet; over 200 meters), narrating Trajan's achievements in the conquest of Dacia. Close attention is paid to costumes, geographical detail, and Roman military engineering, which may once have been painted. Apollodorus placed this historical record between the Greek and Roman libraries enclosed within the Forum of Trajan. Originally the column emerged from a base made of captured war trophies and a wreath of victory. Although Augustus had already erected a column tribute to his victory at Actium (lost), Trajan's Column spawned a host of variants made for later emperors to commemorate their victories and declare their majesty.

Hadrian, Trajan's nephew and successor as emperor (AD 117–38), was not a warrior; instead, his passion for culture led him to initiate a notable revival of Greek forms. Rather than being primarily identified with a central, urban architectural

creation, Hadrian's most famous monument is his villa outside the city at Tivoli, a vast and experimental encyclopedia of Roman construction techniques and innovative designs along with a veritable museum of Greek sculpture (chiefly copies). By the time of Hadrian, clearly, Greek culture was a past heritage rather than a living and evolving tradition of which Roman art was the most recent beneficiary.

THE PANTHEON was the greatest of the buildings erected under Hadrian in Rome and one of the most emulated structures in Western architecture (Fig. **2.61**). Characteristically, its dedication and its name incorporate all of the gods of the Greek *pantheon* (*pan*=every, *theos*=god), with the learned thoroughness and cultivated sensibility of Hadrian himself. Originally this temple, elevated, had a colonnaded forecourt, now lost, but its principal features begin with a traditional temple front porch with grand Corinthian columns. Behind this portico a solid block helps to support the major space: a domed round building, or *rotunda*, crowned with a circular *oculus* (eye) open to the sky. Entered through bronze doors, this domed space encloses a fully spherical interior, although its exterior shell supports itself partly through stepped terraces upon a cylindrical drum. The entire engineering feat is achieved once more through the Roman mastery of cast concrete, which included reducing the weight of the dome itself through the decorative feature of *coffering* (that is, forming

recessed panels in) the ceiling. Sheathed in brick, the structure was originally faced with marble and roofed with gilded bronze, though again this building was used as a quarry by ambitious builders in seventeenth-century Rome. Its otherwise good state of preservation is due in part to its conversion to a Christian church (after the removal of much of its original "pagan" sculptural ornaments) during the seventh century. Still preserved, the marble pavement echoes in its layout the motif of square and circle that defines the geometry of the building. Seven recessed *niches* and projecting altars, presumably dedicated to the seven planetary deities, form their own dialogue of column screens and frames at ground level, in an innovatory, non-structural use of traditional Greek support systems (Fig. **2.62**).

Although Nero's Golden House had already featured both the concrete technology and the association of the dome (there an octagonal hall) with the heavenly spheres, the Pantheon enlarges that concept in a public temple space. However, the ever-present trace of sunlight through the *oculus* (more often a feature of domed bath spaces) animates and focuses the symbolism of heavenly presence in this temple of all the gods.

2.61 Pantheon, Rome, AD 118–25. Exterior view.

2.62 (Right) Pantheon, Rome. Interior view.

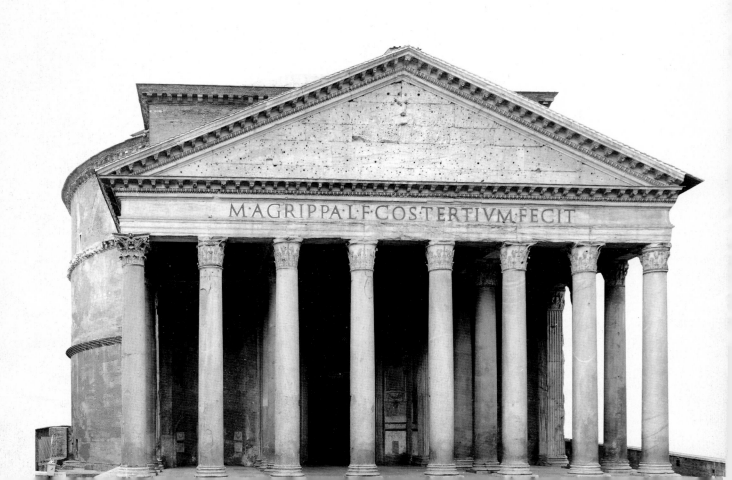

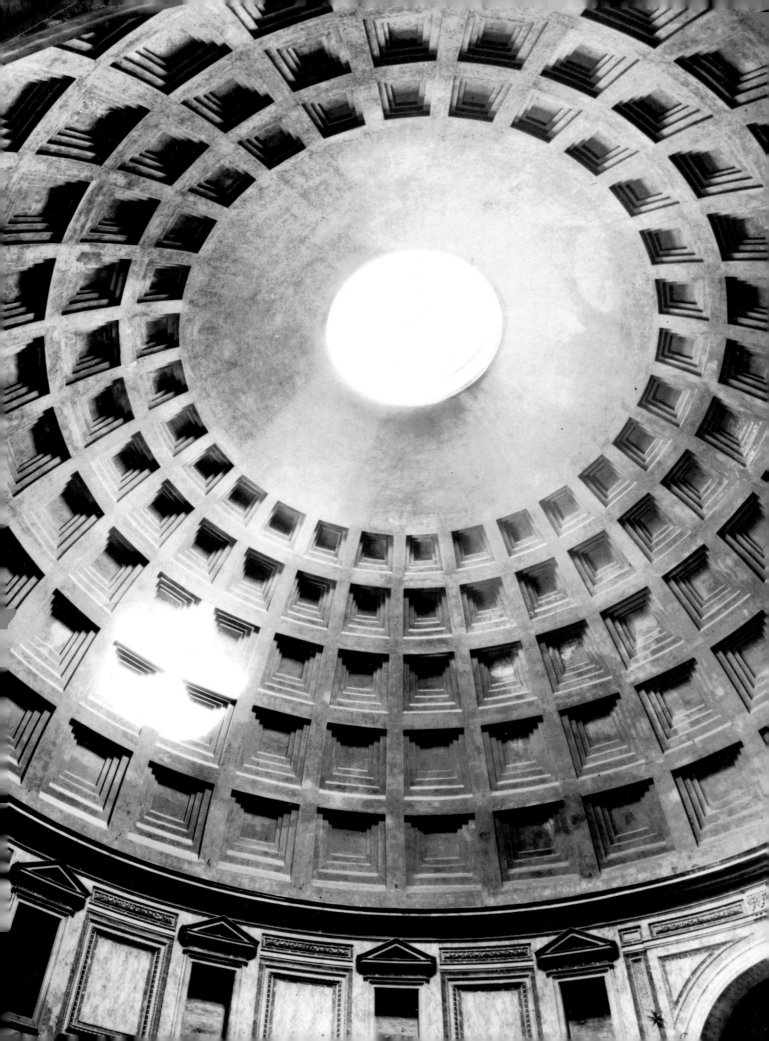

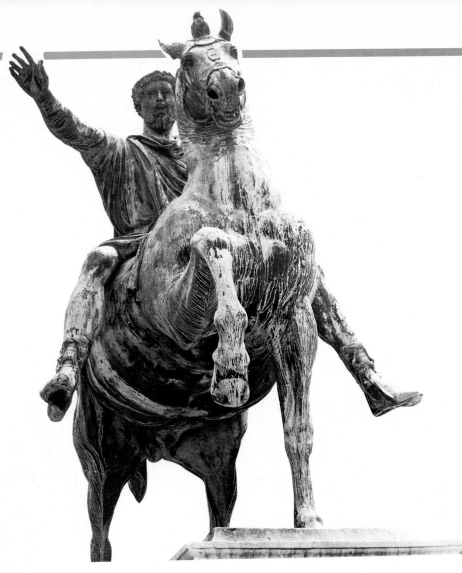

The unprecedented scale and grandeur of this dome form a tribute to Hadrian's patronage as well as his piety, once again associating Roman rulers, deified after death, with heavenly order. The visible prominence and geometric perfection of this building would inspire architects of Renaissance Rome as well as *Neoclassical* students of the English-speaking world (including Thomas Jefferson for both his home at Monticello and the Library of the University of Virginia, Fig. 7.15).

THE STATUE OF MARCUS AURELIUS Last of the "Five Good Emperors" was Marcus Aurelius (ruled AD 161–80), renowned today as much for his Stoic philosophy (his *Meditations* was written in Greek) as for his efforts to protect the empire against war and economic weakness. One of the most famous surviving monuments of imperial Rome is the (formerly gilded) equestrian bronze statue of Marcus Aurelius (Fig. **2.63**), preserved in part because it was misidentified during the twelfth century as Emperor Constantine, whose conversion to Christianity fused the fortunes of the empire and the new mystery religion (see below). The sheer technical skill required to cast such a large sculpture in metal posed a challenge for Renaissance emulators of classical antiquity, while the commanding gesture from horseback inspired portrait images of military leaders in both

2.63 *Marcus Aurelius on Horseback*, Rome, Capitoline Hill, AD 161–180. Bronze, over-lifesize.

painting and sculpture. Numerous such equestrian statues were produced for Roman emperors, but most were destroyed for their metal content or pillaged as spoils when the city lay in ruins. This lone surviving equestrian image shows the emperor in actual battle dress, as depicted on his own victory column reliefs (erected by his son in AD 181), addressing the army as well as the people of Rome. At the same time the portrayal of the bearded, curly-haired emperor, a fine example of later Roman portrait skills, employs a mixture of the traditional Greek philosopher type, favored by Hadrian, with the youth and strength of the general, like the beardless Trajan. Together, these qualities associate an imperturbable calm with Marcus Aurelius by virtue of his Stoic temperament as well as his imperial command. Apparently, the statue originally once showed a captured foe beneath the hoofs of the horse, after a prototype by Domitian in the Forum. Each Roman emperor used busts of his likeness as legal surrogates throughout the empire (just as Roman and modern coinage uses political or cultural leaders as part of its authority); citizens were required to swear allegiance to the likeness in the absence of the human prototype.

THE EMPIRE IN DECLINE

Historians tend to view the third century as a period of rapid decline in political and economic stability in the Roman Empire; most of the emperors were assassinated by mutinous troops, whose power increased as traditional legal instruments waned in the face of anarchy. Stern measures were imposed with the accession of Diocletian (ruled AD 285–305), a peasant who had risen through the ranks of the army. He imposed a vast bureaucracy on the empire, while maintaining the grandiose construction of imperial buildings, most notably a city-sized retirement palace – and fortress – at Split (AD 305; Spalato, in Croatia). In layout the imperial palace remains a Roman camp, structured around a single intersection of main axes. Back in Rome the grand remains of the Baths of Diocletian survive in their restored form as a church (Santa Maria degli Angeli, renovated by Michelangelo) (Fig. 2.64). To the Roman populace, baths were as important a public routine as sports – entertainments at the Colosseum or the races at the Circus Maximus. Such great halls, sheltering over a thousand bathers at once, demonstrate the technique of Roman mural architecture in concrete and brick as well as the ability to engineer great groin vaults at the intersection of tunnel-like spaces. Originally, marble facing and mosaic pavements gave the baths a powerful appearance of civic opulence for the benefit of the populace. Their vast extent exemplifies the Roman gift for spatial organization and the integration of rooms of different sizes and shapes within the overriding order of a massive rectangular precinct. If anything, the colossal scale of the Baths of Diocletian imposes a rigid system on the building elements, compared to the creative playfulness of Hadrian's Villa.

When Constantine emerged triumphant from a period of civil war in Rome, his reign (AD 306–37) marked a new

2.64 Baths of Diocletian, Rome, restored by Michelangelo into Church of Santa Maria degli Angeli, AD 298–306.

2.65 Basilica of Constantine (Maxentius), Rome, AD 307–312.

beginning in imperial fortunes. One of the major Roman buildings of Constantine employs concrete barrel vaults to create a grand ceremonial space. The Basilica of Constantine in the Roman Forum, site of a colossal 30-foot (9-meter) statue of Constantine, supported a great central hall with three flanking cavernous barrel vaults and external buttresses, of which only one side survives (Fig. **2.65**). As such, it served as a final assertion of imperial grandeur and authority in the heart of Rome, ornamented with marble and stucco decoration and lighted by giant, semicircular windows. New, regular rhythms of wall and window articulate the great arched vault openings. *Basilica* structures would later serve as the basic longitudinal building formulas for Christian churches, but in the Roman world they served primarily as imperial audience halls. Their association with the worship of emperors and their open spaciousness made the transfer of their dedication to Christ a simple, even logical step after the conversion of Constantine himself.

Near the Basilica of Constantine, the emperor erected his own triumphal arch, the last one sited on the Sacred Way of the Forum (Fig. **2.66**). As a structure, this later arch employs the opulent elaboration of visual grammar in later Roman buildings, multiplying the arched openings and utilizing appended, fluted Corinthian columns for volumetric surface decoration.

Virtually all surfaces are ornamented with sculpted reliefs, many in high relief. Most are pillaged from earlier imperial commemorative monuments, including works for Trajan, Hadrian, and Marcus Aurelius. Close inspection reveals that typical Hadrianic classicism dominates the larger reliefs of the circular tablets, or *medallions*, where a boar hunt and a sacrifice to Apollo celebrate the traditional valor and piety of the emperor. However, underneath these larger remnants of two centuries earlier runs a smaller scale relief of the emperor (Constantine's head is lost) standing in majesty at the center of a stiffly posed assembly as he addresses the people of Rome. In the rendering of costume, facial features, movement, and space this relief appears to be a crude simplification of previous achievements, such as the Arch of Titus or the Column of Trajan. Here priority is given to hierarchy and authority (the arch in fact commemorates Constantine's civil war victory over Maxentius), even as his use of the traditional arch form, forum site, and a pastiche of former memorials points to Constantine's assertion of his official imperial position. The spatial illusion and interest in figure movement, in short the illusion so basic to classical reliefs, have now all but disappeared, in favor of an art of symbolic assertion and abstract principles, where position and attributes convey notions of status and power. To the new Christian era, late imperial Roman art bequeathed its assertion of authority and militant triumph, fittingly led in its first great wave of patronage, especially of buildings, by the emperor, heir to Augustus's role of *Pontifex Maximus*, chief priest.

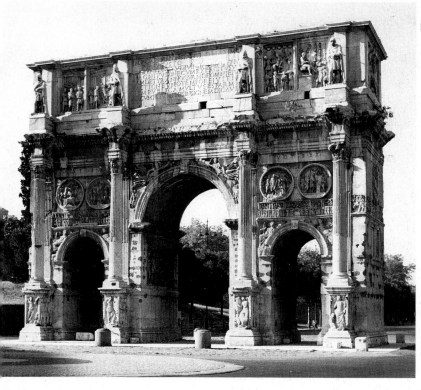

2.66 Arch of Constantine, Rome, AD 312–15. *Below,* detail of sculpted reliefs, including earlier reliefs (*Wild Boar Hunt* and *Sacrifice to Apollo* from ca. AD 131–38), AD 312–15. Marble, frieze 40 ins (102 cm) high.

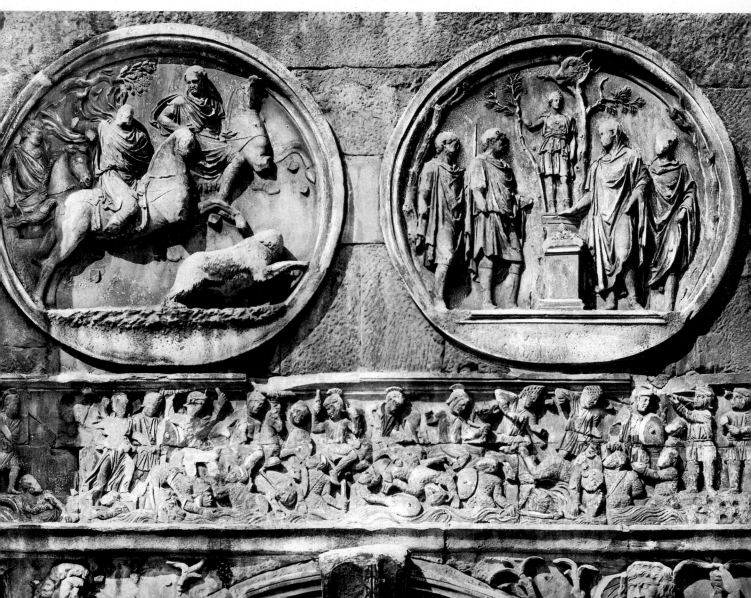

3

CHRISTIAN CULTURE

The demise of the Roman Empire is fixed around the event of the sack of the city in AD 410 by the Visigoths, a Germanic people from the Balkans. However, an event that had more profound consequences for the development of Western art and culture was the linking of the Roman Empire with Christianity. In AD 313 Emperor Constantine (AD 306–337) issued an edict at Milan proclaiming the legality of Christianity, bringing to an end the persecution of Christians carried out by his predecessors, such as Diocletian. In AD 325 Constantine summoned and presided over the first general meeting of the Church at Nicaea, which officially adopted Christianity as the state religion of Rome and determined the outlines of its orthodoxy (preserved in the liturgy as the "Nicene creed"). A further step by Constantine had long-term consequences: the foundation of a new capital, named Constantinople after the emperor, in AD 330 on the shores of the Bosphorus (a site known as Byzantium; present-day Istanbul). With the establishment of this "second Rome," an alternative imperial center developed rapidly. Known historically as the Byzantine Empire, this eastern region survived intact long after Rome herself had fallen into relative poverty and obscurity, and eventually her theocratic political structure led to the formation of an independent Church, the Eastern Orthodox, fully separate from the Roman Catholic Church of the West (the final schism took place in 1054).

Detail of Fig. 3.9 San Vitale, apse mosaic, *Justinian and his Retinue*, ca. AD 547, p. 90.

CHRISTIAN EMPIRES

ROME: THE WESTERN TRADITION

Of all the important projects initiated by Constantine, the most significant was his Christian basilica of St. Peter's in Rome (founded AD 324; Fig. **3.1**). Although destroyed to permit the construction of a new St. Peter's in Renaissance Rome (Figs 5.9–5.11), Constantine's foundation remained the largest church in Western Europe for almost a thousand years. Like most works of Christian art during the Roman era, the form of St. Peter's, a basilica, was borrowed from Roman meeting halls. Rectangular in shape, larger basilicas consist of a high central space, or *nave*, flanked laterally by *aisles*, usually supported on rows of columns. The enormous scale of St.

Peter's dictated double rather than single side aisles. Basilicas could accommodate large crowds, and since they were not associated with pagan religion in Rome, they served the new Christian majority without any associated stigma. St. Peter's took as its site the supposed grave site of its name saint, the first pope and founder of the Christian community in Rome. To house an enormous commemorative shrine, a second transverse nave, or *transept*, was built at right angles to the first. The shrine, a stone canopy, or *baldachin*, stood on a quartet of spiral columns at the crossing of nave and transept; visually this baldachin marked the liturgical focus of the church as well, for mass was celebrated on a fixed altar under its canopy and prayers were addressed to the dead saint from this consecrated site. Just behind the baldachin, the nave terminated in a semicircular recession, or *apse*, on the same axis as the rear wall of the church.

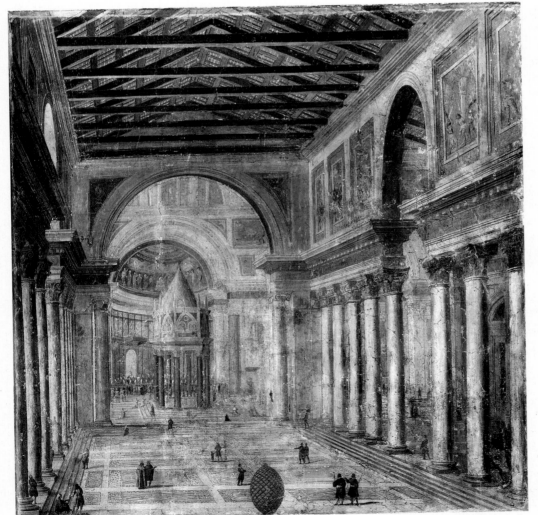

3.1a "Old" St. Peter's, Rome, fourth century AD. Reconstruction fresco, S. Martino ai Monti, Rome, seventeenth century AD.

3.1b Plan of "Old" St. Peter's, Rome, fourth century AD.

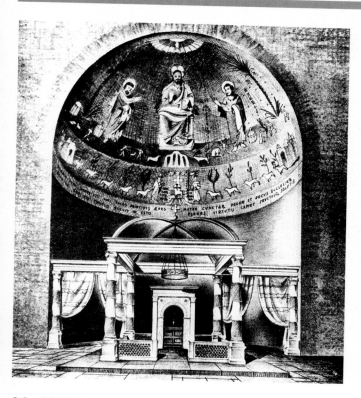

3.2 "Old" St. Peter's, copy of apse mosaic.

INTERNAL DECORATION The decoration of St. Peter's was destroyed along with the original church. Documents record that lavish materials were used for liturgical furnishings. Walls above the columns were decorated with painted narratives, either painted directly into the plaster in the *fresco* technique (scenes added at St. Peter's in the fifth century) or else constructed out of cubic glass colored tiles, *mosaics* a medium usually used for floor decorations by Romans. In St. Peter's the transept and nave were separated by a triumphal arch, like the apse decorated by gilded mosaics. The mosaic of the arch was accompanied by a dedicatory inscription for the entire basilica: "Because under thy leadership the world arose triumphant to the skies/Constantine, likewise victor, has founded his hall in thy honor." The focus of the interior decorations was the mosaic half-dome summit of the apse. Although its composition survives only in a copy, the St. Peter's mosaic proclaims the sanctity and majesty of its holy figures (Fig. 3.2). The largest, most central figure is a fully frontal, enthroned Christ, who sits directly under the gesturing hand of God the Father, at the apex of the mosaic. Framing Christ on either side are smaller standing figures of St. Paul and St. Peter. Like Christ, they bless with extended right hands. This hierarchy of sanctity extends downward, where a second register of figures is linked to the throne of Christ by the four rivers of paradise. A smaller, symbolic throne on this lower level is marked by two symbols of Christ: a cross and a sacrificial lamb (figures of a later pope and a personification of the Church were added in the thirteenth century). Matching the enthroned Lamb of God are a dozen

sheep, symbols of the twelve apostles, and in the corners of the mosaic appear schematic holy cities, labeled Jerusalem and Bethlehem. The message of the St. Peter's mosaic clearly defines the emanation of Christian spirituality from heaven to earth by using a graded hierarchy to move from the top down and from the center outward. Symbolically, the apse and its decoration serve as the link to heaven, diffusing the spirit outward into the sacred space of the church as a whole.

Although St. Peter's has disappeared, something of its original effect can be gauged from the surviving, smaller Roman church of Santa Sabina (AD 422–32; Fig. 3.3). Though built without a transept, like most Early Christian basilicas, Santa Sabina includes a framing triumphal arch in front of its apse. The nave stands on marble columns with Corinthian capitals and bases, borrowed from an earlier building but carefully matched. A series of arches, or *arcade*, topped with marble panels, leads swiftly to the apse, and the wall surfaces above the aisles are generously open to windows, the portion of the elevation known as the *clerestory*. Despite the apparent decline of Rome as a political center, buildings such as Santa Sabina attest clearly to its religious centrality as the main city of Christendom, flourishing during the fifth century through the institution of the papacy.

The climax of this new architectural opulence of Roman basilicas came with Santa Maria Maggiore (AD 432–440), with its massive, wide, well-lit nave, ornately adorned with mosaics (Fig. 3.4, p.86). The apse mosaics were destroyed in the late thirteenth century. The triumphal arch features mosaics of

3.3 Santa Sabina, Rome, AD 423–32.

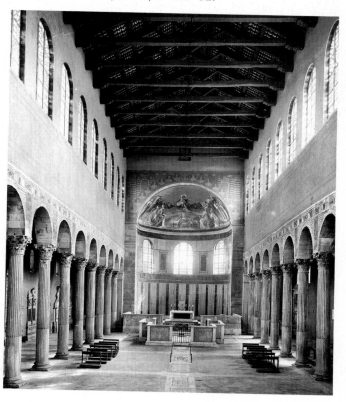

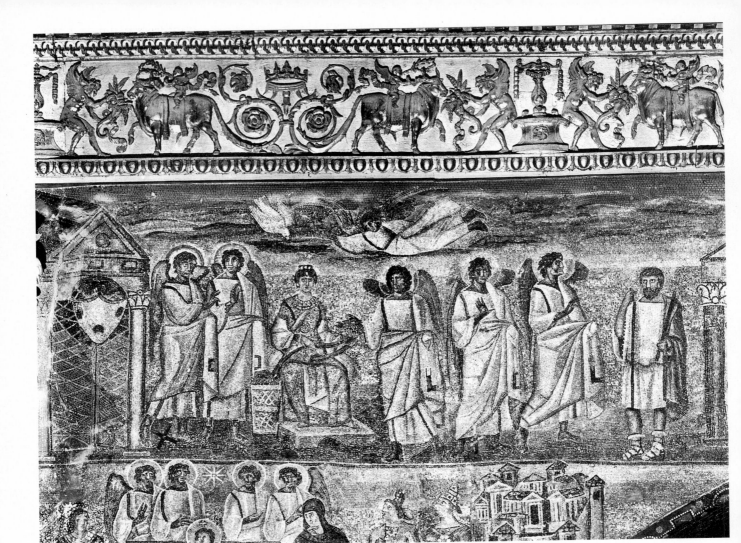

3.4 **Santa Maria Maggiore, Rome, mosaics,** AD 432–40.

3.5 **Sarcophagus of Junius Bassus,** AD 359. Marble, 46½ × 96 ins (118.1 × 243.8 cm). Grottoes of St. Peter, St. Peter's, Vatican, Rome.

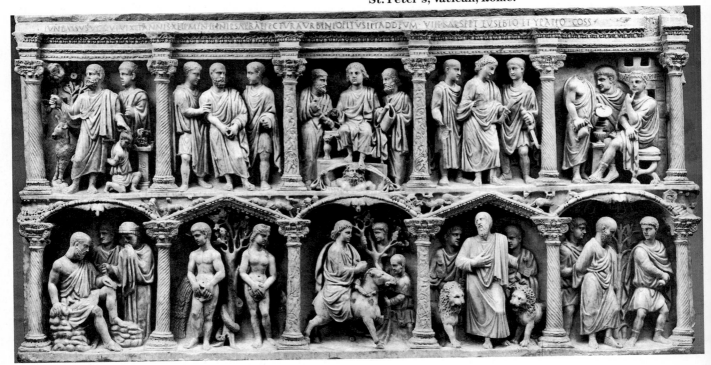

Christ's Infancy, the fulfillment of the Old Testament scenes in the nave mosaics. These mosaics represent the first and finest surviving examples of narrative Early Christian art. Preserved examples of illustrated manuscripts reveal the same reliance on massive figures within schematic settings of smaller buildings or segments of landscape. The Infancy scenes use the radiance of gold to underscore the sanctity of Christ. The Virgin Mary is shown in the top register enthroned, in regal robes, and attended by angels. While the image suggests a narrative of the Annunciation (with Joseph off to the right side), it also presents a pictorial assertion of her role as queen of heaven and bearer of divinity (*theotokos*; a concept affirmed by the Church council of Ephesus in AD 431). In the register below, the Adoration of the Magi also stresses the divinity and regal nature of Christ by posing Him on a magnificent throne, backed by angels and flanked by the Virgin. Atop the entire triumphal arch, a medallion presents another imperial throne filled with symbols of Christ: cross, crown, and lamb. Both the grandeur of the basilica and the splendor of its mosaics assert the spiritual authority of Christ and, by extension, the popes as vicars of Christ in Rome and all Christendom.

Monumental sculpture played a minor role in Christian decorations. The closest analogy to the massive frescoes and mosaic cycles in church interiors comes from the Roman tradition of carved sarcophagi, newly adapted to Christianity. From St. Peter's comes the sarcophagus of Junius Bassus, a Roman prefect (AD 359; Fig. **3.5**). Presenting a variety of narratives in a pair of superimposed horizontal registers, this sarcophagus utilizes columns and niche spaces to frame its scenes. In the upper central panel, an enthroned and frontal Christ, higher than the flanking figures of Peter and Paul, dispenses the law like a Roman emperor. (The bearded figure below his throne is a personification of heaven, indicating that this upper register is celestial.) This Christ is a youthful and beardless figure, akin to Apollo, a facial type popular in Early Christian representations, rather than the more familiar, bearded type (here reserved for the apostles or Old Testament figures). Below, the earthly manifestation of Christ is enacted through the triumphal entry into Jerusalem on the back of an ass. In this respect the hierarchy of the registers resembles the schema of the St. Peter's apse mosaic. As in the mosaics at Santa Maria Maggiore, the sarcophagus uses Old Testament subjects (Adam, Abraham, Job, Daniel) to suggest divine providence and the fulfillment of suffering in grace.

FUNERARY MONUMENTS also formed a major second type of Early Christian building. Instead of the longitudinal, axial plan of a church basilica, tomb buildings or mausolea (named after the Greek King Mausolus, fourth century BC) were round or polygonal in plan, their domes suggesting the vault of heaven. The extant prototype of Christian mausolea was built in Rome (ca. AD 350; Fig. **3.6**) for Constantina, the daughter of Constantine. Now known as Santa Costanza, this mausoleum was built adjacent to a covered cemetery. Its domed *vault* rises from a circular arcade composed out of twelve pairs of columns; twelve large

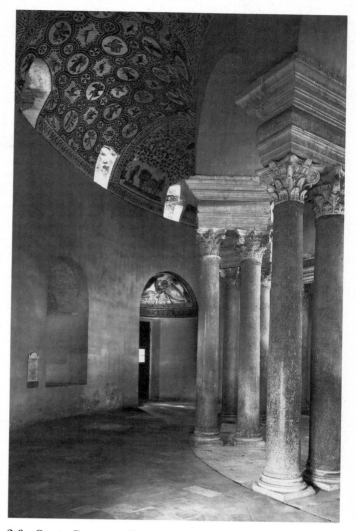

3.6 **Santa Costanza, Rome, ca. AD 350.**

clerestory windows flood the center with light. A darker passage, or *ambulatory*, around the perimeter of the building contains preserved mosaics, many of whose subjects derive from pagan bacchanals, such as vine scrolls and little Cupids. Originally the central space and an axial niche, too, had mosaics, with paradisiacal scenes and marble facing on the walls, ornamenting Constantina's sarcophagus. As befits the Christian doctrine of resurrection, both the ornate setting and the subjects of the mosaics suggest joyous celebration.

In his new, eastern capital Constantine constructed such a mausoleum for himself with his tomb in the center (Holy Apostles; destroyed). The emperor's resting place lay at the crossing point and focus of a *Greek cross* (that is, a cross with equal arms) in the plan of the church. Constantine also used a mausoleum structure at the end of a basilica for the holiest site in Christendom, the burial place of Christ in Jerusalem, site of the church of the Holy Sepulcher (destroyed and often remodeled in subsequent centuries). For later Christian buildings the rebirth suggested by baptism also dictated similar round structures for *baptisteries*, built adjacent to basilical churches.

RAVENNA

Because of the political instability in the peninsula of Italy during the fourth and fifth centuries, the capitals of the surviving Western Roman Empire shifted. Milan was one center of both politics and the Church, and during the fifth century the coastal city of Ravenna became an important remnant of Roman presence on Italian soil. In Ravenna, a regent empress, Galla Placidia, created one of the first significant Christian buildings: a mausoleum and martyr's chapel, consecrated to St. Lawrence and lavishly decorated with mosaics (ca. AD 425). For more than a century Ravenna received imperial patronage, including the eastern, or Byzantine, emperors from Constantinople. The finest sixth-century building in Ravenna is the church of San Vitale (dedicated AD 547), commissioned by the greatest Christian ruler since Constantine, Emperor Justinian (AD 527–65).

San Vitale and other Ravenna constructions served to mark the presence of Constantinople in Ravenna, for Justinian's armies had recently expelled the Ostrogoths (AD 540) and recaptured the city for the empire as part of his comprehensive attempt to restore traditional imperial boundaries under a unified administration. Justinian presided as the sole central authority over army, civil service, and Church, as appointer of the patriarch of Constantinople. Hence his construction of impressive and luxurious buildings, such as San Vitale, was a show of restored imperial and ecclesiastical authority. The design of the church is polygonal, based upon the central plan favored by Justinian for palace churches as well as mausolea (Fig. **3.7**). Eight piers support a dome within a two-storey structure of ambulatory and gallery. However, one segment of the octagon, the easternmost niche, has been expanded outward to become a *choir* space with apse. As a result, the axial emphasis of a basilical church has been subtly introduced. The choir and apse also contained the most luxurious decoration, highlighted by well-lit, radiant mosaics (Fig. **3.8**). On the side walls of this sanctuary appear the patrons of the church, Emperor Justinian with his retinue on one side (Fig. **3.9**, p.90), his empress, Theodora, with her attendants on the other. Justinian, crowned and haloed, stands in the center of this row of figures, representatives of the

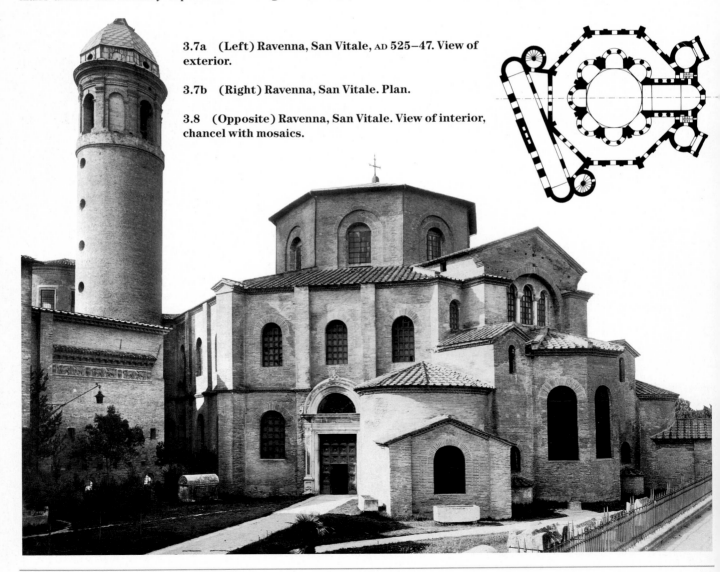

3.7a (Left) Ravenna, San Vitale, AD 525–47. View of exterior.

3.7b (Right) Ravenna, San Vitale. Plan.

3.8 (Opposite) Ravenna, San Vitale. View of interior, chancel with mosaics.

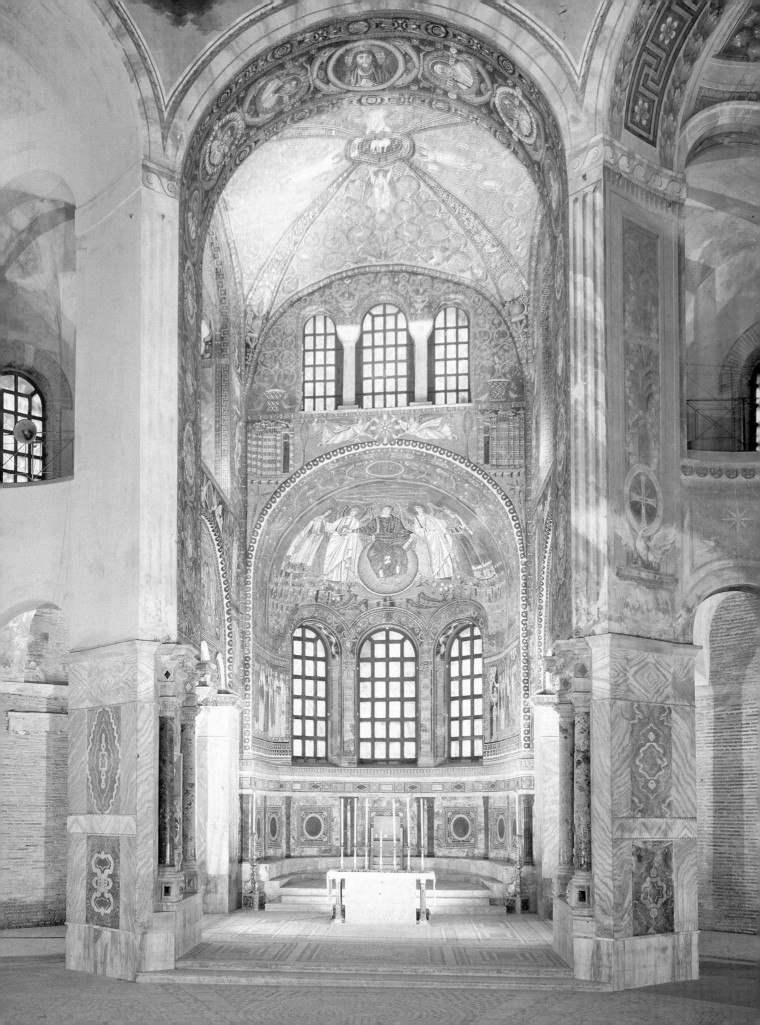

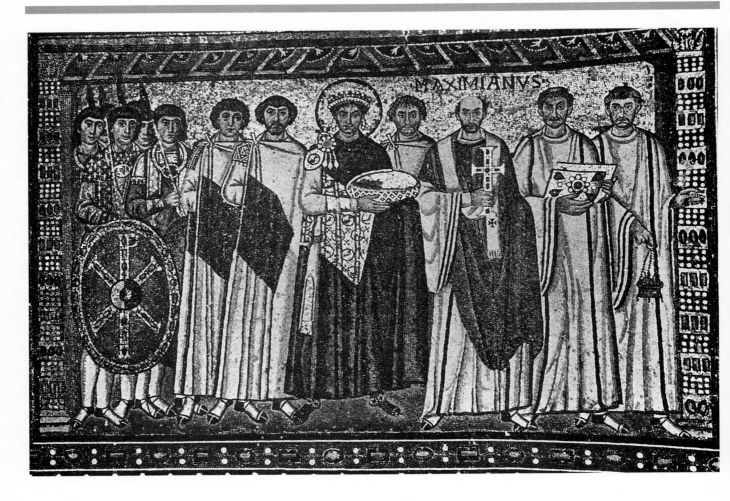

3.9 San Vitale, apse mosaic, *Justinian and his Retinue*, ca. AD 547.

clergy, administration, and the army. Foremost among them, he holds a dedication gift to the church, a eucharistic plate, or *paten*. The bishop of the church, Maximianus, is also identified by name as well as portrait likeness; he was appointed by the emperor and served as his surrogate in reconquered Italy. The depicted procession shows the celebration of the mass in imperial Constantinople, so this decoration marks the apse as the site of the eucharist, now reserved to the privileged few rather than the multitudes, as at St. Peter's. In this fashion, the authority of the emperor received theological as well as political reinforcement through his proximity to holy rites.

In the apse itself Christ appears, seated on the globe of heaven. Once more a celestial hierarchy pertains, with Christ at the center, seated and flanked by attendant figures, angelic mediators. The patron saint of the church, St. Vitalis, receives a crown of martyrdom at Christ's far right, while at His far left the founder of the church stands with a model of the structure. Like the apse mosaic at St. Peter's, this image of authority symbolizes Christ's presence in the mass as well as throughout the sacred space of the church, and the mosaic heralds His promised return (in the East, like the eastern end of the apse).

CONSTANTINOPLE: THE EASTERN TRADITION

In his imperial capital at Constantinople, Justinian's building program was even more assertive. He rebuilt Constantine's Holy Apostles church (AD 536–50; destroyed) as a multi-domed structure, its large central dome flanked by four other domes upon the arms of the same Greek cross plan. However, this centralized structure pales by comparison with Justinian's masterwork, his palace church of Holy Wisdom, or Hagia Sophia (AD 532–37; Fig. **3.10**).

HAGIA SOPHIA Anthemius of Tralles and Isidorus of Miletus – the architects of Hagia Sophia – are remembered by name, and small wonder. Their accomplishment fuses mathematical purity and simplicity, based upon the round profile of a dome, with the complex engineering task of structural support for a seemingly hovering volume. Hagia Sophia is a basilica with a wide nave and broad side aisles with galleries above. But it is dominated by its dome, carried on four arches resting upon corner *piers* in a square ground plan Fig. **3.11**, p.92). The base of the dome is pierced by windows, so that it seems to dematerialize and float above brilliant light. Secondary supporting half-domes on secondary piers flank the

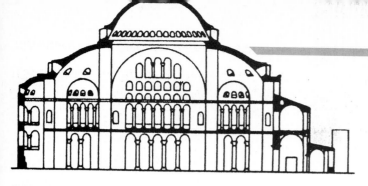

3.10a Hagia Sophia. Section.

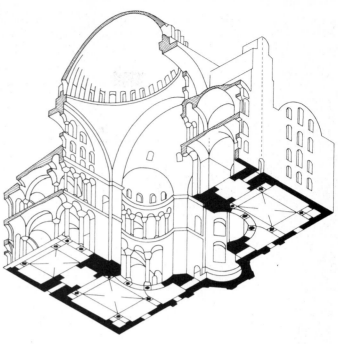

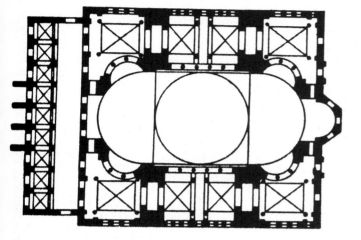

3.10b Hagia Sophia. Plan.

3.10c Hagia Sophia. Isometric view.

3.10d (Below) Anthemius of Tralles and Isidorus of Miletus, Hagia Sophia, Constantinople, AD 532–37, view of exterior. Istanbul.

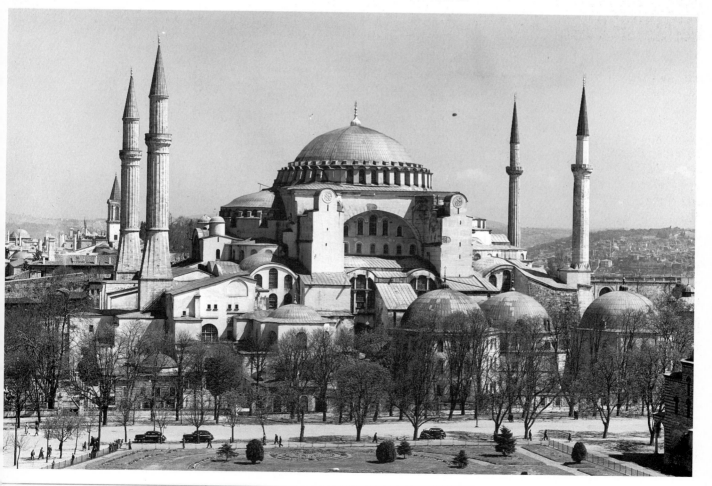

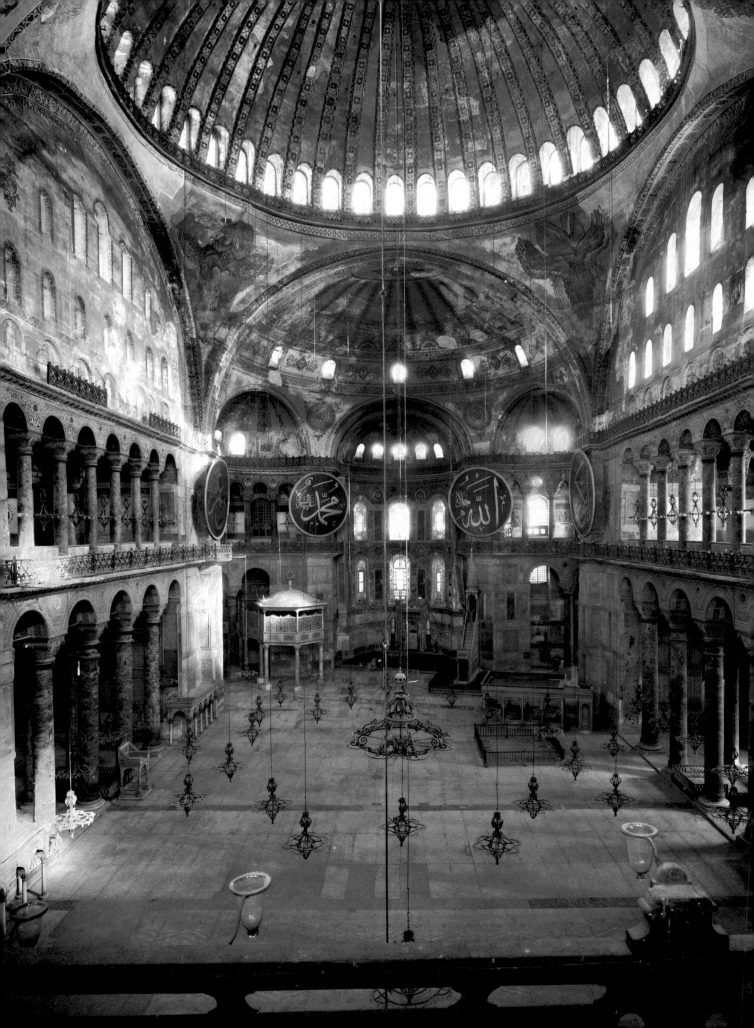

central dome and provide the axis of the basilica, which is further emphasized by a projecting apse and inner porch, or *narthex*. This dramatic centralization of a basilica produces a perfect synthesis of the two previous types of Christian building: the longitudinal basilica and the centralized mausoleum. The end result is a vast open space, the largest vaulted structure in the world before the Renaissance.

As his palace church, built on the ruins of Constantine's basilica, Hagia Sophia provided the visible evidence of the emperor's might. Fusing political with ecclesiastical authority, its grand vaulted space suited the new emperor-centered rite of the mass and the elaborate processions with the patriarch that preceded the mass. Hagia Sophia became the site where the theocratic pretensions of the Byzantine state were performed in public. Justinian's biographer records that on the dedication day as he entered the church, the emperor was heard to exclaim, "Solomon, I have surpassed you!"

Originally, Hagia Sophia was decorated only with gilded mosaics in the dome, although marble, bronze, and precious stones and metals embellished the walls and liturgical furnishings. Later eras, however, added figural mosaic subjects to the overall decoration, making the church a veritable museum of the history of Byzantine mosaics. After *Iconoclasm*, a tumultuous two centuries of debate about the acceptability of making any images of holy figures in Byzantine art (including edicts of abolition of images between 730 and 843), Hagia Sophia received an apse mosaic of the Virgin and Child as part of the restoration of images (AD 867; Fig. **3.12**). An inscription records that this image of the enthroned Virgin-*theotokos* replaces earlier *icons*, or religious images, destroyed by iconoclasts. Indeed, some small, preserved painted icons of the Virgin and Child present this same dignified regal pair with the same subtle modeling as the San Vitale mosaics. Typically, the dark robes of the Virgin are silhouetted against the uniform gold background of the apse tiles, and the figures remain impassive and immobile on their throne.

Where Justinian's gilded dome had contained only a mosaic of the cross, the *cupola* of Hagia Sophia after the ninth century received a new image of the bust of Christ as ruler of the universe (*Pantokrator*; destroyed). This mosaic image has been emulated in smaller, surviving Byzantine churches, such as the Greek church of the Dormition in Daphni (1100; Fig. **3.13**). In contrast to the Apollonian image of a beardless, youthful Christ, still dominant at San Vitale, this overseeing stern image, while human, inspires awe as it suggests cosmic

3.11 (Opposite) Hagia Sophia, Constantinople. Interior.

3.12 *Virgin and Child*, apse mosaic, Hagia Sophia, before AD **867.**

3.13 *Pantokrator*, dome mosaic, Church of the Dormition, Daphni, AD **1100.**

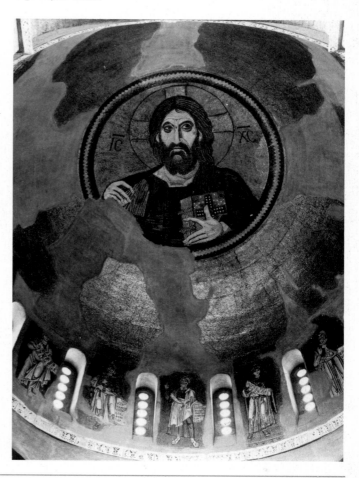

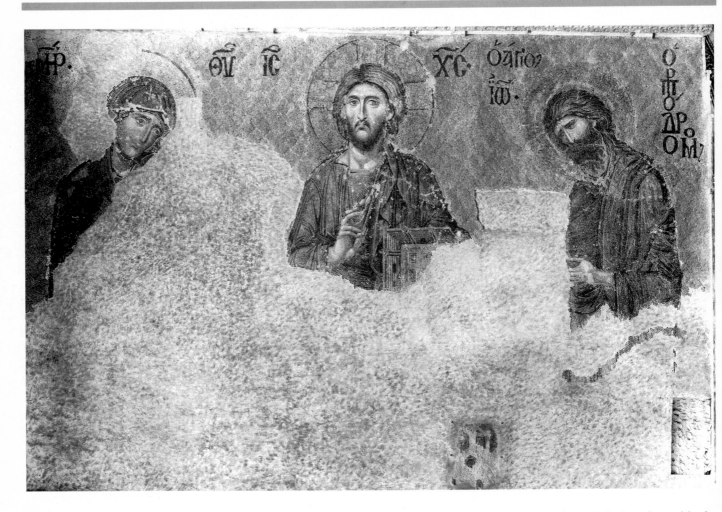

3.14 Deësis mosaic, south gallery, Hagia Sophia, late thirteenth century.

order within the round dome, image of heaven. This meaning of the Pantokrator image emerges from an inscription near the support of the Hagia Sophia cupola: "You sit as on a throne on the vault wrought by our hands, but this is your house." In the elaborate program of mosaics standardized within later Byzantine churches, such as Daphni, the Pantokrator dome was the culmination of a cycle of narratives based on church festivals: Infancy scenes on the supports of the dome, ministry and Passion on the upper walls, saints and Church Fathers at eye level, and the enthroned Virgin and Child flanked by archangels in the apse, as we met them at Hagia Sophia.

After the forbidding image of all-ruling authority in the cupola, the later Byzantine mosaics present an entirely different, more human and tender set of holy figures. After devastations to Constantinople by marauding Crusaders led by rival Venice in the early thirteenth century, the restored Byzantine empire nurtured a more personal and empathic spirituality. At Hagia Sophia this spirituality appears in a mosaic from the south gallery, the *Deësis* (Christ between the Virgin and John the Baptist; Fig. **3.14**). The figure of Christ still stands frontally with a book and a blessing gesture like the Pantokrator, but His gaze is softened, in keeping with the bowed heads and tender expressions of the flanking figures. Minute details of facial modeling further suggest a portraitlike precision and the immediate presence of these compassionate figures – a sharp contrast to the remoteness of earlier mosaics in either apse or cupola.

SAN MARCO Comprehensive mosaic decorations of Byzantine churches are preserved chiefly on a smaller scale in provincial structures, such as Daphni, or in the less expensive mural medium of fresco painting (there are good examples in the Balkans, particularly modern Serbia and Macedonia). However, the grandest surviving building outside Constantinople stands in Venice, which later eclipsed the eastern capital as queen of the Mediterranean and even headed the Fourth Crusade and eventual sack of Constantinople in 1204. The palace church of Venice, San Marco, dedicated to the patron saint of the city, St. Mark, was begun in 1063 and closely based upon the Holy Apostles church of Justinian (Fig. **3.15**). Like its model, San Marco has a Greek cross plan with a central dome and four adjacent domes on the arms; each dome stands on a drum pierced with windows but with a much higher profile than Hagia Sophia. Within the church (Fig. **3.16**, p.96) great dark barrel vaults shape the aisles and *crossing* (where the nave intersects the transepts).

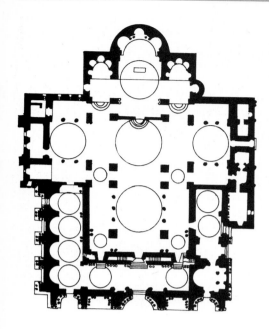

3.15a Venice, San Marco. Plan.

3.15b San Marco, Venice, begun 1063. View of exterior.

The walls are adorned with marble columns and panels below and continuous gold-ground mosaic scenes in the vaults above. These mosaics offer the fullest surviving Biblical narrative cycle, from Genesis to Pentecost, in a mixture of Byzantine and local designs as well as from models provided by a variety of manuscript illustrations.

ST. SAVIOR IN CHORA (ca. 1315–20) contains the most comprehensive surviving decorative program in Constantinople. This small, suburban church was redecorated after the Fourth Crusade, not by the emperor but rather at private expense by the chief controller and adviser to the emperor. The mosaics present likenesses of Christ and the Virgin akin to the Hagia Sophia *Deësis*, as well as narratives from the lives of both holy figures. The scene of the Nativity (Fig. **3.17**, p.97) achieves a convincing sense of drama by means of lively gestures and figures reduced in scale in relation to their setting. This Nativity also conforms to Byzantine traditions in placing the setting for the Christmas story within a cave rather than a stable. At the same time it includes apocryphal figures, such as the midwives in the lower corner, who wash the newborn Child. The entire cycle unfolds against a uniformly shining gold background and within a decorative frame.

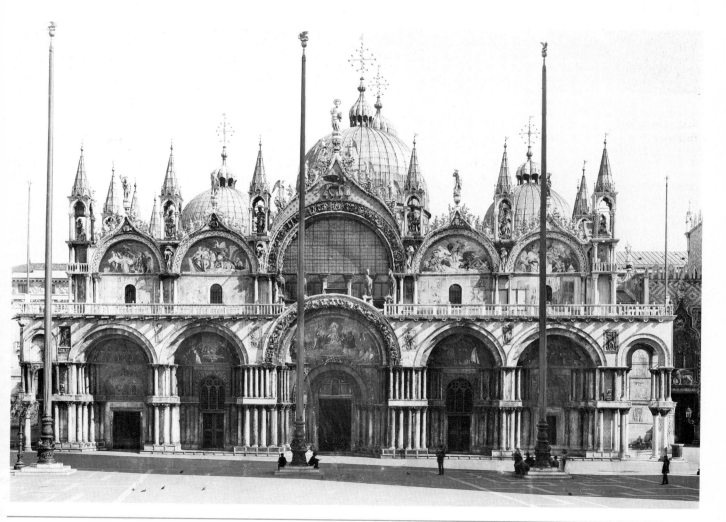

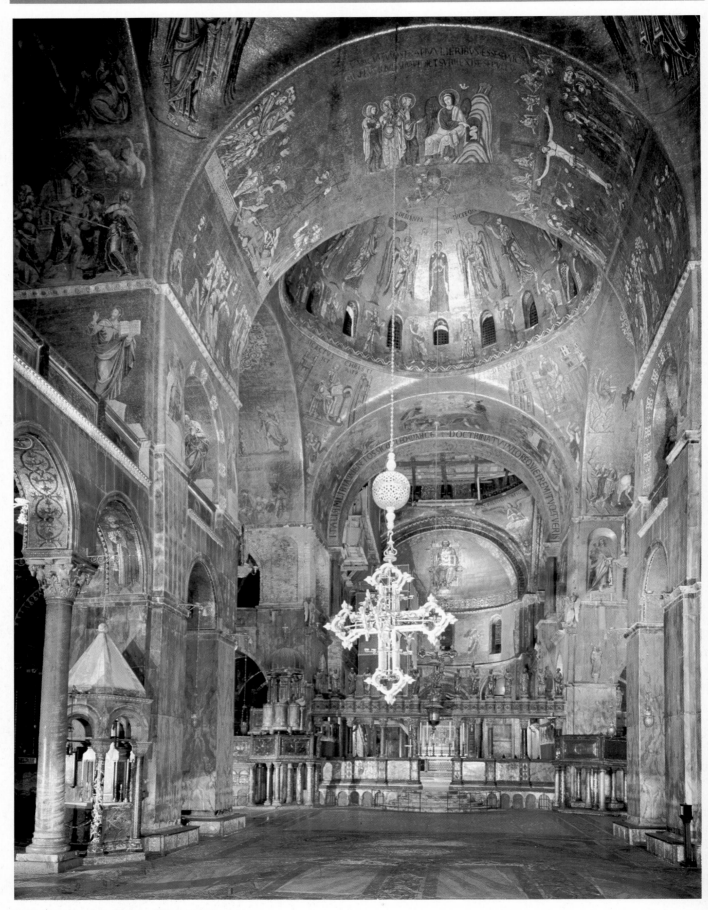

3.16 Venice, San Marco. View of interior.

3.17 *Nativity*, mosaic. St. Savior in Chora, Constantinople, 1315–21. Istanbul.

3.18 *Resurrection and Harrowing of Hell*, apse fresco, parecclesion, St. Savior in Chora, Constantinople.

The donor also added to the original monastery a funerary chapel (*parecclesion*), which was decorated fully with fresco paintings (Fig. **3.18**). Beneath a ceiling rendering of the Last Judgment, the semidome of the apse features the Resurrection of Christ, a festival in the Byzantine Church calendar and an appropriate topic for a funerary setting. Clad in brilliant white robes and standing within an almond-shaped stellar halo, an energetic central Christ figure releases Adam and Eve from their tombs in hell as a general rendering of the triumph of grace over death, of light over darkness. The dynamic intervention by Christ and the attendant saintly witnesses provide a model for the power of the Church, a narrative equivalent of the hieratic, or priestly, apse decorations from St. Peter's or San Vitale as well as a hope for personal spiritual intervention akin to the *Deësis* mosaic of Hagia Sophia (the figure of St. John the Baptist above Adam closely resembles his mosaic equivalent).

Until the political disintegration brought on by the Fourth Crusade, Byzantine society had remained stable under the domination of the emperor. From the time of Constantine and Justinian onward, despite controversies such as Iconoclasm and competition from both Islam and the Catholic West, Byzantine art strove for continuity and adherence to its classical heritage from Rome. During the same millennium in the West, Rome lost her political hegemony, or power over other states, and increasingly surrendered her ability to produce the brilliance of her earliest Christian monuments. Yet the vision of a unified and powerful Christendom continued to inspire pious rulers, and the myth of the Roman Empire survived, even in the West, to inspire politics as well as art.

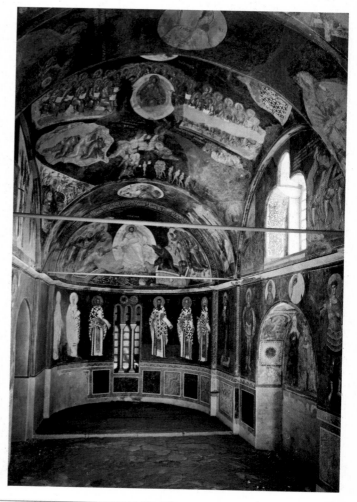

CHARLEMAGNE AND THE CAROLINGIANS

The Roman Empire was symbolically revived on Christmas Day, AD 800, when the Frankish king, known to history as Charles the Great, or Charlemagne (AD 767–814), was crowned Roman emperor in St. Peter's by the pope. As the dominant ruler in Western Europe, Charlemagne thus consolidated a northern realm, later known as the Holy Roman Empire, equivalent to the eastern, Byzantine half of the divided, post-Constantine empire. As part of his effort to reconstitute imperial greatness, Charlemagne maintained a centralized administration, using Latin instead of the local language. His capital became a center of learning, headed by an Anglo-Saxon scholar, Alcuin of York. Charlemagne also sought effective coordination of Church structures, like his model, Constantine, including patronage of Church institutions. The emperor gave particular support to abbey churches, such as St. Denis in France and a cluster of new royal abbeys in Germanic lands (Lorsch, St. Riquier, St. Gall), as effective allies who could help consolidate the lands under his rule. These great monasteries could pray for the successes and salvation of their pious prince, but they also served as hosts to his visits, defenders of his territories, developers of his lands, and centers of the scholarship he so assiduously cultivated.

The capital of Charlemagne at Aachen received a palace chapel (AD 792–805; Fig. **3.19**), akin to the finest structures of previous centuries, chiefly San Vitale. Although adjacent to a lost pair of basilical chapels, the Palatine Chapel, like its model in Ravenna, is a centralized polygon, a domed octagon, with an eastern axis. Its elevation of heavy piers suggests sturdiness and power rather than the luxury or elegance of Ravenna's marble columns; the Palatine Chapel was built of stone rather than the lighter brick of Byzantine structures. At the same time, there is a new vertical and structural emphasis, created by high arches in the gallery storey that support the base of the dome. The high dome itself is composed of eight segments, fulfilling the unity of the octagonal plan below. Originally the cupola held mosaics based on the book of Revelations, with a central lamb surrounded by the twenty-four elders and four symbolic animals of the Apocalypse.

The massive interior is announced on the exterior by a new double structure, the *westwork*, formed out of the public portal at ground level surmounted by a royal throne room in the upper gallery and flanked by cylindrical stair towers. Structurally, this massive stone façade was a necessity; in order to support the stone structures of the interior elevation, the architect of the Palatine Chapel, Odo of Metz, had to take lessons from Roman amphitheater constructions, such as the Colosseum. He used vaulted aisle spaces behind his gallery in order to *buttress* or support his central gallery and dome.

However, this westwork also provided accommodation for important imperial functions within its additional spaces. From his gallery, Charlemagne could participate in the religious services in a private chapel as well as present himself in a balcony appearance before crowds in front of the entry. Charlemagne's westwork encapsulated the emperor's role in all of the functions of the Palatine Chapel: imperial mausoleum, palace church, and site for sacred relics. In addition, its height seems to have had a symbolic association with heaven, appropriate for the glorification of the emperor in this specific function but later extended to use for churches of all kinds as a symbolic triumphal portal.

Next to the Palatine Chapel, Charlemagne's palace buildings (destroyed) were carefully laid out according to a grid plan, like late imperial Roman complexes. A central ornament was a bronze equestrian monument of Theodoric, brought from Ravenna to mark Charlemagne as the worthy martial successor to earlier imperial might. In his other buildings, too, Charlemagne combined his references to both imperial and Christian Rome. His great German abbey church at Fulda (AD 819; destroyed) imitated the scale as well as the basilical plan and transept (for the relics of St. Boniface) of St. Peter's. At the same time, Charlemagne's abbey foundations also superimposed his own architectural innovations on their Roman models: westwork façades and even a new second tower at the crossing of nave and transept.

3.19a (Opposite) Palatine Chapel, Aachen, view of interior, AD 792–805.

3.19b Palatine Chapel, Aachen, axonometric reconstruction.

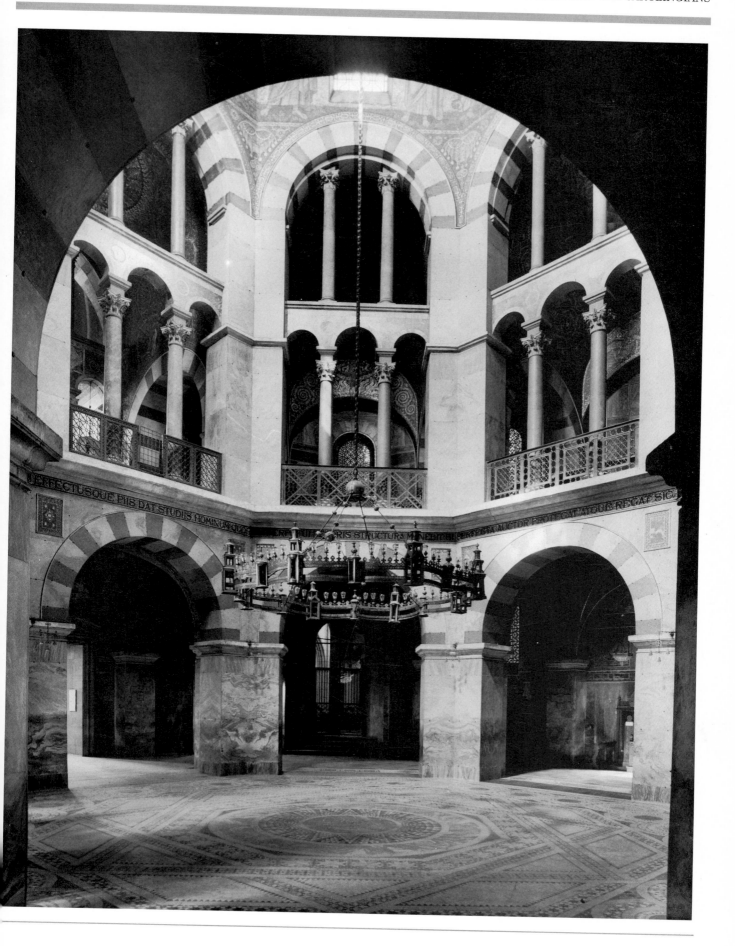

Illuminated Manuscripts

The standardization of Latin liturgy under Charlemagne fostered the production of manuscripts, often with elaborate and costly *illuminations,* painted decorations, for use in the royal palace and the royal abbey foundations. The earliest dated manuscript of this kind dates from AD 781 and clearly derives from an established book-producing workshop at court. These manuscripts were often copied from Early Christian or Byzantine models, but decorative elements and pictorial subjects were also derived from recent manuscripts from Ireland and Northern England.

One of the finest of the Charlemagne manuscripts is the *Coronation Gospels* (ca. AD 800; Fig **3.20**), preserved as part of the German imperial treasury and allegedly found on the knees of Charlemagne himself when his tomb was opened in the year 1000. It includes a signature by a Greek artist, one "Demetrius," so it may actually have been the work of a Byzantine visitor. Precious materials abound, from the gold ink used for careful Latin lettering to the imperial purple dye on the

expensive parchment. The pictorial illusion of the seated evangelists on their thrones clearly derives from Byzantine models of the Justinian era. The delicately modelled facial features and drapery of St. John writing can be compared to the figures in the mosaics of San Vitale (or to contemporary icons and manuscripts). The entire concept of this miniature depends upon seeing it as a framed picture, very much in the Roman tradition of author portraits, here transposed into the celebration of the Christian Gospels.

Although they eventually divided his kingdom into smaller states, Charlemagne's successors also continued to celebrate their combined imperial and Christian rulership within ornate religious books. Charles the Bald (ruled AD 841–877) presented to the royal abbey of St. Denis a costly gospel book, known as the *Codex Aureus of St. Emmeram* (AD 871; Fig. **3.21**). The imagery of this golden codex preserves a series of illuminations from other Carolingian manuscripts, including the elaborate frontispiece miniature of Christ in majesty surrounded by the four evangelists. Its most celebratory imagery, however, is reserved for a double-page opening, showing Charles the Bald participating in the celestial liturgy described in the book of Revelations, representing Charlemagne's own worship in the Palatine Chapel, beneath the apocalyptic mosaic of his heavenly dome. On the right page, the twenty-four elders in an arc adore the Lamb of God above the personifications of Earth and Water. On the left, facing page, King Charles the Bald, enthroned, beholds this vision, flanked by attendants under an arched canopy on columns – a clear reference to Charlemagne's gallery in the westwork at Aachen.

The cover of the Codex Aureus combines gold and precious stones into a cruciform composition (Fig. **3.22**). At the center, enthroned in majesty on a globe, sits a golden metal relief of Christ, a young and beardless figure like the San Vitale equivalent. Writing evangelist figures fill the corners around Christ in stylized variants on the author portraits of earlier Carolingian manuscripts. Scenes of Christ's ministry complete the reliefs in the corners. This fine example of goldsmithing relates closely to the linear designs of manuscript pages and attests further to the great value placed upon religious book production at the courts within the empire.

Given the importance of religious writings for Christianity, whether in the form of Gospels or ensembles of prayers, including psalms, the role of decorated books as major commissions made for prominent figures in both the Church and the state is hardly surprising. The lavish

3.20 *St. John* from the *Coronation Gospels*, Aachen, late eighth century AD. Parchment, 12¾ × 10 ins (32.4 × 24.9 cm). Weltliche Schatzkammer, Vienna.

3.21 *Charles the Bald Enthroned* (fo. 5v) and *Adoration of the Lamb* (fo. 6r), from *Codex Aureus of St. Emmeram*, AD 871. Parchment. Bavarian State Library, Munich.

3.22 Golden cover, *Codex Aureus of St. Emmeram*, AD 871. Gold with precious and semiprecious stones. Bavarian State Library, Munich.

use of gold for both covers (where precious stones further enhanced the material opulence of the object) and illuminations derives from the desire to symbolize sanctity and the glowing mystery of light, associated with the heavenly nature of spirituality. Only in later centuries did lay persons own such luxury manuscripts (see Fig. 3.42). Even when commissioned by kings, such as Charles the Bald, and paying homage to both their majesty and their piety, most religious books were used exclusively by the clergy.

Typically, such manuscripts were produced on durable animal-skin parchment, or vellum, and carefully penned and decorated by teams of monastic scribes and illuminators. The earliest luxury book production in Christian Europe took place in Ireland and northern England (Northumbria) during the seventh and eighth centuries, a decorative model synthesized with the classical heritage of Rome by Charlemagne's court. After the thirteenth century, urban centers, particularly Paris, began to supplant monasteries as the chief sites of manuscript production and to use lay scribes and illuminators to produce secular texts as well as the main religious books of Gospels, prayers, sermons, or commentaries. In addition to the frontispieces, dedication miniatures, or evangelist "author portraits" already mentioned, medieval manuscripts often inserted decorated initials and margins (often with diverting, seemingly irreligious animals or hybrids) as well as full-sized religious Gospel narratives.

PILGRIMAGES AND POWER

By the eleventh century, as the ambitious construction of San Marco in Venice suggests, Europe enjoyed political stability and economic recovery, especially in cities, that permitted more intense and large-scale artistic production. Royal states still depended heavily on feudal lordships over regional lands, so the imperial pretensions of Charlemagne's successors contended with various other artistic centers (although imperial monastic foundations continued to follow the Carolingian model until well into the eleventh century).

The grandest of these later imperial structures is Speyer cathedral (1029–61, 1080–1106; Fig. **3.23**). Founded on land belonging to an emperor, heir of the title of Holy Roman Emperor descending from Charlemagne, it served as a pantheon for the Salian dynasty as well as a symbol, in its very size, of imperial majesty (Speyer is longer than St. Peter's). Deceased emperors were buried in a massive crypt beneath the choir and in front of the altar, so that they could participate

in the ongoing masses within the church. The building announces itself through a massive westwork with two square flanking stair towers above the entryway; an octagonal western tower completes this powerful vertical presence. As in Charlemagne's abbey church at St. Riquier, this western cluster is matched at the east end by a *crossing tower* above the wide transept and spacious eastern apse. In between, the long stretch of the nave provides a horizontal note of contrast and a consistent simplicity of volume for the entire structure. The nave interior reveals a coordinated articulation of wall surface in its elevation. Like the Constantinian brick walls on the exterior of the basilica of nearby Trier, Speyer utilizes a multi-storey integration of vertical elements, in which flattened columns, or *pilasters*, and half-columns overlap the arcade piers and run unbroken to the top of the clerestory windows. There, a series of arches surmounts the window zone to echo and integrate the rhythms of ground level. Not only does this

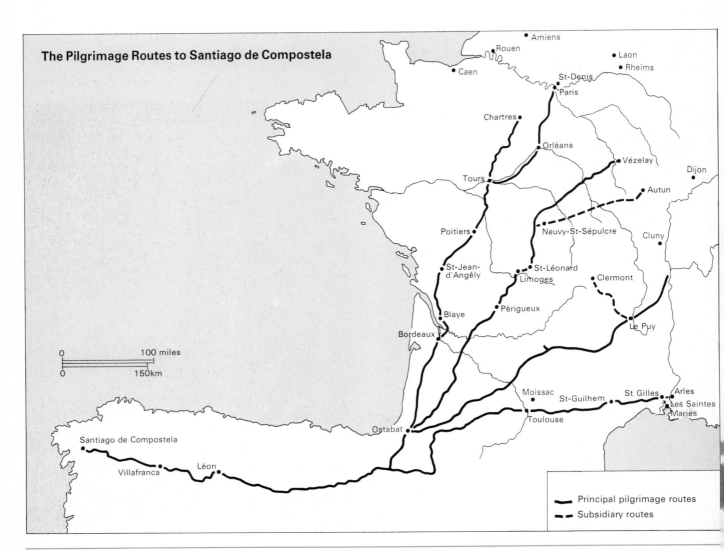

The Pilgrimage Routes to Santiago de Compostela

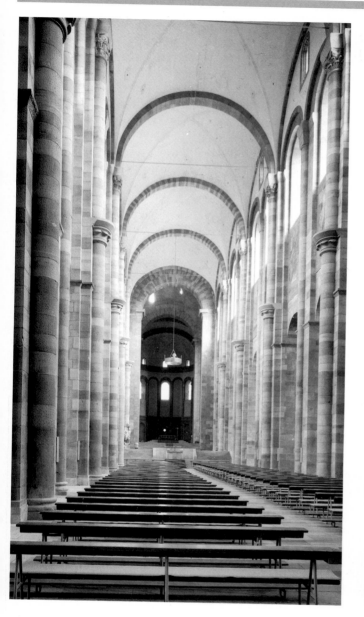

3.23 **Speyer Cathedral, 1029–61, 1081–1106. View of interior.**

CHURCHES OF THE PILGRIMAGE ROUTES

During this period, French kings of the Capetian dynasty had extended the Carolingian domination of Frankish lands after Charlemagne. Their chief regional rivals were the Normans, descendants of the Vikings, who successfully conquered England in 1066 under the leadership of William the Conqueror. The eleventh-century trade routes also brought pilgrims to the sacred sites of Christian Europe, marked by the presence of wonder-working relics of holy figures. Chief among the pilgrimage destinations were the Holy Sepulcher in Jerusalem, the tombs of Peter and Paul in Rome, and the tomb of St. James (Santiago) in northern Spain.

The popularity of relics (and their profitability, in a revived money economy) made the churches holding them realize the need for new and larger spaces to accommodate the flood of visitors.

ST. SERNIN One of the largest of the sites on the pilgrimage road was the church patronized by the counts of Toulouse, St. Sernin (1078–1118; Fig. **3.24**). A massive five-aisled basilica, St. Sernin carried its outer aisle

3.24 **St. Sernin, Toulouse, ca. 1080–1120. View of exterior.**

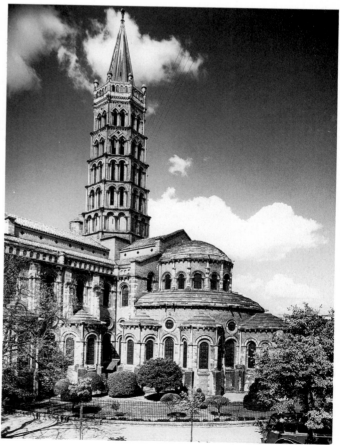

added articulation suggest the immense thickness of Speyer's walls and piers; at the same time it establishes a rhythm, unknown in the Early Christian basilica, of discrete yet uniform nave units, called *bays*. These bays run the length of the church, bound together in a system. Later construction reinforced alternating piers and provided ribs to add further support for the enormous vault above (107 feet/33 meters high) in a system called *rib vaulting*. Yet even with alternating piers and columns, the rhythms of the double bays of Speyer establish a new vertical grandeur and coordination of parts – especially the bay system – within the basilical form. Here the latter-day emperors rivaled the accomplishments in church building of both Constantine and Justinian.

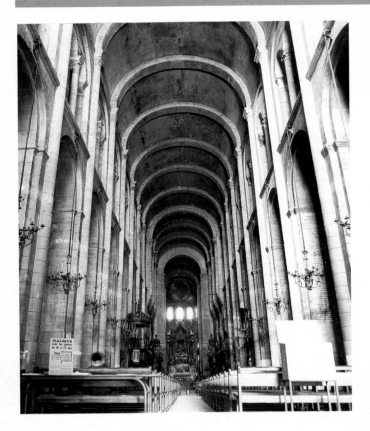

3.25 St. Sernin, Toulouse. View of interior.

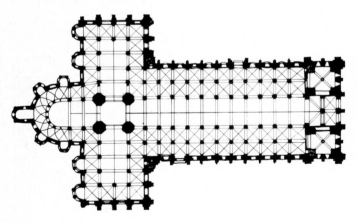

3.25a St. Sernin, Toulouse. Plan.

completely around the church perimeter as an ambulatory for pilgrims (Fig. **3.25**). The plan was based on a long Latin cross constructed out of a nave intercepted by a transept. The new apse was built around the original tomb of the patron saint and sheltered additional chapels, or *apsidioles*, projecting from its semicircular wall. The masonry construction reduced the danger of fire, and the elimination of the clerestory layer of windows provided further stability for the high yet massive barrel-vaulted roof. The result is a dark, if mysterious, building, broken by a *lantern* tower at the crossing, perhaps intentionally enhancing the aura surrounding its prized relics. St. Sernin also utilizes the regular rhythms of the bay system, using transverse ribs on the vault to mark the ground-level

arcade sequence. These ribs grow out of half-columns that serve at once to provide vertical accents as well as to emphasize the great horizontal procession of space in the pilgrimage church.

Pilgrimage churches, such as St. Sernin and Santiago de Compostela, ornamented their entryways with sculpted *portals* to receive their visitors. The Porte de Miègeville at St. Sernin (ca. 1115) opens onto the south aisle with a carved *tympanum* relief under the round arch of its doorway (Fig. **3.26**). The subject, Christ's Ascension into heaven accompanied by angels, draws an analogy with the elevation of the mass and also serves as a large and comforting promise of salvation to the entering pilgrim. Underneath, a smaller row of apostles on the *lintel* above the doorway serve as pious witnesses of the main event. The portal is also flanked with likenesses of SS. Peter and James, principal apostle figures and objects of veneration on the pilgrimage routes. During the course of the twelfth century, such portal reliefs became important features of pilgrimage churches, such as the well-preserved, admonitory Last Judgment with inscriptions at St. Foy, Conques.

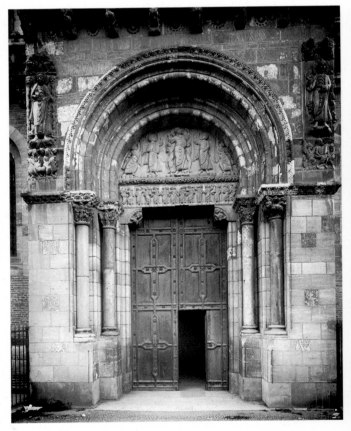

3.26 Porte Miègeville, St. Sernin, Toulouse, 1115.

STE. MADELEINE AT VÉZELAY In the French province of Burgundy a monastic order with vast land holdings, the congregation of Cluny, dominated patronage and construction in the eleventh and twelfth centuries. A series of campaigns built and then expanded the mother

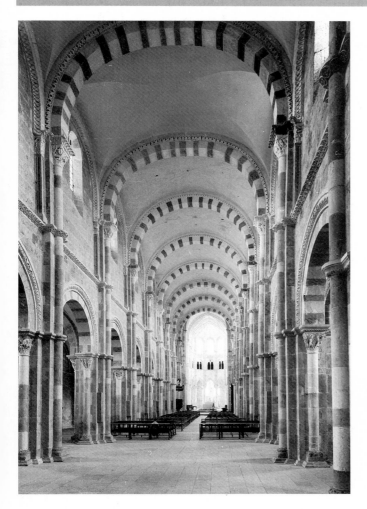

3.27 Sainte Madeleine, Vézélay, ca. 1120–32. View of interior.

The tradition of sculpted figures, highly developed at Cluny, was continued at Vézelay. One glory of Ste. Madeleine is its carved figurative capitals under the nave arcades, comprising a rich cycle of narrative and didactic images for the pilgrims. Grander still is the sculpted portal of the narthex (Fig. **3.28**). The large tympanum depicts the appearance of the resurrected Christ to His disciples and His dispersal of the Holy Spirit from outstretched hands to inspire them with their missions. Once again, a hierarchy of scale prevails, with Christ positioned as the central and largest figure. The periphery of the world is suggested in smaller framing scenes, where the missions are carried out among monstrous races. The ideological content of this missionary work proclaims the consciousness of a larger world, in need of Christian outreach to benighted inferiors. Artistically, this program issues a call to conversion, whether peaceful, or (as the Crusades suggest) by force.

3.28 *Christ Appears to the Apostles*, narthex tympanum, Sainte Madeleine, Vézélay, ca. 1120–32.

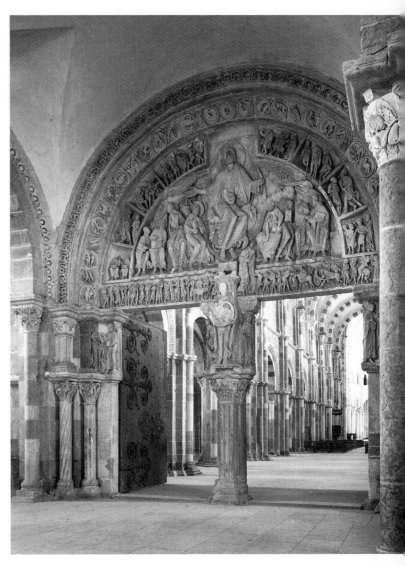

church of the Cluniac order to a size larger than either St. Peter's or Speyer. (It was destroyed in the French Revolution as a symbol of ecclesiastical tyranny.) Cluny was the model for a number of pilgrimage churches in Burgundy affiliated to the order. One such church was the abbey of Ste. Madeleine at Vézelay, closely tied to Cluny when her former prior, Peter the Venerable, became abbot of Cluny in 1125. The attraction of Vézelay to pilgrims was the relics of St. Mary Magdalene, and the church soon became one of the favored starting-points on the pilgrims' road. St. Bernard preached the call to the Second Crusade (the first was proclaimed in 1095) at Vézelay in 1146, and it also served as the launching pad for the Third Crusade by the kings of England and of France a generation later.

After a disastrous fire in its aging Carolingian nave, a new Vézelay was begun, probably completed during the 1140s (Fig. **3.27**). Widely spaced piers create an open effect, and large clerestory windows provide warm lighting. Banded transverse arches, springing from compound piers, create a rhythm of accents within the barrel vault. A spacious interior porch, or narthex, for processions also provided the site of the Crusade exhortations.

ROYAL MONASTIC FOUNDATIONS

Prominent in the eleventh-century consolidation of territory under the feudal rule of dukes and kings is the success story of William the Conquerer (1027–87), Duke of Normandy and King of England after the Battle of Hastings. William's family had already actively supported monastic orders, such as Cluny, and built major monastic structures, including the renowned Mont-Saint-Michel. In 1064 he founded the abbey of St. Etienne at Caen, while his bride, Matilda of Flanders, established a complementary abbey for women in penance for having married as cousins. St. Etienne also served as William's burial site.

ST. ETIENNE The façade of St. Etienne (Fig. **3.29**) presents an imposing and vertical west front, with divisions corresponding closely to the elevation of nave arcade, gallery, and clerestory behind it. A pair of tall towers dominates the skyline with a geometrical severity, emphasized by unbroken buttresses against the façade. Inside, the nave wall has become a skeletal framework of masonry, pierced by an enormous gallery arcade as well as large clerestory windows

Fig. **3.30**). The tunnel vaults of the gallery served, as in the Palatine Chapel gallery, to support the main central vault. Early in the twelfth century the vaulting at St. Etienne was altered (by 1120) and provided with reinforcing ribs. In this case, pairs of bays merged together to provide a six-part rib system, springing from attached half-columns running from floor to ceiling. The entire complex provides a strong vertical accent throughout the nave and works together with the details of *moldings* (ornamental bands) and columns to lighten the effect of the remaining wall surface.

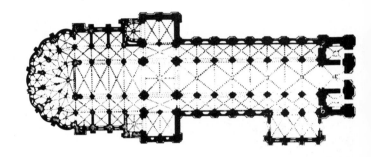

3.30a St. Etienne, Caen. Plan.

3.29 St. Etienne, Caen, 1067–87. View of exterior.

3.30b St. Etienne, Caen. View of interior.

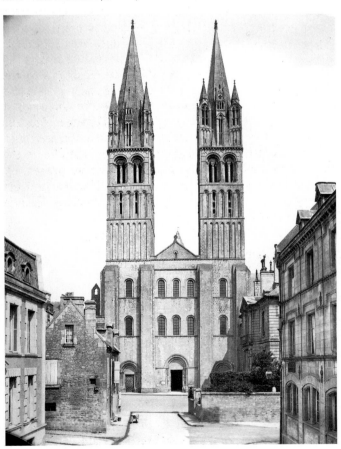

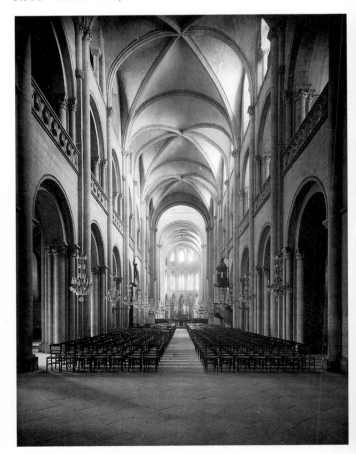

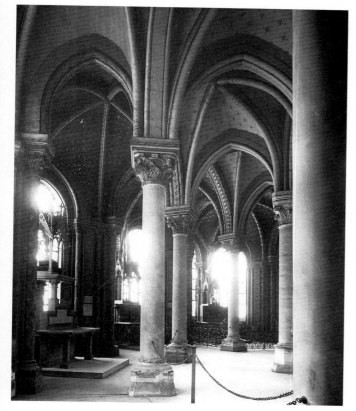

3.31a St. Denis, ambulatory, 1140–44.

3.31b St. Denis, ambulatory. Plan.

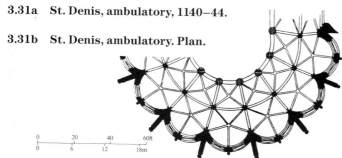

ST. DENIS For the kings of France, the same kinds of monastic support prevailed as in other parts of Europe from the time of Charlemagne. At St. Denis, the French royal abbey near Paris that had once supported the claims of Charlemagne's dynasty, the aging Carolingian structure (consecrated 775) needed repairs. Her abbot, Suger (1081–1151), also principal adviser to King Louis VI, took the opportunity to strengthen both the royal patronage of his sovereign and the splendor of his edifice. Suger proudly recorded his contributions to St. Denis in an autobiography, the first part of which significantly deals with the economic reorganization of the abbey and the second with his renovation of the church building. In particular, he celebrates the union of wealth – and luster since it included precious stones, gold, and stained glass – and piety. The abbot's splendid chalice, carved sardonyx set within gold, still survives (Washington, National Gallery) to confirm that he practiced what he preached. Suger also succeeded in restoring the Frankish tradition of burying kings in St. Denis, beginning with his own patron, Louis VI, which

continued for centuries thereafter (St. Denis, like Cluny, suffered terrible damage during the French Revolution for its royalist heritage). The abbey truly became the religious center of the French nation.

Suger's remodeling began with a new west porch, consecrated in 1140. As at St. Etienne, three large portals between buttresses opened into a narthex that enlarged the historic Carolingian basilica (which Suger planned eventually to replace). To this westwork, Suger added sculpture, akin to Burgundian tympana such as Vézelay, choosing the Last Judgment for his subject over the central portal. Beside the doors on columns he placed carved figures of Old Testament kings and prophets, a tradition borrowed from southern France that later became a hallmark of later French cathedrals. Finally he adorned the top of the nave opening with a round, stained-glass window, or *rose window*. Using the perfect geometrical form of the circle also permitted allusion to both the sun, traditional symbol of light and of Christ, and the rose, thornless symbol of the Virgin and her beauty.

Beyond the Carolingian church, Suger and his anonymous but highly skilled architect built a new choir (1140–44; Fig. **3.31**). As in pilgrimage churches, Suger's choir creates an *ambulatory*, from which *chapels* radiate. But his chapel spaces actually merge, separated only by columns and a webbing of vaults above. Using the technique of the rib vault, already seen at Caen and used for Suger's west porch, meant that the masonry construction of the choir could be greatly reduced, while the ribs acted as support for the vaults. Moreover, the vaults themselves now utilized pointed rather than rounded arches in order to concentrate and reduce downward thrust, a technique in use at Cluny. As a result, Suger could indulge his love of glowing light, symbol of the divine in his theology, by opening up the wall surface to stained-glass windows. Like the gilded mosaics of Byzantine churches, stained glass could provide powerful figural images or narratives and suggest divine light itself, while at the same time seeming to deny the materiality of its wall supports. For Suger, too, the new, open skeletal wall and its luminosity offered the antithesis to the dark, heavy masonry of the largest previous structures. By using technical advances pioneered by his predecessors Suger could fulfill his own spiritual ambition: to create a vision in architecture of the shining city of God.

THE GOTHIC STYLE: CHARTRES

Suger did not live to see his innovations adopted by generations of French religious structures and decorations. But they were quickly absorbed throughout the Ile de France region around Paris. Perhaps the finest surviving total ensemble of early innovations, in the architectural style that later centuries would call *Gothic*, is the cathedral of Chartres, south of Paris (Fig. **3.32**, p.108). Chartres had its own prized relic, a royal donation: the tunic of the Virgin from the Nativity, the gift of

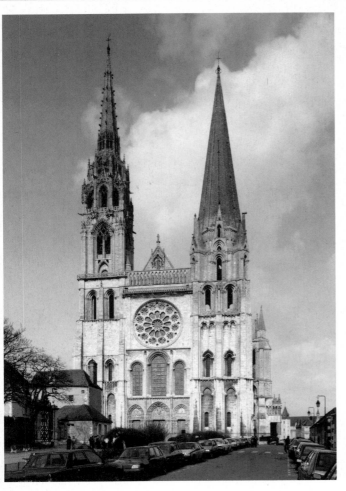

Charles the Bald after he obtained it from Constantinople. Chartres thus developed into a major center for the cult of the Virgin in France, and her cathedral school extolled Mary as the Seat of Wisdom and the compassionate intercessor with Christ on behalf of humankind.

At the same time as Suger's renovations at St. Denis, a new twin-tower façade, known as the Royal Portal (Fig. **3.33**), was added to the entry of Chartres. The sculptures of the Royal Portal were the most elaborate ever made in France. A unified program revolves around the central tympanum, where the Second Coming of Christ unfolds, framed by the symbolic beasts of Revelations and underneath the elders, arrayed in the *archivolts* of the pointed arch opening (Fig. **3.34**). This serene and gentle Christ contrasts utterly with the agitated and oversized figure at Vézelay; His cosmic order extends to symbolic representations of the zodiac and the labors of the months arrayed around an adjacent portal of the Ascension (the same subject as at St. Sernin). The third portal features the enthroned Virgin and Child, symbolic Seat of Wisdom, above a Nativity and surrounded by symbols of the seven liberal arts in a tribute to both the cathedral school and the cult of Mary. Column figures below repeat the precedent of

3.32 (Left) **Chartres Cathedral, west façade, begun 1140.**

3.33 (Below) **Chartres Cathedral, Royal Portal sculptures, west façade, ca. 1140–50.**

3.34 (Opposite) **Chartres Cathedral, Royal Portal, central tympanum,** *Christ in Majesty*, **ca. 1140–50.**

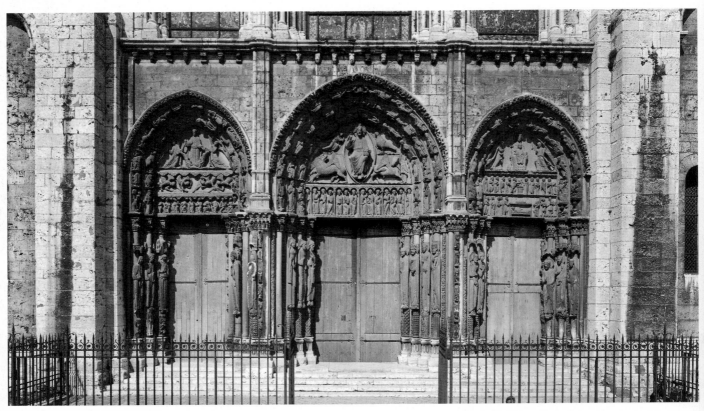

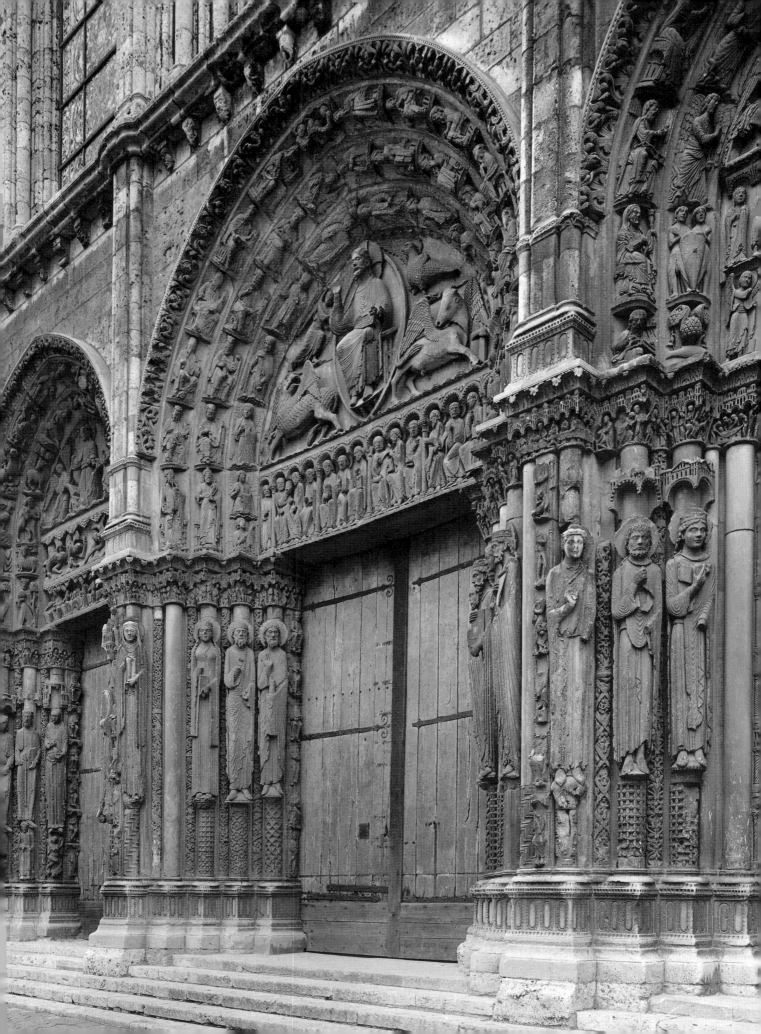

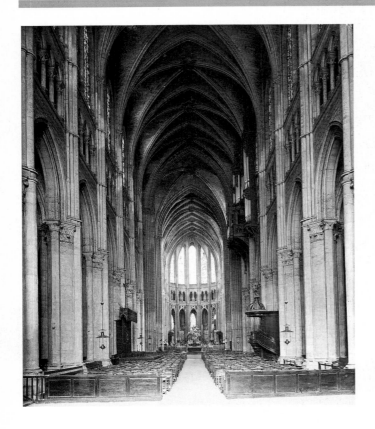

3.35a Chartres Cathedral. Interior towards east, 1194–1220.

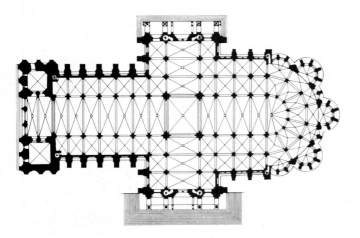

3.35b Chartres Cathedral. Plan.

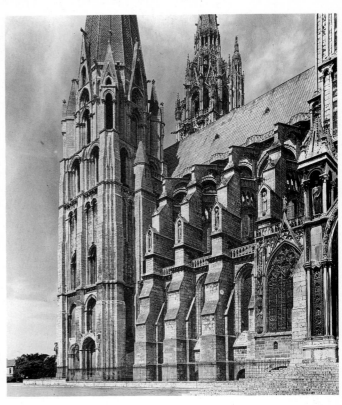

3.36 Chartres Cathedral. Exterior with buttresses.

St. Denis, presenting Old Testament precursors and ancestors of Christ, particularly those connected with his twin aspects of rulership and sanctity. These elongated column statues conform closely to the shape of their supports, providing an integrated vertical emphasis while symbolically serving as the support for the scenes and the arches above them. Thus the New Testament subjects literally stand atop their Old Testament prefigurations. The scheme as a whole thus integrates all of time from the Creation to the Apocalypse and comprehends the entire cosmos of nature and of learning, of reason and revelation. In place of the awe and fear of earlier church programs, Chartres offers comprehension.

After a disastrous fire in 1194 to the old basilica, sparing only the Royal Portal, the architects of Chartres determined to rebuild in the up-to-date Gothic style pioneered by Suger and already emulated at the cathedrals of Sens, Paris (Notre-Dame), Senlis, and Laon. Building proceeded swiftly and was complete at the time of the dedication in 1220 (Fig. **3.35**). The double ambulatory and radiating chapels of St. Denis were combined with a long nave and wide transept with aisles. Inside, a systematic *elevation* now balanced the nave arcade with a narrow *triforium*, or passageway, beneath a glorious expanse of open clerestory window, filled with stained glass. Compound piers with clustered wall *shafts* (cylindrical supports) carry the eye upward to the soaring vaults, now consistently constructed in each bay out of four-part ribs on pointed arches. The key to the support of the soaring height of the building lies on the exterior, where buttresses extend along

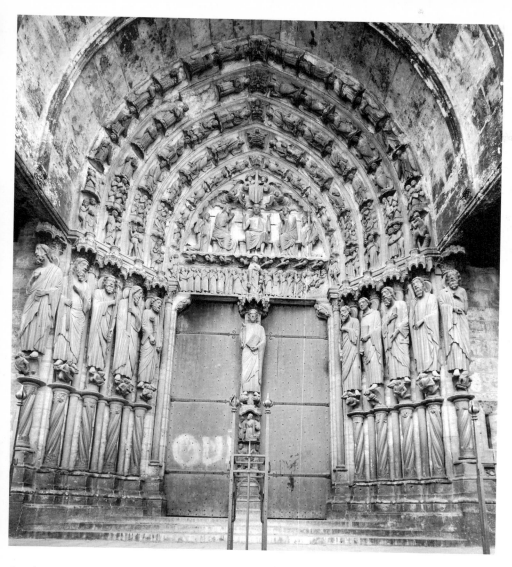

3.37 Chartres Cathedral. South transept portal, begun ca. 1220.

3.38 Chartres Cathedral. South transept portal, jamb statues.

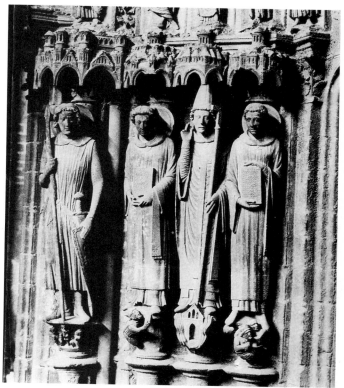

the length of the building beside the aisles; atop those buttresses, *flying buttresses* reach across to bolster the top walls of the nave (Fig. **3.36**). Between these mighty supports lie the glass panels, which irradiate the interior of Chartres with a mysterious colored light and glowing, figured scenes that fully realize Suger's dream.

Chartres is organized according to a belief in the purity of mathematical relations as well, so that simple ratios pertain between elements of height and width. As a result, despite the immense height of the nave peak, a sense of balance and order prevails, just as the great sequence of bays progressing toward the choir counterbalances the soaring rise of the slender *colonnettes* into the ribs of the vault. After the additive system of bays in earlier churches, the coherent design of Chartres proclaims its unity.

When the Royal Portal was retained instead of being replaced with a new porch with sculpture, that porch was relocated, probably to the north transept (for this program repeats many elements from the Royal Portal). Thereafter a matching porch was begun for the south transept (Fig. **3.37**), and all three entrances were given rose windows at their tops, beginning in the 1220s (final consecration was 1260). The column statues of the south transept feature Christian saints – apostles, martyrs, and confessors – thus bringing the universal

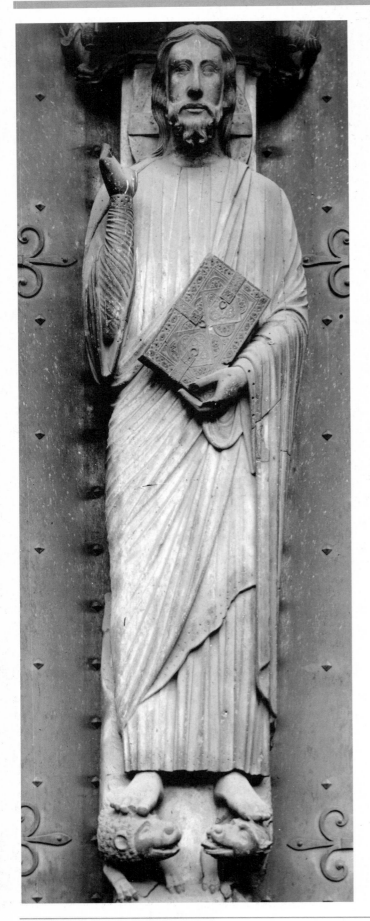

3.39 Chartres Cathedral. South transept portal, trumeau, *Christ Blessing*.

history into a post-Gospel phase. Most of the carved figures on the south portal also stand on fixed *consoles*, or brackets, and move slightly, suggesting their separate identity from the column supports behind them (Fig. **3.38**, p.111). The central column, or *trumeau*, of the south transept entry features a statue of Christ trampling on a lion and dragon but much closer to the eye level of the worshiper (Fig. **3.39**). Christ is shown with a book (with a jeweled cover akin to the *Codex Aureus*), His hand extended in benediction. This more accessible and human figure corresponds to the new intercessory role of the Virgin, celebrated on the central tympanum of the north porch in the subject of her Coronation by Christ, who sits enthroned alongside her in heaven.

STAINED GLASS The rose windows adopted from St. Denis, and the pair of high, narrow *lancet windows*, with pointed arches, in each bay remain the enduring jewel of Chartres Cathedral. Twelfth-century glass has survived in the Royal Portal, portraying the ancestry of Christ (rising in the family "Tree of Jesse") as well as the Passion in a set of twenty-four medallions. Most of the glass at Chartres, however, is thirteenth-century in origin (Fig. **3.40**), connected with the construction of the transept porches. These later windows offer a geometrical clarity of organization in smaller scenes, similar to that found in the contemporary metalwork. Often these window subjects utilize typological relationships between Old Testament antecedents and New Testament fulfillments of prophecy, akin to the scheme in the Royal Portal.

The French royal house paid for some of the stained glass, including the Virgin cycle and rose window on the north transept; the Duke of Brittany matched this donation on the south transept, and his donor portrait appears beneath the blessing Christ of the south porch. Other windows, which include their coats-of-arms, were presented by lesser nobles, both local and in the entourage of the king. But corporate donations for glass also came from the merchants and artisans of Chartres. Their scenes include their patron saints, contemporary renderings of their activities, as well as selected biblical narratives involving trades similar to their own, such as carpentry, baking, or winemaking. Once more the comprehensiveness of the cathedral for the entire community is asserted through the forms and subjects of its decoration.

The technical accomplishments of Chartres and contemporary cathedrals dominated church construction for a full three centuries, although important regional variations on the aesthetics of height and light in France were developed in England, Germany, Spain, and Italy. A fitting conclusion, however, to the innovations of Gothic style was provided in Paris in the final years of Chartres by King Louis IX (reigned 1226–70) in yet another palace chapel (1243–48; Fig. **3.41**). Known today as the Sainte-Chapelle, this jewellike building

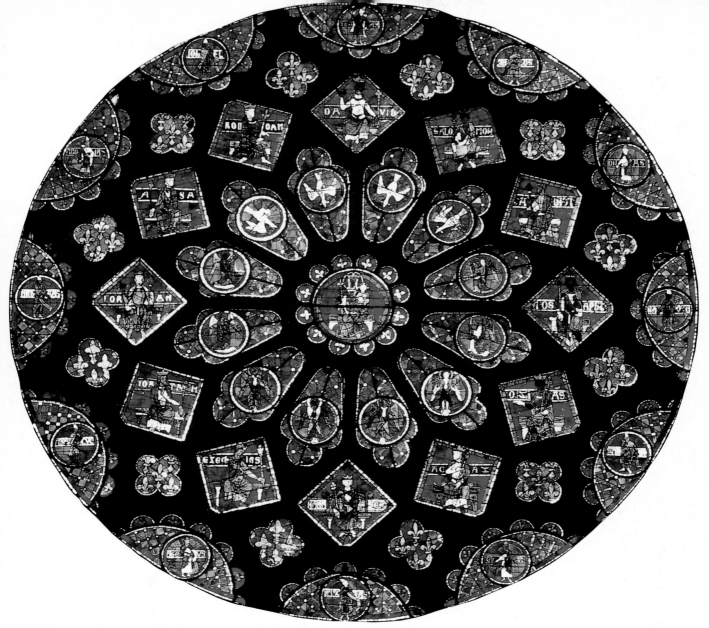

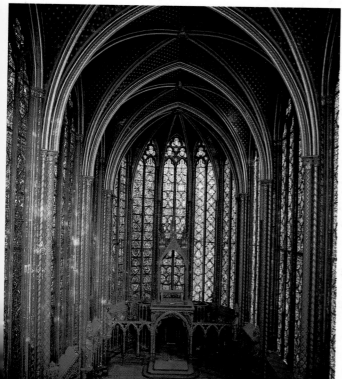

3.40 Chartres Cathedral, north transept, rose window, north transept, begun ca. 1120. Stained glass, diameter 42ft 8ins (13 meters).

3.41 Sainte-Chapelle, Paris, 1243–48. View of interior.

was constructed to house prized relics brought back from the Crusades from occupied Constantinople for the royal house: the crown of thorns, portions of the cross, and other relics of the crucifixion. Louis IX was a major patron of religious buildings and artworks, particularly illuminated manuscripts. He had already assiduously completed the work of Suger at St. Denis by rebuilding the choir, transept, and nave (1231–81; architect Pierre de Montreuil), while adding full expanses of stained-glass windows (even in the dark band of the triforium). Louis IX thereby confirmed and assured the continuing association of St. Denis as a mausoleum of French monarchs, and under his direction sixteen tomb monuments for his ancestors were constructed for the new transept (1263–64).

Louis IX's Sainte-Chapelle was built in two parts, but its climax is the upper storey, connected with the private royal

apartments of the palace and reserved for the king's exclusive use (the lower storey was used as a parish church by members of the royal household). The upper chapel is a simple, open room with the same Gothic emphasis on height, with unbroken shafts culminating in ribbed vaults. This skeletal network provides the frame for an apparently solid field of glowing stained glass. Within the cycle of biblical scenes, the emphasis on royal coronations as well as Christ's crowning with thorns underscores a conflation of kingship and sanctity essential to the pious yet politic king who would be canonized as St. Louis.

Something of the splendor of the architecture and stained glass at the Sainte-Chapelle also emerges from the pages of the king's ornate Psalter (1252–70; Fig. **3.42**), decorated with the same tones of gold, red, and blue. Among the holiday dates in the St. Louis Psalter are anniversaries of royal relatives as well as those of the dedication of the chapel and its relics. With the emphatic linear elegance of window designs, Old Testament kings and patriarchs (here Abraham receiving the three angels) form the subjects of the full-page illuminations in tribute to the saintly royal patron of the manuscript.

The same precious materials, here gilt silver and enamel, as well as the quality of personal possession of a pious object

3.43 *Madonna of Jeanne d'Evreux*, 1339. Silver-gilt with enamel, 27 ins (68.6 cm) high. Louvre, Paris.

3.42 *Abraham and the Three Angels, Psalter of St. Louis*, 1253–1270. Parchment, 8½ × 5½ ins (21 × 14.5 cm). Bibliothèque Nationale, Paris.

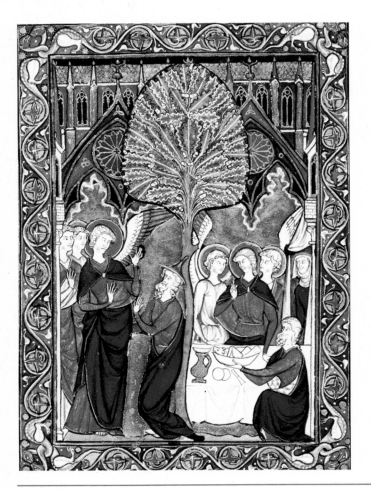

can be found in the small-scale *Madonna of Jeanne d'Evreux*, produced for the widow of King Charles IV as a gift for St. Denis in 1339 (Fig. **3.43**). After the large-scale figures on cathedral portals, this small work accords well with its own mood of tender intimacy between the Madonna and Child. Yet there is a prevailing otherworldliness as well, in part conveyed by the precious substances (contemporary Madonna sculptures were also produced in ivory or marble), in part conveyed by the hip-shot pose, with its artificial S-curve silhouette, and by the delicate features of the Virgin, akin to the angels of the *St. Louis Psalter*. The royal nature of the Queen of Heaven as the prototype for her earthly donor is symbolized on such works by crowns and orbs or scepters.

Increasingly, the cultural center of gravity shifted away from domination by princes and feudal lords or their monastic dependencies toward the new economic powers: free cities. Though royal houses came to dominate countries such as France and England, other less centralized regions on the main trade routes were able to establish their own autonomy in both political and artistic terms. For the next several centuries a new kind of audience demanded its own artworks in regions not yet heard from, chiefly in Italy and the Low Countries.

NARA, MEDIEVAL JAPAN

The complexities of Japanese culture crystallize vividly around a single monument: the state-supported Buddhist monastery, Todai-ji (the Great Eastern Temple), outside the ancient capital city of Nara. Established as the religious capital of the newly consolidated Japanese nation by Emperor Shomu (reigned AD 724–49), Todai-ji occupies a central role in its culture comparable (in scale as well as significance) to such Western medieval structures as Justinian's Hagia Sophia in Constantinople (Fig. 3.10) or the French monarchy's dynastic monastery at St. Denis (p. 107). Because of its close association with the imperial house, Todai-ji suffered brutally at the hands of political opponents during eras of civil war in Japan; the Great Buddha and the hall, the Daibutsu-den, were burned to the ground by warring clans in 1180 and again in 1567.

The Todai-ji site follows principles of Chinese Buddhist site design, exemplified in the preserved temple complex of Horyu-ji, near Nara (Fig. **3.44**). Buddhism entered Japan from China during the sixth century AD, to be adopted by the ruling family in AD 588 (in a decision as momentous as Constantine's conversion to Christianity). The layout of the complex conforms to the cosmological order, including an axial arrangement along the cardinal compass points, with orientation of access through a ceremonial gateway toward the favorable south. As in China, temple buildings at both Horyu-ji and Todai-ji are built of wood. The great Buddha Hall at Todai-ji was, in its day, the largest building in the world, built around a square plan of 164 feet (50 meters). The timber framed roofs stand on columns with cross beams reinforced by decorative brackets (instead of the capitals of classical Western columns).

3.44 Horyu-ji Temple, Nara, AD **670.**

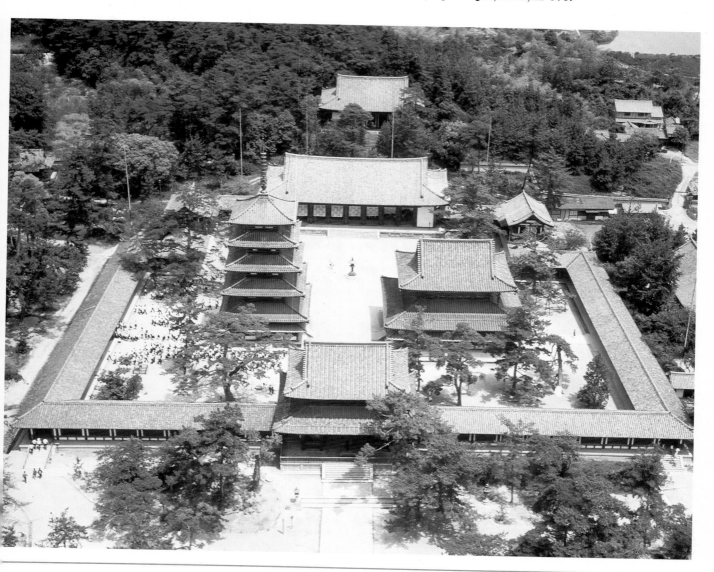

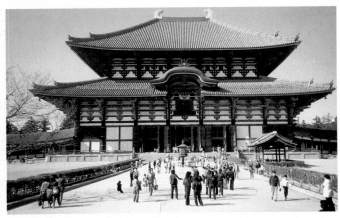

3.45 Todai-ji Monastery, Nara. Daibutsu-den, exterior, 1189–1203; reconstruction completed 1707 AD.

Through the use of cantilevered brackets and eaves the characteristic Eastern *hipped roof* of tiles could be supported. Like Horyu-ji, Todai-ji also once boasted a pair of seven-storey flanking pagoda towers at its entrance, each over 330 feet (100 meters) in height, among the tallest wooden structures ever made (Fig. **3.45**).

In the center of the complex was the Great Buddha Hall, a throne room for the deity, the Great Sun or Illumination (Vairocana in Sanskrit), who forms the central icon of devotion in Buddhist imagery from India throughout East Asia. At Todai-ji the cast bronze – and gilded – central sculpture of the enthroned Buddha Vairocana (dedicated AD 752) was gargantuan: over 50 feet (15 meters) high, intended to rival the great Tang Chinese emperors and their 33-foot (10 meter), rock-cut sculptures at the cliffs of Longmen, completed in AD 675, as well as a lost bronze in Luoyang. Because of its close association with the state, the Great Buddha at Todai-ji was destroyed in both the twelfth and sixteenth centuries (the present reconstruction dates from 1684). To sense the effect of the entire complex of Buddha statuary in the original Todai-ji, one must compare it with the Kondo (Golden Hall) from nearby Toshodai-ji (Fig. **3.46**). Upon a dais, the central, enthroned Buddha is attended by standing statues of Bodhisattvas, enlightened figures of more earthly character (at Toshodai-ji, these figures are 18 feet / 5.5 meters tall). These altar sculptures were reserved for the eyes of the monks, but a porch extension on the building permitted the people to listen

3.46 Kondo (Golden Hall), Toshodai-ji, Nara, ca. AD 759.

3.47 Guardian King, Sangatsu-do, Todai-ji monastery, Nara, early eighth century AD. Dry lacquer.

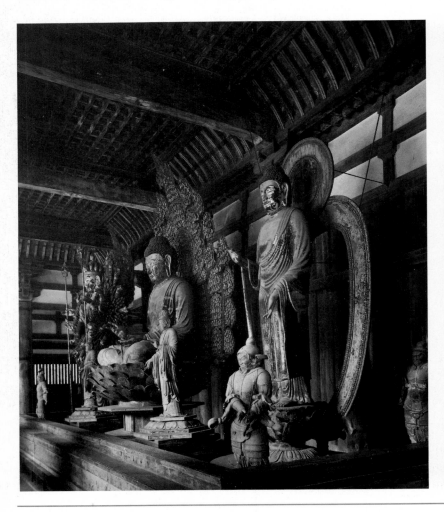

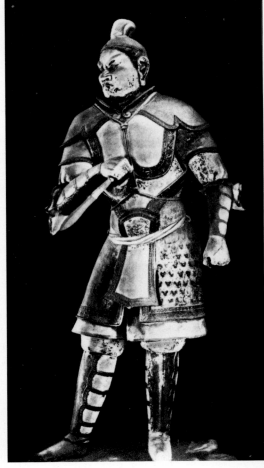

to ritual recitations within the great hall. At their sides stood angry guardian figures (one for each of the compass directions) carved in wood or clay, or built up slowly out of dried lacquer, a lightweight material of impressive durability with the capacity for exquisite detailing and lifelike features (Fig. **3.47**).

The later history of Todai-ji also produced spectacular new additions, along with reconstructions of the architecture and sculpture destroyed during the clan wars of the late twelfth century. With the victory of the Minamoto clan over the Taira (who burned Todai-ji), a period of national consolidation from the new military, or shogunal, capital at Kamakura was capped by the symbolic act of reconstructing the Great Eastern Temple under the direction of the monk Shunjobo Chogen (1121–1206). New schools of sculpture sprang up to meet the new demand for replacement altars and other furnishings for the sanctuaries, but both their techniques and their forms – especially in the emphasis on austere naturalism – were adaptations of the surviving earlier Nara sculptures (akin to the revival of classical Roman sculpture by the Italian Renaissance masters).

THE KEI SCHOOL

The most influential artists of the Kamakura period at Todai-ji belonged to the Kei School, founded by Kokei (active 1175–1200) and led by his son Unkei (d. 1223) and disciple Kaikei (active ca. 1185–1223). A dramatic example of Unkei's creative adaptation of the earlier Todai-ji heritage is his giant wooden guardian figure, Ni-o, of the South Gate from 1203 (Fig. **3.48**). The energy and anger of this twisting colossus (28 feet/8.5 meters) permits exaggeration of body, folds, and grimacing features; swirling scarves and skirts reinforce the overall dynamism. This guardian figure completed a vast ensemble by the Kei School at Todai-ji, beginning in the 1190s with the attendant Bodhisattvas alongside the Great Buddha and the four royal guardian figures. The Kei School achieved its meticulous carved surfaces by assembling several separate hollowed blocks, often painted in illusionistic colors. This technique also minimized splitting in the larger figures. It is possible that scale models in clay served as studies. In such a collaborative enterprise, Unkei and Kaikei may well have served more as project directors than as actual carvers (in the manner of Bernini in Rome, or the Rubens painting workshop in Antwerp, during the seventeenth century).

Kaikei had a particularly close bond with the monk Chogen, who supervised the restoration of Todai-ji, and these two men shared a commitment to Song Buddhist imagery. Kaikei's carvings of Buddha figures show the fleshy fullness of Song Chinese sculptures, such as the model of the Bodhisattva Guan-yin (see 3.56). A smaller standing figure of the Amida, Buddha of the West (less than 3 feet/1 meter high), represents the spiritual movement, Pure Land Buddhism, favored by Chogen, in which Buddha is seen as the lord of the Western paradise, a kind of heavenly vision of spiritual destination and consolation through faith alone. The Amida's gesture welcomes

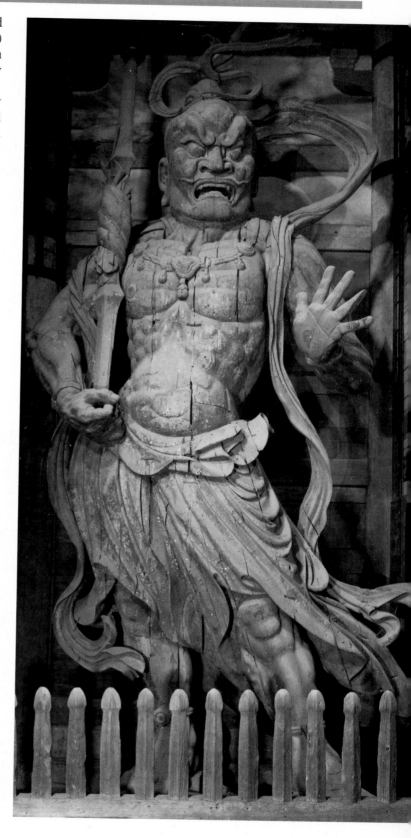

3.48 Unkei, *Ni-o*, 1203, Todai-ji monastery, south gate. Wood, 26ft 6ins (8 meters) high.

the believer to paradise. (A new, corresponding emphasis on the torments of hell also found artistic expression in this period, along with images of the protector Bodhisattva, Jizo.) The Amida's solar aspect is reinforced by the addition of gold leaf to the robes and the lotus halo of the statue. Inlaid crystal eyes and painted hair and lips give the figure an eerie presence. Preserved in the hall, Shunjo-do, dedicated to Shunjobo Chogen, the image served as a prototype for a host of related replicas dedicated to the Amida sect by Kaikei, who was nicknamed An'amidabutsu, carver of Amidas, by Chogen himself.

The Kei School mastery of naturalism reaches a climax in portrait sculpture, none more moving than the aged, wrinkled face of Chogen (Fig. **3.49**). Carved immediately after the monk's death in 1206, this statue was used in his funeral services at Todai-ji, which he had done so much to restore to its former glory. Here, especially, the polychromy and crystal eyes seem to confer the effects of a living flesh (carved separately and attached) above the elegant flow of stylized drapery. Serenity and resolve commingle on this expressive face, yet no signal of his national prestige marks the image of this unadorned monk.

Japanese society became increasingly dominated by powerful military warlords, the shoguns, such as the Minamoto clan who underwrote the rebuilding of Todai-ji after 1185. Indeed, the definers of the culture that prevailed for the next seven centuries were *daimyo* ("great name"), feudal lords and

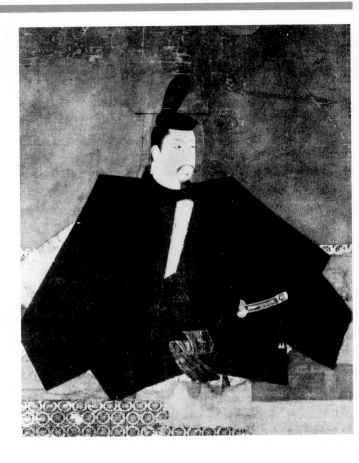

3.50 Fujiwara Takanobu, *Minamoto no Yoritomo,* **ca. 1200, Jingo-ji monastery, Kyoto. Painting on silk.**

3.49 Kaikei or Unkei, *Monk Chogen* **(d. 1206), Todai-ji monastery. Painted dry lacquer.**

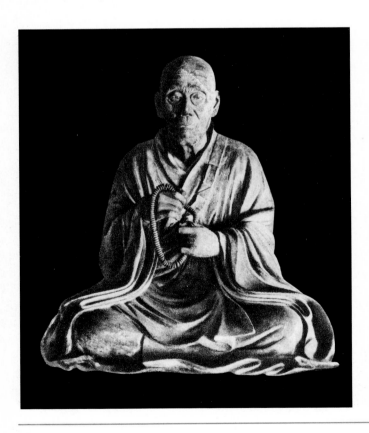

landholders who commanded provincial armies of knightly warriors, or samurai. The great leader of the Minamoto clan was Yoritomo (1147–99), whose official imperial title (Great General Who Quells the Barbarians, shogun for short) marked the end of dominant court culture in Japan. For this reason, Minamoto's restoration of Todai-ji can be understood as an act of assertion of the continuity of traditional imperial values in the face of altered political realities.

One of the great, prototype images of secular Japanese paintings is the portrait of Minamoto no Yoritomo, attributed to Fujiwara Takanobu (1142–1205; Fig. **3.50**). In contrast to the frankness and naturalism of the sculpted portrait of Chogen, this image of the first shogun remains dignified and ceremonial. This Yoritomo is formally dressed, with courtly headgear, blue *obi* sash, and starched, patterned silk attire, and he sits rigid and attentive on a mat, holding a wooden program. This painting abjures any reference to the ruthless military skills of the Minamoto warrior-general. It forms one of a set of four portraits, including the retired emperor, the son of the defeated Taira clan leader, and another leading courtier of the Fujiwara clan. The monastery where the portraits have remained since their creation, Jingo-ji, was likewise rebuilt with Yoritomo's support, encouraged by his personal friendship with the priest, a former warrior in his own right.

SONG (SUNG) CHINA

China already had an ancient civilization by the time of the Middle Ages in the West. Moreover, she valued her traditions far more than the medieval West, including a Confucian tradition of learning and aristocratic cultivation (as well as contempt for the uncultivated "barbarians" who threatened to invade Chinese land). Beginning in the later tenth century AD, invasions, chiefly those by the Tartars in 1127, began to cut into Chinese territories, forcing the royal court into a southern region, where the Song dynasty consolidated itself until it was finally overrun by the Mongols in 1279. Southern Song culture was driven from the top: imperial patronage supported a Neo-Confucian aristocratic governing elite as well as the creation of artistic objects in painting and ceramics.

While the Song dynasty still remained in its northern capital of Kaifeng (Pienching), its emperor Hui Zong (Hui-tsung; 1101–26) headed an academy of painting (founded officially in 984 as Bureau of Painting) and rewarded favored painters with official titles and awards. In 1104 the emperor consolidated the Institutes of Painting and Calligraphy as part of a statewide education program beyond the palace in his desire to reform and restore the vitality of the arts, including music, classics, religion as well as painting and the decorative arts. Famous as a painter in his own right, Hui Zong is credited with a skillful copy of a famous eighth-century painting of court ladies preparing silk (713–42; Tang dynasty, Fig. **3.51**). The scene itself represents palace life in the privacy of the women's quarters. An exquisite sense of limited space and subtle movement is conveyed through the compositional balance of turning robed figures.

Most favored of all subjects at the court academy was bird or flower painting, although Buddhist figural images and landscapes also flourished. Several fine examples bear the signature of Hui Zong himself, such as *Five-Colored Parakeet on the Branch of a Blossoming Apricot Tree* (Fig. **3.52**). The composition of the bird in profile balanced upon delicate branches points to a meticulous technique by a specialist painter for aristocratic connoisseurs. Biological accuracy was a hallmark of academic painting, and the unpainted silk background concentrates the image for the beholder. However, many of

3.51 Attributed to Emperor Hui Zong, early twelfth century, after lost painting by Zhang Xuan (act. 713–741), *Court Ladies Preparing Silk*. Painting on silk, 14½ × 57¼ ins (37 × 145.3 cm). Chinese and Japanese Special Fund, Courtesy Museum of Fine Arts, Boston.

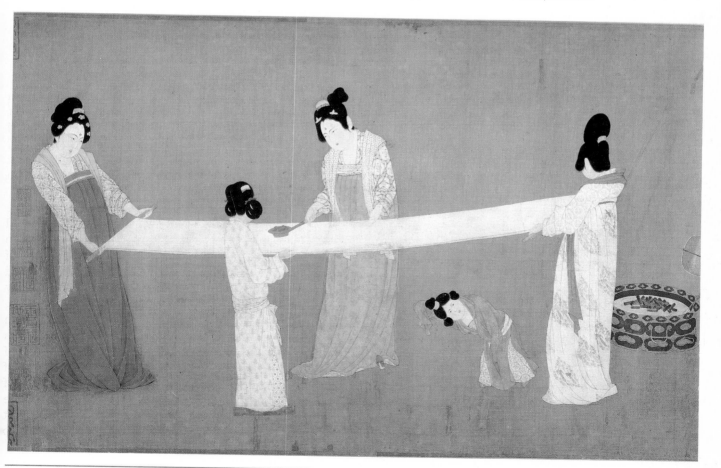

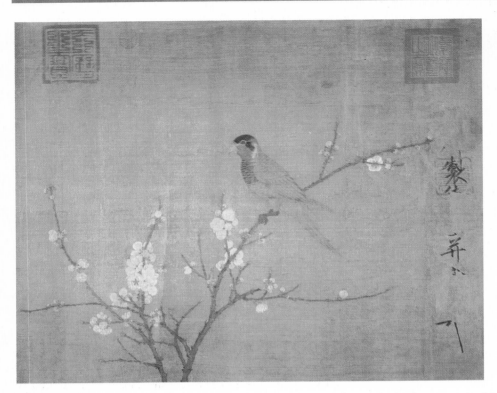

3.52 Emperor Hui Zong (d. 1127), *Five-Colored Parakeet on the Branch of a Blossoming Apricot Tree,* **painting on silk, 20⅞ in (53 cm). Courtesy Museum of Fine Arts, Boston.**

these silk scrolls also contain poems (along with the self-conscious signatures of their artists and later collectors' marks), striving for essences, the *huai-i*, or idea of a picture. Hui Zong's catalogue of his collection praises pictures for their ideas and evocation of emotions, as if the viewer were actually experienced the living beauty of the animals or plant.

After the death of Hui Zong, the imperial court moved to Hangzhou along the Yangtze River in the south. The Academy continued to flourish under the patronage of his son and grandson. Possibly the very political instability and constant threat of invasion led to an introspective assertion of the aesthetic in Southern Song life and to an opposite movement from the academic painting centered at court. The ideal of "painting by scholar-gentlemen" (shih-ta-fu hua), later known as wen-jen hua ("literati painting") arose as early as the second half of the eleventh century and now flourished all the more as a reaction of amateur painters against the professionalized imperial atmosphere of the Southern Song era during the mid-twelfth to early thirteenth centuries. Such individualists also prided themselves on their skills in additional art forms traditional in China, the "three excellencies" of poetry, calligraphy, and painting. In the same vein, the Song dynasty developed one of China's great contributions to world art: landscapes.

THE ART OF LANDSCAPE

Already during the Northern Song dynasty, landscape had attained its preeminence as an art form, supported by the Neo-Confucian principle of *Li*, the inherent order or principle of nature, to be sought and contemplated as a spiritual act. At the beginning of the Song dynasty in the late tenth century AD,

the landscape artist Li Cheng (d. 967) specialized in evocative wintry scenes in ink on silk hanging scrolls. Gnarled, twisted trees before bleak mountain peaks dominate the scroll most closely associated with Li Cheng: *Solitary Temple amid Clearing Peaks* (Fig. **3.53**). This powerful vertical composition employs a varied monochrome ink technique, ranging from misty washes in the distance to vivid linear details of nearby trees and buildings. Moreover, the virtuoso painter combines crisply literal delineation with varied brushwork, especially for rock surfaces. The viewer's eye is allowed to wander imaginatively through the various spaces of the setting, to contemplate its cascades and cliffs and to feel the immensity of nature, towering over the insignificant humans of the lower foreground. Human scale is dwarfed within the tall, narrow format of the hanging scroll. Beneath the temple tower at the center of the image is a foreground cluster of pavilions for humble pilgrims, such as the tiny figures who enter from the lower left corner. Li Cheng's artistic persona was exemplary for Chinese painters: descended from a good family, well educated, abjuring ambition, and painting for his own pleasure rather than for honor. Later periods would celebrate amateur "literati" painters (*wen-jen*), who dedicated their main efforts and talents to administration and to study of literary classics and composition, with painting (and discussion about painting) only a sideline. Thus both Li Cheng and his landscapes served as the model for centuries of Chinese art.

Wonder at the grandeur of nature in Li Cheng gave way gradually in later Song landscapes to contemplation of a more intimate nature, made mysterious by pervasive mist. Rather than the towering hanging scroll, later landscape artists favored the successive views and the extended process of unfolding horizontal scrolls (over time as well as space) as well

as the isolated intimacy of the single album sheet or painted fan. In the typical Southern Song album leaf or view, all the clearly visible elements, much reduced in number and scale, are confined to the foreground in the lower half of the image, often in a single corner. In contrast, the distance lies suffused in mist, painted with a simpler wash technique more suggestive than descriptive.

After the fall of the Northern Song to Tartars in 1126 (when Emperor Hui Zong was carried off in captivity to Mongolia), his son, Emperor Kao-tsung, established a new dynastic court at Hangzhou and attempted to reestablish an academy of painting in the south. The heyday of the Southern Song Academy came at the turn of the thirteenth century with the painters Ma Yüan (active ca. 1190 – after 1225) and Xia Gui (Hsia Kuei; active ca. 1180–1224), both Painters-in-Attendance to the emperor.

Ma Yüan, descended from a family of successful painters in the academy (and father of another successful painter, Ma Lin), specialized in an evocative shorthand, often including peripatetic scholars contemplating beneath wisps of vegetation in misty, open settings. Xia Gui carried this reduction of element still further. His handscroll, *Twelve Views from a Thatched Hut* (ca. 1200; Fig. **3.54**), almost eliminates line completely from its orchestrated washes and firmly controlled brushwork. The scroll unrolls (from right to left) as a continuous setting, but discrete portions are inscribed with their own mellifluous titles (four of an apparent twelve in the original scroll): *Flying Wild Geese over Distant Mountains*; *A Ferry Returns to the Misty Village*; *Pure Serenity of the Fisherman's Flute*; *Evening Moorage by a Misty Bank*. The mood of the titles and execution evoke nightfall and quiet; a few strokes suggest spatial depth extending behind the dark or thick ink gestures of the foreground.

3.53 Attributed to Li Cheng, *Solitary Temple amid Clearing Peaks*, second half of tenth century or early eleventh century. Ink painting on silk, 44 × 22 ins (111.8 × 55.9 cm). Nelson Gallery-Atkins Museum, Kansas City.

3.54 Xia Gui, *Twelve Views from a Thatched Hut*, ca. 1200. Handscroll, ink on silk, 11 ins (28 cm) high. Nelson Gallery-Atkins Museum, Kansas City.

THE CHAN ARTISTS

Academic techniques of dynamic brushwork in ink and intimate immersion in fragments of nature were adopted by a more independent amateur group of artists, steeped in the precepts of Chan (Zen) Buddhism. Based in monasteries around the capital of Hangzhou, these painters practiced techniques of rapid improvisation, allied to the pure intuition of sudden insight espoused by Chan teachings. Both the artwork and the outlook of these artists are exemplified by Liang Kai (third quarter of the twelfth century – after 1246), who began his career in the Academy of the Ma-Xia School and had attained the same exalted rank, Golden Girdle, as Xia Gui before joining the Liutung monastery. His *Hui Neng Chopping Bamboo* depicts the sixth Chan patriarch achieving enlightenment while in the midst of a most humble and everyday activity (Fig. **3.55**). The subject, like the artist, is a monk in simple dress, but his intense absorption in his task has evoked the desired spiritual fusion between subject and object. The painting consists of a range of rapid, angular brushstrokes. Traditional Chinese calligraphy (the art of handwriting) served to reinforce the virtuoso brushwork of both literati and Chan artists, both of whom prized expressive and eccentric individual creation and amateurism (the very opposite of the meticulous rendering of Emperor Hui Zong's bird-and-flower paintings). The rejection of scriptural orthodoxy remained paramount in Chan Buddhism; as a result, mystical contemplation and visual creation assumed particular importance. Liang Kai's companion image, *The Sixth Patriarch Tearing up a Sutra*, literally renders this rejection of the written word.

Relatively few of the traditional Buddhist subjects could serve the informal and individual meditations of Chan artists. However, the Chan priest Mu Qi (Mu-ch'i; also known in China as Fa-Ch'ang; early thirteenth century – after 1279), founder abbot of Liang Kai's Liu-tung monastery in Hangzhou, helped to popularize one such subject: the white-robed Guan-yin. This lesser, earthly Buddhist deity, or Bodhisattva (known as Avalokitesvara in Sanskrit, Kannon in Japanese), is described in texts as seated on a rock amidst vegetation by a riverside, like the isolated contemplative scholars of the Ma-Xia School images. His role is Bodhisattva of Infinite Compassion, a vision serving as a kind of deliverance from anxiety or peril. This image of solace depicts the Guan-yin, simply dressed and deep in contemplation, with downcast eyes. Mu Qi's rendering, a model for later Zen ink works in Japan, recapitulates an entire history of Chinese Song landscapes with its powerful brushstrokes for rocks and elegant outlines for drapery folds and facial features. The Guan-yin forms the central focus of a triptych by Mu Qi, with flanking panels rendering animals in nature: *Crane in a Bamboo Grove* and *Monkey with her Baby on a Pine Branch*, as if to crystallize the Chan precept of a single reality underlying the seemingly disparate phenomena of nature and a link for man of the divine with the animal world.

With increasing attention to the emotional aspects of Buddhism during the Song dynasty, Guan-yin became a

3.55 Liang Kai, *Hui Neng, the Sixth Chan Patriarch, Chopping Bamboo at the Moment of Enlightenment*, late twelfth-early thirteenth century AD. Hanging scroll, ink on paper, 29¼ ins (74.3 cm) high. National Museum, Tokyo.

frequent subject of religious sculpture as well, offering spiritual comfort to the individual. Informality and a relaxed, physical sensuality characterize most of the Guan-yin sculptures of the Song period, such as the gentle and accessible painted figure on a rock (Fig. **3.56**). The pose of "royal ease" suggests tranquility for the protector figure, with a raised yet supported right arm redolent of compassion. The elaborate color and luxurious scarves and headdress of this Song sculpture also serve to underscore the restraint and simplification in Mu Qi's painting.

3.56 *Guan-yin*, twelfth century. Painted wood, 95 ins (241.3 cm) high. Nelson Gallery-Atkins Museum, Kansas City.

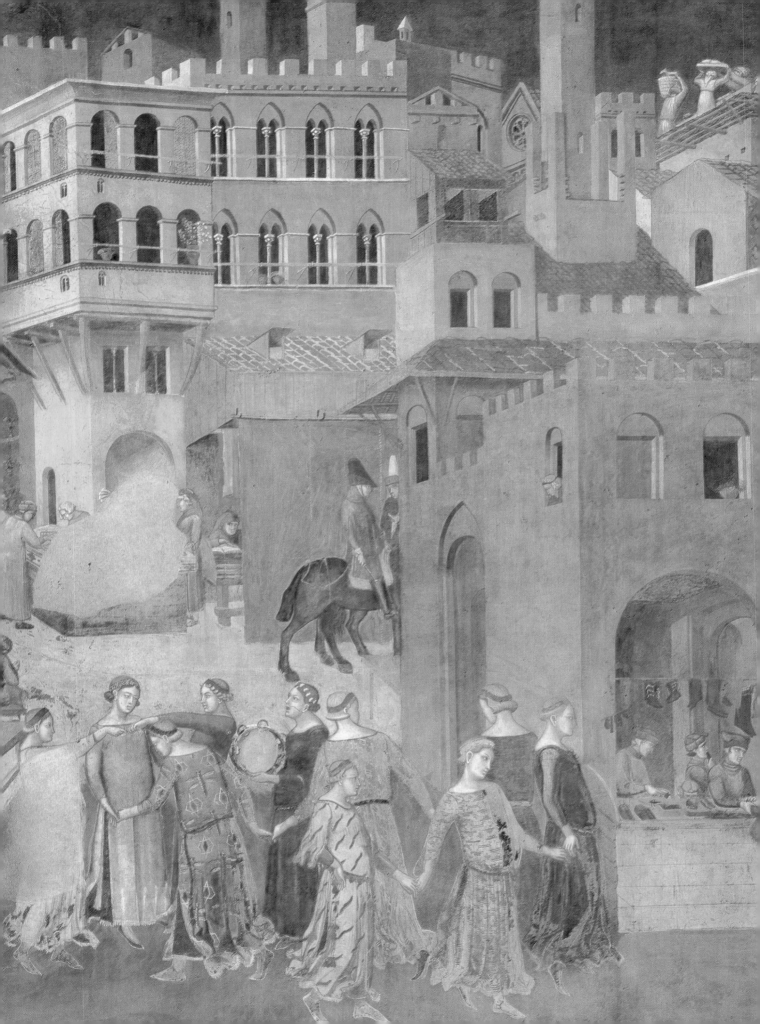

EARLY RENAISSANCE

NORTHERN EUROPE

One measure of the profound changes in medieval piety by the turn of the fifteenth century is the new conception for a church doorway commissioned by a member of the royal house of France for his own dynastic monument in Dijon. Philip the Bold (1342–1404), son of John the Good of France (d. 1364) and brother of the reigning king, Charles V (d. 1380), intended to establish his own branch of the Valois dynasty and his own ducal dominion in Burgundy as a rival to the emerging nation-state of France. He became the *de facto* king of France during a period of internecine rivalry and ongoing conflict with the kings of England, known today as the Hundred Years' War (1337–1453). In emulation of earlier French royal sepulchers at St. Denis, Philip the Bold established his own cenotaph within a new religious foundation, a monastery of the strict Order of Carthusians, the Chartreuse de Champmol, just outside his palace walls at Dijon. For the Chartreuse architecture, he summoned a designer from Paris, Drouet de Dammartin, who had worked on the palace of the Louvre for Charles V. But most of the decorations of painting and sculpture were provided by artists from the Low Countries, led after 1389 by a sculptor from Haarlem who had already worked on the Brussels City Hall: Claus Sluter (active 1379–1406).

When Philip the Bold married Margaret of Flanders in 1384, he assumed political control over the Low Countries and their prosperous cities, major centers of cloth production and international trade, like Florence in Italy. Even before his

Detail of Fig. 4.33, Ambrogio Lorenzetti; *Effects of Good Government*, **p. 158.**

marriage Philip repressed insurrections by peasants and workers, especially weavers in Ghent and Bruges (similar outbreaks were suppressed in England and Central Italy at the same time). Yet for his personal and familial monument at the Chartreuse de Champmol, this powerful duke portrayed himself in life-sized sculptures as the model of piety, kneeling before the Virgin and Child (Fig. **4.1**). Asserting his princely rank and authority in the manner of Charles V, who had himself portrayed with his queen as standing figures (by the court sculptor, Jean de Liège) on the Louvre east portal during the 1370s, Philip the Bold used his doorway to combine the secular with the sacred and to mix princely donors with holy figures.

CLAUS SLUTER Like Jean de Liège in Paris, Claus Sluter had eventually advanced in Dijon to the title of *imagier* and ducal *valet de chambre* for Philip the Bold. His chief assignment was the tomb of the duke and the other sculptural groups produced to decorate the Chartreuse de Champmol. Sluter's portal of the Chartreuse (1385–93) offers

a startling departure from the portals of Gothic cathedrals. Conceding nothing to the great churches in the scale of his figures, Sluter broke new ground by portraying his patrons life-size. Thus he both personalizes and monumentalizes the pious donation of the duke and duchess in their prayers before the Madonna and Child. He emphasizes their individual identities still further by means of richly carved details of facial features; in addition, the sculptures were originally enhanced by painted details and natural colors (added by court painters from the Low Countries, such as Jean Malouel).

Sluter has modified the coordinated upward visual movement of earlier jamb figure groups within a great arched portal and made instead a dynamically activated horizontal space around the *trumeau*. The central holy figures are framed by kneeling donors with their patron saints, who act fully and independently, as if motivated by wills of their own. Patron saints act as genuflecting intermediaries for Philip and Margaret, presenting the donors to the holy figures. However, except for their poses, no differences of scale or color or placement distinguish the saints from their aristocratic

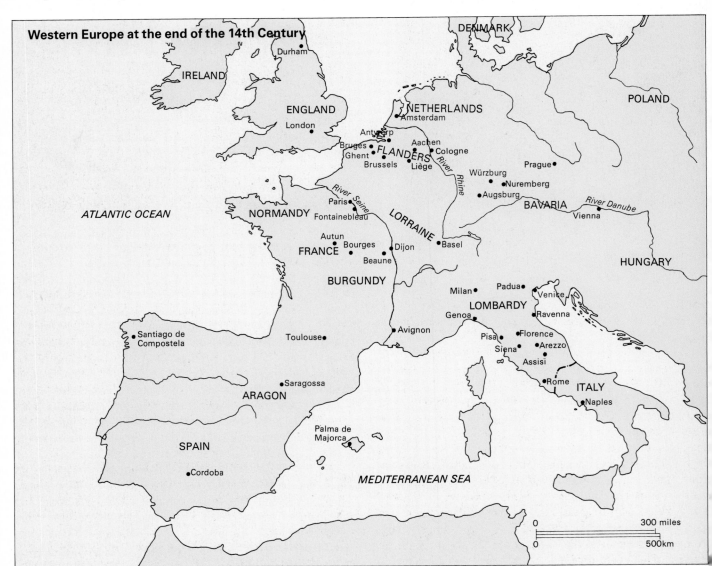

Western Europe at the end of the 14th Century

4.1 Claus Sluter, Portal of Chartreuse de Champmol, Dijon, 1391–97. Painted stone, lifesize.

charges. Sluter's donors and patron saints approach the holy figures directly and personally, even familiarly, across space.

At the same time, Sluter's unadorned holy figures emphasize uniquely human qualities. Amidst her dynamic, swirling drapery that focuses on the Child, this full-bodied Madonna looks at Christ as intently as the donors, but her maternal involvement is occasioned by Christ's upward glance, probably in response to a now-missing angel above Him. At the same time, this tender interaction between Virgin and Child echoes the hip-shot pose and intimacy toward the royal viewer already expressed in small-scale religious works in precious metals or ivory, such as the *Madonna of Jeanne d'Evreux* (1339; Fig. 3.43). Within Sluter's lifelike ensemble of sculptures, then, the spiritual is rendered as natural, while the living princely donors are freely admitted into the company of the celestial hierarchy as a sign of both their royal dignity and their exemplary piety.

ART OF THE COURT

Sluter and the other artists from the Low Countries became court artists and thus managed to evade the usual urban requirements (see Chapter 1) that they be admitted members of local crafts guilds, which dominated artistic life in cities of the Low Countries. To work in such a court setting freed certain distinguished artists from the anonymity of guild membership and civic obligations and restrictions. Indeed, this alternative option had been exercised at other regional and royal courts in France since the latter part of the fourteenth century.

THE LIMBOURG BROTHERS were among the most celebrated and prized artists at the court of Philip the Bold's brother, Jean, Duke of Berry. Paul, Herman, and Jean (active 1404–16) were originally from the North Netherlands, and had previously followed their uncle, the painter Jean Malouel, to Philip's court. In Burgundy but especially later in Berry, the Limbourgs produced exquisite

4.2 Limbourg Brothers, *Meeting of the Magi* **(fo. 51v) from** *Très Riches Heures***, 1413–16. Parchment, 8½ × 5½ ins (21.6 × 14 cm). Musée Condé, Chantilly.**

miniatures in a series of luxury religious manuscripts for the pleasure and piety of the dukes. Most often these were the anthologies of prayers (especially addressed to the Virgin and to the holy cross) and psalms specially selected by individual owners and compiled as Books of Hours. Inventory descriptions of such Limbourg productions indicate that these books were collected as much for their sumptuous pictorial decorations as their prayers: the *Belles Heures* or their masterpiece, the *Très Riches Heures* (ca. 1415).

The Limbourg Brothers paid homage to their princely patron in much the same fashion as Florentine painters would later honor the Medici. For example, they feature the legends of the magi, including the moment when the wise men converge from their separate corners of the world to meet outside Jerusalem (fo. 51v; Fig. **4.2**), whose view is marked by the ornamented *montjoie* column, akin to an ornamented and sculpted religious marker, the "Well of Moses," made by Sluter for the Chartreuse de Champmol. The city of Jerusalem

in the distance, however, is recognizably the skyline of Paris with the Sainte-Chapelle and Notre Dame, symbolically linking the ancient kings with modern ones while also underscoring the religiosity of the French royal house, including Jean de Berry. On the facing page, the *Adoration of the Magi* features a background skyline of Jean de Berry's own provincial capital, Bourges, with its distinctive cathedral and great tower clearly distinguished. For the forms of the three kings the Limbourgs utilized medals from Jean's collection showing the historical and regional costume and traits of the Byzantine emperor, the first Roman caesars, and an equestrian image of Constantine. Further orientalism appears within the retinue in the turbans and brocaded costumes as well as the exotic animals, including cheetahs and camels. Lavish expense on materials featured applied gold, especially for the star of Bethlehem in the heavens, and an ultramarine blue, made out of *lapis lazuli*, also used for the skies. Elsewhere in the *Très Riches Heures* (fo. 161v), the Limbourgs paid homage to their sovereign and his sumptuous patronage in their scene of the Temptation of Christ. Clad in gold, Christ stands at the summit of a tall peak, as He and the devil look down upon the treasures of the world. The greatest of the kingdoms of the world is here represented by a favorite château of Jean de Berry, Mehun-sur-Yèvre, rising majestically up in the foreground (among the picturesque elements included in this landscape construction appear the heraldic symbols of the duke, swans and a bear). By analogy, Duccio's *Temptation* from the *Maesta* had conceived Italian hillside city-states as the glory of the kingdoms of the world, again paying tribute to local pride (Fig. 4.31, p.157).

Best known of the pages of the *Très Riches Heures* are the illustrations of the activities of each month that adorn the ecclesiastical calendar pages at the opening of the manuscript. A portrait of the duke himself and his festive new year's celebration illustrates January (Fig. **4.3**). Dressed in sumptuous robes of ultramarine and gold, the portly patron sits before a fireplace underneath a vermilion cloth of honor with his heraldic symbols: central golden *fleurs-de-lys* on blue, swans, and bears. The walls around contain a vast tapestry image of chivalric combat among knights before a castle; poetic inscriptions on the tapestry identify it as a recreation in modern terms (rather than the revived antiquity that would later be favored in Renaissance Italy) of the Trojan War. The luxurious life of the court unfolds in this lavish domestic scene through the vivid colors and modish fashions of the attendants on the duke as well as the rich setting of his table, highlighted by the ship-shaped salt-cellar, or *nef*, with bear and swan. (A few comparable examples survive, such as the Burghley Nef, in the Victoria and Albert Museum in London.)

Indeed, out of the surviving tapestries from the turn of the fifteenth century, one set with a chivalric theme stems from the collection of Jean de Berry (ca. 1385) and recalls the

4.3 Limbourg Brothers, *January* **(fo. 2r) from** *Très Riches Heures***, 1413–16.**

4.4 Nicolas Bataille, *King Arthur*, from Nine Worthies Series, ca. 1385. Tapestry, 11 feet 6½ ins (3 meters 51 cm) high. Cloisters Collection, Metropolitan Museum, New York.

decoration of the January page. Featuring the subject of the Nine Worthies, three triads of heroes from pagan, Jewish, and Christian histories, these large tapestries include the arms of both Berry and Burgundy (Fig. **4.4**). Each of them focuses on such imposing enthroned figures as Hector of Troy and King Arthur, who served as models of highborn bravery and chivalry for the dukes and their courtly retinue. Documents reveal that Jean de Berry also had the Nine Worthies carved on the fireplace of the great hall at his palace at Bourges and that he even had them included on a golden table *nef*. Woven at special request from new tapestry entrepreneurs in Paris, led by Nicolas Bataille (who was also a *valet de chambre* for the Duke of Anjou, active 1373–99), such tapestry cycles might well have been included in the elaborate gifts that the Valois

dukes gave to one another.

Other scenes from the calendar pages of the *Très Riches Heures* use landscape to provide an image of the duke's vision of the world from his palace. The pages of both June (fo. 6v) and October (fo. 10v) show the agrarian activities of each of these months taking place outside the walls of ducal residences (Fig. **4.5**). In June, simply dressed peasants mow the hay, as viewed from the Parisian residence of Jean de Berry, the Hotel de Nesle. Behind the meadow stands the French royal palace of Jean's nephew, Charles VI, complete with surviving elements, the Sainte-Chapelle and the Tour de l'Horloge. In similar fashion, the Left Bank is the site of tilling and sowing for the image of October, but these peasants in the foreground toil in the shadow of the Louvre, former residence of Jean de Berry's (and Philip the Bold's) brother, Charles V.

4.5 Limbourg Brothers, *October* (fo. 10v) from *Très Riches Heures*, 1413–16.

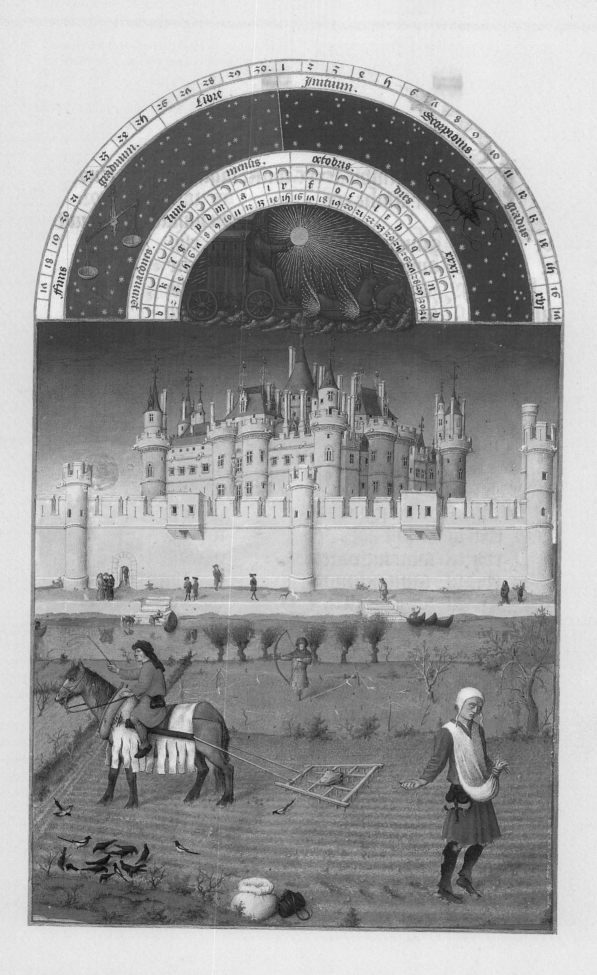

4.6 *Goldenes Rössl* "Little Golden Horse", 1404. Gold and enamel. Parish church treasury, Altötting.

Such images can be compared with the Lorenzetti frescoes of life in the countryside surrounding Siena, where seasonal produce is exchanged in the city by contented peasants (Fig. 4.33). Here, however, in place of the commune and its hardworking urban citizens, a privileged class of lords and ladies pursue courtly entertainments, such as hawking and riding.

The religious scenes for courtly patrons also convey the same sense of privilege and rank. Many of the luxury objects made for Jean de Berry or his royal relatives have been destroyed for their precious materials, but in one notable example costly gems and metalwork combine into a vivid aristocratic vision as a precious object. The *Goldenes Rössl* ("Little Golden Horse") was produced for Charles VI by a Parisian goldsmith and presented as a gift by his wife, Isabel of Bavaria, Queen of France, in 1404 (Fig **4.6**). Staged on an elevated platform reached by stairs, this metalwork ensemble features the Madonna and Child with small angelic attendants in front of an arbor lattice, composed of pearls and precious stones. Such a bower space suggests the enclosed garden of the Song of Songs, often associated with the beauty and the purity of the Virgin. Below, Charles VI kneels before the holy figures at a prie-dieu, or prayer stool, with a holy book, possibly a Book of Hours; opposite him, a page in livery holds his crowned tournament helmet. Childlike saints, the patron protectors of the three royal children, serve as intermediaries between the holy figures and their noble admirer. In the lower storey, a groom attends a white enamel gold horse that gave its name to the ensemble. Like the expensive collaboration of tapestry weaving, such sculpted metalwork continues the heritage of the *Madonna of Jeanne d'Evreux* and typifies courtly taste in France for luxury as well as demonstrating the projection of princely values onto both history and religion. Amidst their hierarchical ceremony and artifice, like the lifesize sculptures of Sluter these charming small figures were fully colored.

JAN VAN EYCK A generation later, Burgundian officials who patronized Flemish painters continued to request images that juxtaposed their own portrait likenesses with palpable visions of the Madonna and Child. Boldest of these images is the *Madonna of Chancellor Rolin* (ca. 1436; Fig **4.7**), painted by Jan van Eyck, court painter and valued *valet de chambre* at the court of Duke Philip the Good, grandson of Philip the Bold (ruled 1419–67). The sitter, Nicholas Rolin, was one of the wealthiest and most powerful men of the Burgundian court in the Low Countries, and in this panel he confronts the Madonna and Child directly, without the mediation of any patron saint. Like Sluter's kneeling Philip the Bold, Rolin receives an answer to his prayer, as he is shown kneeling behind a prie-dieu. The palatial setting for this encounter is ambiguous, for it is appropriate to either a lordly chancellor or a

queen of heaven. What is important is that the two figures meet directly, and the Christ Child clearly responds to Rolin's prayer with a gesture of blessing.

Despite the illusionistic background space, which has led to many a vain search to identify a real landscape setting as a model, each of the sides of the picture corresponds to the foreground sitters. Rolin's side features a monastery with vineyards appropriate to his worldly possessions and pious patronage, whereas Mary appears before a city filled with church spires as well as a larger, cathedral-like edifice linked to her many church dedications as well as her role as a symbol of the whole Church. In the interior, the spaces of the two figures are divided by a boundary zone of floor tiles, continued by the river in the center of the background (although the bridge across the river echoes and visually extends the blessing gesture of Christ toward Rolin). The space as a whole, whether interior or exterior landscape, has been assembled artificially, composed in a calculated way to distinguish as well as to link the figures. Such an imaginary location could not be Rolin's actual dwelling but rather must be a visionary setting that echoes the divine plan and hierarchy. In keeping with this plan, the sculpted decorations within the room above the figures each contain references to appropriate Old Testament scenes. Rolin's scenes are taken from Genesis and show the sins or failings of mankind (including Noah's drunkenness, related to the vineyard landscape), whereas the scene above the holy figures offers a prototype for the institution of the eucharist: the moment when the warrior Abraham meets the priest Melchizedek and receives wine and bread. The donor's

sinfulness and need for redemption are thus met through the response of the holy figures and their instituted Church sacraments, just as the actual depicted prayer of Rolin is answered by the visionary appearance and then the blessing of the Virgin and Christ.

Thus the limits and roles of the living and the holy figures are clearly laid out within van Eyck's picture, despite its powerful illusion of nature achieved through the medium of oil paint. As a result, hierarchy and distinctions between the prominent sitter and his eternal vision can be maintained, just as in the spatial arrangements in Sluter's portal or in Masaccio's fresco *Trinity* (Fig. 4.45). In van Eyck's painted world, worldly signs of power identify the sacred rank and powers of the holy figures: a jeweled crown and throne stool for the Virgin, a crystal orb with jeweled cross for the Christ Child. In addition, the palace garden behind the sitters contains flowers that are traditionally associated with the Virgin: white lilies of purity, roses without thorns, and irises, the "sword-lilies" of Mary's sorrow. Taken together, this space becomes the "enclosed garden," already seen in the *Goldenes Rössl* as a symbol of the Virgin's purity and beauty, which suggests, in turn, the paradise regained through redemption. In such a fashion, everyday items are infused with religious meaning, establishing a poetic equivalence between the observed world and the supernatural for the devout beholder (such as Rolin). Van Eyck's *Rolin Madonna* would in its turn shape the details and the overall arrangement of figures in van der Weyden's *St. Luke Drawing the Madonna* (Fig. 1.1), although the later work simplifies many of the symbols of van Eyck.

4.7 Jan van Eyck, *The Madonna of Chancellor Rolin*, ca. 1436. Oil on panel, 26 × 24⅜ ins (66 × 61.9 cm). Louvre, Paris.

ART OF SALVATION

ROGIER VAN DER WEYDEN Nicholas Rolin also commissioned a major *Last Judgment* altarpiece from Rogier van der Weyden, city painter of Brussels (active 1431–64; see Fig. 1.1) and also portraitist for Philip the Good and his court. This enormous devotional work (Fig. **4.8**) was created for a specific site in its own remarkable building, donated in the heart of Burgundy by Rolin: the Hotel-Dieu, or hospital, of Beaune, built between 1443 and 1451. This pious donation by the powerful and wealthy chancellor can be compared to the expiatory offerings of chapel decorations for the Franciscan church of Santa Croce in Florence by the Bardi family, but the Last Judgment subject of this enormous altarpiece serves as an integral element in the treatment of patients in the hospital. In an era still racked by outbreaks of the plague and still associating disease in general with divine punishment or trial, patron saints and prayers formed part of the therapy for the afflicted. Thus on the reverse of Rogier's altarpiece, the donor and his wife appear in the humblest positions, at the extreme lower side areas of the outside of the image. They are shown praying to sculptures of two of the major saints invoked against plague: Anthony (who also protects against particular skin ailments and whose hospital order was a major administrator of hospitals) and Sebastian. The donors, dressed in somber if expensive black garb, appear at prayer stools with heraldic coats-of-arms, but here they are subsidiary figures in relation to what must finally be a divine act of healing.

The subject of the interior, the *Last Judgment*, evokes the mortal decision between health and disease, even life and death. The vision is rendered with awesome majesty, akin to the portals of medieval cathedrals, such as nearby Autun. The judging Christ is at the top center, directly in line with the archangel Michael, dressed in the robes of an officiating priest, who holds the scales in which tiny, thus less holy, figures

4.8 Rogier van der Weyden, *Last Judgment Altarpiece*, 1444–51. Oil on panel, 88⅝ in × 215 ins (225 × 546 cm). Hotel-Dièu, Beaune.

hover. Rich materials, especially gold for clouds or haloes, serve as the mark of celestial otherworldliness, and the community of saints is much larger than the tiny, naked human souls who are drawn to heaven (depicted as a Gothic portal) on Christ's right or hell on His left. Rogier emphasizes the larger size and majesty of the holy figures, for this is an image intended to elicit awe and prayer. Angels beside Christ hold the instruments of the Passion, records of Christ's own suffering, for the meditative contemplation of the afflicted beholder. However, because demons have disappeared from van der Weyden's altarpiece, the burden of judgment falls squarely on the individual. Only the weight of their sins in terms of natural gravitation will doom the damned, whether in the scale of justice or at the precipice of hell.

In similar fashion, one of the first printed "best-sellers" of the fifteenth century was an instructional book, accompanied by woodcut illustrations, entitled *Ars moriendi* (*The Art of Dying Well*), which rehearses just such a conflict between virtue and vice on the deathbed of an individual, exhorting that soul to choose the good and obtain divine grace. No longer is the Last Judgment a universal event at the end of time; now it has become a personalized drama of individual destiny, linking death with salvation, like the direct prayers by donors for salvation before holy figures in Flemish art.

Beaune's hospital foundation makes explicit the legal and personal bargain made on behalf of his own immortal soul by Rolin in 1443, "Desiring by a happy transaction to exchange for heavenly wealth the worldly goods that have been bestowed on me by the grace of God, and by this exchange to render them eternal."

The hospital building itself (Fig. **4.9**) is an imposing

4.9 Beaune, Hotel-Dieu Hospital, 1443–51. Exterior.

4.10 Jan van Eyck, *Adoration of the Lamb Altarpiece*, 137¾ × 181½ ins (350 × 461 cm) open. Interior center, *Deësis and All Saints*.

palace-like structure, built in a grander version of the Flemish style visible in the background city of van der Weyden's *St. Luke Drawing the Virgin*. Built around a large, open courtyard, the hospital remained a self-contained complex. Its sharply peaked roof alternates large and small gables and dormer windows, enhanced by festive colors in a pattern of roof tiles. The dormers admit extra light into a great vaulted gallery, in which the poor and sick were treated within an open dormitory space, some 170 feet (52 meters) long and 52 feet (16 meters) high at the peak of its open timber roof. Such roofs echo the keel constructions of shipbuilding in both England and Flanders and can still be seen in surviving great halls. Stained glass and floor tiles both paid homage to Rolin by including his coat-of-arms. Like most chapel or institutional foundations, this one endowed masses in the name of the donor. Such masses would be read before the van der Weyden altarpiece – with its exterior donor portraits of the Rolins – in the chapel at the far end of the great hall of the Hotel-Dieu; together with the building itself, that painting forms a lasting and personal, pious legacy for Nicholas Rolin, akin to the donations of emperors or kings in the past.

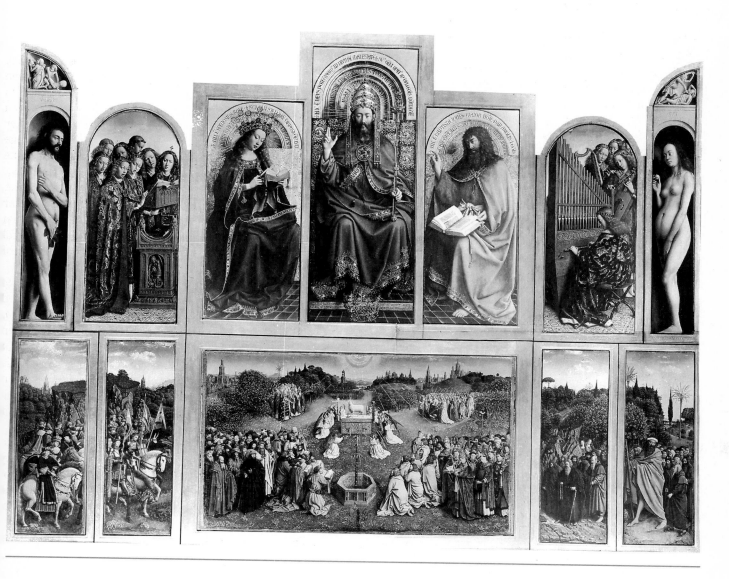

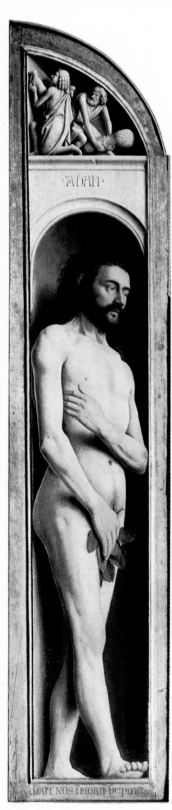
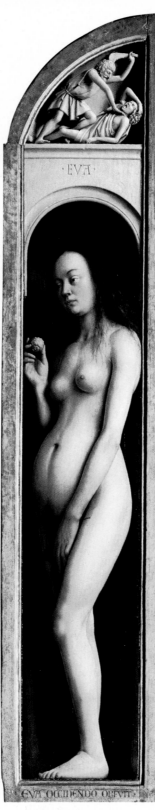

4.11 Jan van Eyck, *Adoration of the Lamb Altarpiece*, outer interior wings, *Adam and Eve*.

4.12 Jan van Eyck, *Adoration of the Lamb Altarpiece*, exterior, with portraits of donors, Joos Vijdt and Elisabeth Borluut.

FLANDERS: SACRED AND SECULAR

Burghers in the cities of Flanders, however, also provided strong support for painters such as van Eyck and van der Weyden. At the same time that the communes of Florence and Siena were prospering in Italy, large cities in the Low Countries, led by the Flemish port city of Bruges, the dominant harbor and trading center in all Europe, also enjoyed economic success and basic political autonomy. Within Bruges, important merchant colonies from all over Europe established residence in order to coordinate their trade. Among these trade colonies, representatives from Italy were organized according to city of origin, and the Medici Bank also had a representative.

THE GHENT ALTARPIECE Shortly before the commission came from Nicholas Rolin for his *Madonna*, a prominent citizen of Ghent, Joos Vijdt, and his wife, Elisabeth Borluut, commissioned a massive altarpiece from van Eyck for their memorial chapel in the local church of St. John (now St. Bavo cathedral). Completed in 1432, according to its inscription, this huge multi-paneled altarpiece, or *polyptych*, presents on its interior a gathering of all saints in adoration of the sacrificial lamb, symbol of Christ (Fig. **4.10**, p. 135). Below, a scene of the earthly paradise, rendered with an unprecedented precision of detail for textures, reflected lights, and surfaces in the new medium of *oil technique*, presents a panoramic landscape for the assembly of holy figures: pilgrims, hermits, martyrs, confessors, prophets, patriarchs, apostles, clergy, knights, and judges. This panoply of figures from the entire history of the Church (some of the judges may include portraits of the dukes of Burgundy) bears witness to the central rite of this and every church, the sacrament on the altar; the lamb bleeding into the chalice illustrates the sacrament of the daily mass held by a priest before this very painting. Above the earthly landscape appear the commanding, oversized figures of the Last Judgment, centered on a majestic enthroned figure of a blessing Christ, here representing a divine Father (who can be read vertically with the descending dove of the Holy Spirit and the Lamb to form a central, axial Trinity). The crowned Virgin and St. John the Baptist, patron of the Ghent church, complete the Deësis of Judgment, known from Byzantine compositions (such as the mosaic at Hagia Sophia; see Fig. 3.14), but their otherworldliness is tempered by the powerful illusion of presence occasioned by the oil technique, where every jeweled or golden surface seems to glow. Beside the Deësis figures appear the joyous musicians of heaven, choirs of angels, as well as the surprising figures of Adam and Eve (Fig. **4.11**). These full-length nude figures in illusionistic niches (surmounted by the figures of Cain and Abel) suggest that salvation is possible through the Church and its sacraments even for sinful humanity; though they appear in the least favored positions at the flanks of the Deesis and angels, they still have attained the

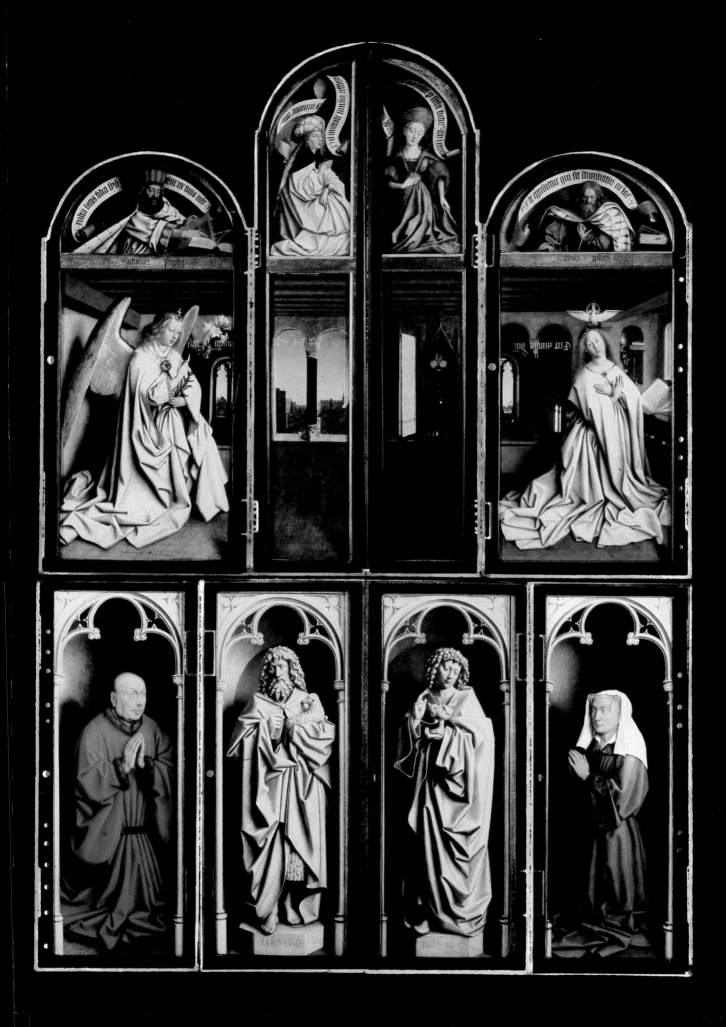

**4.13 Jan van Eyck,
Arnolfini Wedding Portrait,
1434. Oil on panel, 32¼ ×
23½ ins (82 × 69.7 cm).
National Gallery, London.**

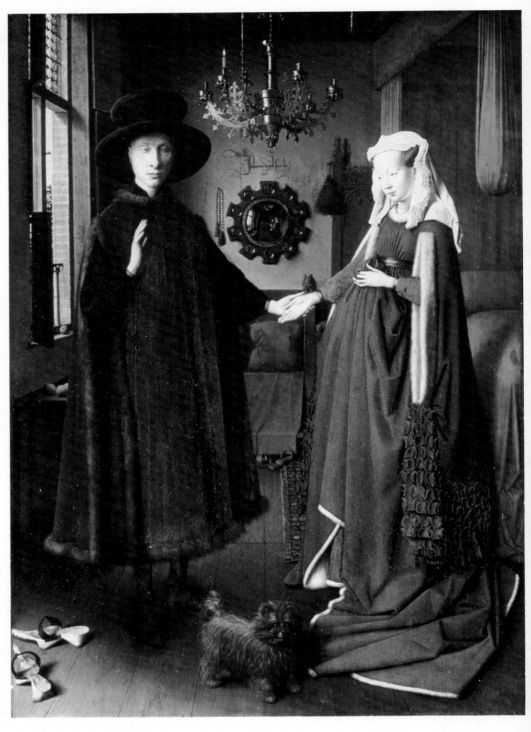

upper register. Here nudity signals the innocent state in Eden as well as the restored grace after resurrection.

The exterior of the Ghent Altarpiece also promotes hierarchy by placing the kneeling donors in the lowest, outer-most positions (Fig. **4.12**). Rendered in careful lighting within niches before illusionistically painted stone sculptures of the two Saints John, these meticulous portraits of the Vijdts emulate in painting the doorway composition by Sluter for Philip the Bold at Dijon (Fig. 4.1). (Van Eyck, in turn, was imitated by Rogier van der Weyden for the portraits of the Rolins on the exterior of the Beaune Altarpiece.) Above the Vijdts appears the Virgin at the Annunciation, the inaugural moment of Christian grace and a fitting prelude for the

recovered earthly paradise of the interior, whose content is prefigured by the prophets and sibyls above. This exterior was the one most often viewed; the spectacle of the interior was only exposed on Sundays and feast days in the Vijdt chapel.

If the portraits of Joos Vijdt and his wife were occasioned for an ongoing religious memorial in a church, the double portrait with his wife commissioned from van Eyck by a nearby Italian silk merchant in Bruges provided no ecclesiastical context for the *Arnolfini Wedding Portrait* (1434; Fig. **4.13**). Here, the new technique of oil painting fully realizes the illusion of a light-filled interior and objects with distinctive substances and textures. Yet in this convincing rendering of two portrait likenesses in space lies the same kind of analogy

between earthly metaphors and spiritual values, conveyed through the individual objects. For the scene presents a wedding, complete with sacred vows of joined hands and the groom's upraised gesture of avowal.

Other imagery further links earthly promises of marital fidelity to spiritual faithfulness, a compact between humankind and God. A loyal dog (often a favorite pet of women and still given the cliché name of Fido, derived from the Latin for faith) signifies faithfulness in general, and the background mirror frames its reflection of the entire scene within a decoration of the events of the Passion. According to medieval doctrine, all of the sacraments, including marriage, resulted from Christ's Passion, and this sacrifice became linked with the analogous mystical marriage of Christ with His Church. Indeed, the convex, or bull's-eye, shape encompasses the entire event of the marriage, including the reflections of two witnesses placed in the position of the viewer. The mirror itself can thus be likened to the all-seeing eye of God as witness to mankind's activities.

Within this earthly world, many of the individual objects can be read not only as commonplace or ritualistic items but also as potent spiritual symbols, charged with the poetic awareness of similitudes between earth and heaven. For example, the orange on the window sill could be a standard wedding gift to signal fertility, like modern wedding flowers, but it also could refer to the "Eastern" apple (oranges were an expensive import in the Low Countries) of Eden itself, regained through the sacrament of marriage and pious faith. The single candle above could simply indicate an official legal act, but light is also a traditional symbol of the divine, and this legal act is also a sacrament before God. Finally, the removed clogs and sandals refer to the local custom of a husband presenting his bride with such clogs, but at the same time the removal of shoes indicates consecrated ground and can be seen as such a symbol in numerous Flemish religious pictures. Like the sculptures behind Nicholas Rolin in his van Eyck picture, a tiny carving of St. Margaret, patron saint of childbirth, adorns the background bedpost to sanctify as well as fructify these nuptials. This double portrait also confirms traditional gender roles, reserving the closed side of the room with its wedding bed for the bride while placing the groom (and the clogs that signify stepping outside the home) on the open side with window.

Thus the *Arnolfini Wedding Portrait* commemorates the marriage of Giovanni Arnolfini and his bride Giovanna, but also incorporates the realm of the sacred within the everyday, as befits a marriage ceremony before witnesses. (Jan van Eyck's signature, with a flourish on the back wall, is the legal script of an eyewitness: "Jan van Eyck was here.") Like the *Rolin Madonna*, this picture is unusual in presenting its portrait figures at full length, in the manner of sculptures of saints or monarchs, rather than at bust length, like most burghers. While this image points to the increasing importance of individual urban patrons for painters in fifteenth-century Flanders, such a double portrait also reinforces the integration of the spiritual within the secular that Flemish art provided –

as a visible form of prayer. This light-filled world of Flemish art irradiates with sanctity the material world of merchants, not just a monastic or cathedral world, like Suger's stained glass.

In the Flemish context, city-states and their artists also forged powerful emotional links to particular religious patron saints, as Siena had done with the Virgin or Florence with John the Baptist. Bruges, for example, had a local cult for the relic of Christ's holy blood, brought back by a local count from the crusades and subsequently housed in its own chapel area next to the splendid late fourteenth-century city hall. The relic of the holy blood even became the focus of an annual springtime civic procession in Bruges, organized in groups according to local guilds and civic corporations (still practiced today). Proud ties between the modern prosperity of the city and its piety were further expressed by means of the inclusion of the Bruges skyline behind the images of saints, particularly of the Virgin. Moreover, the city hall of Bruges (Fig. **4.14**), constructed from 1376 to 1387, itself resembled a precious, ornate reliquary or a chapel with great stained-glass windows; a full program of sculpted figures of the counts of Flanders by the sculptor Jean de Valenciennes (updated later with figures of Philip the Bold and Margaret of Flanders, painted by Jan van Eyck, in 1434–35) adorned its exterior. The great hall inside provided the ceremonial center of Bruges for civic occasions, and its original timber vault with painted and gilded carved *bosses* (1402) has survived.

4.14 Bruges City Hall, 1376–87. Exterior.

4.15 Brussels, City Hall, 1402–54. Exterior.

Dwarfing the city hall in scale and suggested power within Bruges are the civic merchants' buildings. Urban commerce in Bruges (as well as rival Flemish cities, such as Ghent and Ypres) produced a skyline that was dominated by mercantile concerns. Whereas in Siena and Florence the most prominent towers above the city roofs belonged to the cathedrals and the city halls, in Bruges and Ypres the main parish churches (not cathedrals as in Italy) were matched by great towers from the cloth halls that marked the centers of commerce. As in the Italian communes, government in the Flemish cities lay in the hands of a small group of wealthy patricians, chiefly associated with the cloth trade, who administered power through nine main guild representatives. Bruges also organized massive public works, such as the great ring wall of 1297 (partly financed through loans from the Bardi and Peruzzi banks of Florence), the "New Hall, or Waterhall" for cloth warehousing (1295), and especially the city's canals and its major waterway to the North Sea. During the fifteenth century the chief civic construction centered on the huge tower and belfry (with that recent urban invention, the clock) on the sturdy "Old Hall" at the market square. This bell tower, over 352 feet (107 meters) high, serves as a symbol of the city when it reappears along with that of the church of Our Lady in the backgrounds of Bruges religious pictures. Like the Limbourg Brothers' equation of Paris with Jerusalem, proud local artists portrayed Bruges as a city favored by the Virgin and saints.

While the Bruges city hall did not possess a bell tower, the city hall in Brussels (1401–54) on the central market square (Grand Place) displays a proud belfry, crowned by St. Michael, patron saint of the city, atop its elegant façade (Fig. **4.15**). Inside the Brussels city hall, a huge painting by Rogier van der Wyden (burned) represented a prototypical scene of justice being administered by Emperor Trajan, drawn from Roman history, as a model for city magistrates. Small sculptures adorning the belfry portal of the hall have been ascribed to the youthful Sluter, documented as having been in Brussels between 1379 and 1385, because they resemble his smaller figures below the consoles of the Chartreuse de Champmol portal. The architect of the belfry, Jan van Ruysbroek, began his work in 1449, completing the previous designs of architect Jacob van Tienen.

THE ART OF DYING WELL

HIERONYMUS BOSCH Not all artists happily embraced the mercantile, urban patronage represented by Arnolfini, and at the end of the fifteenth century visual dissent and discomfort with the temptations of materialism emerged in the art of Hieronymus (Jerome) Bosch (active ca. 1480–1516). In his *Death and the Usurer* (ca. 1500; Fig. **4.16**), Bosch dramatizes in paint a scene close in content to the *Ars moriendi* illustrations, discussed above. A dying man within a private, vaulted room (reminiscent of the timbered great hall in Beaune hospital) beholds the skeletal figure of Death at his door, holding an arrow that signals his demise. Meanwhile, his soul becomes a subject for contention between an angel at his shoulder and a demon, offering a final temptation in the form of a bag of gold, at his outstretched hand. In the absence of a priest and with the abundance of other demons within the picture, the prognosis for salvation appears slight for this miser. He ignores the angel's guidance toward a crucifix, accompanied by a beam of (divine) light, at the window; at the door is Death. A second old figure (possibly an allusion to the recent activity of the dying man) appears in the foreground. Despite his clasped rosary beads, he is actively involved with worldly treasures, such as coins, sealed documents, and even the armorial trappings of nobility, all surrounded by demons. A possible companion panel of this deathbed scene also shows the triumph of temptation over pious virtue. Composed of the combined panels now called the *Ship of Fools* (Paris, Louvre) and the *Allegory of Intemperance* (New Haven, Yale Art Gallery), these vices complement avarice with the vices of gluttony and lust. Altogether, Bosch indicts the materialistic indulgences of urban merchants, such as Arnolfini and the locals of Bruges and Ghent (as well as the hypocritical monastics in urban preaching orders, featured in the Paris fragment). In contrast to van Eyck and more pessimistically than van der Weyden, he foresees the triumph of sin and damnation as inevitable consequences of a world already too full of demonic temptations.

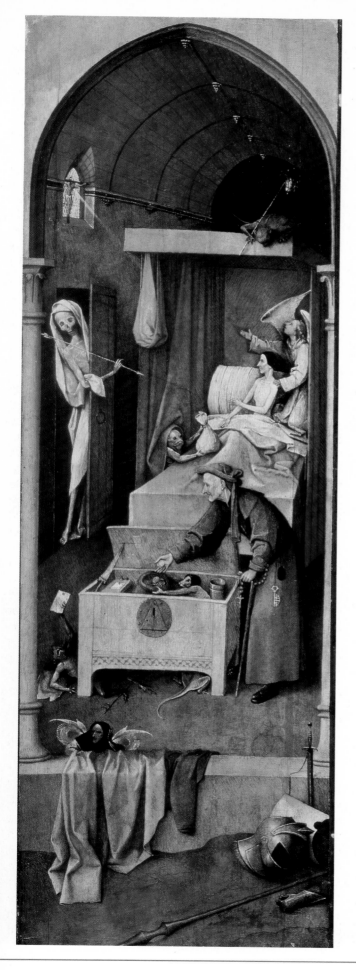

Bosch returned later to the same moral criticism of materialism, using the traditional Flemish format of a three-part altarpiece, or *triptych*, with interior and exterior views, akin to the two-part presentation of van der Weyden's Beaune *retable*. His *Haywain Triptych* (ca. 1500; Fig. **4.17**) takes as its subject not a vision of the Madonna and Child or a New Testament episode, like most altarpieces or earlier Flemish images, but rather a vernacular, Flemish proverb: "All the world is a haystack, and each man plucks from it whatever he can." Hay here symbolizes worldly goods of all kinds, and a giant haywagon moving across a vast panoramic landscape thus offers a global indictment of mankind's greed and luxury. Rather than oxen or horses to draw this giant cart, demonic mutations of insects, fish, bats, and dead trees lead the procession, which is followed by representatives of all worldly estates. In the lower right corner a seated, fat monk orders a cluster of nuns to fetch him hay, while a fool in jester's costume distracts one of them as he performs on a bagpipe. Nearby a country quack probes the mouth of a gullible patient, just as a fortune teller fleeces a well-dressed city woman. In front of the fortune teller, another gypsy woman wipes the bottom of a child in ironic comment on the entire scene; the overall blindness of mankind is summarized in the lower left by a blind pilgrim led by a child.

Grasping for the hay on the wagon and fighting among themselves, both lay and monastic figures (even exotics in turbans) struggle for gain. The higher estates, led by a pope and an emperor and including princes, like the dukes of Burgundy, ride behind the haywagon on horseback with ceremonial dignity. Luxury dominates the top of the wagon, where a courtly couple sit in a love bower and make music; they fail to notice that their lute and voices are accompanied by the nose-flute of a blue demon. Another couple embraces in the bushes under the ominous gaze of an owl, nocturnal bird of evil. Only a praying angel atop the wagon looks upward to behold the compassionate image of the suffering Christ in the clouds, surrounded by a halo and golden light. Here, then, unlike van der Weyden's St. Luke or van Eyck's Chancellor Rolin, no one notices the appearance of the human Christ.

Instead, greed impels the human parade from the center panel into the right wing of the triptych, where hell swallows up the naked humans' souls as demons busily build a new tower. This inexorable fate results from original sin, pictured in the left wing of the *Haywain Triptych*. There, the expulsion of Satan and the rebel angels (again in the form of insects and reptiles), prior to the creation of the world and of Adam and Eve, predetermines the Fall of Mankind and the foreground expulsion from Eden. The exterior of the *Haywain Triptych* shows another solitary individual, a poor, ragged, and aged pilgrim, metaphoric representative of Everyman in the midst of life. This vagabond, like the Prodigal Son, finds himself beset by worldly evils: brigands robbing a fellow traveler, lazy

4.16 Hieronymus Bosch, *Death and the Usurer*, ca. 1500. Oil on panel, 36⅝ × 12⅛ ins (93 × 31 cm). National Gallery, Washington.

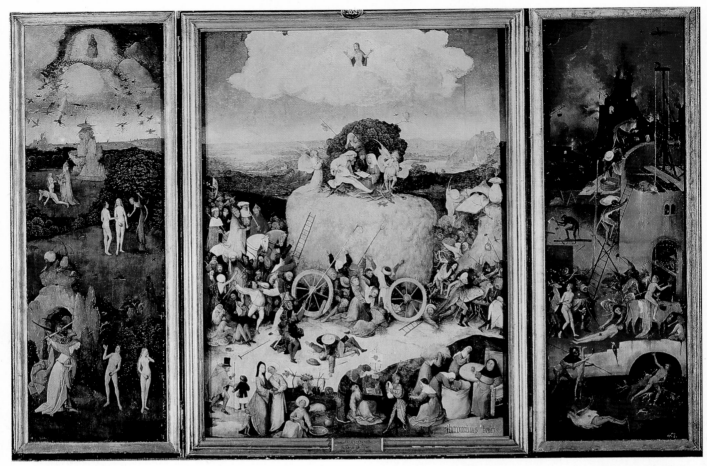

4.17 Hieronymus Bosch, *Haywain Triptych*, ca. 1490–1500. Interior, *Eden, Allegory of Worldly Gain, Hell*. Oil on panel. Central panel 53 × 39¼ ins (135 × 100 cm); the wings 53 × 17¾ ins (135 × 45 cm). Prado, Madrid.

4.18 Hieronymus Bosch, *The Garden of Earthly Delights*, ca. 1510. Interior, *Marriage of Adam and Eve, World before Noah, Hell*. Oil on panel, 86 × 148 ins (218.5 × 378 cm). Prado, Madrid.

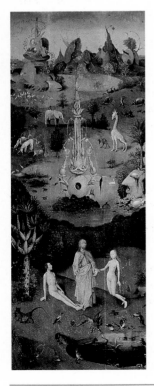
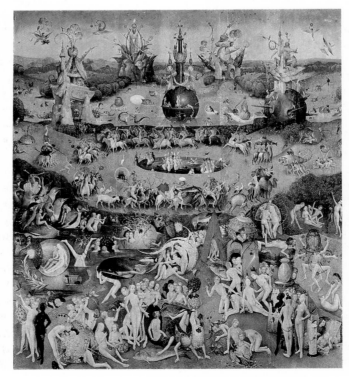

4.19 Mathis Neithart (Grünewald), *Isenheim Altarpiece*, **1515. Oil on panel, 96 × 121 ins (240 × 300 cm) closed. Central panel,** *Crucifixion.* **Unterlinden Museum, Colmar.**

peasants dancing to the bagpipe music of a careless shepherd, distant gallows and foreground menaces in the form of a narrow bridge and a snarling dog. Death and fleshly frailty remain the lot of mankind in this vision of a world filled with evil.

Bosch's pessimism concerning humankind's sinfulness and inevitable punishment also led him to picture the temptations of saints, especially St. Anthony, and the punishments of the Last Judgment as favorite subjects. Despite this dark vision of religion as divine punishment, wealthy patrons, including the Duke of Burgundy, Philip the Fair, commissioned major works from Bosch during his lifetime, and his art continued to spawn imitations long after his death. Even for the wealthy and powerful, heaven seemed far more distant and inaccessible than hell. For that reason they sponsored Bosch's pessimistic work, even as they had sponsored earlier pious donations and painted prayers to spiritual intercessors, both the Madonna and Child and individual patron saints.

Most famous of Bosch's works is the triptych called *The Garden of Earthly Delights* (ca. 1510; Fig. **4.18**). Contemporary accounts place it in the Brussels town house of a prosperous Dutch nobleman, and recent theories suggest that it might have been commissioned as a cautionary message on the occasion of a marriage. If so, this triptych provides a polar opposite to the Arnolfini commemoration by van Eyck, for its layout moves from the introduction of Adam and Eve by God in the Garden of Eden to the punishment of sinful worldliness in the dark flames of hell. In between an earthly paradise, reminiscent of the expanse in the Ghent Altarpiece, is perverted by explicit sexuality from cavorting nudes amidst giant

birds and fruit, the very emblems of fertility. Interpreters read this setting as the world before Noah and the great flood, filled with the decadence that would soon be divinely punished. Once more, Bosch seems to have adopted the precedents of his great Netherlandish predecessors, including the triptych format of the Ghent Altarpiece, only to invert it, substituting sin for salvation, hell for heaven. This dark warning by a religious pessimist alerts even wealthy individual patrons that the implacable Last Judgment awaits all of humankind, regardless of power, prosperity, or rank.

MATHIS NEITHART (known as Grünewald and active 1503–28) produced perhaps the grimmest yet grandest of northern altarpieces in 1515 in the Rhineland for a hospital context similar to that of Beaune. This massive altarpiece (Fig. **4.19**) consisted of three views: exterior, middle, and interior wings around a sculpted centerpiece by the Strasbourg carver, Nicholas Hagenau. Neithart's patron was the hospital of the Antonite order at Isenheim, between Basel and Colmar. Like Rogier's *Last Judgment* at Beaune, this altarpiece served as a solace for the sick, especially those afflicted with the skin disease known as St. Anthony's fire. On the closed exterior of the altarpiece, Neithart's vision of the divine manifests itself before the pious beholder like a statue

come to life. On flanking wings, imitation statues, already colored and in movement within their spaces, show the healing patron saints, Anthony and Sebastian (both already present in the hospital altarpiece by Rogier at Beaune), now animated by the power of prayerful meditation. Sebastian is about to receive a crown of sainthood from hovering angels outside his window, while Anthony is about to be beset by yet another demon, who breaks into his space through the window above him. Together they reenact the alternative outcomes of the Last Judgment and the results of the earthly trials of the hospital patients. These two intercessors go far beyond the physical presence of the unpainted statues offered as cult objects before Nicholas Rolin in van der Weyden's altarpiece exterior.

Yet even they pale before the awesome majesty and unparalleled suffering of the Neithart *Crucifixion* (p.143), the subject of daily meditation by suffering patients. Spiritually greater and thus larger than even the holy figures at the foot of the cross, this Christ crucified offers the ultimate extreme of torment and mortal frailty, as He hangs limply, limbs distorted, extremities racked with pain. Palpable pigment of the richest of

4.20 Mathis Neithart, *Isenheim Altarpiece*, 1515. Interior, *Annunciation*, *Virgin with Angels*, *Madonna and Child*, *Resurrection*. Each wing 98½ × 56 ins (250.2 × 142.2 cm).

reds makes His bleeding wounds a physical reality before the contemplative viewer. Murky darkness surrounding the holy figures reinforces the green, decaying flesh of the dead Christ and creates the overall mood of gloom. No physical symptoms of patients could equal such tortures as those inflicted on Christ Himself; no patient could help but find inspiration in the contrast between this agonized crucifix amid grieving mourners and the glowing promise of the resurrection on the Sunday interior. With all the force of mystic revelation, Neithart's painting offers up a direct and personal vision of the divine that is as powerful, if assertively unnatural or supernatural, as its more illusionistic contemporary Flemish counterparts. If even Christ (and in imitation of Christ, St. Anthony, the patron saint of the hospital) could give way to despair in His

lso fill the landscape, from the humble rosary prayer-beads of the Christ Child to the heavenly stream of angels from a radiant God in heaven above (recalling the celestial apparition in the Eden wing of Bosch's *Haywain Triptych*). One of these luminous angels in the background makes a connection with humble humanity by announcing the glad tidings to the shepherds.

This overall scene of the infusion of the divine in the earthly is completed and reversed in the final image of the middle opening, where Christ's Resurrection liberates his earthly body into an elevated realm of pure spirit. Here golden light as the symbol of the divine reaches a radiant climax, while the glowing body of the Redeemer hovers in miraculous defiance of gravity. This is the same conquest over suffering and death hoped for by each of the hospital patients, where spirit will overcome and slough off the earthly body with all its trials.

In Neithart's paintings, in contrast to those of van Eyck, rich saturated pigment and luminous color dominate illusionistic aspirations by means of his oil technique. Here the literal presence of glowing color assumes the role previously held, in Duccio's *Maesta* (Fig. 4.31) or the Limbourg Brothers' miniatures (as well as in earlier German painting), by the rich substances of gold and ultramarine blue as palpable signals of the divine. In his powerful figures, Neithart strives for the literal manifestation and physical presence of holy figures as a vision before the pious beholder – a vision all the more important within the healing context of a hospital altarpiece.

ART AND THE REFORMATION: NUREMBERG AND DÜRER

German sculpture in church interiors was usually painted and gilded in order to achieve the same effects of physical yet mystical presence before the devout beholder that Neithart produced. One particularly vivid example, double life-size (over 12 feet/3.6 meters tall), can still be studied at its original site in the church of St. Lorenz, Nuremberg (Fig. 4.21). Carved in lindenwood around the same time as the Isenheim Altarpiece, the *Annunciation of the Rosary* (1517–18) by Veit Stoss (ca. 1450–1533) still hangs like a floating vision above the nave of the church. Once more the donor was a wealthy local patrician financier, Anton Tucher II. Here the sculpted figures appear as vivid in their bright colors as the earthly Madonna of Neithart; their deeply cut, swirling folds, held by a train of miniature angelic attendants, provide an extra note of vitality, akin to the flowing drapery in van der Weyden's painted compositions. While the figures capture in their gestures the drama of the Annunciation scene – Gabriel in his upward glance and outward pointing, Mary in her complementary downcast gaze and inward modesty – the framework of the

4.21 Veit Stoss, *Annunciation of the Rosary*, 1517–18. Painted wood, 86 ins (218 cm) high. Nuremberg, St. Lorenz.

rosary garland points to the significance of this event within an overall scheme of personalized pious meditation and prayer. The cult of the rosary was still a spiritual novelty, established only in the late fifteenth century as part of the overall emphasis on the Virgin, found also in the Books of Hours and in the devotional images seen above (note the rosary beads in the hands of Bosch's miser or Neithart's Christ Child). Stoss's sculpted Annunciation thus is framed within a rose garland that also features other significant events from the life of the Virgin, drawn from the rosary meditation on her Joys (to be followed in the full cycle of rosary prayers by meditation on her Sorrows and Glories). At the top of the garland sits the figure of God the Father, from whom (again like the immanent celestial visions of Bosch or Neithart) gilded light radiates in the form of beams. Behind the ensemble, the light of stained-glass windows illumines the whole in a mysterious glow.

The church interior that houses Stoss's sculpture, the St. Lorenz church of Nuremberg, can stand for the current inventive variation on canonical Gothic that developed in Germanic lands (Fig. **4.22**). Like the spacious preaching churches in Italian cities, such as Santa Croce in Florence, German urban churches stressed open, almost unbroken interiors, where side aisles and naves had common ceilings in an open space known as the *hall church*. The sober exteriors of these hall churches usually have plain, unbroken outer walls. In contrast to such solidity, the chief decorative system within German hall churches was usually an intricate network of ribs

4.22 Nuremberg, St. Lorenz, choir, begun 1439.

in the vaults, stressing otherworldly mystery more than structural clarity. The starlike net vault of the St. Lorenz church apse (begun 1439 by Konrad Heinzelmann, completed by Konrad Roriczer) grows out of a simple polygonal ring of chapels, each corresponding to a support system of massive, unbroken piers. The walls of the apse dissolve in two full levels of stained glass, articulated with minimal tracery. This wide, spacious, and airy environment encourages diagonal views across the apse as well as the spatial movement implied by the hanging placement of Stoss's *Annunciation*. In addition to its enveloping ornament of glass, the open space of the St. Lorenz apse draws attention to a massive stone monument of sculpture and architecture located to the left of the altar area and reaching upward (64 feet/19.5 meters) into the vaults beside Stoss's rosary: the *tabernacle* or *ciborium* for the eucharist (1493–96) by Adam Kraft, Nuremberg's leading stone carver. Supported on the backs of figures of his assistants plus a carved self-portrait of Kraft, this tabernacle includes scenes of the Passion within its lacy tracery, made of the same sandstone as the church itself. Once more, like the glass and the Stoss sculpture, this donation stems from a prominent Nuremberg patrician, Hans Imhoff, and is a testimonial to the extensive support of local pious institutions by leading citizens in Northern cities.

Nuremberg's citizens, however, did not continue to sponsor such religious donations or church constructions. In the very year that Tucher commissioned his rosary carving from Stoss, 1517, Martin Luther posted his first, famous objections to ecclesiastical practices, on the door of a church in Wittenberg in Northern Germany. By the year 1525, these same Nuremberg patricians had declared religious independence from their local bishop and officially adopted the new, Lutheran creed as the city's religion. Stoss's final altarpiece for the Carmelite church in the city remained unfinished and ended up in Bamberg cathedral. His *Annunciation* in St. Lorenz was covered over as a relic of the Catholic Worship of Mary, though it was spared the destruction levied on lesser religious artworks in Germany, because the Tucher family still commanded local respect. Not only in Nuremberg but throughout Germanic lands, the Protestant Reformation marked a watershed; Neithart died with Lutheran tracts in his possession, and he took part in abortive peasant rebellions in 1525.

ALBRECHT DÜRER The turn of the century already contained its own warning signs, produced by a young painter and printmaker, Albrecht Dürer (1471–1528). His great illustrated book, the *Apocalypse*, appeared in Nuremberg in 1498, brought out in both Latin and German with the aid of his godfather, the important local printer, Anton Koberger. As if to warn of the coming millennium with the turn of the year 1500, its most celebrated woodcut, the *Four Horsemen of the Apocalypse*, brings vividly to life the text's visionary destruction of the world by the four symbols of War, Pestilence, Famine, and – skeletal on a pale horse – Death (Fig. 4.24, p. 150). Much of the effect of the woodcut emerges from Dürer's powerful command of line – whether the jagged

lines of thunderbolts in the upper left corner, the energetic contour lines of clouds that rise like dust before the dark, distant ground, or the fastidiously descriptive lines of all the individual figures, beasts, and costumes according to the narrative. Death hovers nearest to the earth, next to the medieval image of the mouth of hell. The victims under all these hoofs include not only the world's poor peasants but also a major Church prelate, whose mitered head still cannot save him from perdition. These images powerfully embody what the text suggests: the end of the world and the final conflict between good and evil. They also demonstrate Dürer's profound religiosity, which would inform both his prints and his paintings for the next three decades. But for him the world was just beginning, and his famous monogram, which made its first appearance in the *Apocalypse*, would soon be known all over Europe and would even be forged by unauthorized copyists in Venice (one reason he visited it in 1505).

In 1494 Dürer had visited Venice for the first time. He was already familiar with some Renaissance achievements through Italian engravings that had come his way, and curiosity to study at the source was surely his chief motivation. His travels through the Alps were marked with landscape watercolor studies, and his contact in the port city with exotic animals, such as a lions or a crab (Rotterdam, Museum Boymans-van Beuningen), as well as exotic peoples, especially Turks, also found expression in such study sheets. While in Venice Dürer began another of his lifelong engagements: the study of the nude body both in its sculptural fullness and in accord with rules of proportion. He sought to learn the "secrets" of proportion and the geometrical construction of the human figure from a Venetian artist named Jacopo de' Barbari but failed to obtain Jacopo's "little book" with the theoretical principles.

After a decade of careful study from life and precise measurement with rule and compass, Dürer was ready to publish another defiant challenge to the Renaissance, this time in the form of a quintessential study of the male and female nude. His 1504 engraving, *Adam and Eve* (Fig. **4.23**), is the result of numerous careful studies, based upon both classical models (the famous *Apollo Belvedere* and *Medici Venus*, known through Italian intermediaries) and on geometric measurements, essentially derived from the ancient Roman treatise of Vitruvius. On this print, Dürer's signature goes beyond his renowned monogram to convey his Nuremberg origins ("Noricus") on a tablet above the figure of Adam. The statuesque figures represent a figural ideal, poised in relaxed stasis. Yet it is significant that Dürer, the religious artist, chose not classical figures for his ideal nudes but rather the perfected bodies of the "first parents." He deliberately chooses the moment before the Fall, just as Eve receives the fatal apple from the serpent, in order to present a perfect world, where a cat lies quietly beside a mouse and all of God's creatures are in harmony. Each of the animals in this print had also been studied from life by the artist in his watercolors, such as the famous image of the *Hare* (1502), a feat of "scientific" study just as important as Dürer's ongoing investigations of figural

4.23 Albrecht Dürer, *Adam and Eve*, 1504. Engraving, 9⅞ × 7⅝ ins (25 × 19.3 cm).

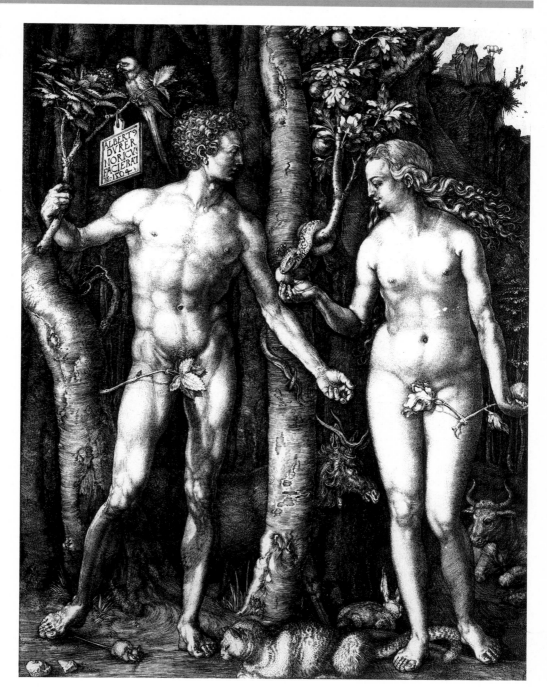

proportion. In similar fashion, the artist has placed his figures not in some imagined Eden but rather in front of a dark, even ominous, forest. This space not only derives from local settings but also alludes in its gloom to the impending Fall, and its nocturnal wilderness character suggests the places held by current superstition to be the site of modern demonism, witchcraft (a seamy subject rendered in prints by both Dürer and his followers).

A decade later Dürer returned to the theme of temptation and trial in the wilderness in another of his greatest engravings: *Knight, Death, and the Devil* (1513) (Fig. **4.25**, p.151). As usual, the image derives from a host of figural studies in both ink and watercolor. Here his subject is fully Northern,

except that the proportions of the knight and especially his horse (in part based upon studies by Leonardo) have been carefully constructed according to the canon he developed in this same period for a treatise on the human body. Once more the subject is a dark and sinister environment, a "valley of the shadow of death," where a steadfast Christian knight moves foward, despite having another figure of Death on a pale horse beside his own, perfect mount. Behind him strides a piglike devil, akin to the monsters who afflict saints in the wilderness, such as St. Anthony on Neithart's contemporary Isenheim Altarpiece. In the Germany of Emperor Maximilian I, who was also Dürer's patron at the time, piety and chivalry were guiding values, so this master engraving of a knight in armor serves as

Early Printmaking

Dürer was not the first artist to make his reputation across Europe through the medium of prints, but he greatly expanded the techniques as well as the range of subjects of both woodcuts and engravings. Both of these new pictorial forms developed as a direct result of new, readily available supplies of their support: rag-based paper, first imported as a technology into Europe in the late fourteenth century.

Woodcuts seem to have begun shortly after the adoption of the technology of paper production, probably emerging from block stencils used in the repeated printing of patterns on fabrics. The earliest dated woodcut is an image of St. Christopher with a prayer to the saint (1423), and simple images of popular saints or other cults of popular religious devotion dominated woodcut production during the fifteenth century. Woodcut is a relief-printing process, that is, it cuts away large surfaces of the printing block and inks the remaining ridges in order to make a print. Because this is the same principle used in the printing of movable type, the same presses used for making early printed books could also be used in the creation of woodcut illustrations for those same books, and illustrations of both sacred and secular texts formed the other main output of early woodcuts. Moreover, printing in the relief process requires relatively little pressure of the block ridges upon the paper surface, so woodcuts are capable of producing enormous numbers of repeatable images from a single block and

4.24 Albrecht Dürer, *Four Horsemen of the Apocalypse*, 1498. Woodcut, 15½ × 11 ins (39.4 × 28 cm).

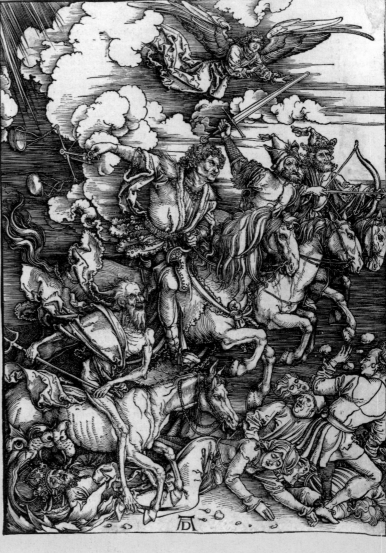

woodcuts were relatively inexpensive. Since wood itself is not easy to carve with intricate patterns, many early woodcuts produced a schematic outline figuration, a "cookie-cutter" effect of angular contours of figures and simple settings. Because of this simplification, and in order to make woodcut images more naturalistic, many of them were colored; in Germany, for example, a trade of professional colorists of early woodcut prints, the *Briefmaler*, sprang up to provide this service.

Dürer's lasting contribution to the woodcut medium was to expand the ambitions of block carving to encompass a rich repertoire of linear elements, including intricate curves and curls as well as a range of descriptive lines to convey either more powerful expressive effects or greater naturalism. In the *Four Horsemen of the Apocalypse*, (Fig. **4.24**), such refinements are especially evident in the successive rhythms of the horses, their manes, and their tails, where the convincing physicality of the animals is complemented by the whipping curves of their motions, in echo of the clouds above.

In contrast with woodcut, engraving is an *intaglio* process, that is, it prints only from within the carved-out grooves upon a surface that has been wiped clean of ink. Most often engravings are produced from a metal plate, such as copper. Engravings arose out of the training and expertise of metalworkers, such as goldsmiths (the profession of Dürer's father). Early engravings often display the professional pride and individual identity of the metalworker by presenting his initials (Dürer's AD monogram was internationally famous). Early engravings often have intricate patterns of ornament, such as scroll foliage or inventive figurated alphabets or studies of animals, and this kind of preservation of well-formulated inventions by metalworkers may have stimulated some of the earliest engravings. The manual dexterity required to push an engraving tool through a copper plate as well as the association with precious metals and the guild structures of metalworking professions gave this print medium a greater prestige and costliness. Moreover, the high-status clientele for such craftsmen provided an outlook receptive to the production of more elite and secular subjects, including many themes, such as the Garden of Love or hunt scenes found in the luxury decorated arts of carved ivories or tapestries.

Because engraving permitted much finer lines, its images could be fully descriptive of surfaces and substances, as exemplified by Dürer's virtuoso renderings of figures and forest in his 1504 *Adam and Eve* (Fig. 4.23). The limitation of engravings is that they must be printed under much greater pressure than woodcuts, in order to force the dampened paper into their inked grooves. As a result, engraving plates wear out much faster than woodblocks and lose some of their finer lines of detail.

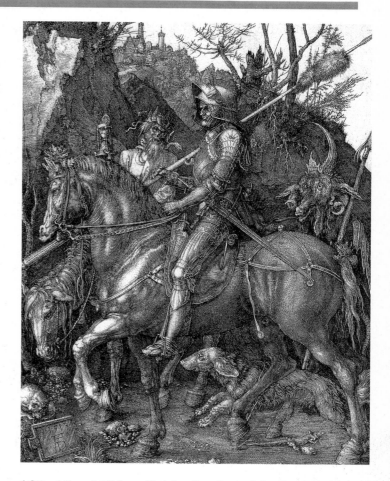

4.25 Albrecht Dürer, *Knight, Death, and the Devil*, 1513. Engraving, 9⅝ × 7½ ins (24.4 × 19 cm).

the very embodiment of courage and virtue. Dürer remains fundamentally a figural artist, whose vivid descriptive powers also extend to natural settings and to animals, but his vision always remains dedicated to the transmission of spiritual values.

Dürer's diary of a trip that he took to the Low Countries in 1520–21 records his deep interest in the recent publications of Martin Luther, some of which he obtained in the metropolis of Antwerp. Dürer's words record his own conversion to the Lutheran creed as well as his desire to make an engraved portrait of Luther, "for a lasting remembrance of a Christian man who helped me out of great distress." He did produce similar portraits of other leaders of the Reformation, including the biblical scholar Erasmus of Rotterdam, based on a portrait drawing made in the Netherlands (Fig. **4.26**, p.152) and Luther's chief learned theologian, Philip Melanchthon (1526). Each of these prints bears an inscription that expresses the primacy of the word in Protestant thought and the new domination of the spirit over the letter, making a portrait image explicitly not the source of a cult or a temptation toward idolatry for a modern spiritual leader. On *Erasmus*, words on the large plaque beside the scholar read (in Greek): "The better image will his writings show."

Ultimately, the artist was able to leave a Lutheran legacy and a personal memorial for his hometown, shortly after Nuremberg itself officially converted to Lutheranism in 1525. That gift took the form of two large panels depicting massive holy figures (1526), usually called the *Four Apostles* (Fig. **4.27**). At Dürer's request, a local calligrapher, Johann Neudörffer, inscribed quotations from each of the depicted saints below the panels. Those quotations in turn derived from Luther's own 1522 translation of the Bible into the German vernacular. The intended message for the city councillors warns them by means of scripture to observe nothing but the word of scripture rather than the false prophets in an era of often extreme sectarianism: "All worldly rulers in these dangerous times should give good heed that they receive not human misguidance for the Word of God, for God will have nothing added to His word nor taken away from it. Hear therefore these four excellent men, Peter, John, Paul, and Mark, their warning." Like the portraits of Erasmus and Melanchthon, each of the faces of these holy men has been individualized (indeed, Melanchthon's features have been taken to be the model of St. John, the youngest of the *Four Apostles*), and the power of these panels results from the stately majesty of the four massive men. Like the textual message of his inscriptions, Dürer's visual message adheres closely to a current, Lutheran viewpoint, one that sees

4.26 Albrecht Dürer, *Erasmus*, 1526. Engraving.

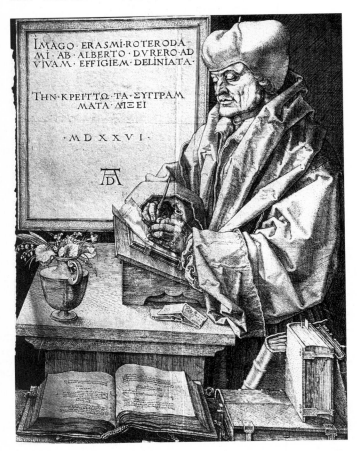

4.27 Albrecht Dürer, *Four Apostles*, 1526. Oil on panel, each 85 × 30 ins (216 × 76.2 cm). Alte Pinakothek, Munich.

nonidolatrous images, such as these images of saintly authors, as unthreatening, even edifying – as opposed to the iconoclastic hostility toward images of radical reformers. Dürer in fact defended religious images according to Lutheran doctrine within his 1525 published treatise on the art of measurement. Thus the artist positioned himself within the Reformation movement but as a defender of appropriate images at a time when all religious images were under attack, while he also allied himself with the civic decision within Nuremberg to follow the Lutheran creed. His enormous, scripture-wielding saints are still modeled on Venetian precedents, specifically four Giovanni Bellini saints in the wings of his 1488 Frari Altarpiece. Using the human figure and Renaissance models to convey heartfelt spirituality, they serve, then, as a fitting memorial of Dürer back in his hometown.

HOLBEIN AND THE ENGLISH COURT

Holbein assimilated both the tradition of painting ideal figures and the classical architecture of Italy in the religious art painted before his departure. His masterwork in this vein is the *Madonna of Jacob Meyer* (1526), painted for the wealthy former burgomaster of Basel, then an embattled Catholic within a dominant Protestant majority (Fig. **4.28**). Like the analogous devotional portrait of a century earlier, van Eyck's *Rolin Madonna*, Holbein has retained all of the illusionistic exactitude of recording his sitters and the details of their setting. These are sitters presented at full size, distinguished chiefly by their prayerful, kneeling gestures (because of the personal memorial function of the painting, both of Meyer's brides and all of his children, including those who predeceased him, are presented together to the holy figures). In some respects the flanking donors on either side of a central Madonna and Child recall the sculpted ensemble by Claus Sluter for the Duke of Burgundy at Dijon (a work Holbein

4.28 Hans Holbein, *Madonna of Jacob Meyer*, 1526. Oil on panel, 56¾ × 39¾ ins (144 × 101 cm). Schlossmuseum, Darmstadt.

Dürer was an older man when the Reformation began to disturb the lives of artists in Germany. For younger artists, however, the potential loss of all ecclesiastical patronage came as a crushing blow, interrupting the synthesis of Northern and Southern traditions that was just beginning to bear fruit through Dürer's images and treatises (his *Four Books of Human Proportion* was published posthumously in 1528). The Swiss city of Basel, a leading center of book publishing as well as of Renaissance-style painting, led by Hans Holbein the Younger (1497/98–1543), can serve as an example. In Basel radical Protestant theology led to the general abolition of religious images, prompting the local painters' guild to petition the city council for redress: "Finally, they [the painters] ask [the council] to consider graciously that they, too, have wives and children, and to see to it that they can stay in Basel, because even so the painters' profession is in a bad way. Several painters have already abandoned their jobs ..." One who soon abandoned Basel for the role of court painter in the England of Henry VIII was Hans Holbein.

surely knew from his trip to France in 1523). But in contrast to van Eyck or Sluter, Holbein reasserts the divinity of his holy figures through his use of the imported artistic idiom of the Renaissance. However human this beautiful and palpable Madonna and Child may be, their Raphaelesque beauty is displayed within a rounded classical shell niche and projecting consoles that clearly remove them from ordinary spaces (just as surely as Sluter uses the convention of the central trumeau of Gothic portals to isolate his holy figures). Within this Renaissance idiom, the sheltering mantle of the Virgin still conforms to a popular late medieval theme, the Madonna of Mercy, who offers protection, often against the plague, to the pious (here perhaps to the Catholic minority in Basel). Ultimately, as with Dürer's *Four Apostles*, a traditional votive image of memorial has been transformed through admixture of Renaissance models into a powerful religious image, one of the last in the German-speaking world, but an image that depends ultimately on Holbein's gift for portraiture, even for the imagined features of the holy figures.

Holbein received introductions to the English court by way of Sir Thomas More, whose portrait he painted upon arriving in London in 1527 (New York, Frick Collection). More, however, refused to compromise his Catholic faith for the

4.29 Hans Holbein, *Georg Gisze*, 1532. Oil on panel, 38 × 34 ins (96 × 86 cm). Staatliche Museen, Berlin.

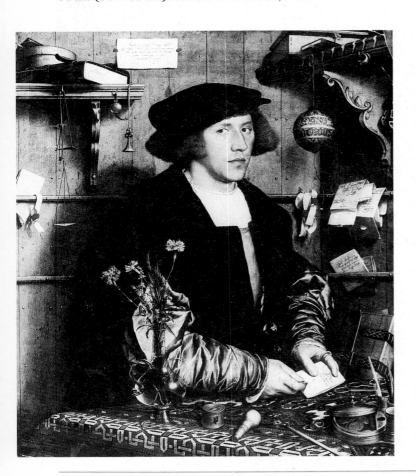

Anglican reformation of Henry VIII, so he fell out of favor and was forced to resign his post as Lord Chancellor in 1532. Thus Holbein found himself once more in a precarious situation analogous to Reformation Basel. He reestablished his credentials through a series of portraits of the German merchant community (the "Steelyard") in London, such as a 1532 portrait of *Georg Gisze* (Fig. 4.29), which could serve as a prototype for the whole successful international merchant class that energized Europe's economies in cities from Bruges to Amsterdam. Within the office and work table of the merchant he shows his industrious motto (in Latin), "No pleasure without regrets." His world contains work objects – writing implements, seals, papers, and scales for measurement – as well as a carefully chosen floral still life with symbolic associations. One flower is Good King Henry, a veiled reference to the current English sovereign; another is the carnation, a symbol of betrothal and fidelity, along with rosemary, for remembrance – appropriate sentiments in a memorial picture to be sent back to a waiting family in the homeland. This still life within a portrait has become emblematic and personalized instead of the universalized, spiritual world of van Eyck's *Arnolfini Wedding Portrait*. Gisze's portrait thus projects his individual identity, even down to his personal signature on the back wall. Thus the likeness resembles the letters contained within it, including the sitter's signature. Holbein's personalized memorial links a single active individual to his larger community, like Dürer's portrait prints.

From such portrait successes Holbein went on to produce portraits for the court of Henry VIII during the remainder of his life (1533–43). An early ambitious court work, *The Ambassadors* (1533; Fig. 4.30), portrays two French envoys, one a titled landholder and the other a bishop, as if to exemplify the active and the contemplative life. If Gisze exemplifies the international merchant, then the splendidly garbed Jean de Dinteville at left, wearing the French royal order of St. Michael, represents the perfect Renaissance courtier. He stands before a table crammed with the paraphernalia of learning and the arts: a lute and open hymnbook, a book of merchants' arithmetic, astronomical instruments, plus globes of both earth and stars. The picture displays the hymnal page with Luther's translation of "Veni Creator Spiritus," and the lute has a broken string, an emblem of discord. Thus the picture, painted at a delicate early moment of religious tension in France, alludes (like Dürer's *Four Apostles*) to issues of spiritual dissension resulting from the diffusion of Protestant ideas. Yet here Luther is represented by just one item among the variety of compendia of learning. For these accomplished and worldly men, the possibility remains that such spiritual decisions can be considered matters of individual temperament and choice, or else that spiritual reconciliation of the religious schism seems attainable by such enlightened gentlemen, one a prince of the Catholic Church.

One final contradiction, however, reverses all of the worldliness of the portraits and the still-life objects in Holbein's *Ambassadors*. The large, angular white object on the floor between the two men is in reality a distorted, oversized skull,

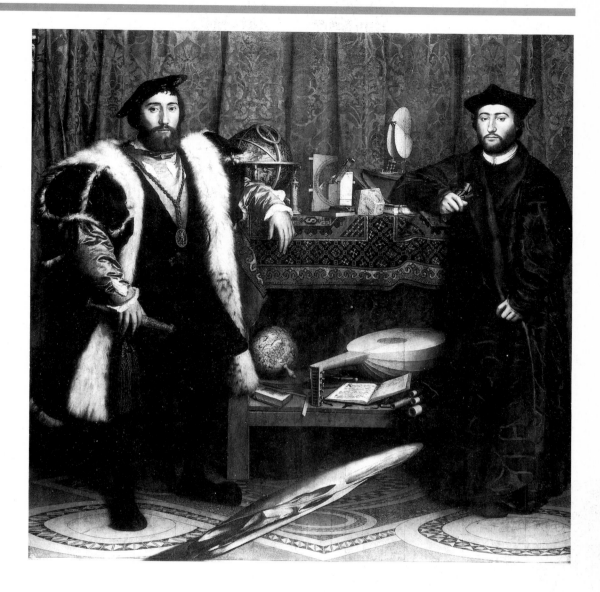

4.30 Hans Holbein, *The Ambassadors*, 1533. Oil on panel, 81⅛ × 82¼ ins (206 × 209 cm). National Gallery, London.

visible only at an extreme angle from the right side of the picture, from which point the remaining glories of the painting are invisible. Thus, the traditional medieval warning of death's ever-present threat cannot be reconciled with the worldly accomplishments and achievement of these illustrious sitters. At a moment when the court – and its meticulous portrait art – has absorbed religion into local, secular concerns, only a position of abasement and marginality permits certain viewers to remember the late medieval warnings of the *Art of Dying* (visualized so vividly by Bosch in his *Death of the Usurer* to attack just such worldly titles and power). Paradoxically, Holbein's great achievement contains its own commentary on the transience of Renaissance ambitions and accomplishments

by pointing out the inadequacy of just such portrait achievement before the lingering face of death itself.

Holbein's double portrait simultaneously celebrates and criticizes Renaissance ambitions for fame and accomplishment. In distant England, the absence of a classical tradition never led to a revival of antiquity as a sign of the new era; however, the precedent of Flemish paintings made for the opulent court of Burgundy, later emulated at the royal court in France, did prompt a new English delight in the oil portraits of Holbein. Under Henry VIII, this taste for the celebration of personal courtliness through aristocratic portraits would have a long life. Later Flemish masters, led by Rubens and van Dyck, would find their most appreciative clients at the English court. Perhaps more important, it was the secular authority of just such emerging nation-states that would assume much of the patronage of art in the following century.

CENTRAL ITALY: SIENA AND FLORENCE

Citizens built the Renaissance. Proud city-states in Central Italy celebrated their newly won independence from dukes and princes by turning to the precedent of the ancient Roman republic. They found inspiration in classical arts and letters for their own assertions of civic virtue, and in the process of effecting this "rebirth" of Roman greatness during the fourteenth century, they also defined the "dark" period in between as the "Middle Ages." In Central Italy, the rival city-states of Florence and Siena competed for political dominance as fully as their wool merchants and bankers competed for capitalist control. As a result, both Florence and Siena prompted artistic competition in their cities for commissions and for fame. Indeed, competition and personal accomplishment remained a hallmark of Renaissance artistic aspiration.

SIENA

Siena's small ruling oligarchy, the Nine, delighted in the special protection of the Virgin Mary, who was not only the patron saint of the local cathedral but was also credited with ensuring a famous victory over the Florentines in battle (1260). Thereafter Siena called itself the city of the Virgin (*civitas virginis*), and its leading altarpiece in the cathedral, commissioned by the Nine from local Sienese artist Duccio (active 1278–1318), was dedicated to her honor. Called the *Maesta*, or Virgin in Majesty (1308–11), this giant ensemble of scenes on panel was installed in the cathedral in solemn procession with musical accompaniment by the entire commune of the city (Fig. **4.31**).

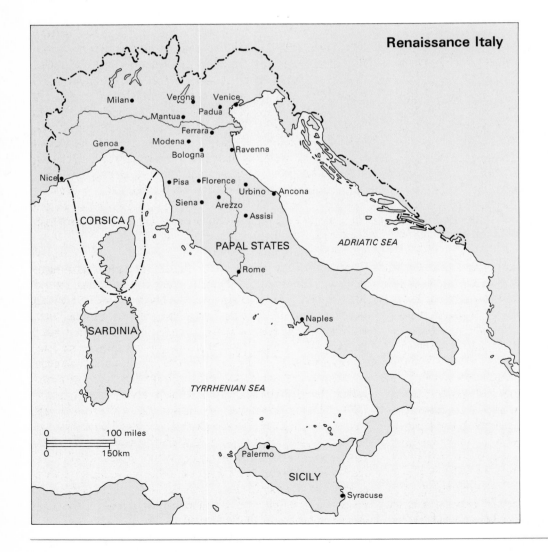

Renaissance Italy

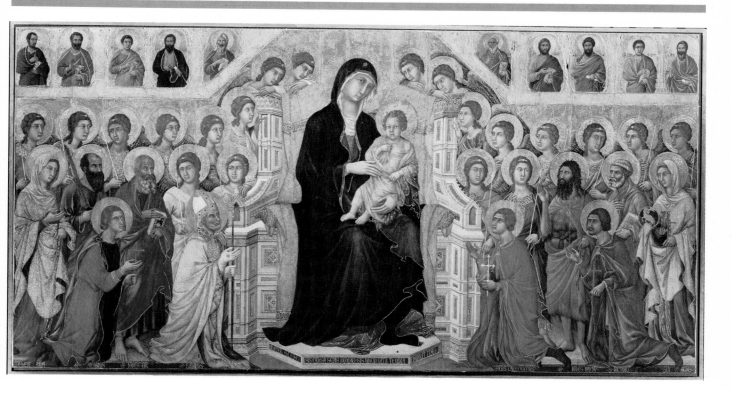

4.31 Duccio, *Maesta Altarpiece*, Duomo, Siena, 1308–11. Central panel, *Virgin as Queen of Heaven*. Tempera on panel, 84 × 162¼ ins (213 × 396 cm). Museo dell'Opera del Duomo, Siena.

The *Maesta* was painted on both sides, the largest altarpiece of its day. Its central image of the Virgin enthroned amid angels and saints also includes important local saints, shown kneeling across the foreground space. Her glory, and that of the religious figures in general, is emphasized by the lavish use of gold for haloes and background. An inscription at the foot of the Virgin's elaborate inlaid throne includes the name of the artist but also reads: "Holy Mother of God, be thou the cause of peace for Siena," echoing the city's bond with its patron saint. Like the cathedral itself, the main cathedral altarpiece by Duccio became a symbol of civic pride and power.

Local vision also informs one of the narrative Gospel scenes from the *Maesta*: the *Temptation of Christ*, where the attractive "kingdoms" proffered from a hilltop by Satan consist of several city-states, each bounded by a wall and marked by towers, like the model city of Siena itself and similar Italian communes.

The Nine carefully supervised the construction of all civic buildings in Siena, including the cathedral (1250–1340). One of Italy's largest churches, this vast space was later planned to serve as only the crossing space of a still-larger cathedral in the grandiose ambitions of the Sienese (again in competition with the cathedral of rival Florence). Those plans were blunted by economic and epidemic catastrophes around mid-century, in particular the Black Death after 1348. But before that moment, the cathedral and its decoration had become a civic project of great priority for the glory of the Sienese commune.

Civic pride, in part the result of Siena's identification with the Madonna as its special patron, also led its artists outside the cathedral to view the world through a distinctly local lens. The significance of the *Maesta* in the life of Siena can be discerned best from a fresco version of it adapted for the wall of the Great Council Chamber of the City Hall, or Palazzo Pubblico, in 1315 by Duccio's disciple, Simone Martini (active 1315–44). There the Madonna is seated on a Gothic throne beneath a canopy along with a similar choir of saints, including local saints, and angels. A lengthy inscription makes the particularly Sienese political meaning of this scene explicit; it begins: "The angelic flowers, the rose and lily/ With which the heavenly fields are decked/ Do not delight me more than righteous counsel."

PALAZZO PUBBLICO Siena has changed little since the building of its main plaza, or piazza, the fan-shaped Campo, and the new city hall, the Palazzo Pubblico or Public Palace (1288–1309; Fig. **4.32**, p. 158), presided over by Martini's *Maesta*. A fortress-like, red-brick edifice with a tall tower, the Palazzo Pubblico dominates Siena's skyline. Some of the decoration for the Chamber of Peace (Sala della Pace) in the heart of the Palazzo Pubblico (1338–40) was painted by another local painter, Ambrogio Lorenzetti (active 1319–48). Ambrogio, whose brother Pietro Lorenzetti was also an accomplished Sienese painter, may have been attractive in part because he had worked in and around rival Florence (where he even held membership in the artists' guild). Like most fourteenth-century painters, he chiefly painted devotional panels and altarpieces for churches, but in the Chamber of Peace he painted a vast panoramic wall fresco, the first important landscape in Western art.

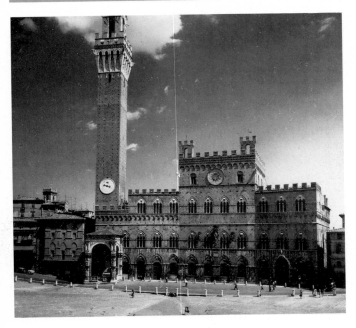

4.32 Siena, Campo with view of Palazzo Pubblico, 1288–1309.

Ambrogio's true subject depicts the *Effects of Good Government* (Fig. **4.33**). Two peaceful spaces, city and country, meet at the gates of a city. Within the protection of city walls, the streets bustle with activity. Numerous merchants offer their wares to passing shoppers at open storefronts. Nearby, a solemn dance by well-dressed maidens attests to the peace and happiness enjoyed by the citizens.

4.33 Ambrogio Lorenzetti, *Effects of Good Government*, Sala della Pace, Palazzo Pubblico, Siena, 1337–40. Fresco (detail).

Their prosperity can be seen not only in the economic activity on the streets but also in the shape of an imposing skyline, including ongoing construction under way. Prosperity also extends beyond the walls of the city to the surrounding countryside, a landscape of fertile farms, whose vines, fields, and herds support the urban population.

This ideal city-state by Ambrogio Lorenzetti is no fantasy. Its distinctive banded and domed cathedral in the upper left corner clearly identifies the commune of the fresco as Siena herself. In addition, the city's south, or Roman gate serves as the wall opening to the countryside. A she-wolf atop that gate pays tribute to the ancient foundations of the city. Of the twins suckled by a wolf, Romulus founded and named the city of Rome; the son of his twin, Remus, was credited with establishing Siena. Above the gate hovers a winged allegorical figure: Security. She holds a gallows to warn malefactors of the power of civic justice, but she also holds a scroll that declares how everyone may walk without fear under the rule of the law. This figure ultimately addresses the rulers of Siena in their own council chamber. Verses beneath the fresco enjoin the council to note the benefits depicted in the fresco, the result of wise government, their responsibility.

What is striking about such an address by the rulers to themselves is its assertiveness and its independence from any external framework. Whereas in medieval cathedrals, merchant guilds or other civic groups sponsored their own windows of stained glass, such artistic offerings honored holy figures, such as patron saints. No independent images of these groups by themselves could arise within the primary religious environment. In contrast, the Lorenzetti fresco adorns a secular building, the town hall of a city-state. Its images of busy and prosperous citizens picture the peaceful commune as an ideal for the proud councillors who govern Siena.

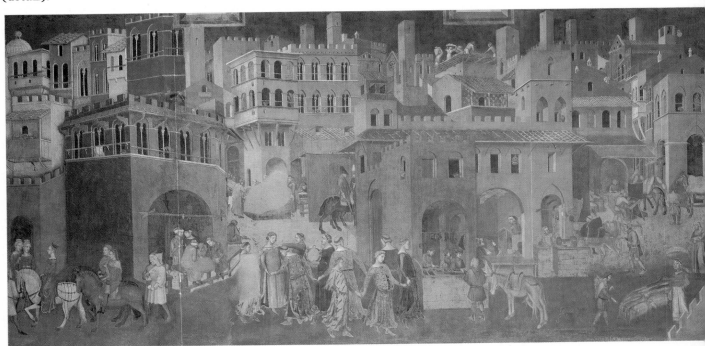

Unfortunately, the victims of the Black Death after 1348, which carried off half of Siena's population, included both Ambrogio and Pietro Lorenzetti. Both the special world of Sienese art and the larger world of Sienese society, symbolized by the grandiose yet unfinished cathedral projects, never recovered their former greatness and would eventually be fully eclipsed by her nemesis, Florence.

FLORENCE: CATHEDRAL PROJECTS

Florence defeated Siena first on the battlefield and gradually supplanted her in banking and general economic activity. Ultimately, Florence rather than Siena reigned as the cradle of Renaissance art as well. Like Siena, the city of Florence is built around an ecclesiastical center, the cathedral (Duomo), and the Palace of the Priors (Palazzo della Signoria), both built by a newly confident city government at the turn of the fourteenth century. Trade guilds, led particularly by the bankers and the wool merchants, dominated Florentine politics and supervised important public art commissions. Each guild had its own officers and special religious chapels and ceremonies, including the support of church spaces and decorations. In particular, the two dominant guilds, the Lana (woolworkers) and Calimala (wool refiners and merchants) administered the construction and the decoration of both the cathedral and the baptistery in Florence. In keeping with their confident conviction that competition brings out excellence in the victors, all important architectural and artistic projects for the cathedral and baptistery were decided by public competition. Public interest in the projects ran high, especially for such public and central monuments in civic life.

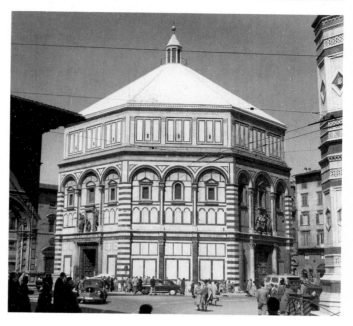

4.34 Baptistery, Florence, ca.1060–1150.

In 1401 the most important civic commission yet held in Florence was opened for artistic competition. For a pair of large decorated bronze doors of the Florence Baptistery (Fig. **4.34**), the Calimala guild, oldest in the city, sponsored a contest using a standard format and theme: Abraham's Sacrifice of Isaac. This theme says much about Florentine self-confidence. Although it would form part of a set of doors with a full roster of other Old Testament subjects, Abraham's divine protection as leader of God's chosen people was taken to have local significance for the Florentines. Not only did they feel

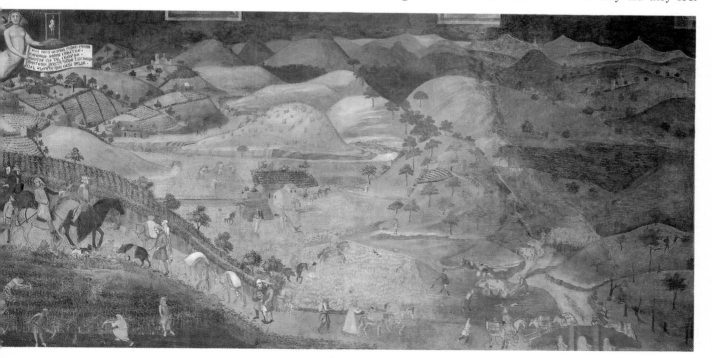

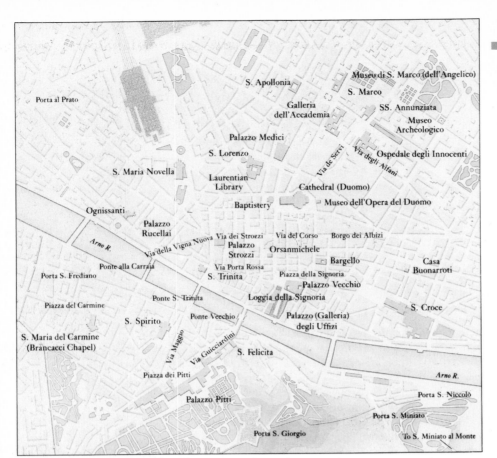

Map of Florence with principal buildings.

4.35 (Opposite) Lorenzo Ghiberti, Baptistery competition plaque, *The Sacrifice of Isaac*, 1401. Gilded bronze relief, 21 × 17½ ins (53.3 × 44.5 cm). Bargello, Florence.

4.36 Filippo Brunelleschi, Baptistery competition plaque, *The Sacrifice of Isaac*, 1401. Gilded bronze relief 21 × 17½ ins (53.3 × 44.5 cm). Bargello, Florence.

their general success to be divinely sanctioned, but they also considered that they had just been miraculously saved from invasion by the Milanese. Moreover, the bronze doors themselves were the ornament of the cathedral bapistery, an old building believed (falsely) to date back to the Roman foundations of the city of Florence. John the Baptist enjoyed a special patron's role for Florence akin to the bond between Siena and the Virgin. Thus the new bronze doors would be a particularly prominent ornament in civic life and a special tribute to the city's own patron saint. The new doors complemented an earlier set of bronze doors (1330) by Andrea Pisano, once more posing the challenge to a modern artist to rival a great civic monument by one of his predecessors. The stage was set for a spirited contest among all the leading sculptors of Tuscany with personal fame and the glory of Florence at stake.

THE BAPTISTERY DOORS Seven sculptors were chosen for the competition of 1401, but the two finalists were Florentines (Siena's leading sculptor, Jacopo della Quercia, was eliminated earlier): Lorenzo Ghiberti (1378–1455) and Filippo Brunelleschi (1377–1446). Each contestant was furnished with bronze and given a year to produce an entry. Within the awkward quatrefoil shape of the stipulated frame (the same shape as Andrea Pisano's door panels), both men produced dramatic renderings of the Sacrifice of Isaac, capturing the moment when the angel rushes in to avert an infanticide (Figs **4.35–36**). Both artists produced works notable for their sculptural rendering of nature, including the wooly coat (staple of the Calimala guild) of the sacrificial lamb or the rocky ledge of the mountaintop. Each sculptor has

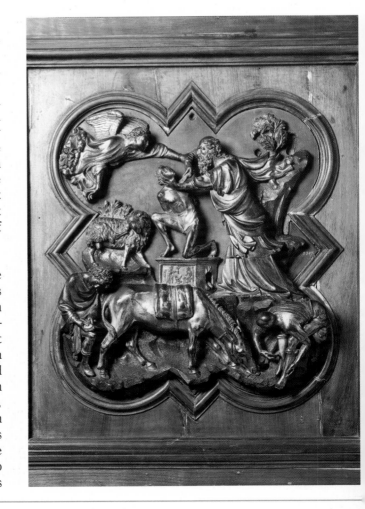

presented an active, twisting nude, derived from classical models, for the figure of Isaac. Brunelleschi has also included a famous composition, the *spinario* (thorn-puller), from ancient Rome as one of the attendants. Each bronze evokes the epic character of the Old Testament subject in order to ornament the Florentine Baptistery.

LORENZO GHIBERTI won the commission for the bronze doors. He had several advantages over Brunelleschi. Like many a metalworker today in Florence, Ghiberti had been trained as a goldsmith by his stepfather. He also had worked as a painter, learning the art of figure composition and movement. The result of these combined talents produced a graceful and elegant figure of Abraham with rhythmic patterns and a fine, gilded finish in his drapery, akin to the painted saints in Duccio's *Maesta*. Although still a young man, Ghiberti as molder of metal had also mastered the refinements of surfaces and spaces in sculpture. His lustrous, nude Isaac and dynamic, diagonal arrangement of the angels and attendants open a new chapter in the history of sculpture. These figures act with an unprecedented energy, their autonomy underscored by both nudity and twisting movements. Such inventiveness promise great contributions to come – great renown for both the sculptor and the city that sponsored him. To use his own words from a later biography, Ghiberti was awarded the palm of victory, a phrase redolent of ancient poets and artists as well as the self-consciousness of personal triumph.

What Ghiberti fails to mention is the other main advantage that his metalworking background afforded him: his construction was far cheaper than that of Brunelleschi. Whereas Brunelleschi cast his figures separately as solids and welded them together to produce a composite group, Ghiberti knew how to cast the entire piece as a hollow sheet of metal. His frugality would also have appealed to the fiscal prudence of the guild fathers of such a major, long-term project. Ghiberti was busy with the bronze Baptistery doors until 1424, and in that year he competed unopposed for selection to do a second set of doors (1425–52).

BRUNELLESCHI'S DOME What happened to the disappointed Filippo Brunelleschi? He turned his talents to other technical problems, abandoning sculpture to become an architect. His next competition resulted in success. In 1418 Brunelleschi returned from an extended stay in Rome, where he had studied and measured the surviving buildings, in order to challenge for the right to build the great dome of Florence Cathedral. No space so vast had ever been spanned since the Pantheon in ancient Rome, and no dome had ever been built at this height. Solving such an enormous engineering problem alone promised to make the architect famous throughout all Italy. Moreover, the huge dome would dominate the city skyline of Florence as the permanent memorial to its designer. Brunelleschi was up to the challenge.

Fifty years had passed while debates raged concerning the structure and the cost of erecting the cathedral dome. Just as Ghiberti had combined consummate mastery of his craft with the elegant and inexpensive solution of bronze casting, so did Filippo Brunelleschi span his 150-foot (46-meter) octagonal crossing with a dome that was visually powerful yet elegantly engineered (Fig. **4.37**). One problem was the prohibitive cost of building vast timber scaffolds to work from. Resourceful Brunelleschi solved this dilemma by suspending

4.37 Filippo Brunelleschi, Cathedral dome, Florence, 1420–36.

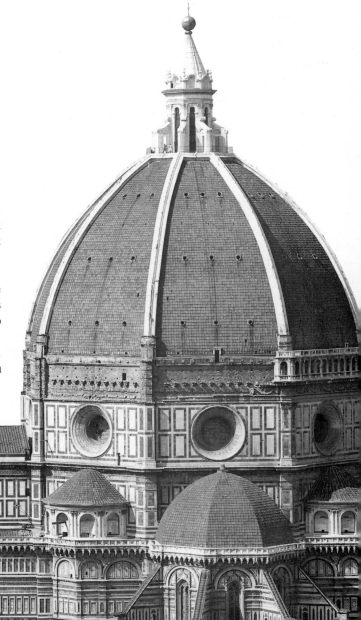

minimal scaffolding from the base, or drum, of the dome. Such a simple scaffold for everyday work already was commonplace; it can be seen on the buildings under construction in Lorenzetti's fresco. From this scaffold a herringbone pattern of bricks ringed the dome and helped to distribute its enormous weight to make it self-supporting. Actually the dome of Florence Cathedral was two domes in a double shell, whose weight was much reduced by the spatial hollow (as Ghiberti's bronze had saved both weight and material through hollow casting). Eight great ribs on the exterior bind the entire dome together and provide a vertical accent that makes the visual effect of the massive crown even mightier. Once again, technical ingenuity combined with an aesthetic problem to produce a lasting civic monument for the commune of Florence. They could justly feel with Brunelleschi's dome that they had not only rivaled the architects of ancient Rome but actually surpassed them. Small wonder that Brunelleschi became the first Renaissance artist to be the subject of a full-scale biography, written in the 1480s by a younger admirer named Antonio Manetti. Brunelleschi was buried underneath his dome in the cathedral of Florence and accorded a Latin epitaph that praises him as a new Daedalus, mythic Greek architect and inventor.

If we listen to the words of a Florentine nobleman who was also one of the first theorists of art, we can sense the significance of such an achievement. One year before the completion of Brunelleschi's dome in 1436, Leone Battista Alberti penned a Latin treatise on painting, *De Pictura*, but when he decided to republish it in Italian in 1436, he added a preface dedicated to his friend Brunelleschi. Alberti's words evoke Florence's ambition – in the arts as well as in all phases of urban achievement – to revive ancient glories and surpass them:

I used to marvel and at the same time to grieve that so many excellent and superior arts and sciences from our most vigorous antique past could now seem lacking and almost wholly lost . . . Since then, I have been brought back here into this our city, adorned above all others . . . In many men, but especially in you Filippo, there is a genius for every praiseworthy thing. Our fame ought to be much greater, then, if we discover unheard-of and never-before-seen arts and sciences without teachers or without any model whatsoever. Who could ever be hard or envious enough to fail to praise Pippo the architect on seeing here such a large structure, rising above the skies, ample to cover with its shadow all the Tuscan people . . . ?

Many of Alberti's themes set the tone for all Florentine artistic achievements of the Early Renaissance. Their works were worthy rivals to surviving ancient artworks, and their achievements attested to the presence of genius in the modern city-state. In a work of architecture, especially the cathedral dome, art and science unite, assuring the fame of the individual architect but also his hometown. Florence could now picture herself as the true heir and reviver of the Roman republic in all its glory.

SCULPTURE IN FLORENCE

THE OR SAN MICHELE No site more perfectly captures the assertive confidence of fifteenth-century Florence than a distinctive central church-and-granary, founded in 1336: Or San Michele, located midway between the Palazzo della Signoria and the cathedral. On the exterior of the Or San Michele stand fourteen niches open to the street, each suitable for presenting a major sculpture. To fill these niches, the guilds of Florence were each given responsibility for choosing an individual sculptor and providing a statue of its patron saint.

The final result serves as a kind of Who's Who of Early Renaissance sculpture in Florence. At the same time, these powerful statues by rival artists for separate guilds mark the distance between the competitive, republican Renaissance city-state and the medieval "Christendom" of Gothic cathedrals, whose sculptures by anonymous craftsmen collectively glorify the Church and the faith.

4.38 Lorenzo Ghiberti, *St. Matthew*, **Or San Michele, 1419–22. Bronze.**

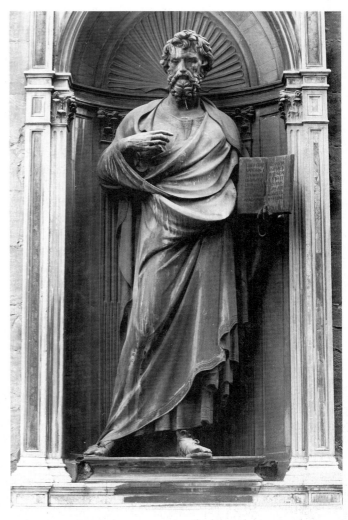

Quite naturally, Lorenzo Ghiberti made major contributions to Or San Michele. He began his work for the same Calimala guild who had awarded him the bronze doors of the Baptistery. Once more he worked in the expensive material of bronze, casting a life-sized *John the Baptist* (1412–16) to honor the patron saint of the guild and the city. This brooding figure nonetheless stands gracefully within his niche, with swooping, rhythmic curves of drapery and curls that recall the earlier Abraham relief. Ghiberti went on to produce a second bronze, *St. Matthew* (1419–22; Fig. **4.38**, p.163), patron saint of the bankers' guild (Cambio). This statue presents greater solidity, with a dignified bearing akin to a toga-clad ancient philosopher. At once more weighty and more natural than the previous *John the Baptist*, Ghiberti's *Matthew* emphasizes the human potential of the biblical figure. The references to antique sculptural models evoke comparison between modern Florence and ancient Rome. This dignity of classical forms now underscores the solemnity of Christian content to convey the unique accomplishment of the Renaissance city-state.

DONATELLO Ghiberti's altered vision of patron saints was not entirely his own invention. Like all Florentines, he was astonished by the sculptural achievements of the third great genius of the early Renaissance in Florence: Donatello (ca. 1386–1466). Trained as a marble sculptor in the workshop that produced statues for the exterior of the cathedral, Donatello served under Ghiberti in the studio for the bronze doors. Donatello's first marble statue for the Or San Michele was *St. Mark* (1411–15; Fig. **4.39**), made for the linen drapers (Linaiuoli). This standing figure emphasizes the drapery purveyed by the sponsoring guild, but his figure is discernible underneath. Mark is a figure capable of movement, resting all his weight on one leg in the dynamic classical stance called *contrapposto*. His aged face and furrowed brow evince considerable experience and accumulated wisdom. This *St. Mark* embodies the ancient bearded philosopher type soon to be emulated by Ghiberti. According to Manetti, Donatello visited Rome with his friend, Brunelleschi, and there absorbed ancient sculptural models suitable for the new Renaissance ethos of Florence. The first carved or painted figure to suggest fully antique dignity for a Christian subject, this *St. Mark* emulates ancient models but evinces its own natural vitality, representing the capacities of the linen drapers in their Florentine republic.

Donatello's next great figure for Or San Michele was *St. George*, made for the armorers' guild (ca. 1415–17; Fig. **4.40**). This powerful warrior emerges from his shallow niche with all the tensed animation of a figure standing fully in the round. No longer directly modeled on antique statuary, *St. George* is a fresh invention in modern armor, emulating the natural movements, proportions, and volumes of classical figures. After the relaxed contemplation of *St. Mark*, *St. George* is all potential action, his eyes focused and attentive. Donatello's figure conveys the vigor and ambition of the city to its citizens on the street. His youth and resolve perfectly embody Florentine confidence and independence. Located midway between the cathedral and the Palace of the Priors, *St. George* symbolizes both the piety and heroic virtue of the young Florentine republic.

Even while still a young artist, carving a buttress statue in marble for the cathedral in 1408, Donatello had achieved fame in his native city. His marble *David*, a boyish victor in battle, was singled out by the city fathers as an appropriate symbol of Florence's own divinely protected successes, akin to the Abraham and Isaac theme of Ghiberti's bronze. The Priors removed Donatello's *David* to the Palazzo della Signoria, where it was installed in 1416. There it received an inscription in Latin, reading: "To those who strive bravely for their fatherland the gods will lend aid even against the most fearful foes." This victory of divine justice over tyranny served to give a judicious warning to the foes of Florence, like the hovering figure of Security by Lorenzetti above the walls of Siena. Yet

4.39 Donatello, *St. Mark*, Or San Michele, Florence, 1411–13. Marble, 94 ins (239 cm).

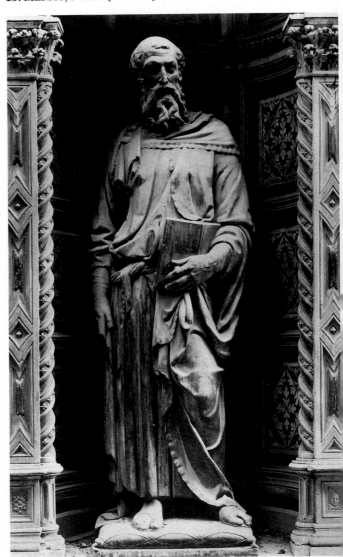

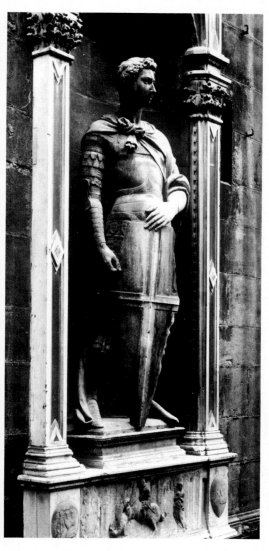

Donatello's career summarizes the kind of domination exerted by Florence over other Italian centers in the fifteenth century. Along with Ghiberti and others he worked on gilded bronze reliefs for the baptismal font in Siena cathedral (1423–34) – a certain sign of the artistic hegemony of Florence over Siena. Besides his visit to Rome, Donatello also spent an extended visit (1444–53) to the north Italian city of Padua, where he produced a bronze crucifix, an altarpiece of bronze reliefs, and an over-lifesize bronze equestrian monument of a military general, nicknamed "Gattamelata" (Fig. 4.41). This massive portrait of a mercenary commander was a fitting rival to figures of ancient Roman emperors on horseback, and it depicts armor that is a mixture of ancient and contemporary forms (cf. Fig. 2.63). His likeness commemorates individual heroism and military prowess within another public space, just as in Florence painters included the portraits of their own mercenary military leaders on walls in their cathedral. The fame of particular servants of the city-state led to authorized monuments of them by leading civic artists. Donatello had become the most famous sculptor of his century as well as the favorite artist of the most powerful and wealthy individual in Florence: Cosimo de' Medici.

4.41 Donatello, "*Gattamelata*," 1443–53. Bronze, originally gilded, approx. 146 ins (340 cm) high. Piazza del Santo, Padua.

4.40 Donatello, *St. George*, Or San Michele, Florence, ca. 1415–17. Marble, 82 ins (208 cm).

Donatello's *David* also inaugurated the realization in sculpture of civic ambitions through biblical heroes, just as a century later Michelangelo's *David* would once more capture the imagination of the Florentine republic.

Sculpture quickly became the quintessential Florentine art form. Statues were permanent, public, and inspirational. Their human forms and scale served as a model for human conduct, recalling great historical and biblical figures or events, such as David's victory over Goliath. When Florentine writers, such as Leone Battista Alberti or the city chancellor, Leonardo Bruni, wrote about sculpture, they saw precisely these values as artistic ideals. Bruni, for example, in a 1425 letter concerning Ghiberti's second set of bronze doors, set out the criteria of judging such civic monuments: "for one they should be resplendent; secondly they should be significant." The niche figures of Or San Michele, and more generally the sculptures in marble and bronze by Donatello and Ghiberti, became the shining examples of Florentine greatness for all of Italy.

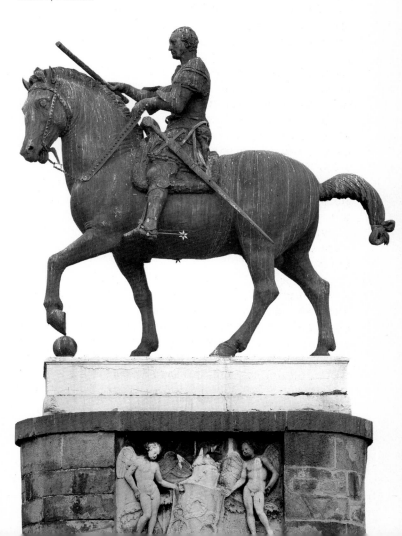

The Medici and San Lorenzo

The Medici family, founded by Giovanni de' Medici (1360–1429), dominated the political and cultural life of Florence through most of the fifteenth century. Cosimo de' Medici, patron of Donatello, gained political supremacy in 1434. This banking and business dynasty also later produced two Popes – Leo X, Cosimo's great grandson and Clement VII. Much of the family's wealth was expended lavishly on patronizing artists. So when in 1491, Giovanni de' Medici commissioned the construction of a parish church near the family home to honor the Medici patron saint, San Lorenzo (Fig. **4.42**), he employed only the most illustrious of the city's artists for "their" church.

Brunelleschi made the plan of the building and also designed a sacristy space, now known as the Old Sacristy (1421–28) to distinguish it from Michelangelo's New Sacristy housing his famous Medici Tombs a century later. Donatello designed the sculpted ornament for the sacristy and also supplied a bronze pulpit (near the end of his life in the 1460s). Such support of architecture and its decorative sculpture benefited the commune spiritually

4.42 Filippo Brunelleschi, "Old" Sacristy, San Lorenzo, Florence, 1421–28.

as well as serving as a magnanimous gesture of piety by a wealthy local citizen.

San Lorenzo reveals Brunelleschi's vision, inspired by Roman architecture, of a Renaissance "Christian temple." In particular, the sacristy, which became a sepulcher for Medici family members (as well as for Donatello eventually), offers a perfect image of geometrical clarity with elements of classical ornament (Fig. **4.43**). Its plan is based on the square, domed with a circle, and accented

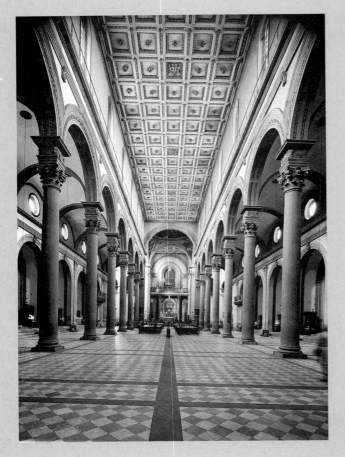

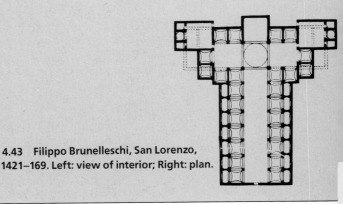

4.43 Filippo Brunelleschi, San Lorenzo, 1421–169. Left: view of interior; Right: plan.

by another small, square domed alcove that serves as the altar. The bright, whitewashed purity of the walls receives articulation through darker-grey stone pilasters and arches. None of the soaring height and open window space of Gothic interiors has been retained here. Instead a classical calm, based upon basic geometric shapes and regular ratios, receives its form from ancient orders for pilasters and from temple pediments for door frames.

A human scale is reasserted after the soaring height of Gothic, not only in the proportions of the parts of the church but also in the anthropomorphic quality of its classical orders with capitals. The central plan of this domed space became a model in its symmetry and geometrical perfection for the human body as well. The ancient Roman architectural treatise of Vitruvius speaks of how the human body can be inscribed within the perfect, centralized shapes of both circle and square. This concept of central space and the harmony between mankind and the cosmos became an inspiration for later Renaissance artists and architects, including Leonardo da Vinci's famous drawing of Vitruvian man (Fig. **4.44**) as well as the new, centralized plans for St. Peter's in Rome at the turn of the sixteenth century (see below, p. 192). To this pure geometry of Brunelleschi, Donatello added reliefs of the four evangelists in roundels above the doors, and he made the doors themselves with bronze

relief panels of paired saints. According to Manetti, Brunelleschi bristled at these decorations as intrusive to the logic of his architectural clarity and harmony of parts.

Brunelleschi constructed the nave of San Lorenzo with an even more extensive use of antique building vocabulary. Based on the simple, three-aisled basilicas of Early Christian Rome, the nave arcade stands on beautiful Corinthian columns. The nave of San Lorenzo also retains a clear proportional relationship of building segments, accented in the darker stone called *pietra serena*. The overall design imparts a geometrical order to the entire space, echoed in details, such as the squares of the floor and classical ceiling coffers. All sight lines in San Lorenzo converge on the altar area. This demonstration of visual perspective within a building space elaborates upon Brunelleschi's own experiments with one-point perspective in pictorial space during the 1420s. Alberti, who codified the technique of designing linear perspective in his treatise, surely shares his understanding of perspective with his friend Brunelleschi.

San Lorenzo offers Florence her definitive Christian temple. Ordered and rational in contrast to the mystery of a Gothic cathedral, the new church space of the Renaissance uses ancient models yet remains in full accord with the calculation prized by the Medici and other Florentine capitalists.

4.44 Leonardo da Vinci, *Vitruvian Man*, ca. 1485–90. Pen and ink, 13½ × 9⅝ ins (34.3 × 24.4 cm). Accademia, Venice.

CIVIC RELIGIOUS NARRATIVE

MASACCIO Florentines believed in a beneficent and ordered universe under divine protection. Perhaps the most vivid image of that belief was painted during the period that Brunelleschi was constructing the sacristy at San Lorenzo. The youthful Florentine painter, Masaccio (1401–28) designed his *Trinity* (ca. 1425; Fig. **4.45**) in accord with Brunelleschi's principles of linear perspective and classical architecture. Within the framework of a vaulted triumphal arch, the viewer looks up at the hierarchy of holy figures. God the Father is uppermost and at the axial center; Christ appears below on the cross, flanked by the mourning figures of the Virgin and St. John. All of these saintly persons are sheltered beneath the coffered barrel space derived from Roman models, as recreated by Brunelleschi. The associations of the architecture with ancient triumphal arches also confers on the image an implication of divine triumph, or grace, witnessed by the viewer as if in a vision.

At the surface of Masaccio's fresco appear two eminent donors, kneeling just outside the ledge of the architectural space. Their humble profile position is diametrically opposed to the frontal elevation of God deep within the triumphal space. Yet these pious citizens offer thanks for worldly attainments. The man is dressed in the costume of a *gonfaloniere*, or banner-carrier, for one of the Florentine guilds, so he has reached a position of honor and respect in his community. Once more piety and civic virtue coincide, although a warning

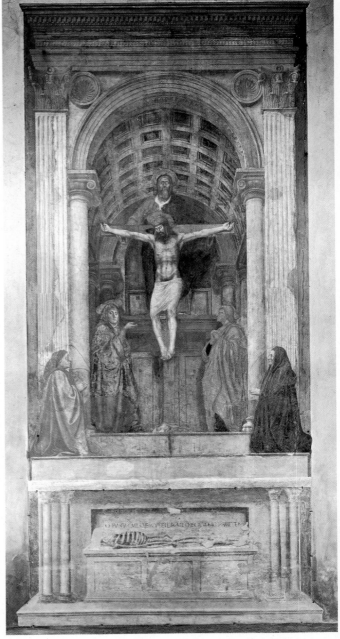

4.45 (Right) Masaccio, *Trinity*, Santa Maria Novella, Florence, ca. 1425–28. Fresco, 261 × 112 ins (667 × 317 cm).

4.46 (Below) Masaccio, *Tribute Money*, Brancacci Chapel, Santa Maria del Carmine, Florence, ca. 1427–28. Fresco, 100 × 236 ins (254 × 590 cm).

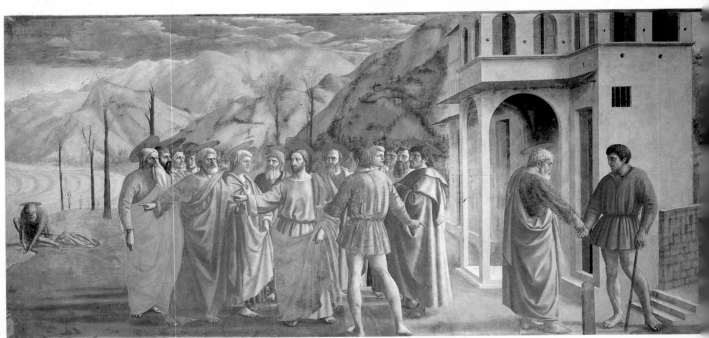

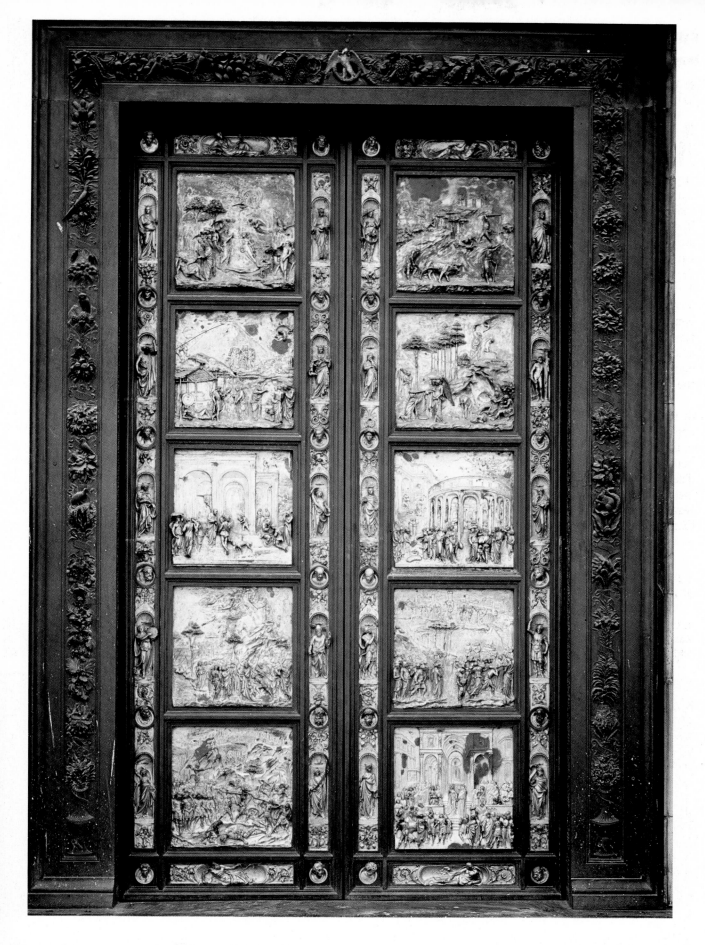

4.47 Lorenzo Ghiberti, "Gates of Paradise," Florence, Baptistery, 1425–52. Gilt bronze, approx. 17 feet (5.2 meters) high.

about worldly vanity emerges from the lowermost zone of the fresco. There a decaying skeleton warns that death comes to all men and that worldly achievement pales before ultimate questions of salvation. The viewer's eye level is placed at the height of the donors of the fresco. One looks up at the holy figures and down at the skeleton, quickly grasping the place of the active citizen in the scale of the cosmic hierarchy.

Masaccio was the only painter mentioned by Alberti in the same breath as Brunelleschi, Donatello, and Ghiberti in the 1436 preface to *Della Pittura*. The tragically early death of this artist cut short a career in painting that might have been the rival of architecture and sculpture in Early Renaissance Florence. His brief career only began in 1422, but in his absorption of Brunelleschi's architectural and perspective techniques Masaccio quickly became the leading painter in Florence. In the *Trinity* all figures have the solidity and dignity of relief sculptures by Ghiberti or Donatello. They hold clearly defined positions and gestures within a rationally coordinated space. This coordination and clarity in human terms, symbolically organized by the perspectival viewpoint of an oberserver's eye, present a fully realized Early Renaissance pictorial image. Masaccio's fresco links the realms of the sacred and secular into a distinctly Florentine synthesis.

Masaccio recounted the story of the *Tribute Money* episode from the Gospels (Matthew 17, 24–27) as part of a fresco cycle in the Brancacci Chapel, Santa Maria del Carmine (Fig. **4.46**). His solid figure group of Christ and the apostles evokes comparison to Donatello's marble figures, and the painter has also characterized these figures as distinct personalities in terms of age, costume, and gesture. Yet Masaccio also renders perspectival space successfully through the recession of buildings and trees into depth. Such attempts to provide space for religious narratives would also inform a contemporary project: Ghiberti's second set of bronze doors for the Florence Baptistery.

THE GATES OF PARADISE When Ghiberti set about designing his second bronze doors for the Baptistery in 1425 (Fig. **4.47**), he had the benefit of the experiments in perspective by Brunelleschi and Masaccio, soon to be codified in the treatise by Alberti. This final set of doors received the favored eastern location, closest to the main entrance of the cathedral, and their lasting fame matches their gilded brilliance. Michelangelo himself is said to have dubbed them the "Gates of Paradise." In place of the artificial quatrefoil shape of the previous two doors, these panels are allowed to take the rectangular format of paintings, to use art to portray biblical events as unfolding within a worldly landscape.

The Gates of Paradise allow a comparison between Ghiberti's ultimate realization of the Abraham and Isaac scene and his initial competition relief, three decades earlier (Fig. **4.36**). Rich and varied descriptions of nature shape the later scene (Fig. **4.48**). Small-scale figures nestle within a setting dominated by craggy rocks and tall trees that recede into distance (conveyed by reduced scale and increasingly shallow relief).

Even biblical events are now presented with a human scale and an illusion of real space (as in the detail of the donkey's strongly foreshortened grazing body). Each posture and gesture carries its earlier dramatic force, but Ghiberti coordinates the entire composition with a lowered horizon reminiscent of the landscape of Lorenzetti's Siena fresco. Ghiberti's *Abraham and Isaac* realizes a Renaissance harmony between biblical mankind and divine angels within a believable, worldly space.

Alberti's treatise prescribes this kind of narration as the appropriate method for presenting sacred history or myth (*istoria*). Consistency and propriety for the individual characters in the story should also be balanced with a variety of figure types and actions. Believable human actions should be expressed through graceful poses and expressive gestures, all within a harmonious space. Ghiberti used almost the same criteria to describe his achievement in the Gates of Paradise: "These stories, very abundant in figures, were from the Old Testament: in them I strove to observe with all the scale and proportion, and to endeavor to imitate Nature in them as much as I might be capable; and with all the principles which I could lay bare in it and with excellent compositions and rich with many figures."

In the concluding panel of the Gates of Paradise, Ghiberti's *Solomon and Sheba* most fully realizes these Renaissance pictorial ambitions within a building space even vaster than Masaccio's (Fig. **4.49**). Here a centralized temple evokes a combination of a Renaissance three-aisled church, such as Brunelleschi's San Lorenzo, with a Roman triumphal arch. The scene unfolds with figures viewed from a central position

4.48 Lorenzo Ghiberti, *Abraham and Isaac*, "Gates of Paradise," Baptistery, Florence, 1425–52. Gilt bronze relief, 31¼ × 31¼ ins (79.4 × 79.4 cm).

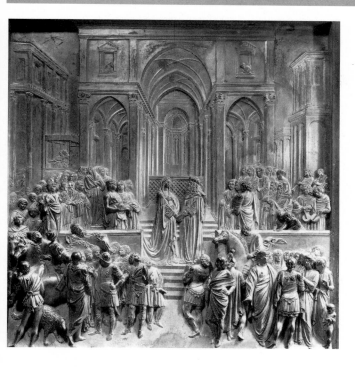

4.49 Lorenzo Ghiberti, *Solomon and Sheba*, "Gates of Paradise," Baptistery, Florence, 1425–52. Gilt bronze relief, 31¼ × 31¼ ins (79.4 × 79.4 cm).

Even better than Alberti's treatise, these *Commentarii* (ca. 1447–55) present a Renaissance vision of the role of art and genius. The first book is devoted to the art of ancient times, a second book to "modern times" from antiquity to Ghiberti, including an autobiography. A proposed third book would have discussed the vital sciences needed by any artist: optics, anatomy, and the proportions of the human body. Ghiberti's account accords with the Renaissance definition of itself as a time of revival of antiquity after a "dark" Middle Ages, and he praises fourteenth-century painters in both Florence and Siena for their pioneering efforts. The *Commentarii* also reveal Ghiberti's own personal ambitions for eternal fame and for a new artistic status. Like Alberti, Ghiberti wished to be acknowedged as a man of letters and learning, rather than as a "mere" craftsman. He sought through both his writings and his art to elevate art-making to the prestige of the liberal arts instead of their traditional association with the mechanical arts, represented by guilds. Ghiberti's own words outline his ambitions for himself and for artists in general: "In order to master the basic principles I have sought to investigate the way nature functions in art . . . and in what way the theory of sculpture and painting should be established."

4.50 Lorenzo Ghiberti, Self-portrait bust, detail of "Gates of Paradise." Gilt bronze, approx. 3 ins (7.6 cm). Baptistery, Florence, 1425–52.

– at the level and position of the two protagonists. The proportions of all figures are coordinated with the scale of the buildings, in a visual unity consonant with Ghiberti's description of his aims. Their carefully rendered costumes include ancient armor and togas, fulfilling Alberti's requirement for rich variety in biblical histories.

This scene adds a festive conclusion to the Old Testament sequence of the Gates of Paradise, suggesting a reconciliation of Hebrews and Gentiles or even pagans and believers in a new Renaissance synthesis. Solomon serves as a prototype of wise and pious rulership, a model clearly in harmony with the support for the revived and strong papacy. Florence's bankers, led by the Medici, had come to power through their alliance with the papacy, so this image also accords well with local economic and political interests. Taken together, Ghiberti's *Solomon and Sheba* succeeds in recreating the biblical scene with both naturalness and dignity, while he provides a lustrous and complex civic religious monument in Florence.

The Gates of Paradise also served as a personal monument. Ghiberti proudly signed his doors, the culmination of a career that spanned half a century. He also included a self-portrait, balding and genial, among the decorative figures of prophets serving as ornament on the door frames (Fig. **4.50**). This likeness may be the first explicit self-portrait in Western art, and it underscores the self-awareness and pride in his accomplishment of the aged Ghiberti. In addition, the artist spent the period after the completion of the Gates of Paradise writing an account of his own life and achievement as well as the history of art up to his own time.

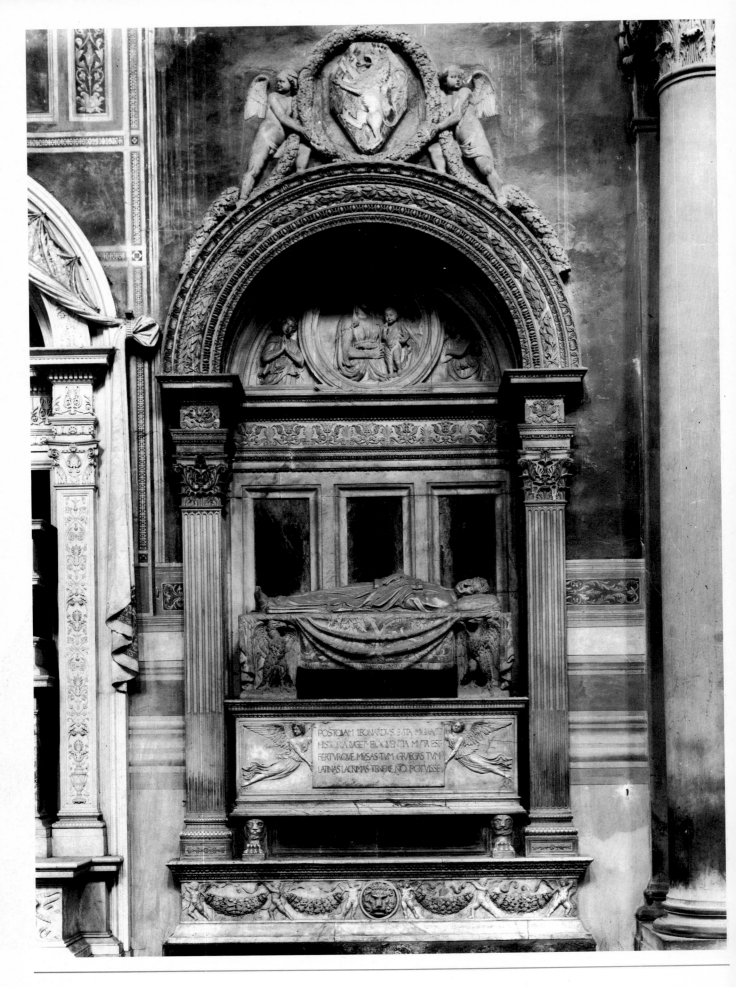

POSTQVAM LEONARDVS E VITA MIGRAVIT
HISTORIA LVGET ELOQVENTIA MVTA EST
FERTVRQVE MVSAS TVM GRVECAS TVM
LATINAS LACRIMAS TENERE NO POTVISSE

172

THE TOMB OF LEONARDO BRUNI The leadership of Florence during Ghiberti's lifetime came from just that kind of learned man of letters. The end of an era came in 1444 with the death of the greatest of these men, Leonardo Bruni, city chancellor and historian of Florence, who had also devised the program for Ghiberti's Gates of Paradise. Following the Roman example of Cicero, Bruni believed that learning could be used to provide a better civic life in the community of the republic. He celebrated Florence as the bastion of liberty, inherited from republican Rome by virtue of her ancient Roman foundation. Bruni's *History of the Florentine People* (1415–29) served local patriotic interests in letters, just as the monuments for guilds made by Ghiberti and Donatello celebrated Florence through civic art.

When Bruni died, he was buried according to his wishes in an antique ceremony. An elaborate tomb monument (1446–47) was commissioned for the church of Santa Croce by a grateful Florence city government from the sculptor Bernardo Rosellino (1409–64), an associate of Brunelleschi (Fig. **4.51**). Bruni's tomb memorial offers a model integration of sculpture with architecture, of antiquity with Renaissance Christianity. In celebration of individual greatness within the civic framework, a full-length recumbent portrait of Bruni formed the center of the monument. Under a rounded arch made out of the laurel of the poet, the chancellor lies with a book on his breast, presumably his own renowned history. The sarcophagus beneath him carries a Latin epitaph: "After Leonardo departed from life, history is in mourning and eloquence is dumb, and it is said that the muses, Greek and Latin alike, cannot restrain their tears." That inscription is borne by winged figures, at once ancient Victories and Christian angels. Roman eagles support the effigy of Bruni. Indeed, the entire architecture of Bruni's wall niche derives from antiquity. Framing Corinthian pilasters once more suggest ancient triumphal arches. Under the rounded arch of the chancellor's space, his assurance of Christian grace is manifested through the welcoming figures of the Madonna and Child within the perfect geometry of the circle. Above the laurel framing arch a final pair of angels carry another garland, this time framing a shield with the lion coat-of-arms of Florence. The achievements and fame of Bruni are blessed by heaven and serve to further the lasting glory of his beloved Florence as well.

MEDICI DOMINANCE

With the passing of giants such as Bruni, Ghiberti, and Brunelleschi around mid-century, the character of Florence and her artistic creations shifted. Political domination now lay firmly in the hands of the uncrowned but all-powerful Cosimo de' Medici. In addition to continuing the building and decoration of the Medici church, San Lorenzo, Cosimo undertook the construction of a massive urban palace block nearby (1444–64; Fig. **4.52**). For his architect, Cosimo first turned to the aged Brunelleschi, but his desire for modest public display led him to choose an alternative design by Donatello's associate, Michelozzo (1396–1472). Like the Palace of the Priors in Florence, the lowest zone of the Medici Palace presents a rough-hewn, fortress-like rustication, derived from the stone surfaces of Roman walls and city gates. This monumental and dignified exterior suggests austere, republican virtues for Cosimo and the Medici family. Their Medici Bank was also situated on the ground floor, open to the street through large, arched entrances. This suggested accessibility and openness within the city fabric only partially modify the effect of the enormous size of the Medici Palace, which rivals the scale of the site of government itself, the Palace of the Priors.

The private grandeur and ultimate importance of Cosimo

4.52 Michelozzo, Medici Palace, 1444–59. View of exterior.

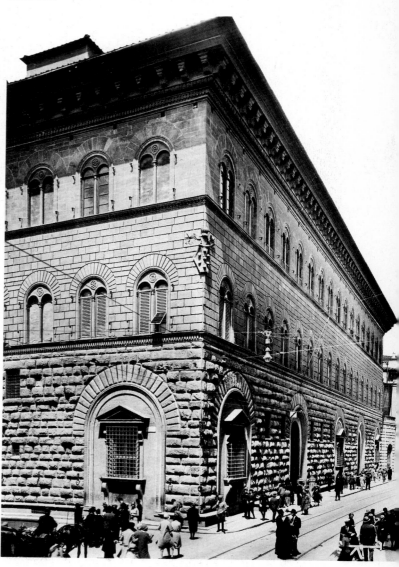

4.51 Bernardo Rossellino, *Tomb of Leonardo Bruni*, Santa Croce, Florence, 1444. Marble, 20 feet (6 meters) high.

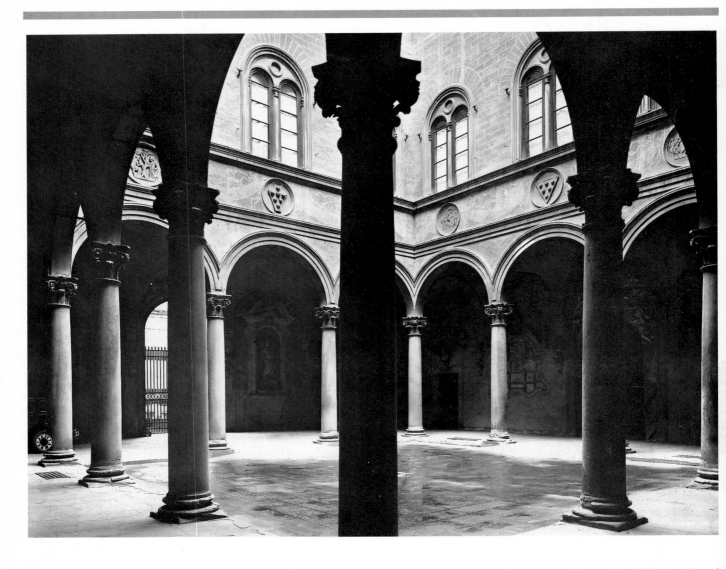

4.53 Michelozzo, Medici Palace. Courtyard.

de' Medici is only visible in the central courtyard of the Medici Palace (Fig. **4.53**). Free of the constraint of public display along the street, this interior surface reveals the architect's inventive use of Renaissance building elements. Derived from the columnar arcade of Brunelleschi, the courtyard is planned around the perfect shape of the square. In the courtyard an axial, central plan prevails, like the geometrical ideal of Brunelleschi's Old Sacristy. The two storeys above provide large window openings and a visibly refined surface finish, suitable to the atrium or peristyle court of ancient Roman houses. Such a generously open private space attests to the true grandeur of the Medici and to their potential for aristocratic luxury and absolute rule in the city.

If competition marked the early phase of the Renaissance in Florence for both artists and merchant families, then Medici dominance prevailed for the rest of the fifteenth century. Quite simply, they had bested all principal rivals in urban competition. During the second half of the fifteenth century, Florence was dominated by patricians, each family housed in its own

palace and each patronizing its favorite artists for decoration of its palace interiors or its family chapel in a church. First among these patrician families were the Medici. The political fortunes of Florence and the Medici family fused inextricably. To be favored by the Medici thus assured success for any artist in Florence.

Under Cosimo de' Medici, Donatello remained the protégé. In fact, he was buried near Cosimo in the church of San Lorenzo where patron and artist had their closest association in life. Donatello's sensuous bronze *David* (ca. 1446–1460; Fig. **4.54**) almost certainly stood on a column within the private courtyard of the Medici Palace. In subject, this youthful hero follows up the civic republican values first advanced in Donatello's 1408 marble sculpture for the cathedral, in order to suggest continued Medici observance of Florentine liberty. However, the emphasis in this later figure on individual identity and confidence verges on arrogance. This *David* accords with the new, personalized centralization of political authority in the hands of the patriarch of the Medici family. Even the location of the statue in a private palace and its execution in the expensive medium of bronze depart from the decorum of exhibiting a marble statue in the public seat of government half a century

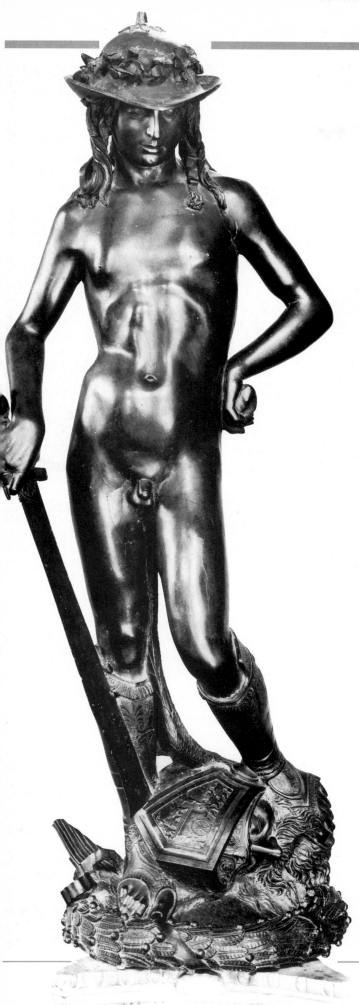

4.54 Donatello, *David*, ca. 1450. Bronze, 62¼ ins (158 cm). Bargello, Florence.

earlier. The highly finished polish of this nude body recalls the beauty of Ghiberti's original Isaac. Yet here a freestanding statue, the first such bronze since antiquity, is aestheticized for private delectation, even in such luxurious details of costume as the boots and hat of the young hero. In contrast to the patron saints of guilds on the Or San Michele, personal triumph rather than public heroism prevails in this later, Medici commission. In addition, the downcast eyes of David suggest the reflective and contemplative temperament of David the psalmist, whose hat also carries a poet's laurel crown.

SANDRO BOTTICELLI Learning remained central to Florentine concerns in the latter half of the fifteenth century, but under Medici sponsorship classical learning turned from republican political theory toward more abstract philosophical speculation. First Cosimo and then his grandson, Lorenzo the Magnificent (d. 1492), supported a Platonic Academy in Florence under the direction of Marsilio Ficino. In the arts, this new stress on beauty was embodied in the mythologies of another Medici protégé, Sandro Botticelli (1445–1510).

Both the *Birth of Venus* and *Primavera* (Spring: ca. 1482) place Venus, the goddess of beauty, at the center of their decorative, verdant compositions. These two images adorned the villa of a Medici cousin of Lorenzo the Magnificent, Lorenzo di Pierfrancesco. In these works, for the first time since antiquity, full-sized pagan gods form the subject of painting. Moreover, unlike the beautiful antique nudes of Ghiberti or Donatello, these figures no longer serve the cause of Christian moralizing. Graceful, linear nudes stand outside earthly reality in a realm of transcendent, purified, divine beauty.

In *Primavera*, Flora, the goddess of flowers, joins a clothed Venus in presiding over the realm of springtime (Fig. **4.55**, p. 176). The three Graces, companions of Venus, elaborate on her beauty in an eternal dance beside the goddess. Botticelli's subject derives from classical texts, such as Ovid's description of the festive beginning of May, the season of Venus, in his *Fasti*. Ovid mentions the figures at the far right of the picture: the west wind, Zephyrus, who pursues the nymph, Chloris, and transforms her into Flora with his touch. This earthward movement is balanced in the painting by the heavenward glance of a contemplative Mercury, god of intellect, on the opposite side. This youthful god echoes both the posture and the accessories of Donatello's bronze *David*.

The significance of the *Primavera* derives from a learned program, prepared by Ficino as the spiritual adviser of his young Medici patron. A letter of Ficino directs the youth's attention to the heavens and what they signify, in this case Mercury as Reason ("good counsel, reason, and knowledge") and Venus as Humanity, that is the learning we now call the humanities. By *Humanitas*, Ficino suggests that the twelve virtues (Love, Charity, Dignity, Magnanimity, Liberality,

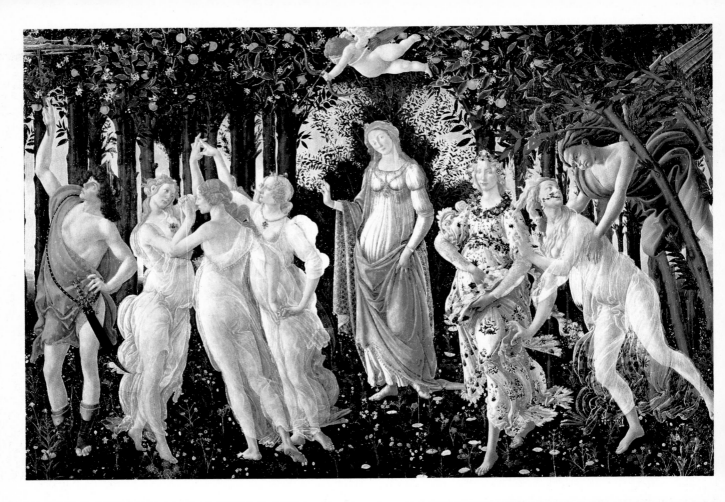

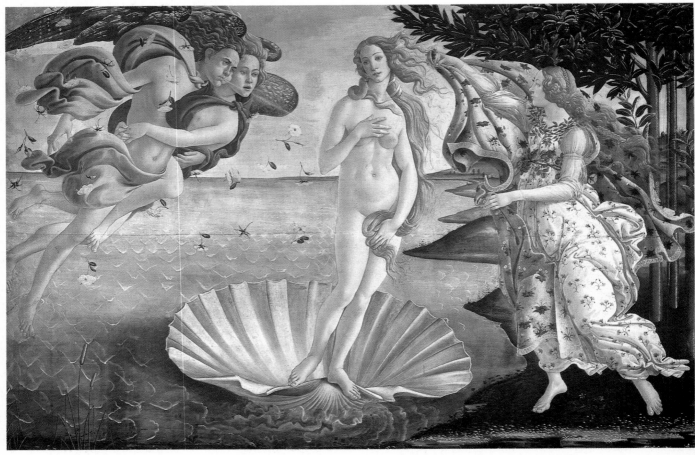

Magnificence, Comeliness, Modesty, Temperance, Honesty, Charm, and Splendor) can be united in the figure of an allegorical nymph of surpassing beauty and nobility. Here a traditional program of learning as the basis of virtuous thought and action finds a new philosophical symbol in the beautiful form of a pagan goddess embodying all refinement and culture.

Botticelli's *Birth of Venus* incorporates that same vision of Ficino, providing ideal beauty as a beacon for a young man's contemplation (Fig. **4.56**). As in Ficino's letter, the goddess serves not as a revival of pagan religion but rather as an allegory of moral values within a learned education program, derived from the classical past but consonant with the training of a Christian prince of the Renaissance. Appropriately, the nude Venus with her modest gesture derives from antique statuary (one famous Venus with this gesture was later owned by the Medici). The mystery of Venus lies not only in her divine beauty but also in her birth itself, full-grown from the sea-foam. Ultimately, this sensuous nude remains an object for private contemplation by a prominent patrician.

It is a measure of the change in Florentine society that moral inspiration now derives from a female nude in the villa of an aristocrat rather than from the bearded philosopher types in public niches on the public streets of the city. The secular allegory in Lorenzetti's fresco was the figure of Security, not Humanity and Beauty. Prosperity and power achieved by merchants and bankers in Tuscan communes had made possible a new wealth and luxury, but now that wealth was utilized for display more suited to the palaces of princes than of burghers in a city. Politics gave way to poetry and philosophy. Throughout the Early Renaissance, competition within the civic republic remained the wellspring of art and learning. Even with the eventual triumph of the Medici, artists continued to strive for personal fame and excellence, emulating the examples of antiquity to adorn a glorious, Christian present. Yet at the end of the century Botticelli would go to Rome to paint frescoes (1481–82) in the newly built Sistine Chapel as a testament to the increasingly assertive theocratic powers of the popes.

With the turn of the sixteenth century, the Medici, too, would set their sights on the more grandiose ambition to papal authority. One of their dynasty would succeed in 1513 and become Pope Leo X. Eventually Medici descendants would also attain the title of dukes of Tuscany. The artistic successes of the Early Renaissance would permit Italians to seek greater glories. Increasingly they would look to ancient Rome for a different model – of the Empire rather than the Republic. Ambition and power would no longer center on Tuscan city-states, Siena or Florence, but on the popes in Rome. A new era, the High Renaissance, had dawned.

4.55 Sandro Botticelli, *Primavera* (Spring), 1478. Tempera on panel, 80 × 124 ins (203 × 315 cm). Uffizi, Florence.

4.56 Sandro Botticelli, *Birth of Venus*, 1482. Tempera on panel, 69 × 110 ins (175 × 279 cm). Uffizi, Florence.

MANTUA AND THE GONZAGAS

The art of Lorenzo the Magnificent and the later Medici more closely resembled paintings produced for smaller, dynastic court centers elsewhere in Italy. One of the most splendid of these dynastic courts belonged to the Gonzaga family in Mantua. Their enlightened patronage extended to Florence, where Alberti was commissioned as the designer of a magnificent church for Mantua, Sant' Andrea (1470), in the manner of Brunelleschi's revived antiquity.

The façade of Sant' Andrea al Mantua (Fig. **4.57**) combines Roman forms of a triumphal arch and a temple pediment, and it clearly demonstrates the harmonious proportions of the interior spaces, dominated by a central aisle. Alberti's interior (Fig. **4.58**, p. 178) is spanned by a classical

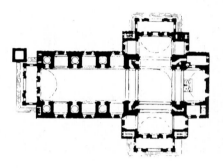

4.57 Leonbattista Alberti, Sant'Andrea, Mantua, designed 1470. Plan (above) and façade.

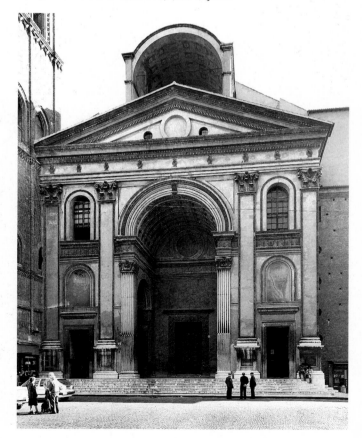

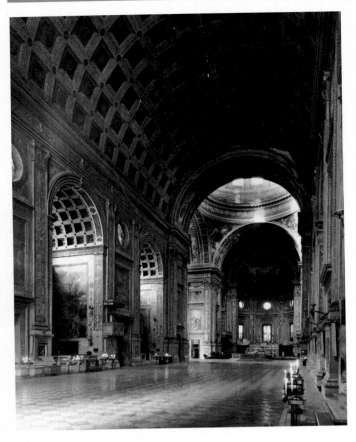

4.58 Leonbattista Alberti, Sant'Andrea, Mantua. View of interior.

4.59 Andrea Mantegna, *Lodovico Gonzaga and his Court*, Camera Picta, Ducal Palace, Mantua, completed 1474. Fresco, wall surface 19½ × 26½ feet (5.9 × 8 meters).

barrel vault on massive piers with all the grandeur of ancient Roman baths and basilicas (see Figs. 2.64–65), akin to the fictive space painted by Masaccio in the *Trinity* (Fig. 4.45). Each of the side aisles has its own barrel vault, behind an opening with pilasters, which echoes the triumphal arch formula of the main entrance on the exterior. This powerful interior, in turn, later inspired the original design for the new St. Peter's in Rome in the following century (see p. 192).

ANDREA MANTEGNA For their palace in Mantua, the Gonzaga family patronized as court painter Andrea Mantegna (1431–1506), a master of perspective and of ancient figural and architectural forms. His chief decorative frescoes in the Ducal Palace of Mantua adorned all of the walls as well as the ceiling of an audience hall, known as the Camera Picta, or Painted Chamber (1465–74; Fig. **4.59**). At the heart of the decoration Mantegna presents the ruling family, Lodovico Gonzaga with his wife, his children, and his favorite courtiers, seen from below by the visitor while they attend to a messenger. Such a combination of state transactions with family life and privy chamber corresponds closely to the actual uses of the Painted Chamber in Mantuan ducal life. On an adjoining wall, framed by fictive architecture and parted gold curtains, Francesco Gonzaga, son of the duke and the cardinal of Mantua, is greeted by Lodovico as well as other family members and dignitaries (Fig. 4.60). By these means, the dynastic continuity of the Gonzagas in both political and ecclesiastical roles is presented through three generations of portrayed representatives. The background of the second fresco opens up into a fanciful walled medieval city, accented by ancient Roman structures with statuary. This illusionistic exterior climbs an imagined hillside quite distinct from the flat plains around Mantua. In both of his frescoes, Mantegna

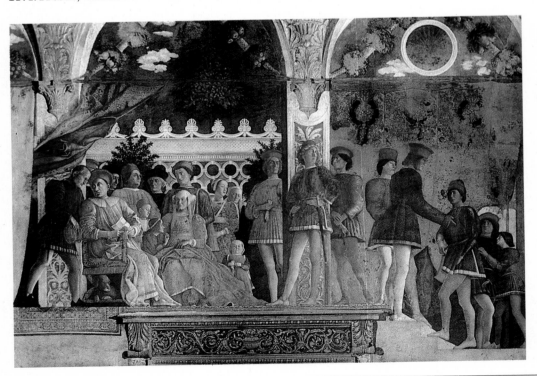

4.60 Andrea Mantegna, *Arrival of Cardinal Francesco Gonzaga*, Camera Picta, Ducal Palace, Mantua.

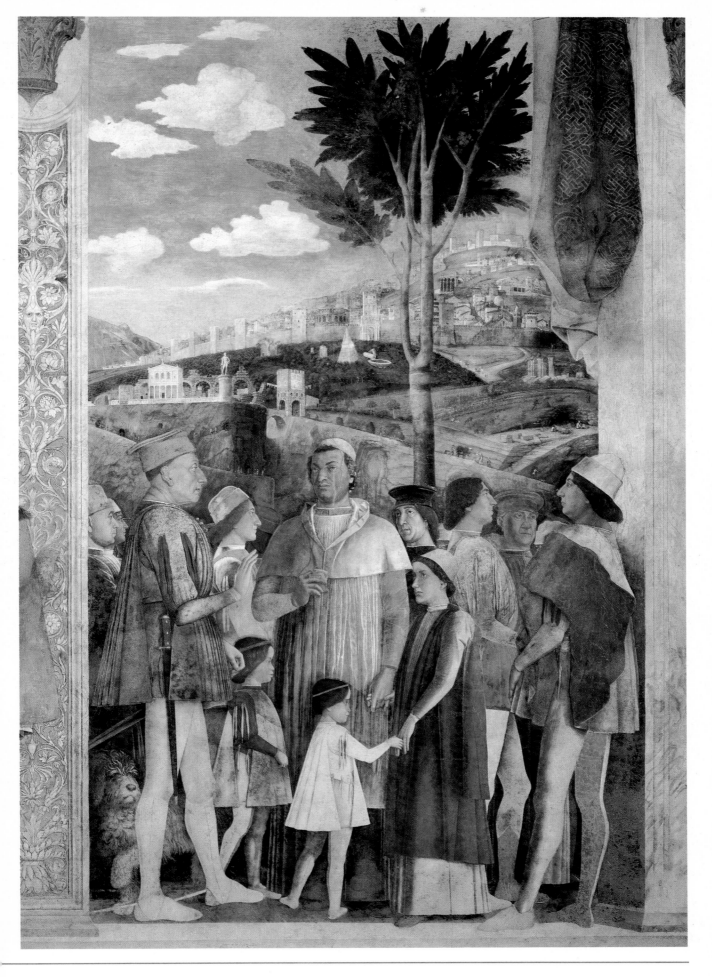

uggests the splendor of the Gonzaga court with his attention
o their colorful costumes; at the same time, his evocation of
Roman buildings in association with the ducal retinue compli-
ents the ruling family by its implied comparison to ancient
mperors (something Mantegna made explicit when he pro-
uced a suite of canvases for the Gonzagas on the subject of
he Triumphs of Caesar).

The painter's own ambitions and accomplishments in the
ealm of creating perspectival illusion are fully indulged in his
eiling fresco of the Camera, where the ceiling seems to
issolve and give a vision from below of an open parapet with
isible sky (Fig. **4.61**). There a cluster of ladies-in-waiting
eer downward, accompanied by the pudgy, sharply foreshor-
ened bodies of tiny winged cupids, evoking a fertile courtly
aradise of love. This inventive Camera mixture of the mythic
nd the courtly, of the imaginative and the commemorative,
ould continue to mark court commissions by Italian princes
or artists such as Titian in the following century (see below,
. 212). Indeed, Mantegna himself would go on to paint a pair
f mythic subjects (*Parnassus, Pallas Athena Expelling the
Vices from the Garden of Virtue*) for Isabella d'Este, the sister-
n-law of Lodovico Gonzaga, to decorate her private study, or
tudiolo, at the castle in Mantua (1496–1502) – a cycle akin to
he Venus pictures by Botticelli for the Medici family in
Florence. The courtier-artist's success can be measured by his
btaining a knightly title of count palatinate, awarded by the
rateful Gonzaga around 1484.

PAPAL COURT IN ROME

Mantegna was summoned to Rome in 1487 by Pope Innocent
VIII in order to paint the decorations of his new Belvedere Villa
chapel in the Vatican (destroyed). Mantegna's Roman project
tallies with other artistic decorations in and around the papal
palace, part of an assertive revival of papal stature and political
power at the end of the fifteenth century. Botticelli had already
lent his talents a few years earlier to a team of artists
decorating the newly constructed Sistine Chapel of Pope
Sixtus IV (1481). The Sistine Chapel resembles Mantua's
Camera Picta in serving not only for papal services but also as
the assembly hall for the conclave of cardinals who choose
each new pope. Along the bottom of the Sistine Chapel
Botticelli and his contemporaries produced a double cycle of
fresco narratives, offering in parallel the lives of Moses and
Christ as the biblical precedents and justifications for papal
leadership of the Catholic Church.

The importance of spiritual authority in the life of Moses
emerges clearly from Botticelli's Sistine Chapel fresco, *The*

**4.61 (Opposite) Andrea Mantegna, Camera Picta, Ducal
Palace, Mantua. Ceiling fresco.**

**4.62 Sandro Botticelli, *The Punishment of Korah*, Sistine
Chapel, Rome, 1481. Fresco.**

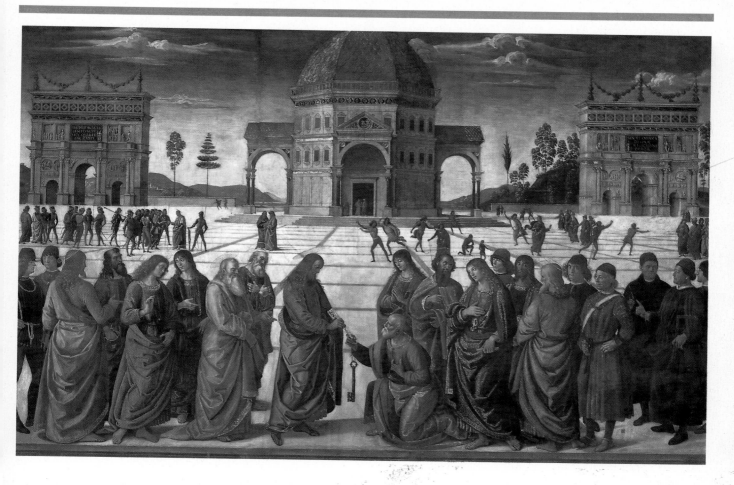

4.63 (Above) Pietro Perugino, *Delivery of the Keys of the Kingdom to St. Peter*, Sistine Chapel, Rome, 1481. Fresco. (Opposite) Detail of center.

Punishment of Korah (Fig. **4.62**, p.181), an event (Numbers 16) where divine punishment for a rebellion against the leadership of Moses leads to the rebels being swallowed up into the earth (at lower left). Botticelli emphasizes the relevance of the Old Testament to papal Rome by placing the image of the Arch of Constantine (Fig. 2.66), the first Christian emperor of Rome, at the exact center of his composition; the arch is inscribed with lines by St. Paul: "No one takes this honor upon himself, but he must be called by God, just as Aaron was (Hebrews 5;4)." Below the arch, the priest Aaron swings his censer, as the patriarch Moses angrily raises his punishing rod. Together they dramatically encompass the roles and powers claimed by the revived papacy.

Significantly, the fresco opposite Botticelli's in the Sistine Chapel is the *Delivery of the Keys of the Kingdom* by Raphael's teacher, Pietro Perugino (Fig. **4.63**). This is the scene in which Christ effectively institutes papal authority through his presentation of the Keys of Heaven and Earth to St. Peter, the first pope. Again the background features ancient Roman triumphal arches, based on the Arch of Constantine. These arches flank an imagined, ideal temple structure, based (like Brunelleschi's San Lorenzo sacristy) on the geometrical perfection of a domed central space, here a polygonal variant of the circle-in-square.

Perugino's Sistine Chapel fresco in many respects presents a summation of the accomplishments of the Early Renaissance in Florence. His solid figures have the dignity and solidity first achieved in painting by Masaccio; their antique costume evokes comparison to the prophets and saints of Donatello. Ancient Roman structures and their modern emulations by Brunelleschi now embody the ideal spaces of the revived Church within the very heart of the Vatican. Pictorial decoration now is capable of fully capturing both natural description (such as the portraits of contemporaries at the margins of Perugino's composition) and ideal figures or structures. Perugino's image, however, adorns not Florence, but rather the spiritual center of papal authority in Rome. The religious center of Italy and of Christendom now boldly asserted its cultural and artistic centrality as well, and for titans such as Michelangelo, Raphael, and Bramante, Rome – not Florence or Mantua – would be the grand stage on which the High Renaissance would find its greatest fulfillment.

5

LATER RENAISSANCE IN ITALY

In 1501, when Michelangelo Buonarroti (1475–1564) returned to his adopted city of Florence after his first sojourn in Rome (1496–1501), he found the city changed. A new constitution provided for rule by an elected *gonfaloniere*, and the city proudly styled itself a republic after years of domination by the Medici. To celebrate the new politics, the city commissioned a colossal sculpture from Michelangelo: *David* (1501–04; Fig. **5.1**). The idea for this carving went back to the era of Donatello almost a century earlier, for the 18-foot (55-meter) block of marble was originally purchased in 1464 to provide a new buttress sculpture for the cathedral, presumably by Donatello, who died shortly thereafter in 1466. The idea for such a colossus follows an earlier terracotta *Joshua* by Donatello (1410; lost), made for one cathedral buttress, and his smaller, life-sized marble *David* (1408–09), removed from its cathedral context to be used as a symbol of Florentine civic liberty. The commission for Michelangelo was actually a fusion of three previous Donatello projects, marble like the *David*, yet colossal like the *Joshua* (which would have been constructed out of separate terracotta elements), and nude like his bronze *David* (Fig. 4.54). Whether Michelangelo came back to Florence because of the challenge of carving this giant marble or because of the new republican government remains moot. Their coincidence nevertheless provided a unique opportunity on the eve of the new century, akin to the great commission for the baptistery doors won by Ghiberti exactly a century earlier in Florence. Typical of artists in Florence, from the bronze doors onward, Michelangelo strove to surpass both his rivals and his predecessors, including Donatello's marble and bronze sculptures of David.

Detail of Fig. 5.33, Albrecht Dürer, *The Feast of the Rose Garlands*, p.209.

ROME REVIVED AND FLORENCE

The great mid-sixteenth-century history of Renaissance art in Italy, particularly in Florence, Giorgio Vasari's *Lives of the Artists* (1550), takes as its guiding premise the proposition that art does not merely evolve from generation to generation but that it actually progresses. From the generation of Giotto and Duccio (Fig. 4.31), art in Italy has attained the current "supreme perfection" of Michelangelo, the first artist who could be said truly to surpass the ancients. As Vasari puts the progress in his preface:

"Although Giotto, for example, was much extolled in his day, I know not what would have been said of him, as of other old masters, if he had lived in the time of Buonarroti; whereas the men of this age, which is at the topmost height of perfection,

would not be in the position that they are if those others had not first been such as they were before us ... But he who bears the palm from both the living and the dead, transcending and eclipsing all others, is the divine Michelangelo Buonarroti, who holds the sovereignty not merely of one of these arts but of all three together ... In his own self he triumphs over moderns, ancients, and nature."

MICHELANGELO: DAVID

The symbolism of the triumph of David over the giant applies not only to Florence's political struggle for independence, like Donatello's marble, but also to Michelangelo's own heroic personal striving to express spiritual beauty through art. The particular, personal significance of the *David* for the artist emerges from one of his drawing studies for the figure's powerful right arm. The artist appended to this preliminary detail, in his own script, the lines "David with the sling/ And I with the bow [or drill]." The courage and daring of the biblical hero thus parallel the artist's own struggles.

In contrast to Donatello's two youths, this sculpture shows not the triumphant hero with his heel resting on the severed head of Goliath after the climactic moment of battle, but rather the apprehensive challenger posed in tension prior to the actual combat. The stance derives from ancient models of *contrapposto*, counterpoise, with all of the weight carried by a single, standing leg, suggesting both ease and readiness for action. Yet in his pose, too, Michelangelo's powerful hero remains tense, for he does not counterbalance the lower body by reversing its weight balance in the upper body but instead he doubles the contrast between the two sides of the figure. Thus David's piercing stare caps an entirely open – and vulnerable – left side, with the sling still resting on his shoulder, showing none of its lethal potential. The relaxation of the lower body builds to a crescendo of tension in the neck, gaze, and brow of the muscular youth, thus investing him with energy and life beyond his athleticism. Ultimately, though, the physical beauty and muscular strength of *David* serve as metaphors for his spiritual strength, just as the superhuman scale of the sculpture suggests heroic human grandeur and potential.

In the *David*, Michelangelo invigorates the forms and ideals of ancient art, fulfilling Vasari's claims of artistic progress and the entire enterprise of the Renaissance, to revive and rival antiquity, as first dreamed of by Petrarch. The *David* is at once a modern creation, in the tradition of ancient sculpture, and a fusion of classical beauty with Christian content. A sculpture such as this enhanced the reputation of the city as well as that of the artist. Not surprisingly, then, the city fathers decided, as did their predecessors with Donatello,

5.1 Michelangelo, *David*, 1501–04. Marble, 14 feet 3 ins (4.34 meters) high. Accademia, Florence.

to install the colossus not on the cathedral but rather at the secular center of the city, the Piazza della Signoria, right in front of the Old Palace. There its stormy gaze turned southward toward Rome, as if issuing an ongoing warning to the exiled Medici. (Ironically, the Medici returned to Florence in 1512 and saw one of their number elected pope in Rome as Leo X in 1513.) Its fame was so great that Michelangelo was summoned away from Florence to Rome in the very next year, 1505, to begin work on an even larger sculpture project: the tomb of the current pope, Julius II (p. 200).

LEONARDO DA VINCI

Michelangelo was not the only great Florentine artist to return to the city at the dawn of the new century. Leonardo da Vinci (1452–1519), actually almost a generation older than Michelangelo, had spent the previous two decades (1481–1500) in the service of a despot, Lodovico Sforza, at the court of Florence's traditional enemy, Milan. When invading French troops occupied Milan in 1499, Leonardo returned to Florence, where his painting caused as great a stir as Michelangelo's

5.2 Leonardo da Vinci, *Virgin and Child with St. Anne*, 1501. Charcoal on paper, with highlights, 55¾ × 41 ins (141.6 × 104 cm). National Gallery, London.

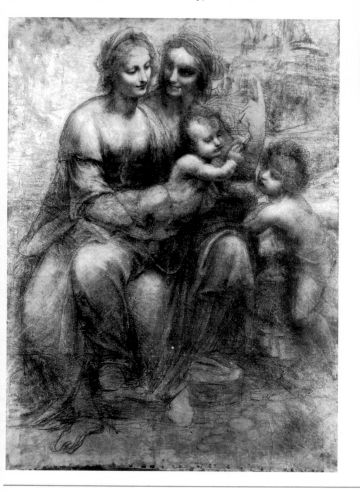

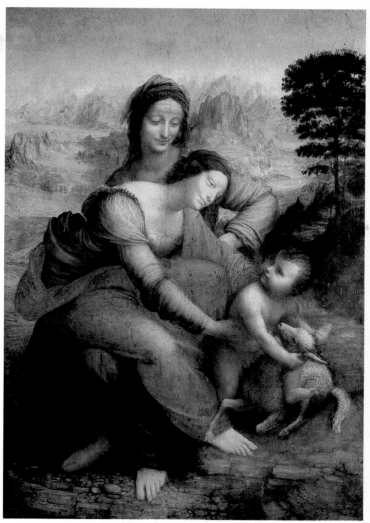

5.3 Leonardo da Vinci, *Virgin and Child with St. Anne*, ca. 1508. Oil on panel, 66¼ × 51¼ ins (168 × 130 cm). Louvre, Paris.

sculpture had done. In 1501, Leonardo put on display a *cartoon*, or full-scale drawing, of the Virgin and Child with the mother of the Virgin, St. Anne. Vasari tells us that this cartoon was "not only marveled at by all artists, but, when it was completed, men and women, young and old, crowded continuously for two days into the room where it was exhibited, as if attending a solemn festival: and all were astonished at its excellence." That cartoon is now lost but must have resembled the surviving second cartoon of the same figures from 1501 (Fig. **5.2**), and it underlies the eventual Leonardo painting of *Virgin and Child with St. Anne* (ca. 1508/10; Fig. **5.3**).

The surviving cartoon primarily displays Leonardo's mastery of drawing. Like most of his figural compositions, this drawing was the culmination of a long series of careful preparatory studies, often in the same chalk medium as the cartoon, of individual heads and bodies as well as the entire group. His constant reworking had a purpose, as he recounted in his reconstructed *Treatise on Art*: "You who compose

subject pictures, do not articulate the individual parts of those pictures with determinate outlines, or else there will happen to you what usually happens to many and different painters who want every, even the slightest trace of charcoal to remain valid; this sort of person may well earn a fortune but no praise with his art, for it frequently happens that the creature represented fails to move its limbs in accordance with the movements of the mind . . . Now have you never thought about how poets compose their verse? They do not trouble to trace beautiful letters nor do they mind crossing out several lines so as to make them better. So, painter, rough out the arrangement of the limbs of your figures and first attend to the movements appropriate to the mental state of the creatures that make up your picture rather than to the beauty and perfection of their parts."

This passage not only suggests something of Leonardo's working method but also one of the reasons why he became notorious for never finishing or letting go of his art projects; they were always subject to revision, to polishing, in search of greater integration or perfection. For this reason Leonardo's art finds its fullest expression in the countless pages of his notebooks, in his preparatory sketches and unexecuted projects. Moreover, his text draws upon a sister art, the more prestigious ancient liberal art of poetry, as the guiding model for painting. He seeks in this way to elevate the professional status of an artist, by attributing to him great learning and emotive power, to that of the poet. Because of the importance of mental activity over the manual execution of a work of art, the principal virtue of any creation thus lies in its inventiveness, its ideas.

If we compare Leonardo's cartoon to Michelangelo's sculpture, their interest in the mental life of the individual is strikingly similar, as is the way in which the parts of the body are coordinated. The mysterious atmosphere of the cartoon is created by the indeterminancy of outline in Leonardo's chalk medium and by his constant revisions. Such mystery, summarized by the phrase *sfumato*, or misty blending of shapes and tones, derives from Leonardo's process of composition. His treatise calls in one famous passage for the artist to contemplate clouds or even irregularities on wall surfaces to produce new visual forms. Both the shadows and the uncompleted sections at the margins of the London cartoon suggest that he was using just such a technique. Painting should stimulate the imagination of the viewer, too, to take an active role in looking at a picture.

In the surviving cartoon a cluster of figures drawn from standard Italian religious imagery coheres dramatically, almost like a narrative. A contemporary description of the lost cartoon (cf. the Louvre canvas) singles out the gestures and motivations of the three generations of holy figures, who interact against the background of a crowded composition. Such complex poses and movements in space by these dominant figures are another kind of invention, different from the sculpted figures of Michelangelo. Leonardo deliberately invokes competition between painting and sculpture for visual supremacy.

This "comparison" (*paragone*) also forms part of his (typically uncompleted) treatise on painting as reconstructed from his notebooks. He stresses the difference between mere mechanical processes and true science, for theory as the guide to practice. On this basis he allies painting with scientific principles (such as perspective and other branches of optics) and thus with philosophy as well as poetry. He prefers painting to poetry by virtue of the "superiority" of vision to hearing, and he favors the more intellectual (also more gentlemanly and tidy) activity of the painter to the sweaty manual labor of the sculptor.

In the more finished Louvre canvas (Fig. 5.3), the holy figures sit before a vast, primeval mountain landscape, shrouded in the hazy blue mists of distance. Both the mountains and the foreground ledge of stratified rocky outcrop derive from the other side of Leonardo's visual explorations, the complement to his inventive *fantasia*: detailed visual observation of nature. Both of the natural elements in the Paris painting derive from individual drawing studies in Leonardo's notebooks. A landscape in red chalk of an Alpine storm (Fig. 5.4) shows his vision of the grandeur and forces within nature, just as a more detailed study of rock formations

5.4 Leonardo da Vinci, *Alpine Storm*, ca. 1500. Red chalk on paper. Royal Library, no. 12409, Windsor Castle.

5.5 Leonardo da Vinci, *Mona Lisa*, 1503–06. Oil on panel, 30¼ × 21 ins (76.8 × 53.3 cm). Louvre, Paris.

reveals a strikingly modern geological awareness of natural processes such as uplift. Leonardo's mountain climbs exposed him to fossils in uplands and led him to conclude that these marine creatures once had lived in former oceans. Leonardo's natural observations ranged from minute attention to botanical specimens (cf. the background tree in the Louvre canvas, akin to a chalk study of lighting on a tree) to studies of fluids in motion, whether water currents or imagined cataclysmic mountain deluges. In the case of such floods, Leonardo's scientific observation combines with his imaginative powers to produce sublime images based on natural principles. He was then able to apply this to his depiction of religious figures in landscape in the Louvre painting.

Much the same mystery informs Leonardo's most famous picture, the portrait of a woman in front of a similar primeval mountain landscape, known today as the *Mona Lisa* (ca. 1503; Fig. **5.5**). Like the cartoon, as well as the later Louvre holy figures, this bust-length figure embodies a complex pyramidal *contrapposto*, turning slightly within space as she confronts the viewer from above a balcony. The same air of mystery through *sfumato* (especially around the eyes and the mouth, with its renowned near-smile) is here employed for a living subject rather than holy figures. Her dignity is further enhanced by her

apparent domination over nature. Behind the portrait an open expanse of geological processes and cycles is visible; they find their echo in the rippling folds of her garments and ringlets of hair. Like the holy figures of both cartoon and canvas, this anonymous woman (the wife of Francesco del Giocondo, "La Gioconda," according to Vasari) seems to be mistress of all that she surveys. Doubtless her commanding presence with its ineffable sense of mystery was what instantly made Leonardo's portrait unforgettable – and much imitated by artists in Florence, beginning with Raphael (*Maddalena Doni*; ca. 1506). In this astonishingly original conception of a mortal figure challenging the very processes of creation in nature, Leonardo da Vinci manifests the same titanic ambitions in paint as Michelangelo's *David* did in stone during those very same years.

"RENAISSANCE MAN" Leonardo returned to Milan in 1508, where he painted the Louvre *Virgin and Child with St. Anne*. His service to the court there consisted of far more than painting, however; he also worked as architect, engineer, and general designer, of pageant scenery and costumes as well as the design and preparation in clay of an equestrian monument. In addition, his personal investigations included meticulous dissections of the human body and equally meticulous rendering of the observed anatomy. Such accomplishments in all fields suggest the versatility and genius of what has come to be known as a "Renaissance man." Although Leonardo's notebooks were not published, his "scientific" drawings and studies serve as a harbinger of what would become the "scientific revolution" later in the century. In keeping with his insistence that there could be no practice without theory, Leonardo's endless exploration of the natural world, as well as his studies of faces, limbs, and anatomy, all found visible form in notebook drawings. Moreover, he did not consider himself primarily as an artist, nor did he distinguish between design as engineering, scientific observation, or artistry. His original letter of introduction to Lodovico Sforza stresses his talents as a military engineer, offering many new and secret inventions of war; only at the end of his letter does Leonardo mention that he could – in peacetime – offer additional skills of building design, hydraulic engineering, sculpture (in marble, bronze, or clay), and "painting I can do as well as any man." He left Milan again in 1513, bound eventually (1516–19) for the court of the King of France, though he first briefly visited Rome and renewed his connection with the reinstated, French-backed Medici. His path to France would later be followed by numerous Italian artists, whose decorations of the royal palace at Fontainebleau from 1533 onward glorified Francis I.

RAPHAEL: THE FLORENTINE INFLUENCE Leonardo's comet-like visits to Florence produced lasting effects on a succession of younger artists, most notably on Raphael (Raffaello Sanzio, 1483–1520), who settled in Florence briefly around 1505, just as Michelangelo and Leonardo were finishing the *David* and *Mona Lisa*. By 1508

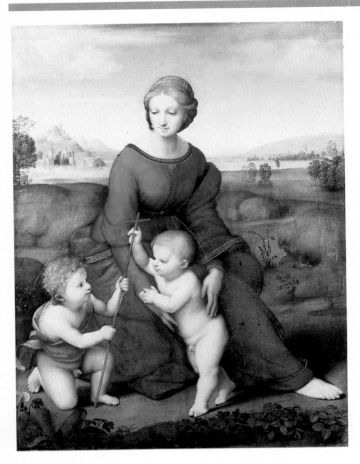

5.6 Raphael, *Madonna of the Meadows*, 1505. Oil on panel, 44½ × 34¼ ins (113 × 87 cm). Kunsthistorisches Museum, Vienna.

Raphael, too, was called to the Rome of Julius II to work alongside Michelangelo at the Vatican. His Florence creations clearly emulate Leonardo's in a series of Madonna pictures more lyrical than their prototype. For example, the 1505 *Madonna of the Meadows* (Fig. **5.6**) adopts the pyramidal composition of the cartoon, as well as Florence's patron saint, John the Baptist, but instead of the craggy mountain pinnacles of Leonardo, Raphael substitutes a summery meadowland that echoes the outlines of the Virgin's shoulders. Clear, lightly shaded color counters the shadowy, mysterious *sfumato* of Leonardo. Both the color and the counterpoised body positions fuse the composition into a harmonious, organic whole, subtly calibrated away from a central axis. Even after his arrival in Rome, Raphael continued to experiment with variations on this basic Madonna and Child theme, using a perfect circle to compose his *Madonna Alba* (ca. 1510) out of a gesture still analogous to Leonardo's floating gestures in the cartoon. In typical Florentine fashion, Raphael produced preliminary drawing studies for both the overall composition and a figure adopting the chosen pose of the Madonna in the Washington circle (*tondo*). Once more, art responds to art; Raphael's serene formulations, in turn, would serve as a model for academic ideals of religious pictures for centuries to come.

THE NEW ST. PETER'S

The Rome of Pope Julius II (1503–13) in which Michelangelo and Raphael arrived buzzed with the pontiff's grand political-religious ambitions, some of which he hoped to realize through art. The measure of his claims to recapture the grandeur of the ancient empire through the modern papacy can be seen in his desire to leave his mark on the church of St. Peter in the Vatican. For Julius II dared to tear down the oldest, most sacred building in Christendom, the basilica of Constantine, in order to erect a much larger, ideal structure based upon the perfect geometrical figures of the circle and the square. In some respects this vision had been that of Julius II's uncle, Pope Sixtus IV, who constructed a new Vatican chapel that took his name, the Sistine Chapel (1473). Among the decorators of the fifteenth-century Sistine Chapel, along with Botticelli, was Raphael's teacher, Pietro Perugino, whose fresco, *Delivery of the Keys of the Kingdom to St. Peter* (1481; Fig. 4.63) sets the stage for Julius's later fusion of imperial forms with Christian content. Behind the principal figures, who enact

5.7 Leonardo da Vinci, Plans and views of domed churches, ca. 1490. Black chalk on paper, 9⅙ × 6⁵⁄₁₆ ins (23.2 × 16 cm). Institute de France, Paris.

the institution of papal power by Christ himself, a centralized church serves to represent the Church itself. That ideal building is flanked by a pair of ancient Roman triumphal arches, themselves based upon the surviving monument founded (like the old basilica of St. Peter's itself) by Constantine, the first Christian emperor. These arches further bear inscriptions that compare the building program of Sixtus IV to that of Solomon, who built the holy temple of the Old Testament (cf. Justinian's rivalry with Solomon at Hagia Sophia): "You, Sixtus IV, unequal in riches but superior in religion to Solomon, have consecrated this vast temple." Dominating Perugino's fresco, the symmetrical polygonal structure is capped by a central Brunelleschi-like dome. Perugino's imagination here has given the new Roman mother church its future form.

The idea of a centrally planned church, composed around the perfect geometry of either circle or square, links architectural planning to the geometrical experiments of painters. Leonardo's famous "Vitruvian Man" drawing (ca. 1485–95; Fig. 4.44) recreates the premise posited in Vitruvius's classical text, *Ten Books of Architecture*; namely, that the perfection and harmony of the human body could be demonstrated by inscribing a man with his hands and feet extended within the perfect figures of circle and square. From this connection between geometry and the body Renaissance architects went on to imagine perfect temples like the one visualized by Perugino around the same geometrical principles. Vitruvius's own text had related the harmony of the body to that of a temple: "In the components of a temple there ought to be the greatest harmony in the symmetrical relations of the different parts to the magnitude of the whole." Leonardo, taking off from this model, designed a building planned around circle and square in his notebooks (ca. 1488–89; Fig. **5.7**). In both the plan and elevation of his design Leonardo utilizes plane and solid geometry of circle, polygon, and square to create a building structured around the support of a massive dome, similar to Brunelleschi's great model in Florence. The design possesses a more massive, symmetrical clustering of integrated supporting chapels and apsidioles than had been conceived in Perugino's painted fantasy in the Sistine Chapel. In his architectural speculations as well as his figures, Leonardo produces organic unities out of geometrically conceived individual parts, rendered convincingly in chalk and ink as if they were three-dimensional figures.

BRAMANTE Working alongside Leonardo in Milan for the Sforza court was a worthy practical architectural successor to Brunelleschi, Donato Bramante (1444–1514). Like many architects of the day (including Michelangelo and later, Raphael), Bramante began his career as a painter-designer, and, like Leonardo, he prized theory and mathematical principle in design more highly than the practical building concerns of masonry construction or engineering. Bramante arrived in Rome in 1499, the same moment as the French occupation of Milan had impelled Leonardo to return to Florence.

5.8 Donato Bramante, Tempietto, San Pietro in Montorio, Rome, ca. 1502.

Bramante, too, created a breakthrough in building design just after the turn of the century. In 1502 he accepted a commission from the king of Spain for a "little temple," or Tempietto, at the church of San Pietro in Montorio in Rome (Fig. **5.8**). This structure marked the site where St. Peter had been martyred, according to legend, and its mausoleum function led Bramante to design it as a round, domed building after the Early Christian model of circular or polygonal *martyria*. Original plans called for a circular courtyard extending around the small building, presenting a fully integrated spatial ensemble with the temple like a central piece of sculpture or enlarged *reliquary*. Although that courtyard was never constructed, the final Tempietto offered a new vision of creative design with classical elements, the first building since antiquity with a colonnaded porch encircling a central space. Even its columns are orthodox Doric, appropriate to the solemn tomb of a great hero. Perhaps more important, the use of the geometrically pure circle plan is reinforced by the central domed structure, which, despite the small scale of the building, has a massive solidity. In contrast to the additive repetition of geometrical and classical elements by Brunelleschi, even in his domed San Lorenzo Sacristy, Bramante has broken free of the ornamented, flat wall surface to create a new kind of centralized space as an integrated volume at the Tempietto.

5.9 Donato Bramante, St. Peter's. Plan, 1506

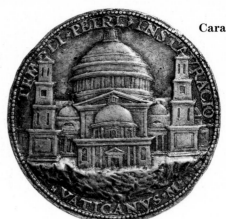

5.10 Christoforo Caradosso, bronze medal of St. Peter's, 1506. British Museum, London.

In 1505 Bramante entered the service of Pope Julius II with plans for remodeling the papal palace at the Vatican. Bramante provided him with an enormous terraced courtyard, framed by walled passageways, that extended up a hill to a great apselike axial niche built into the structure of a small papal retreat, the Belvedere. This courtyard, the Cortile del Belvedere, could serve as a sculpture garden and pleasure garden like that of a villa, and it boldly recaptured the spatial and architectural effects of the grandest ancient Roman imperial villas, such as Hadrian's Villa at Tivoli. This kind of spatial imagination would find its ultimate expression in Bramante's monumental plan for St. Peter's.

In 1506 Bramante was named chief architect of St. Peter's, and his grandiose vision is apparent in the ground plans (Fig. **5.9**). The church was organized in the shape of the Greek cross, its equal arms contained within a square, rather than the longitudinal Latin cross that was traditional in Christian basilicas. Each arm ends in an apse, making the building fully symmetrical around a central, domed space at the tomb of St. Peter. The dome is supported on four colossal piers, each hollowed with semicircular niches, and half-domes cover the apses in the original plan. The exterior of Bramante's building plan can only be surmised from a view of it on a 1506 commemorative medal, struck on the occasion of the laying of the cornerstone (Fig. **5.10**). Its shape resembles Leonardo's drawing project in its massed volumes supporting a hemispherical dome, derived from the Roman model of the Pantheon. Only at the corners, where octagonal *sacristies* support tower accents, is the geometry varied. The total effect of both the plan and the elevation suggests a coordination of geometrically pure elements, radially symmetrical in four directions extending from the central dome, akin to the hierarchical unity achieved a millennium earlier at Hagia Sophia (Fig. 3.10).

The key to Bramante's plan was the four central piers at its core, supporting his dome. Like his smaller experiment at the Tempietto, this kind of design presents a new conceptual framework, built from a central volume outward instead of constructed out of repeated, successive spatial units growing out of either end of a building. On the same principle, Bramante was able to inject voids into the solid masonry of his giant piers, making space into a potentially dynamic and

volumetric force, rather than a mere absence. He borrowed from ancient Rome (particularly from its giant vaulted baths) the technique of concrete construction to permit such a molding of space within the demands of the supporting structure.

The construction work was interrupted by the death of Bramante in 1514 (Julius II died the year before), and it was continued for a full century and a half by a succession of designer-architects, including Raphael, Michelangelo, and, at the conclusion, Gianlorenzo Bernini. A full generation elapsed before Michelangelo, already an old man, assumed duties as papal architect in 1546, but in many ways the definitive form of St. Peter's was shaped by him. He was fully constrained by the piers of Bramante, but cut away the outer arms of the smaller Greek crosses as well as the corner sacristies in order to fuse a "muscular," coherent, square containing wall around the central square formed by the piers. His preference was for a less purely geometrical and more direct structural connection of parts to form a whole. The perimeter, shaped like a

5.11 Michelangelo, St, Peter's, Vatican, 1546–64. Elevation plan, engraving by Etienne Duperac. Metropolitan Museum of Art, New York.

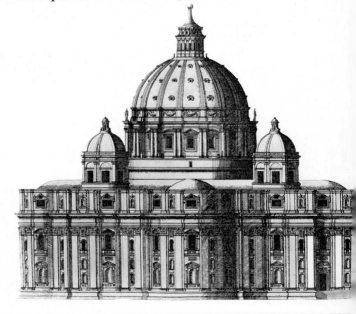

5.12 Michelangelo, St. Peter's, Vatican, 1546–64. Exterior, view from southwest.

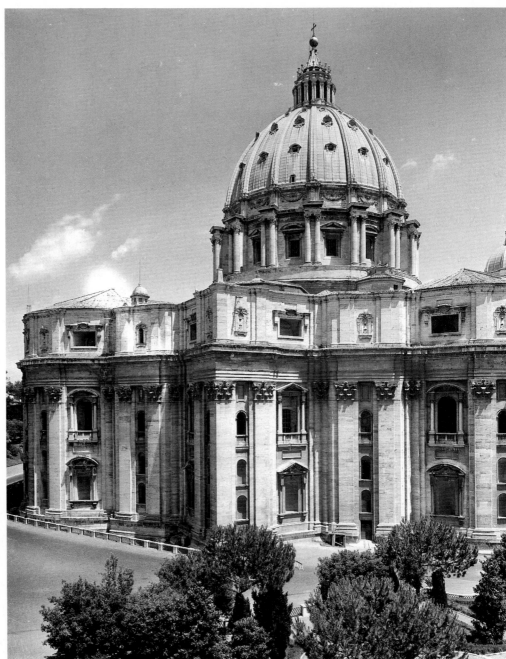

5.13 Michelangelo, St. Peter's, Vatican, 1546–64. Ground plan.

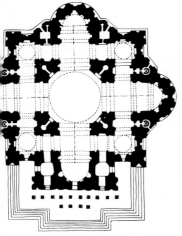

diamond, was articulated on its exterior with strong vertical accents, broken briefly by a thick cornice band and a narrow attic (Fig. **5.11**). Michelangelo used colossal attached pilasters on his wall surface, inside and outside, echoing the interior majesty of the central piers. His own dome project continued this vertical quality through coupled columns in its drum and ribs extending up the dome to a lantern, like Brunelleschi's dome in Florence (p. 162). The result is a dynamic spatial volume, organically coherent but with a subtle accent at its primary, west entrance (Fig. **5.12**). There a colonnaded porch, based on the model of the Pantheon, provides an axial emphasis and suggestion of basilical extension compromising the perfect symmetry of the original central plan.

The plans of Michelangelo, too, would be altered by his successors (his drum was surmounted by a more elevated and pointed dome, and his entrance was eliminated in favor of a traditional, long nave that reasserted basilical tradition and liturgical processions). But except for its lengthened nave, the ground plan and the basic elevation of St. Peter's retain Michelangelo's revisions: a square ambulatory pattern linking three equal apses at the ends of Bramante's Greek cross spaces (Fig. **5.13**). Internal accents in the central apse and over the tomb of St. Peter at the crossing would complete St. Peter's a hundred years after Michelangelo in the hands of his worthy emulator, the sculptor-architect Gianlorenzo Bernini (1598–1680; p. 247).

RAPHAEL AT THE VATICAN

While Bramante's great piers at St. Peter's were still under construction, and while his Cortile del Belvedere was rising at the edge of the papal palace at the Vatican, Raphael began his work on the fresco decorations of the third floor of the papal apartments overlooking the Belvedere. Julius II resided on this elevated third storey, and he commissioned Raphael to decorate a suite of rooms, beginning with the library, known today as the Stanza della Segnatura. In keeping with the function of the room, Raphael's frescoes take learning of all kinds as their subject. Taken together, these frescoes provide a summation of the Renaissance blending of ancient and modern, pagan and Christian, in a new and magnificent synthesis, a reconciliation known as syncretism. The overall scheme is sounded on the ceiling by personifications of Theology, Poetry, Philosophy, and Law, while each wall embodies one of these abstractions.

5.14 Raphael, "*School of Athens*" (Philosophy), Stanza della Segnatura, Vatican, 1509–11. Fresco, 26 × 18 feet (7.92 × 5.49 meters).

THE SCHOOL OF ATHENS Under Philosophy Raphael creates a gathering of ancient sages of various eras under a grandiose, imagined, Bramantesque fantasy vault and dome: the "*School of Athens*" (1510–12, the last of his wall frescoes in the library; Fig. **5.14**). To either side of the vault are classical statues in niches; foremost among them are the presiding deities of poetic inspiration, Apollo (adjacent to the side wall embodying Poetry), and of reason, Athena (alongside Law). The ensemble was carefully plotted from preliminary drawing studies of individual figures, often from poses by studio assistants, and the entire composition was prepared in a full-scale cartoon, which, however, does not yet indicate the vast architectural setting. This vast gathering of venerable thinkers can be compared to the choirs of venerated saints in earlier religious works, such as Duccio's Siena Cathedral *Maesta* two centuries earlier (Fig. 4.31). Spatially, this composition of figures within a large, vaulted, classical space emulates the Florentine precedent of Ghiberti's bronze *Solomon and Sheba* (Fig 4.49). Antiquity has truly been brought to life here, as Raphael completes Bramante's ideal classical space. Heading the roster of philosophers at the top and center are the paired, toga-clad figures of Plato, white-

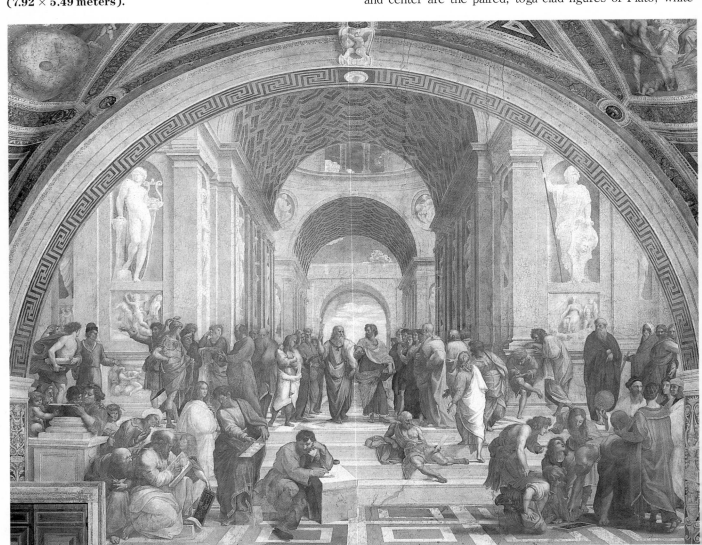

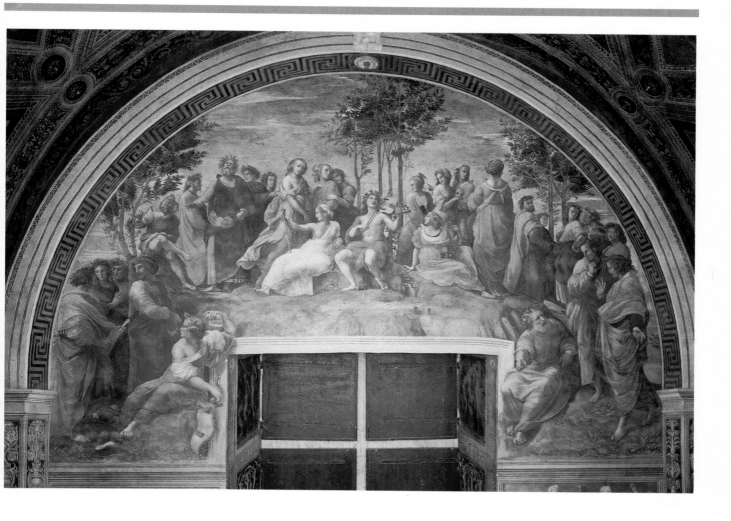

5.15 Raphael, *"Parnassus"*, Stanza della Segnatura, Vatican, 1509–11. Fresco.

bearded and gesturing to the heaven of his Platonic ideals, and Aristotle, dark and turning outward to the empirical, physical world of observation. These two actively debate common philosophical questions in their rational approach to truth.

Numerous other figures in the scene can be identified: Pythagoras making notes in a large book at the lower left foreground, Diogenes stretched out with his bowl on the steps, and Euclid measuring a geometric figure with a compass on a slate at the lower right. Thus to the side of Plato appear the speculative philosophers, whereas on the side of Aristotle the naturalists or empiricists predominate, with their globes of measurement above the head of Euclid. The dark, brooding figure in the bottom center does not appear in the preliminary cartoon; leaning upon a block, this gloomy philosopher is probably the arch-pessimist, Heraclitus, but in fact his features closely resemble the known portraits of Michelangelo. In all likelihood, this figure was added during the final stages of painting the fresco – at the moment when Raphael had his first chance to observe as work-in-progress the ceiling frescoes at the nearby Sistine Chapel (see p. 198), whose dates (1508–12) closely overlap the production period of the *School of Athens*. Thus the Heraclitus figure is Raphael's homage to Michelangelo, following the monumental example of his seated prophets on the ceiling (significantly, Heraclitus stands apart

from the animated discussions of the other philosophers). According to Vasari, the representation of Euclid is a portrait of Bramante, in tribute to his talent as a geometer, and there is also a self-portrait (in the right corner, looking out at the viewer).

THE PARNASSUS If the *School of Athens* presents the scientific and learned background of Renaissance achievement (and art, as the example of Leonardo has shown), then its companion fresco above the window of the Stanza della Segnatura counters with an image of classical poetry (the other model of art-making for Leonardo). Raphael's *Parnassus* (ca. 1509–11) shows the sacred mount of Apollo, who appears at the top center under his laurel tree with a bowed lyre (*lira da braccio*), an instrument used by singers to accompany themselves (Fig. **5.15**). He is surrounded by the Nine Muses

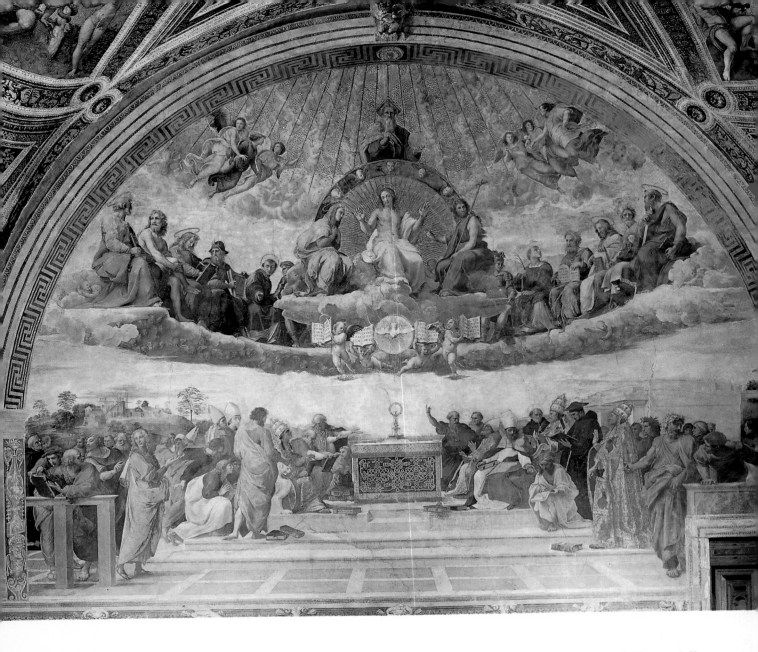

(and his instrument has nine strings rather than the customary seven) and by the great poets of antiquity, augmented by their Early Renaissance epigones, or imitators, Dante is on the summit (next to his mentor in epic poetry, blind Homer, and balanced on the other side by his own guide to the Inferno, Vergil), along with Petrarch and Boccaccio in the lower zone on either side of the window. The one female poet, Sappho, and a complementary writer opposite were added to the preliminary composition, and the plaster base of the fresco painting permitted Raphael to fuse them with the frame of the window, illusionistically intruding into the actual space of the room. This technique, extended still further by the use of stucco projections, would provide a visual bag of tricks for a host of ambitious wall decorators through to the eighteenth century. The painting surrounds the window overlooking the retreat at the Belvedere, home of the papal collection of antique sculptures, as well as its courtyard festival space, so the placement of *Parnassus* surely is intended to complement this realm of Renaissance entertainment and artistry.

5.16 Raphael, "*Disputa*" (Theology), Stanza della Segnatura, Vatican, 1509–11. Fresco.

THE DISPUTA Adjacent to the *Parnassus* and opposite the *School of Athens* is the wall with Christian revelation of truth, entrusted to the learned theologians of the early Church. The subject is usually known as the *Disputa*, or learned discussion (Fig. **5.16**), in this case on the subject of the holy sacrament. This fresco was probably the first one painted in the library room (ca. 1509–11). Like the *School of Athens* painted soon after it, the *Disputa* is structured by the steps, but its top center features not a human but rather the eucharist on an altar. Here the space is created solely through figures, and a celestial assembly of "saints" (actually figures from both Old and New Testaments) sits upon a cloud that recedes into depth like the *hemicycle* of an apse. Like the vertical hierarchy of Masaccio's Florentine *Trinity* fresco (Fig. 4.45), a heavenly axis above the eucharist runs upward from

he altar through the dove of the Holy Spirit to an enthroned Christ in a golden halo surmounted by a blessing God the Father. Pure gold fills the top of the vault of heaven, echoed by the halo of Christ as well as a smaller halo for the dove and the circular, gilded *monstrance* that displayed the eucharist. For the varied assembly of Church Fathers and theologians more than forty drawings survive. These include both individual figure studies, nude and draped, and compositional groups.

In the distance at the left, a building is being constructed, while in the right background sits a massive masonry pile. Both suggest the actual construction of Bramante's piers for the new St. Peter's, and the apselike shape of the clouds and vault of heaven in the fresco above offers a symbolic rendering of the belief that the Church is a community of saints and scholars, living and dead. Taken as a whole, then, this image shows the direct links between heaven and earth in the form of the blessed sacrament, as well as the Vatican church space in which it is continually reconsecrated and celebrated in the mass. However, the eucharist is subject to ongoing and living human interpretation, indicated by the gestures of the theologians surrounding it (including Dante on the right side, adjacent to *Parnassus*). Enlightenment through theology stands alongside poetic inspiration or philosophy and science as a central concern within the modern, revived Catholic

5.17 Raphael, *Pope Leo X with Cardinals*, 1518. Oil on panel, 60½ × 47 ins (153.6 × 119.3 cm). Uffizi, Florence.

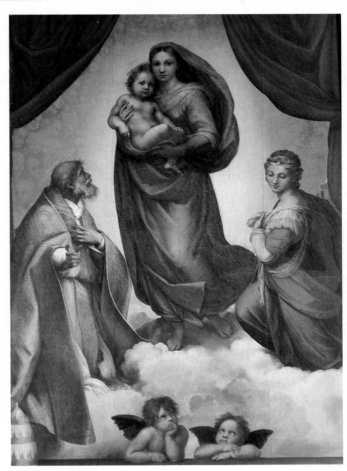

5.18 Raphael, *Sistine Madonna*, 1513. Oil on panel, 104½ × 77 ins (265.4 × 195.5 cm). Gemäldegalerie, Dresden.

Church, now able to embrace classical accomplishments within a Christian framework.

The triumph of the papacy becomes the explicit theme of Raphael's next series of frescoes in the papal apartments, the Stanza dell' Eliodoro, probably used as an audience chamber (ca. 1512–14). Here the frescoes depict dramatic scenes in which the papacy is miraculously protected. Portraits of Pope Julius II are included in these scenes – as the witness to a miracle, as the high priest in the Temple at Jerusalem, and as a fifth-century pope meeting Attila the Hun outside Rome. However, the death of Julius II in 1513 led to the substitution of the features of his successor, the Medici pope Leo X, in the latter fresco; in this case, this identification is highly appropriate, for it was his namesake, Pope Leo the Great, who bested Attila with the aid of the miraculous appearance of the flying saints. Pope Leo X can also be clearly recognized by comparison with a group portrait by Raphael of the pope with his nephews (1518; Fig. **5.17**). This portrait also employs the subtle oblique staging of the main figure of the pope in his chair, but it further reveals the self-indulgent aestheticism of this hedonistic (pleasure-loving) pope by placing the luxury illuminated manuscript and gilded bell on the table before him.

Raphael continued to enjoy the patronage of Leo X until his death in 1520. He served briefly as architect of St. Peter's (where he was the first to suggest a modification of the central plan toward a longitudinal basilica) and as curator of the papal collection of antique sculpture. The collection was the source for many of his figures as well as details of classical costume or attributes, plus decorative schemes of fresco and stucco in the connecting building designed by Bramante. He increasingly depended upon an enormous team of collaborators to assist in vast projects. Chief among his later contributions to the Vatican was a suite of designs for tapestries to hang on the lowest level of the Sistine Chapel (1515–16). Ten cartoons (of which eight survive) on the subject of the lives of Peter and Paul were woven into tapestries with gold and silver thread in Brussels; their powerful figures became a dictionary of High Renaissance narrative for Flemish painters as well as for all future tapestry designers. Such delegation of work increasingly dominated Raphael's later productions and served as a model for later artists, especially Rubens, in the use of a large workshop.

Raphael's most celebrated artistic legacy, however, is his *Sistine Madonna* (ca. 1513; Fig. **5.18**, p. 197), the culmination of his previous Madonna paintings. Commissioned by Julius II in honor of a canonized pope, Sixtus II (namesake of his papal uncle), the image also honors Julius by projecting his features onto the papal figure in heaven. The entire scene unfolds as a celestial vision through parted curtains, yet its luminous clouds appear directly before the viewer, with an unanswering gaze from the holy figures at the center (the flanking intercessor saints, Sixtus and Barbara, look upward and downward in a compositional counterpoint). The parted curtains, a convention on many tombs, as well as the *putti* and papal tiara of Sixtus II on a foreground ledge, are details that have prompted the hypothesis that this picture decorated the funeral bier of Julius

II before it was sent on to its eventual destination, the church of St. Sixtus in Piacenza. If so, it would function as a High Renaissance equivalent of commemorative tomb sculptures, like the Bruni tomb in Florence (Fig. 4.51). Here, too, Raphael's mastery of figural movement and overall composition reaches a climax, subordinating gestures and the sweep of drapery into a harmonious order, an image of heaven that is at once ideal yet human and accessible.

MICHELANGELO: THE SISTINE CHAPEL

After assigning the design of St. Peter's to Bramante, Julius II charged Michelangelo with the painting of the ceiling decoration of his uncle's Sistine Chapel, a task he began in 1508 (Fig. **5.19**). Michelangelo's main subjects are the early events of Genesis, recounting the fall of humankind from creation to the flood and the need for redemption accomplished first through *Mosaic law* and later through Christ and the Church. Yet the overall ceiling decoration devised by the artist already reveals the architectural talent of his later years, in the fictive piers and the thrones linked by transverse ribs. His figural program divides the space into three levels of holiness. The lowest zone fills the upper area of the wall surface and the triangular *spandrel* areas between the tops of the windows with a painted genealogy of the ancestors of Christ. Above them in sanctity and size the holy prophets of Christ's Coming sit on their thrones in the spaces between the triangles but underneath

5.19 Michelangelo, Sistine Ceiling, Vatican, 1508–12. Fresco. General view.

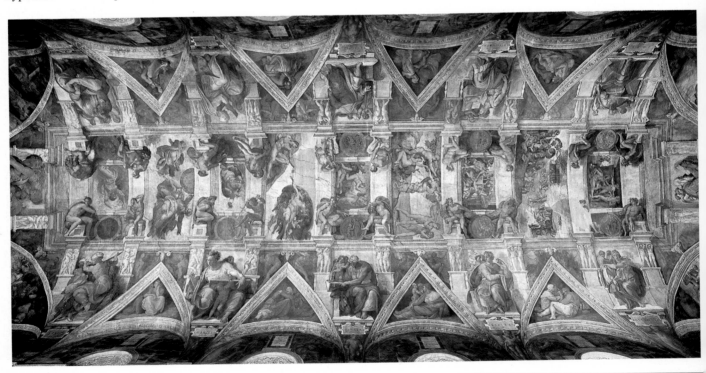

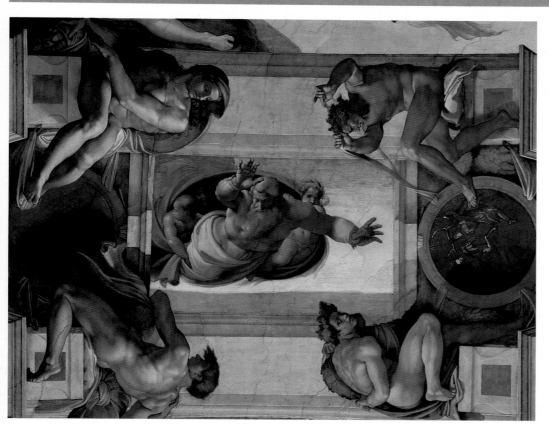

5.20 (Left) Michelangelo, Sistine Ceiling, *God Separates the Water and Earth and Blesses his Work*, 1508–12. Fresco (after cleaning 1989).

5.21 (Below) Michelangelo, Sistine Ceiling, *Study for Libyan Sibyl*, 1510–11. Red chalk, 11⅜ × 8½ ins (28.89 × 21.59 cm). Metropolitan Museum, New York.

the crest of the ceiling. These mighty figures consist of Old Testament males and pagan females, the *sibyls*, whose oracles in apocryphal Greek and Latin texts were interpreted by Christian scholars as enlightened pagan prophecy. In fusing these two sources of prophecy, Hebrew and pagan, Michelangelo accomplishes in the Sistine ceiling the syncretism of Raphael's library fresco cycle.

Michelangelo's prophets and sibyls evolved over four years from smaller figures firmly anchored within their throne framework to powerful, twisting forms which spill beyond their confines and look outward or upward, especially *Jonah* above the altar. For the late, torsioned *Libyan Sibyl*, Michelangelo's preliminary chalk drawing (Fig. **5.21**) shows the same kind of careful figure study as Raphael employed for his Vatican frescoes. This kind of exaggerated pose, typical of Michelangelo's later painting and sculptures, demonstrates the artist's inventiveness and his testing of the limits set by nature.

The climax of the Sistine ceiling, however, remains the Genesis scenes and their framing *ignudi*, adolescent male nude figures best understood as wingless angels. These youths sit at right angles to the biblical narrative and complete the visual continuum of the thrones. In this respect, they animate the painted cross-ribs of the ceiling and act as supports for the narrative, like the winged angels who normally surround and support holy figures (or the wingless angels around God the Father in the adjacent Genesis scenes). Michelangelo drew his inspiration for the *ignudi* from the recent discoveries in Rome of ancient sculptures, in particular the

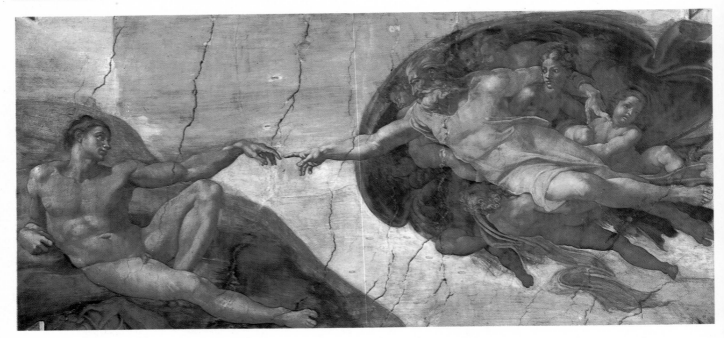

muscular *Torso Belvedere* of the papal collection, whose seated torsion underlies most of the *contrapposto* poses of these figures. Like the prophets and sibyls, the *ignudi*, too, increasingly break away from a mirror symmetry with one another toward a more complex individuality. These nudes epitomize Michelangelo's artistic conviction in his earlier works that the human body is a temple of beauty that is God's creation, even as the restless energy in the later nudes suggests much more a sense of constriction and the carnal imprisonment of the soul in the body than the heroic *David* (Fig. 5.1).

The Sistine Genesis scenes run outward from the position of the priest at the altar, yet they should be read beginning from the entrance opposite. The division between scenes of God creating the world and humankind's subsequent fall occurs right at the center of the Chapel, where a marble screen once separated the congregation from consecrated priests. For the scenes of the creation of mankind, Michelangelo made use of Renaissance precedents, including Masaccio's Expulsion scene in the Brancacci Chapel as well as carved reliefs by both Jacopo della Quercia of Siena and Ghiberti (on the Gates of Paradise) in Florence. He also reduced his images to essentially figural compositions, particularly the scene of the *Creation of Adam*, where God's animating gesture provides an effortless analogy to the creative activity of the sculptor (Fig. **5.22**). No greater claim for the nobility and dignity of the human body could be made, hence also for the sculptor as the artist of the human body. In this painted work Michelangelo provides his own retort in favor of sculpture to Leonardo's *paragone* argument for the superiority and status of painting. The comparison of Adam to *David* reveals a limp version of the same open side, now receptive to the divine touch of life while making explicit the dualism of passive body and active spirit. At the same time God's echoing posture, powerful body, and forceful, directed physiognomy fully embody the High Renaissance grandeur of the divine through the physical.

5.22 Michelangelo, Sistine Ceiling, *Creation of Adam*, 1510–11.

MICHELANGELO: THE JULIUS TOMB

Julius II certainly anticipated his tomb project. In fact, construction of a massive sculpted tomb ensemble for the pope led to the summons of Michelangelo to Rome in the spring of 1505. The enormous scale of the tomb – actually a mausoleum in the round rather than the wall tombs characteristic of Florence – had multiple consequences. Its vast size could not be accommodated to the scale and foundations of old St. Peter's; therefore, reconsideration of the building itself led to the eventual commission to Bramante for a completely new structure.

After the completion of the Sistine Chapel ceiling, Michelangelo returned to his interrupted project of the tomb for Julius II, simplifying what had been planned as a mausoleum in the round into a more traditional hierarchy of figures, still on a projecting slab. At the apex of the monument a standing Madonna and Child, similar to Raphael's *Sistine Madonna*, would have welcomed Julius II underneath on a sarcophagus, his head supported by angels. At the corner of that level on top of the slab, *Moses* (ca. 1515) would appear, complemented by a planned full figure of St. Paul, never executed. The lowermost zone of the tomb consisted of an alternating set of Victories and Captives, derived from an earlier plan with fettered allegories of the Liberal Arts. They recall the experiments of the *ignudi*, although the original forty figures of the 1513 contract with the heirs of Julius II were reduced to only a pair of more finished carvings: *Dying Slave* (ca. 1514; Fig. **5.23**) and *Rebellious Slave* (Fig. **5.24**). Here the bonds of the two

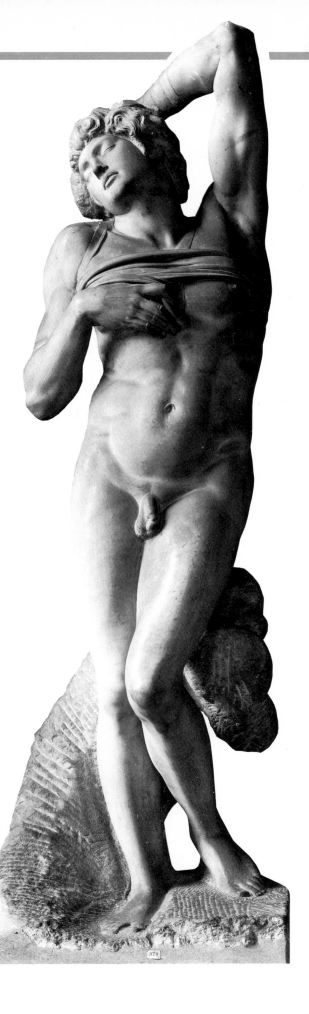

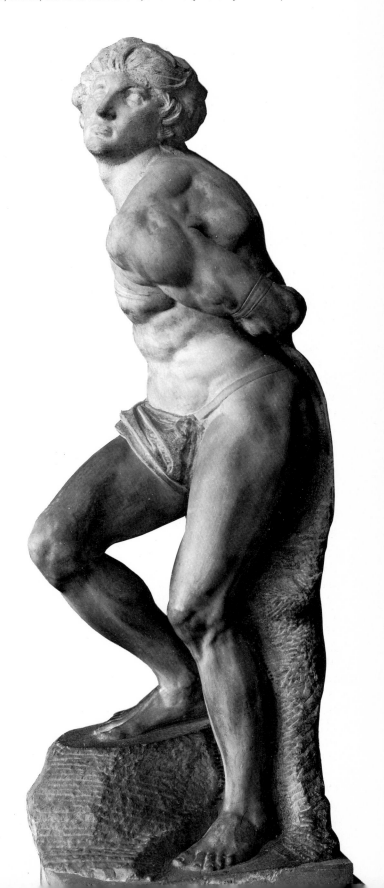

5.23 (Left) Michelangelo, *Dying Slave*, Tomb of Julius II, Rome, ca. 1513 ff. Marble, 90 ins (228.6 cm). Louvre, Paris.

5.24 (Below) Michelangelo, *Rebellious Slave*, Tomb of Julius II, Rome, ca. 1513 ff. Marble, 84⅝ ins (215 cm). Louvre, Paris.

idealized male nudes symbolize a striving spirit in thrall to the flesh. They are distinguished by their different responses to this human condition. One languidly subsides, overpowered by an irresistible force as if in drowsy ecstasy, whereas the other struggles and twists like one of the *Laocoön* figures (Fig. 2.49) or *ignudi* against his bonds. The *Dying Slave* stands in front of a small ape, only partly carved, which suggests the animal nature of mankind as well as the sensual explanation for the dreaminess of the figure, like the *David* overcome by torpor.

Along with the *Slaves*, Michelangelo's only original figure from the Julius tomb to be executed – and installed in the eventual compromise fragment erected in Julius's Roman

church of San Pietro in Vincoli in 1545 – is the *Moses* (Fig. **5.25**). Because of his planned elevated corner position, this great Old Testament leader twists in space and must be observed from below, but his stormy brow and muscular arms are reminiscent of the directed gaze and physical prowess of *David*. His seated *contrapposto* also echoes the pose of Sistine ceiling prophets, particularly *Ezekiel*. Of course, the combination of spiritual and temporal authority exercised by Moses made him an appropriate choice to lend weight to the papal claims advanced by Julius II with his armies, and he had already served as the counterpart of Christ in the Sistine Chapel wall frescoes. Michelangelo's fierce, staring figure conforms not only to the bearded majesty painted by Botticelli but also to the "terrible" bearded visage of Julius himself, the warrior-pope. In his majesty and physical power *Moses* comes close indeed to echoing the very figure of God in the act of creation, on the Sistine ceiling.

In its overall design the Julius tomb presented an ascent from earthbound and fettered bodies in the lowest zone, through the awesome figure of Moses on a level with the papal bier, to the resplendent heavenly goal of the receiving Virgin and Child above. In this progression the tomb plan hints of a hierarchy of both sanctity and resurrection. When Michelangelo's work on the tomb was interrupted yet again in the 1530s to complete the Sistine Chapel with a fresco above the altar, he completed its theme of the unfolding of divine grace amid human sin within a single overpowering image: the *Last Judgment* (1534–41; Fig. **5.26**).

THE *LAST JUDGMENT* AND THE NEW SPIRITUALITY

The request for this climax to the Sistine Chapel decoration came from another Medici pope, Clement VII (1523–34), and it effectively ended Michelangelo's ability to fulfill his earlier contracts with Julius II and his heirs for the tomb ensemble. The fresco project continued under a new pope, Paul III (1534–49), the same patron who appointed Michelangelo architect of St. Peter's. But this new pontiff emphatically redirected the subject of the fresco from initial designs for a Resurrection of Christ, a hope-filled inspiration, to the more ominous and awe-inspiring resurrection of the body on the Day of Judgment. With the execution of this fresco, Michelangelo's earlier ambition to render spiritual beauty through physical beauty came to an end, and in many respects the High Renaissance of Leonardo and Raphael ended as well.

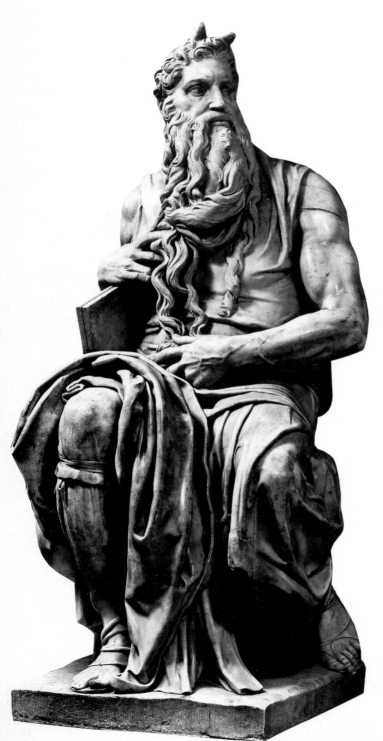

5.25 (Left) Michelangelo, *Moses*, Tomb of Julius II, Rome, ca. 1513 ff. Marble, 92½ ins (235 cm). San Pietro in Vincoli, Rome.

5.26 (Opposite) Michelangelo, *Last Judgment*, Sistine Chapel, 1534–41. Fresco, 48 × 44 feet (14.6 × 13.4 meters).

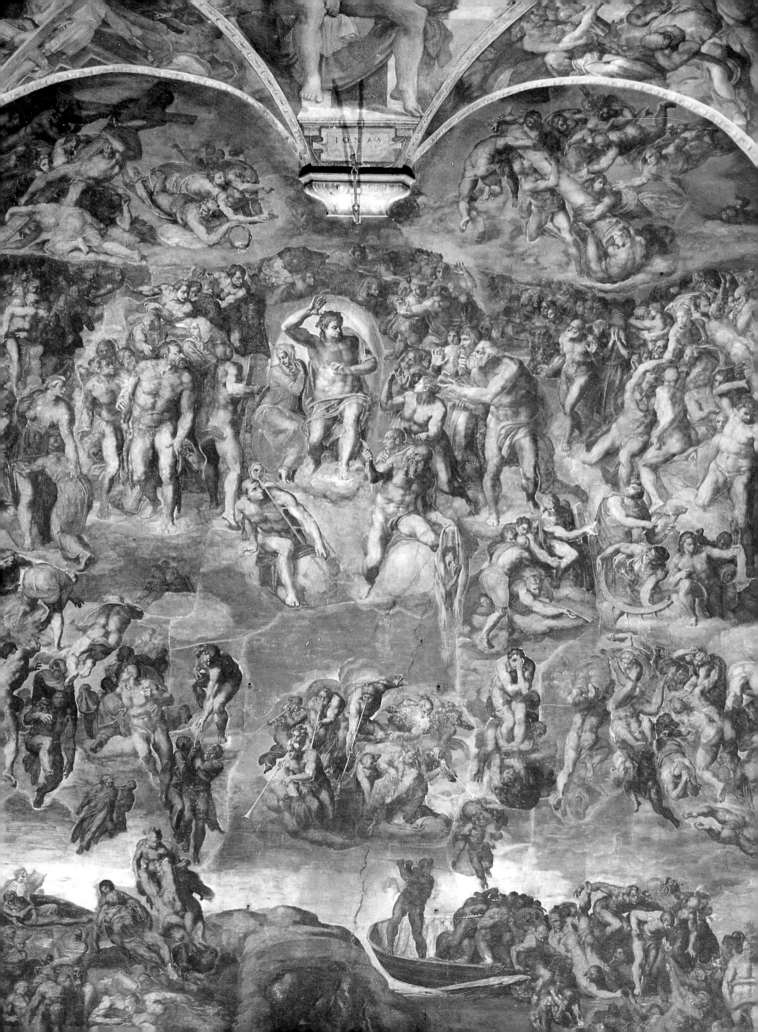

Moreover, the historical episode of energy and enthusiasm that had predominated under Julius II and Leo X had waned in the wake of the challenge by Protestant critics led by Luther after 1517 and a traumatic Sack of Rome by imperial troops in 1527, when the pope himself was held a prisoner, the ultimate consequence of Julius II's political activity and militarism. Thereafter Rome lost much of its artistic leadership and suffered under what was perceived as a sentence of divine wrath and judgment.

Comparison of Michelangelo's giant *Last Judgment* with Raphael's *Disputa* of a generation earlier (Fig. 5.16) reveals how much more gloomy and somber this later conception of heaven had become. In place of the Trinity's benign blessing of the sacrament upon the painted altar of Raphael, this fresco surmounts the actual altar of the Sistine Chapel with a stern and judging Christ on axis with only angelic trumpeters and the gaping mouth of hell. A medieval hierarchy of size predominates, as a massive Christ dwarfs the smaller angels and resurrected souls below Him. In contrast to traditional bearded visages of Christ, Michelangelo presents an Apollo-like beardless youth, but His terrible gaze is directed toward the side of the damned as he raises His hands in a gesture of dismissal and perdition. He shows a power to destroy that was only latent in the earlier figures of *David* and *Moses*. Raphael's hierarchical division of the *Disputa* is repeated in the *Last Judgment*, where horizontal bands of figures and clouds define spatial layers that correspond to the wall elevations of the remainder of the Sistine Chapel.

The overall composition of the fresco, however, pivots around Christ and the cowering Madonna at His right side, whose traditional active role and gaze downward as intercessor on behalf of sinful mankind are tempered by a pose that echoes that of the expelled Eve of the Sistine ceiling. The scene is unified into a chorus of energetic nude bodies, including Christ and the saints (later ordered to be overpainted with loincloths by a prudish pope). A cosmic rise and fall of the saved and the damned unfolds in a clockwise movement around the apex of Christ. As always with Michelangelo, the human figure is the focus of attention, even when painted rather than carved, so spatial description is kept to a minimum, as in the Chapel ceiling, whose creation scenes are brought to a definitive climax here. Yet these massive and powerful nudes no longer present an image of spiritual beauty and noble purity, as in the earlier Adam or *David*. Beauty and grace, the informing principles of classicism, have been replaced by dense, heavy body shapes, almost incapable of asserting their individual wills within this divine scheme.

The resurrection of the bodies at the lower left finds its complement at the right in the boatman Charon from Dante's *Inferno*, who beats the mass of condemned souls. Vasari quotes Dante's words (*Purgatorio*, xii, 67) to describe the whole effect of the *Last Judgment*: "Dead are the dead, the living truly live." Here religious art is supposed to inspire awe and fear, purged of the distraction of beauty, in keeping with a quotation attributed to Michelangelo that the effect of an artwork is directly linked to the piety of the artist. Ironically,

the flayed skin held beneath Christ's feet by the martyr-saint Bartholomew presents a self-portrait of Michelangelo, emptied of earthly fallibility and corporeality and hovering precariously above the abyss of the damned.

Among the saints alongside the judging Christ, St. Peter, the first pope, appears with his keys above the damned to assist in the Last Judgment. Opposite him stands a complementary male figure, nude and without attributes but identified as Adam by Vasari. Through these two figures, then, the full span of time within the remainder of the Sistine Chapel – from the scenes of creation on the ceiling to the foundation of the Church in the Raphael tapestries – is recapitulated at the end of time in heaven on either side of the Last Judgment. By implication, the redemption of Adam has been accomplished through Christ's own sacrifice, yet the redemption of sinful humankind from damnation depends on the petition of the papacy in the form of Peter and the multitude of saints of the Catholic Church. The welcoming Madonna and Child of the *Sistine Madonna* give way to the ineluctable finality of divine justice. Theology replaces philosophy; faith dominates reason.

With the threat to Catholic unity posed by Martin Luther and the Protestant Reformation, a new militant response was organized by Michelangelo's patron for the *Last Judgment*, Pope Paul III. In addition to sanctioning the establishment of the new order of the Society of Jesus (Jesuits) in 1540, the pope convened a new Church Council, the Council of Trent (1545–63). The edicts of the Council eventually produced a cautious and conservative attitude toward liturgical questions, books, and both the subjects and the forms of art. Some of the consequences for artists were fulfilled during the seventeenth century (see Chapter 6), but the backlash against Michelangelo's *Last Judgment* was immediate and severe.

The nudes, including Christ and the saints of the fresco, were denounced as indecent, even blasphemous, and entire repainting was proposed. (One alleged volunteer was a visiting Greek painter, Domenico Theotocopoulos, better known in the history of art for his career in Spain, 1565–1614, as "El Greco.") A compromise was reached after Michelangelo's death, when one of his pupils agreed to paint loincloths over the genitals in order to preserve the remainder of the vast fresco. This thankless task was completed in 1565, shortly after the culmination of the Council of Trent, and it symbolized the abandonment of the ideals of human beauty and classicism so fully realized in the Sistine ceiling.

THE MEDICI TOMBS

After the restoration of the Medici in 1513 to both the papacy (with Pope Leo X) and the rulership of Florence, the Florentine republic that had inspired Michelangelo's *David* no longer existed. Instead, like most of the major urban centers of Italy, the city was ruled by a dynastic oligarchy, its power vested in a few, elite members of the ruling family. However, with increasing military tension among rival large cities and their allied

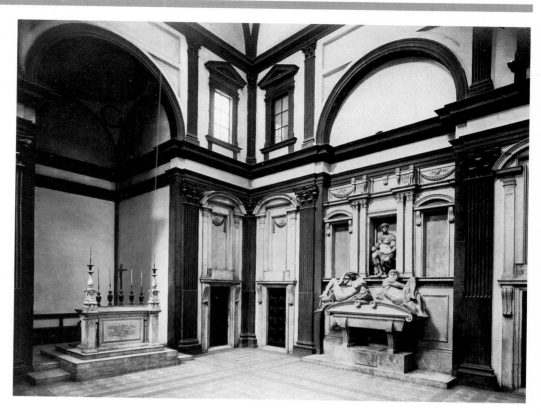

5.27 Michelangelo, Medici Chapel, San Lorenzo, Florence, 1519–34. Tomb of Lorenzo de' Medici. Marble.

5.28 Michelangelo, Medici Chapel, San Lorenzo, Florence, 1519–34. Tomb of Giuliano de' Medici. Marble.

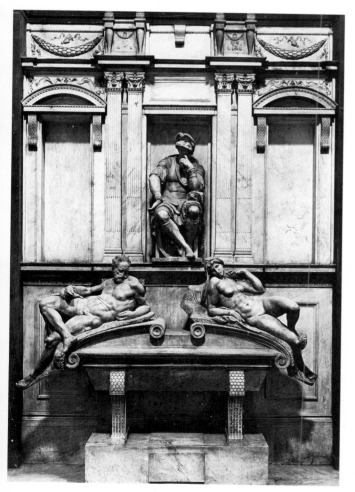

foreign powers (especially the kingdoms of France and Spain), Florence began a period of dependency on its allies (two Medici women became queens of France over the course of a century).

However, the increasingly opulent Medici court (like its equivalents in other cities, such as Mantua, Ferrara, or Urbino; see Titian, pp. 212–18) compensated for its relative lack of political autonomy with its artistic standing. Despite his ongoing commission for the tomb of Pope Julius II at St. Peter's in Rome, Michelangelo was summoned back to Florence to work on an equally ambitious project for the Medici. First he was instructed to build a New Sacristy at San Lorenzo (as well as a façade, never completed), to supplement the fifteenth-century construction by Brunelleschi. Then he was commanded to adorn it with ducal tombs for the Medici, beginning with Lorenzo the Magnificent and his brother Giuliano and continuing with their namesake rulers of Florence from the recent era of Pope Leo X. Only two of the tombs were completed, but the Medici Chapel remains a monument to the final days of glory of both Florentine art and politics as well as to her most famous and celebrated creator (Figs. **5.27** and **5.28**).

The two tombs form the pivot of the Medici Chapel space. Around simple rectangular niches, Michelangelo placed symmetrical blind tabernacles (perhaps originally intended for additional sculpted figures) with hanging volute scroll ornaments and a projecting rounded pediment. This is echoed by the oddly inventive rounded sarcophagi below and in reverse by the relief *swags*, or wreaths, of honor, and casts a shadow in an emphatically plastic yet seemingly arbitrary fashion. The paired pilasters around the central niche frame each main

figure like the fictive architecture on the Sistine ceiling, while the marble of both figures and architecture chillingly eliminates all traces of animating color from this ensemble.

The two main sculpted effigies resemble both the prophets of the Sistine Chapel and the sculpted *Moses* of the Julius tomb. They are dressed in Roman military costume to signal their service as soldiers of the church as well as their timeless nobility. (Michelangelo supposedly replied to critics, who said that his generalized portraits scarcely resembled their sitters, by asserting that in a thousand years no one would know the difference!) The two figures are intended to complement each other: Lorenzo (d. 1519) sits broodingly as the shadowy contemplative, while Guiliano (d. 1516) turns directly toward the light, the active commander. Beneath them on the sarcophagi allegorical figures personify the times of day (originally at the base of the sarcophagi river gods were to have personified the regions of the world), with twilight figures of Dawn and Dusk for Lorenzo and clear antinomies, or oppositions, of Night and Day for Giuliano (Fig. **5.29**). These full-length and full-bodied figures derive from earlier experiments on the Sistine ceiling *ignudi* and the *Slaves* of the Julius tomb, but now they are set within an elaborate allegory of tribute to the lost leaders, who triumph in their fame (partly the result of the artist's fame, partly that of the permanence of his

materials) over time itself. Those materials are shown to powerful effect in the figures themselves: the shadowed face of a sunken figure of Night proclaims her darkness and the powerful muscles of Day stand out as the figure seems to rise and move. All of the figures display an asymmetrical, counterpoised twist (*contrapposto*) of movement, also called the "serpentine figure" by Michelangelo, that is as calculatedly balanced as the complex allegory of oppositions. When he returned to Rome after the death of the last Medici pope, Clement VII, in 1534, however, he left the ensemble unfinished.

CELLINI AND VIRTUOSO ARTISTRY

The influence of Michelangelo's canon of graceful and powerful movement endured in both the sculpture and the painting of sixteenth-century Florence, even as his ambitious projects and mastery of antique models and artistic principles gave new impetus to the artistic careers of younger followers. One such artist was Benvenuto Cellini (1550–71), a sculptor and craftsman in metals whose autobiography renders his life as familiar

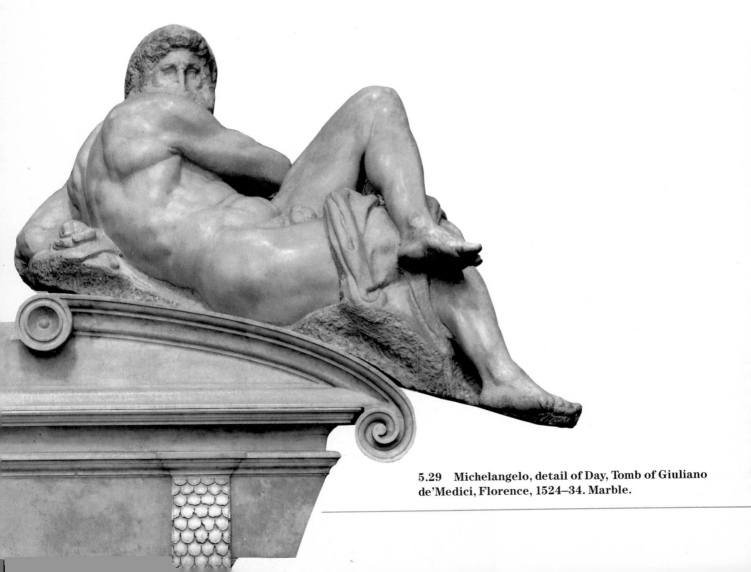

5.29 Michelangelo, detail of Day, Tomb of Giuliano de'Medici, Florence, 1524–34. Marble.

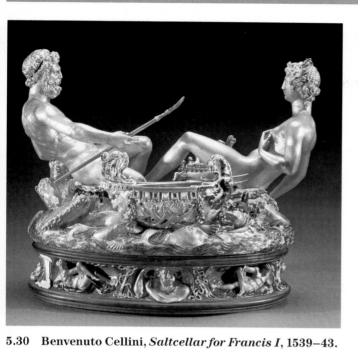

5.30 Benvenuto Cellini, *Saltcellar for Francis I*, 1539–43. Gold and enamel, 10¼ × 13⅛ ins (26 × 33.3 cm). Kunsthistorisches Museum, Vienna.

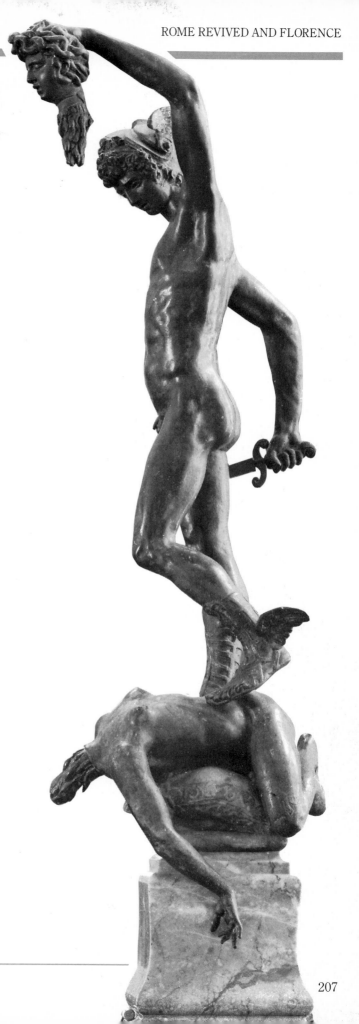

to modern readers as his limited output of artworks. Virtuosity characterized both the art and the flamboyant life of Cellini.

Like many Florentine artists, Cellini spent much of his time away from his hometown: first in Rome, later at Ferrara, and then by 1540 at the royal court of France at Fontainebleau (where the Gallery of Francis I was being ornamented with stucco figure reliefs and fresco paintings by Florentine artists, led by Rosso the Florentine and Francesco Primaticcio). In France the interest in Michelangelo was keen, and a painted *Leda and the Swan* (as well as an early *Hercules* and a collection of drawings) graced the king's collection. Cellini in his turn was commissioned, as goldsmith to the king, to make a dozen silver statues of classical gods and goddesses for the king's table, but these remained unfinished. Before he left France in 1545, however, Cellini did complete a magnificent table ornament in gold and enamel for Francis I: a *Saltcellar* (Fig. **5.30**).

The forms of the gilded figures and the basic allegorical concept of the *Saltcellar* derive directly from the Medici Chapel. For the salt from the sea, Cellini provided a male Neptune (Water) figure with a trident and an accompanying ship that held the spice. Opposite him lay a reclining female Ceres (Earth), whose adjacent temple held pepper. Each of the figures is set against a field of colored enamel that includes appropriate animal companions (sea horses, dolphins, and an elephant). An ebony base included gold reliefs of the winds or seasons as well as the times of day, akin to Michelangelo's concept, and the forms of the figures can be seen as more elegant variations on Dusk and Dawn. But the ambitious Cellini

5.31 Benvenuto Cellini, *Perseus*, Loggia dei Lanzi, Florence, 1545–54. Bronze, 18 feet (5.5 meters) high.

also began work on a colossal statue of Mars, the God of War, for Francis I, a project that was never completed beyond the stage of a lost model.

When Cellini returned to Florence in 1545, he found it ruled by a Medici now holding the title of duke, Cosimo I. He received from Cosimo a civic commission for a massive bronze statue for the same piazza as the *David*. As a complement to the colossus of Michelangelo, the subject chosen was *Perseus* (Fig. **5.31**, p. 207). This hero of Greek myth, who slew the snake-haired Medusa, suited the benevolent despot as a model for the bold cleansing of evil and the establishment of peaceful order and civilization. The statue also would form a complement in the same public space to Donatello's earlier *Judith*, a biblical image of heroism in defense of liberty (as well as his bronze *David*, nude and victorious). Cellini produced a tall bronze figure on an elaborate marble base (which makes the entire statue similar in height to both the Michelangelo and Donatello precedents), filled with further smaller figures of the protector gods and Danaë, mother of the hero. His interest in rich detailing carries over to all views of the figure in the round, and Cellini's *Life* devotes a famous long passage to the complexities of casting bronze on such a scale and with such features through the lost-wax process. The head of *Perseus* also derives from the Medici Chapel, specifically from the idealized head of Giuliano de' Medici.

PORTRAITURE In the realm of courtly art in sixteenth-century Italy, portraiture emerged as a major source of patronage. For Cosimo I in Florence, the principal portraitist was Agnolo Bronzino, who painted an oblique bust portrait of him in armor in the year Cellini returned to Florence. In part as an experiment prior to the more arduous efforts of the *Perseus*, Cellini also accepted a commission for a bronze bust portrait, once gilded, of the duke (Fig. **5.32**). He modeled the bust from life but based it on portraits of the Roman emperors, from which it took its lifelike turn of the head. Also ancient in its inspiration (though confined chiefly to full-length renderings, such as the *Augustus of Prima Porta*; Fig 2.52) is the detailing on the armor, showing the duke as a victorious warrior with a Medusa head at the center of the cuirass to recall the analogy with Perseus (along with trumpets of fame, plus lion heads and eagles to denote royal power).

This portrait image of a locally powerful and self-important duke points the way to general observations regarding the purposes of art in this period. Europe was becoming increasingly fractured along the lines of religious schisms between Catholics and Protestants as well as political rivalries

5.32 Benvenuto Cellini, *Cosimo I*, 1546–48. Bronze bust. Bargello, Florence.

between great states (France against Spain) and smaller principalities. Yet the great achievements of Michelangelo and Raphael in Florence and in Rome spread, diffused by their followers to courts in faraway corners of the continent – to Fontainebleau, Munich, Prague. These artists were celebrated for the beauty or the strength of their created human figures, overcoming the limitations of nature and surpassing all previous models, including the antique. Even in the next century visitors to Italy, such as Peter Paul Rubens or Nicolas Poussin, would absorb and transmit these Renaissance ideals directly and, through the instructions of emerging art academies, indirectly. Giorgio Vasari's *Lives of the Artists*, with Michelangelo as its heroic climax, appeared in 1550. Its emphatic praise of artistic genius and the fame attaching to the career of inventive artists, as well as the aestheticized view of "art for art's sake," took on the cult-like reverence that still – witness this book – attends artistic prominence today.

VENETIAN VARIATIONS

DÜRER In 1506, Albrecht Dürer (see pp. 147–53), visiting from Nuremberg, completed a large altarpiece for a chapel in the church of San Bartolomeo di Rialto in Venice. The chapel belonged to the German trading community in Venice, which had a local "colony" (akin to the foreign communities in Bruges), partly composed of Nuremberg merchants and called the Fondaco dei Tedeschi. Dürer signaled his intention to rival the great painters of Venice with an ambitious image: *The Feast of the Rose Garlands* (Fig. **5.33**). The care with which he prepared his challenge can be seen in the twenty-two studies of details for the picture, each of them drawn with brush on prepared blue Venetian paper. What these works record is Dürer's meticulous delicacy and drafts-

manship in rendering highlight, shadow, contour, and volume through purely linear means, although the background blue color of the paper further permitted him to work within a range of tones from bright to dark (white ink or black). These graphic conventions were the result of Dürer's training as an engraver.

However, graphic abilities were not the talent Dürer wished to assert in his final painting. More important was the test of pigments and atmosphere. Dürer wrote back in triumph after the success of the picture to a friend in Nuremberg:

5.33 Albrecht Dürer, *The Feast of the Rose Garlands*, 1506. Oil on panel, 63⅝ × 75⅝ ins (161 × 192 cm). National Gallery, Prague.

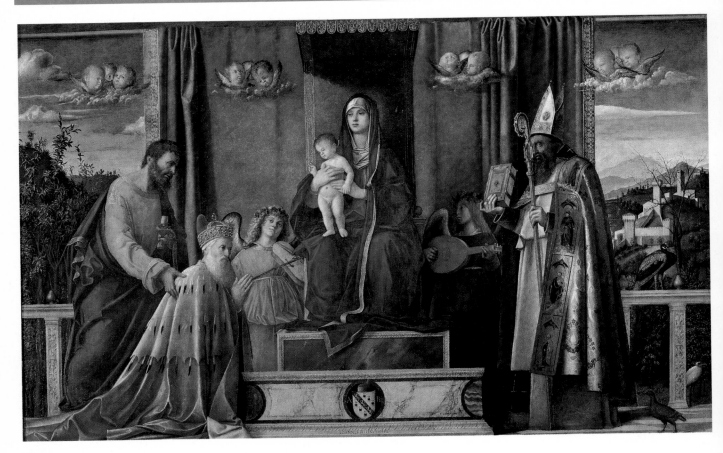

5.34 Giovanni Bellini, *Doge Agostino Barbarigo Adoring the Virgin*, **1488. Oil on panel, 78¾ × 126 ins (200 × 320 cm). San Pietro Martire, Murano.**

"I have stopped the mouths of all the painters who used to say that I was good at engraving but, as to painting, I did not know how to handle my colors. Now everyone says that better coloring they have never seen." Luminous color, as we shall see, was a feature of Venetian oil painting, and Dürer even borrowed the horizontal panel favored in Venetian altarpieces.

The German community followed Venetian example in forming its own religious confraternity, or *scuola*, in this case dedicated to the Virgin of the Rosary (the same cult that would be celebrated in Nuremberg's own St. Lorenz church by the great painted wood sculpture of Veit Stoss; Fig. 4.21). Inasmuch as each *scuola* commissioned religious artworks, usually from local Venetian artists (much as both trade guilds and confraternities commissioned altarpieces in Flanders), the Germans were lucky to have their nation's leading artist turn up for his second visit to Italy in 1505. He, in turn, was proud to be able to sign so prominent a Venetian altarpiece with his German origins (rather than his usual designation of "Noricus," from the city-state of Nuremberg), "Albertus Dürer Germanus," and he has included a self-portrait among the worshipers, holding his own bold, assertive signature.

GIOVANNI BELLINI In the case of the Germans, individual donors insisted upon having their portraits included among the kneeling worshipers of the Madonna and Child. This request, however, still enabled Dürer to follow Venetian precedents, such as *Doge Agostino Barbarigo Adoring the Virgin* (1488; Murano, St. Peter Martyr; Fig. **5.34**),

the work of Venice's leading religious painter, Giovanni Bellini (ca. 1431–1516), whom Dürer himself called "very old and still the best in painting" when they met in 1506. That model not only corresponds well with Dürer's altarpiece, but it also shows clearly what local tradition Dürer was attempting to rival. In both works, the Madonna and Child sit enthroned and elevated under a cloth of honor, while tiny angels, little more than round heads on tiny wings, hover above them on miniature clouds. Larger, music-playing angels with lutes and viols add a celestial serenade to a setting that hovers ambiguously between a summery paradise on earth, appropriate to the donor, and a projection of earthly beauties as a vision of heavenly spaces – the same unresolvable accessibility of the heavenly that van Eyck offered in the *Rolin Madonna* (Fig. 4.7) half a century earlier. In both Bellini and Dürer, the holy figures appear to their earthly worshipers in the brilliant light and atmosphere of open air. In the case of Bellini the background setting features a typical Italian fortress, echoing the composition of the holy figures, angel, and donor, and doubtless meant as a symbol of divine protection. Dürer's landscape also presents a castle in the foothills of mountains at the analogous position, but in his case the rugged setting is a representation of the kinds of Alpine fortresses that Dürer saw

on his trip down to Italy. Typical of the German's omnivorous visual curiosity, he recorded such landscape settings and impressions in the first extant watercolors, such as his *View of Trent* (lost).

Dürer has emulated Bellini in one other important respect. Besides commemorating the specific patrons of his German *scuola*, he has paid tribute to the divine sanction accorded to their role within Christian Europe, represented by its leaders, the pope and the Holy Roman Emperor. Dürer did not have a portrait of the reigning pope, Julius II, the patron of Raphael and Michelangelo in Rome (pp. 194–202). However, he could rely upon a portrait of his own sovereign in Germany, Maximilian I, to serve as leader of the secular arm of

Christendom. He placed the pope, as the spiritual leader, on the right, or more favorable side (see *Last Judgment*; Fig 5.26) of the holy figures, just where Bellini's doge appears, alone except for his patron saints.

In Venice, the position of doge was a very exclusive leadership job, selected from a fixed list (since 1297) of patrician families, who also governed in a Council of Ten within the larger Great Council (Barbarigo served in the years 1486–1501). Thus, when an individual patrician like Barbarigo commissioned such a picture from a leading artist like Bellini, he simultaneously commemorated his rule as doge even as he also celebrated divine protection of his powerful maritime city-state. When Dürer's *Feast of the Rose Garlands* was finally

5.35 Titian, *Pesaro Madonna*, 1519–26. Oil on canvas, 192 × 106 ins (488 × 269 cm). Santa Maria Gloriosa dei Frari, Venice.

complete, it was then admired by the current doge, Leonardo Loredan (active 1501–21), whose portrait was also painted to commemorate his election by Giovanni Bellini (ca. 1501).

The city of Venice that so enchanted Dürer was out of the mainstream of the classical revival and the Renaissance as typified by Florence and Rome. In some ways Venice had more in common with the city-state government of Dürer's Nuremberg than with either these Renaissance cities or the centralized royal government Holbein found in England. Venice's Mediterranean sea trade and naval armada had protected her, yet isolated her from major events in Italy. Yet the princely portraits of doges by Bellini, such as Agostino Barbarigo, also point up the other major characteristic of Venice: her strictly limited aristocratic patrician class. This oligarchic constitution promoted communal stability and continuity in Venice rather than the disruptive family ambitions that so factionalized Florence. During the sixteenth century, the role of Venice, now the only truly independent large commune in Italy, began to shift. Europe's trade routes no longer centered on the Mediterranean but rather on the Atlantic, yet the advance of the Ottoman Turks after the fall of Constantinople in 1453 left Venice as a Mediterranean bulwark against invasion.

TITIAN: NARRATIVE AND COLOR

During the sixteenth century, Titian (Tiziano Vecellio; 1485/90–1576) dominated the output of Venetian painting, based on the technique of oil painting, recently introduced to the city by Giovanni Bellini. It was Bellini who oriented Venetian painting toward the color that Dürer emulated. Titian's debt to Bellini, as well as his own ambitious variations on Venetian tradition, can be seen in his *Pesaro Madonna* (1519–26, Fig. **5.35**), located in the same Franciscan church of the Frari in Venice that held Bellini's *Frari Altarpiece*. The donor of the altarpiece kneels in profile at the left foreground, with his relatives at the opposite corner. He is Jacopo Pesaro, a Venetian patrician who was at once the bishop of Paphos on Cyprus and the commander of the papal fleet that defeated the Turks in 1502. Led by an armored, banner-bearing Christian warrior-saint, Maurice, a captured Turk in a turban appears behind the donor to mark his triumph over the infidel.

From the lowest margin of the picture a spiritual hierarchy is arrayed on a series of steps, proceeding from the donors through the warrior-saint to the representatives of the Church, St. Francis and St. Peter, located below the apex formed by the enthroned Madonna and Child. In many respects, this hierarchy corresponds to the imagined space of Masaccio in his *Trinity* fresco of a century earlier in Florence (Fig. 4.45). Yet Titian has not only abandoned wall painting for the canvas support necessitated by the damp walls of Venice. He has also animated the entire altarpiece arrangement through a diagonal recession upward to the holy figures from the profile base. In the process, he also adds a horizontal emphasis to the otherwise vertical format of the altarpiece. This counterpoint explicitly incorporates the other great religious tradition in

5.36 Titian, *Assumption of the Virgin*, 1516–18. Oil on canvas, 270 × 142 ins (690 × 360 cm). Santa Maria Gloriosa dei Frari, Venice.

Venice: the private patronage of votive images, such as Bellini's *Barbarigo Madonna*, with the kneeling donor before an enthroned figure in front of an extended expanse. In Titian's reworked votive, the open space is filled with clouds but is punctuated by two massive columns. These two columns behind the figures of Madonna and Child are symbols. They derive from passages in the Song of Songs ("and my throne is a cloudy pillar"); religious commentators took this to allude to the recently approved dogma of the Immaculate Conception of the Virgin, a Franciscan-backed doctrine, as well as to the dedication of the Franciscan church. Thus Titian's innovative and personalized altarpiece for a Venetian aristocrat also represents a vision of divine protection for Venice (and Christ-

endom) and a presentation of theological doctrine within the framework of the Church.

Titian had recently completed (1516–18) his first great religious altarpiece for the Franciscans in the Frari (Santa Maria Gloriosa): the *Assumption of the Virgin* (Fig. **5.36**). The dimensions alone (23 feet/6.9 meters high) of this enormous picture compel respect for the artist's ambition, but his control of composition and color is a new contribution to the Venetian tradition. Titian clearly separates the earthly and the heavenly zones by his use of glowing color, where luminous gold paint stands in for the actual gold of Byzantine tradition, so long preserved in the art of Venice. This substitution copies Bellini's use of gold in his oils, but Titian's massive, active apostle figures and energetic angels (probably derived from Raphael via engraved copies) achieve the colossal grandeur of the High Renaissance in Venetian terms. The strict separation of spheres by means of clouds (inverting and echoing the curving frame of the altarpiece) also gives them a clarity that can be easily read across the vast spaces of the preaching church. By distinguishing a higher, holier sphere, Titian offers a supernatural vision above a darker, earthbound area. Such sharp theological and visual distinctions served in the later part of the Catholic Church's Counter-Reformation as a preferred kind of clear, didactic, devotional image.

MYTHOLOGY AND LANDSCAPE A similar imaginative rethinking of tradition characterizes Titian's treatments of mythological subjects. Shortly after the turn of the century, a new poetic vision of such ideal figures in landscapes appears in Venetian art. Important early pictures in this vein seem to be the work of a mysterious artist, Giorgione (ca. 1478–1510), whose brief career overlaps considerably with Titian's early period. The two artists worked together on fresco decorations (1508) for the recently rebuilt Fondaco dei Tedeschi, the center for Dürer's German merchants. And Titian completed the background landscape (and perhaps other sections, including a now-missing Cupid) of a Giorgione canvas, *Sleeping Venus* (ca. 1510; Fig. **5.37**). In contrast to the decorative, standing Venus by Botticelli, this Venus lies recumbent, dreaming, like the mythical sleeping nymphs associated with springs and forests. This picture invites sensual voyeurism and erotic contemplation, putting the viewer into the position occupied in myths by amorous satyrs. Thus it cannot be taken in the allegorical sense laid out in the Neoplatonic educational programs for Botticelli's Medici patrons. Yet the dreamy reverie of this paragon of beauty also inspires a corresponding poetry of place, linking the summery countryside and plausibly worldly landscape (complete with farm buildings) with the goddess. This combination produces a classicizing imaginary world, akin to the antique literary heritage of pastoral poetry. The *Sleeping Venus* offers an image of perfect beauty, but vouchsafed to a mortal gaze as a sensual vision akin to poetic inspiration. Thus this painting draws upon a classical past but instead of Botticelli's learned allegory or some scholarly recreation of antiquity, this image reconciles the pagan gods to the creative pleasures of this world. At the same time, this pastoral vision remains distinctly personal, with its concept of the country as a place of retreat, like imagined or ideal life at a contemporary villa.

5.37 Giorgione (landscape completed by Titian), ***Sleeping Venus*, ca. 1510. Oil on canvas, 42¾ × 69 ins (108.5 × 175.2 cm). Gemäldegalerie, Dresden.**

Titian: Mythologies for Ferrara

Titian's later mythological paintings were produced as private images for princely patrons – first at north Italian courts, later farther afield. Many of these pictures strive to recapture antiquity itself by recreating lost (or imagined) ancient originals described in detail, the literary pictures known as *ekphrases* within classic texts, chiefly those of Pliny the Elder (*Natural History*), Ovid (*Metamorphoses* or *Fasti*), and Philostratus (*Imagines*).

One ambitious collector of Renaissance recreations of *ekphrases* was Alfonso d'Este, ruler of the north Italian court of Ferrara. His ambition was to have a "Hall of Fame" of the contemporary greats of Renaissance painting, each of them recreating a world of pagan myths based on the most famous descriptions of the ancients. The artists Alfonso commissioned for the decorations of his Alabaster Chamber in the palace at Ferrara included Giovanni Bellini of Venice, Raphael of Rome, his own court painter, Dosso Dossi of Ferrara, Fra Bartolommeo of Florence, and Titian. Titian in fact only entered the lists upon the sudden death of Fra Bartolommeo late in 1517. Bellini had completed the first of the canvases for Alfonso in 1514, but he also died before any additional paintings could be added to the cycle. Thus Bellini was replaced by Titian, his successor in Venice,

who was charged at once with painting the topic formerly assigned to Bartolommeo, the *Worship of Venus*. (Titian also later reworked the landscape background plus other details in the Bellini canvas in order to make it harmonize with his own eventual trio of pictures in the gallery.) Raphael had earlier made a drawing design for a painting but delegated the completion of his theme to a local artist in Ferrara; eventually, that theme, the Triumph of Bacchus, also came to Titian. The result is a glowing canvas, *Bacchus and Ariadne* (1520–23; Fig. 5.38). Eventually a complementary canvas was completed with another antique subject on a bacchic theme, the *Bacchanal of the Andrians* (1523–25; Fig. 5.39).

Titian's *Bacchus and Ariadne* derives from a pair of ancient texts, Ovid's *Ars Amatoria* and Catullus's *ekphrasis* in his *Carmina*, describing the embroidered wedding bedspread of Peleus and Thetis. These sources offer neither allegory nor narrative to the artist but images to be brought back to life, reborn. In this respect the story of the beautiful, abandoned, mortal maid, who is suddenly claimed by Bacchus, the god of wine and pleasure, celebrates a licitly erotic, marital union in its original context. Thus Titian reconstitutes a sensuous vision of the ancient gods with all of the vitality at his disposal,

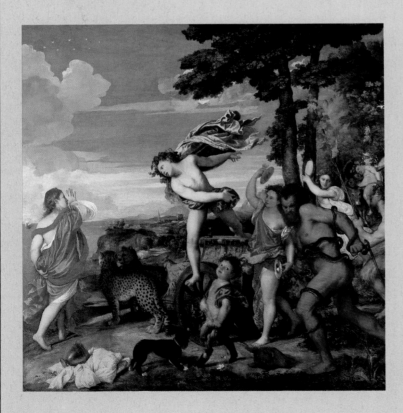

5.38 Titian, Chamber of Alabaster, Ferrara. *Bacchus and Ariadne*, 1520–23. Oil on canvas, 69 × 75 ins (175 × 191 cm). National Gallery, London.

5.39 Titian, Chamber of Alabaster, Ferrara. *Bacchanal of the Andrians*, 1520–23. Oil on canvas, 69 × 76 ins (175 × 193 cm). Prado, Madrid.

appropriate to the frenzy that characterizes all followers of Bacchus as well as the god himself. Yet at the same time, this glowing summery world presents a personal paganism, recaptured for the delight of a discerning private patron, much in the manner of Giorgione's *Sleeping Venus*. Antiquity serves to inspire an image of a lost-and-found golden age, steeped in the transcendent pleasures of the senses; the presiding gods are Venus and Bacchus.

For his vision of Bacchus and his retinue Titian utilized Raphael's archaeologically-informed drawing relief as well as ancient sculptures for individual figures in his scene. For example, the snake-girdled attendant derives from the classical *Laocoön* group (Fig. 2.49), recently unearthed in Rome and widely disseminated through reproduced engravings. The obese figure of Silenus comes from a sarcophagus motif in Rome. But Titian's relative distance from these Roman models was also an asset, for he was able to energize his figures (including the leaping Bacchus, an original invention) with a lively, dancelike grace, free of the compositional rigidity and constraints of Raphael's dignified classicism.

Titian's final canvas for Alfonso d'Este, the *Bacchanal of the Andrians* (Fig. **5.39**) celebrates that vitality of figures and brushwork as it shows the way in which Bacchic energy and love animate a landscape setting. Again the literary source is an ancient *ekphrasis* of

Philostratus, recounting the dreamland of the followers of Bacchus on the isle of Andros. In this picture, mortals and immortals disport themselves together, all stimulated by the river of wine that flows through the island paradise. In the lower right corner a sleeping, sated nude woman recalls the *Sleeping Venus* as a kind of *genius loci* for the site of this joyous orgy. Near her a urinating toddler conjures up the erotic association of Cupid alongside Venus (as in the Giorgione canvas completed by Titian). All stages of imbibing the wine of Bacchus are presented here – from examining the wine and its color to urination and stupor. Moreover, the cyclical nature of the drinking is made explicit through Titian's commentary in the form of a song (appropriately a canon, or round). The sheet music visible in the foreground is actually a song in French composed by a Flemish musician at the court at Ferrara (where music was as favored as art), which reads: "Who drinks and does not drink again knows not what drinking is." Music, of course, permeates the rhythmic dance of these revelers. Wine, then, like the arts, particularly the art of painting with its revival of ancient imagery, can recreate the sensuous world of the pagan gods and transform the connoisseurs who partake of it. This is an artistic world of mythology that is at once more classical in its source (visual as well as textual) than Botticelli's canvases yet also palpably tied to the court of Ferrara.

5.40 Titian, *Federico Gonzaga*, 1529. Oil on canvas, 49¼ × 39¼ ins (125 × 99 cm). Prado, Madrid.

Part of the reason for Titian's greater pictorial liveliness in paintings such as the cycle of Ferrara mythologies is his Venetian independence of careful preliminary figure drawings, used as the basis of most pictures by Florentine or Roman Renaissance artists. He could compose and rework his compositions in successive paint layers directly on the canvas, as Giorgione had done before him. This working method enhances the traditional Venetian interest in color and atmosphere, rather than preliminary design (*disegno*), and increasingly places a premium on the liveliness of individual brush strokes in the very execution of a canvas.

The collecting of ancient subjects by famous Renaissance painters points to the importance of both art-collecting and learning as well as general patronage of the arts in the courts of North Italy. The Este of Ferrara were not alone in their interest in the liberal arts: Titian executed numerous painted projects for the Gonzaga of Mantua, including a cycle of eleven portraits of Roman emperors, now lost (1536–40). The cycle of emperors continues the tradition of a previous artistic revival in Mantua by an earlier court artist, Andrea Mantegna (1431–1506; Bellini's brother-in-law), of ancient historical subjects. At once a tribute to the learning and the dynastic pretensions of the Gonzagas, Titian's *Emperors* freely combine Renaissance academic research into classical busts and coins with his native talent for animated portraiture. In Mantua, Titian also painted

the portrait of Alfonso's nephew, *Federico Gonzaga* (1529), which epitomizes his mastery of delicate color and atmosphere in coordinating the overall rendering of detail (Fig. **5.40**). In contrast to the dry precision of Bellini's *Doge Loredan* or the portrait of Barbarigo from a generation earlier, Titian's court portrait presents the natural ease of the perfect aristocrat and courtier, here relaxed with his faithful lapdog companion. Titian became the model for courtly portraiture for the century to come, and the work of Rubens, van Dyck, and Velázquez is unthinkable without this precedent.

TITIAN: IMPERIAL PATRONAGE

Through Federico Gonzaga, Titian was introduced to Charles V, Holy Roman Emperor, at the time of his imperial coronation by the pope in Bologna in 1530 and again in 1532–33. Charles was so delighted by the artist's full-length court portrait of him that he designated Titian his official imperial painter, "Knight of the Golden Spur, Count of the Lateran Palace and of the Imperial Consistery." No artist since antiquity had enjoyed such favor from so eminent a patron, favor sealed by the unprecedented letter patent of nobility:

"Your gifts as an artist and your genius for painting persons from life appear to us so great that you deserve to be called

5.41 Titian, *Charles V on Horseback*, 1548. Oil on canvas, 131 × 110 ins (332 × 279 cm). Prado, Madrid.

the Apelles of this age. Following the example of our forerunners, Alexander the Great and Octavius Augustus, of whom one would only be painted by Apelles, the other only by the most excellent masters, we have had ourselves painted by you, and have so well proved your skill and success that it seemed good to us to distinguish you with imperial honors as a mark of our opinion of you, and as a record of the same for posterity."

Dürer had served as a favored artistic designer for Charles V's predecessor as emperor, Maximilian, but he had received only a pension, never a title. Moreover, the reference to Apelles, exclusive portraitist of Alexander the Great, shows to what extent Renaissance rulers as well as painters patterned themselves after the model of the ancients for court art. Again, Titian's standing at court would also be enjoyed by his seventeenth-century successors, Rubens (ennobled by the regents of Flanders and the kings of Spain and England), van Dyck (England), and Velázquez (Spain).

Titian went on to paint portraits of Charles V on later occasions, particularly during the period 1548–50, when the emperor was in Augsburg defending the Catholic Church in its conflict with the German Protestant League. One of these portraits, *Charles V on Horseback* (1548; Fig. **5.41**), commemorates the victory (later reversed) in 1547 of the emperor at the battle of Mühlberg. Titian's command of visual detail in recording the precise battle armor of the emperor is balanced by his delicate rose harmonies in the trappings, sash, and the remarkable atmospheric background sunset, one of Titian's most admired coloristic effects. This image alludes to the heritage of ancient Roman equestrian sculptures, such as the Marcus Aurelius in Rome (Fig. 2.63), and the Renaissance ones based on it, including the life-sized bronze in Padua by Donatello (Fig. 4.41). Apelles had painted such a commemorative portrait of a mounted Greek warrior in armor, according to Pliny, and as recently as Dürer's *Knight, Death, and the Devil* engraving (1513; see Fig. 4.25), a riding Christian knight in armor had personified pious, active virtue in a manner appropriate to the role of the emperor as defender of the faith. The painters of the following century would often draw inspiration from this Titian imperial portrait as well, although an artist like Rubens would add allegorical trappings, such as the personification of Fame, above the equestrian subject. Yet the unassuming and straightforward presentation of the emperor without allegorical fanfare suggests a deep bond of sympathy between the artist and his imperial protector, a true friendship often reported with amazement by early biographers of Titian.

PHILIP II OF SPAIN During this mid-century period of his association with Charles V, Titian also began to work for the emperor's son and heir, Philip II of Spain. He produced a handsome, if aloof, full-length standing state portrait of Philip in dress armor (1550–51), which set the formula later followed by Velázquez and subsequent artists of the Spanish court (Fig. **5.42**). From then until his death, Titian's output was dominated by commissions from the Habsburg family and their circle. Thus his progress from city

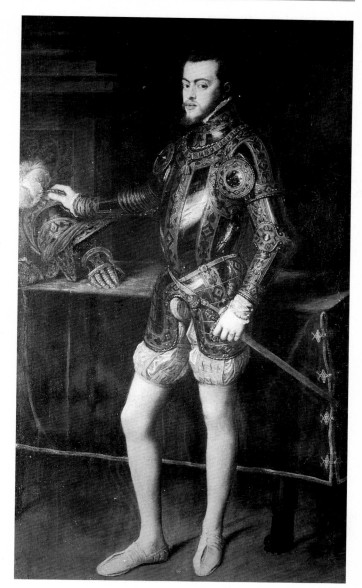

5.42 Titian, *Philip II*, 1550–51. Oil on canvas, 76 × 44 ins (193 × 112 cm). Prado, Madrid.

painter of Venice to imperial or royal court painter, while not exactly linear, was a model for all subsequent artists of ambition (as it parallels the previous, more limited advancement of Holbein from Basel to London).

For Philip II Titian produced many of the great mythological paintings in his celebrated late manner, filled with the vitality of expressive, individual brush strokes as well as the lively color and atmosphere already visible in the cycle for Alfonso d'Este. Titian even defends his looser brushwork against comparison with the finer delicacy of Florentine or Roman *disegno* in an attributed quote: "Sir, I am not confident of achieving the delicacy and beauty of brushwork of Michelangelo [or] Raphael . . . and if I did, I would be judged with them, or else considered an imitator. But ambition, which is natural in my art as in any other, urges me to choose a new path to make myself famous . . ." No greater candor regarding

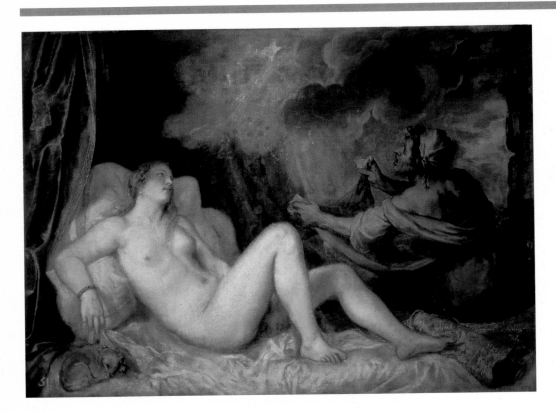

5.43 Titian, *Danaë*, ca. 1549–50. Oil on canvas, 50¾ × 85½ ins (129 × 217 cm). Prado, Madrid.

personal ambition for artistic fame survives from the Renaissance, and the contrast of Venetian *colorito* with Florentine *disegno* is explicit.

Despite the fastidious piety of the Spanish monarch and Pope Paul III, whom Titian also served, many of these paintings, beginning with the *Danaë* (ca. 1549–50), are openly erotic, recounting the loves of Jupiter and Venus as well as other myths derived from Ovid (Fig. **5.43**). That the text alone did not motivate the royal patron is clear from a letter to Philip by Titian: "Because the figure of Danaë, which I have already sent Your Majesty, is seen entirely from the front, I have chosen this other *poesia* to vary the appearance and show the opposite side, so that the room in which they are to hang will seem more agreeable." By using the term *poesia*, Titian implicitly sets up the comparison between the arts of painting and poetry, as if in response to the often-quoted classical dictum of Horace, *ut pictura poesis* ("As is poetry, so is painting"), but the term refers to mythic subject matter, as distinct from devotional pictures.

Competition with another sister art, sculpture, also emerges from the artist's letter, for Titian intended to use a pair of paintings to produce a comprehensive view of an ideal female nude figure, seen from the back in one and from the front in the other. *Poesia* also implied artistic freedom and imagination, poetic license to create, as in the juxtaposition by Giorgione of the landscape with recumbent *Sleeping Venus* (Fig. 5.37) half a century earlier. Titian's letter to Philip also makes clear that the artist consciously composed his mythological pictures to form a decorative ensemble, just as he had harmonized his own canvases (as well as his modified version of Bellini's mythic subject) in the Camerino of Alfonso d'Este.

PALLADIAN VILLAS

The kind of private recreation of antiquity in art for personal contemplation and delectation ultimately derives from the kind of meditative retreat first seen in the courtly world of later Medici patrons in Florence. More properly, these Medici were based not in Florence itself but rather outside the city in villas, such as Poggio a Cajano, favorite retreat of Lorenzo the Magnificent (Botticelli's mythologies were painted in part for a Medici cousin's Villa di Castello; see p. 176). In the history of Renaissance architecture, Venice's chief contribution lay not within her watery city limits but rather in her extended territories, the Veneto, where his later versions of villa architecture brought fame to Andrea Palladio (1508–80). At the same time that Titian was working for noble patrons at the courts of northern Italy or distant Spain, Palladio was providing country housing for gentleman farmers in the Veneto. In contrast to the more contained garden villas of Rome, Venetian villas combine an agricultural emphasis with conventional rural solitude. Land reclamation and farming became new economic enterprises providing alternatives to the deteriorating possibilities for merchant trade in the Mediterranean. Thus villas offered new forms of investment as well as being country estates for the patricians of Venice.

For the Villa Barbaro at Maser, north of Venice (ca. 1555–59), Palladio's patron was more than just a wealthy and noble investor. Daniele Barbaro was also a learned and active scholar, a poet, mathematician, philosopher, and diplomat, who collaborated with his architect on the publication of an illustrated edition and commentary of Vitruvius's Roman treatise

5.44 Palladio, Villa Barbaro, Maser, ca. 1555–59. Exterior, facade.

5.45 Palladio, Villa Barbaro, Maser, ca. 1555–59. Interior, Stanza di Bacco, frescoes by Paolo Veronese.

on architecture at the same time as the villa was under construction (1556). The two men traveled together in 1554 to Rome, and Palladio went on to publish a brief but reliable guidebook to the visible remains of the ancient city. Roman ruins influenced the basic architectural vocabulary of Palladio and also underlay his convictions about an essential connection between classical forms and ancient morality. He freely used the ancient forms of temples and baths in new combinations for his modern houses, palaces, and villas.

Thus, at Maser, the exterior of the Villa Barbaro begins with a central block with a classical, pedimented temple front, then extends outward in arcaded wings to side pavilions adapted for actual farming needs (Fig. **5.44**). This design shows Palladio's facility for utilizing central, classical formulas to designate a central focus, such as an entrance. He then composes the remainder of his building out of basic geometrical blocks of space, distributed symmetrically around his core or central axis, their proportions carefully harmonized with it.

PAOLO VERONESE To enhance the farming life with a gentleman's leisure, Villa Barbaro also includes a classically inspired *nymphaeum*, or architectural pond, decorated with classical gods in niches by the leading Venetian sculptor, Alessandro Vittoria. More traditional, however, are the splendid wall paintings that decorate the interior (Fig. **5.45**). Every room of the upper level was painted with frescoes by a newcomer to Venice, Paolo Veronese (1528–88), who had recently painted Barbaro's portrait with tokens of his

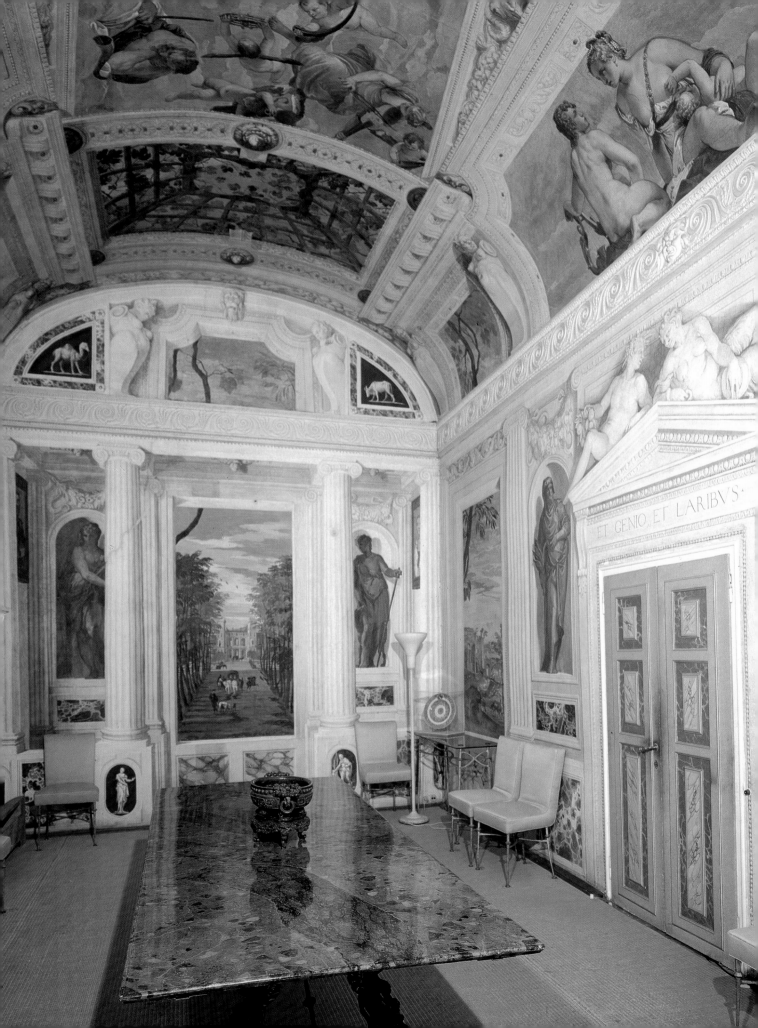

5.46 (Opposite) Palladio, Villa Barbaro, Maser, ca 1555–59. Frescoes, Stanza di Bacco.

5.47 Paolo Veronese, *Daniele Barbaro*, 1556. Oil on canvas, 47½ × 41 ins (121 × 105 cm). Rijksmuseum, Amsterdam.

not only in its classically informed architectural forms but even in its decorations of sculpture and fresco painting.

Veronese's career continued to mingle novel interpretations of religious subjects (he was hauled before the Inquisition on charges of sacrilege for his anecdotal 1573 rendering of the subject of *Christ in the Home of Levi*) with recondite mythologies and allegories. Here his adoption of Titian's dazzling colors for opulent costumes found full expression in full-length figure groups. A principal example is the allegory *Honor et Virtus post Mortem Floret* (Honor and Virtue Flourish after Death), one of a pair of large canvases commissioned from Veronese by the Elector of Bavaria, Albrecht V, in 1567–68 (Fig. **5.48**). The other, showing Hercules as the image of Strength and a standing draped female figure of Christian Wisdom, avers *Omnia Vanitas*, All is Vanity. In composition the male figure of Honor derives from the classical allegory of the Choice of Hercules between Virtue and Vice. Here a young, well-dressed, courtly hero evades a beautiful but sinister female personification of Vice, marked by a sculpted sphinx and blade behind her skirt and a nude caryatid with the thematic inscription above her head. Although the young man, Honor, has suffered a tear in his stocking, he is rescued by the clasp of Virtue, crowned with the laurel of Roman honor and victory. This erudite yet

learned interests, including a recent printed edition of Vitruvius (Fig. **5.47**). Veronese would succeed the aged Titian after 1555 as Venice's leading painter of ceilings, altarpieces, and easel pictures, celebrated for their brilliant color. At Villa Barbaro, his scenes include ancient myths and poetic allegories, chiefly on the ceilings, plus views of various landscape settings, often including the ancient ruins so beloved of both architect and patron (Fig. **5.46**). His landscapes emulate the perspective of ancient murals and seem to dissolve the walls and open up prospects over simulated balconies to the actual hilly countryside around the villa. In decorating a country home with such a variety of settings, Veronese, too, was conforming to ancient descriptions and prescriptions. Pliny mentions wall paintings of groves or hills, and Vitruvius (the author so recently studied by both Palladio and Barbaro himself) cites "varieties of landscape gardening, harbors, headlands, shores, rivers, springs, straits, temples, groves, cattle, hills, and shepherds." This custom of decorating country houses with painted plaisances was renewed by the Florentine theorist, Leone Battista Alberti, in his treatise on architecture (1485), which claims that such landscapes are soothing and more appropriate to wall decorations in country houses than urban palaces. Thus the Villa Barbaro at Maser fulfills its Renaissance purpose of recreating an ancient villa,

5.48 Paolo Veronese, *Honor et Virtus post Mortem Floret*, 1568. Oil on canvas, 86¼ × 66½ ins (219 × 169 cm). © Frick Collection, New York.

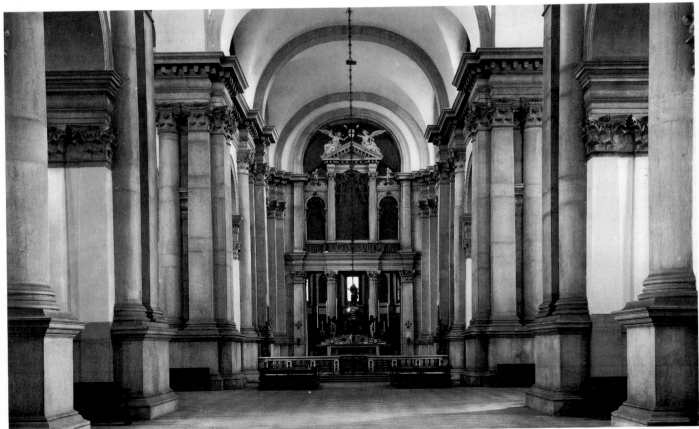

5.49 (Opposite, above) Andrea Palladio, San Giorgio Maggiore, Venice. Facade, begun 1566.

5.50 (Opposite, below) Andrea Palladio, San Giorgio Maggiore, Venice. Interior.

5.51 Andrea Palladio, San Giorgio Maggiore, Venice. Plan.

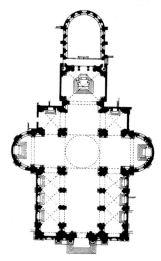

legible conception seems to have been intended for the Elector's son, on the occasion of his marriage, as a suitably radiant yet instructively moral pictorial lesson, and the white satin garment worn by the figure of Honor may well have been a wedding outfit. Later, Veronese supplied ceiling paintings and mythological scenes for Rudolf II, the Holy Roman Emperor. Like Titian before him, Veronese succeeded in moving beyond Venice and the villas of the Veneto to the international stage as a leading court painter in the employ of the rulers of Central Europe.

After completing his own work at Villa Barbaro, Palladio made an important and influential contribution to architectural history in the form of a printed treatise, the *Four Books of Architecture*, published in Venice in 1570. While this publication is informed by classical learning (especially Vitruvius) and first-hand knowledge of ancient ruins in Rome, it offers practical advice based on Palladio's own building commissions. The text advises its readers on the use of classical elements, such as the orders of columns, and on the design of particular building types, including houses (twenty of Palladio's villas are illustrated), public buildings, and temples. Thus it serves a new kind of specialist, the professional architect, rather than the artist-architect, the multifaceted designer of genius, such as Leonardo, Michelangelo, or Raphael. Palladio's treatise also was accompanied by illustrations, woodcuts of both plans and elevations to enhance the practical value (and eventual influence) of the text as well as to demonstrate the principles of measurement and proportion. Thus the architect offers his own career as a case study of the principles of Renaissance architectural composition and theories of harmony. In each instance, his own solution is accompanied by a reconstructed classical model, based upon the text of Vitruvius, to illustrate the general principle.

PALLADIO'S "CHRISTIAN TEMPLE" At around the time he was completing his treatise, Palladio finally got the opportunity to design a major church. Moreover, the site of his church was one of the most prominent in Venice: the island of St, George, framing the entrance to the main square of the city, opposite the ducal palace and St. Mark's basilica. The result is a major complement to the city center and its skyline, the Venetian equivalent to Brunelleschi's cathedral dome in Florence (Fig. **5.49**). Palladio began work for the Benedictine order at San Giorgio Maggiore in 1566, and work on the façade continued after his death until 1610. Its interior space is a compromise between the ambitious principle of centralized construction around a dome by Renaissance architects, such as Bramante at St. Peter's, and the contrasting need for a longitudinal basilical space in accord with Christian tradition (Fig. **5.50**). Thus Palladio's church was designed from the outset to produce the synthesis forced upon Michelangelo at St. Peter's, where the inherited plan of Bramante had to be reconciled with liturgical needs. Because of Palladio's practical experience, he could support a huge dome with minimal masonry and thus keep open a spacious nave expanse on an arcade of piers for a large congregation. A barrel vault with bright windows adds to the openness of the interior, which is complemented by open passages to side aisles. Moreover, by using attached half-columns and a firm entablature alongside his arches in the nave, Palladio articulates his interior space in a regular rhythm with the forms and grandeur of ancient triumphal arches. The high altar is also framed within paired classical columns that echo the nave forms and conform to the proportions of the nave space. As with Brunelleschi's cathedral in Florence, gray columnar elements define space against whitewashed walls, further enhancing the spatial rhythms and light. In San Giorgio Maggiore and in his later Venetian church, Il Redentore, Palladio succeeds in assimilating the lessons of previous Renaissance church architects. While utilizing classical building elements, he creates space on a scale as grand as the vaults of the ancient Roman baths (whose semicircular windows inspired Palladio's interior lighting).

The exterior of San Giorgio Maggiore also fuses various architectural traditions. A red brick campanile answers the bell-tower of San Marco across the lagoon, and its rounded dome also corresponds to the Byzantine heritage of San Marco. But onto this ensemble Palladio has set a classical temple front, modified after his death from the original design but still preserving his basic design. This façade actually presents several interlocking planes of depth, superimposing two separate temple fronts. The chief pediment of the church rises on four attached columns, corresponding to the columns of the nave within. Below, a second, squatter temple front above pilasters shows through and beyond the great columns, presenting niches for sculptures as it suggests the height of the aisle spaces inside. Thus Palladio could conform to Vitruvian canons of the harmony of all parts as well as to the ancient model of the Pantheon, with its dome preceded by a strongly pedimented portico.

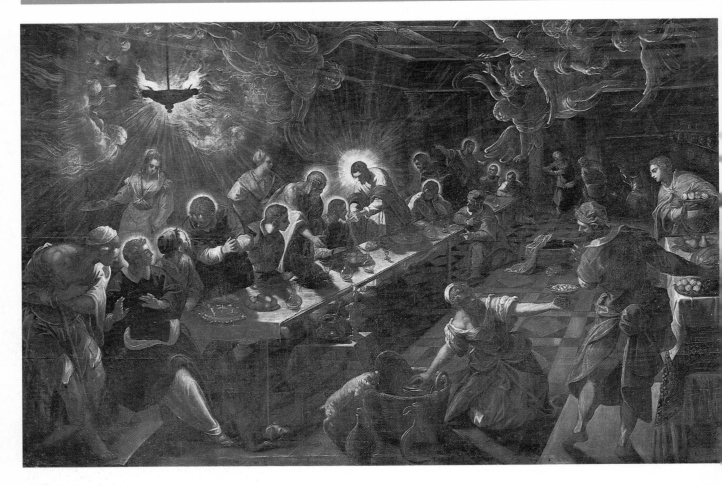

By these means, Palladio realized his goal as a Renaissance architect: a modern, Christian "temple," using the formal elements and principles of ancient models to surpass antiquity itself in both dignity and grandeur. Palladio's San Giorgio is the climax to the design of Renaissance Venice: rooted in ancient Rome but constructed with modern professionalism.

JACOPO TINTORETTO To ornament the chancel of the new church, the other leading religious painter in Venice, Jacopo Tintoretto (1518–94), was called upon to provide a sacramental subject, *The Last Supper* (1592–94; Fig. **5.52**). Its dynamic diagonal composition and somber tones contrast utterly with the classical calm and lucid colors of Veronese. Out of the gloom of this giant canvas emerges the

5.52 Jacopo Tintoretto, *The Last Supper*, San Giorgio Maggiore, Venice, 1592–94. Oil on canvas, 144 × 224 ins (365.7 × 569 cm).

mystical light of revelation, each apostle with a gleaming halo that distinguishes him from the accessory figures of servants. Brightest of all is the larger halo of the central figure of Christ, a brilliance that obscures even the bright lamp as well as the numinous (spiritual) figures of hovering, glowing angels. It reinforces the mystery of the central rite of the church by the way in which it depicts the institution of the sacrament of the eucharist, recalling the visionary spirit of the late Michelangelo. In the coming century, art in the service of Catholic monarchs and of princely popes would continue to assert the Roman creed against rival Protestant challenges.

AZTECS, ANCIENT MEXICO

During the period of the initial consolidation of nation-states in Renaissance Europe, in the New World a millennium of empires in Mexico and Central America came to a climax with the Aztecs (or Mexicas) and their island capital of Tenochtitlán (modern Mexico City). Although conquered by Hernán Cortés and his invading Spanish armies (whose gunpowder was less effective than their correspondence to the Aztec mythic prophecy of a divine advent by sea), Tenochtitlán was one of the world's most populous cities, with a ceremonial architectural center as impressive as anything in Europe.

Tenochtitlán (established 1325) was the ultimate artwork of the Aztecs. The layout of the capital mirrored the structure of the cosmos, a physical demonstration of the links between the nation and natural forces. Unfortunately, modern Mexico City overlies the remains of Tenochtitlán, but excavations (completed in 1986) have helped to recover many of the principal features of the capital. At its center was a walled ceremonial precinct, oriented eastward toward the rising sun, with a royal palace nearby. From the center a network of canals linked the city to its surrounding lake and divided the capital into four quadrants. These segments attest to the importance in Aztec cosmology of the quadrants of the compass, oriented around the passage of the sun from east to west.

The famous Aztec "Calendar Stone" (excavated in 1790 at the downtown center of Mexico City) represents this cosmology and its history of destruction on a large scale; the original site and function of this great stone remain unknown (Fig. **5.53**). At the center, defining the entire circular design of the cosmos, lies a face, crowned and borne by a quartet of animal

5.53 "Calendar Stone," 1427. Stone 142 ins (360 cm) diameter. National Museum of Anthropology, Mexico City.

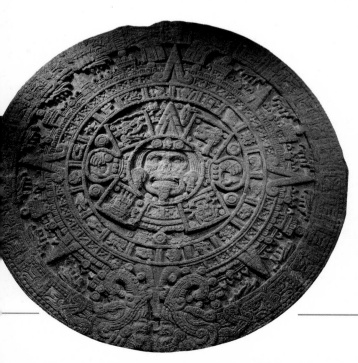

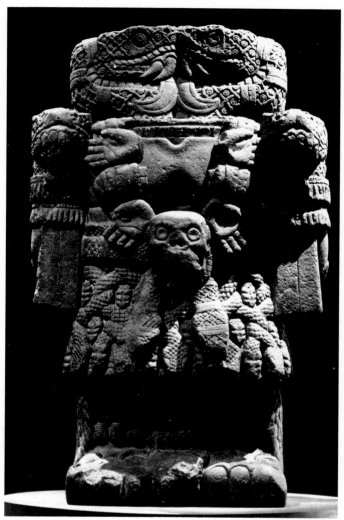

5.54 *Coatlicue*, later fifteenth century. Stone, 99¼ ins (252 cm) high. National Museum of Anthropology, Mexico City.

symbols, representative of four prior eras (and suns), all destroyed by natural forces. In a band around the central disk lie symbols of the twenty days of the Aztec week, which gave rise to the initial interpretation of the image as a calendar. The chief outer band of the stone presents the decorated sun-diadem, ornamented with turquoise and jade and radiating to the cardinal compass points. The entire stone is encircled by symmetrical fire serpents whose tails meet at its top. The specific identity of the demonic central face has been variously interpreted; clearly it represents a fundamental cataclysm, sun fallen upon earth, to be averted only by human blood sacrifice upon the stone itself in its temple precinct.

Such destructive natural forces were central to the Aztec cosmos and to the ritual activities, chiefly human sacrifice, of the Aztec rulers in controlling both their state and their place

225

in the cosmos. To the horror of Spanish soldiers, large and terrifying sculptures of the central temple precinct were covered not only with jewels and gold but also with human blood. The most fearsome surviving Aztec sculpture is Coatlicue (also excavated in 1790), the "serpent-skirted goddess" who probably once resided in the temple with twin pyramids at the centre of Tenochtitlán (Fig. **5.54**, p. 225). This powerful and awe-inspiring goddess was the mother of Huitzilopochtli, the warrior and hunting deity who was the cult ancestor figure of the Aztecs and identified as the sun god. The monumental sculpture of Coatlicue typifies Aztec carving (and much Mesoamerican sculpture) in its intricate, ornamental decorative pattern as well as its solidity. The goddess, an earth deity identified with a snake mountain, has a blocky head composed of two symmetrical fanged serpents. Around her neck hangs a necklace of severed hands and human hearts and the head of a sacrificial victim, redolent of the sacrifices performed in her honor at her pyramid, which was itself decorated with serpents at the base.

THE TEMPLE STONE The original shape of the stepped sacred pyramid structure and its ceremonial importance both emerge from the Temple Stone, datable to 1507 (Fig. **5.55**). Found near the royal palace (1831), this temple-in-miniature probably functioned as the throne of Montezuma II; its date records the last New Fire ceremony, celebration of the end of a 52-year cycle in the Aztec calendar. On the sides of the throne seated priests, dressed like deities, draw blood from their loins in a self-sacrifice that indicates their support of the current Aztec ruler, who performs similar acts. Above, the king would sit on the fearsome earth lord; at

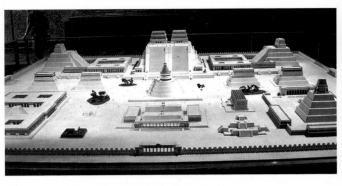

5.56 Reconstruction of Templo Mayor ceremonial precinct, Tenochtitlán (Mexico City), ca. 1500. National Museum of Anthropology, Mexico City.

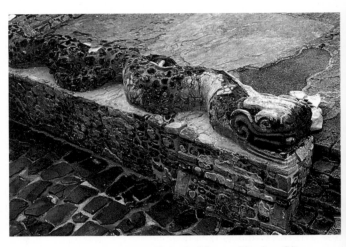

5.57 Serpent guardians, Templo Mayor, Mexico City, ca. 1470.

his back, in the place of the altar area of the pyramid, was a solar disk, similar to the Calendar Stone. Symbolically, the seated ruler then fulfilled his ultimate purpose, the separation of sun from earth, forestalling the destructive forces that end each solar era.

The stepped vertical shape of the Temple Stone clearly echoes the original central pyramid of the sacred precinct, visible also in smaller surviving examples near Mexico City, such as the pyramid of Santa Cecilia Acatitlan near Tenayuca. Architecture repeats the pattern of Aztec cosmology at the ritual center of Aztec life, the sacred precinct as navel of the earth and mirror of the solar disk. At the heart of the capital of Tenochtitlán a quadrangular center was dominated by the Templo Mayor, a lofty pyramid (ca. 197 feet/60 meters in height) in the east with twin shrines dedicated to the rain and sun gods, Tlaloc and Huitzilopochtli, completed in 1487 (Fig. **5.56**). The pyramid was oriented toward the equinox, when the sun rose directly between the two temples; afterwards the sun wandered to the appropriate house of either the rainy or the dry season. Surviving imitations of this prime temple model show it as having a tall square truncated roof, adorned with reliefs, with imagery appropriate to the deities honored at the site. At the base of the temple lay sculpted ornaments of

5.55 Temple Stone, 1507. Stone, 48½ ins (123 cm). National Museum of Anthropology, Mexico City.

powerful animal guardians: serpents, eagles, jaguars; the latter two symbolize day and night as well as principal Aztec warrior societies (Fig. **5.57**). Twin symmetrical pyramids framed the Templo Mayor, and the complex was completed by additional temples, priestly buildings, and a ball court, with the royal palace adjacent to the south. All roads led out from this ceremonial and political center.

Aztec domination was maintained through military power as well as through the intimidation effected by mass human sacrifice of prisoners. Numerous Aztec sculptures or manuscript miniatures of human impersonators of the gods show the use of human skin as an essential part of ritual dress. Natural destruction and mythic violence dominate ideology of the Aztecs, representing them as both rulers of the earth and controllers of the cosmos from its center.

Aztec culture, however, also rested upon the conquered cultures of earlier Mesoamerican civilizations, incorporating their cult figures and forms but subordinating them to their own cult ancestor, Huitzilopochtli. Thus the divinities served by Aztec kings and priests in their impersonations and sacrifices were magical representatives of peoples and territories as well as powers of nature, controlled by ritual. With completely different motivation, Aztec artisans absorbed and incorporated the forms and the cults of previous cultures, analogous to the Romans absorbing Greek culture, or the Renaissance revitalizing classical civilization to form its own identity.

Mesoamerica had its own long-vanished civilizations. To the south in Yucatan lay the Mayas, whose classic phase was over by about AD 900. Mayan warrior-rulers of that period also used cosmic symbols (and uniquely careful astronomical measurements), and they rendered supernatural figures in animal form, such as the jaguar god of the underworld. Mayan relief steles shows their rulers in elaborate costumes with headdresses, carved in an ornamented style. Steep pyramidal structures, 230 feet (70 meters) high, mark temple sites (as well as ornamented tombs, analogous to Egyptian pyramids). The Mayans also perfected the calendar later used by the Aztecs, consisting of 20 days in 13 or 18 months over a cycle of 52 years (the period of the Aztec New Fire ceremony).

TEOTIHUACÁN In central Mexico near Tenochtitlán lay the older culture of Teotihuacán, burned in AD 650. Built on a grid of right angles, this metropolis featured a ceremonial north-south axis, the Way of the Dead, highlighted by stepped pyramids of the sun and the moon (Fig. **5.58**). Teotihuacán is actually the Aztec name for this site, which continued to be a pilgrimage destination after it had been destroyed. The rain god Tlaloc, featured atop the Templo Mayor, derives from this culture (and was also associated with war and sacrifice for Mayans). As in the Templo Mayor, the great Pyramid of the Sun (200 feet/61 meters high), begun before AD 150 at Teotihuacán is oriented eastward; the Pyramid of the Moon completes the axis, aligned with a mountain (source of water) behind it. Architectural ornament from Teotihuacán, at the "Citadel" or Temple of Quetzalcoatl features fanged serpent motifs.

Hence much of the imagery and the cosmology of Aztec art arose from venerable foundations in Mesoamerica. The great new capital at Tenochtitlán established its legitimacy through its literal incorporation of previous cultures, principally Teotihuacán. Like the upstart regional empire of Florence or the politico-religious capital of Rome, Aztec rulers also absorbed a visual heritage in order to consolidate their claims to moral dominion and their historical emergence as a powerful state. With the conquest of Tenochtitlán by the Spanish, Aztec artworks became booty, shipped back to Europe as testimony to the superiority of Christianity over paganism (a royal feather headdress became a trophy of Emperor Charles V Habsburg and remains in Vienna).

Despite cultural differences, these powerful Aztec images could also elicit appreciation from European viewers who saw them for the first time. Visiting Brussels in 1520, the German artist Albrecht Dürer (see p. 148–153) recorded encountering them in his private diary: "I saw the things which were brought to the King from the New Golden Land: a sun entirely of gold, a whole fathom broad; likewise a moon, entirely of silver just as big . . . all of which is fairer to see than marvels . . . and I marveled over the subtle ingenuity of the men in these distant lands."

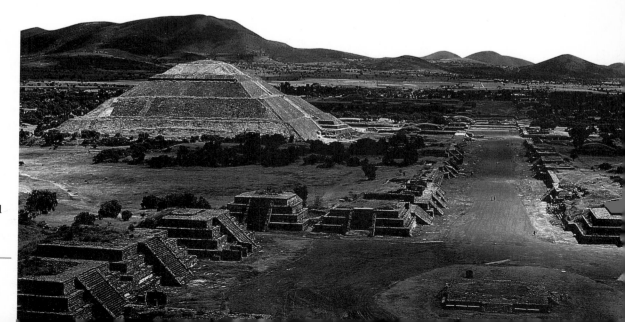

5.58 Teotihuacán, air view of Way of Dead axis, fifth-sixth centuries AD.

IFE AND BENIN, ANCIENT WEST AFRICA

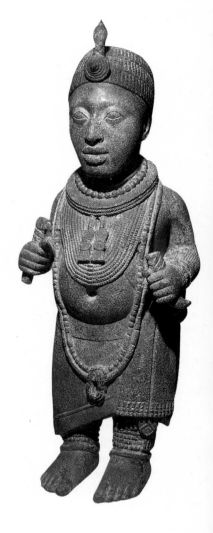

5.60 Figure of an Oni, Ife, early fourteenth-early fifteenth century. Brass. Museum of Ife Antiquities, Lagos.

Although the work of ethnographers and other anthropologists can often give the impression that the African continent was peopled by discrete tribes with little artistic heritage, the archaeological record uncovers the opposite truth. Modern politics has prevented systematic excavations in the most fruitful sites, but what has been unearthed reveals an ancient, royal site at the former city of Ile-Ife within modern Nigeria. Beginning as early as the ninth century of the Christian era, and at its height from the eleventh to the fifteenth century, Ife attained a level of political domination and technological sophistication in art-making comparable to anything in Europe, Asia, or Central America. Like the cultures of China, Japan or Mesoamerica, Ife also follows in the wake of previous civilizations, specifically the nearby Nok culture (500 BC-AD 200), with its distinctive terracotta sculptured heads.

Ife is situated in the heart of modern Yoruba lands to the west of the Niger River delta, and its origins form part of Yoruba mythology. According to mythic history, Ife was founded by Oduduwa, a warrior-conquerer also identified as one of sixteen lesser gods who descended from heaven on an iron chain to create the world for the high god, Olodumare.

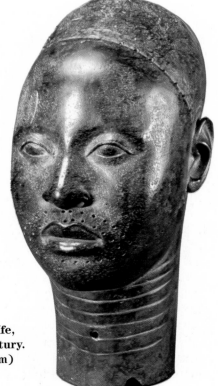

5.59 Head of an Oni, Ife, twelfth-fifteenth century. Brass, 12³⁄₁₆ ins (31 cm) high. Museum of Ife antiquities, Lagos.

Oduduwa served as the first king (*oni* or *oba*) of Ife, thus establishing that Ife rulers are semidivine and their capital the very cradle of civilization.

Kingship clearly dominated the political structure of Ife (and it does today, because the modern *oni* has put a stop to the archaeological dig at his palace). Because of the limitations placed on archaeological excavation at Ife, the outlines and scale of the original palace compound cannot be reconstructed with certainty. However, it is clear from extensive potsherd and stone pavements, that the sacred royal precinct was set apart, probably defining a rectilinear ground plan within earthen defensive walls. Impressive lifelike heads in terracotta, as well as stylized or grotesque evocations of faces in the same medium, formed a major part of Ife creations, possibly with links to the earlier models from Nok.

BRASS HEADS Most striking of all Ife creations are the life-sized brass heads of rulers, whose striking naturalism even suggests portraiture (Fig. **5.59**). Produced from an alloy of zinc, copper, and lead, these brass heads show a sophisticated casting technique without parallel at that period. This technique permitted even the casting of smaller heads in almost pure copper within sealed molds. Myths associated with the warrior god Oduduwa, tracing his descent from heaving on an iron chain, suggest the importance of metalworking in the Ife tradition, which also honors a god of iron, Ogun. The function of the brass heads demanded additions that would have fitted into holes still visible in the neck, lips, and hairline.

Scholars have theorized that these heads were used in solemn second burial ceremonies of the recently deceased monarch, bearing his crown, or, alternatively, that they were used within some renewal ritual, such as formal coronation. In either case, this effigy, with the head atop a wooden body clad in robes, would have demonstrated the continuing power of the royal office through the mimetic presentation of a royal crown and other signs of office (probably including a beard or else a veil around the mouth). Thus the brass heads of Ife kings provided for the continuity of the royal dignity, employed anew by each successive Ife king as the sign of his authority. The number of surviving brass heads, sixteen, also corresponds to the number of Yoruba sacred city-states, so each effigy might well have served as the emblem of authority from the center of the empire, Ife, to each of its provincial capitals. One can compare the diffusion of Roman emperor portraits from the capital city to its own provinces.

The brass heads seem to have been used in rituals: several of them were found with traces of paint (on eyes and neck) as well as fragments of thread, nail, and a bead. Some of the heads also bear striations, though this could indicate either some ritual scarification of the *oni* or else a suggestion of a fabric veil. One smaller, full-length brass figure of a king from Ife shows him wearing a crown and carrying the emblems of his office: a scepter made of beads and cloth in his right hand, a ram's horn filled with magical substances in his left hand (Fig. **5.60**). Around his neck hangs a heavy beaded collar with a double bow, badge of his royal office, as well as a large rope of beads. Beadwork crowns have continued to serve as symbols of royal authority for more recent *oni* of the Yoruba.

One surviving Ife head in pure copper was actually worn as a mask, equipped with narrow slits below its eyes for the wearer. In this special case, the new ruler could literally fuse with his royal ancestor as he assumed the role of kingship in Ife society (in this case through the personification of Obalufon II, third king of Ife and legendary inventor of the process of brass-casting). By so doing, he could assume the various qualities of his deified ancestor, who was the deity of war, peace, prosperity, and the arts of beads and brass in Ife. A crowned and striated (as well as bearded/veiled) face mask in terracotta (Obafemi Awolowo University) also has eye slits for the wearer as well as the same stepped crown (crest missing) found on the full-length bronze.

THE ART OF BENIN

To the east of Ife lies Benin, another capital city, whose ascent marked the decline of Ife. According to oral tradition, Oranmiyan, son of Oduduwa, the founder of Ife, came to Benin and established the powerful ruling kingdom, eventually claimed by his son, Eweka. During the fifteenth century the Benin empire expanded greatly, particularly under the leader (*oba*) known as Ewuare the Great, who laid out the new centralized capital city on a plan radiating out from the palace. Tradition further claims that Oguola, sixth *oba* of Benin, sent for bronze-casters from Ife in the late fourteenth century. Certainly the great surviving works from Benin are also bronzes (more often brasses, alloys of copper and zinc rather than true bronze, which is an alloy of copper and tin). In this case, however, the copper so essential for the alloy was imported from Europe after 1485, thanks to the new routes opened up by Portuguese traders. Copper from the Alps was exchanged at Antwerp for gold, ivory (including tusks carved by the Benin), and pepper imported by the Portuguese from Africa's west coast as well as from the Indian Ocean (after Vasco da Gama rounded the Cape of Good Hope in 1498). Slaves were also part of this trade with the Portuguese, as coastal Africans bartered captured enemies and rival peoples with the new European sea powers.

The Benin people, or Bini, held a monopoly of trade with the Portuguese in Africa, and their resulting wealth permitted conspicuous display of bronze and ivory artworks in honor of the *oba* in his palace. Bronze-casters and brass-casters worked exclusively for the *oba* on pain of death. According to modern informants, the significance of the metalwork for Benin rulers lay in its shiny surface and bright color, intended to be both beautiful and frightening, as befits a royal symbol. Patterns on the ground of the brasses usually feature quatrefoil ornament, cosmological symbols of life-giving sun.

Although the glory years of the Benin empire were largely over by the eighteenth century, it was only with the 1897 invasion by a British colonial expedition, which carried off four centuries' worth of palace treasures to the British Museum, that this art tradition came to a halt. Indeed, photographs of *obas* from this century show the continuity of costume, especially of crowns and carved ivory cuffs, depicted in earlier bronzes.

BRONZE PLAQUES Surrounded with all the trappings of divine kingship, the royal palace compound in Benin had wooden columns decorated with rectangular bronze plaques (about a thousand survive) showing court life, hunting, and warriors, as well as some of the visiting European traders in costume (the unusual rectangular shape has been related to the format of pages in European books, as one of the sources of these commemorative plaques). Benin plaques reveal a consistent hierarchy, in which the arrangement of figures is determined according to rank. Attendant figures always appear at the side of a centralized leader,

229

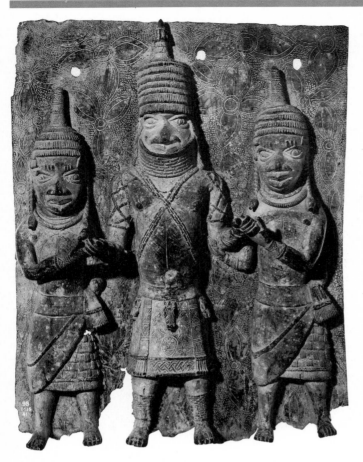

5.61 *King with Two Chiefs*, Benin City, sixteenth-seventeenth century. Bronze plaque, 15 ins (38 cm). British Museum, London.

BRONZE HEADS Similar insignia can also be found on Benin bronze heads, some serving as pedestals for the carved ivory tusks, decorated with images of former kings and warriors and with symbolic royal animals, which were among the items of tribute to the *oba* (Fig. **5.62**). Ancestral commemorative heads functioned ceremonially to honor the power of the deceased and to beautify ancestral shrines. These heads were first made of wood, then of terracotta, and eventually in the early historic period out of bronze for the *obas*. In addition to heads of ancestors, some purport to be trophy heads of enemy warriors, captured kings brought to the *oba* in victory and cast.

Bronze-casters of Benin also produced water vessels in the shape of animals, such as the royal leopards sacrificed in rituals on royal ancestor altars (in ceremonies supposed to have originated with Ewuare the Great) as symbols of the conquest of wilderness by civilization. The *oba* kept live leopards at court as a mark of his own power, and one of the earlier British Museum plaques shows an *oba* swinging a pair of them by their tails. In addition, a pair of brass or ivory leopards used to be placed at the side of the king when he sat in state (the British Museum houses a pair of ivory ones, each constructed out of five separate tusks and covered with copper discs for spots). Other bronzes depict foreign visitors, chiefly

5.62 *Head of a King (Oba)*, Benin City, seventeenth century. Bronze, 15½ ins (39 cm). University Museum, Philadelphia.

whether warrior or *oba*, and foreigners or lesser figures appear at a reduced scale (Fig. **5.61**). In this instance from the British Museum booty, the crowned *oba* stands central, frontal, and tallest in the composition. He often holds the insignia of his divine office, usually the ceremonial sword (*eben*) in his right hand and an ivory proclamation staff, shaped like a gong, in his left. His attendants' reduced height results from their postures of genuflection before him, as they turn slightly inward toward him in a symmetrical parenthesis. The *oba*'s marks of kingship, echoed by his courtiers, recall the insignia of wealth and power found already in Ife: necks encased in coral beads and tall pointed crowns of coral beadwork, symbolic of the ceremonial sword of life and death (*ada*), carried by chiefs during the *oba*'s public appearances. Some plaques depict the *oba* in a secret ritual, part of a yearly agricultural cycle that drives evil forces from the land (the two other main rituals honor his deceased father and reinforce his mystical powers). Sometimes foreigners, usually Portuguese, also appear in the plaques above the main figures, presumably farther away but also reduced in scale because of their lesser, outsider status.

5.63 *Leopards*, Benin City, sixteenth-seventeenth century. Ivory with brass inlay, 32⅝ ins (82.8 cm). British Museum, London.

the Portuguese, in animated and informal poses, often accompanied by symbols of sea power, such as crocodiles (or pythons or mudfish). One British Museum sixteenth-century figure is shown with a matchlock musket as well as contemporary military helmet and armor.

Benin carved-ivory tusks, or oliphants, served as hunting horns of high status, because the *oba* reserved ivory for his own use. But oliphants were also imported by the Portuguese as their own symbol of worldwide domination, leading to a hybrid artistic form that included the coat-of-arms of the Portuguese royal family and hunting scenes, along with Benin

guild designs and symbols of rank and wealth (swords, feathers). Ivory figures were also carved, such as the leopard with brass inlay which served, like its brass counterparts, to guard the royal palace (Fig. **5.63**).

THE PALACE AT BENIN was burned in 1897, although European illustrated accounts (such as the one published in Amsterdam in 1668) give a suggestion of its original appearance as well as the claim that it was the size of the Dutch city of Haarlem. One bronze box survives, however, to represent both the palace entrance and its guardian symbols of power, in the form of two Portuguese musketeers and two ibis birds on its roof (Fig. **5.64**). A tall, pyramidal central tower emerges like a chimney with a python ornament (described as cast copper in accounts) on its side and a crested bird at its peak. Fragmentary bronze remains of both the serpent, king of snakes, and the leg of the bird, symbol of a warning prophet, have been recovered, confirming the essential accuracy of the box-palace. Descriptions also refer to a succession of galleries in the palace, giving an idea of the extent and domination of the royal court of Benin. Like the rest of West Africa, Benin employed mud-brick and timber construction, covered with wood shingles, which has prevented the long-term survival of the buildings, in contrast with the stone structures of Europe and Mesoamerica.

5.64 Bronze box in shape of Benin Palace, sixteenth-seventeenth century. Museum für Völkerkunde, Berlin.

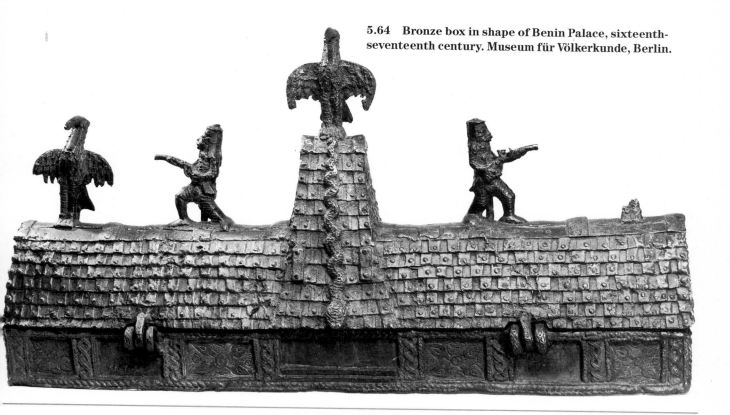

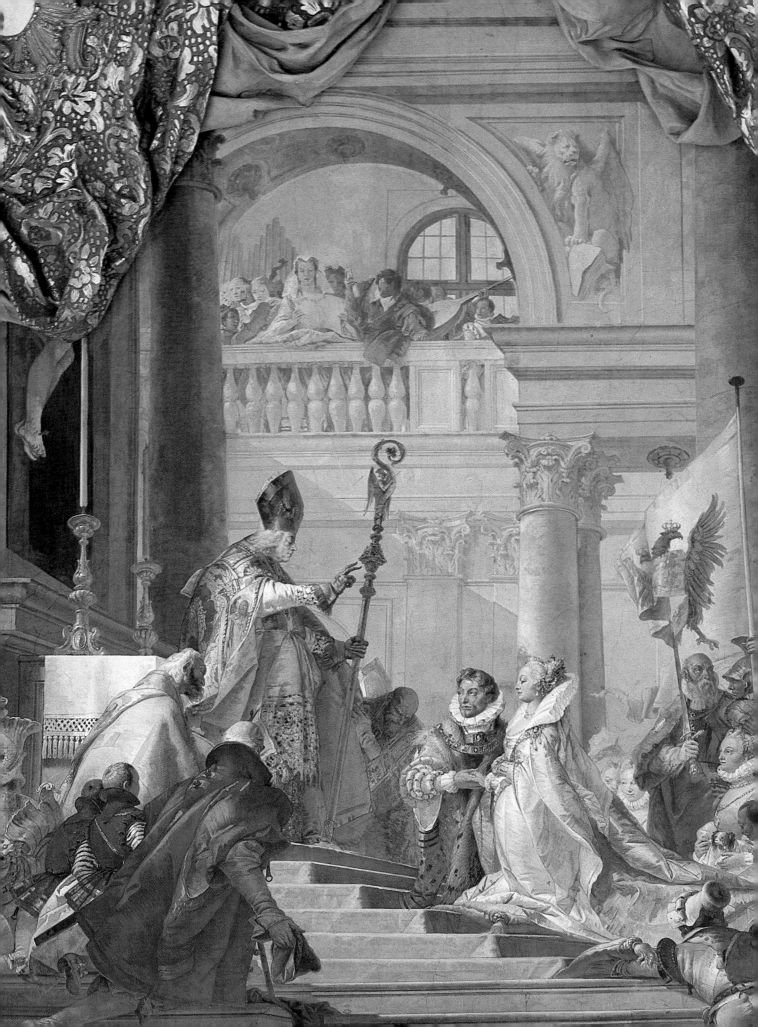

AGE OF ABSOLUTISM

CATHOLIC EUROPE

Claims made by the Counter Reformation for the authority of the Catholic Church were complemented in the consolidated nation-states of Spain, France, and England in the late sixteenth century by royal assertions of rule by "divine right." This reflected the increasingly regal aspects of papal court life in Rome. Taken together, these assertive authorities provide the name, "Age of Absolutism," for the whole of the seventeenth century. As usual, artworks operate to promote, even to make propaganda (a contemporary, Jesuit term) for such ideologies.

CARAVAGGIO AND CARRACCI

At the beginning of the seventeenth century, the parameters of religious art were firmly established in Rome by a pair of newly arrived artists: Michelangelo Merisi da Caravaggio (1573–1610) and Annibale Carracci (1560–1609). Both artists labored under the burden of Renaissance tradition, especially the epic achievements in Rome of Raphael and Michelangelo. Both produced art with powerful spatial illusion, deriving from their great Roman artistic models yet also mocking them. Annibale Carracci and Caravaggio worked for an elite circle of nobles and princes of the Catholic Church, combining their art in the service of religion with daring, private experiments on secular or mythic themes.

Detail of Fig. 6.37, Giovanni Battista Tiepolo, *Marriage of the Emperor* (see p. 258).

Carracci's *magnum opus* emulated Michelangelo's Sistine ceiling in the gallery or reception hall of the Farnese Palace (1597–1600; Fig. **6.1**). Numerous careful figure drawings are the basis for the active nude bodies of the Loves of the Gods that adorn the ceiling within simulated frames, medallions, and atlantean reliefs that imitate models from antiquity as well as echoing the fictive complexities of Michelangelo. Here, however, the subject of the ensemble is not the epic sequence of Genesis but rather a series of very human tales of mythological infatuation. The patron of this fresco ensemble was Cardinal Odoardo Farnese, a wealthy descendant of Pope Paul III, and the overall sensuous subject was apparently designed for the wedding festivities of his brother, Ranuccio. The frescoes also echo the themes and figures of the Psyche decorations made by Raphael almost a century earlier in another family palace, known today as the Farnesina. Such references to both ancient and Renaissance precedents emphasize the collecting of the visual arts in this gallery room, which would have housed a sculpture collection as well. The muscular, energetic figures and the Michelangelesque presentation of the Farnese ceiling serve to frame the private and personal nature of the collector's concept. These playful and satirical amorous scenes of the gods also follow the precedent of a suite of amorous pictures made by Titian for Alfonso d'Este at Ferrara (Figs 5.38 and 5.39) that collectively illustrate the *mock-epic* theme of "Omnia vincit Amor" (Love conquers all).

The same theme of conquering love formed the subject of a provocative contemporary canvas by Caravaggio: the *Victorious Cupid* (ca. 1601–02; Fig. **6.2**). This obviously boyish youth also derives from the fuller-figured wingless angels, or *ignudi*, on the Sistine ceiling as well as the later twisting allegory of *Victory* by Michelangelo from the unfinished tomb for Pope Julius II. But this boy's triumph over the arts and sciences, represented by meticulously rendered still-life objects (armor, musical instruments, books, scepter, crown, laurel leaves of poetic triumph) has a mocking effect. The grinning youth who looks out at the viewer is clearly not an ideal, built on the heroic model of Michelangelo, but rather a jesting send-up of the very concept of idealism, obviously studied from a quite ordinary boy model in the artist's studio. Once more, the Roman patron of this picture was a prominent figure; he was the Marchese Vincenzo Giustiniani, a nobleman famous for his learned writings and his wide interests. Thus the staging of this picture offers an ironic, if more private, address to its owner, with hints of homosexuality overlying the satire on the owner's accomplishments.

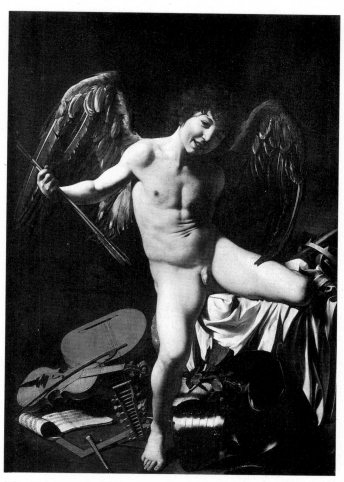

6.2 Caravaggio, *Victorious Cupid*, ca. 1601–02. Oil on canvas, 60⅕ × 43⅖ ins (154 × 110 cm). Staatliche Museen, Berlin.

THE CERASI CHAPEL

THE CERASI CHAPEL At just about the same time as they were producing these secular subjects, Annibale Carracci and Caravaggio worked together (1600–01) on the decoration of a private chapel in Santa Maria del Popolo in Rome. The patron was Monsignor Tiberio Cerasi, treasurer general under Pope Clement VIII, and his adviser was the same Vincenzo Giustiniani. This chapel is a powerful example of the aggressive visual assertion of the Counter Reformation, which had its center in Rome. Led by the example of the Jesuit order, the militant Church emphatically reaffirmed the spiritual importance of the Virgin Mary and the community of saints within both doctrine and the visual arts against the Protestant challenge. In the Cerasi Chapel, Annibale Carracci produced the central altar picture, the *Assumption of the Virgin* (Fig. **6.3**, p. 236).

Though ponderous, indeed almost earthbound within her ample draperies, this Madonna is a brightly colored and ideal form, intentionally grand in scale and in the gesture of her outstretched arms. The model for this imposing image again stems from Rome: Raphael's final picture, the *Transfiguration of Christ* (1520–22). Carracci used it for its densely composed clusters of venerable apostles and for the heroic gestures of its

6.1 (Opposite) Annibale Carracci, Rome, Palazzo Farnese, ceiling, 1597–1600. Fresco, 67 × 20 feet (20.4 × 6 meters).

Caravaggio's two pictures for the Cerasi Chapel embody both religious elements of agony and ecstasy. In both cases, the same sharp lighting as *Cupid Victorious* provides a dramatic focus to the scenes, simultaneously underscoring the prosaic physicality of the human actors in the spiritual dramas. The *Conversion of St. Paul* by Caravaggio has stripped the religious subject down to its essentials, rendering Saul, the persecutor of Christians, as an isolated, coarse-featured youth (Fig. **6.5**). In place of his Roman legions, we behold a single, unexceptional horse, led by a solitary groom. Yet here the spotlight serves not only to emphasize the ordinary, material aspects of the story, but also, by its sudden and dramatic contrast, to mark the moment of grace, of literal "enlightenment," at which St. Paul was spiritually reborn. Indeed, the prostrate youth's outstretched arms echo from the ground the gesture of Carracci's adjacent, elevated Madonna. With its simplified cast of characters, strong spotlighting, and the dramatic, foreshortened gesture of the saint, Caravaggio's *St. Paul* immediately engages the attention of the viewer and brings the religious story palpably to life as a conversion experience.

Using similar techniques, Caravaggio's other canvas for the Cerasi Chapel, the *Crucifixion of St. Peter*, represents the grace attained by saints through martyrdom (Fig. **6.6**). Here, however, in contrast with the unmerited grace of Paul's youthful conversion, an aged saint strains like his tormentors as he is hoisted onto an inverted crucifix (Peter humbly wished

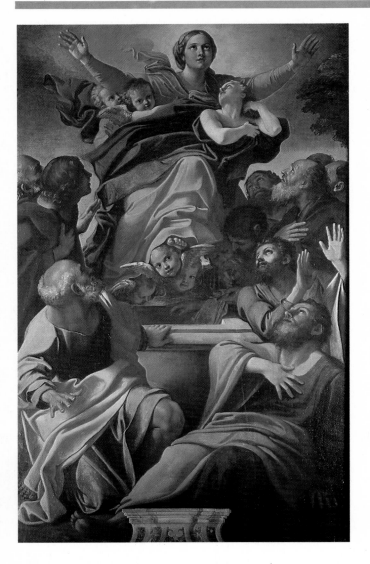

6.3 Annibale Carracci, *Assumption of the Virgin*. Oil on canvas. Cerasi Chapel, Santa Maria del Popolo, Rome, 1600-01.

6.4 Annibale Carracci, *Pietà*, ca. 1600. Oil on canvas, 61½ × 58½ ins (156 × 149 cm). Capodimonte Museum, Naples.

hovering holy figure. If Raphael became the pattern for future generations of artists, Annibale Carracci should be taken as his first acolyte, or follower. By the 1580s he had established in Bologna one of the first academies of painting to study the canonical models of Michelangelo and Raphael, along with the Venetian techniques of Titian – in combination with a careful study of nature.

A similar study of the monumental human body from both artistic models and nature informs Carracci's *Pietà* (ca. 1600; Fig. **6.4**), a work surely deriving from Michelangelo's sculpted *Pietà* with youthful Madonna at St. Peter's in Rome. This moving canvas was commissioned by Cardinal Odoardo Farnese at around the same time as the Farnese ceiling, and it conveys the other side of the coin in the religious art of the Counter-Reformation: mourning that complements the transports of saintly ecstasy.

6.5 Caravaggio, *Conversion of St. Paul*, Cerasi Chapel, Santa Maria del Popolo, Rome, 1600–01. Oil on canvas, 90½ × 70 ins (230 × 175 cm).

6.6 Caravaggio, *Crucifixion of St. Peter*, Cerasi Chapel, Santa Maria del Popolo, Rome, 1660–01. Oil on canvas, 90½ × 70 ins (230 × 175 cm).

not to be crucified in the same manner as Christ Himself). Again, dramatic lighting and foreshortening place the viewer firmly in a position subordinate to the emerging action, and the figure types are uncompromisingly plebeian and ordinary in their dress and features. Contemporary critics even complained about the dirty feet and lack of dignity of the saint and his tormentors, but for Caravaggio it was essential to represent his religious figures as humble and simple. In this canvas Peter's gaze is directed not at the viewer but out of the picture in a dynamic spatial relationship with the chapel environment – he focuses on Carracci's adjacent altar painting, with the Virgin in glory as his hope and inspiration in his suffering. (In similar fashion, the gaze of Paul is also oriented diagonally toward the Madonna, who becomes by implication the source of light.) Of course, Peter and Paul were the two figureheads of the Catholic Church, with Peter the first pope and Paul the first evangelist, but, in the context of the Cerasi Chapel, Caravaggio has rendered them as powerfully present physical actors. The portrayal is based as fully on the human figure as any Michelangelo prototype, although the vision is manifestly antiheroic and individual.

RELIGIOUS HEROISM: GENTILESCHI

Although Caravaggio had no direct pupils, the influence of his descriptive naturalism and dramatic chiaroscuro lighting soon spread throughout Italy as well as to France, Spain, and the Low Countries (particularly the traditional Catholic site of Utrecht). Among the artists who adopted elements of "Caravaggism" was Artemisia Gentileschi (1593–ca. 1652; see Fig. 1.8). While continuing to paint "history" subjects (that is, religion as well as mythology) along with her leading male counterparts, Artemisia Gentileschi chose themes involving heroic women. She also imbued her paintings with a distinctive woman's viewpoint where often male artists had shown women as the vulnerable objects of domination.

Her favorite subject was the biblical heroine, Judith, who saved her people by gaining access to the tent of an invading Assyrian general and beheading him there. That inversion of the traditional ethical position, murderous strength in the noble cause of salvation, had often been treated by men artists with

237

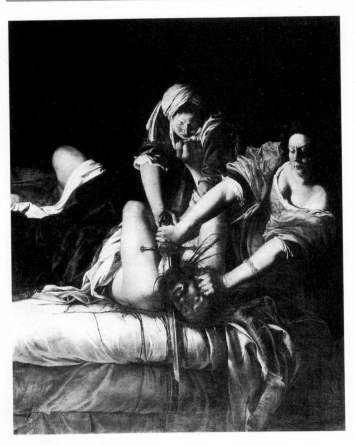

6.7 Artemisia Gentileschi, *Judith and her Maidservant*, ca. 1625. Oil on canvas, 72½ × 55¾ ins (184 × 141.6 cm). Institute of Arts, Detroit.

RUBENS

Artemisia Gentileschi was not the only artist to visit Rome and draw inspiration from its artistic resurgence in the new century. From Flanders Peter Paul Rubens had come to work in Rome shortly after the works by Carracci and Caravaggio had been painted for the Cerasi Chapel. His years in Italy, 1600–08, were begun at the Gonzaga court in Mantua but the highlight of these years was a commission for the new Oratorian order in Rome (Chiesa Nuova). He studied both ancient statuary and Renaissance painted masterpieces, recording his observations in sensitive chalk drawings. Rubens also studied Caravaggio and even purchased a rejected Caravaggio altarpiece, the *Madonna of the Rosary*, for the Dominicans in his hometown, Antwerp. Upon his return to his native city, Rubens began to produce altarpieces full of religious action and heroism after the examples of both Carracci and Caravaggio, as well as the artists of the High Renaissance.

Rubens's *Raising of the Cross* (Fig. **6.8**), completed in 1610–11, includes figures in energetic movement that can be related to drawings after Michelangelo's *ignudi* and to the antique ensembles in the Vatican sculpture collection, especially the *Laocoön* (Fig. 2.49). The altarpiece is arranged in a traditional Netherlandish triptych formula but actually extends in an unbroken panorama across all three panels.

Prepared in an enormous workshop, the altarpiece developed according to a working method that Rubens would utilize throughout his career. First an oil sketch of the entire composition was produced, perhaps presented to the patrons as the basis for a contract of commission; this oil sketch was supplemented by detailed studies, often in chalk, of individual figures, here particularly for the figure of Christ on the cross but also for the straining muscular figures who elevate the cross. Between the oil sketch and the final, large-scale painting, Rubens made numerous alterations, and he delegated parts of the vast altarpiece to his workshop assistants, accomplished if anonymous artists. His visual sources may have included an antique sarcophagus showing the raising of a Dionysus *herm*, as well as the recent Caravaggio image in the Cerasi Chapel, and the study of individual figures from live models.

Certainly the final product combines the heroic action of Carracci with the naturalism and strong lighting of Caravaggio. Christ's monumental nudity stresses the spiritual heroism of the crucifixion, which also reasserts the Catholic doctrine of the physical presence of Christ's body in the mass, elevated by the priest before this very altarpiece. Christ's physical perfection combines with His upward glance and upraised arms to emulate the religious achievements of the Italians.

The *Raising of the Cross* was designed to dominate the altar, raised over a vast nave in a parish church in Antwerp, St. Walburga's, but its commission was only made possible by the intervention of an important wealthy local merchant, a spice dealer and art-collector, Cornelis van der Geest. In contrast to the noble families and church officials who were art patrons in

ambiguity at best, even going so far as to show Judith's real power over Holofernes to be her (sometimes nude) beauty. Gentileschi, in contrast, often showed the scene in all of its potential horror, with Judith and her maidservant struggling together in a grisly beheading, ultimately derived from a Caravaggio model. However, in her large final rendering of the subject (ca. 1625), she shows Judith and her maid pausing after their joint deed in candlelit stillness (Fig. **6.7**). Here the gore is minimized in darkness, with the head just visible at bottom center. Yet the element of suspense hangs in the air of the enemy tent, amplified by the momentary pause of Judith's hand just in front of the bright spotlight of the candle; both women peer anxiously in the same direction, as if in response to a noise. This well-dressed woman, painted full length, suggests a capacity for further action, inverting yet strengthening gestures that in another context might be read as signs of modesty. The armor on the table suggests that the general has been dispatched with his own sword, an ironic commentary on the dangers inherent in lustful impulses.

6.8 Peter Paul Rubens, *Raising of the Cross*, 1610–11. Oil on panel, 182 × 134 ins (462.3 × 340 cm). Cathedral, Antwerp.

Rome, the bourgeois connoisseurs of mercantile Antwerp, together with the nearby Habsburg regents of Brussels, were the principal sponsors of Rubens's art.

Like Jan van Eyck in his relation to the Burgundian court of Philip the Good in fifteenth-century Flanders, Rubens enjoyed the official court patronage of Albert and Isabella of Habsburg, yet he continued to live in his native Antwerp. Like van Eyck, Rubens also embarked on sensitive, sometimes secret diplomatic missions on behalf of his sovereigns; his contacts with other monarchs in this absolutist era included visits to Spain, England, and France, where he not only executed commissions for enormous cycles of pictures but also negotiated for peace during the height of Europe's Thirty Years' War.

Thus, when the newly married artist painted his self-portrait with his bride, Isabella Brant, shortly after his return to Flanders in 1609, he presented himself in the pose of an elegant gentleman taking his ease and joining hands with his wife in a honeysuckle bower, the traditional symbolic site of marital fruitfulness and romantic love, usually the preserve of the nobility (Fig. **6.9**, p. 240). This claim to nobility is also asserted in the double portrait by the splendid fashions as well as the inclusion of a sword at the side of the artist, in the manner of traditional knights and ladies. For similar reasons, Rubens incorporated his studies of Italian architectural writings and of the palaces of the nobility in Italy into the design of his own house in Antwerp, which included a formal garden, a portico with classical gods, and a semicircular annex for his sculpture collection. Eventually, his wealth and gentlemanly pursuits, his court activity and scholarship were rewarded with a knighthood by Velázquez's sovereign, Philip IV, as well as by Charles I of England.

Rubens's early, Michelangelesque style of muscular and active male nudes in his religious works gave way later in his career (after his tour of the Spanish collections in the company

of Velázquez in 1628) to a softer, more luminously colored vision of (primarily female) saints after the model of Titian. A glowing example of this later manner is his *St. Ildefonso Altarpiece* (1630–32), painted in the traditional triptych format but presenting a vision of a Spanish national saint before the throne of the Madonna and an entourage of female saints (Fig. **6.10**). The altarpiece was commissioned for the chapel of St. Ildefonso in the Brussels court church of St. Jacob-on-the-Coudenberg by Rubens's court patron, the Infanta Isabella, to commemorate her late husband, Archduke Albert, who had founded a brotherhood in honor of the saint. Ildefonso was an early defender of the doctrine of the Immaculate Conception, one of the fiercely defended tenets of the Counter-Reformation, so Rubens's choice of the Madonna surrounded by virginal holy women had contemporary religious significance

6.9 Peter Paul Rubens, *Rubens and Isabella Brant in Honeysuckle Bower*, 1609. Oil on canvas, 69 × 53½ ins (178 × 136 cm). Alte Pinakothek, Munich.

6.10 Peter Paul Rubens, *St. Ildefonso Altarpiece*, 1630–32. Oil on panel, centre: 138 × 92½ ins (350 × 235 cm); each wing 138 × 42 ins (350 × 106.6 cm). Kunsthistorisches Museum, Vienna.

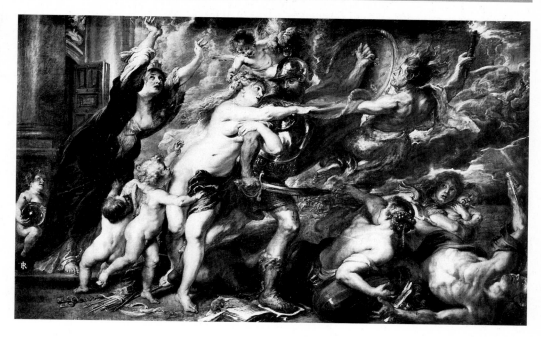

6.11 Peter Paul Rubens, *The Horrors of War*, 1638. Oil on canvas, 81 × 125⅞ ins (205 × 320 cm). Pitti Palace, Florence.

besides being a tribute to his sovereigns. They were depicted in the traditional altarpiece wing poses as prayerful witnesses along with their patron saints. Here, too, Roman models still played a role: first in the form of the classical allegory of Pudicitia, chastity or modesty, used for the veiled saint, and second in the classical architecture adapted by Rubens from Raphael's Vatican frescoes.

Rubens employed this same mixture of divine and secular elements in his great secular allegories for monarchs, associating rulers with saints or with abstract allegorical qualities, represented by pagan gods. Despite the watchful suspicion of Cardinal Richelieu, he completed one great cycle of twenty-four canvases for the Luxembourg Palace in Paris celebrating the life of the queen mother of France, Marie de' Medici, and he also began work on a complementary cycle in memory of her late husband, Henry IV.

SPANISH OPPRESSION in matters of taxation and local privilege combined with a lack of religious freedom and led to an outbreak of rebellion in the Netherlands that extended over eighty years (1568–1648). Eventually this war of independence destroyed the prosperity of Rubens's Antwerp, caught in the middle between warring factions and eventually restored to the Spanish and Catholic side of the new border. This more local conflict became caught up in a Europe-wide conflict, the Thirty Years' War (1618–48), between Catholics under the Spanish-Austrian aegis and their enemies, an alliance of Protestant states along with France, nemesis of the Spanish Habsburgs. Rubens, in his dual roles of diplomat and painter for the regent Habsburg cousins in the Low Countries, attempted to play the role of peacemaker. His mission in France, including his cycle of allegories for Marie de' Medici, had been to try to dislodge the opposition of the French crown within the broader conflict. And when he voyaged to Spain and then to England in 1628–30, Rubens attempted first to

dampen the war posture of Madrid and then to assure the neutrality of England.

Rubens summarized his ambitions for peace in an isolated painting, *The Horrors of War* (1638), produced for Josse Suttermans, Flemish court painter of Ferdinand de' Medici, Archduke of Tuscany, and probably intended for the collection of the nobleman (Fig. **6.11**). Not only is this late work a superb example of Rubens's mastery of figure painting as well as color, combining the models of Roman painting with those of Venice, but it also demonstrates his immense yet useful learning, based upon both visual and literary sources. A letter from Rubens to Suttermans permits us to interpret even small details of this picture within its carefully planned allegorical programming:

The principal figure is Mars, who, leaving open the temple of Janus [which it was a Roman custom to keep closed in times of peace], advances with his shield and his bloodstained sword, threatening the nations with great devastation and paying little heed to Venus his lady, who strives with caresses and embraces to restrain him, she being accompanied by her Amors and Cupids. On the other side Mars is drawn on by the Fury Alecto, holding a torch in her hand. Nearby are monsters, representing Pestilence and Famine, the inseparable companions of war. On the ground lies a woman with a broken lute, signifying Harmony, which is incompatible with the discord of war; there is also a mother with her babe in her arms, denoting that fecundity, generation, and charity are traversed by war, which corrupts and destroys all things... That lugubrious matron, clad in black and with her veil torn, despoiled of her jewels and every other ornament, is unhappy Europe, afflicted for so many years by rapine, outrage and misery...

No more heartfelt profession of dismay at the destruction caused by the Thirty Years' War survives.

A Royal Commission

In 1635 Rubens offered Charles I of England an allegorical cycle for inclusion in the Banqueting House of Whitehall Palace, London, where it still remains. This cycle grew out of Ruben's visit to England in 1629–30 to help negotiate a treaty between Philip IV and Charles I, and its program expresses the absolutist claims and spectacular pageants of the Stuart dynasty.

Charles I sponsored masques, written by Ben Jonson and staged by the architect-engineer, Inigo Jones, who had also designed the Banqueting House (1619–22) that holds Rubens's canvases, its interior strongly oriented toward the king's throne at one end (Fig. **6.12**). The larger, central canvases address the glories of the reign of Charles I's father, James I, while ovals at the corners show Olympian gods as personifications of heroic virtues in triumph over allegorical vices. As in the earlier large-scale canvases by Rubens, these Whitehall paintings were prepared for workshop production by means of oil sketches, some of entire compositions, others of particular figure groups. Directly over the throne is *The Peaceful Reign of James I*, addressing the visitor together with the person of the reigning monarch. For this subject, a sketch of the whole composition from around 1629 survives (Fig. **6.13**), along with several studies of

6.13 Peter Paul Rubens, *The Peaceful Reign of James I*, sketch for Banqueting House Ceiling, Whitehall Palace, London, ca. 1629. Oil on canvas. Gemäldegalerie, Akademie der Bildenden Künste, Vienna.

individual figures, such as *Peace Embracing Plenty*. The spiral columns around the king identify him as a modern Solomon, whose wise rule generates the allegorical activities around him: Mercury vanquishes assailants to the throne, as Minerva rebukes Mars, who in turn uses his powers of war to subdue another evil figure. The king clearly inclines away from these struggles toward the two embracing figures of Peace and Plenty. Both the layout of the ovals and rectangles in Jones's ceiling and the figure types and rich colors of Rubens's sketches owe a considerable debt to the Venetian ceiling paintings by both Titian and Veronese (see p. 221), as well as to Rubens's own activity in producing ceiling pictures of biblical scenes for the Antwerp Jesuit church (1620).

6.12 Inigo Jones, Banqueting House, Whitehall Palace. Interior, view of throne.

Like the painter, the architect and stage designer, Inigo Jones, appointed Surveyor of the King's Works in 1613, transplanted Italian design to the North. Jones used the model of architecture synthesized by Palladio for villas in the Veneto in the second half of the sixteenth century and published in his *Four Books of Architecture* (see p. 167). Essentially, this English royal palace is a simple block with elegantly articulated subdivision of its two equal storeys. Rational principles dominate the relations between the parts and the whole in Jones buildings, which eliminate many of the decorative details of previous English architecture.

Even though the main surviving elevation of the Banqueting House is actually a side view, its central attached half-columns and projecting entablatures ensure a centralized accent (Fig. **6.14**). Lateral pilasters complement these half-columns to frame strong window units with pediments. A simple *balustrade* crowns the basic block, balancing a high podium base. What emerges is an urban palace of graceful simplicity, subtly integrated with discreet Italian ornament to enclose the unbroken interior space of a double cube, topped with Rubens's decorations. Like Rubens himself, Jones had fully assimilated Italian precedents and successfully transplanted them to northern soil to serve as the modern adornment of absolute monarchs.

6.14 Inigo Jones, Banqueting House, Whitehall Palace, London, 1619–22. Exterior.

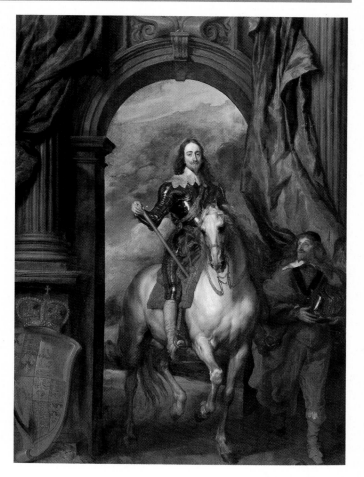

6.15 Anthony van Dyck, *Charles I on Horseback*, 1633. Oil on canvas, 145 × 106¼ ins (368.4 × 269.9 cm). Collection of Her Majesty the Queen, Buckingham Palace, London.

VAN DYCK England's royal house continued to sponsor important commissions from visiting artists, including Rubens's former protégé, Anthony van Dyck (1599–1641), who like Rubens was knighted by Charles I. Van Dyck had assimilated the lessons of Titian and Venetian color earlier in his career after an extended stay in Genoa (1621–28), but his greatest legacy was the portraits of king and courtiers that he painted in England from 1632 up to his death in 1641. His most majestic image of the king's authority is an equestrian portrait within a triumphal arch bearing the royal arms; van Dyck shows Charles I in armor and with his baton of command as if mounted for a victory parade after a battle (Fig. **6.15**). Like Titian's image of Charles V of Spain at the Battle of Muhlberg (Fig. 5.41) and subsequent portraits by Rubens and Velázquez of their royal patrons, this image derives ultimately from the Roman equestrian sculptures, surviving in the bronze statue of Emperor Marcus Aurelius (Fig. 2.63). Inventories reveal that it was intended to complete the vista of a room in which Titian's portraits of the Roman emperors (now lost), purchased by Charles I from the dukes of Mantua, also hung. In another portrait van Dyck depicted the English

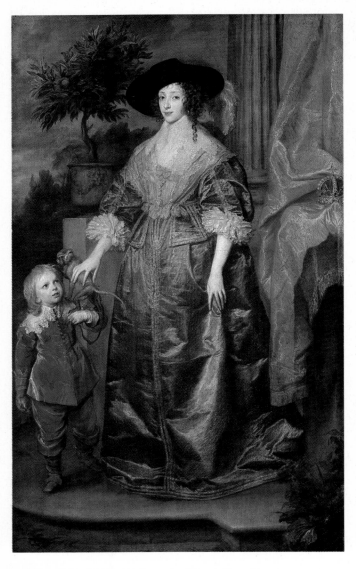

6.16 Anthony van Dyck, *Queen Henrietta Maria with Sir Jeffrey Hudson*, 1633. Oil on canvas, 86¼ × 53⅛ ins (219.1 × 134.8 cm). Samuel H. Kress Collection, © 1992, National Gallery of Art, Washington.

monarch dismounted beside his horse during an informal break in the princely pastime of hunting (1635). At the same time as he painted the great equestrian portrait of King Charles, van Dyck also painted the queen, Henrietta Maria, dressed in her blue hunting dress (Fig. **6.16**). The outdoor setting shows the colonnaded porch and step of a grand, classicizing building, using vocabulary similar to that of Inigo Jones. While the queen's dress and her discarded crown, lying on top of the golden curtain at the right, give an air of informality to this portrait, her dignity and control over the monkey, symbol of animal instincts, also attest to her role at court. In masques, the queen was represented as a paragon of beauty and virtue, whose pacific influence fostered harmony and chaste love, possibly symbolized in this image by the potted orange tree.

CHURCH MILITANT: BERNINI

As with monarchs, so with popes. In Rome, aristocratic patronage by great families in and around the papacy led to a similar fusion of grand design in public architecture and sculpture with the general aims of the Counter-Reformation. During the second quarter of the seventeenth century, the master planner of most of this ambitious papal construction was Gianlorenzo Bernini (1598–1680), the most indefatigable artist in Rome since Michelangelo.

Bernini worked for a succession of popes: Urban VIII Barberini (1623–44), Innocent X Pamphili (1644–55), and Alexander VII Chigi (1655–67). He essentially completed the construction and much of the decoration of St. Peter's, ornamenting its altar area at the crossing with a baldachin and its apse area with the symbolic chair of St. Peter (Latin: *Cathedra Petri*) in addition to providing the finishing touches to its façade by designing a great piazza space in front of the church. At the same time, Bernini worked on other projects in sculpture and architecture for the popes and their families throughout Rome, including papal tombs for St. Peter's. In all these projects, his sculptures form dynamic pictorial ensembles, whose figural movement is the three-dimensional correlate of the paintings of Carracci and Caravaggio.

6.17 Gianlorenzo Bernini, *David*, 1623. Marble, 65 ins (165 cm) high. Borghese Gallery, Rome.

6.18 Gianlorenzo Bernini, *Ecstasy of St. Teresa*, Cornaro Chapel, S Maria della Vittoria, Rome, 1645–52. Marble and bronze, figures approx. 11 feet six inches (3.5 meters) high.

Early in his career, Bernini had worked for the Borghese family under the lavish patronage of Cardinal Scipione Borghese. An example of his precocious talent is the sculpted *David* of 1623 (Fig. **6.17**), a marble that deliberately challenges comparison with Michelangelo's masterwork of the previous century (Fig. **5.1**). Basing his figure on Hellenistic sculpture and Michelangelo's twisting Sistine *ignudi*, Bernini emulates the active torsion of Carracci's muscular Farnese gods in motion. This David is frozen at a climactic moment, as he begins the propulsion of his sling. Instead of being self-contained, static, and thoughtful, Bernini's *David* strides energetically forward with the insistence of the diagonally composed painted figures of the Cerasi Chapel.

Bernini's success at tying sculpture to the space around it reached a climax in his Cornaro Chapel in the church of Santa Maria della Vittoria, Rome (1645–52; Fig. **6.18**). Here the artist had total control of the environment of his sculptural and architectural ensemble and the result is a fully integrated pictorial tableau, strikingly illusionistic in its staging. The chief subject, framed within an elaborate convex *aedicule* niche above the altar, is the *Ecstasy of St. Teresa*, a sixteenth-

century Carmelite mystic. Her writings detail how an angel pierced her heart repeatedly with a flaming golden arrow, producing a sweet pain of spiritual ecstasy, akin to the rapture of St. Paul in Caravaggio's painting. Bernini's sculpture is like a theatrical scene, bathed in natural lighting from above and marked by beams of golden rays behind the figures. These heavy marble figures appear to be magically suspended on stone clouds, and in the swooning saint Bernini achieves a paradoxical weightlessness that transports her heavenward.

Along the side walls of the chapel above the doors, eight members of the Cornaro family of Venice, led by the cardinal who donated this chapel, appear in group discussion behind prayer-stools that resemble theater boxes. Their positions as spectators along the sides of the chapel and at a diagonal remove from the central altar sculpture correspond exactly with the location of Caravaggio's pictures relative to the Carracci altar in the Cerasi Chapel – subordinate yet integrated. Thus the entire space becomes a dynamic physical unit, combining pictorial sculpture and architecture into a climactically frozen vision of the sudden, dramatic religious experience of divine grace.

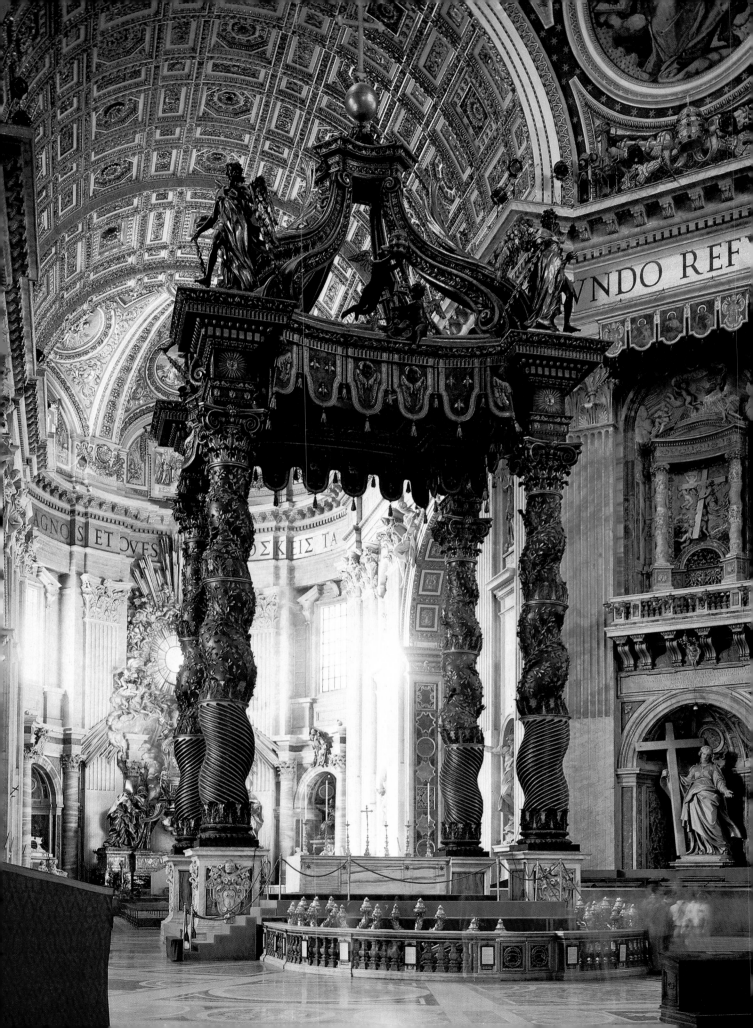

ST. PETER'S Bernini's architectural work was characterized by a similar use of space and formal positioning. Within St. Peter's, he began his lifelong work as chief architect with a baldachin (1624–33), a triumphant canopy raised above the tomb of St. Peter and the papal altar at the crossing of the church (Fig. **6.19**). At once both sculpture and architecture, this great canopy is set on cast bronze spiral columns, a reference (like Rubens's Whitehall ceiling, Fig. 6.12) to the Temple of Solomon. On top of each column stands a bronze angel, as well as a culminating orb with cross on four scroll volutes, symbolizing the four corners of the earth as well as the four Gospels of the faith. This cloth marker serves to identify the key point in the gigantic space of the church: it mediates between the colossal crossing piers of Bramante and Michelangelo and the human scale of the officiating pope or priests at the altar beneath. At the same time, the baldachin itself is a dynastic memorial to the Barberini pope, Urban VIII, who commissioned it; the heraldic insignia of bees and suns as well as laurel vine that decorate its surfaces are all Barberini emblems.

Refashioning the crossing of St. Peter's prompted Bernini to redesign the decoration of Bramante's piers by forming niches within them for sculptures. Four figures were planned, each one of them commemorating a venerated local relic. Only one of the four statues was produced by Bernini himself: a *St. Longinus* (1629–38), the Roman centurion who converted to Christianity after he stabbed Christ with his spear (Fig. **6.20**). In much the same manner as Rubens had prepared his giant compositions with preliminary oil sketches, Bernini planned his sculptures with clay models, called *bozzetti*. One of *Longinus* survives; it reveals an initial emphasis on the figure and its graceful, balanced pose with outstretched arm, but as yet there is little attention to the dynamic drapery of the finished statue. Here again, the human figure gives life to the space, in this case both the limited space of his niche and also the larger space of the crossing. Longinus's outstretched arms and upraised glance again suggest the moment of ecstatic grace as literal illumination, here coming from the light-filled dome above the center of St. Peter's. The intense emotion of the moment is suggested by the movement of the drapery folds, which seem to swirl without gravitational constraints, as if in echo of the prayerful open gesture of the saint.

Bernini's final great contribution to the interior decoration of St. Peter's was his *Cathedra Petri* (Fig. **6.21**), the symbolic

6.19 (Opposite) Gianlorenzo Bernini, Baldacchino, St. Peter's, Rome, 1624–33. Gilded bronze, approx. 93 feet 6ins (30.5 meters).

6.20 Gianlorenzo Bernini, *St. Longinus*, St. Peter's, Rome, 1629–38. Marble, 14 feet 6 ins (4.4 meters).

6.21 Gianlorenzo Bernini, *Cathedra Petri*, 1657–66, St. Peter's, Rome

6.22 Gianlorenzo Bernini, Colonnade, St. Peter's, begun 1656, aerial view.

throne of the popes as successors of St. Peter (1657–66). Built at the site of the tomb of Peter, the first pope, this sculptural ensemble thus marks the center of Catholic Europe and is seen as such through the frame of Bernini's baldachin of a generation earlier. Its powerful assertion of spiritual authority emerges from another Bernini multimedia spectacle, combining stained glass, sculpture, and architecture. The throne itself rests not on, but rather "hovers" miraculously above the solid supports of four traditional Church Fathers from West and East, and it is flanked by smaller angels. The gilt bronze of these figures gives them a flexible mobility and its color glows against their framework of marble and stucco. The darker, heavier, more physical three dimensions of the lower zones give way to a luminous vision above, where the golden glass of the dove of the Holy Spirit radiates outward into stucco clouds and beams that overflow the architectural framework of Michelangelo's giant apse pilasters. This celestial vision breaks into the church, to confirm the central authority of the papacy.

Just as he unified the interior space of St. Peter's through his architectural and sculptural constructions at the crossing

and the apse, Bernini also integrated the exterior of the church with its surrounding piazza. At about the same time as he was working on the *Cathedra Petri*, as papal architect he began his grand design for the public reception space of pilgrims to the center of Catholicism (1656–67; Fig. **6.22**). Despite the irregular setting of the papal palace and the narrow approach streets of the quarter, Bernini unified the piazza within an oval defined by two great arcs of columns, echoing the materials and scale of the church façade and connected directly with the church to form an open entrance area (in the shape of a broadening trapezoid). In Bernini's original plan, a third columnar arm would have fully enclosed the piazza, providing an exterior enclosure for hearing papal proclamations and for preparing the visitor to enter the church proper.

Overall, the effect of the flanking colonnades on the viewer is of an embrace by architectural "arms" of the church, despite the vastness of the open space. In the words of Bernini himself this environment embodies the Church, "embracing Catholics in order to reinforce their belief, heretics to reunite them with [her], and agnostics to reveal to them the true faith." His projects at the Vatican, both interior and exterior, effectively completed the designs of Bramante, Michelangelo, and the other architects of St. Peter's while making his own distinctive contribution to the spaces and façades.

BERNINI AND THE SUN KING

Like Rubens, Bernini also used his energies in the service of secular rulers. On one occasion, he received a long-distance commission from the pope for a marble bust of Charles I, Rubens's patron, whose Catholic background encouraged the pope to hope for a reconciliation of England with the Church. In order to provide the sculptor with a three-dimensional model, Charles I commissioned Anthony van Dyck to paint a triple likeness (1635) that could present multiple views. The portrait provides another entry in the history of the rivalry between painting and sculpture, as van Dyck strove, with his characteristically lively brushwork, to fabricate the delicate lace and the deeply shadowed softness of the king's rich fabric doublet. Bernini, for his part, had recently rendered a "speaking" marble likeness of his protector, Cardinal Scipione Borghese (1632), based upon a host of careful chalk studies of the subject from life (Fig. **6.23**). The liveliness of Borghese emerges from the momentary movement of his head, from the lively glance of his eye, from his half-opened mouth, and from carved drapery "crumpled" to catch light in irregular patterns. Bernini's portrait of Charles was burned in the disastrous fire at Whitehall Palace in 1698, but the sitter's engagement with the viewer in the Borghese bust continued the sculptor's interest in figural animation across space.

Thus when, shortly after the completion of his projects at

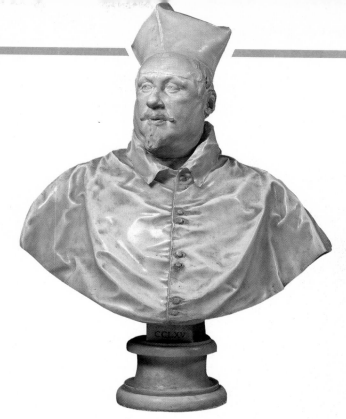

6.23 Gianlorenzo Bernini, *Scipione Borghese*, 1632. Marble, 30¾ ins (78 cm). Borghese Gallery, Rome.

6.24 Gianlorenzo Bernini, *Louis XIV on Horseback*, bozzetto, 1673. Terra cotta, Borghese Gallery, Rome.

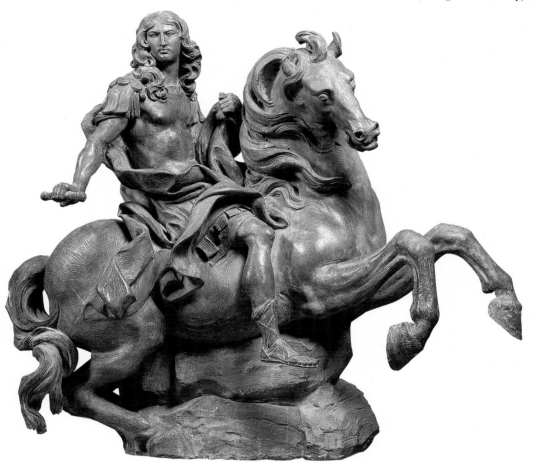

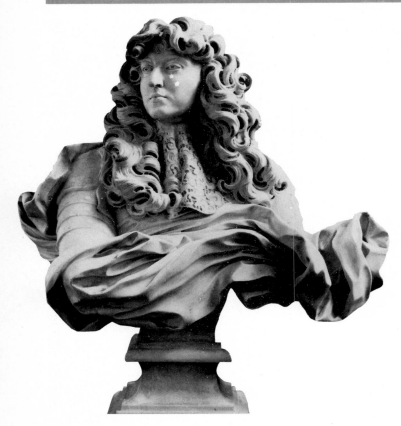

6.25 Gianlorenzo Bernini, *Louis XIV*, 1665. Marble, 31½ ins (80 cm). Palace of Versailles.

the Vatican, Bernini began work for the greatest of absolutist monarchs of the seventeenth century, the Sun King, Louis XIV, his art combined his earlier mastery of likeness with an ability to embody the numinous. He designed an equestrian monument for Louis XIV (ca. 1673; Fig. **6.24**, p. 249) like that of van Dyck for Charles I. The young monarch was set on top of a high rock, like a second Hercules atop the steep mountain of Virtue. The king appears as a classical military commander, with antique armor and the baton of a general. His beauty is matched by the perfection of his steed, and the energy of both emerges from their flowing locks and mane (unfortunately, this great equestrian monument, completed in 1677, was defaced when it was reworked to accord with later taste in France).

Bernini visited Louis XIV and his powerful minister Colbert in Paris in 1665, to discuss a commission to design the completion of the Louvre. Although that commission fell through for political reasons, Bernini's visit enabled him to complete what remains the most powerful sculpture of the "divinely sanctioned" ruler of the seventeenth century (Fig. **6.25**). Based in part on studies from life, the *Louis XIV*, despite its full armor, is brought to life by the devices used for Scipione Borghese. The remarkable animated drapery looks like moving clouds beneath him, running against the direction of the ruler's powerful gaze. His curly locks suggest the leonine majesty associated with ruler portraits since the time of Alexander the Great.

FRENCH CLASSICISM

If Bernini's version of classicism in sculpture and architecture did not ultimately find favor with the King of France, the presence of French artists in Rome during the seventeenth century led to a powerful assimilation of Roman Renaissance models back in France. Where Carracci had found in Michelangelo his main inspiration, Nicolas Poussin (1594–1665) turned to Raphael in order to convey his own nostalgic vision of ancient Roman values and virtues.

POUSSIN arrived in Rome in 1624 and worked for private clients, who were often learned collectors. After a single major commission for an altarpiece for the Vatican (*The Martyrdom of St. Erasmus*, 1630), he confined his activity to easel paintings, almost exclusively devoted to religious and mythological subjects. Yet his bright, well-ordered works offer a polar opposite to the provocative, dark scenes created by Caravaggio in Rome just a generation earlier.

Poussin's 1628 *Death of Germanicus* presents a scene from ancient Roman history, drawn from the *Annals* of Tacitus (Fig. **6.26**). It recounts the tale of the adopted son of Emperor Tiberius, who poisoned Germanicus out of jealousy of his military successes and popularity. On his deathbed, Germanicus asks his friends to avenge his death, and his wife to bear his loss with dignity. The commission to Poussin came from Cardinal Francesco Barberini, nephew of Pope Urban VIII, and led to other commissions in Rome, including his Vatican altarpiece project. The regular disposition of a row of figures in antique costume evokes a pictorial comparison to ancient Roman sculpted reliefs (cf. Chapter 2, p. 81). Their dignified poses and gestures evoke the Roman virtue of seriousness, *gravitas*, especially in the face of human suffering and strong emotion. Poussin's *Germanicus* enjoyed centuries of admiration, serving as a textbook model for serious painting to French artists visiting Rome, especially in the late eighteenth century, when Enlightenment calls for order and universals led to yet another revival of classical forms and subjects (see Jacques-Louis David, Fig. 7.17).

Order, calm, and stability also inform the landscape images produced by Poussin. Each of these settings contains a narrative scene or a key figure from ancient or biblical history. *St. John on Patmos* (ca. 1640; Fig **6.27**) was commissioned by another prelate in the court of Pope Urban VIII, paired with a pendant *St. Matthew*. Here again the archaeological attention to ancient styles, like the armor in the *Germanicus*, reappears in the obelisk, temple porch, and pedestal in the landscape, vestiges of the antique world that was nearing its eclipse when St. John wrote his Book of Revelations. Yet, for Poussin, the harmony between saint and setting, conveyed by the verdant foliage and brilliant blue sea and sky, suggests a synthetic view of Christian history in Rome and a serene vision of its modern glory under the Catholic pope.

The "grand manner" of Raphael, especially the Roman Raphael influenced by Michelangelo, finds its fulfillment in

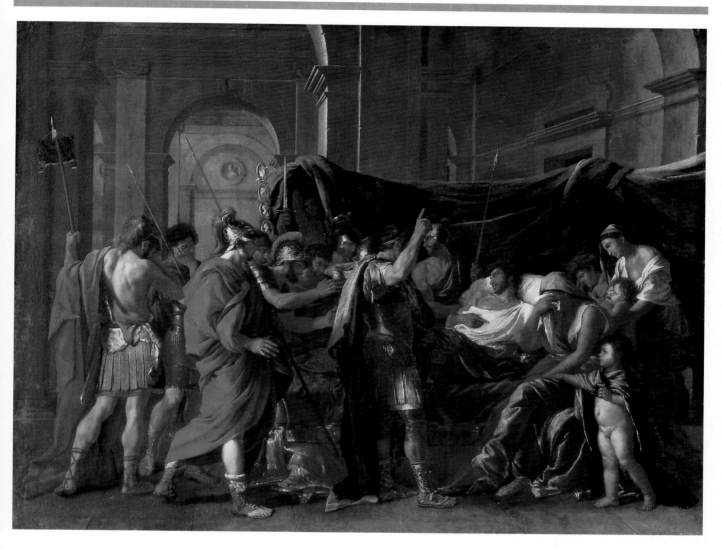

6.26 Nicolas Poussin, *Death of Germanicus*, 1628. Oil on canvas, 58¼ × 77⅜ ins (146 × 195 cm). The Minneapolis Institute of Arts.

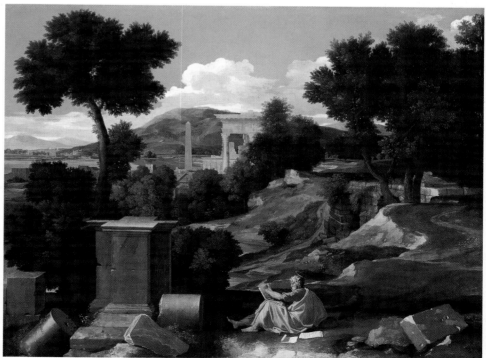

6.27 Nicolas Poussin, *St. John on Patmos*, ca. 1640. Oil on canvas, 40 × 53⅝ ins (101.8 × 136.3 cm). A.A. Munger Collection. Photography courtesy of The Art Institute of Chicago.

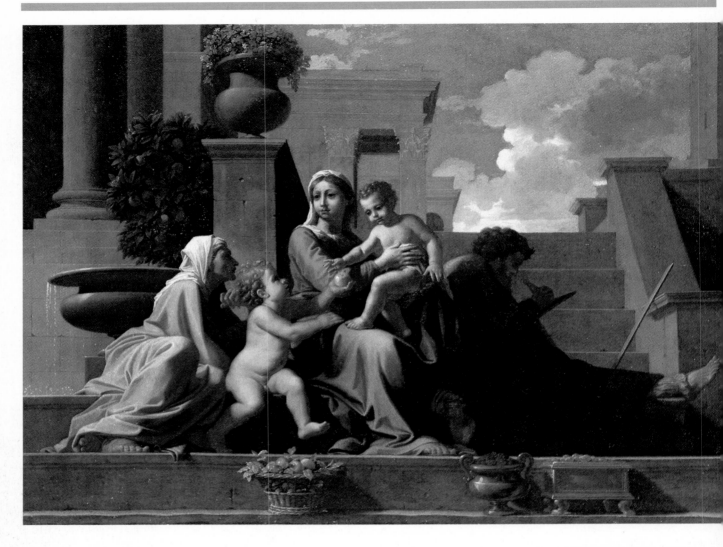

6.28 Nicolas Poussin, *Holy Family on the Steps*, 1648.
Oil on canvas, 28½ × 44 ins (72.4 × 111.7 cm).
Cleveland Museum of Art.

Poussin's mature paintings. In his *Holy Family on the Steps* (1648; Fig. **6.28**), the colors of the costumes have been reduced to the three primaries, while the architecture's rectangular solidity frames a pyramidal figural composition right out of Raphael's Madonnas (see Fig. 5.6). A delicate compositional harmony is subtly modulated in lights and darks. Each of the details – the basket of apples, a reminder of original sin redeemed, or the staircase proclaiming Mary's role as pathway to heaven – fulfills both a pictorial and a thematic function. This small yet polished work reveals by what it excludes exactly why Poussin's brief return to the Paris of Louis XIII in 1640–41 produced only disastrous results. The king tried to commission elaborate, allegorical ceiling paintings for the Long Gallery of the Louvre, a task more suited to Rubens than to Poussin.

THE PALACE OF VERSAILLES

The greatest monument created in seventeenth-century France, by and for King Louis XIV, was the vast palace complex on the outskirts of Paris where the monarch was able to create his own universe, centered on himself as absolute ruler: Versailles (Fig. **6.29**). In 1677, Louis moved both his court and his administration to this country site; by 1685, construction had begun on vast gardens, designed by André Le Nôtre (1613–1700). The palace forms a city of its own, organized symmetrically around a central axis in the formal gardens. These gardens, set out in geometrical patterns, are composed according to a principle of intellectual planning and ordered rules. At the very center and closest to the axis of the palace is the Basin of Apollo, the sun god and *alter ego* of the "sun king." Although the gardens are based upon those of Italian villas of the previous century, their grandeur and axial openness are closer to Bernini's piazza at St. Peter's, as sites for massive spectacle.

For the palace building itself, Louis XIV called upon the team of architect Louis Le Vau (1612–70) and painter-decorater Charles Le Brun (1619–90), together with Le Nôtre

(Fig. **6.30**). Beginning in 1668–71, this team expanded an earlier château of Louis XIII with an "envelope" of buildings that preserved its orientation. The chief outlook was therefore still toward Paris, across views of the gardens that were coordinated with the palace buildings. Like the gardens of Le Nôtre, the building offered a clear, Italianate block with articulation in the form of classical columns and pilasters above traditional palace rustication (compare the analogous, if more modest, Whitehall Banqueting House by Inigo Jones, p. 243). After 1677, the principal architect became Jules Hardouin-Mansart (1646–1708), who designed the famous Hall of Mirrors, a royal reception room overlooking the garden axis from the central block of the complex (Fig. **6.31**, p. 254). In this richly ornamented setting, some 240 feet (73 meters) long, consistent coordination of window frames with frames of mirrors opposite them integrates the interior with the exterior at the edge of the main block and privileged royal vantage

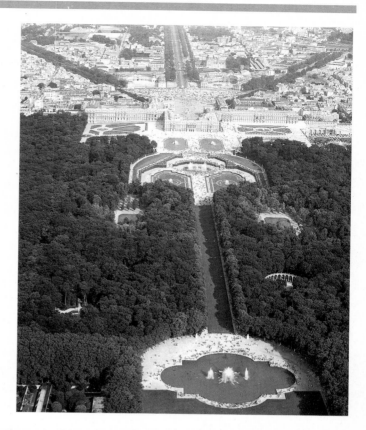

6.29 (Right) Louis Le Vau and Jules Hardouin-Mansart, Palace of Versailles, 1669–85. Aerial view of center, chapel and garden.

6.30 (Below) Louis Le Vau and Jules Hardouin-Mansart, Palace of Versailles, Garden Façade.

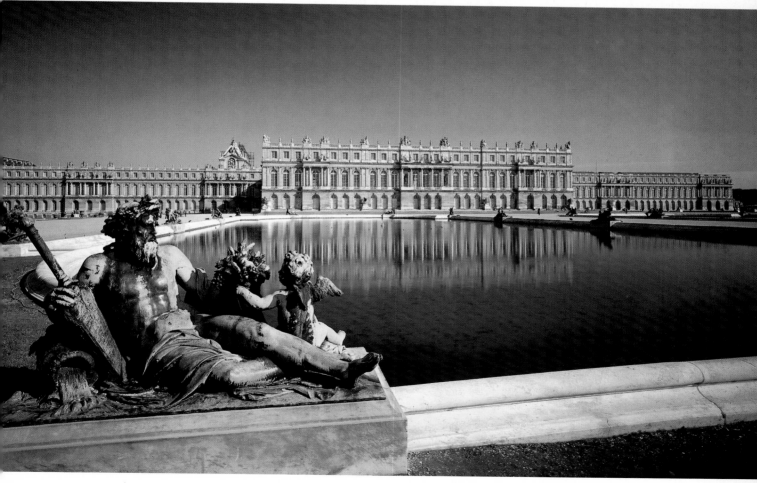

point. To the classical block of Le Vau, Hardouin-Mansart also added massive wings with the same basic articulation as that of his predecessor. That extension tripled the size of the palace and contained important new areas – a theater as well as a chapel (Fig. **6.33**) – while maintaining both the centralization and the integration of the whole. Ultimately, the palace at Versailles, viewed together with its gardens, serves to affirm the conquest of nature by the absolute ruler, who, despite the indefinite extension of both gardens and buildings, remains the fixed center.

The interior decoration of Versailles remained in the hands of Charles Le Brun, whose domination of French art was almost as absolute as the political power of his sovereign. His career was the inverse of Bernini's, for he had begun with study in Rome in 1642 (he was in contact there with Poussin). After his return to Paris, Le Brun became a founder of the French Royal Academy of Painting and Sculpture, a society eager to free artists from guild restrictions and to elevate their social and intellectual status. Le Brun, supported by Colbert, came to dominate the Royal Academy as its chancellor. He helped to formulate its prescriptive rules for a hierarchy in kinds of painting, ranging from "history," i.e. themes drawn from either the Bible or antiquity, based on figure drawings, at the top, to landscape or everyday subjects as lesser categories. Canons, or rules of art, as well as Italian artistic models (especially those from Rome) for imitation underlay a vast program of artistic instruction. Like the royal administration itself, the Royal Academy centralized its authority through its supervision of courses, as well as virtually obligatory membership for any artists with ambition. Through Le Brun and Colbert, the Academy not only controlled the decoration of royal projects but also linked art production in general to court taste.

At Versailles, Le Brun took responsibility for designing decoration. In the Hall of Mirrors, his ceiling paintings commemorate the victories of Louis XIV in Holland. This more worldly subject was substituted at the request of the king for

6.31 Jules Hardouin-Mansart and Charles Le Brun, Hall of Mirrors, Palace of Versailles, begun 1678.

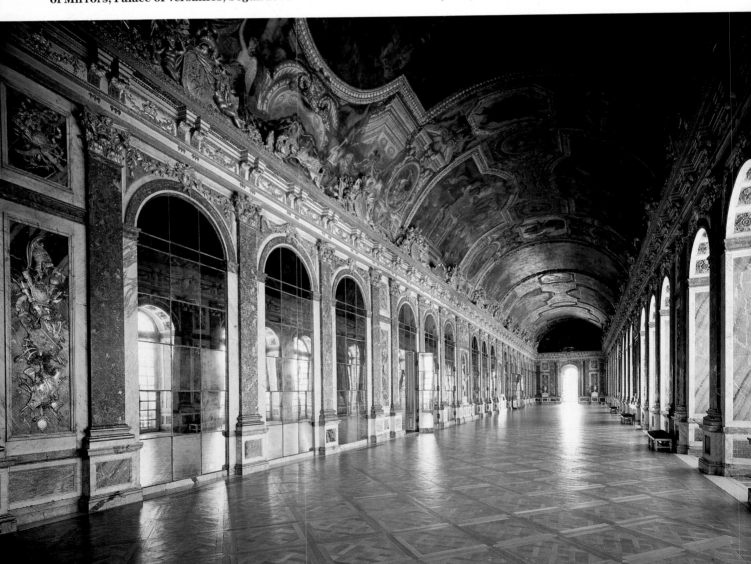

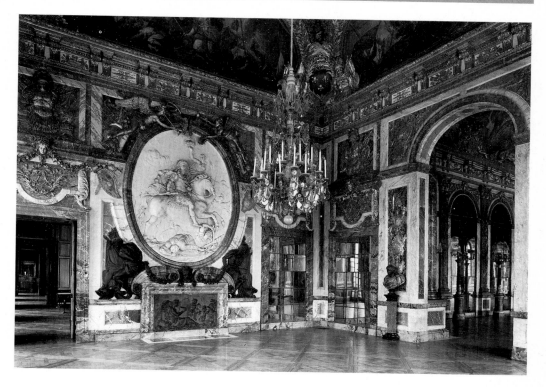

6.32 Charles Le Brun and Antoine Coysevox, *Louis XIV on Horseback*, Salon of War, Versailles Palace, 1683–85. Stucco relief, over life-size.

earlier allegorical identifications of his majesty with first Apollo, then Hercules (following Bernini's concept). In fact, the Roman models persisted in the final painted cycle, for the king is shown in the canvas of the *Crossing of the Rhine* as an ancient general in a triumphal chariot, like a modern Apollo bearing the thunderbolts of Jupiter; behind him Hercules subdues the Rhine river god, while before him flies a winged Victory. This is the same bombastic use of allegory previously made popular for the English crown by Rubens in the Whitehall ceiling (and for the French crown in the Rubens cycle for Marie de' Medici, grandmother of Louis XIV, for the Luxembourg Palace, 1621–25). In similar fashion, Le Brun followed the example of Bernini in coordinating multimedia decorations with Hardouin-Mansart's architecture on a great Stairway of the Ambassadors (later destroyed), as well as in the royal apartments adjacent to the Hall of Mirrors.

Perhaps the most spectacular is the Salon of War (Fig. **6.32**), matched symmetrically on the other side of the Hall of Mirrors by a Salon of Peace, begun in 1678. At the heart of the decoration is a stucco relief, *Louis XIV on Horseback* by Antoine Coysevox, in many ways a refined extension of Bernini's concept, in which the monarch, arrayed like a Roman emperor, tramples indifferently upon his enemies while he is crowned by Glory with a victor's laurel wreath. The Salon of War also contains ceiling paintings by Le Brun as well as elaborate relief sculptures in gilded bronze, and bronzed stucco. The overall illusion is one of profusion and richness (an effect that would have been still more spectacular if the original silver furnishings, melted down in 1689, had survived). Yet the decorative elements overlap and are interrelated within the ordering framework of a total vision, in this case Le Brun's tribute to the military victories of his sovereign.

PAINTED MAGNIFICENCE: WÜRZBURG

Versailles provided a model for other sovereigns throughout Europe, although neither its size nor its luxury were ever equalled. Yet a rival blending of architecture and multimedia decoration emerged in the middle of the eighteenth century in a relatively minor German principality, Würzburg, ruled by a prince-bishop who came from a powerful family of bishops, the Schönborn/Greiffenklau.

NEUMANN The architect of their Residenz in Würzburg (1719–44, under Johan Philipp Franz and then Friedrich Carl von Schönborn) was Balthasar Neumann (1687–1753; Fig. **6.34**). Neumann's military training as an engineer was supplemented with "finishing" visits to Vienna and to Paris (to consult Germain Boffrand, pupil of Hardouin-Mansart). Apart from the Residenz, he worked continually out of Würzburg as a designer of palaces and parish churches in central Germany. In his court church at the Residenz of Würzburg (1732–34, decorated and furnished 1735–44), Neumann utilizes many of the spatial and decorative effects that he would later perfect in such masterworks as the pilgrimage church of *Vierzehnheiligen* (Fourteen Helper Saints, near Bamberg, 1743 onward). In both works the focus lies in a fantastic and inventive interior, organized around an axis of successive oval vaulted spaces. The freestanding columnar supports of these unequal oval areas thus seem to undulate spatially in a rhythm more syncopated than regular. In addition, the longitudinal oval spaces are counterpointed by in-

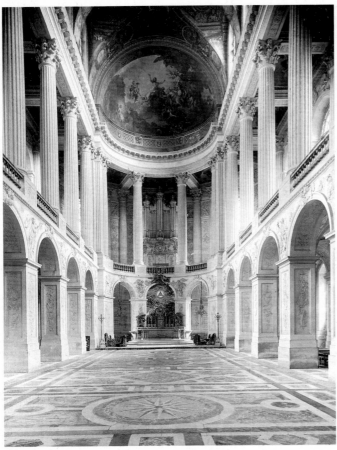

6.33 Jules Hardouin-Mansart, Royal Chapel, Palace of Versailles, 1689–1710.

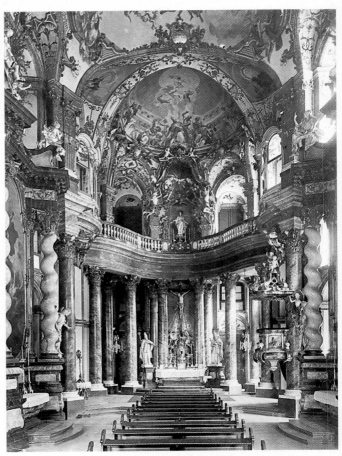

6.34 Balthasar Neumann, Residenz, Würzburg, 1719–44. Court Chapel, 1732–34, decorated 1735–44.

tersecting, lateral oval spaces. Within this complex, well-lighted space, a rich decoration of gilded and painted stucco complements brightly colored ceiling frescoes. The entire church has thus been dematerialized by the multimedia effects of light, space, and ornament integrated within the kind of mystical vision that informed Bernini's Cornaro Chapel or *Cathedra Petri*. Yet this ensemble has a bright and festive quality at odds with Bernini's awesome theatricality or with the dignified, classical order and bright lighting of Hardouin-Mansart's chapel at Versailles (Fig. 6.33).

Like Bernini and Hardouin-Mansart, however, Neumann was a designer of vast spatial complexes, and both the gardens and the interior spaces of the Residenz have an airy openness. The climax of the interior comes in the combination of his majestic vaulted staircase and the entrance into the reception room or Kaisersaal which follows it (Fig. **6.35**). The staircase itself broadens and brightens as it ascends from a central vessel to two side vessels in order to attain an enveloping platform. This staircase, the grandest in palace interiors from sixteenth-century Italy through Bernini and Hardouin-Mansart, serves primarily as the overture to the climax of the Kaisersaal, an immense, richly decorated oval with the same bright windows and combination of stucco, painting, and sculpture as Neumann's churches (Fig. **6.36**).

TIEPOLO was the painter invited to decorate these Neumann spaces. A Venetian, Giovanni Battista Tiepolo (1696–1770), was a master of fresco and self-conscious heir to the tradition of Titian and Veronese. He had been active since 1716 and held an international reputation that led to his employment in Stockholm and Madrid as well as in Würzburg. His subjects continued the epic praises of absolute rulers and of holy figures, with dissolved ceilings opening onto distant views of heaven. Tiepolo produced two altarpieces within a frame of twisting columns for the Residenz chapel; his subjects depict grandiose visions of the Assumption of the Virgin and the Fall of the Rebel Angels. In the Kaisersaal paintings (1751–52), Tiepolo recreates German history important to the prestige of the Würzburg bishops within a sumptuous decor of polychromed marble curtains, suspended by stucco cherubs under gilded stucco scrollwork. Here, as in the ensembles of

6.35 (Opposite, above) Balthasar Neumann, Residenz, Würzburg, 1719–44. Staircase, 1737–42, frescoes by Giovanni Battista Tiepolo, 1752–53.

6.36 (Opposite, below) Balthasar Neumann, Kaisersaal, Residenz, Würzburg, begun 1720, frescoes by Giovanni Battista Tiepolo 1751–52.

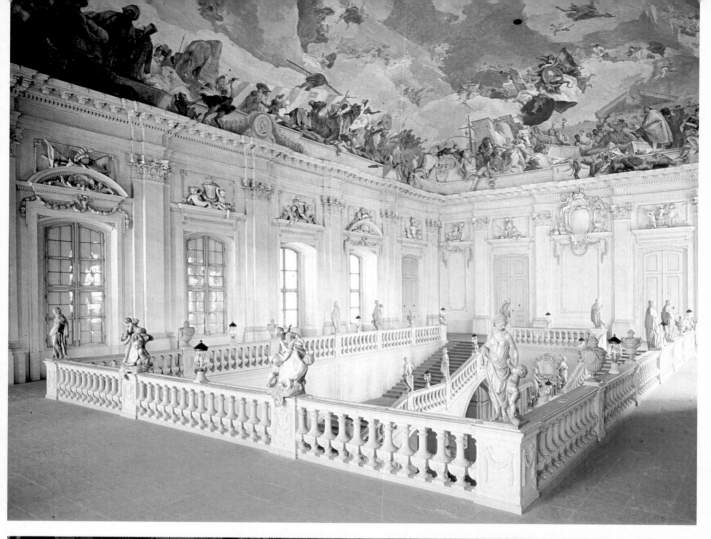

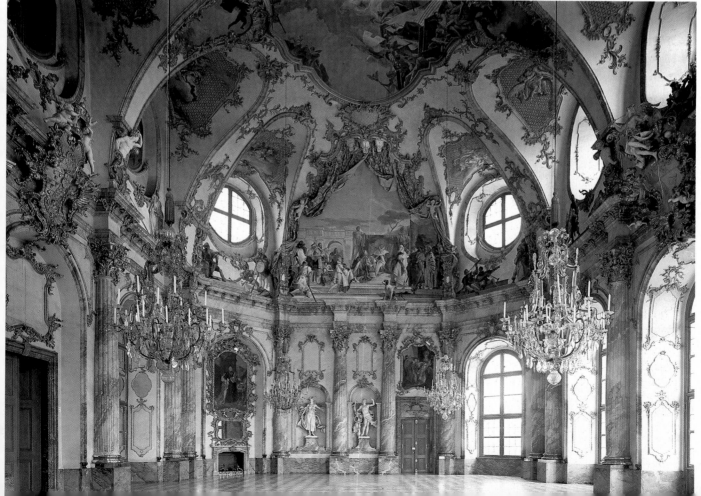

Bernini, illusionistic figures penetrate the physical spaces of the room and strike the viewer as the visible manifestation of the glory of the patron. The stipulated historical subject is the twelfth-century consecration at an imperial diet of the Bishop of Würzburg and his subsequent blessing of the marriage of Emperor Frederick Barbarossa (Fig. **6.37**). In the center of the ceiling, however, is an allegorical subject: the arrival of the bride in the chariot of Apollo before the personification of Imperium. Like Rubens, Tiepolo worked from oil sketches, but his spaces are vaster, and his active figures emerge from the margins of an open, luminous empyrean on either stucco clouds or hanging draperies beyond the confines of a gilded frame. For the historical scenes, the presiding bishop has the features of Tiepolo's Würzburg patron, the prince-bishop Carl Philipp von Greiffenklau, while the settings are filled with a profusion of exotic costumes and character types, including the turbaned orientals so frequent in Venetian art.

6.37 Kaisersaal, Residenz, Würzburg, detail of Giovanni Battista Tiepolo, *Marriage of the Emperor*, 1751–52. Fresco with stucco frame.

The grandest painted decoration in both extent and imagination, however, is Tiepolo's ceiling above Neumann's monumental staircase, an allegory of the four continents (Fig. **6.38**). The artist has realized in paint the cosmic dance around the central figure of Apollo that had informed both the gardens and the interior decoration at Versailles. Around the edges of the ceiling sit the Four Continents, with Europe presiding, enthroned amid symbols of the arts, over her fellows at the top of the landing of the staircase (before the entrance to the Kaisersaal). Here again, Tiepolo's love of the exotic enabled him to indulge himself in a variety of races, costumes, and animals for the non-European allegories. Painted stucco figures at the corners (already sketched in the *modello*) produce the same illusionistic penetration of space as in the Kaisersaal. A final reference to the patron, von Greiffenklau, is in the form of a gilded wreath medallion profile portrait, borne aloft by trumpeting figures of Fame and Glory above the area of Europe.

In this manner, Tiepolo pays tribute to his (temporary) sovereign by positioning him as an axis of literal as well as figural enlightenment. He is akin to Apollo, the sun god as well the god of the creative arts, around whom turn the celestial gods and the terrestrial continents. This is the same message

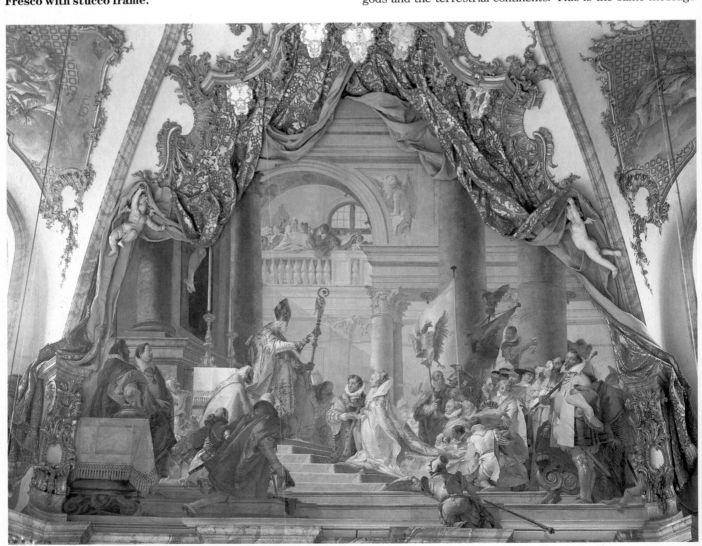

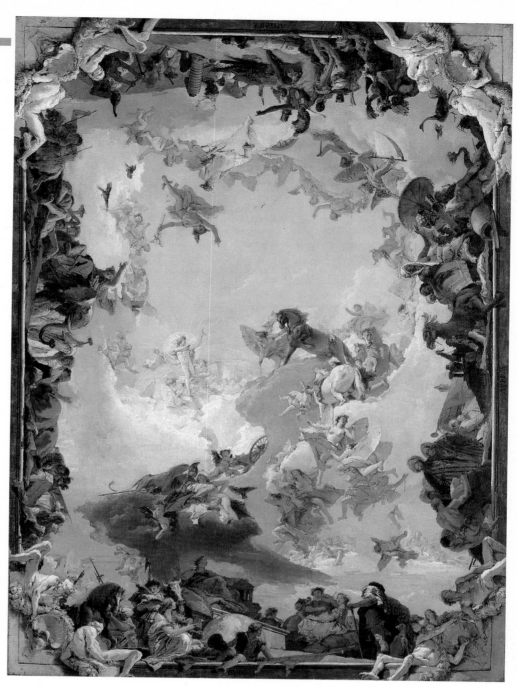

6.38 Giovanni Battista Tiepolo, *Allegory of the Planets and the Four Continents*, 1752. Oil on canvas, 73 × 54⅞ ins (185.4 × 139.4 cm). The Metropolitan Museum of Art, New York.

of apotheosis and of centrality within a palace and a court space that Rubens had provided at Whitehall. At the same time, Tiepolo's tribute also echoes the idea of the central role of the prince and his image that Velázquez had introduced (without allegory) on behalf of his sovereign in Spain (Fig. 1.6). Fittingly, Tiepolo also ended his career at the royal palace in Madrid, painting a similar ceiling program for the same absolutist dynasty: the *Triumph of Spain* (1761–70, *modello*, Washington).

Absolutist dynasties throughout seventeenth-century Europe were given a lasting memorial by the artists who served their powerful princes. Whether from Velázquez in Spain, van Dyck in England, Carracci or Bernini in Rome, Le Brun in France, or Rubens and later Tiepolo throughout Catholic Europe, the grand pretensions of princes and popes alike received their realization in the integrated realms of art and architecture. Often the inventions of such master designers required teams of collaborators in diverse media to create the complex visions of architecture, sculpture, painting, and decoration that could transform a physical setting into something metaphysical and mystical. Almost by definition, these fantasies had to be contained within the private universes of palaces or churches. Generally, they turned their backs on the bourgeois environments of commercial cities that had been the wellsprings of artistic enterprise in both Italy and the Low Countries during the Renaissance. Within Protestant Europe, however, under the continuing leadership of the Low Countries, it was precisely that alternative, middle-class culture that was defined in and through art – not in grand, multimedia ensembles but rather in small-scale, personal easel pictures that glory in the world around them rather than in imagined glories from above.

CAPITALISM AND CALVINISM: HOLLAND

Antwerp was the port city that had supplanted Bruges in the sixteenth century as the queen of commerce, now world commerce. Here, Portuguese spices from Asia and gold or ivory from the African coast were exchanged for south German copper and silver, mined in the Alps. Antwerp was also the world's money market and the first depot for goods from the new continent of America. America, Antwerp and the Low Countries were all ruled by Spain, which had absorbed traditional Burgundian claims through dynastic intermarriages. Yet Antwerp maintained her own mercantile and entrepreneurial independence, a free city at the hub of all these economic and political developments.

BRUEGEL

Pieter Bruegel (1525–69) was a master of the painters' guild of Antwerp. Within the commercial framework, his earliest creations were designs for prints, engravings produced from his drawings and mass-produced by a printer-publisher named Jerome Cock. Cock's publishing house was aptly named "At the Four Winds" (*Aux Quatre Vents*, 1550–70), and its Antwerp location was truly a world crossroads. A sample of

Bruegel's drawing for the Cock engravings is his allegory of "Everyman" (*Elck*; 1558), in which a foolish, bespectacled old man vainly seeks fulfillment through worldly goods and activities (Fig. **6.39**). Drawn again and again as he inspects the full variety of commodities in the bales and barrels that were then crowding the busy wharves of Antwerp, Everyman remains frustrated. Ultimately, despite the great bags of money at his side, his world, like the broken orb at his feet, is empty. The reason is clear from the little image on the wall behind; in it, a foppish courtier in archaic, Eyckian costume sits among broken household items, lost in a narcissistic gaze at his own reflection in a mirror. He is Nobody, and the inscription in the Flemish vernacular underneath his picture makes his folly explicit: "Nobody knows himself." Thus the paradox of Nobody brings home the message (also conveyed beneath the print in Latin, French, and Flemish verses) to bourgeois clients of Bruegel's print in mercantile Antwerp: the search for private gain is a vain and empty activity, like the discarded dice and cards in the foreground.

His *Everyman* print establishes Bruegel's agenda in his later paintings: continually to redefine the moral position of middle-class burghers relative to the world around them. For such images, Bruegel used subjects and spaces that were alien to

**6.39 Pieter Bruegel,
Elck,(Everyman), 1558. Ink
on paper, 8¼ × 11½ ins (21
× 29.3 cm). British Museum,
London.**

6.40 Pieter Bruegel, *Wheat Harvest*, **1565. Oil on panel, 46½ × 63¼ ins (118 × 160.7 cm). Metropolitan Museum, New York.**

the urban setting of Antwerp. He made careful landscape drawings of Alpine scenery that he had seen on an early trip to Rome in 1551–53 and incorporated them in his paintings along with visions of a more local, Flemish countryside. And he made the inhabitants of the countryside, the peasants, another kind of Everyman, whose common way of life helps to highlight moral issues within the more complex and transitory world of the city.

In 1565 Bruegel painted a series on the activities associated with each month for a wealthy Antwerp banker and royal official named Nicholas Jonghelinck. In many respects, this series harks back to the aristocratic vision of the labors of the months from calendar pages in Books of Hours, such as the Limbourg Brothers' *Très Riches Heures* for Jean, duke of Berry (Figs 4.3 and 4.5). For example, in the summer scene, *Wheat Harvest* (Fig. **6.40**), the peasants are resting, not working as they are on the June page of the Limbourg Brothers. Closer inspection of the painting reveals that elements of the landscape are recomposed from separate, if well-observed, details. The golden fields and hamlets derive from Bruegel's native Netherlands, as does the large stretch of open water on

the horizon. Taken as a whole, this composite scene is an artificial vision, constructed, like its viewpoint from the lower right corner, from a higher social elevation than that of the peasants who are depicted in the painting.

In similar fashion, the other summer scene preserved from Bruegel's cycle of the Months presents adjacent images of rural fecundity, the bounty that underlay real wealth for a landholder. Clearly the images of *Haymaking* and *Wheat Harvest* were meant to be seen together on the walls of Jonghelinck's town house. Their hazy horizons meld together in a common vista, seen from complementary foreground angles. Within these warm harvest scenes, small figures of peasants appear as anonymous laborers, whose efforts in the fields are rewarded with well-earned midday leisure. Their activities are tied to the changing seasons on the land, while the ownership of that rural land belongs not to the peasants who work on it, but rather to the benign *seigneur*, their social superior in the city, who owns both pictures and land.

Peasant leisure also formed the subject of some of Bruegel's most influential pictures. For example, his *Peasant Dance* (ca. 1568; Fig. **6.41**, p. 262) presents a closely observed kermis, an annual village church festival in honor of the local patron saint. While this panel is not viewed omnisciently from above like the Months, it nonetheless reveals a bemused detachment on the part of the painter, expressed in the comical, caricatured faces of these awkward, ingenuous smoochers and

6.41 Pieter Bruegel,
Peasant Dance, ca. 1568.
Oil on panel, 44⅞ × 64½ ins
(113.9 × 163.8 cm).
Kunsthistorisches Museum,
Vienna.

6.42 Pieter Bruegel, *The*
***Blind Leading the Blind*,**
1568. Oil on panel, 34 × 68
ins (86.3 × 172.7 cm).
Capodimonte Museum,
Naples.

brawlers. Here a simple yet alien culture is revealed to a sophisticated urban burgher, with the proviso (as stated on one of Bruegel's peasant prints of 1559) that "not every day is a kermis." One can laugh with and at these rustic merrymakers, like the "rude mechanicals" of Shakespeare's *A Midsummer Night's Dream.* Through their artlessness, one can sense the opposing artifice inherent in the concept of the "civilized" gentleman, so often underlying the social pretensions of the urban burgher. Thus an ironic Bruegel can mock hypocrisy and pretense among his viewers yet avoid setting up the peasant as an anti-hero. As in his print design, *Everyman*, the core of Bruegel's art remains moral instruction on a local level, viewed through both leisure and work.

One of Bruegel's final paintings is a canvas rendering of one of the parables of Christ, *The Blind Leading the Blind* (1568; Fig. **6.42**). Here a clinically meticulous attention to the precise kinds of blindness establishes the pitiful and terrible yet inevitable fall of these sightless men, blinder even than the bespectacled Everyman. Their disastrous temerity follows the downward course of a steeply sloping river bank, countered by the horizontal background stability of a quiet countryside with a humble parish church. Originally, this damaged section also showed a small, anonymous Bruegel peasant, a herdsman, toiling and oblivious to the vagabond blind beggars in the foreground and morally contrasted with them. Here, then, blindness should be understood as the folly of spiritual blind-

ness (despite the visible rosaries or crosses on the blind men) and of overreaching ambition. At a time of conflict between Protestants and Catholics, Bruegel's image counters with a generalized teaching parable from Christ Himself.

Like most parables, this one offers a model of conduct through a rural example of true humility within the limits set by nature. Here he reverses the imagery of Bosch's *Vagabond* on the exterior of the *Haywain Triptych* half a century earlier; in this case, the evil lies not in surrounding nature, besetting a wayfaring stranger, but within those who embody evil through blindness and have no eyes to see the simple order and beauty all around them in nature.

After having acquired wealth and noble titles unprecedented for an artist, Peter Paul Rubens (see above, p. 238–43) retired in the 1630s to the life of a country squire at Steen,

near Brussels. Once he had settled on the land, he rediscovered the local Flemish heritage of Bruegel. His paired canvases (ca. 1636) of *Landscape with Château Steen* and *Landscape with Rainbow* (Figs **6.43** and **6.44**) echo Bruegel's summer scenes painted for an earlier would-be squire. Again, a common horizon links Rubens's two panoramas, which show peasants toiling at activities such as haymaking in the late summer season. Rubens includes a hunter stalking partridges for his artist-master as well as Bruegel's herdsman with cattle and waterfowl. Both pictures bask in the luminous golden glow of a colorful palette that Rubens had rediscovered in Titian's work late in his career, especially within the royal collection in Madrid. Yet within their grand compositions, both paintings are also based upon the precise, detailed observation of nature.

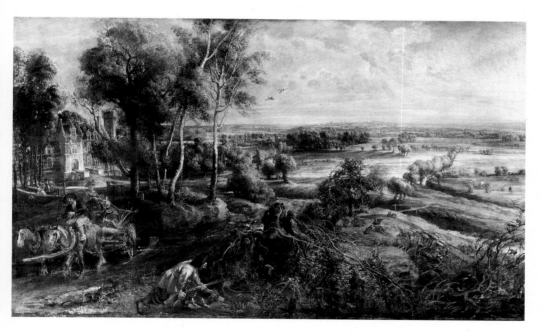

6.43 Peter Paul Rubens, *Landscape with Château Steen*, ca. 1636. Oil on canvas, 51⅝ × 90¼ ins (131 × 229.2 cm). National Gallery, London.

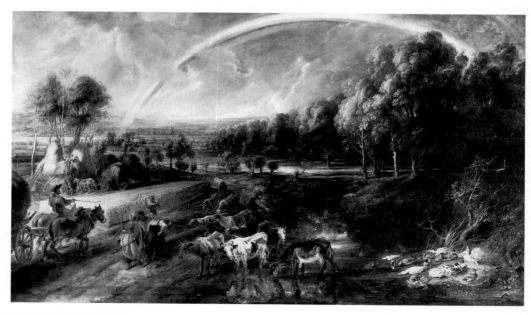

6.44 Peter Paul Rubens, *Landscape with Rainbow*, ca. 1636. Oil on canvas, 37¼ × 48½ ins (94.6 × 123.2 cm). Wallace Collection, London.

CIVIC PORTRAITURE: REMBRANDT

In nearby Amsterdam, the war between Spanish Flanders and Holland, which had so troubled Rubens, was a subject that was deliberately suppressed in life and in art. The city was able to maintain its new economic position effectively throughout the seventeenth century despite the wartime circumstances. The closest subject in Dutch painting to either Rubens's allegories of royal absolutism or *The Horrors of War* (Fig. 6.11) is the traditional group portrait of civic militia companies, already becoming something of an anachronism by the 1630s. Of all militia-company group portraits, the most famous is the so-called "Nightwatch," actually the *Company of Captain Frans Banning Coq* (1642; Fig. **6.45**) by Rembrandt van Rijn (1606–

69). This huge canvas is one of six civic-guard group portraits (plus a seventh of the militia governors) commissioned to decorate the new assembly and banqueting hall of the Kloveniersdoelen, the musketeers' branch of the civic militia.

The image celebrates the two officers of the militia, putting them at the center in bright light. However, what separates it from a host of similar group portrait commissions, with members arrayed around a banquet table, is the way in which Rembrandt brings the ensemble to life. Around the leaders, their soldiers actively "fall in" for a march, loading their muskets, raising their pikes, and unfurling their banners before setting out across a bridge from a city gate that recalls a triumphal arch. Although no specific historical moment is

6.45 Rembrandt, "*Nightwatch,*" (*Company of Captain Frans Banning Coq*), 1642. Oil on canvas, 136¾ × 175 ins (363 × 437 cm). Rijksmuseum, Amsterdam.

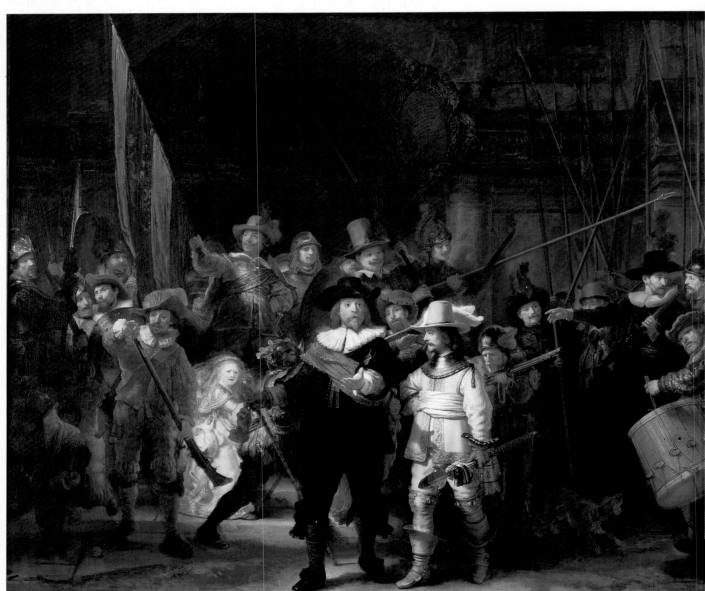

6.46 Rembrandt, *Syndics of the Drapers' Guild*, 1662. Oil on canvas, 75⅜ × 109⅞ ins (191.5 × 279 cm). Rijksmuseum, Amsterdam.

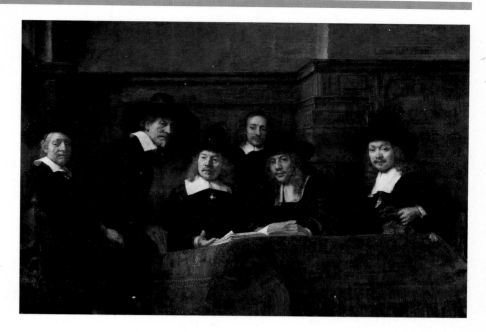

indicated in this group portrait, Rembrandt's image suggests a past era of heroics in the recent revolution against Spain. In fact, the group portrait was commissioned in honor of its bourgeois officers and paid for by subscription contributions from each of its depicted well-to-do members. Typical of Dutch pictures, the "Nightwatch" captures human drama vividly, giving to individuals a heroic significance normally reserved for history pictures in other parts of Europe. At the same time Rembrandt violates the decorum of hierarchy, observed by such artists as Le Brun, in according such grandeur to a group portrait of ordinary local burghers. Thus did the new, bourgeois republic of Holland choose to see itself near the end of its long war for independence; however, after the final Peace of Westphalia of 1648 recognized the new nation, no further pictures of this type were commissioned.

More typical Dutch life, however, emerges from Rembrandt's final group portrait in 1662, the *Syndics of the Drapers' Guild* (Fig. **6.46**). Here, of course, the legacy of the cloth trade and guild organization of late medieval Bruges had survived into the seventeenth century. Whereas in Catholic Europe, including Rubens's Antwerp, such groups would have commissioned altarpiece paintings of religious subjects and of patron saints for their chapels in the local cathedral, Calvinist Holland sought its own memorial in personal or corporate terms through portraits. In the case of Rembrandt's *Syndics*, the hierarchy among these soberly dressed regents, as in many a civic-guard group portrait, centers upon the seated figures at table and diffuses outward and upward. The lofty status of the entire group is clear from a vanishing point that places the viewer below them all (perhaps the portrait was originally placed above a fireplace in the guildhall). These men were elected officials who were charged with the supervision and inspection of textiles manufactured in Amsterdam, pictured imposing exacting standards from the samples in their open book. Their role was essential to trade in their profession in the busy port city.

Rembrandt moved from his native Leyden, a smaller university town, to the bustling metropolis of Amsterdam in 1631 and immediately made a name for himself as a portrait painter. Although his commissions tailed off later in his career, Rembrandt still painted for discerning patrons, such as the nobleman, Jan Six, for whom he made both a portrait (1654; Fig. **6.47**) and an etching (1648; Fig. **6.48**, p. 266). Like many of

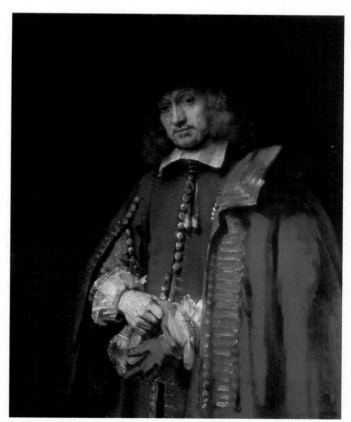

6.47 Rembrandt, *Jan Six*, 1654. Oil on canvas, 44 × 40⅛ ins (112 × 102 cm). Private Collection, Amsterdam.

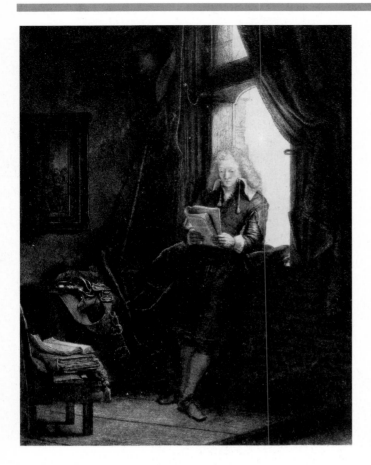

6.48 Rembrandt, *Jan Six*, 1648. Etching, 9⅝ × 7½ ins (24.4 × 19.1 cm). Six Foundation, Amsterdam.

6.49 Rembrandt, *Self-Portrait as Gentleman*, 1639. Etching, 8 × 6½ ins (20.5 × 16.4 cm). Collection Museum Het Rembrandthuis, Amsterdam.

6.50 Rembrandt, *Self-Portrait as St. Paul*, 1661. Oil on canvas, 37⅞ × 30⅓ ins (91 × 77 cm). Rijksmuseum, Amsterdam.

Amsterdam's newcomers, Six's family had fled religious persecution of Protestants by Catholic Spain to enjoy the relative toleration of Amsterdam (Rembrandt himself lived near a prosperous quarter of refugee Portuguese Jews, some of whom posed for him). Six's poetic temperament is visible in his air of reverie in both of Rembrandt's portraits; his fashionable dress and nonchalant pose emulate the dominant aristocratic portrait conventions established by van Dyck for English gentlemen. The etched portrait conveys Rembrandt's remarkable mastery of graphic conventions in the finished details of light and shadow, whereas the painted portrait demonstrates his later, distinctively personal touch through lively, virtuoso brushwork. Such a technique suggests the animation of the sitter himself as well as his momentary informality. What is striking about these images of Six, a Dutch citizen who later became Mayor of Amsterdam, is how unheroic he appears in comparison to the political and military figures in the portraits from Catholic Europe.

SELF-PORTRAITS Rembrandt's favorite subject for portraits was his own face, recorded during his entire career in all media – paintings, drawings, and etchings. At the height of his popularity in Amsterdam (the period when he bought his grand new house), Rembrandt emulated portrait models by both Raphael and Titian to produce both an etched

(1639; Fig. **6.49**) and painted portrait (1640) of himself as a gentleman. Again, the nonchalant air of relaxed elegance, arm resting on a ledge, combines with the meticulous rendering of luxurious, fur-trimmed garments to mark the prosperity and courtliness of the ambitious young painter, who would shortly complete the "Nightwatch."

At the end of his life, however, features depicted in the self-portraits combine with lively brushwork to suggest a franker, more personal, almost confessional confrontation with the viewer. Rembrandt uses his own aging features for the meditative image of *St. Paul* (1661; Fig. **6.50**) from his late, portraitlike series of the Apostles and Evangelists seen either in prayer or in contemplation over the Gospel text. By identifying himself with St. Paul, Rembrandt is making a declaration about his own abiding faith.

REMBRANDT AND RELIGION

Rembrandt's path to this kind of introspection went hand in hand with the internalized and personal religion of his homeland. Dutch Calvinism abjured the trappings of ritual even more than did the creed of Luther, and both firmly rejected the Catholic emphasis on priestly sacraments, on papal authority, and on the cult of Mary and the saints that we have seen reasserted in seventeenth-century Rome. Instead, Calvinist religion placed its emphasis on the holy word, to be read and interpreted by every individual Christian and preached by those who had that spiritual vocation. Significantly, some of Rembrant's most persuasive early portraits in both paintings and prints include famous preachers of the day in action, Mennonite as well as Calvinist.

Early in his Amsterdam career, Rembrandt's ambitions led him to emulate the example of Rubens, who was clearly the leading painter in all the Low Countries, despite his being across the arbitrary border imposed by the revolution. Thus in response to a commission for a Passion cycle to be delivered to

6.51 Rembrandt, *Descent from the Cross*, **1633. Etching, 20⅞ × 16⅛ ins (53 × 41 cm).**

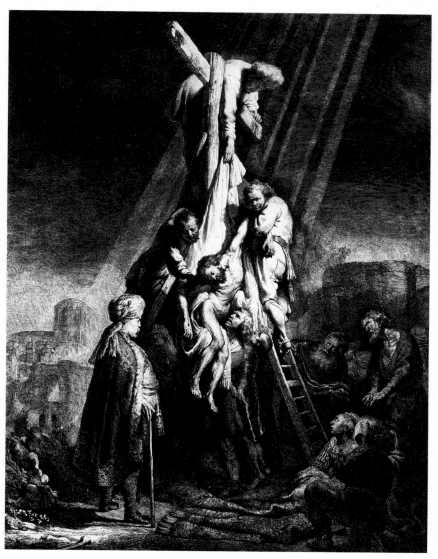

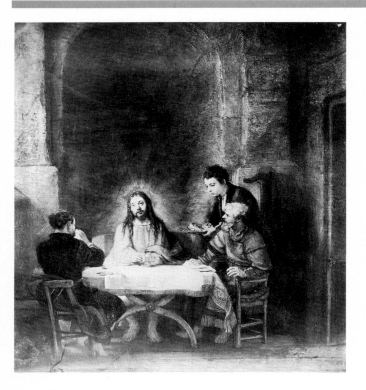

the Dutch ruler (actually called a *stadhouder*, or lieutenant of the state, rather than a king), Frederick Henry of Orange, Rembrandt followed the lead of Rubens. Typically, he meticulously rendered his painting in an etching of the same year; in copying his own work in etchings, he was again following the practice of Rubens. His meditations on the Bible, both Old and New Testaments, formed a staple of his print output throughout his career. However, his 1633 *Descent from the Cross* (Fig. **6.51**, p. 267) reveals how far the personalized spirituality of Calvinist Holland lies from the contemporary heroic theatricality of Rubens's *Raising of the Cross* (Fig. 6.8) in nearby Antwerp. Although it was based on a second Rubens Antwerp altarpiece of the same subject, available through the medium of an engraved replica, this nocturnal image shows an all-too-human and mortal Christ, whose body sags with its dead weight. Rembrandt displays here his love of exotic costume in

6.52 (Left) Rembrandt, *Supper at Emmaus*, 1648. Oil on canvas, 26¾ × 25⅝ ins (68 × 65 cm). Louvre, Paris.

6.53 (Below) Rembrandt, *Christ Preaching* ("100 Guilder Print"), ca. 1649. Etching, 11 × 15½ ins (28 × 39.3 cm). British Museum, London.

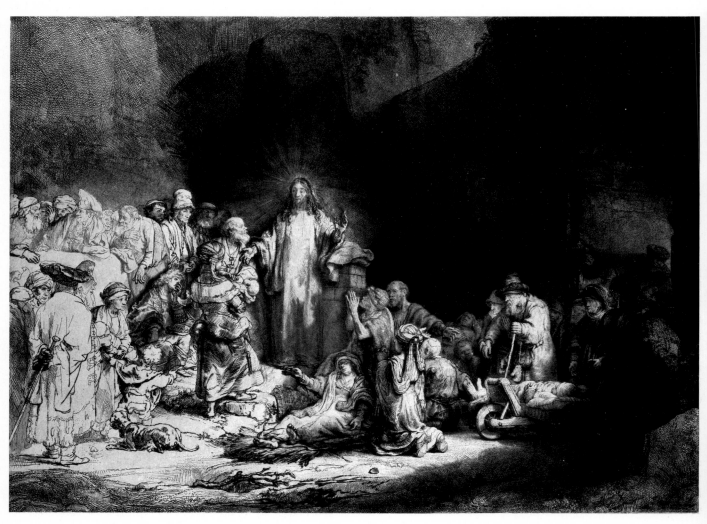

the chain and oriental turban of his supervising magistrate, elements already prepared in his work on numerous prints and even painted studies of heads. Yet the saintly attendants and witnesses are distinctly ordinary, even beggarly, and their grief is obscured in shadow. In particular, the artist renders his own empathy for the emotional state of the followers of Christ by including his self-portrait, shadowy and thoughtful, as the man holding the limp arm of the body.

This kind of quiet and reflective piety was developed in his later religious subjects. When he turned to the *Supper at Emmaus* (Fig. **6.52**) in 1648, the radiance of Christ's face only subtly deflects the mood of the setting from its otherwise quite ordinary presentation of an impoverished trio of pilgrims in a dimly lighted inn (the nichelike background arch could also be recalling the dark tomb of Christ). We cannot even be certain that the apostles have fully discerned the indentity of their lord, though their modest gestures of prayer and arousal distinguish them from a waiter who is oblivious to it. The youthful but individualized face of Christ, prepared by a series of careful painted studies, was probably based on a model, one of the artist's young Jewish neighbors.

At the same time as he produced the *Emmaus*, Rembrandt was also using this same portraitlike head to complete his most ambitious etched print, *Christ Preaching* (Fig. **6.53**), celebrated in history as the "Hundred Guilder Print" because of the high price it fetched in his lifetime. Nowhere is the preached word of Calvinism more vividly enacted than in this amalgam of various moments of Christ's mission. The parables of both Bruegel and Rembrandt are derived from sermons, although in the "Hundred Guilder Print" Christ is compassionate toward the lame as well as the innocent children, unlike the parable's rejection of the blind men. At the left of the etching a separate disputation among Jews turns them away from Christ and marks them off (despite Rembrandt's interest in their costumes and features, again probably derived from life study) from the mass of His listeners. Beneath them, a rich man (not unlike the youthful Jan Six, whose etching dates from this period) sits in meditation, perhaps moved by Christ's warning about the danger of riches. This, then, is a print squarely within the moral tradition of Christian humility and poverty, again addressed to the capitalists of the world's leading commercial center. (While the Prodigal Son will eventually find fatherly forgiveness, he must first return home a repentant beggar – a scene rendered movingly in both etching and painting by Rembrandt.) This print is orchestrated with the same control of large groups of figures and irregular lighting as characterized the "Nightwatch" a few years earlier, but instead of heroism it uses portraitlike variety to depict ordinary individuals. Spirituality is the result of direct, personal contact and inward meditation on the word of Christ rather than dramatic miracles or transcendent visions. That subtle radiance around the head of Christ is visible only to those who can glimpse it against the background darkness that dominates the etching. Indeed, the entire presentation arises from Rembrandt's own personal meditation on various passages of the Bible (Matthew 19), for the subject is an original invention.

CHURCH INTERIORS

The word of Christ was preached within bare, whitewashed Calvinist churches in Amsterdam and elsewhere in Holland, for the new faith required abolition of all "idolatrous" imagery. This change had already begun even in churches built before the Reformation, as contemporary images reveal. A painting of the great church of St. Bavo in Haarlem (1660) by the local artist Pieter Saenredam (1597–1665) shows the austere grandeur of Dutch church interiors (Fig. **6.54**). Rather than ornamenting their churches with altarpieces or shrines, Dutch painters developed instead a new pictorial category, with church interiors as the sole subject. In Saenredam's case, careful drawings from the site preceded his paintings. Each drawing was carefully organized as an exercise in perspective layout, sometimes from low or eccentric angles, and in most cases a precise label and date specify the location and occasion. In most of Saenredam's images figures play a small role; these large, open spaces offer quiet meditation to the viewer and to the few small figures reminiscent of Rembrandt's listening congregants around the preaching Christ.

By mid-century, Dutch church interior paintings included more figures and even some patriotic elements, as in the case

6.54 Pieter Saenredam, *Interior of Church of St. Bavo, Haarlem*, 1660. Oil on panel, 27¾ × 21⅝ ins (70.5 × 54.9 cm). Worcester Art Museum.

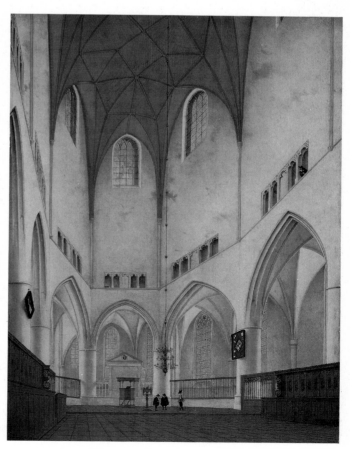

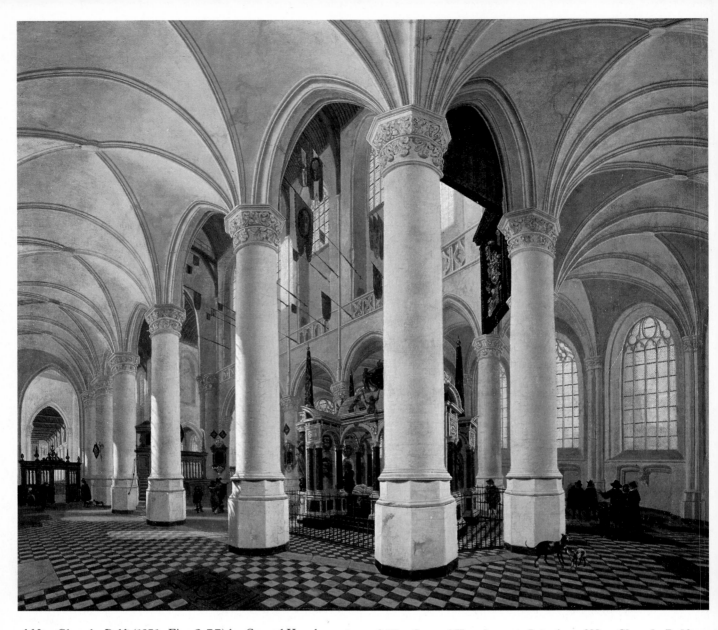

of *New Church, Delft* (1651; Fig. **6.55**) by Gerard Houckgeest (1600–61). At the center of this image is the massive tomb to the father of the Dutch revolution, William I of Orange (William the Silent). An object of reverent admiration by a family at the right and young children at the left, this national shrine would have held special significance for Delft and The Hague, the sites of the Dutch royal house of the new state. But the House of Orange was never a powerful factor in Dutch politics, in contrast to the neighboring absolute monarchs. Instead the prevailing values emanated from Amsterdam, where merchants prized peace and independence over the international politics of princely rulers. Nonetheless, this whitewashed church in Delft substitutes the bones of a national hero for the relics of a saint and thus demonstrates clearly the close link between Dutch independence and religious toleration in a country dominated by Calvinism.

The specialized category of church interiors was only one of several kinds of themes available to Dutch artists in the absence of the patronage readily available elsewhere in Europe: a strong court center or the adornment of Catholic churches. Painters in particular were obliged to make a living

6.55 Gerard Houckgeest, *Interior of New Church, Delft, with Tomb of William the Silent*, 1651. Oil on canvas, Mauritshuis, The Hague.

from the sale of their pictures on the open market, often for low prices. As a result, they frequently developed specialized, easily repeatable subjects, such as church interiors, landscapes, or portraits. Others turned to secular subjects from daily life. Rembrandt was exceptional in his steadfast commitment to religious pictures, but even he often rendered Old Testament subjects in preference to the emphasis on Christ and the Virgin in Catholic Europe (and his Christ, as we have seen, is usually emphatically human and often depicted as preacher or healer). For most artists, painting lay close to the level of the traditional craft or guild with its lower social status. Like Bruegel, later Dutch artists were not too proud to produce cheap prints as well as paintings of landscapes or of the lower classes for middle-class collectors in the city. And they also discovered the ready appeal of painting local landmarks for the proud citizens of this newly independent country.

SCENIC VISTAS

Dutch painters went beyond church interiors to offer exterior views of scenic vistas within their hometowns, particularly after the official national independence in 1648. Saenredam's drawings had already served as illustrations for a 1628 volume that described and praised his hometown of Haarlem. Many other Dutch painters made their careers from the rendering of civic centers and landmark buildings, often churches or town halls, such as the palatial Amsterdam Town Hall built just after mid-century (the old town hall, painted by Saenredam from an earlier study, had burned in 1651).

In the flatness of Holland, church towers commanded the horizon, as is evident from Rembrandt's delicate etching of the Amsterdam skyline (ca. 1640; Fig. **6.56**), where the wind-mills are their only rivals above the foreground marshes. Rembrandt's skyline exemplifies the prevalent Dutch landscape vision, where a high sky dominates the composition.

VAN RUISDAEL Another specialist landscape painter at Haarlem and Amsterdam was Jacob van Ruisdael (1628/9–82). In his distant view of Haarlem, also painted by Rembrandt, the one visible landmark of the city is the great church of St. Bavo (Fig. 6.54). Rembrandt's 1651 etching, *Saxenburg Estate* (nicknamed "Goldweigher's Field"; Fig. **6.57**), and Ruisdael's *View of Haarlem* (ca. 1670; Fig. **6.58**, p. 272) render essentially the same panorama. For Rembrandt, however, the foreground estate celebrates the same life of the seigneurial manor that underlies Rubens's landscapes at Château Steen (Fig. 6.43), a life to which he also vainly aspired (the owner of this estate was the gentleman who had

6.56 (Below, top) Rembrandt, *View of Amsterdam*, ca. 1640. Etching, 4½ × 6 ins (11.2 × 15.3 cm).

6.57 (Below, bottom) Rembrandt, *"Goldweigher's Field"* (*Saxenburg Estate near Haarlem*), 1651. Etching, 4¾ × 12 ins (12 × 31.9 cm).

6.58 (Above) Jacob van Ruisdael, *View of Haarlem*, ca. 1670. Oil on canvas, 21⅞ × 24⅜ (55.5 × 61.9 cm). Mauritshuis, The Hague.

6.59 (Left) Jacob van Ruisdael, *Windmill at Wijk*, ca. 1670. Oil on canvas, 32⅔ × 39¾ ins (83 × 101 cm). Rijksmuseum, Amsterdam.

sold Rembrandt his expensive town house). For Ruisdael, the Haarlem landscape features local industries that led to the region's prosperity, specifically the foreground bleaching fields with long white outstretched linens. No less than in Rembrandt's *Syndics of the Drapers' Guild* (Fig. 6.46), this landscape asserts the ongoing economic importance of cloth in the economy of the Netherlands.

Jacob van Ruisdael's rendering of another specific site, the great *Windmill at Wijk* (ca. 1670; Fig. **6.59**), exemplifies his ability to dramatize, even to attribute heroic stature to, the humble Dutch countryside. Once more, the high sky, filled

with moving clouds, produces changing atmosphere and light. Much of the remainder of the picture is taken up by water, the other constant element in Dutch nature. Against this background the powerful cylinder of the windmill stands as virtually the only solid in the picture, complemented by the smaller nearby masts of ships. The grandeur of this picture is certainly sufficient to allow it to serve as a national symbol, but it is also possible that the poetic and metaphoric significance attached to natural objects during the era of van Eyck survived into Ruisdael's day, if outside the realm of traditional religious art in Calvinist Holland. Popular Dutch *emblem-books* frequently used such commonplace visual images along with homiletic verses to convey spiritual values. In one such emblem-book of 1625, for example, the miller's use of the wind to make his livelihood is likened to humankind's dependence on the moving spirit of the Lord for life itself ("The spirit giveth life"). One cannot assert definitively that Ruisdael's image was intended to evoke such associations, but in the poetry of his Dutch countrymen nature frequently elicited just such a spiritual reaction. Like the Delft church with its patriotic tomb or the Haarlem landscape with bleaching fields, such reflections need not be divorced from either the national or the economic connotations of the mill.

6.60 Jan Vermeer, *View of Delft*, ca. 1662. Oil on canvas, 38½ × 46¼ ins (97.8 × 117.4 cm). Mauritshuis, The Hague.

VERMEER

The greatest of Dutch cityscapes was painted by a local artist who otherwise rarely painted landscapes of any kind: the *View of Delft* (ca. 1660; Fig. **6.60**) by Johannes Vermeer (1632–75). Unlike some other city skylines, commissioned by their proud municipalities, this large view of the city of Delft from just outside her gates was painted for a Delft patron who underwrote many Vermeer pictures, probably on a retainer basis. In this fashion, a civic painter could enjoy many of the benefits of a court artist, enabling him to work more slowly and carefully on a limited number of pictures. Such an arrangement was unusual, however: most painters had to work within a market structure that set fairly modest prices for most of their paintings. Vermeer's civic view would stimulate local pride in the city, which had recently been rebuilt following a disastrous explosion (1654), and it shows prominent Delft landmarks, notably the tower of the New Church (the site of the tomb of William I). He also clearly delights in depicting flickering Dutch light and changing cloud patterns, akin to Ruisdael's vistas.

Vermeer's ability to capture these fleeting effects as well as the city's permanent structures was partly due to his use of a viewing device, the *camera obscura*, forerunner of the modern photographic camera: the picture is a record of his mastery of both oil technique and optical instruments. Thus the *View of Delft* simultaneously celebrates the city of artist and patron while highlighting the remarkable talents of the artist himself.

DOMESTIC SCENES Most of Vermeer's limited range of pictures concentrate on the life of prosperous Dutch burghers, chiefly women, within their homes. His paintings present a dignified and decorous world of figures who are well dressed and clearly prosperous. Often, however, their behaviour is tinged with moral tensions occasioned by pleasure and the passions, as Vermeer and his contemporaries wrestle with the same problems of ethics within bourgeois urban life as Bosch and Bruegel before them.

For example, *Woman Reading a Letter* (ca. 1665; Fig. **6.61**) shows a self-possessed female figure within her own, light-suffused domestic space, fully absorbed in her private activity. The letter in her hands is associated in other Dutch paintings with love missives, which would explain her rapt attention.

This woman is monumental, a conical solid poised weightily in the center of the picture; she is surely pregnant. Her basic dignity and undisturbed privacy act in tension with her social situation as a pregnant woman attending to the words of an absent lover. But her tranquil world remains self-contained. The map of Holland hanging on the background wall only underscores how closed and private is this domestic sphere, Vermeer's abiding subject. The quiet interior, only softly lighted from outside, provides a spatial equivalent of the concentrated mental interior of a woman's thoughts. Vermeer's imagery and that of many of his Dutch contemporaries remains focused on the prosperous Dutch household, headed by women, whose moral behaviour in various female social roles becomes a major pictorial concern.

6.61 Jan Vermeer, *Woman Reading a Letter*, ca. 1665. Oil on Canvas, 18⅛ × 15¼ ins (46.5 × 39 cm). Rijksmuseum, Amsterdam.

Class distinctions also figure in Dutch domestic paintings. The celebrated Dutch penchant for cleanliness and the importance of a well-run household often necessitated assistance from maid-servants, so many Dutch pictures feature mistresses with their maidservants as emblems of urban industry and domestic virtue, the practical godliness equivalent to peasant labor in Bruegel's rural universe. Vermeer's *Milkmaid* (ca. 1660) shows a young woman pouring milk, one of Holland's principal products (many Dutch landscapes celebrate the cow along with the windmill as a national symbol) (Fig. **6.62**). The woman's careful attention to her everyday task contributes to the well-ordered if spare household and seems to show the practical fundaments behind (and below, in terms of class) the *Woman Reading a Letter*. Only a small footwarmer in front of the back wall represents any comforts for the milkmaid. Like the windmill of Ruisdael, this powerful, dignified, large-scale figure looms before the viewer as the very model of Dutch domestic virtue and productivity. Unlike some of his contemporaries, Vermeer never painted mothers and children, but his use of milk in this picture surely also alludes to the subject's labors in constant provision for the family.

6.62 Jan Vermeer, *Milkmaid*, **ca. 1660. Oil on canvas, 17⅞ × 16⅛ ins (45.4 × 40.9 cm). Rijksmuseum, Amsterdam.**

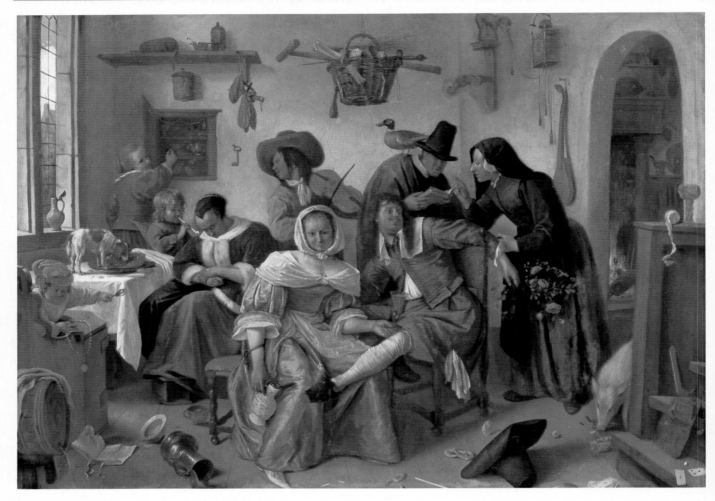

6.63 Jan Steen, *Beware of Luxury*, 1663. Oil on canvas, 41³⁄₈ × 57¹⁄₈ ins (105 × 145 cm). Kunsthistorisches Museum, Vienna.

STEEN The antipode of domestic virtue forms the subject of Jan Steen's (ca. 1625/26–79) contemporary image of a dissolute household, aptly entitled with an inscribed warning, *Beware of Luxury* (1663; Fig. **6.63**). This interior exudes luxury, brought indoors from the indulgent world of Bosch or the tavern festivity of Bruegel. Here the artist also aims to instruct but through the sardonic use of counterexample. At the center of the image sits a gaily dressed, overtly amorous couple, besotted with wine; nearby overturned tankards and open wine barrels spill their contents wastefully on the floor (in contrast to the husbandry of Vermeer's *Milkmaid*). The young libertines are chastised by a prudish old couple in sober dress (he reads from a book but may be a pious hypocrite, even a medical "quack," as the duck on his shoulder suggests). Meanwhile, the real mistress of the house has fallen asleep at table, the very symbol of the sin of sloth. Her neglect not only permits the lascivious couple to indulge themselves but also releases animal instincts from both

children and pets: a dog nibbles a meat pie on the table, while a child puffs on a clay pipe. A second flirtation develops above the sleeping housekeeper between a music-playing boy and a thieving young girl. The unattended helpless baby in a high chair drops its bowl onto the dirty floor right next to an important document and the wine barrel. The wildness of the children in this household illustrates yet another Dutch proverb, a favorite in other Steen paintings: "As the old pipe, so the young sing." At the opposite corner a pig runs wild, sniffing a rose (and thus expressing the Dutch proverbial equivalent of "pearls before swine"), amid the vestiges of card games and other frivolous activities. In the next room a roast has fallen into the untended, roaring fire (itself probably another symbol of lust). In a country where cleanliness truly ranked next to godliness, the painting presents us with a systematic catalogue of ills in this "world upside down," a metaphor of dissolution as complete as Bosch's *Haywain* (p. 142).

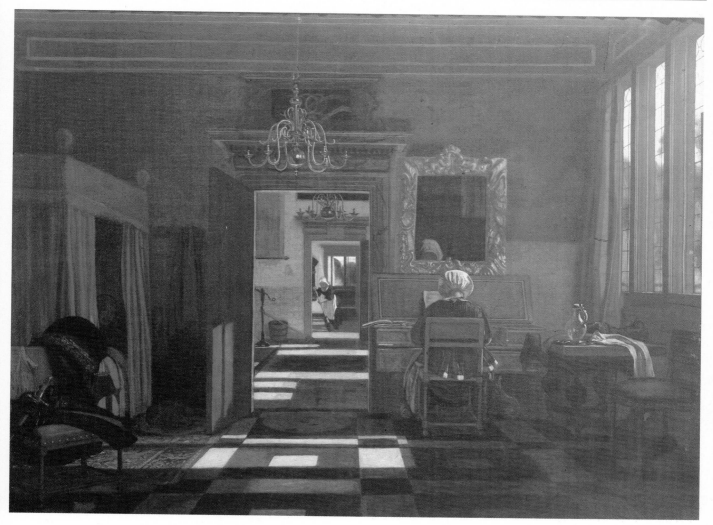

6.64 Emmanuel de Witte, *Interior with a Woman at a Virginal*, ca. 1665. Oil on canvas, 30⅖ × 41 ins (77 × 104 cm). Boymans-van Beuningen Museum, Rotterdam.

EMMANUEL DE WITTE'S *Interior with a Woman at a Virginal* (ca. 1665; Fig. **6.64**) encapsulates most of the images of Vermeer in a single vista of a household. Strongly illuminated with pools of light and deep shadows, this house is grander than any actual canal residences in Amsterdam. Its vaults and depth are rivaled in Dutch art only by church interiors, the normal métier of de Witte, following Saenredam and Houckgeest. Maintenance of these spaces is by a servant, visible sweeping in the far room; the mistress of the house is presumably the woman at the keyboard. Gradually we discover a listener, the owner of the men's clothes slung over the chair in the lower left corner, who is dimly visible in the shadows of the canopied bed. His sword, the traditional attribute of the nobleman or gentleman (see the Jan Six etching, p. 266) is more often associated in Dutch art with the loose morals of itinerant soldiers. Yet the officer seems to be a mere visitor, while the mistress and her servant are truly at home here. As in Vermeer's *Love Letter*, even this questionable (shadowy) behavior still retains a private dignity, consis-

tent with the setting, as it provokes new questions and tensions about moral conduct in the real world of urban leisure rather than the sermons of Calvinist preachers.

De Witte's image reminds us that most secular subjects in Dutch art represent the spaces, lives, and occupations of women. Women were the guardians of the family, that microcosm of the Dutch state at large. As Calvinism fostered the ideal of permeating daily life with religion, of substituting temperance for luxury, industry for idleness, home formed the central arena of training and the first line of defense against worldly temptation. Not that the Dutch were entirely prudish: their annual kermis or ceremonial banquets, such as those of the militia guilds, punctuated the annual calendar with moments of merriment. Nonetheless, their pervasive religion had the paradoxical effect of emphasizing worldly conduct as an ongoing test of moral rectitude. Small wonder that artists from Bruegel to Steen not only mingled religious themes with secular subjects in their art but also illustrated, often in a literal and sardonic fashion, the everpresent proverbs by which the Dutch (then and now) so often lived their daily lives. In this respect, the Reformation confirmed what earlier urban life in Bruges and Antwerp had already cultivated: a truly bourgeois culture, centered on the home and family.

Still-life Painting

Tensions and ambiguities about the relationship between the home and the outside world as well as between humility and prosperity find expression in a Dutch seventeenth–century speciality: the still life. Dutch still-life painting often focuses on fragile and ephemeral consumer items, particularly flowers and fruits; a few are even explicit in their warnings, including such items as skulls or hourglasses to signal the vanity of earthly possessions. Others truly belong to the realm of serious scientific study, particularly of flowers. Holland was a major early center of botanical research with its national passion for collecting flowers, particularly tulips (imported from Turkey at the end of the sixteenth century).

Collectable materials often enliven Dutch still-life paintings. Not only flowers but also shells (another import of the Dutch maritime empire), precious metalwork and exotic foreign porcelains attest to both the prosperity and the acquisitive natures of Dutch art patrons. One category of still-life images from around 1640 (earlier in nearby Antwerp) features such ornate possessions and the suggestion of material abundance. One of the leading practitioners of the ornate still life, describing yet questioning this materialism, is Willem Kalf (1619–93), a contemporary of de Witte, Steen, Ruisdael, and Vermeer who worked in Amsterdam. Kalf enjoyed an enviable reputation during his own lifetime for works featuring such elements as Ming porcelain, silver salvers, a variety of elaborate glassware, often with gold bases and rich oriental table carpets (Fig. **6.65**). Such pictures invite comparison between the virtuoso control of lighting by Kalf and the artistry of the exquisite precious objects in the painting. At the same time, they raise anew the ambivalences in Dutch culture concerning what one scholar has aptly characterized as "the embarrassment of riches."

Still-life painting was one arena in which women were able to emulate male artists, as the careers of Clara Peeters (1594-?; chiefly active in Antwerp), Maria van Oosterwijck (1630–93; Delft), Maria Sybilla Merian (1647–1717; learned scientist and botanical illustrator), and Rachel Ruysch (1663–1750; Amsterdam) attest. Judith Leyster (1609–60; see Fig. 1.9) is the chief woman artist to make a career in the painting of daily subjects, as a younger contemporary of Frans Hals in Haarlem.

However, specialized output and limited circles of clients led to general obscurity within a fairly short time for these women artists and other Dutch painters, such as Vermeer. He only emerged from obscurity in the France that produced Impressionism (the women artists are only now being rediscovered and researched). These French admirers saw in the frank description of worldly subjects by the Dutch artists an expression of independence and bourgeois national character, and they strove to emulate such seventeenth-century models of a free society. However, the French viewers neglected to notice that Dutch artistic "realism" was anything but a direct transcription of seventeenth-century Dutch reality. Instead this art presented highly charged images, often in direct opposition to prevailing absolutist and Catholic cultures, even though (indeed, partly because) it pictured those values artistically in everyday terms. Just as Calvinism remained the dominant religion in a pragmatic country that covertly permitted wide religious latitude, so did Dutch art embody prevailing values and ideals of domesticity and proper moral conduct while recognizing, even at times delighting in, excesses and exceptions to that code. From Bruegel onward, Dutch art steadfastly concerned itself with the conduct of life – in work and in play, rendered in lively and natural terms that would actively engage the viewer in this moral dialogue.

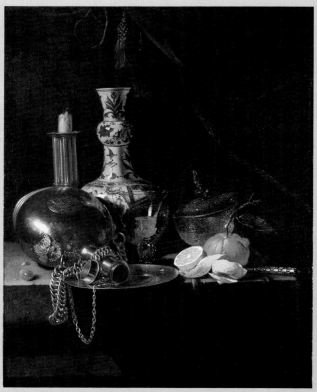

6.65 Willem Kalf, *Still Life with a Delft Vase*, 1663. Oil on canvas. Harold Samuel Collection, Corporation of London.

IMPERIAL ISLAM – ISFAHAN AND INDIA

From its beginnings in the Arabian peninsula in the seventh century AD, the world of Islam stretched at its zenith from the Pillars of Hercules at the western end of the Mediterranean (even including Spain until the year 1492) to the edges of Southeast Asia. At the time of the consolidation of nation-states and kingdoms in the West under Christianity, Islam, too, had developed into the state religion of some mighty empires. Chief rival to the West was the Islamic empire of the Ottoman Turks, whose capital in Istanbul, formerly Constantinople, had been wrested from the last Byzantine emperors in 1453. Two other major cultures had also succumbed to Islamic rulers: Iran (Persia) and India.

6.66 Isfahan, Masjid-i Shah (Shah Mosque), 1612/13–1630/31.

ISLAMIC ARCHITECTURE IN PERSIA

In Persia a succession of Islamic societies had arisen east of the Arabic caliphates (successor-rulers of Mohammed) in Mesopotamia by the mid-tenth century. In Isfahan after 1121–22, a major religious structure, or congregational mosque (*masjid-i jami*), was (re)built under the Great Seljuk rulers of Central Asia. Like most mosques, it is oriented in a direction called the *quiblah* toward the sacred city of Mecca in Arabia. The entrance from the courtyard is here marked by a great pointed arch vault, or *ivan*, derived from traditional Sassanian palace architecture from the Roman era in Persia. Behind the

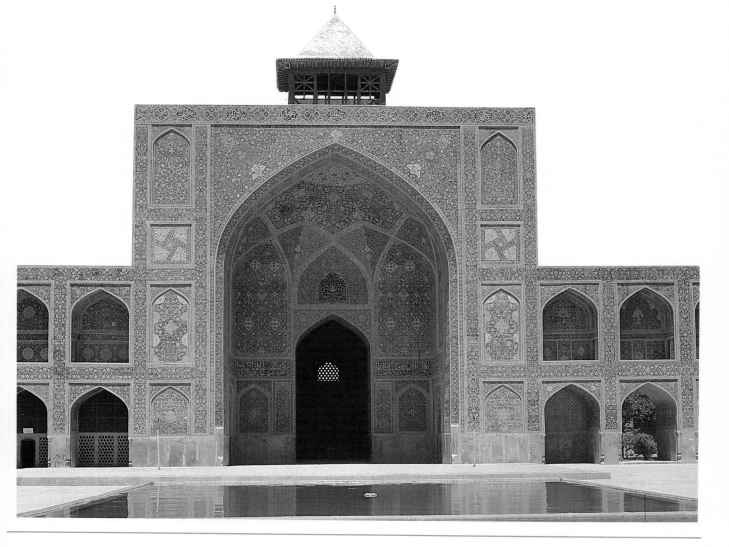

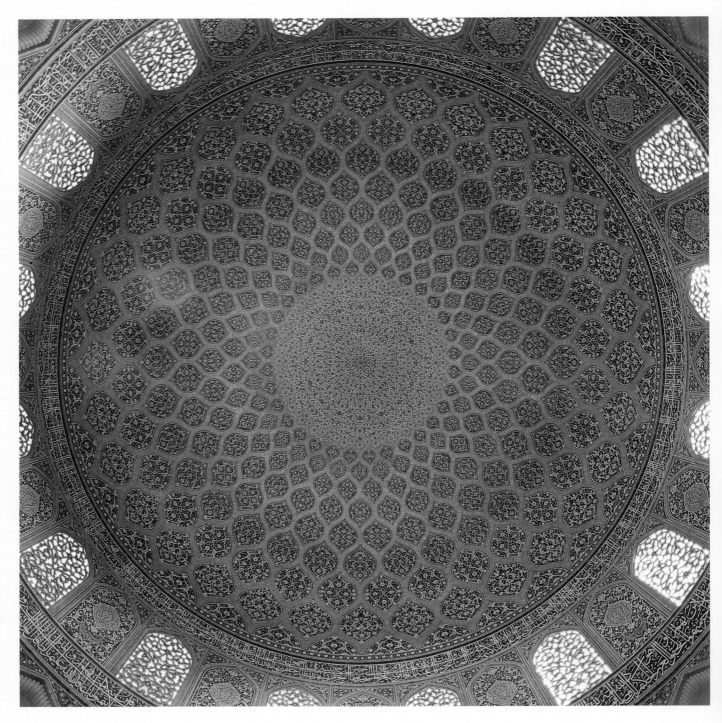

ivan of the façade, the Great Mosque of Isfahan was crowned by an eleventh-century brick ribbed domed structure which still survives.

Chief of the later Central Asian conquerors in Persia was Timur Lang (1336–1405; known in the West as Tamerlaine) in the late fourteenth century. In place of earlier decoration with shaped stucco or terracotta, Timurid architecture, centered on the capital of Samarqand, was ornamented chiefly with a novel element of tilework, brilliantly colored in turquoise or cobalt blues as well as glazed brick and mosaic, which permitted a rich and inventive combination of patterns and inscriptions (usually from the Moslem holy book, the Qur'an, or Koran).

The next conquerors of Iran, the Safavid dynasty, beginning

6.67 Isfahan, Mosque of Shaikh Lutfallah, 1602/03–1618/1619.

with Shah Ismail Safavi in 1502, used these elements in the magnificent monuments they built during their heyday in the sixteenth and seventeenth centuries. Shah Tamasp, son of Ismail, ruled from Herat and was succeeded by the greatest of Safavid rulers, his grandson, Shah Abbas (ruled 1587–1629), who transferred the capital to Isfahan and successfully withstood attacks by the Ottomans and Uzbeks. After 1598 Shah Abbas set about the lavish construction of both religious mosques and palace structures in a systematically planned capital center at Isfahan, complete with grand avenues, bridges, and gardens.

The heart of the new Isfahan is the Maydan, or Royal Quadrangle, a great rectangular courtyard space used for markets, polo matches, and military review. At the south end of the Maydan is the Masjid-i Shah (Fig. **6.66**, p. 279), the mosque of Shah Abbas (1612/13–30). Like the Great Mosque of Isfahan (which was also decorated with lustrous blue tiles at this time), this entrance is marked by a high *ivan* archway, flanked with twin balconied minaret towers. Behind is a domed space over a round drum, whose entire exterior is covered with the same blue surfaces as the façade (the nearer elements of the façade are mosaic, while the more distant dome is glaze-painted). The patterns on the façade include the kind of rich floral scrolls, medallions, and cartouches that are found on other decorated Islamic objects, ranging from book pages and covers to knotted carpets (see Fig. 6.69). The Koran forbids figural representation, as only God can be creator, so devotional Islamic art emphasises ornament and calligraphy – ornamental script developed to honor holy writ.

Even more spectacular is the interior of a slightly earlier mosque off the east side of the Maydan, the royal oratory known as the Masjid-i Shaikh Lutfallah, named for the father-in-law of Shah Abbas (Fig. **6.67**). After a dark vaulted corridor, the visitor enters a brilliant vision of the other world, illuminated by light coming through grills onto a golden bricked dome rising from turquoise arches. Around the drum at the base of the circular dome runs an inscription in white tile; at the peak of the dome there is a sunburst pattern with surface tiles in the scroll pattern called "arabesque." A similar pattern adorns the exterior of the subtly rounded dome. Inside the mosque the *quiblah* is marked in brilliant blue tiles with scrollwork and inscriptions around a wall niche, called the *mihrab*; inside the *mihrab*, the niche is further marked by stalactite spandrels, or *pendentives* (*muqarnas*).

Shah Abbas also provided elaborate palace buildings off the Maydan. Opposite the Lutfallah Mosque a palace pavilion, called the Ali Qapu (High Gate), forms the entrance to the royal gardens as well as a viewing platform for the shah to observe events staged in the Maydan. As a ceremonial gate of two main storeys and various subsidiary floors, the Ali Qapu could also be a reception area for ambassadors and other court entertainment – particularly the open upper balcony with its commanding view.

ILLUMINATED MANUSCRIPTS IN PERSIA

The richness of palace life and the pleasures of the gardens of Isfahan have faded, but in the pages of Persian manuscripts they can be recaptured in part. Most splendid of the many lavishly illustrated and decorative pages of these manuscripts is a traditional epic of the early history of Persian kings up to the Islamic conquest, the *Shah-nameh*, whose text was first composed by Firdausi around 1010, just prior to the advent of the Great Seljuks. Persian rulers since the Timurids had produced their own versions of the *Shah-nameh*'s battles and rulers, in order to legitimize their own place in the succession of kings. Among Safavid versions of the epic, the most resplendent is a volume, usually known as the "Houghton *Shah-nameh*," produced by a team of artists, led first by Sultan Muhammed and later by Aqa Mirak, for Shah Tahmasp around 1527 – 28 (Fig. **6.68**). The imagery of this manuscript's 258 miniatures derives from the illuminations of the celebrated Bihzad, who, after a long creative period at Herat, was at that time the elderly director of the royal library at the new capital of Tabriz.

6.68 *Shah-nameh* of Shah Tahmasp, Tabriz, supervised by Sultan Muhammed ("Houghton *Shah-nameh*"), *The Court of Gayumarth*, ca. 1525 – 35. Pigment and gold on paper. Metropolitan Museum, New York.

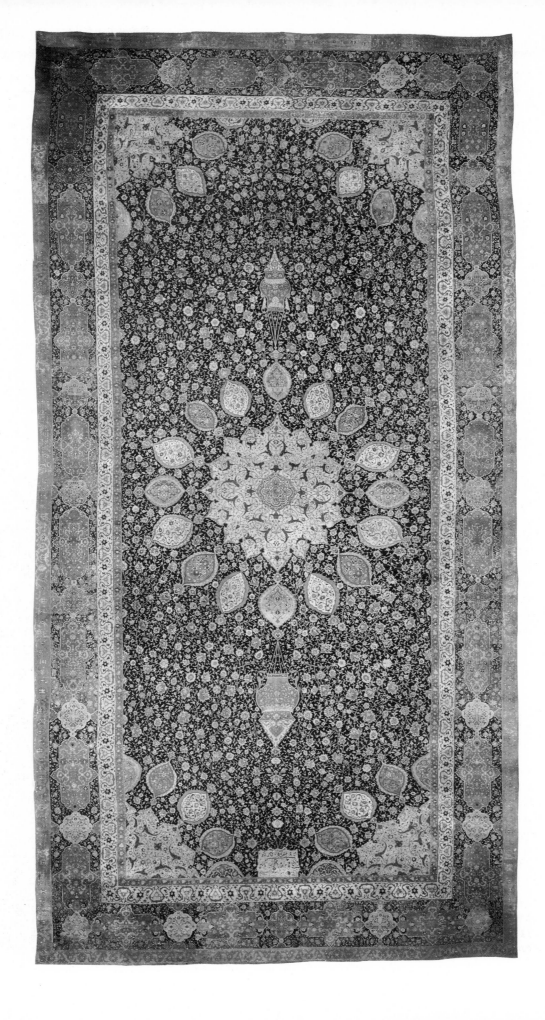

282

PERSIAN MINIATURES are marked by an extraordinary fineness of precise brushwork, portraying in exquisite detail and vivid color all of the delicate patterns of ornament or costume within discrete outlines. Little of the Western interest in atmosphere or lighting intrudes into these distilled essences of composed, geometrical staging. What is presented is an unchanging and ideal world, such as the blooming trees and flowers imagined as the garden idyll for the poet of the *Shah-nameh*, in a haven at the edge of a hillside and uncultivated open space. The delicate ornament of the palace pavilions echoes the patterns seen throughout Safavid decoration as well as the world of reception halls, terraces, and balconies suggested by surviving palace fragments (including the wall decorations of animal scenes akin to some bookbindings and drawings).

Most celebrated of all the miniatures in the *Shah-nameh*, probably painted by Sultan Muhammed himself, is the *Court of Gayumarth*, (Fig 6.68, p.281), legendary first Shah of Iran, who ruled from a mountain-top. This miniature displays the profusion of gold, the delight in play with frames, and the wealth of meticulously described animals and details that characterize this luxury book.

The decorative patterns and animal motifs of the manuscripts were repeated on the court costume of the Safavids, which was made of woven silks, such as taffeta (*tafteh*, woven), *lampas*, or velvet, and on their carpets. Perhaps the most spectacular of all carpets are the Safavid knotted ones with their distinctive curvilinear patterns in a frame around a a a central medallion (sometimes called a *shamsa*, or sun-disc). In the great carpet donated by Shah Tahmasp to a mosque at Ardabil, a corona of lamps hangs from the central disc motif (itself akin to the climax of the dome of the Lutfallah Mosque) to show that the decorative splendor of the carpet also signals the glories of heaven (Fig. 6.69). Like the tiled *mihrab*, this carpet could serve as an aid to prayer for the pious believer, who would kneel and touch his head on its edge as he headed towards Mecca.

MUGHAL ART AND ARCHITECTURE

Beginning in the sixteenth century, India succumbed to Islam through the conquest of Mongol rulers, Central Asian descendants of Chingiz Khan and Timur, who established the Mughal empire. One of the early Mughals, Hamayun (1508–56), spent a brief period in exile at the Safavid court of Shah Tahmasp and developed a taste for Persian art; he imported the painters Mir Sayyid Ali and Abd-as-Samad to his own court, eventually centered in Agra. Hamayun's son, Akbar the Great (1542–

6.69 (Opposite) "Ardabil" Carpet, probably Tabriz, 1539–40. Woolen pile, 34 × 17½ feet (10.5 × 5.3 meters). Victoria and Albert Museum, London.

1605), consolidated the Mughal possessions across northern India and eventually established Mughal artistic culture as well.

Akbar was an activist member of his dynasty, though he also delighted in stories and illustrations relating to Islam, to Persia, and to India. He had the history of his reign commemorated in both text (by Abu'l-Fazl) and images of the *Akbarnameh* (ca. 1590; Fig. 6.70). A well-organized system of illustration, subdivided into image design, coloring, and finishing details of portraits or animals, developed within the large court workshop, headed by Basawan. The extant manuscript is only a fragment, two out of a projected five volumes, but it contains 116 miniatures. One scene of Akbar riding a ferocious elephant, an image of leadership and valor, relates to

6.70 *Akbar restrains Hawa'i*, ca. 1590, from manuscript of *Akbar-nameh* (History of Akbar) of Abu'l-Fazl, designed and partly painted by Basawan, colored by Tara Kalem, Mughal. Pigment on paper. 13½ × 8½ ins (34.5 × 21.7 cm). Victoria and Albert Museum, London.

pictorial traditions of equestrian portraits and royal hunts (see Figs 6.15, 6.24). Such narratives retain many of the elements of Persian miniatures, such as the distinctive open spaces within either delicately washed hillsides or buildings, as well as outlined shapes with distinctive patterns. However, in the portrait of the ruler an emphatic interest in details of shading and of likeness emerges. This derived in part from Akbar's exposure to Western engravings, and would color later Mughal imagery, notably separate portraits or animal imagery on album leaves, particularly under Akbar's successor, Jahangir (World-Seizer).

FATEHPUR SIKRI To commemorate the birth in 1569 of his son and heir at the small town of Sikri near Agra, Akbar decided to build a new capital with a palace and a mosque on the site, and he named it Fatehpur-Sikri, City of Victory. Red sandstone quarries furnished much of the material for this new capital, as well as for Akbar's Red Fort in Agra (1565–73). Fatehpur-Sikri, particularly in its palace reception hall and throne room, the Diwan-i Khass (Hall of Private Audience), reveals Akbar's assimilation of previous Indian Hindu architectural traditions of platform construction with post and lintel, along with various decorative motifs, such as serpentine brackets. The grand entrance to the mosque, or Buland Darwazah, is approached by a steep flight of steps from its riverside prospect. Its *ivan*-like opening, framed with inscriptions, derives from Persia but is surmounted by characteristic Indian pavilions and culminates in a half-dome space with smaller doors below. The sanctuary interior contains polished stone decoration; here in 1579 Akbar read the Friday

sermon after the model of Timur and others, but he ended with what seems to be a blasphemous pun on his own greatness while praising "Almighty God" (Allahu-Akbar).

Jahangir's successor, Shah Jahan (Ruler of the World) became the ruler of the most sumptuous court of Mughal India during his peaceful reign (1628–58). He transferred the court from Agra to Delhi, where he constructed the renowned Red Fort (Lal Qila, 1639–49). The numerous portraits of the monarch show him as august and stiff, in particular the image of him in stately profile on his renowned Peacock Throne. The throne itself (lost) was first used in 1635 and then moved in 1648 to the Diwan-i Khass (Hall of Private Audience) of the Red Fort. Gilded and jewel-encrusted, it symbolized the splendor of the ruler, and in its patterns emulated the heritage of Persia, also seen in the carpet and canopy. The enamel-like flower and bird ornaments in the border of the miniature continue the Mughal fascination with observed nature, also evident in the portrait of Shah Jahan, in combination with the heritage of arabesque patterning.

Some of the splendorous patterns of Islamic ornament, found already in Persia, also reappear under the patronage of Shah Jahan. A notable instance appears as the opening page sun-disc (*shamsa*) of an album (ca. 1645; Fig. **6.72**). The elegant inscription reads: "His Majesty Shihab ad-Din Muhammed Shah Jahan, the King, Warrior of the Faith, may God perpetuate his kingdom and sovereignty!" Its brilliant design of sophisticated scrollwork and delicate animal decorations is picked out in blue and gold materials.

In the Diwan-i Khass of Shah Jahan's capital at the Red Fort

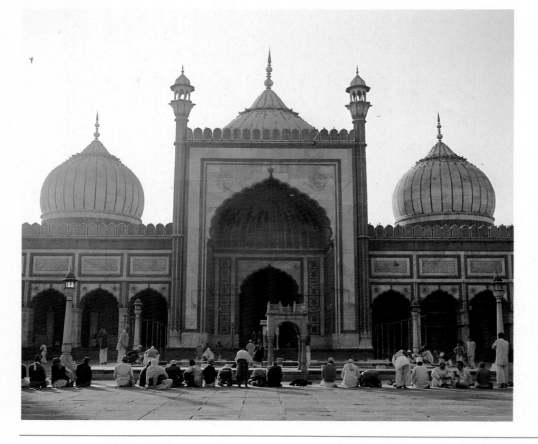

6.71 Friday Mosque (Jami Masjid), Delhi, 1644–58. View of façade.

6.72 (Opposite) Sun-disc rosette (*Shamsa*), bearing name and titles of Emperor Shah Jahan, opening page, Kevorkian Album, Mughal, ca. 1645. Pigment on paper, 15³⁄₈ × 10½ in (39.1 × 26.7 cm). Metropolitan Museum, New York.

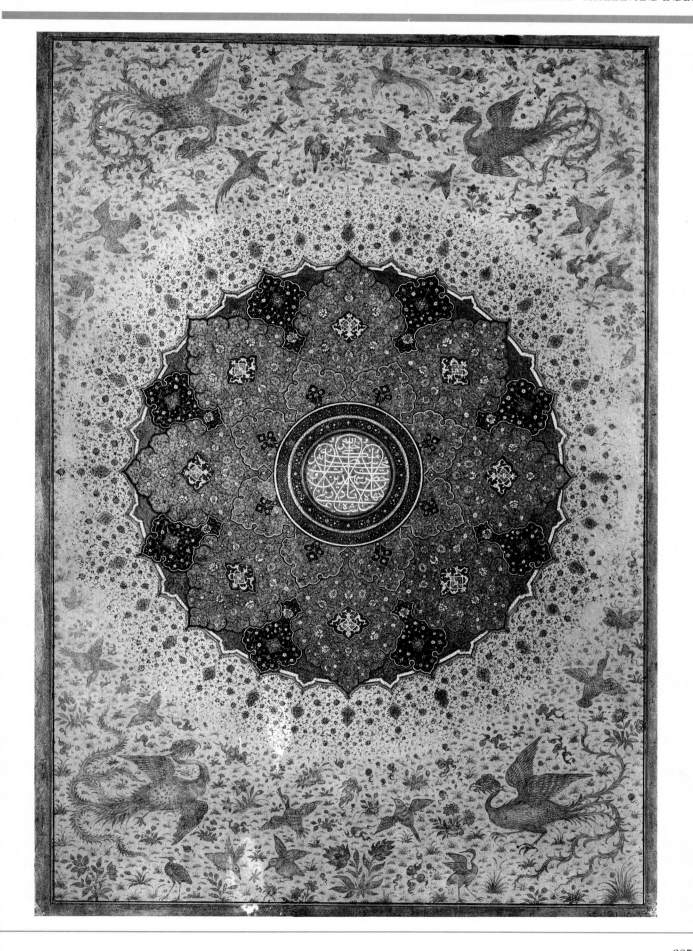

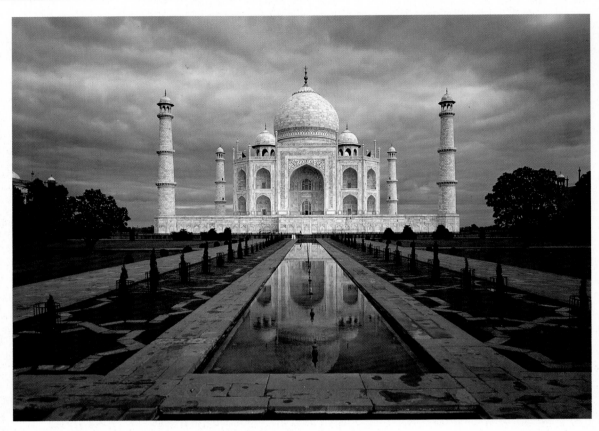

6.73 Taj Mahal, Agra, 1623–43. General view.

complex in Delhi, sumptuous inlaid stone patterns on marble and gilded arches and ceilings evoke Persian inscriptions of paradise on earth. Across from the Red Fort in Delhi lay the royal Friday Mosque (Jami Masjid, 1644–58) of Shah Jahan (Fig. **6.71**, p. 284). One of the largest courtyard mosques in India, this served as a monument to both his power and his piety while emulating the earlier fortress-mosque of Akbar. The mosque is framed with two tall minarets with red sandstone stripes against white marble. Its façade, following the Iranian model, features a central ivan in front of three bulbous white marble domes on raised drums. The mosque dominates a large open courtyard, framed by scalloped arches and raised on a high plinth. However, the most famous building of Shah Jahan, possibly by the same architect, Ustad Ahmad Lahori, was a tomb monument to his beloved wife, Mumtaz Mahal (d. 1631), back at the old capital in Agra: the Taj Mahal (the crown of Mahal; Fig. **6.73**). This building, too, is an image of paradise, based upon the descriptions of the four rivers in the Qur'an (as well as the traditions of Persian gardens), whose crossing is marked by a reflecting pool. The mausoleum itself is built on a terrace at the end of a carefully laid-out square garden. Grand in scale and sumptuous in its

marble materials, the building is flanked by corner minarets and pavilions and crowned by a higher central dome. The combination of arched entry and dome ultimately derives from mosque portals in Persia but with the modification to half-dome entries also seen at the Buland Darwaza at Fatehpur-Sikri. Surfaces of the exterior as well as the interior of the Taj Mahal are richly ornamented with patterns akin to those in the manuscripts. Spandrels and parapets are inlaid with semiprecious stones in arabesque scrolls, while pilasters carry chevron patterns in colored marbles, and surfaces are also ornameted with shallow carved marble reliefs of flowers and scalloped cartouches (Fig. **6.74**). The climax of the interior is the octagonal screen of twenty-four panels with even more inlay and arabesque carving around the cenotaph of the queen (as well as that of Shah Jahan, despite his intention to build a black marble version of the same design for himself across the River Jumna). A vision of paradise, informed by religious as well as secular traditions, a fusion of courtly Persian as well as local Indian building traditions, and a celebration of both private love and dynastic power, the Taj Mahal sums up the essential strands that combine to form the rich tapestry of Mughal culture.

6.74 (Opposite) Taj Mahal, Agra, 1623–43. Detail.

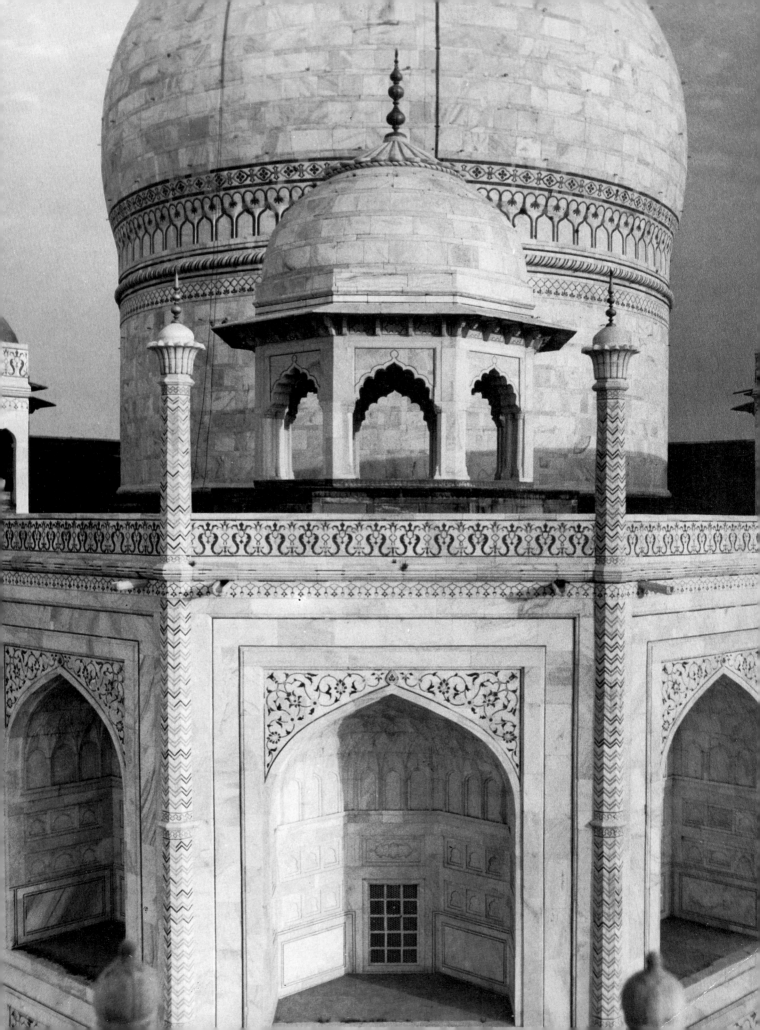

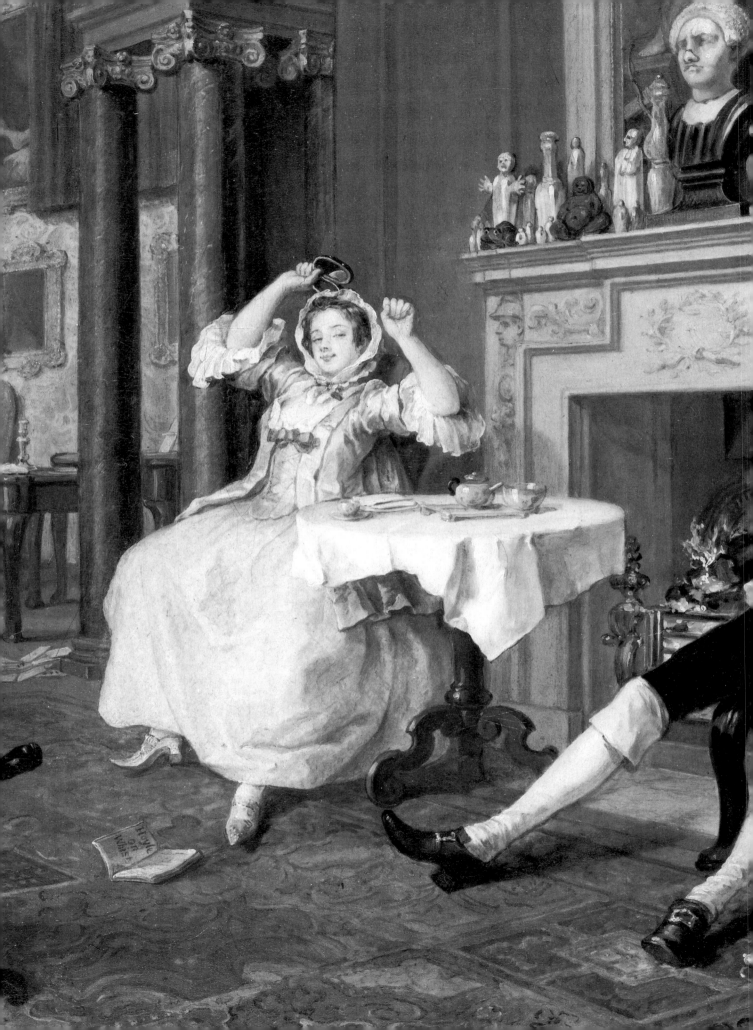

7

DAWN OF THE MODERN ERA

AGE OF ENLIGHTENMENT

London was Europe's largest city in the eighteenth century, and her prosperous middle-class population, bolstered by the trade from a maritime fleet in touch with her North American colonies, soon began to assert its domination over English culture. Whereas the country's government, military, and Church establishments had previously been the province of the titled nobility, securely settled in their country houses, now power – in Parliament and in patronage – passed to merchants in the City, the financial capital of London. Newspapers and novels, both centered on people's daily lives, addressed this middle-class audience and crystallized the contrast between city and country.

HOGARTH Visually, this cultural shift finds expression in the paintings and prints of William Hogarth (1697–1764). Hogarth produced narrative series, called "progresses," in the style of traditional history painting – religious or mythological sequences – but using images drawn from contemporary English culture. At the same time, he satirizes his subjects to provide moral instruction in the same way as Dutch *genre* painters of the previous century. Trained as an engraver as well as a painter, Hogarth issued printed replicas of his sequences in the form of engravings, available by subscription. In a characteristic combination of artistry and business acumen, Hogarth succeeded in effecting the passage through Parliament of an Act (1735) to guard against piracy of prints, giving engravers and designers copyright privileges.

Detail of Fig. 7.2, William Hogarth, *After the Ball* (see p.291).

In *Marriage à la Mode* Hogarth both documents and pillories the social changes in his England. The narrative opens with *Signing the Contract* (Fig. **7.1**), a scene in which a foppish nobleman with no money greedily yokes his title to the daughter of a wealthy, socially ambitious merchant. Hogarth centers his drama on the contrast of human types: the scrupulous merchant father and his legal contract against the decadent, gouty earl, with nothing but his family tree and aristocratic garb to offer. The ostentatious trappings of nobility appear throughout the image, in both the background history paintings (including a large portrait of a family ancestor, presumably the earl in his glorious youth) and the massive manor house, under construction in the background. The expensive mortgage for the house is being presented to the earl in the foreground, presumably occasioning the need for this marriage of convenience. The mansion is in the Palladian fashion that dominated English country architecture in the

early eighteenth century. The state of the pending nuptials is evident from Hogarth's characteristic caricature of manners and dress, where the unhappy young woman sits ignored by her narcissistic fiancé, who has eyes only for himself in a mirror.

Hogarth's presentation begins with all the conventions of setting, dress, and manner appropriate to an unfolding drama. He allows his viewer to "read" his scenarios like a book, from left to right across his composition, with all of the clarity of a Raphael narrative. However, in contrast to the subjects of the High Renaissance or the academic tradition that followed it, Hogarth's images are mock-heroic, akin to the contemporary literary satires of Alexander Pope or Henry Fielding.

Moving the same cast of characters into a new setting, Hogarth also suggests – like the novelist or dramatist – the passage of time. In the second scene of *Marriage à la Mode*, *After the Ball*, we see the rotten fruits of this misalliance (Fig. **7.2**). Here the alienation of the couple from each other is complete. Their decadent life in the expensive, Palladian manor is evident from the lateness of the hour shown on the garish clock. The grotesque collection of knickknacks – Roman

7.1 William Hogarth, *Marriage à la Mode*, 1743–45. *Signing the Contract*. Oil on canvas, 28 × 35⅞ ins (69.9 × 91 cm). National Gallery, London.

7.2 William Hogarth, *Marriage à la Mode,* **1743–45.** *After the Ball.* **Oil on canvas, 28 × 35¾ ins (69.9 × 90.8 cm). National Gallery, London.**

bust, or Chinese and Central European porcelain – is complemented by casually strewn objects of idle leisure, in the form of her cards, book, and music, plus his broken sword from a duel. The house steward departs in despair with a sheaf of bills. Like the Dutch masters, such as Jan Steen (Fig. 6.63), Hogarth here represents a caricature of luxury in order to warn his middle-class viewers – or subscribers – of the folly of this decadence and the danger inherent in it.

Hogarth's purpose in his art was to instruct through laughter. Indeed, a late self-portrait shows him at his easel painting a rendition of Thalia, the muse of Comedy. His friends and contemporaries were not slow to take his point. The epitaph on his tomb by the great actor, David Garrick (whose portrait Hogarth painted and engraved on several occasions), reads:

Farewell, great Painter of Mankind!
Who reach'd the noblest point of Art
Whose pictur'd Morals charm the Mind,
And through the Eye correct the Heart.

PORTRAITURE AND LANDSCAPE

While Hogarth served the cause of moral instruction in London, his contemporary Thomas Gainsborough (1727–88) recorded both the portraits and the well-groomed, productive landscapes of the country gentry, such as *Mr. and Mrs. Andrews* (ca. 1749) (Fig. **7.3**, p. 292). Real sitters, painted sympathetically, Gainsborough's couple casually face the viewer together, masters of all that they survey. Here the backgrounds and the sitters command equal attention; their property is also the subject. Stacked grain and grazing sheep can be seen in their fertile fields, and the husband's dog and gun imply that there is game in the grounds. This setting offers a favorable vision of the country – and the rural opposite to Hogarth's city decadents. Gainsborough worked throughout his life in places associated with the rural gentry: Ipswich (Suffolk) and Bath, the favored social retreat of moneyed classes. In his later portraits of patrons such as these, Gainsborough revitalized the aristocratic portraiture of

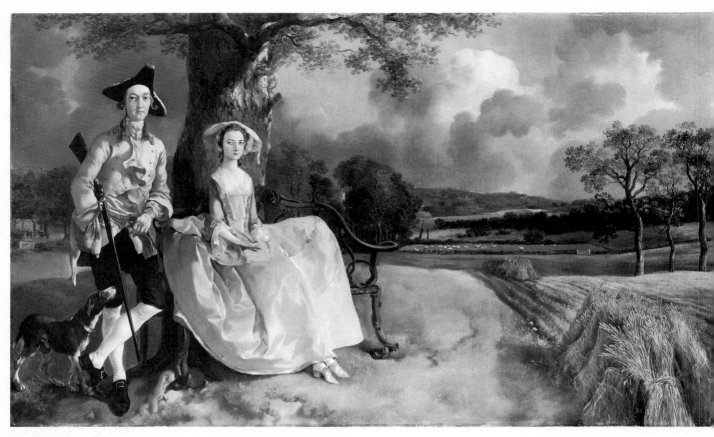

7.3 Thomas Gainsborough, *Mr. and Mrs. Andrews*, ca. 1749. Oil on canvas, 27½ × 47 ins (69.8 × 119.4 cm). National Gallery, London.

7.4 Henry Hoare, Stourhead (Wiltshire), gardens, laid out 1743.

Anthony van Dyck, usually with a shimmering, wooded backdrop for his fashionably dressed, full-length subjects.

Such imagined, fantasy improvements on sitters and their landscapes became a staple of British country life during the eighteenth century. The expansion of farming estates through forced enclosure of common land enabled landowners to devote space to the cultivation of gardens. In contrast to the symmetry and formal, geometrical ordering of French gardens, such as Versailles, the ideal of an English garden, particularly as laid out by its leading designers, William Kent (1685?–1748) and Lancelot ("Capability") Brown (1716–83), was to allow "Nature," or the "genius of the place," to dictate a much more informal arrangement of successive spaces and views. In order to assure minimal disturbance of the setting, the garden was separated from adjacent areas not by a fence, but rather by a ditch, or "ha-ha." Hence the country gentleman could survey his property – from his graceful and natural garden park outward to his fields – in an unbroken vista.

An English garden often included buildings reminiscent of the classical virtues. Classical temples, akin to the imagined structures in the dusky golden Roman landscapes of Claude Lorraine (1600–82), were built in the garden parks of English country homes at Castle Howard, Stowe, Rousham, and Stourhead. Stourhead was conceived as a country retreat for a London banker, Henry Hoare, and was begun in the 1740s (Fig. **7.4**). Like the succession of images in a Hogarth narrative, Stourhead made a "progress," this time both allegorical and classical, a pilgrimage of learning. Bridges over streams and a path through groves along a lake evoke Vergil's *Aeneid* as they ascend from an "underworld" grotto past a Temple of Ceres and a Pantheon of heroism to a climax at the Temple of Apollo, the seat of wisdom. Inside the temples the visitor discovered versions of renowned classical statues. The entire experience, visible from the end point of the Temple of Apollo, suggests an allegory of the cultivation of the country gentleman: an ascent from wilderness and wildness through farming and the harvest, virtue and fame to wisdom and beauty.

7.5 Robert Adam, Syon House, Plan.

7.6 Robert Adam, Syon House, 1762–64. Entrance hall.

THE CLASSICAL HERITAGE

English wealth permitted the would-be young gentleman to set off on a "Grand Tour" of Europe as part of his education. The ultimate goal of that pilgrimage always remained Rome. The English love of classical learning and its associated virtues of rationality and sobriety was seen as the proper instruction for a freedom-loving, democratic nation – in contrast to the pomp and bombast (which implied absolutism) of Continental culture. This new outlook led to the widespread adoption of "Augustan" or Roman republican ideals in English literature and in architecture, beginning with the Palladian buildings satirized by Hogarth.

SYON HOUSE by Robert Adam (1728–92) vividly encapsulates these English values after mid-century. Adam himself went to Italy on the Grand Tour (1754–58), after which time he revised the Palladian model from his more detailed archaeological study of Roman antique architecture, based on originals. The eighteenth century was the great age of archaeology in Italy, when Pompeii (1748) and Herculaneum (1738) were both excavated. The English Society of Dilettanti (established 1732), an association of gentlemen with archaeological interests, began to assist in the survey of ancient sites,

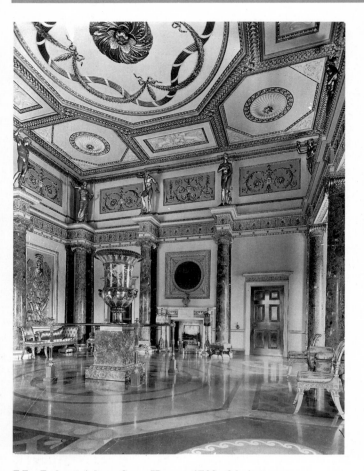

7.7 Robert Adam, Syon House, 1762–64. Anteroom.

including the Acropolis at Athens and Diocletian's Palace at Split (1757), the publication of which was supervised by Adam after his time in Rome. Hence, Adam was an unrivaled authority on Roman architecture when he set out to make a Neoclassical creation of his own.

Renovated for Sir Hugh Smythson, first Duke of Northumberland, Syon House retains its seventeenth-century exterior and quadrangular layout (Fig. **7.5**, p. 293). Its entrance hall is based on the classical form of the basilica, a rectangle with apse closure (Fig. **7.6**, p. 293). Roman ornament in the form of stucco panels and moldings articulates the surfaces of apse, walls, and ceiling. A planned central rotunda was never built, but its domed space would have functioned to pull together the varied geometrical shapes of the rooms around the quadrangle. In addition to his use of stucco ornament, Adam designed furniture and furnishings (from mirrors to piano cases and candlesticks) for his interiors; his goal was an ensemble of classical forms and decoration that could bring to life the architecture that he saw in classical ruins. This inventive recreation was realized by a rich diversity of variations on the classical canons and forms and by a costly use of materials, including gilding, pastel wall painting, and polychrome materials (Fig. **7.7**).

What Robert Adam orchestrated was the creation of an interior environment analogous to the gardens of Hoare, that

is, suitable for the comfortable lives of erudite English gentlemen. His clients were men who had been given a liberal education, with an emphasis on the classics, and had reinforced their studies with visits to Rome on the Grand Tour. They were the rulers of England through Parliament and mercantile influence, and they used their wealth to acquire antiquities. More often than not, as at Syon, Adam took over an earlier building and renovated its interior, sometimes adding new façades or extensions.

Other famous houses renovated by Robert Adam and his brother-collaborator, James, include Harewood, Kedleston, Bowood, and Osterly. At Kenwood (1767–68), on Hampstead Heath in surburban London, Lord Mansfield first enabled Adam to add his design touches to the exterior of the house as well. Thereafter, Adam constructions of the 1770s were made predominantly for Londoners, such as St. James's Square for Sir Watkin Williams-Wynn and Portman Square for the Countess of Home. In these cases his previous experience in accommodating to the restrictions imposed by the existence of an earlier building served him well in responding to the constraints of the reduced scale and restricted lots of the city spaces. Over 8,000 Adam drawings survive (Soane Museum, London), and he provided a legacy of design in published form in the engravings for *Works in Architecture by Robert and James Adam* (1773–79).

The entrance hall at Syon shows how fitting the Romanized space is for the display of collections of antiquities in these English interiors. English portraiture also captured this close association of the individual collector with his love of classic art. By using the informal and interactive group portrait, pioneered by Hogarth and known as the "conversation piece," an artist such as Johann Zoffany could memorialize both a circle of friends and the art collection of an individual. This is precisely the accomplishment of *Charles Townley in his Gallery* (1782; Fig. **7.8**). The group portrait makes clear the social change that had taken place in collecting, from the absolutist monarch, around whom the entire collection revolved, to the learned antiquarian, surrounded by his peers and his scholarly adviser (at the table), engaged in open discussion. Of course, something of the comedy of Hogarth's *Marriage à la Mode* emerges unintentionally from the overabundance of busts, statues, and reliefs jammed together with the humans into this ideal room. The statues remain intact at Towneley Hall, which is preserved as a museum – like Zoffany's painting an expression of the individual who collected them in Rome (Zoffany has even exercised his visual wit in matching the poses of the antiquarians with those of some of the objects around them). Moreover, the skylight has Neoclassical plaster ornament akin to the settings designed by Adam.

7.8 (Opposite) Johann Zoffany, *Charles Townley in his Gallery*, 1782. Oil on canvas, 50 × 39 ins (127 × 99 cm). Towneley Hall Museum and Art Gallery, Burnley.

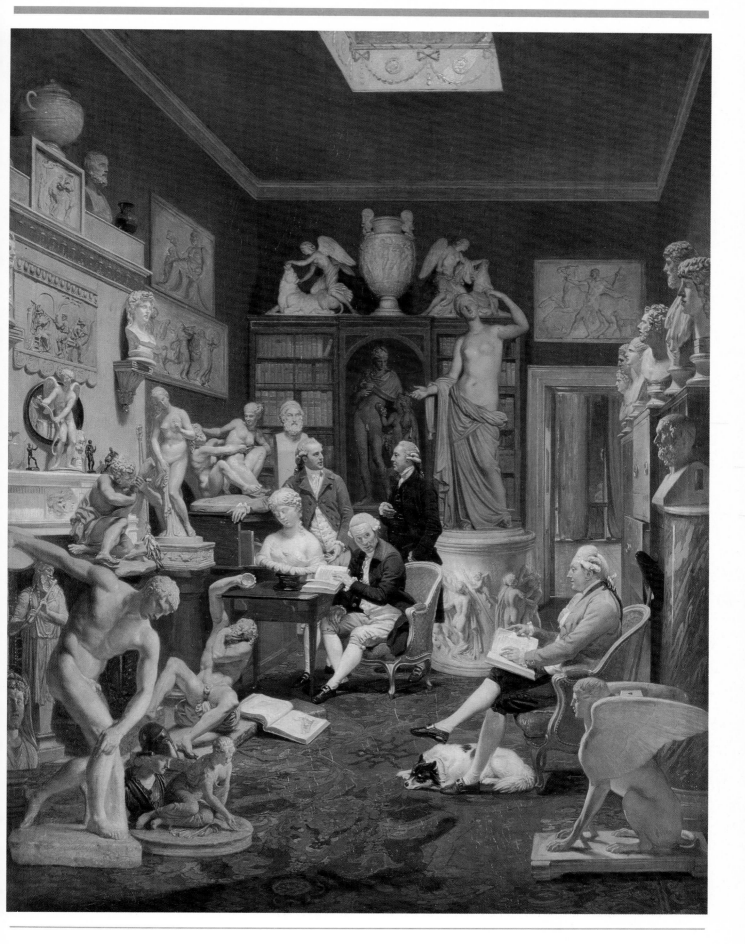

THE ROYAL ACADEMY

Within the realm of painting, the artist's emulation of antique and Renaissance models was codified in academic training, a fixture in Italy from the late sixteenth century and in France from the foundation of the Royal Academy in 1648. Led by Sir Joshua Reynolds (1723–92), who became its first president in 1768, England, too, established a Royal Academy to foster a modern school of English painting and sculpture based upon the study of classical models.

JOSHUA REYNOLDS Reynolds recommended the study of the antique in order "to attain the real simplicity of Nature." Like Robert Adam and Charles Townley, Reynolds had made the Grand Tour to Rome, though Renaissance painters attracted him more than ancient marbles. In his annual presentation speeches to the Academy, collected together as his *Discourses*, Reynolds recommended (Discourse no. 1)

"that an implicit obedience to the Rules of Art, as established by the practice of the great Masters, should be exacted from the young Students; that those models, which have passed through the approbation of ages, should be considered by them as perfect and infallible guides."

The aim of art, said Reynolds, was moral improvement; art must endeavor to improve mankind by grandeur of ideas and the embodiment of ideal beauty.

Because of the English predilection for portraiture, Reynolds's paintings often attempt to infuse the grand manner of his models into his production of likeness. When commissioned to paint the portrait of Sarah Kemble Siddons, a leading tragic actress and friend of Garrick, Reynolds reached back to Michelangelo for his model of *Mrs. Siddons as Tragic Muse* (1784; Fig. **7.9**). Exhibited at the Royal Academy, this portrait equates the actress with Tragedy, as Hogarth had portrayed himself painting Comedy and Reynolds had earlier portrayed *Garrick between Tragedy and Comedy* (1762). This grand portrait suggests by her throne and pose that Mrs. Siddons is like one of the sibyls of the Sistine Ceiling. Her gesture derives from Michelangelo's Isaiah, while the mournful figure behind her with a dagger derives from one of the companions of Jeremiah. The cup and dagger traditionally serve as attributes of Melpomene, the muse of Tragedy; the facial features of the two companions express Aristotle's doctrine of tragedy as a mixture of pity and fear. Taken together, the heroic grandeur of the sitter combines with the visual and verbal erudition of the artist. By her association with Reynolds and his association with past masters, the sitter is aggrandized and given a learned character akin to that of Townley through association with his collection.

ANGELICA KAUFFMANN Scenes from Roman history became a staple of several of Reynolds's colleagues and co-founders of the Royal Academy, many of whom had met each other in Rome. One of the most accomplished

and professional women painters of the century, the Swiss, Angelica Kauffmann (1741–1807), joined the group of English artists in Rome and arrived in London by 1766, where she enjoyed considerable critical and financial success. In Kauffmann's history paintings from ancient literature, her slim female figures, derived from fresco paintings from Herculaneum, add an element of Neoclassical authenticity to her images of classical women.

Kauffmann dedicated herself to the subjects of history painting, regarded by academics as the pinnacle of moral worth and artistic accomplishment, rather than the less prestigious, if more lucrative, portraits that dominated the career of Reynolds. (When Kauffmann made portraits, her sitters were almost invariably women, including Frances Hoare of Stourhead, allegorized in the manner of Reynolds as offering a sacrifice to a statue of Minerva.) Kauffmann also painted panels for

7.9 Joshua Reynolds, *Mrs. Siddons as Tragic Muse*, 1784. Oil on canvas, 93 × 57½ ins (236 × 146 cm). Huntington Library and Art Gallery, San Marino, California.

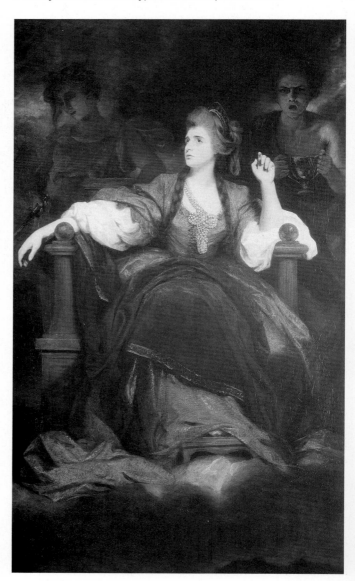

7.10 Angelica Kauffmann, *Cornelia, Mother of the Gracchi*, 1785. Oil on canvas, 40 × 50 ins (101.6 × 127 cm). Virginia Museum of Fine Arts, Richmond. The Adolph D. and Wilkins C. Williams Fund.

insertion into decorative ensembles, especially those of Adam. (Her second husband, the painter Antonio Zucchi, was a regular collaborator with Adam – at Kenwood House, for example.) The most famous of such works are the oval allegories for the Royal Academy residence (1778), representing the elements of pictorial form: Color, Design, Composition, and Genius.

Kauffmann's *Cornelia, Mother of the Gracchi* (1785) offers a perfect example of the artist's interest in classical subjects with prominent heroines (Fig. **7.10**). The tale comes from Valerius Maximus: Cornelia, daughter of Scipio Africanus, a great general, and widow of Titus Gracchus, a great politician of Rome, presents her children, themselves future tribunes, to a visitor with the famous words, "These are my most precious jewels." The moral of this image could not be more explicit: the future welfare of the republic – and by analogy of modern England, if it learns from such classic texts and images – depends upon such model maternal modesty and commitment to education. This classical paragon of modern motherhood stands beside her sewing basket and, like Hercules, chooses virtue over luxury, offered by her ornamented visitor. Moreover, Kauffmann attends to the "rules of art" by observing classical models: costumes of an exacting archaeological correctness, and a composition of figures across a shallow relief space sanctioned by both classical frescoes and Renaissance precedents.

BENJAMIN WEST Roman history was also a staple of an American artist who befriended Kauffmann and the English circle in Rome and likewise became a founding member of the Royal Academy in London, as well as its second president after Reynolds (in 1792): Benjamin West (1738–1820). Along with such sober classical subjects as *Agrippina*

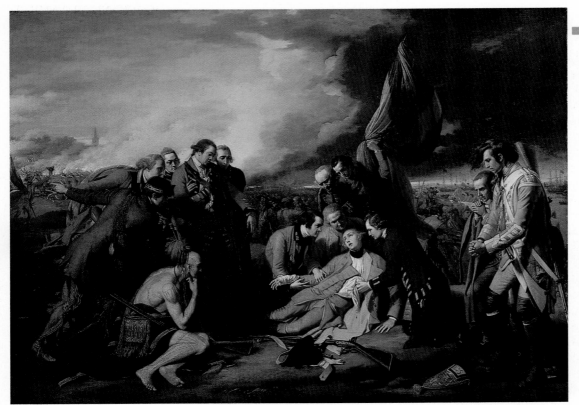

7.11 Benjamin West, *The Death of General Wolfe*, ca. 1770. Oil on canvas, 59½ × 84 ins (151 × 213.4 cm). National Gallery of Canada, Ottawa.

7.12 Benjamin West, *Death on a Pale Horse*, 1796. Oil sketch on canvas, 23½ × 50½ ins (59.7 × 128.3 cm). Detroit Institute of Arts Founders Society. Purchase, Robert H. Tannahill Foundation.

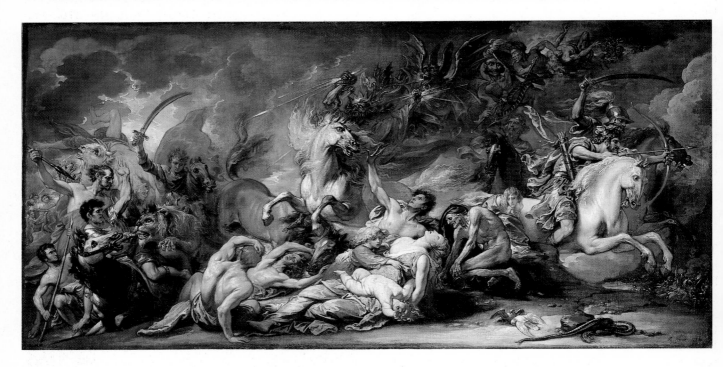

Landing at Brundisium with the Ashes of Germanicus (1768), West created a stir at the Academy when he painted a subject from contemporary history with all the trappings of history painting, in the grandiose style of Reynolds's portraiture. *The Death of General Wolfe* (1770), a military event from the contemporary war with France in North America (known in American history as the "French and Indian War"), was a subject that was obviously quite moving to the young American expatriate (Fig. **7.11**). Though the figures are all represented in modern dress, the composition clearly evokes other

images of mourning, such as references in the dying general to Poussin's famed *Death of Germanicus* (1628; Fig 6.26) and, more generally, to the tradition of Christ's Passion. Reynolds advised West to avoid modern costume in favor of antique garb, like Poussin (or Kauffmann and the Roman subjects of West). But to West, this conquest of Quebec in 1759 held a modern, not a timeless significance. He uses allegory in the form of an Indian (whose pose suggests Michelangelo's prophets and whose torso echoes his *ignudi* and their source, the *Torso Belvedere* of the Vatican) in order to represent the

continent of America. Such references to pictorial traditions, including mythic and religious scenes of mourning, add universality to the specificity of costumes and event. Like Reynolds's portraits, these individual heroes acquire increased stature through artistic reference. At the same time, West could use both the particular and the general aspects of this scene to evoke an emotional response in his viewing public, indulging the new interest of English writers and artists in "sensibility."

West was appointed Historical Painter to the King by George III in 1772 and maintained that position even after the American War of Independence. His increasing interest in imaginative and terrifying imagery – what Edmund Burke called the "sublime" in his influential essay of 1757 – led West to aspire to paint religious themes in the grand, traditional manner, even though Protestant England had had no heritage of such imagery since the Reformation two and a half centuries earlier. He was charged by the king to produce a cycle of over-lifesized canvases on the theme of "The Progress of Revealed Religion" for a royal chapel at Windsor Castle, but, despite his numerous oil sketches and some finished works, the Chapel was never realized in its intended form. The power and animation of West's *Death on a Pale Horse* (1796; Revelations 6) show the apocalyptic side of history painting, where death and pestilence fill the world (Fig. **7.12**). This horrific aspect of the sublime would find fulfillment in Turner's cataclysmic landscapes a few decades later (see Fig 7.26); however, a vision of the sublime as a religious experience found no real echo in the classicism and rational morality espoused by the eighteenth century. Moreover, in the wake of revolutions against the crown in America and France, such devastation would have been poorly received by traditionalists in England and rejected by revolutionaries elsewhere. West's abortive chapel project, then, signals not just a false start in England but also an end to effective religious grandeur in Western painting.

ART AND REVOLUTION

The imagery for the young American Revolution began as an import. Just as in politics, links between America and France began early in art. Portraiture remained for Americans, as for the English, a tangible connection to their leaders and heroes. The greatest of American colonial painters, John Singleton Copley (1738–1815), was a portrait painter who settled in England after 1775. However, for sculpture, a medium undeveloped in America, the demand for American figures was filled by a Frenchman, Jean-Antoine Houdon (1741–1828).

HOUDON Though conventionally trained at the French Royal Academy and then in Rome, Houdon followed Reynolds in turning to portraiture for his livelihood; however, his subjects were the living Great Men of France. In emulation of classical and Renaissance models, Houdon used the bust form for strikingly lifelike physiognomies in momentary arrest. Most of Houdon's sitters, of course, were Frenchmen, usually intellectual leaders, such as Denis Diderot (1771),

the author of the *Encyclopédie* and one of the first noted art critics. The sculptor's avowed purpose was "truthfully to preserve the form and render imperishable the image of men who have achieved glory or good for their country." Houdon also created a renowned *Voltaire* (1778) from life and expanded his plaster figure to full length, showing the frail old man in a Roman toga, as the modern counterpart of a classical philosopher, seated but alert, gazing away from his chair. Because Houdon's sculptures were so popular, he often made multiple versions in many media – plaster, terracotta, bronze, and marble. He also made busts of American emissaries in France, beginning with Benjamin Franklin and Thomas Jefferson.

Thus, when the Virginia legislature wished to commission a marble statue of George Washington after the success of the Revolution, it followed Jefferson's suggestion and turned to Houdon. With his typical fastidious attention to detail, Houdon visited his sitter at Mount Vernon and took measurements as well as plaster casts of his hands. After modeling a bust like those of Franklin and Jefferson, he set about carving a full-length standing portrait of Washington in the contemporary costume of a general rather than classical garb (Fig. **7.13**). The iconography of Washington, however, still makes pointed

7.13 Jean-Antoine Houdon, *George Washington*, 1785–96. Marble, 74 ins (188 cm) high. State Capitol, Richmond.

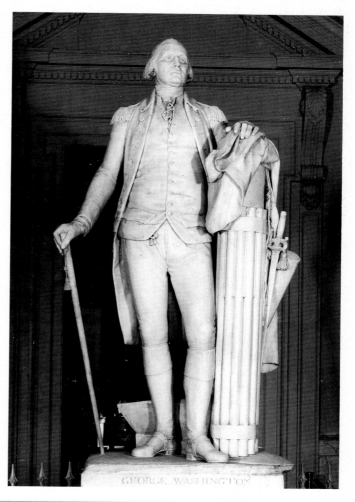

classical references. The general's sword, no longer needed in peacetime, hangs from a bundle of rods (in this case, thirteen for the number of states), the *fasces* of the Roman republic, symbol of the restraint of disciplinary power in the hands of the citizenry. Houdon has even added a witty American touch to his *fasces* by including Indian arrows between the rods. Behind the *fasces*, the plow symbolizes not only Washington's own love of his farm estate of Mt. Vernon but also the Roman Cincinnatus, who left his plow to rescue the republic but then returned to that plow when the danger had passed (a move suggested by Washington's removal of his cloak, even though he still wears the uniform of a general). Jefferson and Virginia, in accord with the self-restraint of Washington and the American aversion to kingship and tyranny, decreed that the statue should be exactly life-sized and not colossal – in short an image to evoke the Rome of the republic, not the empire.

7.14 Thomas Jefferson, Virginia State Capitol (wings added later), 1785–89.

THOMAS JEFFERSON AND THE ARCHITECTURE OF THE NEW NATION

If Houdon's image of Washington conveyed the ideal of the virtuous farmer, Cincinnatus, called to serve his country, then the architecture that Thomas Jefferson realized for himself and his country embodied that same ideal in his native Virginia. While he was in France as minister to the court, Jefferson had absorbed Neoclassical architectural principles, based on the careful study of ancient monuments, from Charles-Louis Clerisseau, who had also influenced Robert Adam. Jefferson began from such fundamentals, in order to create a suitably edifying tradition of architecture ("Federal") for the new nation. He therefore rejected entirely the dominant English architectural traditions ("Colonial"), such as Williamsburg, the former capital (Jefferson himself recommended the new site).

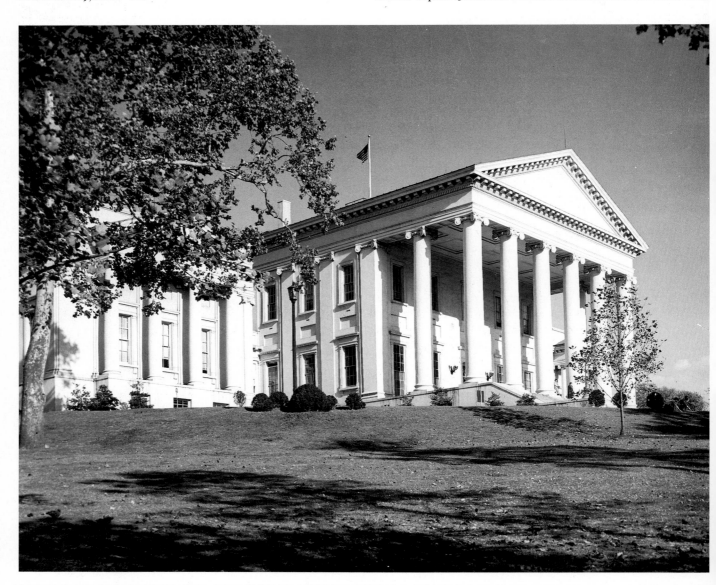

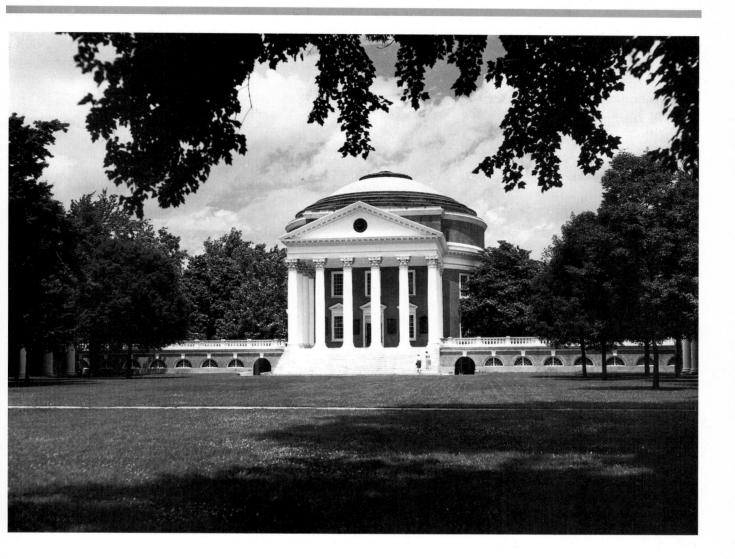

7.15 Thomas Jefferson, University of Virginia, 1804–17. Rotunda/Library.

For the Virginia State Capitol in Richmond (1785–89; Fig. **7.14**), the building that still houses Houdon's *George Washington* on its original site, Jefferson chose as his model a Roman temple – significantly, a late republican temple – in southern France, the Maison Carrée in Nîmes, which he had seen on his travels with Clérisseau. He made modest modifications to this dignified temple of government, altering the more ornate Corinthian capitals of his model to a sober Ionian and creating a shorter porch to emphasize the solidity of the building. Instead of being placed within the private prospects of an English garden, like earlier adaptations of Roman models, this new, American temple of virtue was intended to stand at the heart of state government, to affect the values and behavior of an entire population.

Late in his life, after serving his nation as governor of Virginia, as secretary of state under Washington, and as third president, Jefferson devised a project for the University of Virginia, the first state university in America (1817–26). Here the statesman-scholar could combine his varied active in-

terests with his amateur architectural design to produce, near his own estate in Charlottesville, an ideal training-ground for future citizens. At the head of a tranquil, rising lawn, framed by an "academic village," he placed an emulation of the Pantheon (Fig. 2.61), the Rotunda (Fig. **7.15**). The visual focus and climax of the university campus, this domed building housed the library, lecture hall, and other common spaces, including a gymnasium and the first planetarium in America. Here, even more than in the Richmond Capitol, Jefferson asserted the perfection of geometrical solids and masses, altering his model to maintain the continuity of the façade levels around the bold cylinder of the drum. He also used the smaller, modified temple fronts of the dormitories along the mall to unify the open spaces for both students and faculty, who were to live together. Sky and land, including gardens between the parallel rows of dormitories, complement the rationality and order of this American Academia. Yet each dormitory, true to the concept of independence, had its own identity as well, subtly articulated by the learned Jefferson with different orders, each derived from a well-known classical model, serving as a kind of archaeological and architectural encyclopedia as well as the analog to states in the larger union.

NEOCLASSICISM IN FRANCE

The power of Rome as both an artistic and a moral center dominated French art of the later eighteenth century, particularly through the Academy award, the Prix de Rome, a funded study trip for the winners of a competition. Perhaps the most celebrated of all artists in Rome – and back in France as well through the influential criticism of Antoine-Chrysostome Quatremère de Quincy – was the sculptor Antonio Canova (1757–1822), the "Phidias of our time," whose cool marbles of classical heroes perfectly presented the moral triumph of virtue over vice.

CANOVA Beginning with a *Theseus and the Minotaur* (1781–83), Canova developed his successful formula of depicting a moment of repose, suggestive of timelessness, in his handsome, strong, and youthful victor over a slain monster. In his *Perseus with the Head of Medusa* (1800; Fig. **7.16**), Canova directly takes on the most famous of classical paradigms: the *Apollo Belvedere*, now "restored" with arms, a sword, and the decapitated head of Medusa. Here even the head of Medusa derives from a classical model, the Rondanini *Medusa*, a Greek work (fifth century BC) then in a renowned Roman collection. Canova's work, paralleling in its imitation of the masters the Neoclassical approach of Reynolds, Adam, or Jefferson, focuses the horizontal energy of Perseus's stance and gaze on his victim. Severity and purity, stylistic correlates of Roman *gravitas*, were the hallmarks of Canova's celebrated creations. However, Canova would eventually lend his talents to more imperial ambitions, portraying members of Napoleon's family as the incorporation of divine physicality, despite his distaste for the French despoliation of ancient monuments from Rome (including the *Apollo*). Perhaps the most bombastic of these is the colossal nude statue of Napoleon himself in the guise of a standing Mars dispensing victory (1806; ironically,

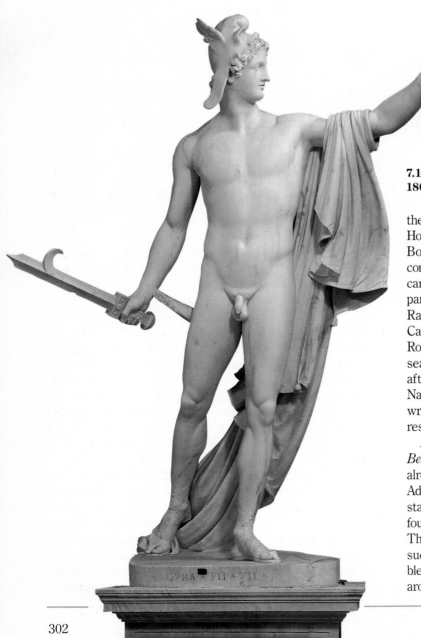

7.16 Antonio Canova, *Perseus with the Head of Medusa*, 1800. Marble. Vatican Museums, Rome.

the work is now a trophy of the Wellington collection at Apsley House, London). Another Canova conceit pictures Pauline Borghese, Napoleon's sister, as a recumbent Venus (1808). In contrast to these French images of apotheosis, Canova also carved his own image of George Washington (1821), counterpart to Houdon's Richmond Cincinnatus, once housed in the Raleigh, North Carolina, capitol until destroyed by fire. In Canova's typical fashion, the American general appeared in Roman battle dress but with his antique sword laid down, a seated rather than standing echo of Canova's 1781–82 *Theseus* after his struggle. As if in opposition to the assertion of Napoleon/Mars, Washington was also shown in the act of writing (in Italian!) his celebrated Farewell Address as he resigned from his presidency.

Although casts of ancient sculptures, such as the *Apollo Belvedere*, had been made for collectors (and the *Apollo* already appears amongst other casts in bronze and plaster in Adam's entrance hall at Syon House), access to ancient statuary in Rome increased during Canova's career with the foundation of one of the first museums in the modern sense. The Museo Pio-Clementino was founded at the Vatican by two successive popes, Clement XIV (d. 1774, whose tomb ensemble was carved by Canova, 1783–87) and Pius VI (d. 1799), around the papal collection of the Belvedere Palace. In part an

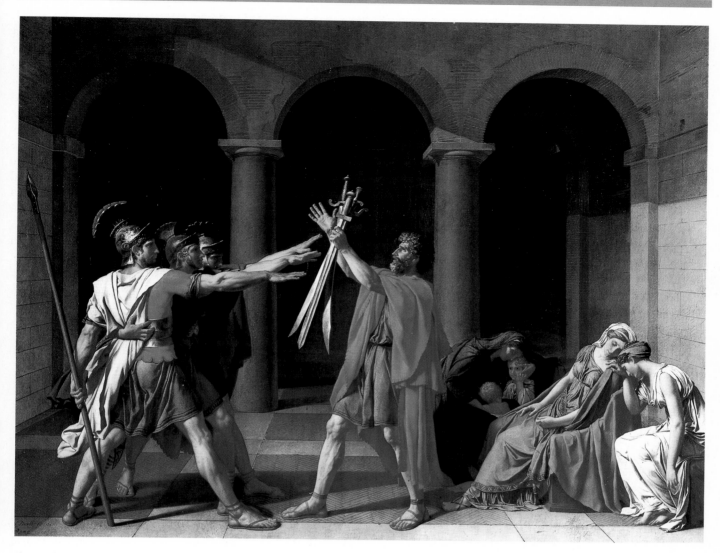

7.17 Jacques-Louis David, *Oath of the Horatii*, 1784–85.
Oil on canvas, 14 × 11 feet (4.27 × 3.35 meters). Louvre,
Paris.

alarmed reaction to the loss of Roman antiquities to avid English collectors and their ilk, this museum offered artists like Canova the chance to study directly works like the *Apollo Belvedere* and the *Laocoön*. Soon the world's most famous museum and the model for Napoleon's own Galerie des Antiques in the renovated Louvre (opposed by Quatremère de Quincy), the Museo Pio-Clementino professed its intentions to foster study of, devotion to, and research on the fine arts. Canova's own emulation of the *Apollo Belvedere* or the Medici *Venus* (his *Venus Italica*, 1804–12, shown as if emerging from the bath) was intended to serve as the desired flowering of this call to realize ancient values in modern sculpture.

DAVID AND HISTORY PAINTING

French painting also took the pure and the severe to be the goal of canonical academic ambition, appropriate to selected moral subjects, drawn from classical literature and history. The outstanding artist in this field was Jacques-Louis David (1748–1825), whose career as painter spans the end of the old monarchy, the French Revolution, and the Napoleonic era. As

winner of the Prix de Rome, like Canova David spent five years immersing himself in the world of archaeology and Neoclassicism. When Diderot saw David's triumphant return to Paris in the Salon of 1781, he warmly praised the young artist for finally realizing the goal of a noble and edifying imagery for modern France. David's talent for presenting a climactic moment of Roman history in a composition filled with action reached its zenith in his 1784 *Oath of the Horatii* (Fig. 7.17).

This work, redolent of such balanced compositions and archaeological correctness as Poussin's *Death of Germanicus* (Fig. 6.26), may well have taken its inspiration from the revival of a classic French drama, Corneille's *Horace*, based on Livy's history of Rome. Its subject is a pledge of honor by the triplet sons of Horatius to fight for their country against their enemy, the Curiatii. Their dedication and purposefulness are evident in the outstretched gestures of salute to their swords, held by

Images of Napoleon

David dedicated his artistry to the service of glorifying France's great hero, Napoleon. Using his technique of artistic reference , David's celebration of the young first consul, later emperor, continued in images painted by his talented students, including battlefields by Antoine-Jean Gros and formal portraits by Jean-Auguste-Dominique Ingres. Perhaps the most powerful of all David's images of Napoleon is the first of many commissions, recording the 1800 crossing of the St. Bernard Pass (Fig. **7.18**). Napoleon requested a traditional image of equestrian dominance, showing him calm on a fiery steed, and David complied with a heroic horse whose pedigree extends back to Leonardo da Vinci's battle cartoon and Rubens's equestrian hunting scenes and mounted noblemen or heroes. Napoleon shows the calm assurance and ease of his authoritative control as he glances outward toward the viewer, yet his extended arm provides the martial command equivalent to the gestures of the *Horatii* or the *Tennis Court*. This assurance is the more impressive against the backdrop of jagged mountains, already eliciting some shivers of fear and awe generated by the sublime (as outlined by Burke in England) and

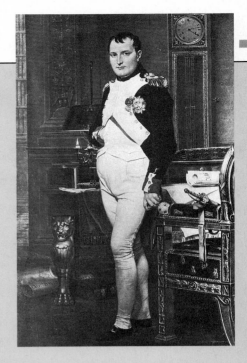

7.19 Jacques-Louis David, *Napoleon in his Study,* 1812. Oil on canvas 80⅓ × 49¼ ins (204 × 125 cm). National Gallery of Art, Washington.

showing animal terror in the face of the rearing horse. The historicity of this event has again been inscribed literally by David, as in his *Marat*, where the name "Bonaparte" has been added on a foreground rock to two illustrious predecessors in crossing the Alps with their armies: Hannibal (scourge of imperial Rome and model for the conquest of Italy, the goal of Napoleon's campaign) and Charlemagne (the great model for both military prowess and the title of emperor in France).

When David turned to the figure of Napoleon again in 1812 in order to stress his accomplishments as founder and lawgiver, he made use of a visual tradition of the philosopher in his study in order to express wholly modern and specific accomplishments (Fig. **7.19**). Though Napoleon is shown in his military uniform, like Houdon's or Canova's Washington, he is busy with his peacetime contribution. The clock in his study shows the depth of his self-sacrifice for his country, for it shows the time to be 4:13 a.m., an hour confirmed by a burned-down candle. On the adjacent chair, punctuated by the now-familiar motif of the discarded sword, is the Napoleonic Code of civil law. The book on the floor epitomizes all the classical models adduced in this period; it is the lives of great men by Plutarch, and, by implication, the subject of this portrait, like the subjects of Houdon's portraits, deserves comparison in the modern era with these models of antiquity. This heroic individual, military leader yet learned student of ancient literature and civil law, is the fulfillment – at least in David's vision – of ancient models in the modern world. Like Canova in sculpture or Adam and Jefferson in architecture, David's achievement in painting seemed calculated to generate a new, golden age, a morally edifying admixture of art and politics.

7.18 Jacques-Louis David, *Napoleon Crossing the Alps*, 1800. Oil on canvas, 8 feet 11 ins × 7 feet 11 ins (2.7 × 2.4 meters). National Museum, Versailles.

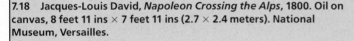

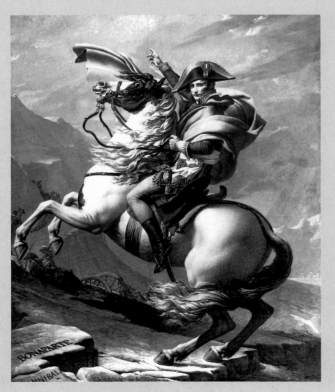

their impassioned father; their virile firmness contrasts with the swooning sorrow of the family females (one of whom is engaged to a Curiatius, who will die at the hands of her brother as the story unfolds). Here even the stone vaults and Doric columns of the triple-arched setting suggest the stoic severity of their patriotism and self-sacrifice over any nearer considerations of family comfort or personal fortune.

The *Oath of the Horatii* was commissioned by the monarchy through the Royal Academy with the express didactic purpose of using art to inculcate public morality, like the series of sculptures of Great Men of France produced on commission by Houdon and others. The *Oath* was followed in 1789 by another massive David painting of a Roman subject, this time inspired by a play of Voltaire: *Brutus*, the consul, seated in his home while lictors carry in the bodies of his only sons, executed at his request for treason against the state. Both pictures soon took on revolutionary implications when patriotism could be rallied against tyranny on behalf of new political principles. Following a revival of Voltaire's play in 1790, a year after the storming of the Bastille, the actors assumed the pose of David's *Oath*, a gesture intended to transform the audience into latter-day Romans.

David was quick to make paintings of the events of the unfolding French Revolution. His Roman models, however, soon gave way to modern representations of classical values. When he came to show an actual oath, the Oath of the Tennis Court in 1789 (when the deputies of the Third Estate declared themselves a National Assembly and refused to disperse until they had given France a new constitution), he showed modern figures in contemporary costume, arms outstretched like a hundred Horatii. Building up the figures in characteristic academic fashion from his study of nude models, David made a large drawing design for his major painting of the *Oath of the Tennis Court*. At the same time, he re-exhibited his pre-Revolutionary paintings of the *Oath* and *Brutus* for the new regime, or Convention; however, with the rapidly changing political climate of the revolution, the work on the *Oath of the Tennis Court* never served as a modern equivalent to its predecessors. In 1792 David became a deputy in his own right. He voted for the death of Louis XVI and served as pageant master for a series of public spectacles, such as the 1793 Festival of Republican Reunion or the grand 1794 Festival of the Supreme Being, which he designed with the head of the Committee on Public Safety and head of the Terror, Maximilien Robespierre.

For the Convention, David painted the moving *Assassination of Marat* (1793), a commemoration of a slain radical theorist of the Revolution, who was immediately canonized as a martyr by the Jacobin rulers of France (Fig. **7.20**). The painting shows David's own political sympathies, for its signature is also a dedication "to Marat." Because of the avowed rationalism and anti-Christian positions of the French Revolu-

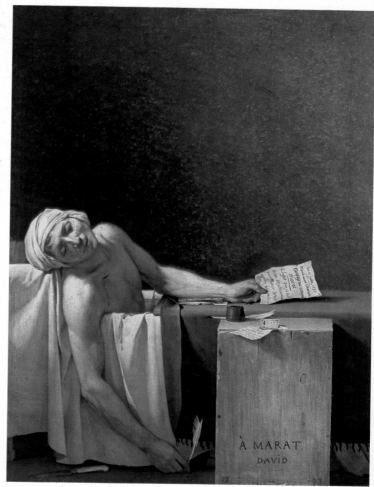

7.20 Jacques-Louis David, *Assassination of Marat*, 1793. Oil on canvas, 63 × 49 ins (160 × 124.5 cm). Royal Museums, Brussels.

tion, which abolished the Christian calendar, Anno Domini, and replaced it with years after the Revolution, David's picture is dated to "year two." At the same time, however, David uses much traditional Christian iconography in his work, essentially equating the dead Marat with the dead Christ of the *pietà* or with martyred saints. The tilted face, studied from Marat's own burial likeness, nonetheless combines with a limp arm redolent of Michelangelo's Vatican *Pietà* or Raphael's *Entombment*. In this case, David has also included historical specifics: Marat worked in his tub because of a skin affliction and received a note of petition from the woman who would assassinate him (her bloody knife lies beside his hand, still holding its pen). Once again, as in West's *Death of General Wolfe* (Fig. 7.11), modern and historical subjects take on added mystery and significance through the overlay of visual reference to the heritage of Christian and pagan myth.

REBELLION AND HISTORY

The French Revolution brought about an inevitable reaction throughout the remainder of Europe. In England, Burke's *Reflections on the Revolution in France* (1790) outlined the horror of traditional England at the excesses of the Revolution toward property and hereditary rights – the basic assumptions underlying the portraits of Gainsborough and Reynolds – even prior to the regicide in 1792 and its aftermath in the Terror. Nor did all artists share David's or Canova's embrace of Napoleon. Ludwig von Beethoven dedicated his massive and revolutionary Third Symphony ("Eroica," or Heroic Symphony) to Napoleon, but when he heard that Napoleon had had himself crowned as Emperor in 1804, he crossed out his name from the title-page, changing the dedication as printed "to celebrate the memory of a great man." With the abolition of the Christian calendar and the ruthless exclusion of all but classical models from the new French revolutionary culture, other nations in Europe began to view their own national identities and artistic heritages more positively, even when they were at odds with the prevailing taste for classical forms. If revolution led to reaction, even revulsion, it also prompted a new self-consciousness on the parts of both individuals and nations and a will to assert themselves culturally against the prevailing norms of rationality, universality, and ideality, based on the dominance of the classical.

This era has been called the Romantic era, based on a literary form, the romance, a medieval French vernacular narrative of knights and ladies, which stood outside the classical Latin tradition. In recovering the native and medieval heritage of France, and also of other countries, artists were rejecting any normative or universal claims and seeking alternative, more local forms of expression. Indeed, individual artists now affirmed the concept of self-expression, derived from earlier appeals to emotion in the form of "sensibility" in England, as in Burke's essay on the sublime. Rejection of inherited academic and classicist traditions became the standard attitude. Charles Baudelaire, poet and critic, defined the movement in 1846: "To say the word Romanticism is to say modern art – that is, intimacy, spirituality, color, aspiration toward the infinite, expressed by every means available to the art."

GOYA

Individual powers of imagination and invention would dominate both the paintings and prints of one lonely genius – the cult of genius itself is a Romantic legacy – the Spaniard, Francisco de Goya (1746–1828). Goya attained the pinnacle of conventional success in Spain as court portraitist to the king, in which capacity he painted the group portrait of the royal family (1800) in emulation of his great predecessor, Velázquez (see Figs 1.6 and 1.11). That this picture dates from exactly the same moment as David's *Napoleon Crossing the Alps* (Fig. 7.18) shows the vast difference between the repressive royalism of Bourbon Spain and the post-revolutionary dynamism in France. Goya carefully guarded his own political views, but his membership of a circle of learned and liberal friends suggests that his portrayal of his royal patrons as clumsy and ordinary was the direct result of his own, unvarnished vision of them. The traditional claims to the divine right of kings from the absolutist era of Velázquez and Rubens disintegrate before our eyes in the harsh, prosaic mirror of Goya's gaze.

More outspoken and critical are the private images of Goya, first conveyed in pen drawings but then converted into etchings. Encouraged by the brief political influence of his

7.21 Francisco Goya, *The Sleep of Reason Produces Monsters*, from suite of *Los Caprichos*, 1799. Etching and aquatint, 8½ × 6 ins (21.6 × 15 cm). Metropolitan Museum, New York.

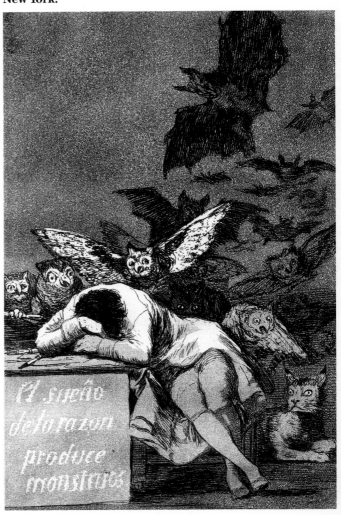

liberal, reform-minded friends when they were ministers, Goya produced a set of eighty etched and tinted prints called the *Caprichos* (Jokes), which used animal allegories and grotesques like modern political cartoons to pillory the social and intellectual ills of his society. Issued in 1799, the *Caprichos* were almost immediately recalled from sale by the royal censor, despite Goya's use of fantasies to veil his scathing social criticisms.

In a work originally intended as the frontispiece of the *Caprichos* but then safely tucked away in the middle of the series (as no. 43), entitled *The Sleep of Reason Produces Monsters*, Goya shows the dark side of the ideal of Enlightenment, the fragility of the veneer of civilization and rationality (Fig. **7.21**). This is a nocturnal world, explicitly opposed to that of enlightenment, and the darkness is populated by sinister animals long associated with witches, such as bats, owls, and cats. Sleep has interrupted the work of the artist and led to his assault by these horrible phantasms. An inscription in Goya's manuscript gives an explicit explanation of the image: "Imagination forsaken by Reason begets impossible monsters; united with her, she is the mother of the arts and the source of their wonders." In short, this imagery conveys the perversion of art in the absence of the rationality so avidly cultivated by the Enlightenment. Goya in many respects is agreeing with his European contemporaries by showing the antithesis of beauty and ideality, employing satire and caricature in the manner of Hogarth. The first version of this composition showed a self-portrait of Goya above the head of the sleeping artist; a second drawing of the same scene held another inscription redolent of the overall ambition of the *Caprichos*: "The author dreaming. His only purpose is to banish harmful ideas commonly believed and to perpetuate with this work of *Caprichos* the solid testimony of truth."

Combating superstition remained an ongoing ambition of this etched series. In Plate 3, *The Bogeyman is Coming*, the artist castigates the practice of raising children in fear of what does not exist by showing a towering white ghost silhouetted against inky blackness in front of a mother and her terrified children. All of the plates of the *Caprichos* emphasize the contrast of darkness with light. Goya populates his series with grotesque figures, including witches, who represent the dangerous, nightmare fantasies of irrationality or social repression, as well as the lesser folly, in contemporary dress, of self-delusion under the guise of social custom by the nobility and the Church. Goya, then, also hoped for moral and intellectual reform in his country and an ideal world free of traditional institutions, but he used dark and ironic imagery as his own instrument for change – and, in typical Spanish fashion, his art in turn was suppressed.

GOYA AND THE DISASTERS OF WAR
Spain was exposed to the bitter aftermath of the French Revolution. Bonaparte's troops invaded the country in 1808, and Napoleon placed his brother Joseph on the abandoned throne, as the Spanish king deserted the country. Despite the repressions imposed by Spanish kings, including the Inquisition and

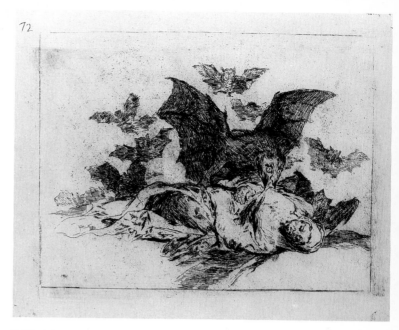

7.22 Francisco Goya, *The Consequences*, Plate 72 of *Disasters of War* series, ca. 1812. Etching, 4 × 6 ins (10 × 15 cm). The Norton Simon Foundation.

the vestiges of feudal law favoring landholders, the Spanish people rose up in counter-revolution (in combat which gave the term *guerrilla* to the vocabulary of war) against the French occupation. Goya himself was both a victim and a witness of this new brutality against poorly armed civilians and guerrilla resisters, in initial uprisings in Madrid (May 2, 1808) and subsequent sieges at Zaragoza. He recorded the horrors of what he saw in a private indictment (a series of etchings begun in 1810 but only published posthumously in 1863) of ignoble warfare in general: *Disasters of War (or Fatal Consequences of Spain's Bloody War with Bonaparte and Other Striking Caprichos)*.

In addition to numerous scenes of atrocities committed against both the living and the dead citizenry, Goya also presented the gruesome aftermath of the dead and starving of Madrid in his print (no. 60), *There is No One to Save Them*. The titles of other prints in his series indicate not only his status as an eyewitness to many of these horrors but also his perplexity in the face of such cruelty, even in warfare: *They Are Like Wild Beasts* (no. 5), *And There Is No Help* (no. 15), *Even Worse* (no. 22), *One Cannot Look* (no. 26), *Barbarians!* (no. 38), *I Saw It* (no. 44), *What Madness!* (no. 68). In a later addition to the set of the *Disasters of War*, Goya produced a grisly allegory, *The Consequences* (no. 72; Fig. **7.22**), which utilizes the same nocturnal imagery of bats as his *Sleep of Reason Capricho*. In this instance, vampire bats prey on the shrouded figure of a corpse. On the reverse of the working proof of this print, Goya appended a red chalk drawing of a medal – ironically, a decoration worn by the victorious Duke of

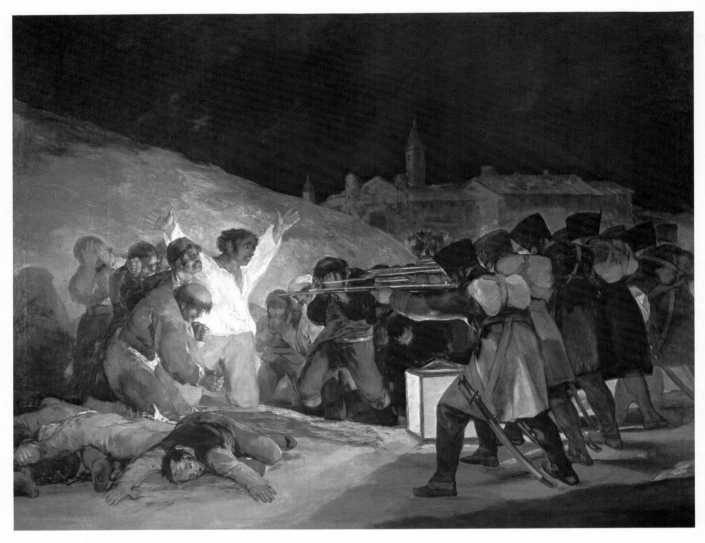

7.23 (Above) Francisco Goya, *The Third of May, 1808*, 1814. Oil on canvas, 105 × 136 ins (260 × 345 cm). Prado, Madrid.

7.24 (Right) Francisco Goya, *Saturn Devouring his Children*, 1820–23. Oil on canvas, 57⅞ × 32⅝ ins (146 × 83 cm). Prado, Madrid.

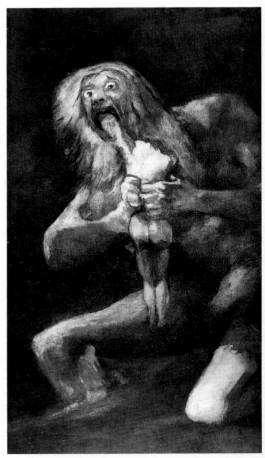

Wellington, the picture of heroism at the end of the Peninsular War, as he sat for a traditional, heroic equestrian portrait (1812). Like Canova's standing nude figure of Napoleon as Mars, left as a trophy of victory for Wellington, the contrast between this drawing and its accompanying allegory reveals the chasm between the traditional art of individual aggrandizement and the destructive chaos of modern warfare.

When King Ferdinand VII was restored to power in Madrid, he commissioned Goya in 1814 to paint a heroic commemoration of the popular uprising that had spurred the successful revolt against the French. Continuing the imagery of his *Disasters of War*, Goya celebrated only the contrast between ordinary citizens and the dehumanized, uniformed brutality of the French soldiers who executed them (Fig. **7.23**). In *The Third of May, 1808*, Goya again counters the idealized heroism of David's Napoleon and the Horatii or even the martyrdom of a general by Benjamin West by depicting anti-heroes, frightened

and defenceless victims of systematic military oppression. Despite the commission to celebrate the restoration of Spanish monarchy, Goya's painted image unblinkingly asserts the obliteration of Enlightenment hopes, caught between the militarism of Napoleon and the traditionalism of an unreformed Spanish crown.

Goya's despair never abated. Beset by physical ailments (including total deafness, brought on by an illness as early as 1792), after an abortive revolution in 1820 he withdrew from the court and lived a life in retreat on the outskirts of Madrid at "Deaf Man's Country House" (Quinta del Sordo). He painted the walls of that private sanctuary with a series of fantasy images, the "Black Paintings," whose witches and monsters recall the nightmares of the *Caprichos* and the bitter allegories of the *Disasters of War*. Perhaps the grimmest of these images is *Saturn Devouring his Children* (Fig. **7.24**), a work indebted to Rubens's mythology of the same subject, then in the Spanish royal collection. This work may contain one final political allegory, because Saturn devoured his children lest they depose him from his kingship of the gods; Goya's hope, bitterly expressed here, might call for a Jupiter of constitutional politics to rescue the body politic from its infanticidal parent. But this brutalizing horror, akin to the mutilated corpses of the *Disasters*, transcends any narrow interpretation. Intended only for the private viewing of a totally disenchanted visionary, this is the monster bred by the "Sleep of Reason," the very incarnation of bestial inhumanity.

TURNER: NATURE'S GRANDEUR AND EMPIRE'S DEMISE

Much more public than Goya's private meditations were the enormous canvases produced by Joseph Mallord William Turner (1775–1851), who served as a prominent instructor, Professor of Perspective at the Royal Academy from 1807. Turner, too, was conscious – and critical – of events in France and in the emerging British Empire, but he expressed his version of the limits of human capacity through aggrandizement of the scale and power of the forces in nature, a vision based on Edmund Burke's concept of the sublime.

In 1812 Turner exhibited at the Royal Academy his *Snowstorm: Hannibal and his Army Crossing the Alps* (Fig. **7.25**), a work that stands as a commentary on Napoleon's own reversal of fortunes as well as a critical undercutting of the heroism (and favorable reference to Hannibal) in David's 1800 *Napoleon Crossing the Alps* (Fig. 7.18). This is a scene of devastation, in which the light of the sun is obscured by

7.25 J. M. W. Turner, *Snowstorm: Hannibal and his Army Crossing the Alps*, 1812. Oil on canvas, 57 × 93 ins (145 × 236 cm). Tate Gallery, London.

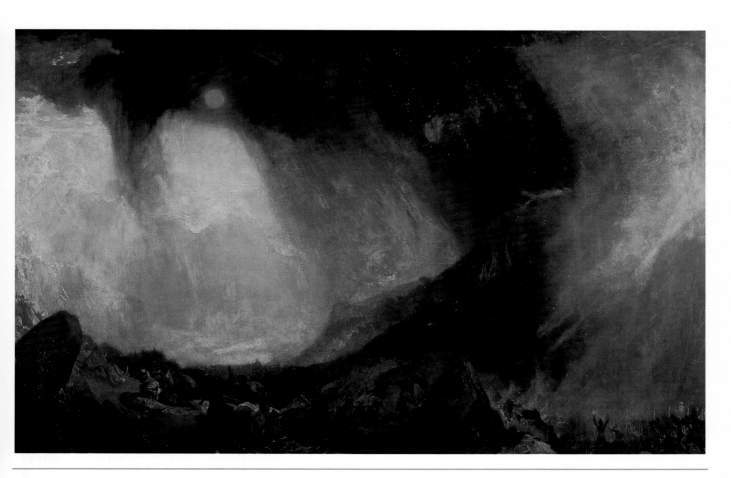

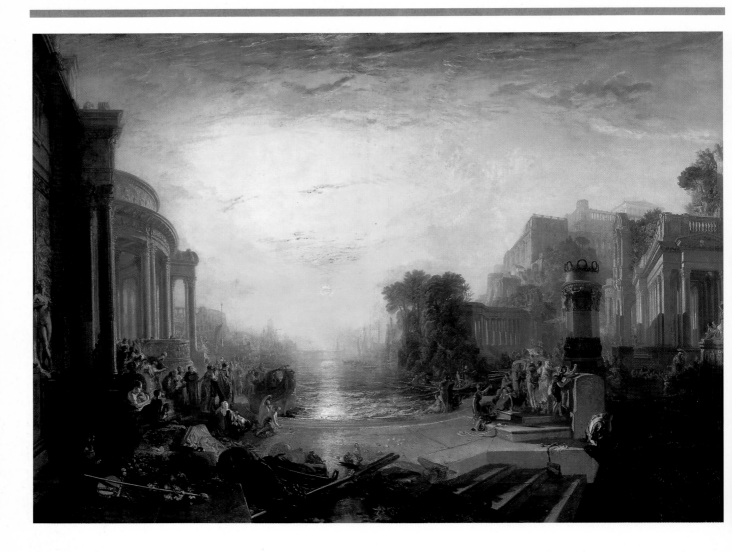

7.26 J. M. W. Turner, *Decline of the Carthaginian Empire*, 1817. Oil on canvas, 67 × 94 ins (170 × 238·5 cm). Clore Gallery for the Turner Collection, London.

colossal cataclysms, storm clouds, and mountain avalanches. The disorder and violence of nature emerge from Turner's own bold technique, scumbling his pigments as he applies them with broad brushwork, even a palette knife, a practice much criticized by early observers. The tiny scale of the human subjects, consumed by a swirling vortex of destruction, underscores the futility of human ambition (just as historical events in Russia and Spain would reveal the limits of Napoleon's militarism). Based on Turner's own visit to the Alps in 1802 and on his knowledge of classical sources (the event took place in 218 BC), this painting's scale and imaginative power elevate to the status of allegory a moral landscape of nature's terrors and sublimity.

Turner would take up the challenge of previous landscape painters, such as Claude Lorraine, in other works. His *Dido Building Carthage* (1815) was bequeathed to the National Gallery in London on the condition that it be exhibited next to works by Claude. Its subject explicitly updates Claude's idyllic vision of imaginary ancient buildings immersed in a golden sunset light by the addition of a companion painting, *Decline of the Carthaginian Empire* (1817; Fig. **7.26**). The fuller title of this image makes explicit its prophecy of declining empire as it might apply to Britain: "Rome being determined on the overthrow of her hated rival, demanded from her such terms as might either force her into war, or ruin her by compliance: the enervated Carthaginians, in their anxiety for peace, consented to give up even their arms and their children." Turner's own verses in the catalogue spoke of his concept of Hannibal's declining homeland as a metaphor of sunset, drawn from nature like the image of the snowstorm: "While o'er the western wave th' ensanguin'd sun,/ In gathering haze a stormy signal spread,/ And set portentous."

In many respects, all of these Carthage images conform to the Royal Academy dictates for serious history subjects, akin to the heroic tales of epic poetry, and their serious, moral message can be taken as having relevance to modern history. Through the lens of comparative history France is again seen as the surrogate of Carthage and a cautionary example to England, whose own empire was capable of Decline and Fall (as chronicled by the great English author Edward Gibbon, 1776–88).

including San Giorgio (see Fig. 5.49), as well as the Customs House (Dogano), evoking the commercial dominance of Renaissance Venice but topped by the suggestive figure of Fortune. In the second canvas, Fortune has spelled decline for the great city. The scene is the *Campo Santo*, a view across the lagoon to the city cemetery, with only small sailing vessels visible (Fig. **7.28**). Once more, by implication, Venice's fate holds a message for England, then at the apogee of her mercantile domination (perhaps in echo of Byron: "in the fall/ Of Venice think of thine, despite thy watery wall").

TURNER AND MODERNITY

Turner also showed a willingness to offer his opinion on contemporary issues through his paintings, as if in extension of his prophecies concerning the history of empire. In 1841 he took on the increasingly debated topic of slavery, using the depiction of current subjects in light of their victims that Goya also used to such powerful effect in the *Disasters of War* or *Third of May*. In *The Slave Ship*, or in its full title *Slavers Throwing Overboard the Dead and Dying – Typhoon Coming On* (1840), Turner transformed the genre of his lifelong love, marine painting, into a tragic drama (Fig. **7.29**). The dangers of the sea provided a perfect occasion of the sublime, dwarfing, as here, even the largest sailing vessels, and in this case a hurricane storm with the power of Hannibal's Alpine tempest threatens sailors and slaves alike. However, this painting adds the additional horror of the macabre, where

innocents are sacrificed callously by their indifferent masters. This human offering appears only in the form of partial reference, as a chained foot emerges in the right foreground, now reduced to food for an eerie assortment of fishes of all sizes. Elsewhere in the waves appear grasping hands amid traces of blood. All the while an implacable, blinding sun, crimsoned with the suggestion of impending death and the prophetic dusk of Carthage, dominates the picture, as the dark clouds of the title's typhoon gather at the left horizon. Turner's original verses accompanying this ambitious seascape also echoed his earlier poetic creations, quoted in his Hannibal painting; now anonymous victims rather than great individual heroes lose their lives with these lines, "Hope, Hope fallacious Hope!/ Where is thy market now?" Modern slavery, it seems, occasions only anti-heroes and sacrifices to almighty commerce. Debates concerning slavery had only recently ended in England with the abolition in 1833 of slavery throughout British dominions; however, the continuing debates and ongoing trade relations with the American South made such references in Turner's picture still topical and charged for British audiences.

Ever mindful of historical change, in 1844 Turner seems to anticipate a later embrace (especially by Impressionist painters in France – see Figs 8.12, 8.16) of industrial technology in the form of the railroad: *Rain, Steam, and Speed* (Fig. **7.30**). This image appeared *alongside* three marine landscapes and three Venetian scenes by the artist. In effect, this painting, too, is an allegory, but the forces of nature referred to in its title are now harnessed for the improvement of life and for the assured

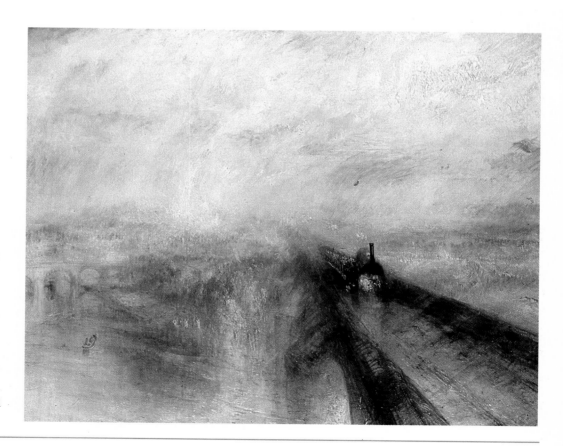

7.30 J. M. W. Turner, *Rain, Steam, and Speed*, 1844. Oil on canvas, 35¾ × 48 ins (90.8 × 121.9 cm). National Gallery, London.

supremacy of Britain as leader of the Industrial Revolution. The national significance of the new railway line to ports in the west was confirmed by both Prince Albert and Queen Victoria. Turner himself was always an inveterate traveler, and he availed himself of modern conveyances as they appeared, particularly the marine equivalent of the railroad, the steamship. In this image, the dazzling brushwork dissolves representation into brilliant color, evocative of light itself as well as the steam and speed of the title. Only with Impressionism would this combination of virtuoso form in the emphatic service of modernity find an echo, and by the latter part of the nineteenth century all poetic evocation of the sublime was lost.

A sense of loss pervades other English landscapes, as the consciousness of the changing effects of the Industrial Revolution sparked a nostalgia for a simpler, older, agrarian era. Turner's own tributes to the historic buildings of England did not consist merely of recording their destruction, like the *Houses of Parliament*; many of his most beautiful, composed watercolors recorded "picturesque" abbeys and ruins within the English countryside long before he discovered the romance of a decaying Venice. He even collaborated with a professional engraver, W. B. Cooke, on picturesque views of various parts of Great Britain, culminating in the series, *Picturesque Views in England and Wales*, a projected 120 plates of which 96 were actually engraved (1827–38).

CONSTABLE AND RURAL ENGLAND

Turner, however, remained a tourist, and his views offer a drama of historical significance appropriate to his elevation of landscape to a grand subject within the Royal Academy. To his countryman, John Constable (1776–1837), the English countryside was home, and his highest ambition was to capture its appearance unaltered. Constable grew up in rural England, in the farming country of Suffolk and Essex, specifically the Stour River Valley. The son of a landowning farmer and miller, he painted the landscape that he knew well and imbued it with sentiment. If the traveler-adventurer poet Byron offered inspiration and analogy for Turner, then the self-conscious, autobiographical William Wordsworth ("The Child is father of the Man"), steeped in English landscape, stood closest to Constable.

Constable, then, studied working farms and the man-made

7.31 John Constable, *The Vale of Dedham*, 1814–15. Oil on canvas, 21¾ × 30¾ ins (55.3 × 78.1 cm). Museum of Fine Arts, Boston.

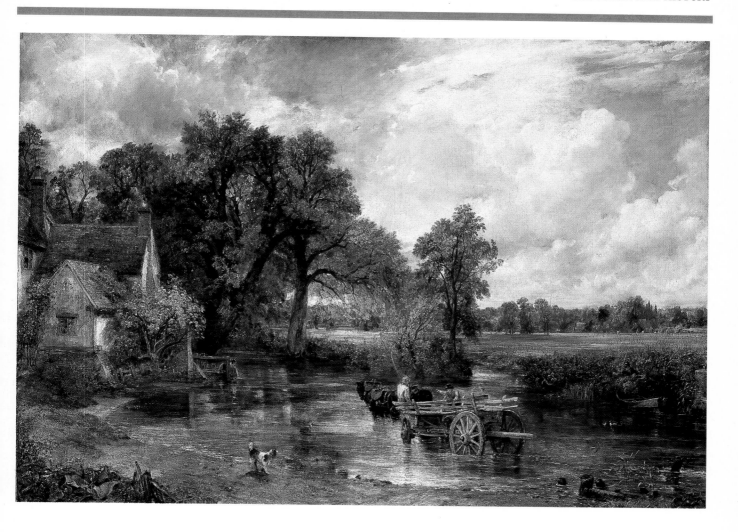

7.32 John Constable, *Landscape: Noon (The Haywain)*, 1821. Oil on canvas, 50½ × 73 ins (128 × 185 cm). National Gallery, London.

canals on the Stour. His *Vale of Dedham* (1814–15) vividly captures the dappled light on golden grain and green river bottom a short distance from the house where he grew up (Fig. **7.31**). Constable does not shy away from showing the most humble of tasks, in this case men shoveling dung onto a wagon. He is conscientious about the specifics of locality, punctuating his horizon with a favorite and prominent local monument, the tower of Dedham parish church. In his effort to emphasize the momentary effects of "lightness and brightness," Constable made separate and careful oil studies of clouds out of doors, worthy of scientific description (he called such exercises "skying"). Half of this image of Dedham Vale is given over to the cloudy brightness of an English summer sky. The other half is dedicated to recording accurately the fruitful and harmonious husbandry of local nature.

In Constable's mature works, the scale of his canvases grew, taking on the dimensions of the "six-footers" that he exhibited annually at the Royal Academy after his belated recognition; yet he changed the subjects very little. *Landscape: Noon*, also known as *The Haywain* (1821; Fig. **7.32**), records another humble moment from Constable's memories of childhood. It was not the product of spontaneous outpouring but rather the

culmination of a full-sized preparatory oil sketch, and its dimensions rival the largest of Turner's history paintings. Yet, in contrast to Turner, Constable assiduously avoided any suspicion of imitating earlier paintings, preferring his own direct vision of unadorned nature: "When I sit down to make a sketch from nature, the first thing I try to do is to forget I have ever seen a picture." If history and art history are the subjects in Turner settings, then nostalgia animates Constable's Stour: "Painting is but another word for feeling." Here clouds and dogs and tumble-down cottages, previously the province only of Ruisdael and Dutch landscapes, again occupy the full attention of the modern spectator, in spite of – or because of – the shift of modern life to the bustling cities. The lessons of Constable were not lost on an admiring French public, when the vivid effects of his lighting and the emotion underlying ordinary sites and subjects – the *Haywain* in particular – served as a revelation of what landscape could be, at the Paris Salon of 1824.

THE ROMANTIC LANDSCAPE IN GERMANY: FRIEDRICH

For the German painter Caspar David Friedrich (1774–1849), landscape provided an expression of much more spiritualized, mystical internal states. Friedrich's first famous image was a mountaintop crucifix at sunset, painted in 1807–08, a work which borrowed the landscape vocabulary of the sublime to convey religious awe and stillness. A pious Protestant from north Germany, Friedrich strove to express ultimate truths through settings that were at once intimate and infinite: "Just as the pious man prays without speaking a word and the Almighty hearkens unto him, so the artist with true feelings paints and the sensitive man understands and recognizes it."

Friedrich's *Monk by the Sea* (1809–10) juxtaposes a small and isolated figure in the black cowl of a monk against the empty landscape of an expansive sky and open sea (Fig. **7.33**). Although this setting could easily have come from Friedrich's childhood memories along the shore of the Baltic Sea at Greifswald, the loneliness and insignificance of the monk, already a cue to the transcendent in the picture, leads the viewer to meditation on emptiness. Frequently the quiet wanderers of Friedrich's paintings give themselves up to reveries before open landscapes of awe-inspiring grandeur,

such as craggy mountaintops or steep cliffsides, or before natural wonders, such as the glowing moon in darkness, or a rainbow. We see the figures from the back and are invited to join their contemplations.

Abbey in the Oakwoods (1810), the pendant to the *Monk by the Sea*, showed a landscape dominated by a building (Fig. **7.34**). As in Turner's early picturesque watercolors, this is a historical ruin, a Gothic abbey. Both artists use their own national and medieval architectural heritage to bring out the atmosphere of ruins rather than adapt the foreign classicism of Greek or Roman antiquity. As in the writings of Goethe on Strassburg cathedral, where Nature herself is taken to be the inspiration of the soaring height and pointed arches of Gothic architecture, so the placing of this ruin amid thin winter boughs suggests the primal religiosity underlying German Christianity. Within the wintry setting, too, basic issues of life and death are played out. A small procession of monks walks through the snow-covered graveyard carrying a coffin, bringing the ceremonial of this ancient site back to life, despite its ruinous condition. Friedrich's favorite motif of a crescent moon hovers overhead. These images of mortality could be taken as

7.33 Caspar David Friedrich, *Monk by the Sea*, 1809-10. Oil on canvas, 42½ × 67 ins (107.9 × 170 cm). Schloss Charlottenberg, Berlin.

7.34 Caspar David Friedrich, *Abbey in the Oakwoods*, 1810. Oil on canvas, 44 × 68½ ins (111.7 × 174 cm). Schloss Charlottenberg, Berlin.

metaphors of life's end, overcome by time like the building itself, or else interpreted as points in a recurrent cycle, perhaps implying resurrection and new life. The dominant mood, however, remains somber, appropriate to both the solemn burial and the winter season (a similar melancholy pervades German romantic poetry, such as the cycle of *Die Winterreise* (The Winter Trip), poems by Wilhelm Müller, later set to music by Franz Schubert).

THE GOTHIC REVIVAL AND OTHER HISTORICISMS

Gothic architecture, with its traces of proud national pasts in England, Germany, and France, proved to be a popular alternative to the dominant Neoclassical architectural revival. Already during the eighteenth century, small-scale Gothic structures had appeared within English gardens, sometimes even as mock ruins to stimulate contemplation of the ravages of time. The Gothic also came to be seen as the appropriate form of spiritual building, in contrast to public buildings in the classical idiom.

SCHINKEL The imagined worlds of Gothic and classical cultures, revolving around their distinctive buildings, were brought to life in painted reconstructions by the Berlin architect, Karl Friedrich Schinkel (1781–1841). In *Above the City Cathedral* (1813), perfectly symmetrical, soaring towers dominate a medieval town setting and its tiny inhabitants (Fig. **7.35**, p.318). Schinkel claimed that the Gothic was the architecture of the spirit, dominated by the "character of the necessary, grave, dignified, sublime." As he surely sensed, the symbolism of a Gothic building could evoke the same sentiments of awe as mountains or unspoiled forests. (In another Romantic variant on the emotionality of the sublime, old manor houses were invested with a Gothic gloom that provided a suitably atmospheric setting for horror tales in English novels of the turn of the century.)

Schinkel began his career as a designer of theater sets; his ability to conjure up historical building forms of various eras contributed to his later versatility as an architect. His buildings formed the centerpiece of the newly emerging capital city of Berlin, where Schinkel served as State Architect to Friedrich Wilhelm III after 1815, immediately after the liberation of

7.35 Karl Friedrich Schinkel, *Cathedral Above the City*, 1813. Oil on canvas, 37 × 49½ ins (93.8 × 125.7 cm). Bavarian State Collections, Munich.

Prussia from Napoleon. He began with a Greek revival gateway, the Neue Wache (1816), complete with Doric columns and a Grecian pediment. His first celebrated building is the National Theater (1819–21; Fig **7.36**), set near the grand boulevard, Unter den Linden. Here the crisp exterior massing of volumetric parts is enhanced by elegant Greek ornament of geometrical clarity, culminating in an Ionic portico. The building's exterior reveals its hierarchy of functions: the high and deep central block, the auditorium, dominates the lower wings with their offices and rehearsal spaces. Like Adam, Schinkel was in complete control of the design of his interior spaces both their ornamentation and their furnishings (he also designed the stage set for the opening play, a Greek tragedy by Goethe).

Perhaps the most influential of Schinkel's creations is his design for a comprehensive museum on an island in the heart

of official Berlin. The Altes Museum (1824–28; Fig **7.37**) emulated the cultural centers already established in Rome (the Vatican Museo Pio-Clementino), Paris (the renovated Louvre), and even Munich (Leo von Klenze's classical Glyptothek of 1815–30). He began his museum at the same moment as Robert Smirke began work on the British Museum. Presenting a screen of Ionic columns on a raised platform with central steps, this museum offered a consistent Greek revival vocabulary to accord with its role as a temple of art. The public mission of the building was educational, presenting the history of art as a succession of great cultures over time, beginning (like Schinkel's imaginary paintings) with Greek culture. The visitor was encouraged to walk around a grand rotunda, which Schinkel called the "sanctuary" of the building, appropriately consecrated to antiquities. Ascent of a grand staircase to a second storey completed the process, enabling the study of Renaissance paintings within bright galleries, well lit by outside windows (Fig. **7.38**, p.320). Each distinct historical period could be experienced in turn, in much the same fashion as Schinkel and his contemporaries could employ different historical styles for their buildings and ornament (Schinkel even designed frames

7.36 Karl Friedrich Schinkel, National Theater, Berlin, 1819–21.

7.37 Karl Friedrich Schinkel, Altes Museum, Berlin, 1824–28. Exterior view. After drawing by Schinkel.

7.38 Karl Friedrich Schinkel, Altes Museum, Berlin. Interior. Drawing by Schinkel.

7.39 Charles Barry and A. W. Pugin, Houses of Parliament, London, 1836- ca. 1860.

for the paintings upstairs that would accord with their period styles). Renaissance painting, reaching its climax in Raphael, was regarded as the high point of art history, but works of other nationalities were appreciated for their distinctive qualities. The famous scholar Wilhelm von Humboldt, founder of Berlin University, realized the significance of this new, historical vision of art in the Schinkel museum: "The gallery here is distinguished by systematically extending through all periods of painting."

Schinkel was largely constrained by the prevailing taste for Greek revival forms in public buildings from designing Gothic structures. However, in England the search for a national style for the new Parliament buildings after the disastrous fire of 1834 (captured so dramatically by Turner; see Fig. 7.27) made the choice of Gothic almost inevitable.

PUGIN The chief propagandist for the Gothic revival in England was Augustus Welby Northmore Pugin (1812–52), a convert to Catholicism who had studied medieval architecture and promoted it chiefly as the form most suited to spiritual buildings (a lively issue in overpopulated London, where Parliament had passed a Church Building Act in 1818). Pugin also published a far-reaching defense of the Gothic as the expression of a preferred moment, pervaded by true piety, in English national history, contrasted with the squalor of the modern industrial city. His portentous title alone conveys his claims: *Contrasts, or A Parallel between the Noble Edifices of the Fourteenth and Fifteenth Centuries and Similar Buildings of the Present Day; Shewing the Present Decay of Taste* (1836). Like apologists for the classical revival in architecture, Pugin also contended that by bringing back the grand and sublime forms of Gothic architecture, society could begin to recover its "ancient feelings and sentiments."

Pugin, then, provided the basic concepts for the new Houses of Parliament (begun 1835) for the supervising architect, Charles Barry, whose plan maintained a symmetry between the Houses of Lords and Commons more appropriate to a classical structure (Fig. **7.39**). Although the frustrated Pugin consequently complained that the resulting building was "Tudor details on a classic body," the exterior of Parliament did derive closely from the Chapel of Henry VII at the adjacent Westminster Abbey. Pugin also designed the details of the building, including hat-racks and ink-stands as well as polychromed tiles and wallpapers.

Pugin's influence was pervasive in church architecture in both England and America, and his medievalism was echoed in the writings of John Ruskin (1819–1900). A fervent supporter of Turner in his criticism, *Modern Painters* (1843–60), Ruskin railed against the architecture of his own day. In his influential writings on buildings and history, *The Seven Lamps of Architecture* (1849) and *The Stones of Venice* (1851–53), he states his preference for periods before the iron age of industry and praises the medieval attention to craftsmanship and decoration. He, too, argued that to restore the crafts and the styles of the past could lead to a general restoration of society.

ORIENTALISM IN FRANCE

While England was rediscovering her medieval past, France looked outward to her colonies. A renewed interest in the Levant was stimulated by the Napoleonic campaigns in Egypt in 1798–99, commemorated in a host of paintings, especially by Antoine-Jean Gros, a celebrated follower of David. A cultural breakthrough was achieved in France in 1821 when Champollion succeeded in deciphering Egyptian hieroglyphs from the Rosetta Stone, found during the Napoleonic campaigns. The other principal stimulus toward "the Orient," as the eastern Mediterranean was called, came via Greece, chiefly through Byron. The poet's literary themes were soon swept up in the greater drama of his life, chiefly around the Greek War of Independence, beginning in 1821. Byron's *Childe Harold* (1812) lamented the subjection of Greece to the Ottoman Empire of the Turks. The poet went to join the Greek cause and his death at Missolonghi in 1824 claimed the sympathy and admiration of all Europe, nowhere more than in France.

7.40 Eugène Delacroix, *Greece on the Ruins of Missolonghi*, 1826. Oil on canvas, 83½ × 56½ ins (212 × 143.5 cm). Musée des Beaux-Arts, Bordeaux.

EUGÉNE DELACROIX a young painter (1798–1863), took up the Greek struggles in large-scale, public paintings for the Paris Salon. In 1824 he displayed the victims of a conquered Greek island in *Massacre of Chios*, the fuller title of which is "Scenes of the Massacre of Scio: Greek Families Awaiting Death or Slavery." Showing nude and seminude figures, some with quite classical, academic pedigree, helpless before the domination of armed and mounted Turks in exotic costumes, Delacroix utilized a topical current event as a subject for heroic martyrdom, like Goya's *Third of May*, but with a commitment to display this foreign atrocity. To commemorate the loss of Byron and the plight of Greece, Delacroix's next variation of his theme was a more traditional allegory with a single, female personification: *Greece on the Ruins of Missolonghi* (1826; Fig. **7.40**, p. 321). In the background a black Turkish soldier stands proudly in full battlefield attire with a tall staff; from beneath the rubble emerges a corpse's arm. Nonetheless, the figure of Greece, arms outstretched, expresses not only anguish but resolve; her mood is conveyed by a dark indigo sky and blue garments,

painted with strong brushwork by Delacroix, who was a keen emulator of Rubens.

From Byron, too, came Delacroix's most energetic, imaginary Oriental theme. *The Death of Sardanapalus* (1828) depicts the Byronic story of the King of Nineveh, who ordered the destruction of himself and all that he possessed when his palace was about to be captured by the Medes (Fig. **7.41**). Here all of the brilliance of color and brushwork that Delacroix learned from his study of Rubens is employed in the service of dynamic spectacle. Black slaves, sensuous female nudes, exotic costumes and furnishings – all combine to produce a shiver of horror for the victims of such wanton destruction. But these are fictional figures of sex and violence, distanced both geographically and historically from the French viewer. Orientalism of this kind provides an extension of the historicizing imagination that animated medieval – and before them

7.41 Eugène Delacroix, *Death of Sardanapalus*, 1828. Oil on canvas, 154 × 195 ins (392 × 496 cm). Louvre, Paris.

7.42 Eugène Delacroix, *Liberty Leading the People*, 1830. Oil on canvas, 102 × 127 ins (259 × 325 cm). Louvre, Paris.

classical – themes and forms, but now any pretense at normative morality underlying the subject has disappeared. Only the spellbinding power of the artistic imagination and glowing color of the brush prevail, transforming history painting into a source of excitement.

Delacroix's interest in recording authentic elements of his Oriental world led him to take a trip to Morocco in 1832, and he was followed to North Africa and Egypt by other painters and by early photographers. Moreover, the nascent interest in ancient Near Eastern cultures became a stimulus to non-classical archaeology. Actual remains from Nineveh had been brought to the Louvre and the British Museum by mid-century. Nonetheless, it was not documentation of a real locality but rather its unspoiled, even savage character in the French imagination that Orientalism invented as an alternative to modern Europe. Filled with harems (Delacroix's *Women of Algiers*, 1834), slaves, and dark-skinned peoples, this Orientalism would become a staple of French painting and sculpture for the rest of the century.

Popular uprisings in Paris in July of 1830 sufficed to evoke one more echo of the French Revolution in Delacroix and his contemporaries. In his Salon painting of 1830, *Liberty Leading the People*, Delacroix once again combines allegory with historical overtones to portray the idealism of contemporary history and history painting (Fig. **7.42**). The figure of Liberty, based upon earlier figures personifying the nation just after the French Revolution, rallies her followers of all ages behind the French tricolor. Grimly depicted corpses of martyrs at her feet, and the smoke-shrouded skyline of Paris, add a note of uncompromising documentation to an otherwise inspirational scene, directed outward toward the viewer. Although it was bought by the state, this exhortatory painting was considered inflammatory and often not displayed. However, *Liberty Leading the People* remained an exceptional image of local insurrection and rebellion – a last gasp of the heroic civic ideals that had once motivated Jacques-Louis David and his fellow revolutionaries. Prosaic description of the everyday world and concerns for the novel conditions of modernity – already latent in the figures who surround Liberty – would supplant the classical vocabulary and idealism of Delacroix's allegory for the remainder of the nineteenth century.

8

NATURE AND NOVELTY

In June 1848 Louis Napoleon, nephew of Napoleon Bonaparte and head of the family, was elected President with strong executive powers, after another uprising in France (part of the Europe-wide revolutions of 1848). By 1851 he had proclaimed himself head of the Second Empire as Napoleon III and set about transforming Paris into the capital of Europe. In part his desire was to modernize and beautify the city, but he also sought to use new broad boulevards as an instrument of social control, promoting the movement of government troops and preventing the erection of any more barricades within the narrow, medieval byways that had been a focus for the 1848 revolts. To create the new Paris, in 1853 Napoleon III gave Baron Georges-Eugène Haussmann (1809–91) as much power in the realm of urban planning as he himself enjoyed in the government of France. This was the first overall redesign of a modern city, and its impact would be felt throughout Europe as well as further afield.

Haussmann supervised every detail of the renovation of Paris, including the installation of a massive infrastructure of water supply and sewers underneath his renowned gaslit boulevards that made rapid urban transportation possible. He demolished the old city walls and used the rings of land left in their wake to build whole new districts around the edges of the city. After creating an axial crossing of main streets, he established great parks at each end of his east–west axis for recreation and leisure. Blocks of apartment houses with uniform height and roof design lined his avenues and provided better housing for the growing middle class. At ground level, shops and cafés offered new activities for promenading citizens. Standardization and the technology of the industrial age, including mass production of concrete for construction, now gave coherence to an entire urban environment, but at the cost of wholesale destruction of historic districts.

Detail of Fig. 8.14, Claude Monet, *La Grenouillère* (see p.336).

PARIS: MODERN CITY

PARIS OPÉRA The great, tree-lined avenues of Haussmann converged at new nodes of civic activity, including the railroad stations that brought so many new inhabitants to Paris. Of the new urban centers, none was more opulent than the Place de l'Opéra, marked by the building that was intended to serve as a splendid cathedral of culture for the metropolis. Built between 1861 and 1875 by Charles Garnier, the new Opéra occupied a site designed to be the nexus of chic and prosperous Paris (Fig. **8.1**). In its scale, design, and lavish decoration, the Opéra perfectly conveys the pomp and public ostentation of the Second Empire (in contrast, for example, to the austerity of the Greek revival of Schinkel's National Theater in Berlin half a century earlier). Garnier, a leading member of the dominating Ecole des Beaux Arts academy of design, defended his palatial evocation of absolutism (see Balthasar Neumann's Würzburg Palace, Fig. 6.35) on the grounds that a theater of spectacle demanded spectacular architecture. Moreover, like the promenades on the boulevards outside the Opéra, the interior of the building, beginning with its grand staircase, encouraged a strolling, fashionable audience to participate in the display of the building (Fig. **8.2**). Such gathering and display had previously been confined to the palaces of the rich and noble, but in modern Paris the prosperous bourgeoisie could now assume that role at the Opéra.

To meet the needs of modern Paris a carriage entrance was placed to the side of the building. Those arriving through the main façade saw a grand arcade, topped by paired columns evocative of the seventeenth-century façades of the Louvre and Versailles. All of the visitors gathered to ascend the three-storey main staircase, adorned with ceiling frescoes, great columns, gilded polychrome decoration, and sensuous candelabra sculpture, in imitation of grand staircases, such as Neumann's, which double back to permit a full view of everyone else on its steps. Despite these references to past splendor, modern technology in the form of elevators and a ventilation system, as well as an iron framework of construction, underlay the functioning of the building.

8.1 (Below) Charles Garnier, Opéra, Paris, 1861–75. Façade.

8.2 (Opposite) Charles Garnier, Opéra, Paris, 1861–75. Grand staircase.

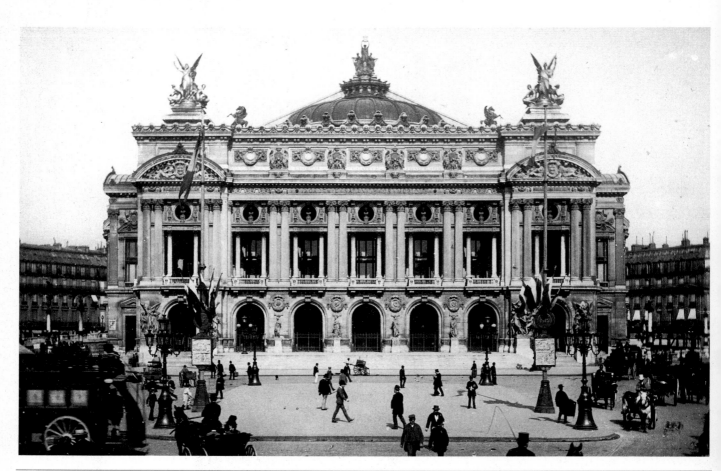

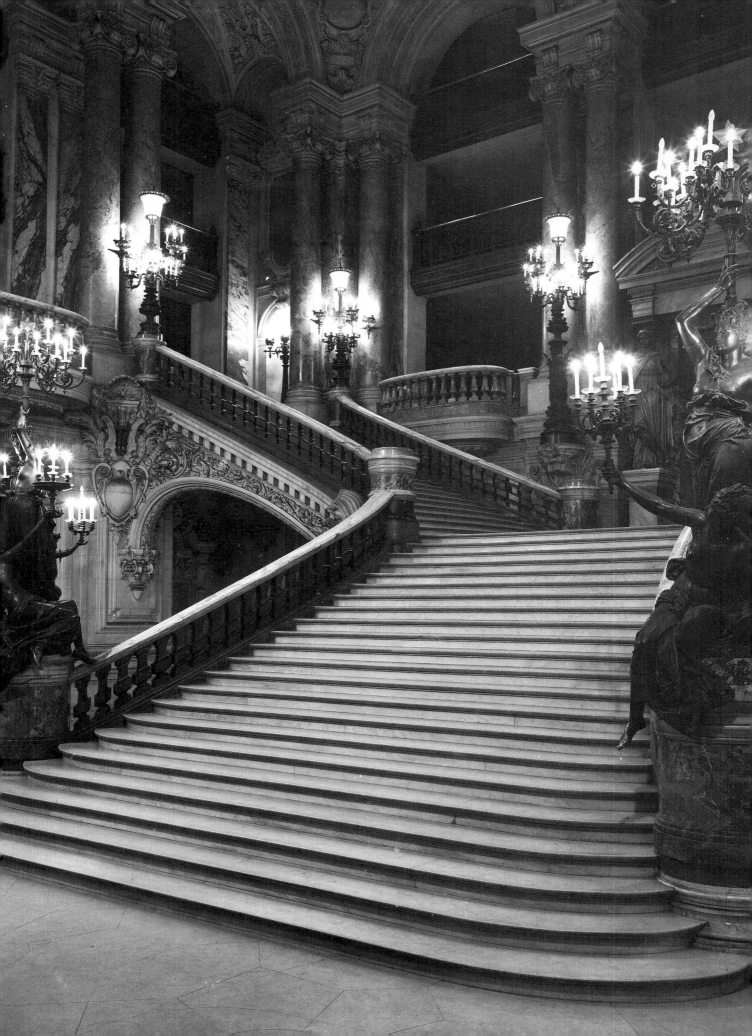

Iron Architecture

If the Industrial Revolution really began in England with the use of steam power for the textile industry, its second point of origin was the development of usable iron. Construction with metal altered building techniques more than any previous technology since Roman concrete. For many buildings, whether the churches of the Gothic revival or the splendors of Garnier's Paris Opéra, the underlying iron armature was adorned with ornament of some other historical period. But, increasingly, the aesthetic as well as the structural potential of iron was exposed to view. The compressive strength of iron in arches and its potential to provide light through glass openings offered new design opportunities, particularly for the spanning of vast open spaces.

The spanning capacity of iron was first revealed in Shropshire, England, where Abraham Darby III produced a bridge (1779) across the Severn River at Coalbrookdale, site of the famous family ironworks. The advent of the railroad after 1830, led to the rapid exploitation of the basic principle of the iron arch for bridges and stations. The iron girder was developed to withstand the weight of engines, as well as the reinforcing mechanism of the iron *truss* (an adapted timber technique) and new engineering feats of suspending iron over open spaces through suspension-bridge cables or *cantilevering*.

From bridge construction to practical enclosures was a small step, since the spans involved are usually much smaller. However, the open acknowledgment of iron supports as a visible and desired design element developed gradually. There was one early, practical application during the 1820s in public covered shopping places, usually called "galleries" or "arcades." The most famous early example in Paris was the Galerie d'Orléans (1828–30). By the time of the Second Empire, this technology was employed for the creation of large department stores with extended street fronts of display glass along Haussmann's new boulevards. The groundbreaking monumental department store in Paris, conceived in 1852 but built between 1869 and 1876, was the Bon Marché (architect Louis-Charles Boileau) on which Eiffel served as a consulting engineer.

Public buildings were still conservatively ornamented, like Garnier's Opéra, although Henri Labrouste

8.3 Joseph Paxton, Crystal Palace, London, 1851 (destroyed).

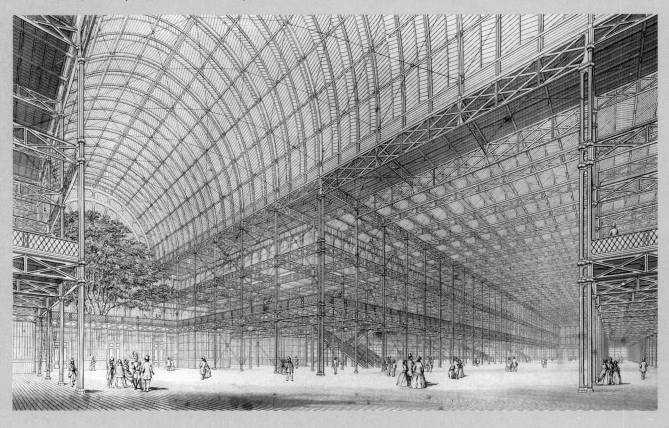

dared to open up the reading room of the Bibliothèque Ste.-Geneviève in Paris (1842–50) with high barrel vaults of iron supported by Ionic cast-iron columns. He was roundly ridiculed. Most public buildings that used iron were practical sheds, such as the markets (Les Halles in Paris, 1853) and the great trusswork arches of train sheds, particularly in England and France. Open, high vaults were needed to disperse clouds of smoke and steam, and the arches had to be wide enough to accommodate the extent of platforms and tracks, so practical engineering took precedence over references to past styles, usually confined to the gateway façades.

However, the most influential of all iron and glass constructions of the nineteenth century was the ultimate market hall, a temporary building, erected in 1851 in London for the first of what would be called World's Fairs. At the behest of Prince Albert, who wanted to display his nation's prowess in industry and technology in a spirit of friendly competition, England sponsored "The Great Exhibition of Works of Industry of All Nations." Its home was Joseph Paxton's massive Crystal Palace (Fig. **8.3**). Paxton had been a garden architect, and he used the model of the greenhouse – glass panes in iron frames – for what at the time was the world's largest building in terms of volume and where use was first made of prefabricated components, necessitated by the mere six months allotted for construction. The building covered 18 acres (7 hectares), offering almost a million square feet of covered floor space. Together with its exhibits, the Crystal Palace symbolized the Industrial Age for its 6 million visitors.

Futuristic design dominated the ambitions of the 1889 Paris Exposition Universelle, so, instead of the functional greenhouse shed of Paxton's Crystal Palace, a more radical structure was designed to symbolize the fair itself and serve as its gateway. It was a triumphal arch of modernity, displaying soaring height rather than earthbound curves. The colossal scale of Gustave Eiffel's Tower (1887–89), essentially derived from his wrought-iron trussed bridge structures, now curving from four sides to meet at its summit, dwarfed everything in the old city (Fig. **8.4**). Significantly, Garnier circulated a petition calling for its abolition, but even though it was designed as a temporary fair structure, the Eiffel Tower still stands as a symbol of modern Paris. Elevators, invented by Elisha Otis in America in 1852 (and demonstrated at an industrial fair), permitted fairgoers and subsequent visitors to ascend mechanically to this new record height of 984 feet (300 meters).

8.4 Gustave Eiffel, Eiffel Tower, Paris, 1887–89.

8.5 Honoré Daumier, *Rue Transnonain, April 15, 1834,* 1834. Lithograph, 11½ × 17⅝ ins (29.2 × 44.7 cm). Victoria and Albert Museum, London.

8.6 Honoré Daumier, *Third-Class Carriage,* ca. 1862. Oil on canvas, 25¾ × 35½ ins (65.4 × 90.2 cm). The Metropolitan Museum of Art, New York.

DAUMIER Not all Parisians or Parisian artists welcomed the advent of modern urban life. Even during the previous regime, excesses in government had been the target of visual satires, particularly in the popular press. The greatest of the visual satirists was Honoré Daumier (1808 –79), who used the new graphic medium of *lithography* to draw cartoonlike caricatures on printing stones. These offered instantaneous and topical pictorial editorials on current life in the city. Daumier worked chiefly for weekly periodicals such as *La Caricature,* which was repeatedly censored or fined, or its less political successor, *Le Charivari.* He once spent six months in jail for a lampoon of the current king, Louis Philippe. Daumier also turned his satirical eye on corrupt public officials, particularly politicians, judges, and lawyers, as

well as pretentious members of the art world, from the visitors to the annual state-sponsored Salons to the would-be buyers at small galleries. Some of his caricatures of pompous politicians, sketched from the visitors' gallery of the Chamber of Deputies, also appeared as cast bronzes from modeled clay busts.

Daumier's most poignant lithograph, however, followed the lead of painters such as Goya and Delacroix in documenting an actual event which showed sympathy for the victims of a scandalous massacre. In *Rue Transnonain* (1834; Fig. **8.5**) a government riot squad had harshly put down riots in the city, murdering innocent residents by mistake while firing on a sniper. Daumier issued his lithographic indictment of police brutality in the pages of an illustrated monthly. The inelegance of his bloodstained corpses suggests an eyewitness recording, akin to Goya's *Disasters of War* (Fig. 7.22); at the same time, their composure and the vivid contrasts of black and white from the lithographic crayon render them as martyrs after the stark model of David's *Marat* (see Fig. 7.20). These defenseless nocturnal victims include a father, clad only in a nightshirt, on top of his dead baby and lying beside an old man in the moonlight. Due in part to the sensation caused by this print, *La Caricature* and other periodicals were banned by government order in 1835, obliging Daumier to confine himself to more comical, less pointedly political, satire of social mores.

In paintings, too, Daumier was concerned with the disruptions caused by modernization. His *Third-Class Carriage* (ca. 1862; Fig. **8.6**) takes the opposite view of railroad travel from Turner's celebration of speed (Fig. 7.30). The subjects in this striking vignette of daily life consist of the poor and humble of all ages and both sexes, jammed together on the wooden benches that brought them all, without distinction, to the big city. The viewer, too, is given an equivalent position opposite these figures, on a level with the ordinary, fatherless country family of the foreground. As in his lithographs, Daumier's figures are humble and ordinary, yet they also appear to be general types, symbolic of the displacement and anonymity brought about in both country and city by the Industrial Revolution.

RURAL REALISM: COURBET

In the wake of the 1848 revolutions, some artists sought to confront their viewers with the plight of the downtrodden or to show the working class, including the peasants of the changing countryside, in a heroic light. One crusader for an unadorned vision of the country by the city was Gustave Courbet (1819–77), who was born in a village in the Vosges. In some respects Courbet was an insistent self-promoter in the art world of

8.7 Gustave Courbet, *The Stone Breakers*, 1849. Oil on canvas, 63 × 102 ins (160 × 259 cm). Formerly Gemäldegalerie, Dresden, (destroyed).

Paris: he began his career in the 1840s with a long series of self-portraits, but he followed this narcissistic exercise with scenes of his native village, Ornans, painted life-size yet matter-of-fact and unheroic in its presentation of a range of country activities. *The Stone Breakers* (1849; Fig **8.7**, p. 331) presents a pair of laborers, one old and one quite young, engaged in back-breaking effort, recorded with meticulous fidelity to rocks, costumes, and humble luncheon in the bright glare of midday light. Indeed, Courbet insisted throughout his career that he confined himself strictly to visible objects; he ridiculed past artistic traditions, still promoted within academic training, especially those concerned with allegory or transcendence ("Show me an angel, and I will paint it!"). Courbet's images steadfastly abjure heroics and sentimentality: his large, hard-working figures, and their stiff, silent awkwardness suggest only the effort of their task. Perhaps on that account, his picture was celebrated as an indictment of capitalism by his friend (later the subject of a Courbet portrait in 1865–67), the socialist theorist Pierre-Joseph Proudhon. Indeed, Proudhon's own theory of art echoed other contemporary critics in demanding that paintings "depict men in the sincerity of their nature and their habits, in their work, in the accomplishment of their civic and domestic duties, with their present-day appearance." Such rural labor, often rendered sympathetically, became popular as a subject through the work of many artists throughout Europe, including Courbet's contemporary in France, Jean-François Millet, and the later Dutch émigré, Vincent van Gogh (see below, pp. 355–57).

Courbet believed that his insistence on tangible reality led to a "democracy in art," and his *Burial at Ornans* (1849; Fig. **8.8**) is an appropriately egalitarian composition of an ordinary event, painted nonetheless on a canvas on the grand scale that was previously the province only of history painters, from David to Delacroix. In contrast to the moral instruction of David or the excited imagination of Delacroix, Courbet's simple country burial offers a pictorial inventory of some diverse yet ordinary inhabitants – posed from life – of his native village. The stark colors, dominated by black, white, and red, and the blank emptiness of the open grave led Courbet's detractors among the critics at the Salon of 1850 (where both the *Burial* and *The Stone Breakers* were shown) to charge the artist with blasphemy; his defenders, including Proudhon, argued equally vehemently that the image captured the loss of religiosity in the modern world. To Courbet this image, like the Dutch militia pictures of the seventeenth century, depicted a corporate community gathering, a social rather than a spiritual expression.

Through the controversy surrounding his name, aroused by the Salon of 1850, Courbet became known, like Daumier, for his visual attacks on social values in the Paris art world. The artist was able to seize further artistic attention when Paris became the focus of an international art exposition, associated with the 1855 World's Fair, or Universal Exposition. For this occasion, Napoleon III wanted to show the cultural vitality of France and the Second Empire by means of a glorious retrospective of the careers of her most famous painters, including Delacroix. Courbet's participation was solicited as well, but when two of his pictures were rejected by the Exposition jury, both the *Burial at Ornans* and his massively ambitious 1855 *Painter's Studio, A Real Allegory Defining a Phase of Seven Years of my Artistic Life* (See Fig. 1.12), he took an extraordinary alternative course. Backed by a private patron, Alfred Bruyas (who appears at the right rear among the portraits in the *Painter's Studio*), Courbet rented land across from the Exposition and erected a pavilion for a one-

8.8 Gustave Courbet, *Burial at Ornans*, 1849–50. Oil on canvas, 123 × 261 ins (314 × 663 cm). Musée d'Orsay, Paris.

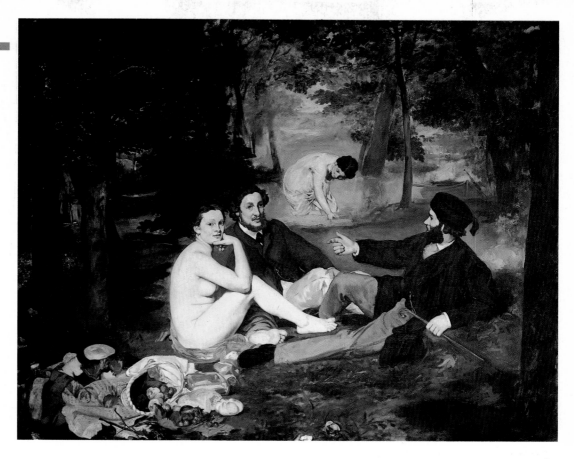

8.9 Edouard Manet, *Déjeuner sur l'Herbe* (*Luncheon on the Grass*), 1863. Oil on canvas, 84 × 106 ins (214 × 279 cm). Musée d'Orsay, Paris.

man retrospective of his own. At the same time, he published a manifesto, "On Realism," and produced advertisement posters.

Courbet's individual promotion as well as the state-sanctioned retrospectives of esteemed masters effectively challenged the composite, national conception of "Schools." France and other contributing nations (led by England, Germany, and Belgium) had all submitted their artworks collectively, undergoing the same process of selection by jury as the annual public Parisian Salons. Moreover, by challenging the authority of the state-sponsored jury, Courbet rallied the art world to the cause of the "refused" artist (subject of a mordant Daumier cartoon in *Le Charivari*, May 1855). By grouping artists and movements, often according to the bias of their journals, critics reinforced the political nature of the forms and themes of artworks as well, and lent currency to debates about controversial artists like Courbet. To those critics who also supported the "revolutionary" aspects of Delacroix's art, Courbet's heroism in setting up his one-man pavilion was a gesture of liberation for artists' rights.

"THE PAINTER OF MODERN LIFE": MANET

If Courbet's project called for the unsparing depiction of the actual and commonplace, for most artists who followed his lead the proper subjects of modern art lay not in the countryside but rather in Paris. Daumier is credited with the remark, "Il faut être de son temps" (One must be of one's time). The

poet-critic Baudelaire, already included in the right corner of Courbet's *Painter's Studio* (although he found Courbet's Realism vulgar and trivial and championed Delacroix in his Salon reviews), led the call, in an 1859 essay, for "The Painter of Modern Life," who could capture "the transitory, fleeting beauty of our present life." A new consciousness of history led to the desire to present the modern era as it unfolded, instead of depicting either past or future. It is hardly surprising that photography was invented in this era of Realism and modernity (see p. 363).

After a decade of painting copies of his favorite old master models, especially the lively brushwork and color harmonies of Goya, Velázquez, and Titian, Edouard Manet (1832–83) set out in the 1860s to paint what he saw in Paris, partly in the company of Baudelaire. Manet's 1862 *Concert in the Tuileries* captured with rapid strokes and bold colors the bustle and fashionable middle-class dress of dense crowds at leisure in the public park at the heart of Paris, adjacent to the palace of Napoleon III. The artist's cultural affiliations can be determined through the portraits in this painting: Offenbach, composer of light operettas; Baudelaire and Théophile Gautier, authors and respected art critics; and at the right Manet himself. Painted on a large scale, like Courbet's *Burial at Ornans* and the grand Salon paintings of the previous century, this painting effectively signals that the agenda for modern painting in the coming decades will be a sunny vision of Haussmann's Paris: boulevards, parks, and bourgeois leisure.

Son of a prosperous and respectable family, Manet was an ambitious painter, a public figure who combined respect for tradition with modern subjects. In 1863, he submitted to the Salon *Déjeuner sur l'Herbe* (*Luncheon on the Grass*; Fig. **8.9**)

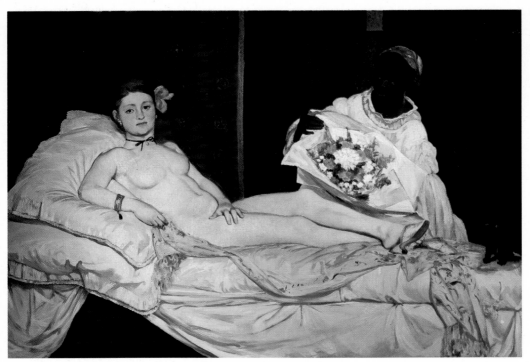

8.10 Edouard Manet, *Olympia*, 1863. Oil on canvas, 51 × 74¾ ins (129.5 × 190 cm). Musée d'Orsay, Paris.

8.11 Edouard Manet, *Emile Zola*, 1867–68. Oil on canvas, 57⅛ × 44⅞ ins (145 × 113.9 cm). Musée d'Orsay, Paris.

that began its composition with the inspiration of works in the Louvre by Titian, the eighteenth-century French master Watteau, and an engraved Raphael design of water-gods. However, in this scene of bathing and picnicking, his retention of the tradition of painting women naked or in undergarments seemed to clash with the contemporary dress of their gentleman companions, and the jurors of the Salon rejected the painting along with two other Manets. The large numbers of rejections of paintings by many artists provoked such an outcry that Napoleon III himself donated an exhibition space in the palace for a Salon des Refusés, where *Déjeuner sur l'Herbe* became a controversial and scandalous success. The bright skin tones and confrontational stare of the nude woman as well as the unmistakably discarded pile of clothes beside her seemed designed to offend social propriety, despite the artist's references to venerable old master models for his composition and theme. Even the broad brushwork and flat, bold color areas offended the critics, who were accustomed to more conventionally "finished" paintings, although Manet's subject is a virtual compendium of traditional categories of painting – still life, nude, landscape, and portraiture likenesses (of Manet's brother and future brother-in-law).

Manet's reputation suffered even more when his 1863 painting, *Olympia* (Fig. **8.10**), was exhibited in the Salon of 1865. Here, too, the composition derived from tradition, specifically from Titian's reclining *Venus of Urbino* and the heritage of the Renaissance female nude. However, Manet's model again stares directly out of the painting at the viewer, and the frankness of her nudity is reinforced rather than dispelled by the placement of her hand at her crotch. Both her name, familiar from contemporary literature on the modern city (specifically Dumas *fils*, and his Lady of the Camellias), and the flowers brought by a visitor suggest that she is a modern, urban Venus, a prostitute. Even the sleeping dog of the Titian model has been replaced with a more sinister hissing

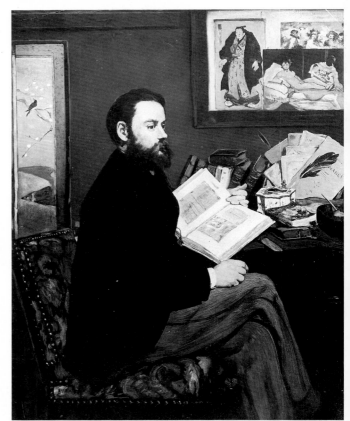

cat, redolent of sexuality in the poems of Baudelaire and of nocturnal evil in the etchings of Goya. Any sense of timelessness that Olympia might have had is compromised even in details; she is in fact partly dressed with a necklace, a bracelet, and a single house-slipper. Harsh lighting flattens the forms, and despite exquisite variations on buff and brown tones, the color and brushwork remain assertively flat and unmodeled relative to the conventions of Salon painting. With their total

resistance to idealization or sentiment, both the technique of the painting and its overtly modern, sexual content offended the Parisian art world in 1865.

Emile Zola, naturalist novelist of modern France and art critic, defended the work of the embattled Manet on both counts as the work of a descriptive naturalist interested chiefly in color, not ideas. (Manet would also go on to paint an image of the celebrated prostitute of Zola's own scandalous novel, *Nana*, in 1877.) The important role played by critics such as Zola in the contemporary evaluation of art led to Manet's sympathetic portrait of him in 1867–68 (Fig. 8.11). This work includes a reproduction of *Olympia* (Manet also produced an etching of the work in 1867) fixed to the wall above Zola's desk along with other artistic references, as if he were painting a manifesto of an aesthetic credo. Here the pervasive flatness of the sitter and the setting is explicitly linked to the artistic model of Japanese prints, already enjoying a vogue ("Japonisme") after the opening of Japan to Western trade in 1854; both a color woodcut of a wrestler and a screen with a bird on a branch indicate this alternative to Western academic art. Moreover, behind the *Olympia*, a Goya etching of Velázquez's *The Drinkers* demonstrates Manet's fascination with both Spanish artists and with other traditional painters who reveal layers of meaning beneath the mundane. By displaying on the desk Zola's defense of him in his 1867 pamphlet, Manet is able to indicate his debt to and his close association with the critic. Like the homage to Marat by David, this is the testimonial of an engaged artist for his champion, now, however, in the field of artistic politics rather than revolution.

Manet continued to produce imagery of modern Paris, but after the attacks on his earlier works, his *Gare St.-Lazare* (1872–73; Fig. 8.12), displayed in the Salon of 1874, departs from traditional reference to other artists and to nudes. Manet employs subtle self-reference in this work; his model is still Victorine Meurent, sitter for both shocking nudes of the 1860s. Again the artist presents a coloristic harmony of blues and whites, but the lack of activity and the expanse of steam and smoke mystified the critics. The title of the painting refers to the view through its iron fence, the railroad right-of-way to both the new railroad shed, Gare St.-Lazare, as well as the massive pedestrian bridge over the tracks, the Pont de l'Europe. Both would become major subjects for Impressionist paintings, particularly by Claude Monet (see Fig. 8.16). Yet Manet remains committed to the presentation of figures rather than urban townscape; though this is his first painting to have been produced out-of-doors with the directness advocated by Impressionist painters like Monet, modern clothes and sitters still dominate over modern sites and sights. Manet's visual consciousness, capturing the instant, like photographs, conveys modernity by means of the qualities Baudelaire called "the transitory, the fugitive, the contingent." The painting, however, goes beyond depiction to evoke mental activities as well: the reverie of the woman who has interrupted her reading and the gaze of the child, absorbed by the insubstantiality of a cloud. Here, then, Manet searches for poetic suggestiveness, the mental states or dreams elicited by the Symbolist poetry of his friend, another supportive critic (and portrait subject, 1876), Stephane Mallarmé.

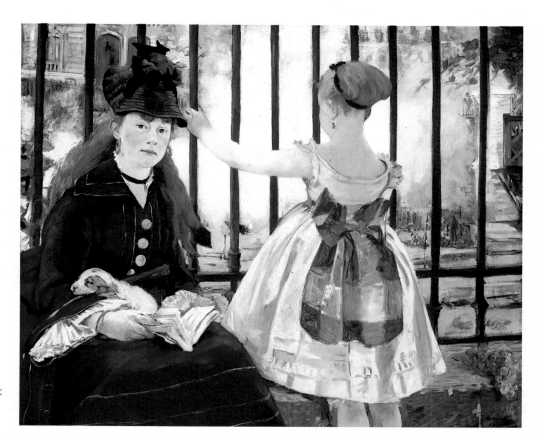

8.12 Edouard Manet, *Gare St.-Lazare*, 1873. Oil on canvas, 36¾ × 45⅛ ins (93.3 × 114.7 cm). National Gallery of Art, Washington.

CAPTURING THE IMPRESSION: MONET

The open-air painting of a woman within a garden was already a staple of the art of Claude Monet (1840–1926) in the 1860s. *Women in the Garden* (1866–67; Fig. **8.13**) offers a private version of the public park of Manet's *Tuileries*. Moreover, Monet had been working on a massive canvas of both men and women, in contemporary clothes, picnicking under trees, as a kind of corrective update on Manet's scandalous *Déjeuner* for the Salon of 1866 (the work, never finished, survives in preparatory sketches). Even this more modest painting, however, was rejected by the Salon of 1867, again for being sketchy and "unfinished." Its dazzling and unmodulated bright colors were painted outdoors in direct sunlight, where the precise tones on leaves and fabrics are more significant than the figures and their trivial activities. The very act of *plein-air* (open-air) painting by Monet and his fellow Impressionists, with its techniques and informal composition, constituted an act of rebellion against the dominant conventions and aesthetic judgments of Salon juries.

Monet and his Impressionist colleagues delighted in the outdoor leisure sites of their middle-class subjects, the suburban destinations of train journeys from Paris. One such site on the River Seine, painted together by Monet and his friend, Pierre-Auguste Renoir, in 1869, was Bougival, twenty minutes by train from Gare St.-Lazare, at La Grenouillère (The Frog Pond), site of boating, swimming, and dining or drinking on a floating restaurant. Here Monet painted the dappled light of

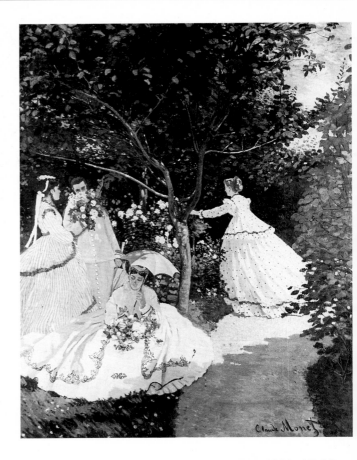

8.13 Claude Monet, *Women in the Garden*, 1866–67. Oil on canvas, 100½ × 80¾ ins (255.3 × 205 cm). Musée d'Orsay, Paris.

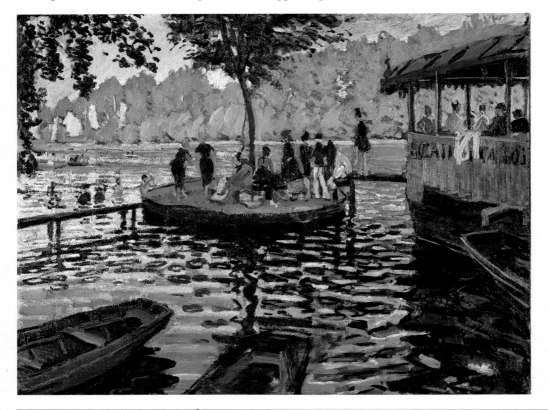

8.14 Claude Monet, *La Grenouillère*, 1869. Oil on canvas, 29⅜ × 39¼ ins (74.6 × 99.7 cm). The Metropolitan Museum of Art, New York.

summer sun on water (Fig. **8.14**), with an immediacy of sensation carried by unmodulated adjacent colors (Manet owned this painting and Renoir made a version of the identical scene). Figures have been reduced to blobs of paint whose shape and color alone record incidentals of clothing.

By 1873 the criticism of the Salon peaked with the creation of a new Salon des Refusés, like that of a decade earlier when Manet had been the *succès de scandale*. However, Monet and other young artists required a space where no authority could impose any restrictions on painting. This group called itself the Société Anonyme and opened its first exhibition just before the Salon in April, 1874, at the studio of the photographer, Nadar (see p. 341). Monet had already painted a view of the Boulevard des Capucines (Fig. **8.15**) from Nadar's studio. Here again, blotches of pigment convey not only figures but also their movement on the street, viewed from a distance. This is the kind of momentary "impression" that Monet strove to realize out-of-doors in both nature and the city. One of the other paintings he exhibited in 1873, *Impression, Sunrise*, depicting Le Havre harbor at dawn, gave the overall name of "*Impressionists*" to this new group of artists, thanks to derisive attacks on it by a hostile critic.

When Monet turned specifically to the subject of Manet's *Gare St.-Lazare* in 1877, he had fully mastered both the color and brushwork necessary to suggest the ephemera of steam engines (Fig. **8.16**). Monet even painted the same view as Manet had painted, without the two figures or the iron fence (*The Europe Bridge at St-Lazare Train Station*, 1877).

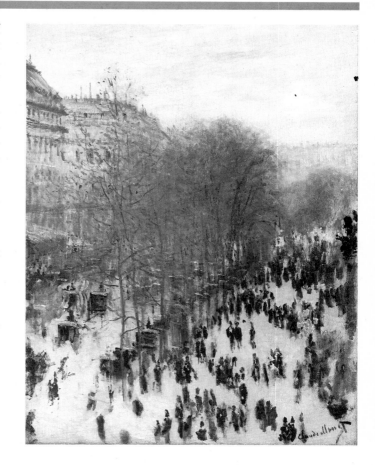

8.15 Claude Monet, *Boulevard des Capucines*, 1873. Oil on canvas, 31¾ × 23³⁄₁₆ ins (79.4 × 60.6 cm). Collection Nelson Atkins Museum of Art, Kansas City.

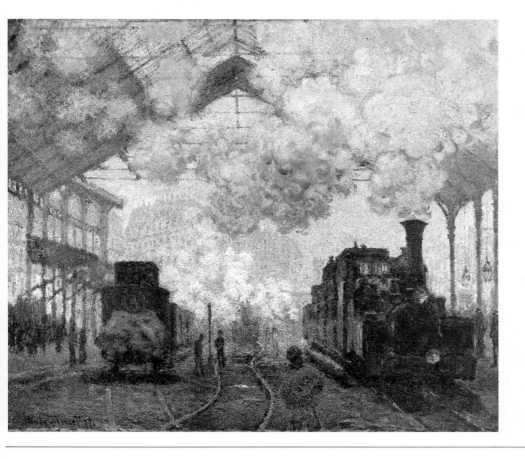

8.16· Claude Monet, *Gare St.-Lazare*, 1877. Oil on canvas, 32¾ × 39⅞ ins (83.1 × 101.5 cm). Fogg Art Museum, Cambridge, Massachusetts.

However, for most of his station images, painted in a series of related views (eight were at the third Impressionist exhibition), he stood inside the great iron shed. Monet concentrates on momentary effects of light and color, including the blue condensation of rising steam, akin to Constable's cloud studies, under the glass roof and in front of the bright open sky beyond. He also chose an arbitrary frame of vision, which cuts off a foreground figure at the knees.

MORISOT A similar momentary yet overall impression of the Paris skyline was depicted by one of the women in the Impressionist movement, Berthe Morisot (1841–95), in *On The Balcony* (Fig. **8.17**), which repeats the panorama of her *View of Paris from the Trocadero* (1872). This site soon became familiar as the location of the 1889 World's Fair and Eiffel Tower construction. Like Monet's images, this outdoor scene captures effects of light and atmosphere more fully than recognizable landmarks or figures, though the gilded dome of the Invalides offers a focus for the woman and her daughter. This painting records the private intimacy of a real mother and daughter, in contrast to Manet's posed models in *Gare St.-Lazare*. The relaxed familiarity of Berthe Morisot's models results from her frequent use, as here, of her own sister, Edma, and niece, as well as the support of the actual iron balcony of the Morisot family house, in contrast with

8.17 Berthe Morisot, *On The Balcony*, 1874. Watercolor and goache over graphite, 8⅛ × 6⅞ ins (20.6 × 17.3 cm). Art Institute of Chicago. Gift of Mrs. Charles Netcher in memory of Charles Netcher II, 1933.

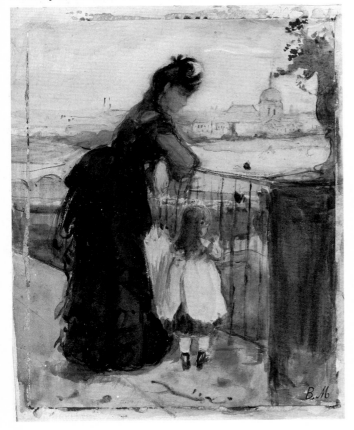

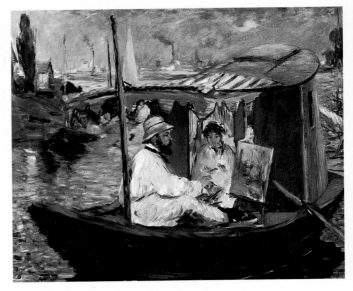

8.18 Edouard Manet, *Monet on his Houseboat Studio*, 1874. Oil on canvas, 31½ × 38½ ins (80 × 98 cm). Neue Pinakothek, Munich.

Manet's painting of the same year. Morisot's career and life were both inextricably bound up with Edouard Manet; she married the painter's brother, Eugène, in 1874. Berthe and her sister, Edma, were both given training in art by their family, despite warnings about career problems from an early teacher. Both sisters exhibited in Salons during the 1860s, though Edma's marriage in 1869 ended her career as a painter, to her chagrin. After 1874 Morisot exhibited with the Impressionists, of whom she was a charter member. She was later joined by Eva Gonzales, a pupil and friend of Manet (who, like Manet, only showed at Salons rather than with Impressionists proper), and by American expatriate Mary Cassatt (see pp. 346–47).

These women painters found in the more democratic principles of the Société Anonyme and the new emphasis on outdoor or urban modern subjects a much greater opportunity for personal achievement than ever they had had under the restrictions of the Academy. Of course, their family wealth (Morisot in Paris, Cassatt in Philadelphia) also made them more independent and able to pursue their careers as they chose. Nonetheless, their subjects are usually limited to a few topics, chiefly using family members as models (Morisot herself also posed for Manet during the 1870s) and putting their images of modern Paris in places, particularly parlors, deemed suitable for respectable women.

IMPRESSIONISTS AT ARGENTEUIL The work of the Impressionists left an indelible mark on the art of Manet, even though he never exhibited with them during the period of their group shows, 1874–86. When Monet decamped from Paris in 1871 for the suburban weekend resort of Argenteuil, his presence there drew a series of visiting artists, including Renoir in 1873 and Manet in 1874. The subject of all these artists was the boating basin, site of sailing regattas, and riverbank promenades of the vacationing bourgeois. Manet remained true to his love of the human figure, even while he was painting in the open air at Argenteuil alongside Monet. His *Monet on his Houseboat Studio* (1874;

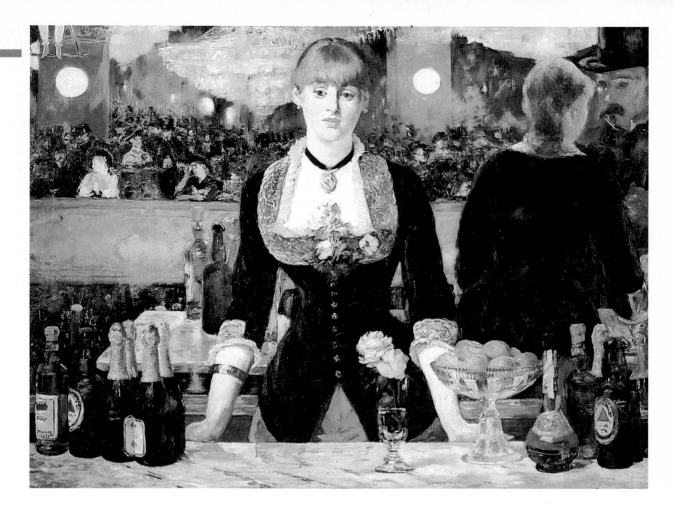

Fig. **8.18**), a work greatly influenced by Monet's loose brushwork, captured the momentary light effects and water reflections on the water of the Seine. Argenteuil was Monet's visual province much more than Manet's Paris, and this painting records Manet's homage to his colleague for the lessons of outdoor landscape technique – just as he had previously commemorated Zola in the company of his own earlier art projects and sources.

CITY BOULEVARDS

In their celebration of the spectacle of modern life Impressionist artists, particularly Edgar Degas (1834–1917), were drawn to favorite leisure spots along the boulevards of Paris. At the most casual level, the boulevards spawned cafés, some of them, *cafés-concerts*, with evening entertainers, particularly cabaret singers. Degas in particular made these nocturnal locales his own, while Renoir recorded their gaiety by day. Manet, too, depicted numerous bars and cafés after 1874. Most elaborate and formal of entertainments was the Opéra in Garnier's ornate new palace (Manet, *Ball of the Opera*, 1873), but other theater arts, such as Degas's beloved ballet, also occupy Impressionist attention under the new artificial lights of Paris. Manet's most ambitious late work, exhibited at the Salon of 1882, presents a *Bar at the Folies-Bergère* (Fig. **8.19**), one of the most fashionable floor shows in the new districts. This large canvas was prepared in preliminary sketches, yet its deft

8.19 Edouard Manet, *Bar at the Folies-Bergère*, 1881–82. Oil on canvas, 37½ × 51 ins (95.2 × 129.5 cm). Courtauld Galleries, London.

brushwork suggests the evanescence of flickering reflections, including artificial lights, an audience in evening dress and rising plumes of smoke, in the mirror behind the barmaid. Like Monet, Manet shows the artifice of his frame of vision by cutting off a trapeze artist in the upper left corner at the ankles. The anonymity of the crowded city boulevard is also seen in the audience, contrasted with the direct, if blank and distracted, stare of the barmaid (in contrast to the confident assurance, even defiance, of *Olympia*). Painterly artifice is further suggested by the oblique reflection of the barmaid and a top-hatted customer in the mirror at one side of her. Her responsive tilt to the gentleman in the mirror contradicts her immobile indifference before the viewer and undermines any clear sense of her position, her behavior, or her role. Indeed confusion about her precise image and nature (some early critics assumed that she was a covertly available prostitute) mirrors the ambiguity of dress and comportment of the crowds on the modern boulevard outside. The foreground still life (also reflected at variance) further suggests the artificial delights offered for sale in attractive bottles (including one of the first modern trademark symbols, the red triangle of Bass ale) or in crystal, like the shimmering mirror a metaphor for the entire project of painted and packaged modern entertainment summoned up by Manet.

Photography: Pencil of Nature

Like many great ideas, the process of photography was invented almost simultaneously by two men. The first to announce his discovery in 1839 was Louis-Jacques-Mande Daguerre, a French painter of scenography, or dioramas, in Paris, in partnership with a printmaker, Joseph Niepce, who had already experimented with "chemical printing" or the use of sunlight on sensitized copper plates — "heliography." At the same time in England William Henry Fox Talbot's "photogenic drawing" produced a negative, to be developed into "calotypes" in a patented process akin to the modern notion of printed photographs. Because of their greater detail and clarity, *daguerreotypes*, although able to produce only a single picture, were the chosen technique for pictures in photography's first decade. Early daguerreotypes, using silver salts as the agent to "fix" the image on a plate, usually required lengthy exposures and had to concentrate on immobile images such as natural scenery, still life, or portraits of public figures (though these categories had already been sanctioned by painting). Calotypes, while more efficient, were less light-sensitive and exaggerated the deep contrasts between light and shadows. Hence, early on, two principal effects could be observed in the new light-pictures according to which technique was being used: extraordinary detail even within general masses, or else an overall effect of atmosphere and lighting. In both cases, the subjects and the record they enshrined accorded well with the emerging taste for charged observation in painting, whether in Constable's England or Courbet's France.

In the era of Orientalism as well as of a new national interest in important local historical monuments, photographs could provide images of astonishing clarity of detail or dramatic contrast. In the wake of Delacroix's visit to North Africa, some of the largest and most powerful early images were taken with the modified calotype process of paper negatives, suitable for printed replication, during the 1850s in Egypt by both Frenchmen (Maxime DuCamp, Auguste Salzmann, Félix Teynard) and

8.20 Gustave Le Gray, *Cloister at Moissac*, 1851. Albumen photograph. Musée d'Orsay, Paris.

Englishmen (John Beasely Greene, Francis Frith, Francis Bedford). At the same time, a team of photographers, Gustave Le Gray (1820–82), Henri Le Secq, and Edouard-Denis Baldus, appointed in 1851 by the Comité des Monuments Historiques to record the architectural heritage of France, was absorbed with medieval monuments. Le Gray's image *Cloister at Moissac* depended on his own invention of a waxed-paper process that permitted easier, shorter outdoor photography, including forest or coastal scenes akin to those of Courbet (Fig. **8.20**). This photograph anticipates the intensity of Monet's Impressionism as it makes dramatic use of both stark contrasts and perspective to suggest distance by means of light, while still providing a faithful record. Le Gray studied painting with the history painter Paul Delaroche and even exhibited in the Paris Salon before making photographs and training other photographers, such as DuCamp and Le Secq, in his art.

Portraiture became a commercial – and for the sitters a physical – possibility during the 1840s, when the clarity of daguerrotype exposure could be obtained in less than a minute. The resulting image, however, could not be replicated. One of the first successful portrait firms sprang up in Edinburgh, where David Octavius Hill and Robert Adamson (1843–47) relied on calotype, maximizing the limits of the high contrast process by producing expressive likenesses with dramatic lighting effects worthy of a Rembrandt. Development of a new technique in the 1850s of wet-plate (or collodion) photography on glass, although demanding exposures like daguerrotypes, introduced the possibility of making multiple prints, like calotypes. At last commercial photography became a real possibility for portrait studios.

In England the first great portraitist was Julia Margaret Cameron, who self-consciously posed and lighted her famous sitters, declaring, "My aspirations are to ennoble photography and to secure for it the character and uses of High Art by combining the Real and Ideal and sacrificing nothing of Truth by all possible devotion to Poetry and Beauty . . ." In Paris the portrait innovator was a former caricaturist who had worked alongside Daumier at *Le Charivari*; his abiding interest in the faces of leading cultural figures, including artists, drew him to the new medium of photograph.

Gaspard Félix Tournachon, known as Nadar (1820–1910), made portraits in the mid–1850s that deserve comparison to any painted works of the era, stressing with unadorned frankness the "intimate resemblance" of the sitter, often a friend of the artist. Nadar even experimented with aerial photography from a balloon; his friend Daumier satirized this effort (1862) by caricaturing him in his balloon above a Paris filled with photographic parlors, along with a caption, "Nadar ele-

8.21 Nadar, *Honoré Daumier*, ca. 1855. Albumen photograph. George Eastman House, Rochester.

vating photography to the height of Art." In return Nadar memorialized the features, including the characteristic sharp and focused gaze, of *Daumier* (1859; Fig **8.21**), a work that gave special attention to composition in light and dark, like Daumier's own lithographs. The roots of Nadar's enterprise, whether in his caricature lithographs for a "Pantheon" of 1853 or in his photographs, extend back to Houdon's portrait sculptures of famous men from the late eighteenth century (Fig. 7.13), yet the informality of his portraits influenced both Manet and Degas in the 1860s. Of course, the Impressionists owed Nadar one other major debt for his early support of the most tangible kind – the donation of his studio space on the Boulevard des Capucines (viewing point for Monet's vista, Fig. **8.15**) for the first Impressionist exhibition of 1874.

CHICAGO, AMERICA, AND AMERICANS ABROAD

Americans have always been part of a dialogue between the New World and the Old, in addition to devoting their own talents, as in the case of Benjamin West (Figs 7.11 and 7.12) and John Singleton Copley, to careers abroad. (West succeeded Joshua Reynolds as President of the English Royal Academy and even worked for King George III well after the American Revolution.) Moreover, the tour of European collections and monuments was the ambition of most American artists and architects. For example, Samuel F. B. Morse (the inventor of the telegraph), who studied in London with West and became the founder-president of the National Academy of Design in New York, produced a Zoffany-like collection picture, *Gallery of the Louvre* (1833). It pays homage to the old masters and demonstrates the importance of studying originals abroad. As well as London and Paris, Düsseldorf and Munich were favored by aspiring American artists in the nineteenth century.

8.22 Albert Bierstadt, *Among The Sierra Nevada Mountains in California*, 1868. Oil on canvas, 71 × 120 ins (183 × 305 cm). National Museum of American Art, Smithsonian Institution, Washington.

LANDSCAPE

BIERSTADT One American painter of German descent who studied in Düsseldorf and traveled in Italy was Albert Bierstadt (1830–1902), whose desire was to paint the mountainous sublime of Turner with an American accent. Bierstadt traveled westward with exploratory expeditions to the Rocky Mountains and Yosemite Valley in the early 1860s, and he transformed Turner's Alps into awe-inspiring crags, such as his 1868 panorama, *Among The Sierra Nevada Mountains in California* (Fig. **8.22**). In this view all the drama of Turner's nature has been activated, from clearing storm clouds to golden light (though without the virtuoso brushwork and detached color of Turner's poetic late works). However, this is an unspoiled wilderness, an object of delightful contemplation rather than horror, intended, like the National Park system proposed in America by naturalists at just this time, to be the antidote to crowded cities.

Bierstadt's painting grew out of a period of American landscape charged with sentiment and an American version of

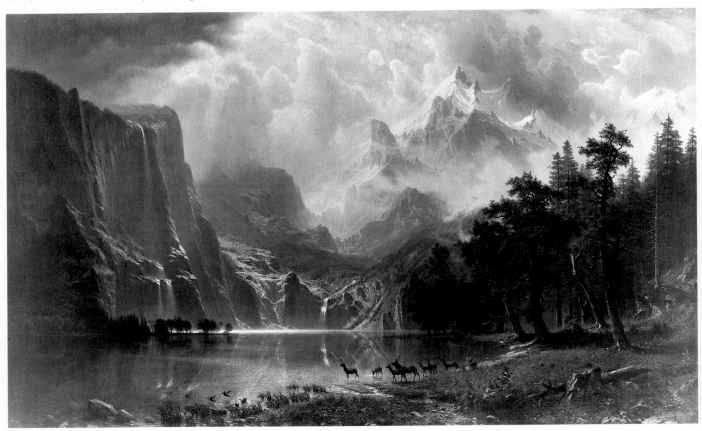

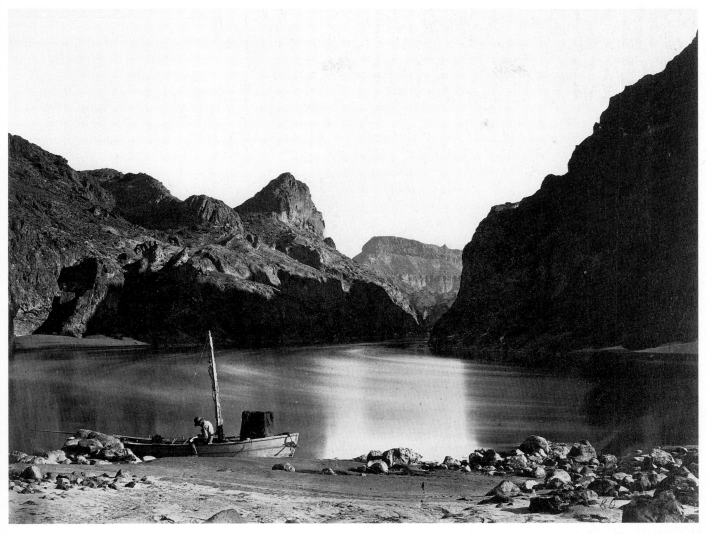

8.23 Timothy O'Sullivan, *Black Canyon, Colorado River*, 1871. Albumen photograph. J. Paul Getty Museum, Malibu, California.

the sublime, ranging from the Hudson River settings of Thomas Cole (a transplanted Englishman) in the 1820s and 1830s to the far-flung Andean and Arctic vistas of Cole's student, Frederic Church, in the 1850s and 1860s. Like Cole and Church, for Bierstadt the size of the painting had to be as grand and expansive as its subject. The foreground animals around a lake are dwarfed by the majesty of the mountains, and no trace of humanity has intruded onto the scene. Ironically, this quintessential evocation of an America still new to its own people was painted while Bierstadt resided briefly in Rome, and it was exhibited in Berlin, London, and Paris. Nonetheless, the adaptation of Turner's landscape to the new land became the basis of an assertively nationalist school of American landscape.

AMERICAN PHOTOGRAPHERS also followed the lead of European masters by taking portable collodion studios on wagons out with them into far-flung settings. Instead of Egypt, however, the Americans joined up with painters on expeditions into the unsettled Western wilderness. Some of their photographs achieved national renown through unabashed sentiment and overt religiosity, most notably Wil-

liam Henry Jackson's 1873 *Mountain of the Holy Cross*, where the pattern of snow in notches of a peak in Colorado formed the shape of a cross. Other photographers, such as Carleton Watkins in Yosemite, provided a far more documentary splendor of unretouched wonders than Bierstadt's paintings of the same locality. However, even within the constraints of the US Geological Survey, the most awe-inspiring visions of American nature, in both its grand stillness and its forbidding dangers, were produced by Timothy O'Sullivan (ca. 1841–82).

The absence of sentiment in O'Sullivan's images emerges from his own 1871 version of a lake with mountains, *Black Canyon, Colorado River* (Fig. **8.23**). Compared to Bierstadt's inflated crags and the artifice of his lighting, O'Sullivan's quiet mountain basin remains understated and bright, accented with dazzling surface ripples and deep shadows. Yet despite the presence of a lone boatman in the foreground, this is an inhospitable setting, devoid of animal or plant life, even empty of picturesque clouds. In similar fashion, O'Sullivan's evocation

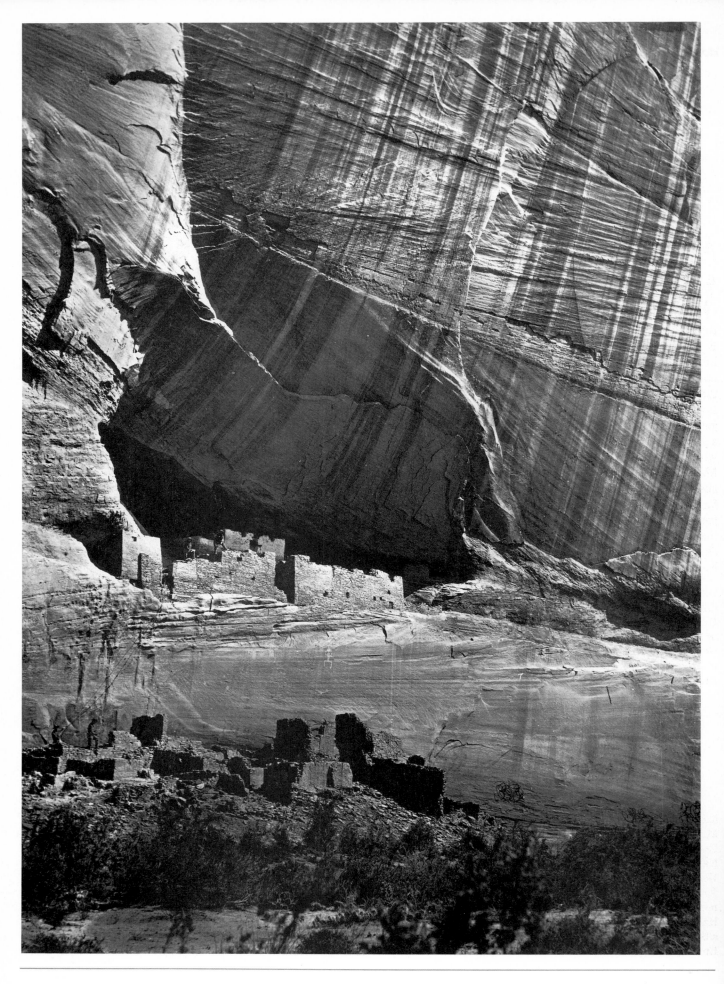

of American ruins in *Ancient Ruins in the Canyon de Chelly, New Mexico* (1873; Fig. **8.24**) shows how tenuous and temporary a toehold humankind can achieve in such a hostile environment, revealed above the pueblos by the striations caused by weathering and centuries of geological forces upon the very rock face. In contrast to the European images of Egypt's pyramids or fallen dynastic wonders, here the photograph of the American shows the dominance and time scale of nature rather than human history as his subject.

AMERICANS IN EUROPE

WHISTLER Instead of glorying in the unspoiled, inherent qualities of their country, other American artists went to the opposite extreme, continuing to align themselves with the artistic traditions of Europe. The most Europeanized American since Benjamin West was James McNeill Whistler (1834–1903), who moved to Paris as a young man and became an admirer of Courbet and Manet as well as the critics Gautier and Baudelaire. Although he settled in London in 1859, he kept up his contacts with Paris, and even joined Manet and Degas in the Salon des Refusés of 1863 with a painting entitled *Symphony in White, No. 1: The White Girl*, which was fully as scandalous to conventional critics as Manet's *Déjeuner*. That title signaled Whistler's ambition to liberate art from the strictures of narrative and academic formulas. Like Manet, he was an early enthusiast of the flatness and alterity, or "otherness," of *Japonisme*, insisting that the essence of paintings was "line, form and color." To emphasize artifice and abstraction, his titles – Symphonies or Nocturnes, each given an arbitrary number – also deliberately

conjure up the harmonies of music and the emerging doctrine of "art for art's sake."

Whistler's most famous painting, a portrait of the artist's mother, bears the ponderous abstract title *Arrangement in Black and Gray, No. 1* (1871). True to that title, the image conveys far less of the sitter than contemporary portraits by Nadar or Cameron. Instead, it carefully harmonizes the sober colors of the title as well as the composition of rectangular shapes into an overall flat yet balanced asymmetry. Like Manet's *Zola* (Fig. 8.11), Whistler's Japonisme is imprinted on his painting in various ways, including his signature mark, a butterfly monogram in the upper left corner, which imitates collectors' stamps on Japanese prints. Also, like Manet, Whistler includes self-reference in his image: a prominent print on the wall above his mother is his 1859 etching, *Black Lion Wharf*.

Whistler was one of a number of nineteenth-century artists who revived the medium of etching, emphasizing its improvisatory, personal techniques of sketchy drawing and variable tonal printing after the model of Rembrandt. He also experimented with lithography because of its rapidity and convenience; crayon drawings made on transfer paper could be directly pressed onto a printing stone. He revolutionized the marketing of both etchings and engravings by varying the qualities of his individual etched impressions and by making a distinction between prints he signed (with butterfly monogram) in pencil and those that remained unsigned. Whistler also invented the practice of systematically limiting the editions of his prints through "canceling" the copper plate or stone in order to prevent later printings. His etched subjects, in particular, emphasize the picturesque, often with a nostalgic cast: aging Thames bridges and wharves or Venetian canals,

8.24 (Opposite) Timothy O'Sullivan, *Ancient Ruins in the Canyon de Chelly*, New Mexico, 1873. Albumen photograph. George Eastman House, Rochester.

8.25 (Right) James McNeill Whistler, *Little Venice*, 1880. Etching. National Gallery of Art, Washington (Gift of Mr and Mrs J. Watson Webb in memory of Mr and Mrs H.O. Havermeyer). From "Venice, a Series of Twelve Etchings."

8.26 James McNeill Whistler, *Nocturne: Blue and Gold –* *Old Battersea Bridge,* **1872–75. Oil on canvas, 26⅜ × 19¼** **ins (67 × 49 cm). Tate Gallery, London.**

depicted with a greater intimacy and atmosphere of decay than Turner's famous models.

An example of Whistler's achievement in etching is his 1880 *Little Venice* (Fig. **8.25**, p. 345). However, in an etching Whistler could modify each print impression by using plate tone slightly differently to suggest the changing nocturnal light on open water, with the silhouetted buildings (here, Palladio's San Giorgio; cf. Fig. 5.49) and ships. In the surviving prints, Whistler's horizons vary from the silhouette effects of dusk, to the deepest black ink surface of middle night. Each print evokes an impression (in Monet's sense of the word), but now like a hazy distillation of memory, a calculated manipulation rather than the preservation of a particular moment, where the artist's rearrangement of observed natural features creates a pictorial harmony and poetic mood of reverie. Final evidence of Whistler's calculations concerning the print market for this image can be found in the deep scratches he made on the surviving copper plate in order to render it useless for future impressions.

JAPONISME

Close to some of his etchings of Putney and Battersea bridges, Whistler's *Nocturne: Blue and Gold – Old Battersea Bridge* (1872–75; Fig. **8.26**) owes a considerable compositional debt to Japanese prints, specifically to Ando Hiroshige's bridge in the colored woodcut series, *One Hundred Views of Famous Spots in Edo* (1847–48). Once more the emphasis in the picture is on color tone harmonies of blue-greens and thin, almost transparent brushwork. In the background above the flat silhouette of the bridge appear flecks of bright gold colors; these depict the glare of fireworks, and they were the subject of a controversial isolated painting, *Nocturne in Black and Gold: The Falling Rocket*, which the critic Ruskin attacked as "a pot of paint in the public face" when he visited Whistler's one-man exhibition in 1877. In return, Whistler sued Ruskin for libel, and the public trial (won by the artist but with no award) became a *cause célèbre*. Amid arguments concerning the proper finish on a painted work and time spent in painting it to a level of verisimilitude, Whistler replied that his fee and his achievement were not dependent on how many days he worked on a canvas but "for the knowledge of a lifetime." The entire debate brought to England a taste of the controversy surrounding Whistler's Paris colleagues, Monet and the French Impressionists.

8.27 Mary Cassatt, *Woman in Black at the Opera,* **1880.** **Oil on canvas, 31½ × 25½ ins (80 × 64.8 cm). The Hayden** **Collection, Museum of Fine Arts, Boston.**

8.28 Mary Cassatt, *Coiffure*, **1891. Color softground etching, 14½ × 10½ ins (36.5 × 26.7 cm). Hayden Collection, Courtesy of Museum of Fine Arts, Boston.**

CASSATT Another American, daughter of a Philadelphia industrialist, Mary Cassatt (1844–1926), made Paris her home, exhibiting her paintings with the Impressionists after 1877 and citing Manet, Courbet, and Degas as her "true masters." She benefited from the encouragement of her friend, Edgar Degas, who used her as a model for one of his own finest etchings, *At the Louvre: The Painter Mary Cassatt* (1879–80), a work whose framing through a doorway and richly textured decorative patterns show an allegiance to the pictorial conventions of Japonisme. Cassatt, too, deployed silhouetted forms in dark costume and the eccentric bird's-eye perspective of Japanese prints in her painted compositions.

Woman in Black at the Opera (1880; Fig. **8.27**) takes up a popular theme of Impressionist artists from modern Paris, but in characteristic Cassatt fashion this work views the commonplace event of an outing at Garnier's Opéra from a unique and female vantage point. The artist's principal attention is on her female subject, who holds opera glasses in her hand; at the same time, the oblique curve of the loges (boxes) occasions a spatial dislocation as severe as the perplexing mirror in

Manet's *Bar at the Folies-Bergère*. Even while she attends to the stage, this vulnerable woman in a public place is herself the object of a male gaze, from a man on her level whose opera glasses are trained on *her*. In this painting Cassatt makes explicit the tension between public and private demeanor in the crowded leisure spaces of the modern city. Little wonder, then, that most of her paintings and prints depict women only in the company of other women or children and in spaces confined to the private sphere of the home (for example, the contemporary *A Cup of Tea*, ca. 1880).

In 1891 Cassatt's ten colored, soft-ground etchings made full use of Japanese inspiration to produce memorable images of women in the most intimate moments of modern private life. A work like *Coiffure* (Fig. **8.28**) explicitly derives from Japanese prints, using multiple tints, printed simultaneously (*à la poupée*), to simulate the several colored blocks of the woodcut models. Both her theme of unclad informality and the juxtaposed color patterns link Cassatt to the precedents of such eighteenth-century printmakers as Suzuki Harunobu (*Eight Views of Indoor Life*, 1765) and Kitagawa Utamaro (*Ten Aspects of Feminine Physiognomy*, mid–1790s; Cassatt owned a dozen of Utamaro's prints). The features of Cassatt's figure even have the almond eyes of her models.

Of course the receptivity to both the subjects and forms of such Japanese examples was conditioned in Cassatt by her experience of the intimate images of women bathing and the eccentric perspectives and pastel colors introduced by her good friend, Degas. Yet the common subject vividly underscores the contrast between Cassatt, a woman depicting women, and her sources, Utamaro and Degas. Whereas the latter artists offer the intimacy of voyeurism, Cassatt's world remains domestic, pairing *Coiffure* with prints of a *Fitting*, *Letter-Writing*, or *The Bath*, where a mother tends her child rather than exposing her own nude body.

REBUILDING CHICAGO

The renovation of Paris under Haussmann was traumatic for those residents who cherished aspects of the older city, but in America most cities still had room to grow from scratch and architectural traditions had to be imported from Europe. Hence the development of modern buildings was often welcomed, as indeed were many of the technological innovations, such as the elevator of Elisha Graves Otis in New York (1852). Even more drastic than the overhaul of Paris was the renewal of Chicago after the disastrous fire of 1871.

As in Europe, American construction with a cage of iron or steel was initially reserved for buildings of a more practical nature rather than for cultural showplaces. Commercial buildings similar to the Bon Marché department store in Paris were quickly erected in American cities. Their large window openings within cast-iron façades provided a bright alternative building form amidst crowded lots and permitted maximum use of open space within such structures because of the reduction of load-bearing walls.

THE MARSHALL FIELD STORE Typical of both the revival of Chicago and the design of a modern warehouse with an iron armature was the Marshall Field Store (1885–87; destroyed), designed by the Massachusetts architect, Henry Hobson Richardson (Fig. **8.29**). Richardson (1838–86) was the second American to enroll in the Ecole des Beaux-Arts in Paris (1859–62), so he was mindful of older French traditions of stone masonry as well as some of the most recent designs of Haussmann's boulevards, plus innovative combinations of the two, such as Henri Labrouste's Ste.-Geneviève Library (1842–50), a masonry shell enclosing iron vaults.

The Marshall Field Store occupied an entire city block, and its internal structure was iron, but Richardson insisted on constructing an imposing masonry façade, based on his lifelong love of stone massing. The characteristic uses of coloristic (here, red sandstone) and historicist elements common to Richardson buildings provided dignified solidity for all his projects, whether churches, homes, train stations, or courthouses (Richardson's last great structure was the Allegheny County Courthouse in Pittsburgh, 1884–88, completed posthumously). These elements linked his massive, austere designs, known as "Richardson Romanesque," to other nineteenth-century historicist architecture, from Schinkel's National Theater (Fig. 7.36) and Barry and Pugin's Houses of Parliament (Fig. 7.39) to Garnier's Opéra (Fig. 8.1). For the Marshall Field Store, Richardson employed unbroken stone piers as his frames, suggesting the vertical emphasis of iron

8.29 Henry Hobson Richardson, Marshall Field Store, Chicago, 1885–87 (destroyed).

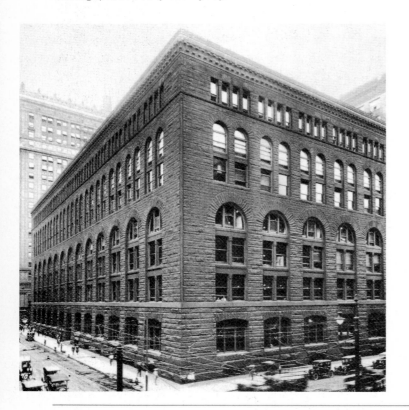

even where it was not present; at the same time his rounded arches for window openings and heavy *cornice* suggest classical elements close to the largest Renaissance palaces. Imitations of Richardson's masonry constructions became the favored style for public buildings in American cities at the end of the nineteenth century.

Nonetheless, subsequent Chicago architects rejected the historicist elements of Richardson's masonry architecture and embraced the clarity and modernism of iron-cage construction. William Le Baron Jenney led the way with his Home Insurance Building (1884–85), followed by massive downtown department store buildings, especially the Second Leiter Building (1888–91), a block like Richardson's Field Store but now composed only out of steel beams (thanks to Bessemer's steel process of 1856) in a lattice grid instead of rounded stone arches. This metal frame could support its own weight without traditional walls, thus opening up unbroken, uniform interior space for flexible subdivision through "curtain" walls. Such a building would be much brighter than masonry structures, allowing glass to be used as extensively as in the Gothic cathedrals. In Chicago, a new local window design was developed to straddle the width between girders and to provide visual rhythm: one large, fixed central window with two supportive side sash windows for circulation. Of course, with the reduction in the weight of buildings and the strong yet uniform thickness of their walls on steel cages, the possibility for vertical expansion was soon adopted (masonry buildings had to have thicker walls at their base, reducing window openings at street level, and they had practical constraints of about ten storeys). The symbol of modern America, the skyscraper, could now be developed.

SULLIVAN The architect who perfected the classic design of the early skyscraper was another Chicagoan, Louis Sullivan (1856–1924). Sullivan, too, trained at the Ecole des Beaux-Arts, but his approach to building was increasingly non-historicist. It was Sullivan who coined the phrase that became a watchword of modernist aesthetics – its original meaning greatly reduced by later architects – "form follows function." In partnership with Dankmar Adler, Sullivan produced a cultural variant on Richardson's Marshall Field Store with his Auditorium Building (1887–89). This multipurpose block also filled an entire Chicago city street; its ten storeys included a theater, hotel, and office building. In the 1890s, however, Sullivan worked more systematically on the development of his skyscraper formula, first in St. Louis (Wainwright Building, 1890–91), then in the Chicago Stock Exchange (1893–94; destroyed), and finally a tower block located in Chicago's rail partner, Buffalo (Guaranty [now Prudential] Building, 1894–95; Fig **8.30**).

Because a steel-cage construction has no inherent articulation within its identical interlocking parts, Sullivan turned to Richardson's Field Store for inspiration. Ultimately his solution in the Wainwright and Guaranty buildings was to model the vertical segments of his skyscraper blocks on the classical columnar orders, though without the historicism of detail and

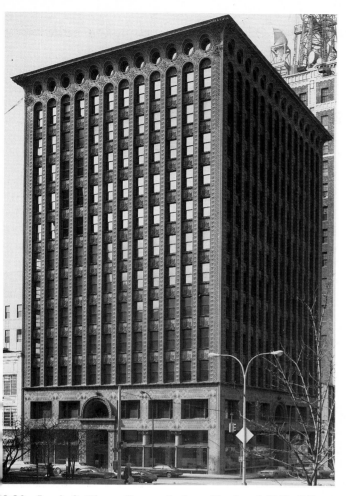

8.30 Louis Sullivan, Guaranty (now Prudential) Building, Buffalo, 1894–95.

ornament that he objected to in Beaux-Arts designs. The structure consisted of a strongly defined base of two storeys with central entrances, marked in Buffalo by a rounded arch over the main door. In the main, "columnar" central segment of the building, Sullivan emphasized the verticality of the block through unbroken vertical piers, twice as many as the actual girders of the structural support, and he ran their course like fluting (or Gothic window mullions) above the horizontal members of the floors. These piers terminate at the capital stage with climactic rounded arches surmounted and echoed by round *oculi*. The entire thirteen-storey building is capped by a strong terminal cornice that reasserts the firmness of structure.

Sullivan did not abjure ornament like some of the more pragmatic Chicago architects. Indeed, he collaborated with an ornament designer, George Elmslie, to provide his fireproof terracotta piers and other surfaces with a lively and organic character not available from the materials themselves, especially around the *oculi*. Because terracotta (and cast iron) could be molded, Sullivan could use them to suggest vegetal living matter, animating the building block and springing from it (on the Guaranty Building, the *oculi* wall surface swells outward at its corners to join the cornice). Sullivan's ornament articulates his building's several surface parts while fusing them into a more organic whole.

Back in Chicago at the turn of the century, Sullivan realized the perfect fusion of structure and ornament in his own version of the department store, Schlesinger and Mayer (now Carson Pirie Scott), built 1899 to 1903/4 (Fig. **8.31**). Here all the upper storeys have been defined by subtly inset Chicago windows, and the principle of the vertical skyscraper has been rotated 90 degrees so that the unbroken terracotta courses run horizontally to echo the large storefront windows of the ground floor. In conjunction with this transparent expression of

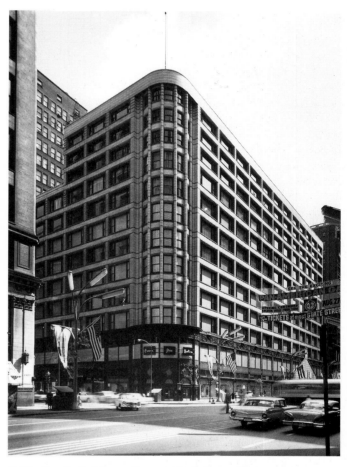

8.31 Louis Sullivan, Carson Pirie Scott Department Store, Chicago, 1899–1900, enlarged 1903–04. Exterior.

8.32 Louis Sullivan, Carson Pirie Scott Department Store, Chicago. Detail of cast-iron ornament.

the steel skeleton of the building Sullivan introduced his most exuberant cast-iron ornament at the entrance corner, and its scrollwork finds echoes above the street-level glass openings (Fig. **8.32**). These iron frameworks together define the lower pedestal segment of Sullivan's modified columnar structure, and the refined ornament continues above with delicate terra-cotta moldings around the windows. The entire structure pivots horizontally around the ornamented entry and its columnar hub of rising corner piers, the only unbroken vertical element in the entire elevation of the building. Independent of the burden of historical styles, Sullivan was free to create in wide-open modern Chicago an elegant and invitingly ornamented form to grace a necessary urban function.

DOMESTIC ARCHITECTURE: WRIGHT

If Sullivan's large-scale buildings attempted to appropriate nature in the form of ornament, then the American fantasy of living with nature, expressed in the welcoming painted wildernesses of Cole and Bierstadt, informed the Prairie School ideals of Sullivan's younger associate, Frank Lloyd Wright (1869–1959). Even while the influence of the 1893 Chicago World's Fair (Columbian Exposition) was shifting American taste in buildings back toward the grandeur, the ornamentation, and the historical styles of Beaux-Arts instruction, Wright applied his principal designs to tranquil and suburban domestic architecture. His aim of making the household into a collective unit in a space that could be considered a work of art had much in common with Pugin's and Ruskin's nostalgia for preindustrial life, and the resulting English Arts and Crafts movement. Although Wright also steadfastly denied deriving any of his ideas from foreign sources, the austere simplicity of the Japanese house surely shaped his own reaction against Victorian box spaces and turreted accretions. He was inspired by the Japanese example of working in natural materials, particularly wood, and creating interpenetrating open spaces, demarcated by bright, screenlike wall surfaces with dark trim. Even if the influence was unacknowledged (though he could have seen a Japanese temple at the 1893 World's Fair, and he did collect Japanes prints and went on to design the Imperial Hotel in Tokyo), Wright's use of Japanese sources as an alternative to the prevailing styles and academicism of his own era parallels the French embrace of Japonisme in visual arts.

For Wright the family was the cornerstone of an ordered, democratic society, and the center of family life – and consequently of all his domestic designs – was the hearth. On one of the rare occasions when he designed an office building, the

8.33 Frank Lloyd Wright, *Larkin Building*, Buffalo, 1904 (destroyed). Exterior.

8.34 Frank Lloyd Wright, *Larkin Building*, Buffalo, 1904. Interior.

8.35 Frank Lloyd Wright, Robie House, Chicago, 1909. Exterior

8.36 Frank Lloyd Wright, Robie House, Chicago. Interior and plan.

Larkin Building not far from Sullivan's Guaranty Building in Buffalo, Wright imposed his own familial ideals onto its structure (Fig. **8.33**). Built around a skylit atrium that filled the entire interior of the building, the office structure was also lit by Chicago windows on its flanks. Wright employed structural piers around his interior, but used warmer tones of brick for the cladding as if to bring the home into the office space (Fig. **8.34**). The architect composed here in large, pure blocks of spaces and solids, all the while fostering integration and interpenetration along the floors and across the storeys of the atrium. He also supervised the design and production of all furnishings in the Larkin Building to promote the harmony of even the smallest parts within the ensemble. Wright would only once more design such a comprehensive industrial ensemble, for the Johnson Wax Company (Racine, Wisconsin, 1936–39), but there too he retained his principles of integrated space to express a paternalistic ideal of business.

In his Prairie School homes Wright's obsession with "breaking the box" of domestic settings developed out of his study of Japanese elements. In the modest but tightly crafted Robie House (1909; Fig. **8.35**), a ribbon of window openings serves to dissolve the walls of the main living space, which is sited around the family hearth (Fig. **8.36**). He also eliminated doors and enclosing walls from the low-ceilinged, paneled main spaces on either side of the hearth. By means of a thrusting roof-line like the prow of a ship, supported by *cantilevering* (with internal steel beams), he extended the living area onto a porch outside, blurring the distinction between indoor and outdoor space. The extended horizontal proportions recall the openness of the Midwestern prairie. Robie House seems to radiate outward in terraces, balconies, and open spaces from the fulcrum of its fireplace and chimney, like the growth of boughs from the trunk of a tree (see plan). Again, Wright attended to all the details of his work, from the slablike,

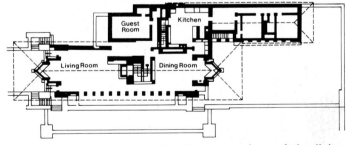

custom-made bricks, imitating the proportions of the living spaces, to the grill-like, rectilinear furniture, whose planes and surfaces harmonize with the accents and natural materials of the interior. Here the austere aesthetic of modernity, imposed by steel construction, has been adopted out of preference for geometric abstraction over historic styles or surface ornament. With a heightened attention to "organic" aspects in his work, however, Wright complements this integrated, emphatically "modern" design by his consistent use of natural materials and attention to the site.

SENSE AND SENSIBILITIES

The depiction of modern urban life and leisure had been among the aims of French painters during the era of Courbet's Realism and Monet's Impressionism. However, the term "impression" contains a tension between the objective depiction of a landscape setting and the subjective visual sensation of an individual viewer. By their evocation of momentary, subjective experiences, Manet's *Gare St.-Lazare* or Whistler's *Nocturnes* turned painting away from the goal of naturalistic transcription toward self-consciously suggestive, abstract formal constructions. Whistler could liken his harmonies to music, Manet to the poetry of his friend Mallarmé, who is quoted as saying, "Paint, not the thing, but the effect that it produces." Whistler in fact declared explicitly that "Nature is usually wrong," and that if painting were only about imitation then the photographer would be king of the artists. He cultivated a concept of purity, even sanctity, of a separate aesthetic realm inherent in the phrase "art for art's sake." For French artists in the 1880s and 1890s the reassertion of artistic manipulation and subjectivity guided a diversity of responses to the naturalist orientation of Impressionism usually called Post-Impressionism and Neo-Impressionism.

SEURAT

Even beginning with a premise like Monet's that painting could present vivid effects of lighting through the use of unmixed, contrasting colors, Georges Seurat (1859–91) went beyond the Impressionist model in his compositions ("Art is harmony"). Following the procedures of the Academy, Seurat did not attempt to record the visual impression of a single moment painted outdoors. Instead, he worked up a vivid picture of a contemporary scene through numerous studies, drawings as well as oil sketches, of both individual figures and the overall composition.

For his *Sunday Afternoon on the Island of La Grande Jatte* (1884–86; Fig. **8.37**), displayed at the final Impressionist exhibition in 1886, Seurat retained the favorite Impressionist subject of summer bourgeois leisure, choosing a favorite Paris park akin to Monet's Bougival or Argenteuil. The subjects wore the latest fashions, whether informal for boating or formal bustles and top hats. Yet Seurat's continual refinement of figural shapes and his calculated overall composition, manipulating curvilinear echoes and colors, produce an image more powerful for its static abstractions than for its observation. Moreover, in contrast to the easel paintings of Impressionist outdoor scenes, the scale of this work is as large as the grandest Salon works. Observed elements, like the bright pools of light amid shadow, are overlaid with simple geometrical structuring as well as Seurat's obsessive, small, dot-like brushstrokes. He composed in tiny juxtaposed bursts of

primary complementary colors according to scientific theories of perception and color, as developed especially by Michel Eugène Chevreul, Ogden Rood, and Charles Henry (*A Scientific Aesthetic*). Seurat objectifies and rationalizes the perceptual ingredients inherent in Monet's concept or "impression" to the exclusion of spontaneity or individualized subjectivity.

CÉZANNE

Another kind of reduction to essentials was developed out of Impressionism by Paul Cézanne (1839–1906), whose work and career took a deliberate turn toward introspection and isolation. After exhibiting with the Impressionists as late as 1877, Cézanne returned to his home town, Aix-en-Provence, in southern France, and fixed his attention on a limited repertoire of generic subjects, neither modern nor historicist: landscapes and still lifes.

The insistent brushwork and meticulous color harmonies in Cézanne's representations of natural objects are a reminder of the intensity and individuality of the artist's own contribution to a picture, the subjectivity inherent in capturing an "impression." Because of the removal of the human or momentary elements from Cézanne's still lifes or landscapes, his images appear to have a more universal significance. During the 1890s Monet, too, repeatedly painted in series the same simplified subjects – grainstacks, cathedral façades, or poplar groves – to suggest the primacy of technique as well as a particular sensibility on the part of the artist to harmonize shifting "sensations."

In a landscape painted in Aix-en-Provence, *Mont Sainte-Victoire* (ca. 1885–87), Cézanne juxtaposes colors (here primarily golds and greens) and manipulates shapes that pick out echoing curves between mountains, river bed, and foliage and the visual intersection of a central tree with a railroad viaduct (Fig. **8.38**). This composite order still suggests an affiliation with Impressionism in its use of colors to create effects of light and space and in its depiction of a local landscape. However, the flatness of the brushwork and shapes contends with its intention, and the manifest artifice of its composition contrasts with the informality and seeming spontaneity of many Impressionist works. This meticulously constructed landscape

8.37 (Opposite, above) Georges Seurat, *Sunday Afternoon on the Island of La Grande Jatte*, 1884–86. Oil on canvas, 81 × 120 ins (205.7 × 304.8 cm). Art Institute of Chicago, Bartlett Collection.

8.38 (Opposite, below) Paul Cézanne, *Mont Sainte-Victoire*, ca. 1885–87. Oil on canvas, 25¾ × 32⅛ ins (64.5 × 81.6 cm). The Metropolitan Museum of Art, New York.

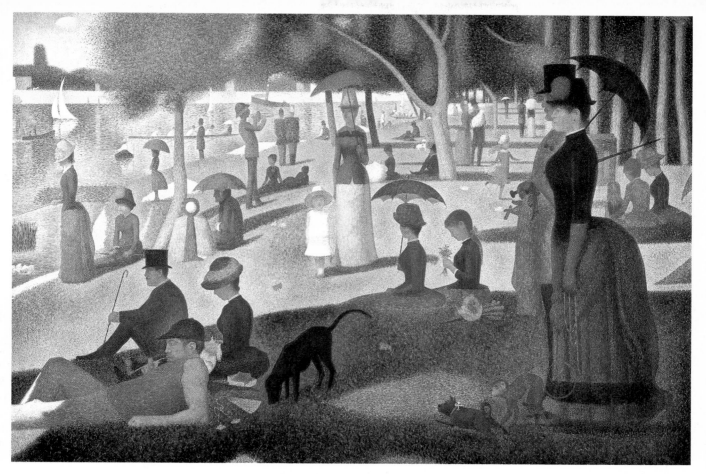

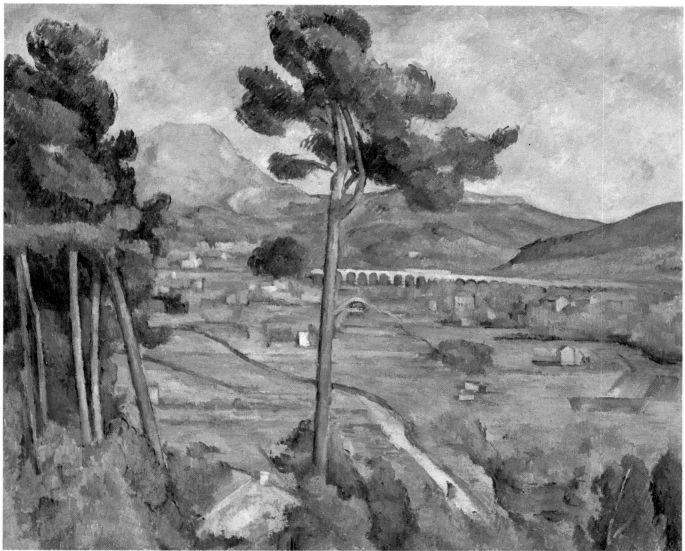

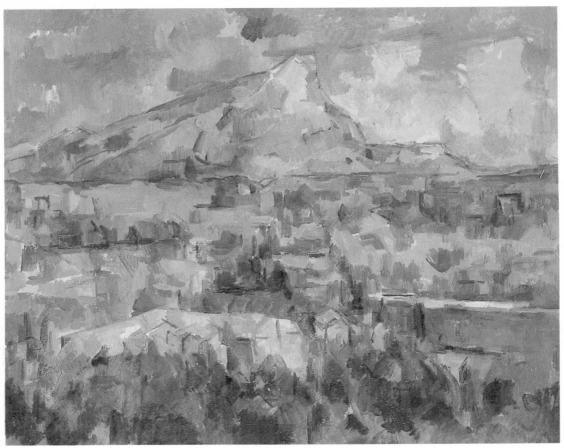

8.39 Paul Cézanne, *Mont Sainte-Victoire*, 1902–06. Oil on canvas, 27½ × 35¼ ins (69.8 × 89.5 cm). Philadelphia Museum of Art, Elkins Collection.

8.40 Paul Cézanne, *Large Bathers*, 1899–1906. Oil on canvas, 82 × 98 ins (208.3 × 248.9 cm). Philadelphia Museum of Art, Wilstach Collection.

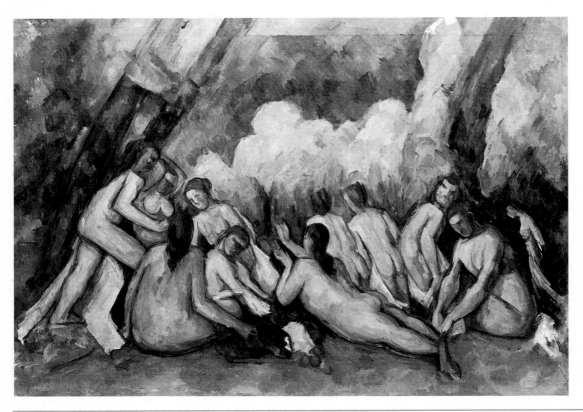

also deliberately evokes "classic" settings by the great French seventeenth-century academic standard-bearer, Poussin; moreover, Cézanne intended the comparison, for he spoke of "remaking Poussin by way of nature."

At the end of his career, Cézanne was still engaged with the same subjects. His late *Mont Sainte-Victoire* (ca. 1902–06) now turns away from the composition of shapes in favor of a patchwork of brush strokes in basic colors (green, yellow, blue) above a rudimentary basic design (Fig. **8.39**). Patches of color are now detached from local forms: color and handling assume independent importance as signs of the distinctive, original "interpretations" of the painter himself. In his final works, the external reality that gave such a stimulus to the Impressionists is fully subordinated as a motif to the construction of a visual harmony of color contrasts and parallel brush strokes, without any explicit line or modeling. Art, like the nature of Cézanne's landscapes and still lifes, exists apart from ordinary perception, entirely as the construct of the artist.

Cézanne, however, also aspired in his final decade to making his own contribution to the history of art in the form of classical nude subjects, specifically in combination with landscape backdrops. Such a subject further distanced him from the *plein-air* enterprise of the Impressionists, although similar historical ambitions underlay the Salon paintings and historical references of Manet in the 1860s. The climax of many preparatory studies in watercolor and oil paint, the *Large Bathers* (1899–1906) composes its clusters of figures into pyramidal shapes, echoed by the artificial canopy of trees (Fig. **8.40**). The entire painting, the largest of Cézanne's career, is painted thinly, as if in the artist's watercolor technique, in a harmony of tans, blues, and greens, using delicate swatches of brushwork. After nearly four centuries of carefully modeled and sensuously erotic female nudes in outdoor settings, from the Venuses of Botticelli or Giorgione, this image subordinates the human dimension of its tradition to the manipulation of formal elements. (Cézanne also worked on a variant series of male bathers, especially for his *Large Bathers* lithograph of 1896–98.) Some of the figure poses may derive from his museum studies of antique statuary, including the renowned *Venus de Milo* in the Louvre, but they remain subordinate to the overall compositional structure, shaped by the setting.

EMOTION THROUGH FORM: VAN GOGH

Like Cézanne, Vincent van Gogh (1853–90) spent the final years of his brief career, ended by suicide, in southern France, chiefly at nearby Arles. Van Gogh, however, sought an art that was anti-materialistic. Trained as a fervent evangelical in Holland, van Gogh had spent time as a missionary in a Belgian coal-mining village, and in his art he tried to portray the dignity of humble labor. Often his later paintings are idyllic visions of farming peasants, emulating the mid-century era of Courbet – or, more important for van Gogh, Jean François Millet. This nostalgia in the industrial age for the countryside and the simple satisfactions of its farmers also underlay

8.41 Vincent van Gogh, study for *The Sower*, 1888. Vincent van Gogh Foundation, Van Gogh Museum, Amsterdam.

Monet's series of "Grainstacks," but van Gogh focused on the human dimension or the specifics of locality. Moreover, thanks to the encouragement of his brother, Theo, an art dealer in Paris, Vincent spent a year (1886–87) in the city, discovering the vibrant colors and self-conscious brushwork of the latest painting, particularly Seurat's *Grande Jatte*.

Hence, when he painted *The Sower* (1888) in rural Arles, van Gogh focused on the bond between the farmer and his fields, depicted as freshly plowed through the energetic brushwork of thick, creamy pigment (Fig. **8.41**, p. 355). The dark silhouette of the anonymous sower is echoed by the angular dark shape of an old, trimmed tree, whose sprouting boughs already suggest new life and growth to match the promise of the scattered seeds. Behind the entire scene stands the brilliant golden globe of the sun, source of all life, which suggests the allegorical significance and sublimity of a Turner epic, here imposed deliberately on the French rural countryside. The strength and seasonal regularity of sun, farmer, and field stand together as the very image of stability, antipodes to the constant flux and crowding of the modern city. At the same time, the intensity of execution reveals the degree to which this symbolic message also expresses the deepest personal convictions and emotions of van Gogh.

The Sower was painted while Vincent was in contact with another powerful artistic personality, Paul Gauguin (1848–1903; see below), who spent two turbulent months living with van Gogh at the insistence of Theo, who was also his dealer. From Gauguin, van Gogh learned a simplified stylization of shapes in pure, unbroken color. In his letters to Theo, Vincent claims to be using colors as powerful symbols, arbitrarily, as if forcing himself away from nature as his source toward memory and mystery. Even early letters show his tendency to endow nature with "expression and soul." He sought to draw the sensitive viewer into sharing this universal feeling through the forms of his paintings.

In his *Night Café*, for example, van Gogh experimented with contrasting complementary colors, not simply for their visual vibrancy like Seurat, but rather to convey a state of emotional revulsion or horror: "I have tried to express the terrible passions of humanity by means of red or green . . . the idea that the café is a place where one can ruin oneself, go mad or commit a crime" (Fig. **8.42**). Indeed, he describes the shocking walls of this picture as "blood red" against a yellow glare to create an "atmosphere like a devil's furnace, of pale

8.42 Vincent van Gogh, *Night Café*, 1888. Oil on canvas, 28½ × 36¼ ins (72.4 × 92.1 cm). Yale University Art Gallery, New Haven.

8.43 Vincent van Gogh, *Wheatfield with Cypresses and Flowering Tree*, 1889. Pen and ink on paper, Vincent van Gogh Foundation, Van Gogh Museum, Amsterdam.

sulphur." His letters also attest to the importance of a simplified technique as the mark of sincerity, an extension of the Impressionist credo that the seeming lack of composition of a landscape attested to the spontaneity of its having been painted directly while outdoors. Van Gogh considered both the *Night Café* and *The Sower* to be his "ugliest" pictures, but "these are the only ones which appear to have any deep meaning." His repeated copying of favorite Japanese prints, usually landscapes of Hiroshige, also stimulated his use of simplified forms, strong color areas, and oblique and striking perspective displacement, as in the *Night Café*.

The projection of emotions through vibrant forms extended for van Gogh to ordinary landscapes and even still-life objects, particularly flowers, such as sunflowers. The combination of form and feeling can be seen in van Gogh's landscapes with cypresses, such as his 1889 ink drawing, a study for a painting, *Wheatfield with Cypresses and Flowering Tree* (Fig. **8.43**). Here, as in the artist's oils, each substance is given its own visual equivalent, in tone of ink and consistently repeated strokes, as if each element of the landscape were recreated individually. The energy of the penwork line for both earth and sky again suggests the intensity of Vincent's perceptions, in contrast to the stability and ordered structuring of Cézanne displayed in similar southern settings. However, the flamelike cypresses also had their own deeper significance – as markers in southern France for the site of a grave, for van Gogh they connoted death in the midst of life and growth. Hence, along with the assertion of the primacy of original artistry and technique over any direct transcription of nature, in the tradition of Romantic poetry van Gogh also included in his pictures his own strong concern with life and death.

ESCAPE TO THE PRIMITIVE: GAUGUIN

The artistic program of Paul Gauguin was explicitly religious while, at the same time, like van Gogh, he sought to retreat from modernity toward an "unspoiled" simpler existence. For the visual equivalent of these ambitions, Gauguin took the model of Japonisme, reducing his images to stark, unmodeled areas of color within firm outlines. Like Courbet in 1855 and Manet in 1867, Gauguin and his associates used the Paris World's Fair of 1889 as a staging-ground for their radically simplified forms, when they mounted an exhibition outside the Eiffel Tower gateway of the fair at the Café des Arts (Café Volpini). Like van Gogh and Cézanne, Gauguin had already retreated from Paris to a simpler rural French society at Pont-Aven in Brittany (1886–90), interrupted by his brief stay with Vincent in Arles in 1888. However, in search of a more genuine primitivism, he also briefly visited the French Caribbean colony of Martinique in 1887. In the wake of his experience of Javanese natives at the 1889 fair, he made his bold move to Tahiti, first in 1891–93, then for the remainder of his life, 1895–1903.

During his final year in Brittany, Gauguin painted *Yellow Christ* (1889), a work whose religious content is given a local context (Fig. **8.44**, p. 358). The image is of Breton peasant women, dressed in their native costumes and linen caps, kneeling in prayerful meditation at a humble roadside crucifix. In an effort to bring the observer into the picture, Gauguin has used the framing edge of the canvas to truncate the figures, in

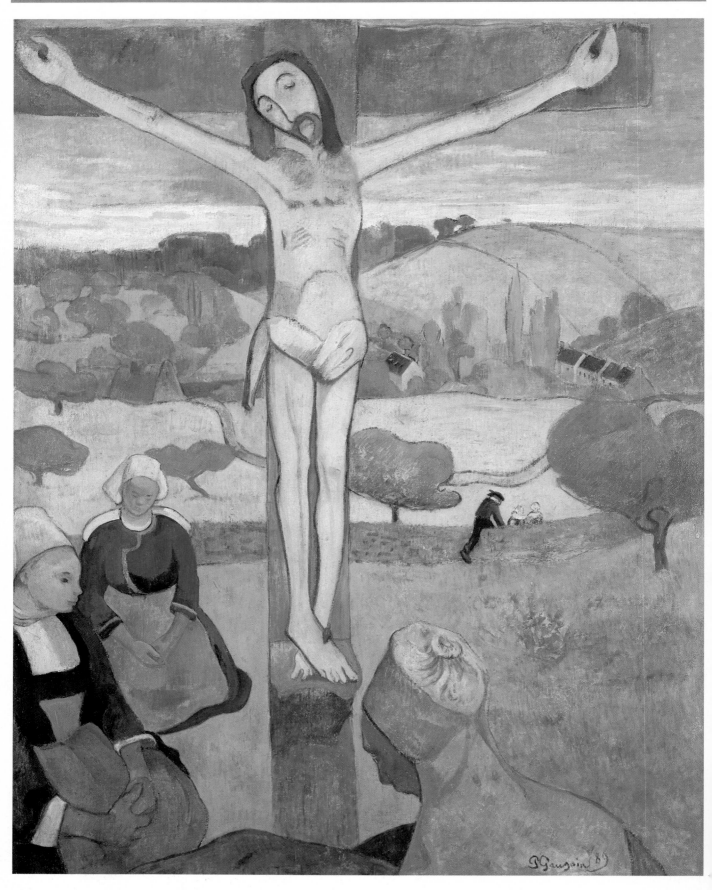

8.44 Paul Gauguin, *Yellow Christ*, 1889. Oil on canvas, 36⅜ × 28¾ ins (92.7 × 73 cm). Albright-Knox Art Gallery, Buffalo.

the manner of Japanese prints. The setting, too, uses the bold color shapes of Japonisme to reduce the range of autumnal hues, arbitrarily echoed by the yellow Christ figure. Gauguin celebrated the unquestioned faith of the simple peasant women by utilizing a "naive" or "primitive" technique in his painting, which matched the form and sincerity of this folk crucifix. Moreover, he also exalted his own artistic strivings by identifying himself with the suffering Christ, for in the same year he produced two works of near-blasphemy. In one of them Gauguin put his own features on a red-bearded Christ in agony on the Mount of Olives (a work that offended the pious van Gogh, who went ahead and painted olive groves as a response); in the other he juxtaposed the yellow crucifix canvas with a self-portrait. The artist, then, exists both as creator and sufferer, whose life mission, though accompanied by poverty and even ridicule, will eventually triumph with an art that expresses true spirituality.

Even in Tahiti, Gauguin continued to strive for the same mixture of profound subjects and non-representational colors. His 1894 *Day of the God* attempts to present the mystery of Polynesian religion as equivalent to the fervent Christianity of

Brittany (Fig. **8.45**). In fact, the sculpted deity at the center of the picture is a fabrication by Gauguin, based on photographs of ancient Javanese sculptures. The nude figures in fetal position repeat poses suggestive of both birth and death. Such poses had already been used by Gauguin for roughly carved, sketchily printed, hand-colored woodcut images with the general title "The Specter Watches over Her" (Manao tupapau; there was a similar woodcut of The *Day of the God*). The significance of this painting is made explicit in the title of another large allegory of 1897, with figures in similar poses beneath an almost identical idol; it bears the enigmatic title, *Where Do We Come From? What Are We? Where Are We Going?* In *Day of the God*, beneath the feet of the figures, a pool of water has dissolved into the ultimate mystery – a welter of brilliant, unrelated colors.

For Gauguin Tahiti offered an ideal escape, akin to the

8.45 Paul Gauguin, *Day of the God (Hahana no atua)*, **1894. Oil on canvas, 27³⁄₈ × 35⁵⁄₈ ins (69.5 × 90.5 cm). Art Institute of Chicago, Bartlett Collection.**

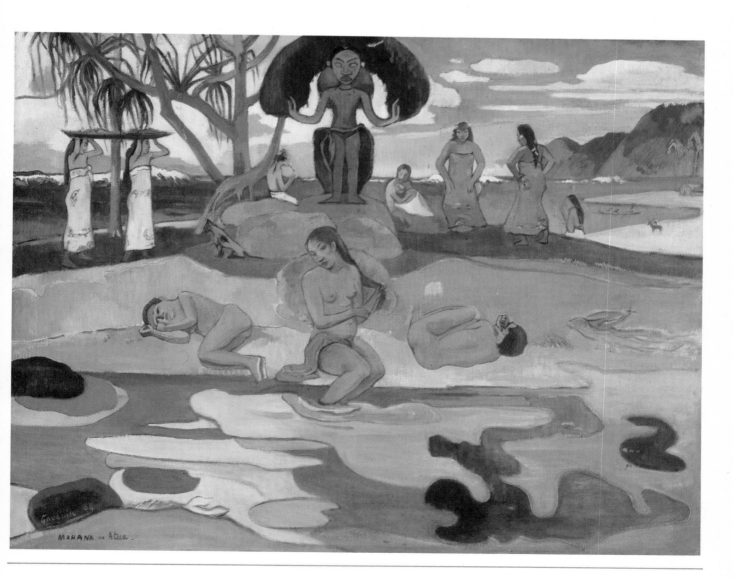

Orientalist fantasy of Delacroix's Algeria. He was already predisposed to find in Tahiti the charged sensual primitivism that also marked Delacroix's harem in works such as the *Women of Algiers*. In 1890, shortly before his departure from Paris, Gauguin carved a stylized, rough wood relief, based on Javanese models he had seen at the 1889 World's Fair. Depicting one of his favorite symbols of the period, a nude woman in the waves, Gauguin entitled his work *Soyez mystérieuses* (Be Mysterious; Fig. **8.46**). Gazing at the face of a mirroring female moon-head, this figure suggests a link between womankind and nature as well as a complex mixture of spirit and matter. A similar set of symbolic images appeared during the interval of his return to Paris from Tahiti, 1893–94, when Gauguin wrote a book of memoirs, *Noa Noa* (Fragrance). For this project he also produced tonal prints of apparently nocturnal scenes, using the medium of woodcut, because this early form of European printmaking would have been equally accessible to Polynesian artisans. The entire ambition of both artworks, text as well as prints, is to simulate the closeness to nature as well as the enviable primal religious sense of the "savage." The titles of his prints suggest fantasy and reverie, later crystallized in *Day of the God: The God* (*Te atua*), *Fresh Water is in Motion* (*Auti te pape*), *To Make Love* (*Te faruru*), and *Delightful Land* (*Nave nave fenua*).

8.46 Paul Gauguin, *Soyez mystérieuses*, 1890. Wood relief. Musée d'Orsay, Paris.

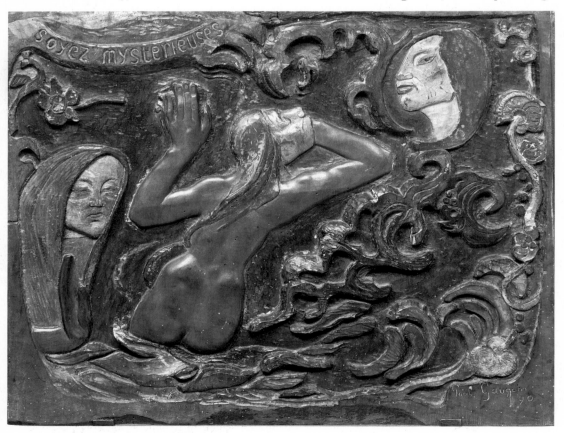

THE SCULPTURE OF RODIN

While Gauguin used the human figure to represent spiritual mystery, even in the form of relief carvings, the leading French sculptor, Auguste Rodin (1840–1917), used the human form to reveal inner states. His most ambitious work, commissioned in 1880 to adorn the proposed Museum of Decorative Arts in Paris, was a portal of *The Gates of Hell* (Fig. **8.47**). Never finished, the work was cast posthumously from plaster models, but it contains in miniature some of the most famous figure groups, cast separately in a larger scale by Rodin. Amongst these was the *Thinker*, a brooding Michelangelesque nude (influenced both by the Medici tomb and by the painted *Last Judgment*) above the lintel of the museum portal (Fig. **8.48**). Originally conceived as the poet Dante, whose *Inferno* inspired the theme of the *Gates of Hell*, the *Thinker* (Fig. **8.49**) eventually became a generalized personification of the creative poet or artist. It is like a projection of the sculptor himself, brooding about the imagery surrounding him (later, as if brooding about immortality, the figure adorned Rodin's own grave). Rodin planned to have a standing Adam and Eve in a similar role, alongside the doors, and he cast them as separate figures; the *Adam*, multiplied by three, eventually became the triad of the Three Shades atop the final *Gates of Hell*. This group, too, was cast as a large and separate image. Other figures were extracted from the writhing interlaced bodies within the domain of hell, such as the stretching, upward-striving nude; as a separate figure he was designated the

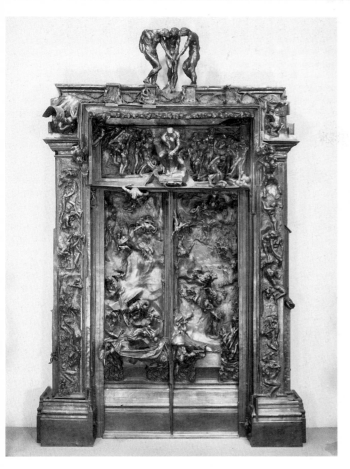

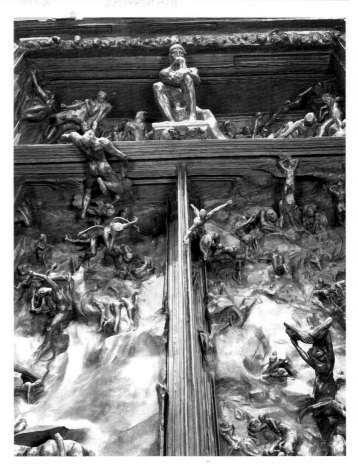

8.47 Auguste Rodin, *Gates of Hell*, 1880–1917. Bronze, 18 feet (5.5 meters) high. Stanford University Museum of Art. Gift of B. Gerald Cantor Collection.

8.48 August Rodin, *Gates of Hell*, 1880–1917. Bronze, detail.

8.49 August Rodin, *The Thinker*, 1880. Bronze, cast from model in *Gates of Hell* (original size), 28 ins (71 cm) high. The Metropolitan Museum of Art, New York.

Prodigal Son (1889). The nude figures of Dante's Paolo and Francesca da Rimini, indulging in forbidden sensual license, were enlarged separately and, as *The Kiss* (1886; marble 1898), became as renowned as the *Thinker*.

However, in contrast to the paneled biblical narratives of Ghiberti's Florentine gilt bronze Gates of Paradise (Fig. 4.47), Rodin's swirling figures and clifflike/cloudlike space-pockets fill the entire field of the doorway and spill outward onto the frames. The architectonic form of door structure and narrative logic or perspectival clarity has been undermined and dissolved into an overall field of movement. The restless energy of irregular figures, tangled in varying degrees of relief within the complex material matrix of the enfolding bronze, produces a general effect of turbulence and agonized frustration, which has been compared with the tragic vision in Baudelaire's verses, *Flowers of Evil*, as much as with Dante. The overall effect is worthy of the damned in the Sistine altar fresco (Fig. 5.26) by Michelangelo, a crucial model for Rodin. Body gestures that suggest mental or emotional states appropriate to his grand subjects are firmly grounded in anatomy and the use of the bronze material ("I have remained a realist, a sculptor").

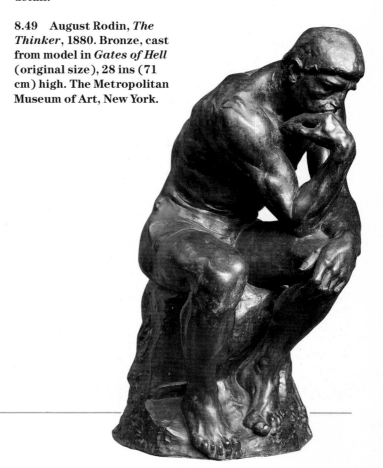

THE BALZAC MONUMENT In 1891 Rodin received another commission, this time from the Society of Men of Letters (of which Emile Zola was president), which wanted a public monument to the early nineteenth-century novelist, Honoré de Balzac. This task differed from the studies by Houdon, such as *Voltaire* or *George Washington* (Fig. 7.13), because Rodin had no opportunity to study his sitter from life; however, in a photographic era literal resemblance was not a problem. What Rodin sought was an alternative to the standard use of allegorical figures on public monuments, a new means to convey the personality and significance of the novelist. He began in the spirit of Balzac's naturalism, in keeping with his own insistence that life itself should be the subject of art rather than "the dream, the imagination, or illusion." To that end, the sculptor not only read all the books by or on the author and studied every visual image he could find; he even interviewed Balzac's surviving tailor and ordered replicas of his suits. The first major proposal for the monument was a daring nude study of the portly novelist, legs outstretched and arms crossed as if in defiance (perhaps based on a phrase by the biographer of this "courageous athlete") (Fig. **8.50**). The stance echoes the physical qualities of the middle-aged Balzac, short-haired and already jowly. Rodin has not compromised the actual body likeness of his subject, though he has suggested what he termed his "intense labor . . . incessant battles and his great courage."

The final form of the *Balzac Monument* (1898), however, was vastly different. The figure is swathed in full-length

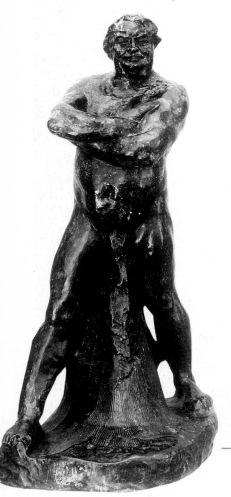

8.50 August Rodin, *Naked Balzac*, 1892. Bronze, 50¼ ins (128 cm) high. Art Institute of Chicago.

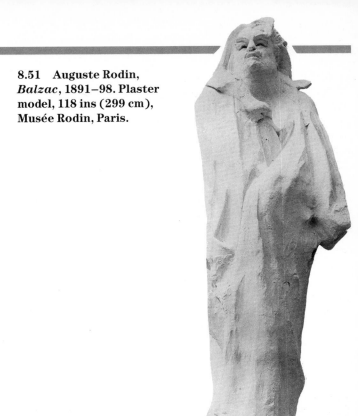

8.51 Auguste Rodin, *Balzac*, 1891–98. Plaster model, 118 ins (299 cm), Musée Rodin, Paris.

"monk's robes," the costume he habitually wore for writing, so the tradition of likeness is at least partially respected, as is a degree of naturalism in the robes – Rodin dipped actual drapery in plaster as a preparatory study (Fig. **8.51**). The final result, however, is much more commanding: the towering silhouette of the creative artist, his craggy features now generalized, forms a standing, mature counterpart to the poetic *Thinker*. Rodin claimed to be presenting a scenario in which the novelist got up at night to write down a sudden inspiration, but he admitted that he had exaggerated Balzac's own features in a "synthesis for the whole." The amorphous robe does more than conceal the writer's ungainly body; it distances Balzac from the time-bound contemporaneity of modern costume, like the toga used by Houdon for his seated *Voltaire*. But the standing Balzac, tilted away from the viewer, remains a distanced figure, dominated by a peering head that is always deep-set in shadow. Ultimately, this image symbolizes the creative artist as seer, with his own unique vision of the world, transforming natural appearances into artworks which go beyond those appearances, akin to the imagery of van Gogh or Gauguin – or Rodin's own sculpture.

EDWARD STEICHEN At the Paris World's Fair of 1900, Rodin followed Courbet's precedent, constructing his own pavilion – this time in the fairgrounds – for a personal retrospective of his work (later the basis for an individual museum in Paris). He was the most famous artist in France, and his imagery inspired innovation in others. In

particular, the young American, Edward Steichen (1879–1973), took photographs of an entirely new kind, which were part of the movement known as "pictorialism," or "art photography." This movement wanted photography to be given the status of other visual arts. As part of a wider rejection by artists of materialism and confidence in technological and scientific progress, photographers were no longer content merely to capture physical likenesses through their apertures. They took pains to distance themselves from both commercialism and amateurism (now greatly expanded with the development after 1888 of George Eastman's hand-held Kodak box camera). Instead, photographers, too, desired to express subjective states of mind, even to suggest transcendent universals in their own form of visual art. Their techniques included manipulation of photographic images in the printing process by the use, for example, of special tinted or coated papers. They could suppress or enhance details from their negatives to achieve a new, controlled synthetic image.

In addition to producing misty, undefined subjects, filled with poetic associations, such as *The Pond, Moonrise* (1903), Steichen also turned directly to Rodin and his creations. His portrait of *Rodin – The Thinker* (1902) confronts the profile of the sculptor in silhouette with his own creation, the *Thinker* (Fig. **8.52**). The entire image is in soft focus, like a vision or a dream, making the thoughts of the sculptor equivalent to the creative process recognizable in the brooding pose of the *Thinker* itself (once entitled "The Poet"). As if in echo of this main theme, the bright background image, also spectral in its soft focus, is another Rodin monument to a great literary figure, *Victor Hugo*. Steichen also went on to produce a mysteriously lighted, brooding image of Rodin's *Balzac* (1908) that was much praised by the sculptor.

8.52 Edward Steichen, *Rodin – The Thinker*, 1902. Photograph. Art Institute of Chicago.

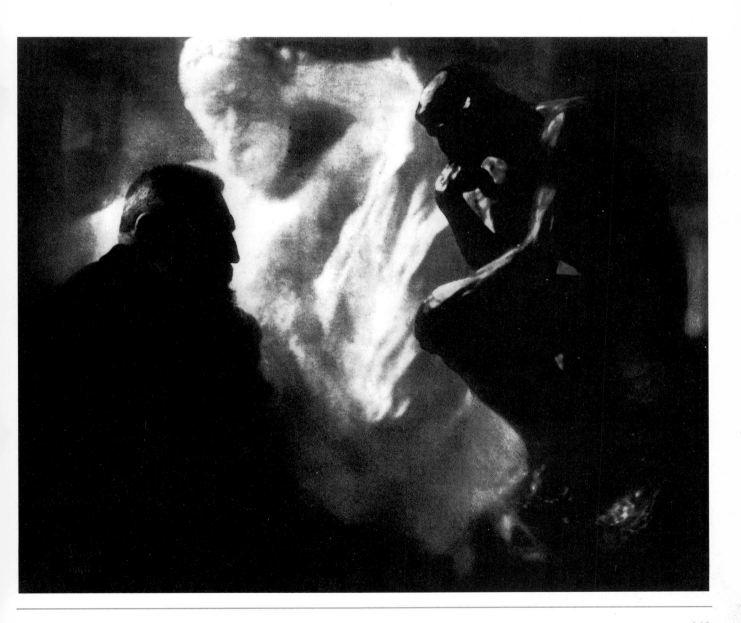

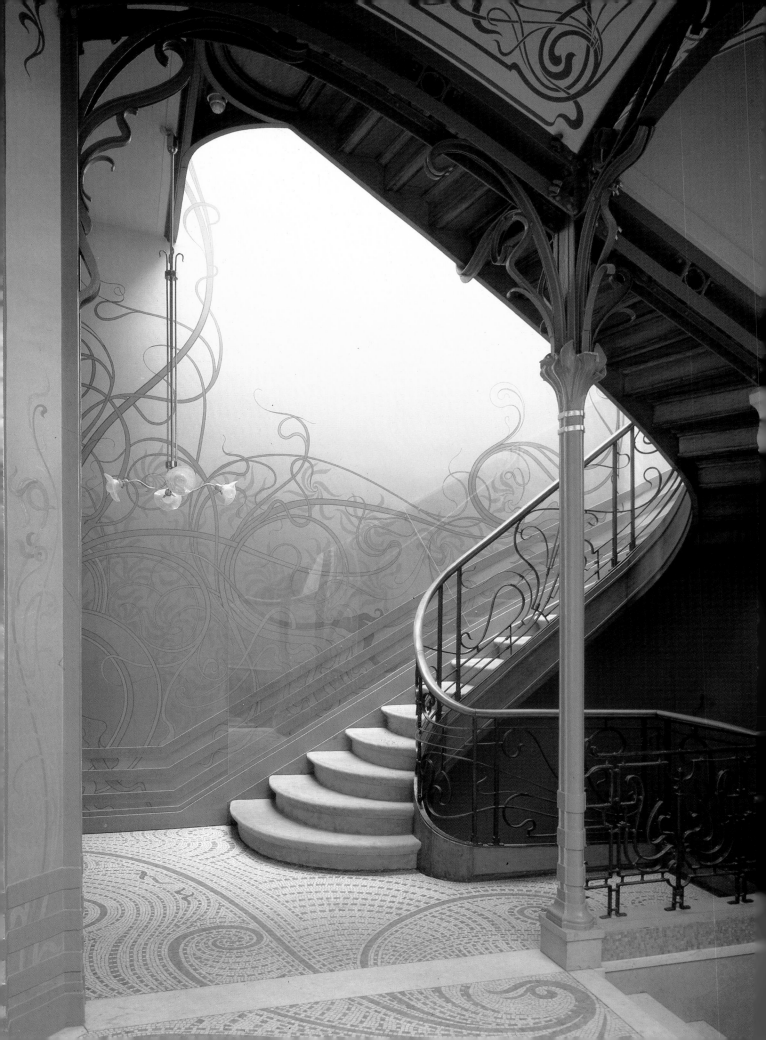

ART NOUVEAU

At the same time that Louis Sullivan was developing his cast-iron vegetal ornamentation for American skyscrapers and department stores (Figs 8.30–8.32), in both Paris and Brussels a cluster of architects and designers were beginning to transform the appearance of urban interiors with "*Art Nouveau*," new art. As in Frank Lloyd Wright's prairie homes, they wanted to create a domestic world which was suffused with natural imagery; however, the "organic" world in this case depended upon motifs rather than structures. Employing decorative traditions ultimately stemming from Japonisme but already seen in Gauguin, they used curvilinear graphic ornament to suggest growth, even to evoke a dreamlike vision. Whether in the form of household objects, such as the glass and furniture of Emile Galle (1846–1904), or posters and prints, the aim of Art Nouveau was to transform the interior environment and with it the interior state of its inhabitants. Ambitiously striving for a unity of the fine and decorative arts, Art Nouveau designers attempted to combat the starkness and uniformity of urban modernity and to return to the inspiration of nature, the mysterious "forest of symbols" beyond ordinary reality, such as Baudelaire and Mallarmé achieved in poetry and Gauguin, above all, in art.

VICTOR HORTA The startling first monument of Art Nouveau was built not in Paris but in Brussels, in 1893, when Victor Horta (1861–1947) completed the Tassel House in a fashionable residential district (Fig. **8.53**). Like Wright's contemporary designs, Horta's spaces (still symmetrical) open more freely into one another, but what is new in his building is the detail. Interior walls assume different sizes and shapes to provide irregularity; metal supports are freely exposed. A bowed bay-window space marks the clearly visible ironwork on the façade. Most important, the entire interior surface is covered with curvilinear scrollwork, expressed both in metal tendrils and in painted wall decoration as well as patterned floor mosaic.

Horta's innovations were quickly absorbed throughout Belgium and by the Parisian architect, Hector Guimard, best remembered for the sinuous, vegetal, bowed openings and entrance markers he made from cast iron for the Metro, Paris's subway system (1898–1900). Here was an architecture both contemporary and human, both practical and ornamental, using the modern materials of iron but without either the austerity of pure engineering (Eiffel's Tower) or the revival of historical styles (Garnier's Opéra). Art was thus able to change daily life and to produce a more integrated community (extending the ideas encountered earlier in Pugin and Ruskin and, more recently in England, in William Morris). The social implications of this reforming design, with its striving for visual harmony in the city, were realized by some of its practitioners, especially in Belgium. Like other Art Nouveau designers, Horta was a member of the Belgian Worker's Party and designed for them a House of the People headquarters (Maison du Peuple, 1897–98).

In Paris, the wellspring of the movement was the Maison de l'Art Nouveau of Siegfried Bing, an art dealer already long associated with a love of Japonisme. Oriented more to an elite clientele than to social reform, Bing nonetheless sought to foster a new collective workshop of design, partly in imitation of the American productions in furniture, glassware, and metalwork by Louis Comfort Tiffany. To this end, he encouraged the importation and display of Belgian decorative objects for interiors, and he particularly encouraged the design talents of Horta's compatriot, Henri van de Velde (1863–1957). Trained as a painter and printmaker, van de Velde sought in his own house (1895) to design and harmonize every element in the interior, particularly the furniture with its dynamic, curving lines (see Wright's furniture designs and integrated interiors in contemporary suburban Chicago). He also designed all the furnishings, down to the clothing his wife wore in her home interior. Bing took up this Belgian concept of total design and the unity of the arts in his Maison de l'Art Nouveau ensembles to create a unified, luxurious, nature-oriented private space, an oasis in the city. He commissioned three separate room ensembles from van de Velde as well as rooms by French artists and helped to foster a climate in which trained painters would also make designs for works in other media.

JOSEF HOFFMANN: THE PALAIS STOCLET The fullest realization of the "total work of art" in domestic architecture was also built and decorated in Brussels, but its designers were Viennese. The Palais Stoclet (1905–11) was designed by Josef Hoffmann (1870–1956), founder of a crafts association in Vienna, the Wiener Werkstätte, set up in 1903 in order "to establish an intimate connection between public, designer, and craftsman, to create good, simple articles of household use." Connections between Belgium, France, England, and Vienna at the turn of the century were particularly strong, due to the emergence of international art magazines, which spread the new forms as well as the programs and doctrines of Art Nouveau. In Vienna the new style of overall decoration was called "Jugendstil" after the magazine, *Jugend* (Youth, 1896), that brought its designs to a German-speaking public. The Vienna adoption of Art Nouveau was soon connected to a larger movement, the Secession, which sought to assert a modern design in all the arts against the prevailing academic conservatism in Germanic centers such as Vienna, Berlin, and Munich. In Hoffmann's mature designs, including the Palais Stoclet, the organic exuberance of Art Nouveau is tempered with a more austere, geometrical refinement, an elegant and luxurious simplicity that emphasizes rich materials.

The Palais Stoclet begins with a conception of walls as unadorned planar surfaces trimmed with dark moldings (Fig. **8.54**, p. 366), like the interior panels of Wright's contempor-

8.53 Victor Horta, Tassel House, Brussels, 1892–93.

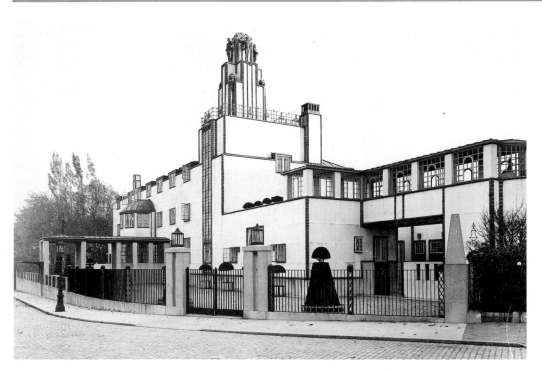

8.54 Josef Hoffmann, Palais Stoclet, Brussels, 1905–11. Exterior

8.55 Josef Hoffmann, Palais Stoclet, Brussels, 1905–11. Interior.

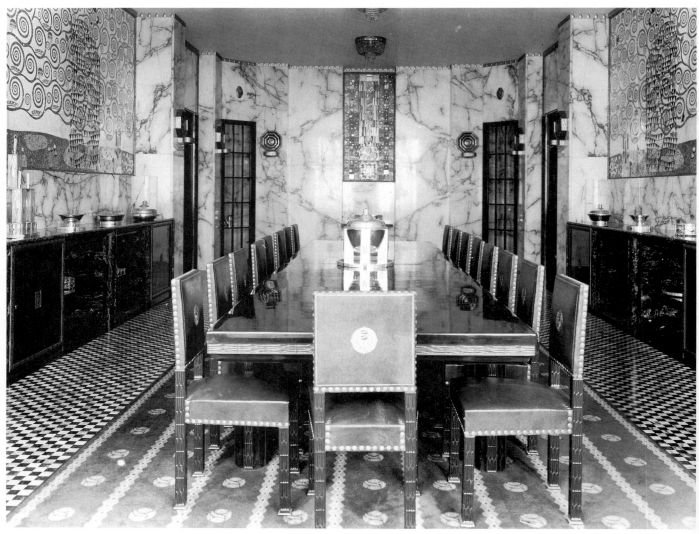

8.56 Gustav Klimt, *Dancer*, segment of frieze, dining room, Palais Stoclet, Brussels, 1905-11.

ary prairie homes. Its asymmetrical façade is marked by a dramatic stair tower and a car port as accents within an overall clear surface expanse. The grand interior of the house features luxurious materials – different colors of marble faced the walls – plus the splendor of its dining-room decoration painted by another Viennese, Gustav Klimt (1862–1918; Fig. **8.55**). Hoffmann designed the cutlery as well as the glassware of the dining room in conjunction with colleagues from the Wiener Werkstätte, and the decorative elements of Klimt's gilded mural frieze echo the shapes and patterns of the table setting. Although Hoffmann's geometry eliminates some of the linear vegetal exuberance of ornament from the Art Nouveau/Jugendstil vocabulary, Klimt's frieze restores an Edenic luxuriance of abstract growth. A field of flowers with a triangular bush and a stylized tree of life with many branches and gilded foliage enfold a young female dancer (Fig. **8.56**). In an attempt to break down the distinctions between fine and applied arts, between painting and decoration, Klimt rendered his image as a flat pattern in the composite medium of enamel, glass, and metal, painting and mosaics. The flatness of his images and their decorative arabesques, based on ancient Egyptian and Greek murals or Byzantine mosaics, display a

fundamental visual "primitivism" well suited to his idealized image of purity and splendor.

With their brilliantly patterned ornamental splendor and their allegory of life and love, the Palais Stoclet Klimt murals fulfill the aims adumbrated by Gauguin's rustic Polynesian reliefs. A totally harmonious, stylized interior environment had been created, its dreamlike mystery focused on primal themes of the erotic and spiritual, of life and death. Such an environment was already implicit in Whistler's controversial 1876 Japoniste "Peacock Room," a work rejected by its owner but a fulfillment of Whistler's injunction to produce art for art's sake. To Klimt and his circle in Vienna, art had become a "sacred spring," source of a new, inspirational beauty, no longer grounded in the natural world but rather in the expression of personal, emotional, subjective visions and symbols by a heroic, isolated artist. The stage was set for a new century of visual experimentation with both abstract decoration and personal expression.

IN SEARCH OF MODERNITY

ENDLESS EXPERIMENT – PARIS

In 1907 Pablo Picasso (1881–1973) completed his largest, most ambitious painting to date, *Les Demoiselles d'Avignon* (Fig. **9.1**, p. 370). The subject of the picture derives from traditional Western themes: five nude women with a foreground still life. Picasso took an intense interest in the images of bathers and still lifes by Cézanne (see Fig. 8.40) from the end of the previous century (recently on view at a retrospective Cézanne exhibition at the newly founded Salon d'Automne in Paris, 1904). Yet Picasso's picture expresses a new sensibility through the angular shapes and discordant colors of his assertive nudes, who confront the viewer directly, even challengingly. Dissonance predominates; even the title refers to a Barcelona brothel and identifies the nude women as prostitutes, posed in front of a voyeuristic viewer-client. Again, such subjects appeared in nineteenth-century Parisian art – the works of Manet (Fig. 8.10), Degas, and Toulouse-Lautrec – but Picasso emphasizes the menace of these women.

Detail of Fig. 9.36, Wassily Kandinsky, *Small Pleasures* (see p. 394)

9.1 Pablo Picasso, *Les Demoiselles d'Avignon*, 1907. Oil on canvas, 96 × 92 ins (244 × 234 cm). Collection, The Museum of Modern Art, New York. Acquired through the Lillie P. Bliss Bequest.

Picasso has utilized models for his women from "primitive" sources that go far beyond the recent presentation of a South Pacific Eden by Paul Gauguin (who was also given a retrospective at the Salon d'Automne in 1903). The three nudes at the left are based on the ancient sculpture of his Iberian homeland; for the two figures at the right, he has adapted elements from African masks and ritual sculpture. The ritual use of African art was then largely unknown in the West, but such artifacts already formed a quasi-scientific "booty" from French colonies to document the "primitive" stage of development from which paternalistic colonizers claimed they were "liberating" them. The scarification on the two faces at the right surely derives directly from African models, although the number of examples available for study was limited. One specific source lay in the Bakota tribe's reliquary figures (Fig. 9.2), which not only have strong diagonal scars on the facial surfaces and outlined, staring eyes but also a suggestion of bent "knees" akin to the arms and legs of the squatting nude in the lower right corner. Picasso uses such alien, staring and deformed faces in the *Demoiselles* as a frontal attack on the refined modeling of the Western tradition and its attitudes to female beauty.

The content of the picture becomes clearer with examination of the numerous preliminary sketches, the clearest of which shows a sailor in blue uniform seated at the table amid

9.2 Bakota reliquary figure, Gabon, late nineteenth century. Wood and copper sheeting, 26¾ ins (68 cm) high. British Museum, London.

the parading nudes, who compete for his attention. The painting itself eliminates him, compresses its female nude figures into a dense, more vertical network, and heightens the confrontation between the female subjects and the outside observer. By attacking the classical canon of female beauty, the *Demoiselles* shares a theme common in *fin-de-siècle* art and literature: the *femme fatale*, sexually alluring and available yet ultimately savage and ominous, particularly in the literal threat of venereal disease. The primitive forms carry this threatening message in place of the more explicit narrative with the sailor.

Picasso searched for alternative visual traditions of the nude precisely in order to shock his viewer, and he chose archaic and African forms in order to suggest unfamiliar and menacing forms of energy, the potency of primal forces such as those described in Conrad's fictional voyage to the *Heart of Darkness*. The concept of the female, of sexual activity, and of the primitive offers a polar opposite to Gauguin's alluring, sensual women (also presented apart from male companions in most cases), who preserve the romantic stereotype of the "noble savage" as an alternative to Western urban decadence. Instead, as Picasso's brothel subject indicates, this is a specifically modern and urban sexual encounter, its seamy subject and formal distortions expressive of profound anxiety and fear appropriate to the century of Freud (and just as sexist in its identification of the female with terrifying natural forces).

The formal inventiveness that was required by this intense subject was a radical revision of Western assumptions about picture-making that had persisted since the Renaissance. Spatial coherence gives way in favor of a color harmony of the rose, red, and blue tones of the picture. Even where vestiges of coherent forms, such as the red curtain at the left or the jutting table of the foreground, remain essentially intact as volumes, the vigorous brushwork in areas normally taken to be spatial voids (the blue interstices) undermines traditional consistency. The corporeal integrity of the individual figures is undermined by arbitrary patches of color, modeling, or disembodied shapes that fail to cohere (as in the lower leg of the profile figure at the left). Cézanne's earlier exploration of the intricate relationship between rendering and reality here explodes into a declamation of the arbitrariness of the visual sign, where three-dimensional figures are irregularly and randomly marked with emphatically planar edges of lines and arcs.

Many of the elements broached by the *Demoiselles d'Avignon* would be elaborated in various combinations by later twentieth-century artists. Picasso would not long elaborate on his discovery of the primitive as a wellspring of creative energy in dialogue with the Western tradition of the female nude before other artists took up his cue, often for explicitly sexual subjects. The expression of psychic energy and anxiety present in the *Demoiselles* influenced an enormously varied range of later art, including art based explicitly on dreams, fantasies, or presumed psychic universals. Picasso's own interests would soon develop his new formal austerity and planar economy into a self-conscious experiment in the limits of artistic convention and what it suggests about the way the human mind works. In turn, those visual experiments, usually denoted by the label

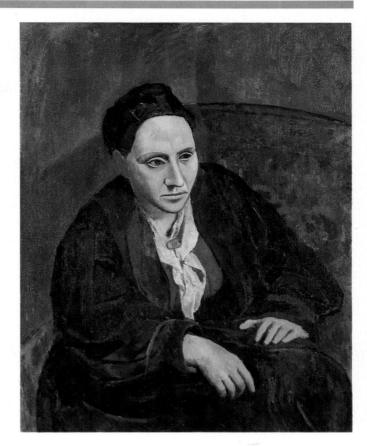

9.3 **Pablo Picasso,** *Gertrude Stein*, **1906. Oil on canvas, 39¼ × 32 ins (99.7 × 81.3 cm). The Metropolitan Museum of Art, New York.**

"Cubism," would be extrapolated into radical inventions of abstraction and formal purity, not only in painting but in sculpture and architecture as well. What all of these artistic experiments seek, however, is a break with tradition and a new way of creating that proclaims itself to be unique as well as "modern."

For the ambitious young artist in Paris, the financial support and friendship of an intellectual circle was of paramount importance. Picasso's chief support in his early career came from the circle of Leo and Gertrude Stein, whose portrait the artist painted in 1906 (Fig. **9.3**). Painted from memory and later reworked, the eyes in this portrait reveal much of the geometrical stylization and flattening of color areas that would develop even more radically a year later in the *Demoiselles*. This stylization has been related to the artist's experience of archaic sculpture, but it also points to his self-conscious assertion of the flatness of the picture and the need to compose its elements relative to one another rather than to strive for spatial illusion and verisimilitude. The artist allegedly replied to criticisms that the masklike portrait bore little resemblance to the sitter by saying that "in the end she will manage to look just like it." Art-making thus predominates over portraying likeness, conception over perception, in the manner of Oscar Wilde's remark a few years earlier that "Nature copies art."

CUBISM

By the end of the decade, Picasso's experiments in geometrical composition and limited color had moved in a radical direction: an underlying human figure or still life lies obscured under a network of facets. Portraits formed an important component of this new development, later known as Cubism. One such portrait (1909–10) depicts Picasso's (earlier Cézanne's) dealer in Paris, Ambroise Vollard (Fig. **9.4**), in an even more muted grayish monochrome than the rose tones used for *Gertrude Stein*. The blocky, bald head of the bearded man is clearly discernible within the overall composition of erratic and angular planes; his downcast eyes seem to be taking in a newspaper or a large, open book. His features in this painting can be compared to a more conventional portrait likeness of him (Fig. **9.5**), a drawing Picasso made in 1915 with a calculated efficiency of convincing illusion that nonetheless remains close to the composed *Gertrude Stein* of a decade earlier. Indeed, the contrast between these two works reveals Picasso's discovery of the artificiality of pictorial convention of

all kinds, as well as the degree of complicity used in "reading" a picture. Picasso demonstrated the theoretical discovery by modern philosophers of art that portraits have more in common with other portraits than they do with their sitters.

Only a limited circle of cognoscenti, of dealers and their most engaged clients, such as the Steins, even saw Picasso's experimental Cubist pictures, including *Vollard*. As in the competitive and individualized climate of Renaissance Florence, Parisian artists such as Picasso asserted their personal identity and their contribution to the "progress" of "modern" art in aesthetic terms. They adopted the French military term "*avant-garde*," or precursor, for aesthetic innovation on the assumption that their "advanced" vision heralded future directions of art and thought. They were painting for enlightened, elite audiences, not for the bourgeois and liberal patrons who frequented public salons and purchased most paintings. Thus the rejection of inherited pictorial conventions and traditional, "academic" appearances (or the adoption of non-Western alternatives) became the stimulus to continuous inventiveness by ambitious modernists like Picasso. The momentum toward

9.4 Pablo Picasso, *Ambroise Vollard*, 1909–10. Oil on canvas, 36¼ × 25⅝ ins (92 × 65 cm). Pushkin Museum, Moscow.

9.5 Pablo Picasso, *Ambroise Vollard*, 1915. Pen and ink on paper, 18⅜ × 12⁹⁄₁₆ ins (46.7 × 31.9 cm). The Elisha Whittelsey Collection, The Metropolitan Museum of Art, New York.

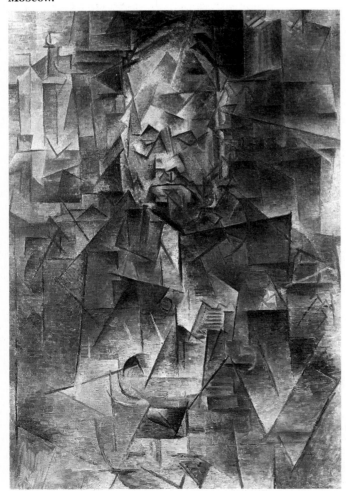

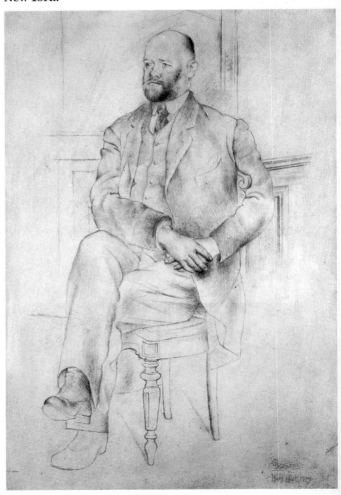

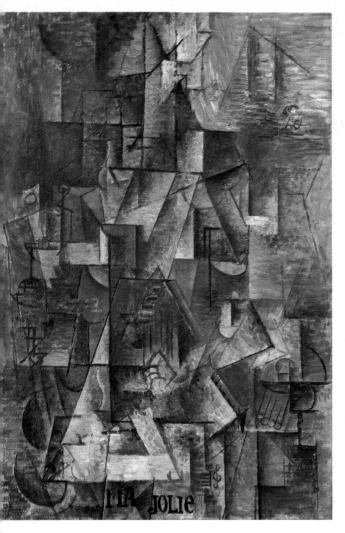

9.6 Pablo Picasso, *Ma Jolie*, 1911–12. Oil on canvas, 39⅜ × 25¾ ins (100 × 65.4 cm). Collection, The Museum of Modern Art, New York.

personal promotion as well as shocking innovation had begun in earnest with the independent, one-man 1855 Realist exhibition of Courbet (see p. 332), but no single twentieth-century artist set the agenda for the future of modern painting more than Picasso.

Shortly after *Vollard* Picasso retreated from the specific model implied by portraiture and continued his Cubist experiments in an image of a nude female guitarist: *Ma Jolie* (1911–12; Fig. **9.6**). The subject of this picture was the artist's current mistress, and the title of the work refers to both a current popular song and the tender nickname Picasso gave her. Once more, the analogy between visual art and music is evoked, in this case with a self-conscious analogy between pictorial forms and symbolic notations of letters and music. The title appears in block letters at the bottom of the canvas along with a treble clef, indicating musical notation as well as verses. Most of the coherence of the figure and the setting has dissolved in the fragmented surface of the picture, here modeled in subtle modulations of brown and gray. Behind the pictorial facets, the center of the picture shows the parallel strings of the instrument and a row of arcs for the musician's

fingers, linked to her bent left elbow. These marks take us into a realm of almost pure symbolism, forcing us to discriminate those elements that signify objects, such as the wine bottle and glass at the left edge, from those that simply articulate the picture surface with no outside reference. Figure and ground merge within a unified pictorial composition, at once insisting on the two-dimensionality of all pictures and depending upon the inherited convention of figure painting to suggest a woman with a guitar *underneath* an enigmatic surface.

COLLAGE *Ma Jolie* became a *ne plus ultra*, a limiting case, for the decomposition of traditional space and illusionism in Picasso's art. In the next few years, he extended the lessons of that kind of picture, later known as Analytical Cubism, in order to build up simpler composites assembled from fragments of illusion. This second kind of picture, later known as Synthetic Cubism, usually presents a conventional still life, still requiring a conceptual reintegration by an active viewer. Often the elements of these still lifes are drawn deliberately from the everyday and mundane objects of popular culture, just as *Ma Jolie* takes its cue from a hit tune. In *Guitar* (1913; Fig **9.7**), Picasso actually glues on fragments of both newspaper and wallpaper that present themselves as

9.7 Pablo Picasso, *Guitar*, 1913. Collage, 26⅛ × 19½ ins (66.4 × 50.5 cm) Collection, The Museum of Modern Art, New York.

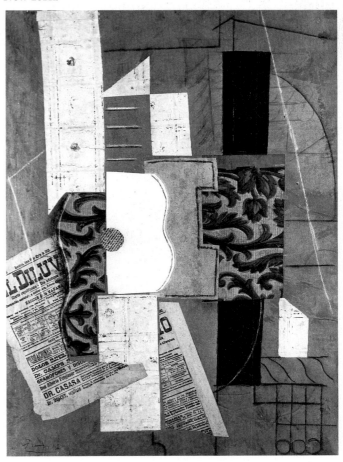

9.8 Pablo Picasso, *Guitar*, 1912. Sheet metal and wire, 30½ × 13⅛ × 7⅝ ins (77.5 × 35 × 19.3 cm). Collection, The Museum of Modern Art, New York. Gift of the artist.

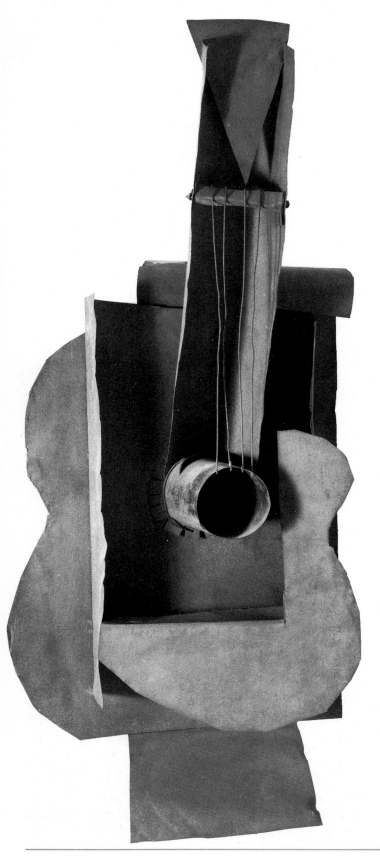

items from an everyday spatial environment but also take on the shapes of other objects. These glued papers, or *papiers collées*, produce a new art form, *collage*, the paste-up image of assemblage. Such an activity implies a breakdown of the autonomy of the artwork from its surroundings, and it places greater stress on the imaginative invention of the artist-assembler than on his or her manual craftsmanship. In the case of *Guitar*, the patterned wallpaper not only forms the shape of one side of the guitar; it also provides a bottom plane of pattern below – and thus by implication behind – two other scraps of paper (one of them in white, the other forming half of the guitar with the sounding-hole made out of newspaper). The resulting guitar form also plays with varieties of shapes and artistic marks. Picasso contrasts the rounded body of the instrument with its long vertical neck and fretwork, which are represented by a rectangle of another kind of wallpaper. The entire set of glued paper is placed upon a transparent blue ground, which in turn is enhanced by delicate lines drawn in crayon and charcoal. Within the newspaper itself there is a subtle connection with the theme of the *Demoiselles*: both the newspaper and the brothel subject come from Picasso's native Barcelona. Such a use of printed wallpaper and newsprint within an avant-garde artwork mingles mundane experience with rarefied intellectual exercise. This dialogue between commonplace objects and the exclusiveness and privilege associated with art remains a powerful issue for modernism in a world increasingly dominated by mass-production (the wallpaper) and images of all kinds in mass media (the newspaper).

In his collage *Guitar* (Fig. 9.7), Picasso eliminates all those vestiges of traditional shading and modeling which had persisted in his Analytical Cubist imagery. Just as he develops a new concept of figure and ground in two dimensions through constructed, overlapping planes of paper, he also addresses the problem of representing three dimensions anew in a sculptural *Guitar* (1912; Fig. **9.8**). In contrast to traditional formulations of solid and void within a basic carved figure, Picasso builds his *Guitar* out of fragments of sheet metal. Like a Cubist painting or collage, the object loses its volumetric integrity and presents fragments of its surface, contour, and profile within a new composite order. Its top surface in fact is an open hollow rather than a void, whereas the empty opening of its sounding-hole is defined by a cylinder rather than by empty space, akin to the newsprint hole in his collage *Guitar*. Some of Picasso's reversals of spatial expectations in sculpture derive from African masks, which also challenge Western conventions with protruding volumes, such as cylindrical eyes, and attachments, such as feathers, fibers, or nails. His use of humble materials links his sculptural constructions with his planar Synthetic Cubism and rejects the heritage of stone or bronze or wood for sculpture. His replacement of the human figure with a common and familiar object also opens up sculpture to other possibilities, both imagined and referential.

For all of his pictorial and sculptural experimentation during the decade of Cubism, Picasso never abandoned his interest in representation, as his drawing of Vollard of 1915 makes clear. In 1921 he consolidated the results of a decade of rethinking

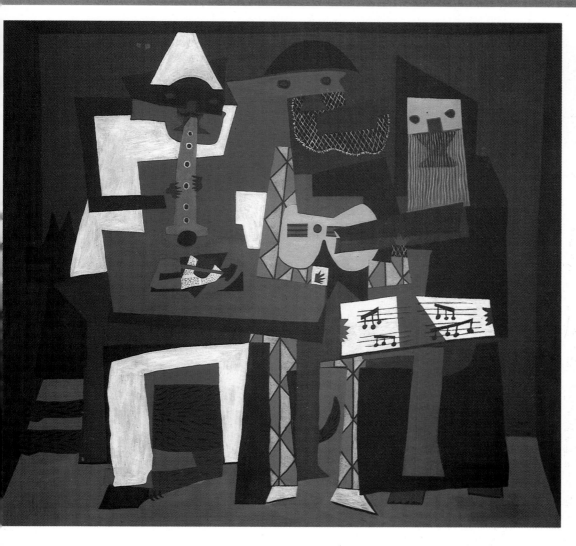

9.9 Pablo Picasso, *Three Musicians*, 1921. Oil on canvas, 79 × 87¾ ins (200 × 223 cm). Collection, The Museum of Modern Art, New York.

art-as-construct by returning to his major themes. The *Three Musicians* (Fig. **9.9**) recapitulates Picasso's interest in the sister art of music, as well as his fascination for musical notation. The three buskers of the picture also recall the relationship between artistic creativity and social marginality, for the three players are a monk, a clown, and a harlequin (two of them traditional Italian comedy stock figures who were among Picasso's favorite subjects). He delights in visual rhymes and echoes, such as the small black dots of the clarinet, guitar hold, and musical notes. The patterns of the three figures are fused together, the bold patterns of color in jigsaw shapes overlapped in a way similar to the glued papers of collage. Colors are then distributed, especially blue, black, and white, around the two-dimensional composition. Thus the severity of the upright poses of these three figures and their clarity are both undercut and enlivened. Picasso even inserts a whimsical element in the reclining black dog, discovered beneath and behind the clown. His return to emphatic costumes and legible presentation in the *Three Musicians* coincides with his recent activities as a designer for theater and for ballet, particularly the renowned experimental troupe of Diaghilev, the Ballets Russes (1917, 1920–21).

"LUXURY, CALM, AND VOLUPTUOUSNESS": MATISSE

Music and dance were equally important sources of inspiration for Henri Matisse (1869–1954), who was in Paris at the same time as Picasso. The dialogue between them had already begun before the *Demoiselles d'Avignon*, which in many ways responded to the challenges of a large Matisse canvas, *Happiness of Life* (1906), a work also owned by Gertrude and Leo Stein (Fig. **9.10**, p. 376). Like Picasso, Matisse admired Cézanne's late canvases of bathers and drew lifelong artistic inspiration from the study of the female nude. However, the world of *Happiness of Life* presents a nostalgic and imaginary golden age extending beyond the island fantasies of Gauguin. Matisse offers "luxury, calm, and voluptuousness" (the title of another painting) rather than the menace of Picasso's brothel nudes. The exuberance of the lyrical lines of dancing or piping figures in Matisse's landscape is emphasized by the rich, glowing colors that saturate every part of his painting. Matisse has absorbed the untroubled, flat, bright vision of Gauguin,

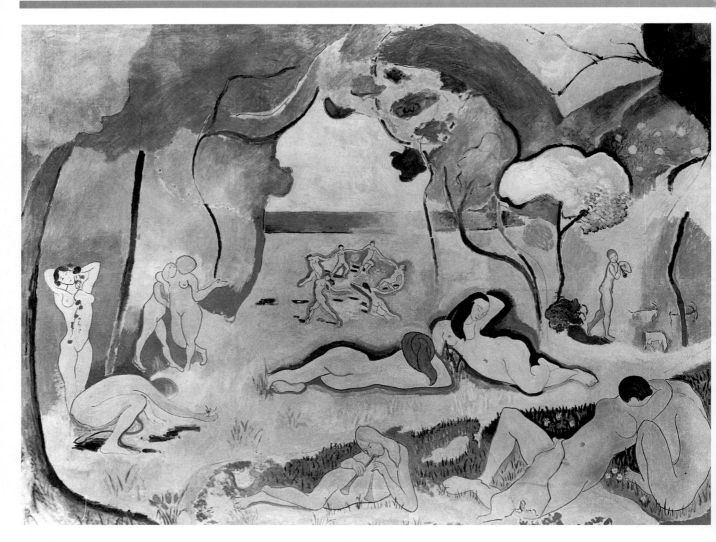

9.10 Henri Matisse, *Happiness of Life*, 1906. Oil on canvas, 68¾ × 94 ins (174.6 × 239 cm). Barnes Foundation, Merion, Pennsylvania.

but he has removed it still further from modern Paris – into a timeless, neutral ideal. Where Picasso confronts the viewer with angular poses and staring figures in a shallow space, Matisse delights in sinuous curves and the dreamy languor of lovers, immersed in a tradition extending back to Venetian Renaissance works, such as Giorgione's *Sleeping Venus* (Fig. 5.37) and Titian's *Bacchanal* (Fig. 5.39). Where Picasso's prostitutes sound the harsh and frank note of Manet's *Olympia*, Matisse's nymphs represent the idyllic harmonies of arcadian academics. He, too, celebrates music, but it is pastoral and amorous music, like Titian's, rather than the melancholy twang of Picasso's flamenco guitar. Thus all of Matisse's formal experiments deal with harmonies of color and boldness of pattern, and he would exploit his own canvas of *Happiness of Life* for a good half-decade in developing those compositions.

In 1907, the same year as Picasso's *Demoiselles*, Matisse extracted from the center of his *Happiness of Life* composition a reclining *Blue Nude*, his first large-scale figure, adopting a

9.11 Henri Matisse, *Reclining Nude* I, 1907. Bronze, 13½ × 19¾ × 11¼ ins (34.3 × 50.2 × 28.6 cm). Collection, The Museum of Modern Art, New York. Acquired through the Lillie P. Bliss Bequest.

classical pose also used for Renaissance Venus figures. Its subdued tonality derives from Matisse's immersion in the works of Cézanne, including a small, early Cézanne, *Bathers*, that he owned. Its deliberate ungainliness and rearranged anatomy attest to the influences of African full-figured statues (Fang reliquary figures), in the collection of an artistic colleague, André Derain. Like Picasso, Matisse repeatedly experimented in both sculpture and painting. He produced this same figure and pose in a bronze *Reclining Nude I* (Fig. **9.11**). While the painting emphasizes bright color and bold contours, the sculpture asserts the materiality and surface luster of its bronze medium. Either as painting or as sculpture, this accessible and voluptuous, if deliberately plain, nude remains Matisse's chief artistic concern.

The reduction of the palette reaches a climax for Matisse in his 1911 painting, *The Red Studio* (Fig. **9.12**). After a period in which he had applied color arbitrarily to his dynamic figures, Matisse now uses color with thresholds of spatial illusion.

However, instead of reducing colors to the grays or browns of Picasso's Cubist experiments, Matisse intensifies his limited palette. His studio world includes a set of his recent pictures as the principal splashes of non-red color on the walls. Art about art, begun as a modern and autobiographical concern with Courbet's 1855 *Real Allegory* . . . (Fig. 1.12), here culminates in a world of nothing but color and pattern. Space is suggested by the scale and angles of the artist's framed canvases as well as by the oblique intrusion of a foreground table (in outline) with still-life objects, including the same vase of nasturtiums used in other Matisse paintings of his studio. Yet the monochrome red of the overall setting insistently reminds the viewer that this canvas remains a fiction, an

9.12 Henri Matisse, *The Red Studio*, 1911. Oil on canvas, 71¼ × 86¼ ins (71.2 × 219 cm). Collection, The Museum of Modern Art, New York.

artifact of lines and colored shapes just as surely as do Picasso's Cubist constructions.

Toward the end of his career the old Matisse made one last, brilliant contribution to the collage technique pioneered by Picasso and thus added his final rejoinder to their lifelong dialogue. By cutting brilliantly tinted papers to create bold color compositions of many of his golden age subjects, he synthesized their working methods in themes first explored in his *Happiness of Life*. The creation of each single color shape also finally led Matisse to integrate the two artforms of contour drawing and figure sculpture that had been his primary concerns throughout his life. Some of these "cutouts" (*découpages*) explored musical exuberance; one group of them was published as a book, *Jazz* (1947), and stencil prints

followed cutouts such as *Circus* (1943). However, the bulk of these late cutouts are paeans to the same imagined lush Mediterranean or tropical paradise. *Memory of Oceania* (1953) continues to compose in bold primary color masses, above swelling crayon gestures that suggest either mountain forms or the sensuous contours of a female nude (Fig. **9.13**). In effect, all of Matisse's experiments – with pure, intense color; with the relationships between figure and ground; or with suggestions of volume through contour – reach a dazzling climax in his cutouts.

SCULPTURE AS FORM: BRANCUSI

One sculptor who simplified shapes, like Matisse, to present a vision of nature as nurturing was Constantin Brancusi (1876–1957), like Picasso, an émigré to Paris (from Romania) in 1904. Brancusi celebrates the intrinsic properties and surfaces of each sculptural medium, whether wood, stone (polished and unpolished), or metal. Often he creates pedestals out of similar materials in order to control the display of his carved works. Brancusi's sculptures represent fundamental forces of nature through geometrical simplification of natural forms – eggs, fish, birds, human heads, and torsos. In keeping with the general movement toward the "primitive," Brancusi drew inspiration from African sculpture, particularly in wood, as well as the folk tradition of Romania. His subjects celebrate life through innocent children, energetic animals, and love itself.

Brancusi's 1915 versions of *Newborn* use the ovoid simplicity of the egg shape as well as the diverse properties of shiny bronze or translucent marble to show an abstracted image of an unformed head, open-mouthed with the primal cry (Figs **9.14 – 9.15**). Form and theme become inextricable. Characteristically, Brancusi returns repeatedly to the same basic purified forms and themes for his sculptures, refining his shapes and materials in multiple variants. A later version of a bronze egg on a polished bronze circular base is entitled *Beginning of the World* (ca. 1924). Transformed into a vertical form and enhanced with the barest suggestions of lips and hair ornament, the white marble becomes another tribute to the "primitive": *White Negress* (1923), perched on a cylinder and a cruciform base made out of the same material.

9.14 Constantin Brancusi, *Newborn*, 1915. Bronze, 5¾ ins (14.2 cm). Collection, The Museum of Modern Art, New York. Acquired through the Lillie P. Bliss Bequest.

9.15 Constantin Brancusi, *Newborn*, 1915. Marble, 5⅝ ins (14.3 cm). Philadelphia Museum of Art, Arensberg Collection.

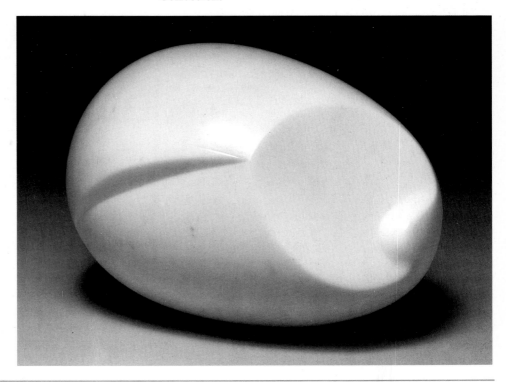

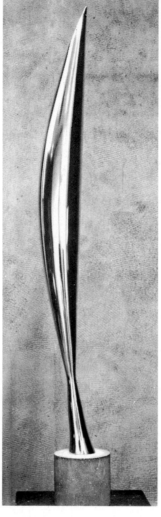

**9.16 Constantin Brancusi,
Bird in Space, 1928.
Polished bronze, 54 ins
(137.2 cm) high. Collection,
The Museum of Modern Art,
New York.**

THE SEARCH FOR A PURE GEOMETRY

Color abstraction in the wake of Picasso and Matisse could be applied to the speed and dynamism of modern transport. The husband and wife Robert (1885–1941) and Sonia Terk Delaunay (1885–1979) together produced works that look to achievements in other spheres. For example, his *Homage to Blériot* (1914) commemorates the first pilot to fly over the English Channel in 1909 (Fig. **9.17**). It includes recognizable, modern examples of engineering and design: the Eiffel Tower at the upper right, a biplane in flight, and a grounded plane with propeller at lower left. Emanating from brightly colored celebrations, however, to dominate the picture are concentric disks of pure colors, echoing the wheels of the plane and the whirl of the propeller. These disks appear for the first time in the Delaunays' art in 1912. Their geometrical and coloristic purity suggest at once rationality and dynamism, like the wheels and propellers of aviation. At the same time, such disks consciously break away from the confinements of current Parisian painting: the faceted structures of Picasso's Cubism, or the figural constraints of bright colors in Matisse. In a similar fashion, Sonia Terk Delaunay uses the abstraction of color disks to convey the pulsating, new world of radiant electrified lights in her *Electric Prisms* (1914).

Brancusi's favorite subject throughout his career was birds (twenty-seven sculptures over a period of thirty years), a study in vertical equilibrium intended to suggest soaring flight. As early as 1910, his first polished marble, *Maiastra* (repeated in bronze the following year), presents a heraldic wingless eagle standing on a stone base. The subject is a golden-feathered magic bird of Romanian folklore that leads the handsome prince to his destined princess; its appearance in Paris coincided with the première of Igor Stravinsky's innovative ballet, based on Russian folklore, of the *Firebird*. The climax of Brancusi's meditations on bird shapes, particularly the suggestion of their flight, comes in *Bird in Space* (Fig. **9.16**), a precariously balanced, featherlike shaft that seems to hover above its stone cylinder base, whether in marble (1924) or in bronze (1925–40; various versions).

Brancusi's work exemplifies the process of abstraction, the search for essential forms behind externals, although the representation of nature remained his artistic goal. His sculptures also insistently underscore the importance of artistic autonomy and sensibility. Other Parisian artists applied the same geometrizing abstraction to produce "modern" images they thought could be based on timeless principles. Some of them extolled the manmade realm instead of the unspoiled nature contemplated by Brancusi; they chose to celebrate modernity through embracing technology. Others, often with an eye toward architecture or general design, promoted visual structures as a moral absolute.

9.17 Robert Delaunay, *Homage to Blériot*, 1914. Tempera on canvas, 98½ × 99ins (250 × 251cm). Kunstmuseum, Basel.

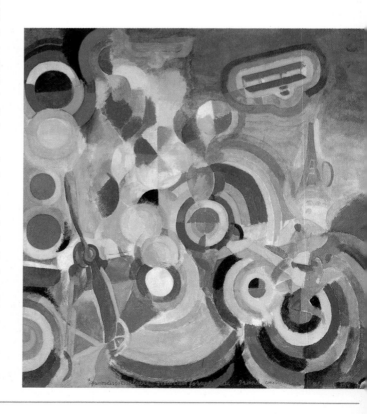

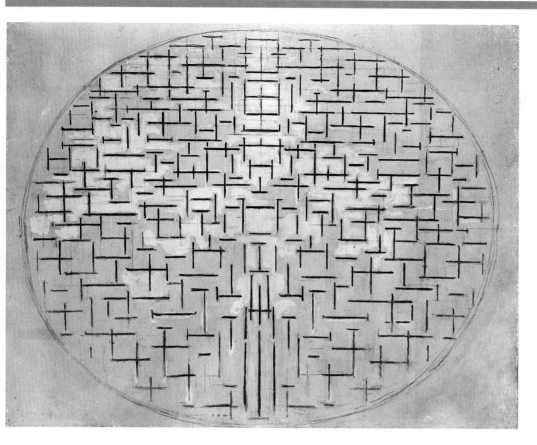

9.18 Piet Mondrian, *Pier and Ocean*, 1914. Charcoal and watercolor, 34⅝ × 44 ins (87.9 × 111.2 cm). Collection, The Museum of Modern Art, New York, Mrs Simon Guggenheim Fund.

9.19 Piet Mondrian, *Composition*, 1925. Oil on canvas, 15⅞ × 12⅝ ins (40.2 × 32 cm). Collection, The Museum of Modern Art, New York. Gift of Philip Johnson.

MONDRIAN Pictorial abstraction in the service of universals underlies the spiritualized geometry of a Dutchman, Piet Mondrian (1872–1944). Mondrian drew inspiration from landscape, but after moving to Paris in 1912 he embraced the muted palette and geometrical constructions of Cubism. His pictures provide a progressive and increasingly rationalized abstraction from such natural objects as trees and the seaside to ordered arrangements of intersecting segments of short lines, as in his *Pier and Ocean* of 1914 (Fig. **9.18**). In this bold experiment in Cubist landscape, Mondrian has used an oval frame (one of Picasso's variations on traditional conventions) to suggest a globe, and he accents a central axis at the bottom (the abstracted form of a pier), against which vertical and horizontal variants (abstracted waves) play.

In his mature works, Mondrian strives to present the underlying principles and distilled spiritual essence behind all appearance. He fuses spatial concepts of figure and ground into a single, encompassing composition, increasingly confined to the oppositions of horizontals and verticals, which he called "equilibrated relationships." Just as he eventually reduces all linear and spatial design to intersecting edges, Mondrian pares his colors down to the opposition of black and white and to the primary colors of red, blue, and yellow. These calculated essences hold a moral imperative for the artist, a balance that evokes concepts of justice and truth. Through his mature works, such as *Composition* (1925; Fig. **9.19**), Mondrian hopes to transcend the material world and produce a timeless yet dynamic geometrical purity.

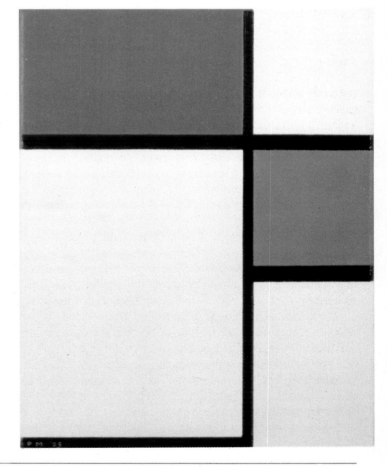

9.20 Le Corbusier, *Still Life*, 1920. Oil on canvas, 31⅞ × 39¼ ins (80.9 × 99.7 cm). Collection, The Museum of Modern Art, New York. Van Gogh Purchase Fund.

LE CORBUSIER

The urge to produce perfect geometry in images dominated much of Parisian art-making in the devastation after World War I (1914–18). Perhaps such art offered an escape from harsh realities, suggesting new possibilities of reasserting French predominance in the artworld. For one young Swiss who came to Paris in 1917, the call to Purism began in painting but quickly extended to an almost missionary zeal for architecture. Le Corbusier (Charles-Edouard Jeanneret, 1888–1965) began to paint in a style that consciously changed the Cubist lack of clarity by offering integral objects painted with exactitude, like his 1920 *Still Life* (Fig. **9.20**). The goal of machine-like perfection carried over to Le Corbusier's designs for buildings with clear volumes, immaculate surfaces, and a minimum of ornament.

Le Corbusier retained his fascination with simple geometry in combination with an embrace of the modern machine, particularly the highly engineered yet mass-produced machine, such as the steamship or automobile. In the process, he equated good design with classical purity. His ideal building, "a machine for living in," thus became a white concrete box, opened by industrial windows while supported on columnar stilts, with carefully proportioned spaces stripped down to their essentials. Le Corbusier tested his ideas in the early 1920s by building homes for his artist friends. His developing architectural theory and vocabulary are crystallized in his masterpiece: the Villa Savoye at Poissy (1928–29; Fig. **9.21**).

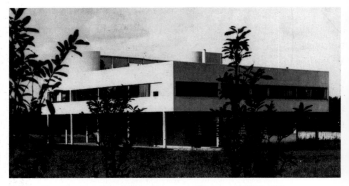

9.21 Le Corbusier, Villa Savoye, Poissy, 1928–29. Exterior.

THE VILLA SAVOYE Many of the elements favored by Le Corbusier appear at the Villa Savoye: roof garden, large open spaces supported on stilts (*pilotis*), "ribbon" window strips on an uncluttered concrete façade. All of these ingredients are calculated to produce contact with the rural surroundings (as well as access by car to the open lower level). Inside the square house tall, open space fills the core, but a central ramp adds dynamism as well as integration to the several storeys (Fig. **9.22**). Le Corbusier conceived of his building as a procession "promenade," culminating in the curved spaces of the roof terrace, evoking a ship's deck, from which the setting of this luxurious country villa could be

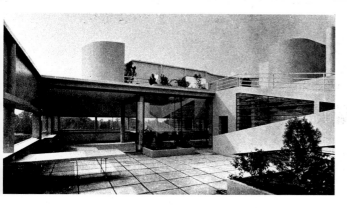

9.22 Le Corbusier, Villa Savoye, Poissy, 1928–29. Interior view. Below: Section plan.

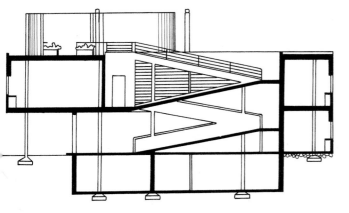

surveyed. In its totality, the Villa Savoye resembles nothing so much as a muscular sculpture compounded out of geometrical volumes, the solid eqivalent of his still-life *Purist* painting.

Le Corbusier never abandoned his utopian schemes for integrating this architectural vocabulary with modern urban needs. His Unité d'Habitation, Marseilles (1947–53), offers a mature construction that steps off the drawing-boards of much

vaster projects for a series of high-rise city housing, his "Radiant City" (Fig. **9.23**). Like the Villa Savoye, this apartment house is a box on stilts, whose bottom level is a refuge of shade amid the massive pillars. Again, the rooftop offers a ship's deck viewpoint, punctuated by decorative solids. On the building façade interior functions are clearly expressed as concrete slabs at the locations of the elevator and lateral stair towers and as a strip of windows at the transverse storey of shops. Concrete construction still offers large, open windows and balconies for all apartments, which combine to produce a screen. Corbusier wanted to use modern construction techniques in order to produce habitable, low-cost housing; the vertical slabs of his buildings would also permit the efficient concentration of populations amid open expanses of space for parks and for efficient transport. Unfortunately, without such open spaces the insensitive replication of his utopian model in post-World War II cities has produced an urban blight of "vertical slums" instead of the amenities of comfortable low-cost public housing envisioned by Le Corbusier.

After its first two decades the twentieth century had already made a decisive break with previous artistic traditions. In painting, sculpture, and architecture the building blocks of each art form were explored: color, line, shape, surface (just like rhythm and pitch in music or word and sound in literature). Non-Western traditions, especially from "primitive" sources (including African or premodern, folkloric, or archaic Europe) assisted modern artists in breaking away from post-Renaissance conventions. However, rational exploration and the search for pure form developed against an often troubled background, beginning with the alienation from modern life expressed by Picasso and culminating in the widespread disillusionment of World War I. Other artists would rebel against the satisfied spirituality and celebrations of life of these pioneer modernists and would attack the very smugness of bourgeois institutions that not only supported modern art but also permitted catastrophes like world conflict. Their vision – ironic, bitter, and cynical as well as deliberately non-rational – would dominate the next two decades.

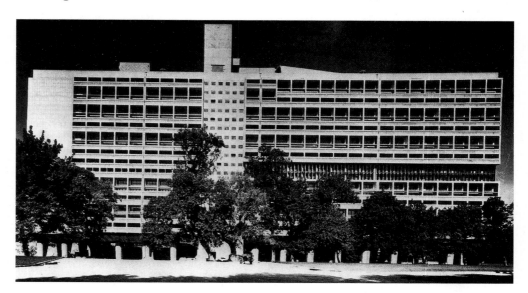

9.23 Le Corbusier, Unité d'Habitation, Marseilles, 1947–53.

MODERNIZING AMERICA – NEW YORK CIRCLES

Almost exactly at the time when Picasso and Brancusi were experimenting with the fundamental forms of painting and sculpture in Paris, artists in New York were also beginning to investigate the essentials of pictorial imagery. They fragmented and flattened objects as Cubism did; they employed vivid colors to evoke subjective states and feelings; and they even produced fully abstract, or "non-objective" pictures, often with suggestive titles redolent of music.

One of the watershed events in the history of art in America was the sudden exposure of Americans to recent European art in New York (along with Boston and Chicago) at the Armory Show of 1913. Even though fully three-quarters of the works (approximately 1,600) of "contemporary art" on display were by Americans, the most provocative, even scandalous, images came chiefly from Paris. The previous generation was represented by van Gogh, Cézanne, Gauguin, but the exhibition also presented living contemporaries. Brancusi, Matisse, Picasso, Delaunay, and the young Marcel Duchamp (especially his Cubist *Nude Descending a Staircase*, which was soon to be notorious) captured particular attention, often in the form of critical abuse. Not only did the Armory Show pose puzzling new problems for American critics and artists, but it also served to attract a cluster of important new collectors and patrons, particularly Walter Arensberg, the patron of many subsequent Dada artists, including Duchamp, in New York (the Arensberg Collection remains today a staple of the Philadelphia Museum of Art). Indirectly, the influence of the Armory Show led to the active sponsorship of "modern art" in New York, and to the official foundation of the Museum of Modern Art in 1929.

STIEGLITZ AND GALLERY '291'

In New York a new gallery system, adapted from the successful Parisian prototype, served to promote and protect experimental artists as well as to provide exhibitions of current art from Europe. Most celebrated of the New York galleries was '291' (named for its address on Fifth Avenue), opened in 1908 by Alfred Stieglitz (1864–1946), a noted photographer who had founded a "Photo-Secession" movement (patterned on the various Germanic "Secession" movements like those in Berlin and Vienna, at the turn of the century; see pp. 391–95. In the gallery's first year, Stieglitz staged America's first exhibition of

Matisse, and he opened Picasso's first one-man show in America at 291 in 1911. Numerous other Parisian modernists, including Brancusi, enjoyed their American premières at 291, and Stieglitz also mounted challenging installations of both African and ancient Mexican art and of children's art as well. In addition, the gallery featured "Younger American Painters," particularly those whose own work was in step with developments in Europe. By the time that 291 closed in 1917 (in the 1920s Stieglitz opened similar galleries for short periods), it had launched the careers of several eminent American modernist painters, including Arthur Dove, Marsden Hartley, and Stieglitz's wife (after 1924), Georgia O'Keeffe, as well as several innovative sharp-focus photographers, such as Paul Strand.

9.24 Alfred Stieglitz, *City of Ambition***, 1910. Photograph. George Eastman House, Rochester.**

grime of the metropolis alongside its vitality. Another photograph by Stieglitz, *The Hand of Man* (1902), depicts a trainyard with an advancing, smoking steam engine, capturing the atmosphere and reportage of Monet's *Gare St.-Lazare* (Fig. 8.16) without either sentiment or compromise.

MARSDEN HARTLEY One of Stieglitz's leading painters, Marsden Hartley (1877–1943), found inspiration in the Picassos he saw in 1911 at 291 and went to Europe shortly afterward for the better part of the decade, though he chiefly resided in Germany. From Picasso, as well as from Kandinsky in Munich (see Figs 9.35–9.37), he developed a distinctive, geometrized style of organizing highly contrasting shapes and colors, punctuated with recognizable letters and symbols. On the eve of World War I in 1914, Hartley (then in Berlin) captured the proud heritage and militaristic splendor of Prussian uniforms in *Portrait of a German Officer* (Fig. 9.25). While the initials and insignia of this image may specifically record Hartley's tribute to his lover, slain at the outset of hostilities on a battlefield at the Western Front, the image itself appears like a construction of Synthetic Cubism, composed of brilliant color patterns and outlined shapes. Those shapes, however, carry an emotional charge, the patriotic force evoked by flags and other national symbols, such as the Maltese Cross military decoration in the top center of the composition. Their bright gaiety, however, is set against a somber black background, as if in recollection of the sacrifices of young lives in the war.

In 1910 Arthur Dove (1880–1946) painted the first of a number of what he termed "abstractions," often evoking equivalence with music or pure sound by means of color and shape. He continued these experiments over the course of his career (e.g. *Fog Horns*, 1929), sometimes with evocations of organic shapes borrowed from nature, akin to the geometrized images of nature that formed the staple of Dove's output.

9.25 Marsden Hartley, *Portrait of a German Officer,* 1914. Oil on canvas, 68¼ × 41⅜ ins (173.3 × 105.1 cm). The Metropolitan Museum of Art, New York, Alfred Stieglitz Collection.

Stieglitz's own credo as a photographer rested on his unswerving commitment to the evocative power of material things, in contrast to the current fashion for suggestive soft-focus, akin to Impressionist paintings (see Steichen, *Rodin – The Thinker*, 1902, Fig. 8.52). His *City of Ambition* (1910) captures the towering skyline of New York from the waterfront and makes no effort to edit out the smoking tug and warehouses of the dock area (Fig. 9.24). Stieglitz was attracted to the repetition of related shapes, but his was not a photography of calculated beauty nor did he deny any imagery that he regarded as representative of a distinctively American energy and character. In this image Stieglitz confronted the bustle and

GEORGIA O'KEEFFE Another artist in the Stieglitz group was Georgia O'Keeffe (1887–1986), whose paintings also make a personal and abstract interpretation of nature. O'Keeffe had arrived in New York in 1914 after originally studying anatomical drawing at the Art Institute of Chicago, and later teaching and working as a commercial artist in Chicago. Her *Blue and Green Music* (1919) simultaneously uses its color tones to suggest the harmonious sounds of its title; at the same time, wavelike rhythms in the picture evoke ripples and ridges appropriate to water or tilled earth in the title colors (Fig. 9.26). Dark chevron shapes provide breaks in the picture surface and suggest an overall structure as well as a consistent frame within which the undulating colors unfold.

O'Keeffe turned her interest in geometry to depictions of the city's skyscrapers; like Stieglitz (whom she married in 1924) she emphasized the looming shapes of buildings by painting them as silhouettes, often at night (*New York – Night*, 1928–29). However, her love of geometrical simplification

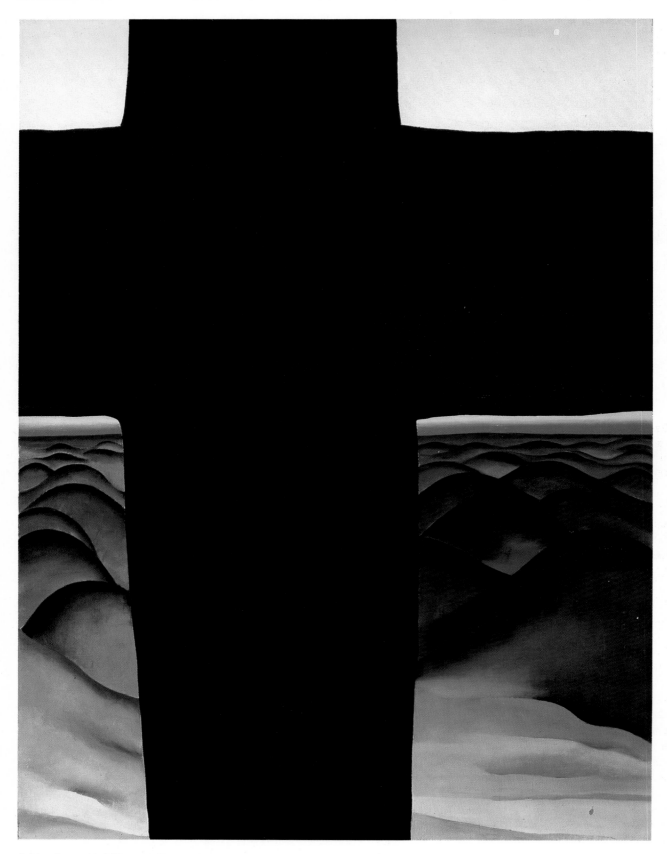

9.26 Georgia O'Keeffe, *Black Cross, New Mexico*, 1929.
Oil on canvas, 36 × 30 ins (91.5 × 76 cm). Art Institute of
Chicago.

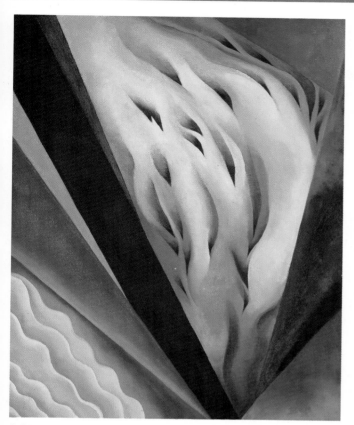

9.27 Georgia O'Keeffe, *Blue and Green Music*, 1919. Oil on canvas 23 × 19 ins (58.4 × 48.2 cm). Art Institute of Chicago. Gift of Georgia O'Keeffe to the Alfred Stieglitz Collection.

combined with a new delight in wide, open spaces after she made her first trips to the American Southwest (she eventually settled permanently in New Mexico) along with other artists of the Stieglitz group, such as Hartley and the photographer Paul Strand. Her silhouette *Black Cross, New Mexico* (1929) transposes her precise delineations of skyscrapers into the open desert environment with its brilliant sunset colors (Fig. **9.27**). Here the graded yet vivid color tonalities of her experimental abstraction become reattached to the representational task of evoking light and atmosphere across an open space. The simple cross, of course, captures the heritage of Spanish missionaries to the Indians of the region; its darkness connotes the somber heritage of that religion. Hartley produced even less celebratory landscapes of bleak, dark mountains above barren yet rolling country.

O'Keeffe also gave unremitting large-scale attention to the microcosm. She selected bleached skulls and other animal bones to represent the harsh and bare beauty of the southwestern desert. Imposingly oversized flowers, sometimes even isolated parts of flowers, such as the sexually suggestive stamens of a bloom, exhibited natural forms distilling the generative powers of human, more specifically female, sexuality, as in her *Black Iris* of 1926 (Fig. **9.28**). At the same time that O'Keeffe was exploring sexuality through flower surro-

gates, Stieglitz was focusing his camera lens on her body, both as a whole and in parts, in a male exploration of the same intimate female sexuality.

O'Keeffe's ideas for paintings cross-pollinated with those of the photographers who also frequented her New Mexico retreat. Paul Strand (1890–1976), a younger protégé of Stieglitz, delighted in the capturing of textures and material details of ordinary objects, including driftwood, fencing, and flowers (*Iris*, 1928). Strand also successfully captured the stark geometry and simple grandeur of the church at Taos, New Mexico (1930), a favorite subject for both Hartley and O'Keeffe. The New Mexico art colony of the transplanted Stieglitz circle opened up a shared pictorial exchange and experimentation as a summer antipode to their New York artworld, akin to the Impressionist circle's excursions to the countryside around Paris (pp. 336–37).

EDWARD WESTON At the same time, Edward Weston (1886–1958), a California photographer who had met both Stieglitz and Strand in New York in 1922 (as well as the new artists of Mexico shortly afterward; see pp. 414–21), soon turned his camera's attention to the close-up of organic materials. His favorite still-life objects were nautilus shells and vegetables, especially peppers, but he also explored sensuous female nudes as objects akin to still life. Weston's *Pepper, no. 30* (1930; Fig. **9.29**) offers at once a fulsome

9.28 Georgia O'Keeffe, *Black Iris*, 1926. Oil on canvas, 36 × 29⅞ ins (91.4 × 75.9 cm). The Metropolitan Museum of Art, New York, Alfred Stieglitz Collection.

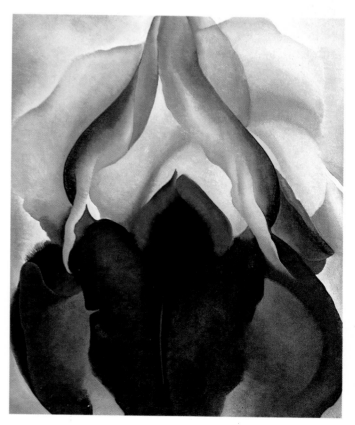

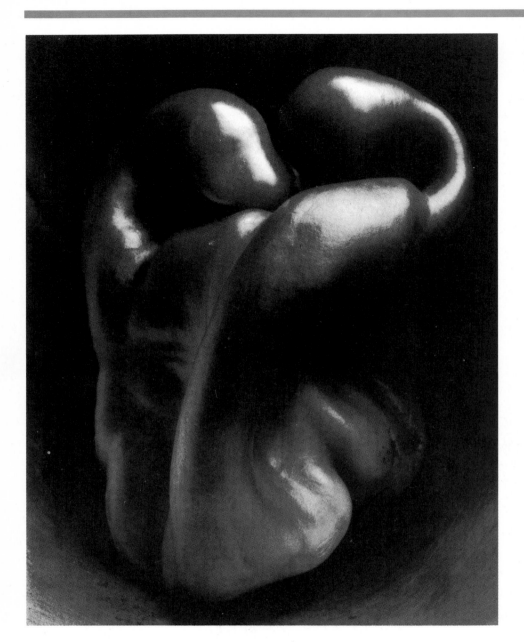

representation of the surface and texture of this familiar object
which also seems to radiate a physical energy of balanced
tensions, akin to flexing muscles. Its looming, oversized
presence in large prints, analogous to the flowers of O'Keeffe,
manifestly establishes photography as an "art form" rather
than as a mechanical transcription of reality, while asserting its
capacity to capture vivid tonal values, seemingly transcending
the object under scrutiny. (Doubtless the choice of photo-
graphic nudes, a standard academic subject of "serious art"
since the Renaissance, also derived from Weston's ambitions
for his images to be taken seriously and viewed as somehow
greater than their material subjects.)

In addition to Dove and Hartley from the Stieglitz group a
salon group of artists and authors (including the poet William
Carlos Williams) assembled around the figures of the collector-
writer Walter Arensberg and his Parisian visitor, Marcel

Duchamp, in New York during the wartime years of 1915–18
(indeed, many of the innovations of Duchamp, discussed in the
next section, originated during his sojourn in New York). One
talented artist from the Arensberg circle was Charles Demuth
(1883–1935), whose "poster portrait" of Georgia O'Keeffe
(1924) shows his own affinity for her close-up, stylized flowers
(Fig. **9.30**). Demuth drew upon his own extensive experience
with softly washed watercolors, influenced by the late waterco-
lor still lifes of Cézanne. In this work, however, the arrange-
ment of the letters of O'Keeffe's name forms a radiant cross,
evocative of both the tall, glowing buildings and the desert
cross of her own (slightly later) pictures. The potted plant
undulates like O'Keeffe's musical abstractions; it is sur-
rounded by further symbols of fecundity, silhouetted fruits,
Demuth's rejoinder to his friend through phallic equivalents to
O'Keeffe's uterine flowers.

9.30 Charles Demuth, *Poster Portrait: Georgia O'Keeffe*, 1924.
Oil on poster. New Haven, Beinecke Library.

CRITIQUE OF UNREASON: GERMANY AND WORLD WAR I

Picasso's *Demoiselles d'Avignon* (1907) had deeper implications for art and its roles than he realized in his own later formal experiments of Cubism. The disturbing subject of prostitution and the unsettling way in which the Western tradition of the beautiful was distorted conveyed a vision of social isolation and alienation. His hostile image of women and their sexual threat proposed a new category of art – based on the grotesque rather than the beautiful, on the violent and primal rather than the ideal. This kind of art could no longer be viewed as aesthetically transcendent and detached from everyday life. Instead, it assaulted bourgeois and liberal assumptions about the integrity of art, provokingly infusing it with unsettling psychological and moral questions.

9.31 Edvard Munch, *The Scream*, 1893. Oil on canvas, 35¾ × 29 ins (91 × 73.5 cm). Nasjonalgalleriet, Oslo.

EXPRESSIONISM

Picasso's image appeared at the time when Freud's theory of Oedipal sexuality and the unconscious was challenging traditional patterns of social behavior. Within this framework, an alternative modern art emerged – art born out of anxiety and frankly intimate, personal expression. Often this art strives for a kind of unalloyed truthfulness to baser instincts. It uses shocking visual forms in order to confront complacency and vestigial propriety or decorum in its conventional audience. Ultimately this kind of art stressed the suffering of its heroic protagonist, the artist (usually male, with a morbid fear of the female), and the intensity of his vision. In German-speaking countries this new movement in art is generally known as *Expressionism*.

MUNCH Often the new art took the human figure as its locus of psychic conflict. Unadorned, even shocking, self-revelation served as the fundamental subject of painting. In Berlin at the turn of the new century a young Norwegian artist, Edvard Munch (1863–1944), strove to portray the emotional lives of "living people who breathe, feel, suffer, and love." In his 1893 painting, *The Scream*, (Fig. **9.31**), pictorial distortion – the charged reds and golds of sunset, the steeply receding perspective of a bridge, the lively detached brushwork of an insubstantial landscape, plus the simplicity of hands and masklike head in staring panic – portrays a subjective state akin to hysteria. No external cause for this fear exists within the painting; indeed, the other two figures on the bridge are respectably dressed and of upright demeanor. But the individual sensibility of the artist, projected onto his main figure, perceives the world differently. Here he describes his own subjective state:

> I was walking along with two friends . . . the sun set . . . suddenly the sky became a bloody red . . . and I felt a tinge of sadness . . . I stood alone, trembling with fear. I felt the great, unending scream through nature.

Munch employs lively brushwork like van Gogh and charged colors like Gauguin to project not a fantasy of tranquillity but a horror beyond that of even van Gogh's *Night Café* (Fig. 8.42). Munch visited Paris in the early 1890s, but much of his artistic contribution emerged from a close circle of artist and writer friends in Berlin, akin to the Stein circle of Picasso and Matisse in Paris a decade later.

9.32 Edvard Munch, *Madonna*, **1895. Color lithograph. Munch Museum, Oslo.**

In 1892 an exhibition of Munch's art by the Society of Berlin Artists led to a storm of critical protest and the eventual cancellation of the exhibition. In protest against this censorship, a group of ambitious painters who were influenced by what was happening in France eventually broke off from official, imperial, sponsored art organizations and salons. By 1898 they had formed their own association, the Berlin Secession. During the 1890s, Secession groups sprouted throughout German-speaking Europe, forging bonds between such cities as Berlin, Munich (established in 1892), and Vienna (established in 1897), and eventually serving as the model for shorter-lived artists' groups.

Munch, meanwhile, continued to reside in Berlin until 1908, and he exhibited his later works with the Berlin Secession. In addition to his world of terrified memories and nightmares Munch produced more generalized visions, with a sense of mystery reminiscent of the later Gauguin. His *Madonna* (1895; Fig. **9.32**) captures the sexual paranoia that haunted him, presented according to the tradition of painted frontal icons. Here, however, instead of the Virgin Mary a primal, nude, corpselike woman-vampire confronts the viewer. Instead of a nurturing spiritual mother, this *femme fatale* poses in a posture of sexual availability. Her natural force dwarfs and

dominates a shriveled fetal male in the lower corner of the frame, the successor to Munch's screaming man, and her liquid environment is suffused with spermatozoa. Munch attempts to replace traditional religious imagery with an internalized mystery, projected onto womankind: sexual fantasy based on anxiety.

SCHIELE In Freud's own Vienna, Egon Schiele (1890–1918) introduced his own sexual fears and fantasies in images of brutal candor, intended as both confession and provocation. A friend of Schiele remembers the artist as mournful and pained in expression, and it is this visage that stares out at the viewer of Schiele's confrontational, sexually explicit self-portraits (Fig. **9.33**). Angular, emaciated, bony limbs are projected against unadorned, blank backgrounds. All semblance of aspiration toward beauty has been ruthlessly expunged from these bare compositions. The artist's features constrict in grimaces or scowls, suggestive of physical or psychic anguish. Schiele obsessively presents himself alone, always suffering. Several of the works explicitly convey sexual tension, including masturbation, which complicates the artist's ongoing narcissism with sexual guilt. Taken together, these self-portraits offer a frontal attack on sexual repression and bourgeois propriety. Like Picasso's *Demoiselles*, Schiele's drawings place the viewer in the uncomfortable position of voyeur.

Schiele also made drawings of female nudes during these same years (around 1910–12); they offer an overt erotic availability and frankness matched only by Picasso's prostitutes

9.33 Egon Schiele, *Self-Portrait, Nude Facing Front*, **1910. Black chalk and watercolor on paper, 17⅜ × 12 ins (44 × 30.5 cm). Albertina, Vienna.**

9.34 Egon Schiele, *Female Nude*, **1910. Pen and ink on paper, 17¾ × 12½ ins (45.5 × 32 cm). Albertina, Vienna.**

(Fig. **9.34**). His images of women emphasize their genitalia and autoeroticism, on unabashed display. These models are the objects of voyeurism, dressed in long stockings to suggest their deliberate worldliness rather than the academic tradition of studio ideality or posing for optimal beauty of composition. Typical of Schiele is the choice of drawing or watercolor as his medium – the most informal and personal of creations. He daringly posed his own younger sister for a frontal nude drawing in 1910, and he lived openly and scandalously with his favorite model after 1911. His moral lapses shocked respectable Viennese society, and he was accused of pornography; in 1912 he was sent to prison briefly after a judge openly burned one of his drawings in court. Paradoxically, the success of the rebellious young artist rose with his condemnation by public morality. He was able to exhibit his works with associated independent artists and architects from the former Vienna Secession.

KANDINSKY AND THE "BLUE RIDER"

A leader of the prewar Munich artist community was the Russian émigré Wassily Kandinsky (1866–1944), who in 1901 joined the Munich Secession. By 1909 he led the way in organizing a smaller, more concerted group, the New Artists' Association, that after 1911 re-formed and took the name "Der Blaue Reiter" ("Blue Rider") after one of Kandinsky's own pictures. Despite a short stay in Paris (1906–07), he turned away from the formal experimentation of Picasso and Matisse toward another form of nostalgia that departs from the world of urban modernity: the folkloric tradition of his native Russia.

Kandinsky's early Russian subjects are painted in the traditional medium of *tempera*, with bold brush strokes and color patterns shaping characters and costumes evocative of Russian folk tales. The activities are festive and innocent like Matisse but within a pre-modern native Slavic tradition left behind by the artist. In 1911, Kandinsky depicted one of the central motifs of traditional Russia, a *Troika*, or three-horse sled (Fig. **9.35**). This motif has the feeling of irresistible speed as well as a distinctly Russian character. However, Kandinsky renders his figures and landscape in sweeping, bold color tones of oil paint, held within simple dark contours, thereby reducing the details to suggestive essentials.

Because of this kind of reduction of explicitly depictive elements, Kandinsky has been celebrated as a pioneer of abstraction during phases of the twentieth century that otherwise set primary emphasis on purely formal arrangements of art, such as the Parisian experimentations of Cubism (see pp. 372–74). Moreover, he supported such an interpretation through his own writings and his deliberately general or obscure titles. Yet Kandinsky's work ultimately depends upon our realization that beneath his schematic forms, such as *Troika*, lies a traditional landscape, akin to Matisse's *Happiness of Life*, whose brilliant colors he adopts in this image. In *Troika*, crashing waves splash along the bottom edge of the composition, while at the right edge a trio of portly men, one with a rifle, sail in a boat. Behind them a wooded hill rises, balanced above the troika by a tall fortress.

Like Matisse and many academically trained artists since the Renaissance, Kandinsky still used a series of compositional sketches for each larger final canvas. Yet the reliance on such basic formal elements as line and color, and the rejection of spatial illusion in favor of overall surface arrangements, link his pictures to the innovations of both Picasso and Matisse. Kandinsky willingly associated himself with progressive tendencies in Paris, and his New Artists' Association attempted to include Picasso and others in its 1910 exhibition in Munich.

Kandinsky codified his pictures using a range of subtle distinctions. He called his finished, definitive pictures "compositions"; in contrast, he called more spontaneous expressions "improvisations," and more natural references "impressions." The artist has given his own account of a breakthrough

9.35 Wassily Kandinsky, *Troika*, 1911. Oil on canvas, 28¾ × 42 ins (73 × 106.6 cm). Art Institute of Chicago. Arthur Jerome Eddy Memorial Collection.

in 1908 to a more fully abstract use of color and line in his story of returning to his studio and seeing one of his own paintings afresh because it was accidentally left upside-down. Kandinsky saw art creation less as an issue of abstraction versus representation than as a mystical activity. He also adopted the turn-of-the-century aesthetic theory that advocated *synaesthesia*, the transfer of perceptions from one sense to another, or from one art form, specifically music, to another. He deliberately makes analogies to music in his titles. For him, analogies between color and sound, expressed through the common term "harmony," became an ongoing preoccupation in his attempt to reach his viewers directly, bypassing clear depiction and developing an intense visual "language." His 1910 essay (published 1912), "On the Spiritual in Art," suggests a purpose, even mission, in his art.

Unlike Picasso, whose own feverish experimentation with Cubism coincides with Kandinsky's explorations of 1911–13, he strove to depict the transcendental, although he accepted that pictures used symbol, artifice, and convention. Kandinsky

considered art to be a purifying and spiritual experience beyond material concerns, which could engage the soul of both artist and viewer. Only recently have many of his ongoing themes been understood: Last Judgment, Deluge, apocalyptic battles as well as Edenic idylls or Paradise.

The technique of abstraction and recomposition of an underlying ideal image can be seen in Kandinsky's 1913 composition, *Small Pleasures*, prepared by several oil improvisations and watercolor studies (Fig. **9.36**, p. 394). Here a conceptual landscape can still be discerned in the red sun in the upper left corner and central hill forms rising above foreground foliage. Kandinsky's ever-present heroic riders gallop up the highest hill, but their forms have been distilled down to a mere suggestion of line and thinly brushed brown color for the mounts. The hindmost horse at the center of the left edge is blue, a reference to Kandinsky's signature figure, the "Blue Rider," in all likelihood an apocalyptic Christian knight. On a clearly visible central peak Kandinsky presents a walled city like the one in *Troika*, while a second fortress with a blue wall awaits the arrival of the horsemen at the summit. Dark colors above the right side suggest storm clouds above a turbulent sea, in which a rowboat (also akin to *Troika*) with three black oars struggles to survive. The enormous pair of jawlike forms at the lower right may indeed be a reference to a whale or to

9.36 Wassily Kandinsky, *Small Pleasures*, 1913. Oil on canvas, 43¼ × 47⅛ ins (109.8 × 119.7 cm). David Heald © Solomon R. Guggenheim Museum, New York.

9.37 Wassily Kandinsky, *Black Lines*, 1913. Oil on canvas, 51 × 51⅝ ins (129.4 × 131.1 cm). David Heald © Solomon R. Guggenheim Museum, New York.

the traditional medieval mouth of Hell. Like Christian depictions of the Last Judgment, Kandinsky divides his composition into a blessed left side versus a cursed right side; though he veils his landscape and figures with bright color washes, the contrast of sun with storm makes this division explicit. In many ways, his subject-matter and his spiritual aim to use his art as an agent of religious reform can be compared to that of Albrecht Dürer (see pp. 148–52), who also depicted mounted Christian knights, a heavenly city on a hill, and apocalyptic strife within a metaphoric landscape.

A final step toward fully abstract use of brilliantly juxtaposed color bursts and non-representational linear accents occurs later in the same year in *Black Lines* (1913), a lyrical "improvisation," though vestiges of sun, mountain peaks, and trees appear in the graphic marks at the top of the canvas (Fig. **9.37**). In this painting, however, Kandinsky truly celebrates the unfettering of color from the linear contours of the landscape shapes in tonal bursts of flowery brilliance that suggest the intensity and openness of Matisse together with the "abstracted" purity of the Delaunay disks.

THE IMPACT OF WAR: BECKMANN

The apocalyptic themes of Kandinsky sometimes seem to herald the oncoming clashes of World War I, even though the painter himself rejected such equations. Instead, he insisted that his premonitions foretold a spiritual struggle. Yet World War I forced him to leave Munich and return to Russia. The conflict dispersed or traumatized many of his artistic colleagues in the German-speaking countries. Many of them made similar criticisms of materialism and decadence in their pre-war art, which was followed by a sharp cynicism afterward.

For Max Beckmann (1884–1950), violence and struggle formed the essential subject of a fragmented career, riven by two world wars. He began painting in Berlin and joined the Secession movement there before World War I. Having served briefly in the German army as a medical orderly, he received a medical discharge for nervous exhaustion. His letters reveal traumatic wartime experiences: "My will to live is for the moment stronger than ever, even though I have already experienced dreadful things and died myself with them several times." After an initial burst of patriotic enthusiasm for the war, many German artists like Beckmann quickly became disillusioned and critical. Others were killed before they had reached their prime. The dominant tone of the art of the survivors became either dark despair or deeply politicized cynicism.

Shortly after the end of World War I, Beckmann's perennial themes began to emerge: human violence and lust within an unfathomable world, filled with mysterious symbols. His *Night* (1919) is a gruesome picture (Fig. **9.38**), recalling the angular "Gothic" figures and torments visited upon saints in earlier German art, such as Neithart's *Isenheim Altarpiece* (see pp. 143–45). Deliberately crude figures with jutting limbs pack a claustrophobic attic space. Outside only a bare crescent moon interrupts the ominous quiet of a black nocturnal sky. Inside

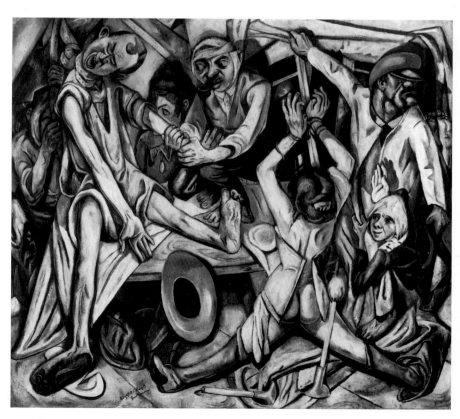

9.38 Max Beckmann, *Night*, 1919. Oil on canvas, 52³⁄₈ × 60¹⁄₄ ins (133 × 153 cm). Kunstsammlung Nordrhein-Westfalen, Düsseldorf.

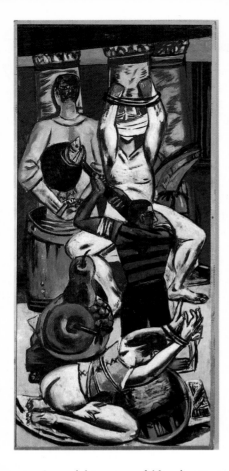

an urban nightmare unfolds. A group of sadists attack and torture a family at the dinnertable, maiming and hanging a man from the rafters and sexually assaulting a manacled woman. This brutality is orchestrated at the upper right by a man in a cap, a caricature of Lenin. Even the space of the room has broken down into a dreamlike, crystalline network of crowded angles. By means of such nightmares and fantasies of violence, Beckmann unflinchingly confronts the breakdown in society's values in the wake of World War I. His series of prints from this same year shows urban poverty and conflict, with maimed war victims, under the general title of *Hell*. Beckmann describes such suffering and cruelty as inevitable: "We must participate in the entire misery that is about to come." The horrors of war have now entered the home.

Beckmann revived the traditional German Gothic form of the triptych (again from the era of Neithart) in some of his later works, in order to produce a more systematic vision of human nature in the form of complex allegory. In this respect, he is heir to the expressions of torment and despair created by artists such as Munch and Schiele. One of his first altarpiece-like allegories is *Departure* (1932–35), a work that again features visions of torture and bondage on its side panels (Fig. **9.39**). At the left an executioner hoists a strange, blunt weapon above bound prisoners, one with maimed hands. A bound woman below kneels upon a globe. At the right a woman and man are bound together: he is nude and inverted; she carries a lamp; and a blindfolded bellman behind them carries a fish. A noisy bass drum fills out the foreground. This enigmatic scene was partly explained by Beckmann in a letter to a friend. According to the artist, these side panels convey

9.39 Max Beckmann, *Departure Triptych*, 1932–35. Oil on canvas, 84¾ × 113⅞ ins (215.2 × 289 cm). Collection, The Museum of Modern Art, New York.

the essence of life, "torture, pain of every kind – physical and mental – men and women are subjected to it equally." The nude inverted man symbolizes the weight of past memories, "wrongs and failures, the murder everyone commits at some time of life." Against the unremitting darkness and crowding of the wings on either side, the central panel of the *Departure Triptych* is bright and open. Here one of Beckmann's favorite figures, a king, recalling simpler, primitive societies, floats with his family in a fishing boat (for Beckmann, fish frequently appear in situations charged with sexual tension, often with bondage, as on the side panels of *Departure*). Here, however, the boundless expanse of a brilliant blue sea promises liberation from life's tortures, an alternative to the complexity and imprisonment portrayed on the wings. The ultimate image of freedom in this triptych is the Christlike child, linked to the idea of hope and fresh beginning conveyed by the title. But it is significant that Beckmann's construction of a central realm of freedom is filled with retrospective and nostalgic figures in period costumes – in absolute contrast to the constraints of modernity in the narrow wings.

Departure was produced shortly before Beckmann lost his teaching position in Frankfurt, the direct result of Nazi criticism of his "degenerate" art. His subsequent migrations – to Berlin, Paris, Amsterdam, and finally after World War II to the United States – read like a metaphor of the homelessness of the sensitive and suffering artist during the present century.

ART AND ANTI-ART: DADAISM

Other German-speaking artists expressed the somber mood of postwar alienation by other means. Some chose to attack the very institutions that valued artmaking, condemning it as a realm of aesthetic distance from worldly reality. They did so in part by introducing overtly political subjects into their images, but they also criticized the role of art within the institutions – cultural as well as political – that had involved Europe in the mass destruction of World War I. Their protest undermined the concept of creativity and artistry that was traditional in the artworks displayed in a gallery or museum.

Beginning in Zürich in 1916, a group of artists and writers, largely refugees from Germany and France, formed a group that challenged, even repudiated, all notions of art. If rational calculation and traditional culture, including art, had led to the disastrous carnage of the war in Europe, then their goal would be oppositional, to liberate the irrational, even the anarchic. The group took its name, *Dada*, from a children's nonsense word in order to underscore its mocking opposition to adult logic and coherence. Dada members generated the concept of art-as-performance, taking their activism to the street in collective, anti-establishment expressions of freedom and spontaneity, such as simultaneous poems or "noise music." Both as artists and as poets, the Dada group experimented with works created by pure chance. For example, Hans Arp (1887–1966), an Alsatian sculptor-poet within the Dada group, once tore up one of his drawings, dropped the fragments on the floor, and glued them where they fell, to form his new "work," a collage of randomness, *Squares Arranged According to the Laws of Chance* (1917; Fig. **9.40**). Arp's productive inventiveness was deployed through organic abstract form and flowing contours into more permanent objects. He constructed painted wood reliefs, and he also sculpted smoothly polished, irregularly curving stone or bronze shapes, such as the vertical bronze, *Growth* (1938; Fig. **9.41**).

If Arp's Dada group in Zürich during the war was largely countercultural in its thrust, then Dada in the cities of Germany immediately after the war often preached revolution. Slogans pasted on placards in the 1919 Berlin Dada exposition included the following assortment:

9.40 Hans Arp, *Squares Arranged According to the Laws of Chance*, 1917. Pasted paper, 19⅛ × 13⅝ ins (48.5 × 34.6 cm). Collection, The Museum of Modern Art, New York.

9.41 Hans Arp, *Growth*, 1938. Bronze, 31¼ ins (79.3 cm) high. Gift of Curt Valentin, Philadelphia Museum of Art.

**9.42 Georg Grosz, *Republican Automatons*, 1920.
Watercolor on paper, 23⅝ × 18⅝ ins (60 × 47.3 cm).
Collection, The Museum of Modern Art, New York.**

> DADA stands on the side of the revolutionary Proletariat.
> Open up at last your head. Leave it free for the demands of
> our age.
> Down with art. Down with bourgeois intellectualism.
> Art is dead.

Their principal artistic medium was the newspaper clipping,
using photomontage to portray the ills of society. Berlin Dada
also employed the ironic pen of the political cartoon. These
techniques were fused to pungent effect in the hands of the
Berlin revolutionary, Georg Grosz (1893–1959). His water-
color, *Republican Automatons* (1920), depicts a Berlin street
populated by well-dressed figures, whose fashionable mode
includes both a flag and a military decoration (Fig. **9.42**).
However, they are manikins, constructed out of mechanical
parts and devoid of facial features. Where they should have
heads, they have only numbers and words – automated cheers
for the Weimar Republic of postwar Germany. The tautly
drawn scene is otherwise empty, suggesting the cultural void
at the heart of the modern metropolis. In his harsh commen-
tary Grosz unleashes a Beckmannian cynicism along with
a focused political agenda, hoping to use art as an agent of
social revolution.

THE BAUHAUS

Founded in 1919 by Walter Gropius (1883–1969) as a state arts
school in Weimar, capital of the postwar Germany, the
Bauhaus deliberately evoked the traditions of corporate crafts
of the medieval cathedral and attempted to integrate architec-
tural design with fine arts, crafts, and industrial design. Its
utopian ambitions grew out of the same postwar despair as the
powerful expressionism of Beckmann or the revolutionary art
of Grosz; however, Gropius and the Bauhaus sought social
redemption through art and architecture, like the collective
artists of post-revolutionary Russia. As a result, critics quickly
labeled the Bauhaus as "Bolshevik" or "degenerate," and the
controversy led to its removal in 1925 to a new building site in
Dessau (Fig. **9.43**). Nevertheless, over the span of its fifteen-
year heyday until 1933, the Bauhaus retained on its faculty
some of the people who were most influential in developing the
program of modernity.

In his new Dessau building, Gropius allied his architecture
with the austere and precise modern forms of Malevich and

**9.43 Walter Gropius, Bauhaus building, Dessau, 1926.
Workshop façade.**

**9.44 Walter Gropius, Bauhaus building, Dessau, 1926.
Air view.**

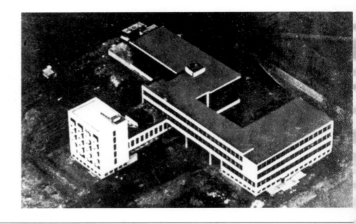

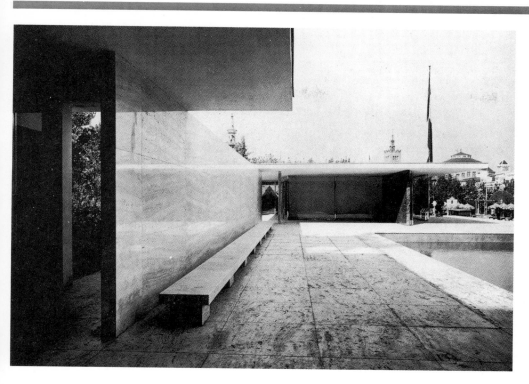

9.45 Ludwig Mies van der Rohe, Barcelona Pavilion 1929, (destroyed).

Lissitzky in Russia, or of Mondrian and Le Corbusier in Paris, asserting the importance of functional clarity and absence of ornament. He gives visual emphasis to the essential elements of construction: clearly layered floors with unbroken windows or even curtain walls of glass, made possible by the supporting skeleton of steel beams and concrete walls. The Bauhaus most fully realized the analogy between modern technology and design; like a machine, such as an airplane, it suggested both efficiency and beauty (Fig. **9.44**). Arguing for an alliance between creativity and craft, Bauhaus designers also produced prototypes for mass-produced furniture and other household objects, from fabrics to wallpapers. Moreover, they practiced what they preached, mixing together different kinds of areas such as classrooms, studios, workshops, and living quarters in their headquarters in Dessau. Architecture provided a flexible yet unequivocally "modern" framework for all activities.

MIES VAN DER ROHE As both a teaching institution and a collective of diverse artists and architects, the Bauhaus was continually changing its curriculum and its theories (Gropius himself departed in 1928 for private practice). The shift from Weimar to Dessau had already seen an increasing emphasis on modernity rather than the original communal crafts lodge ideal. In the final phase of its existence, 1930–33, the director of the Bauhaus was a Berlin architect, Ludwig Mies van der Rohe (1886–1969). Much less of a visionary than Gropius, Mies nonetheless followed fastidiously the functional stress on the essential elements of a building, particularly the steel armature and the curtain walls of glass permitted by steel-cage construction. As early as 1921 he had designed a high-rise building as extreme in its reduction as Mondrian's paintings: a glass skyscraper. Rejecting Le Corbu-

sier's obsession with geometry as well as references to steamships or other modern technology, Mies continually strove for maximum effect through minimal means. His dictum was always, "Less is more." Open space, calculated proportions, and refined materials distinguish every Mies building.

Mies later emigrated to Chicago, where his work after 1938 became a hallmark of postwar American skylines (see p. 439). But his German masterpiece was a temporary building, the German pavilion (Fig. **9.45**) at the Barcelona World's Fair of 1929 (the same year as Le Corbusier's Villa Savoye). The elegance and stark simplicity of this interior derived from a few supporting stone pier slabs and steel piers that carried the weight of the flat roof yet served as the only subdivisions within an otherwise open and flexible space. In plan, the Barcelona pavilion resembled one of Lissitzky's Proun designs of intersecting planes (see p. 402). On a raised podium, accented with a rectangular pool, the entire rectilinear structure suggested a play of geometrical harmonies in which walls, floors, and roofs functioned as accents rather than as traditional loads and supports. In effect, the entire building and its reduction to essential planes and materials has rightly been compared to Mondrian's contemporary experiments with the basics of color and intersection in pictures.

PAUL KLEE A host of diverse artists of all kinds made up the faculty of the Bauhaus, including Kandinsky (from 1922 to 1933). One of the most influential was Kandinsky's younger friend from Munich, Paul Klee (1879–1940), at the Bauhaus from 1920 to 1931. Klee's outlook on art was largely summarized by the title of his published lectures on principles of design from the Bauhaus years, *Pictorial Thinking*. Like Kandinsky, Klee also strove for the essentials of form as the basis of his art; however, instead of approaching it

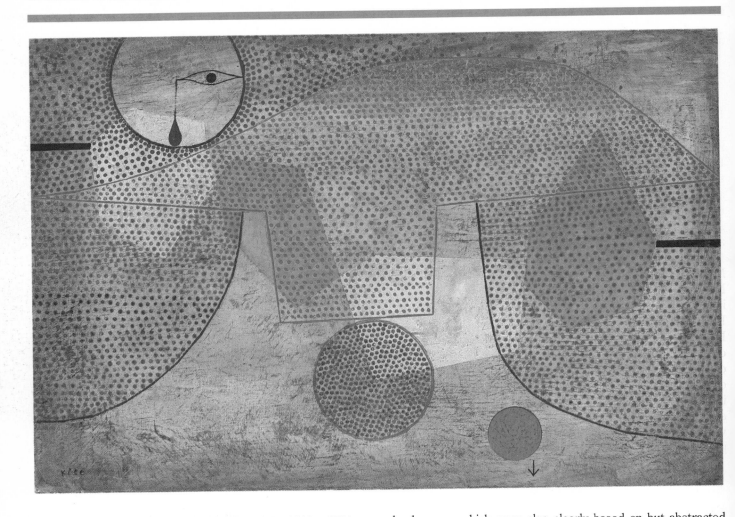

9.46 Paul Klee, *Sunset*, 1930. Oil on canvas, 18⅕ × 27⅝ ins (46.2 × 70.2 cm). Art Institute of Chicago. Gift of Mary and Leigh B. Block.

through the distillation of color like the earlier Kandinsky or through geometry like the Bauhaus Kandinsky, Klee used unusual formal sources. Adapting the art of children or the art of "primitives," Klee made a constant effort to rid himself of European pictorial traditions, placing particular emphasis on the signifying potential of pictographic signs such as arrows or hieroglyphs. Like Kandinsky, he often sought analogies between art and music, and he worked hard at producing appropriate poetic titles for his imaginative pieces.

In works like *Sunset* (1930; Fig. **9.46**), Klee tested to its limits the use of visual symbols as a method of representation as well as the harmonies of adjacent colors and shapes. In its composed linear abstractions ("*ideograms*") upon a brightly colored field of mosaic-like paint spots and lines, this late work suggests affinities with the pointillist dots of color in Seurat's

landscapes, which were also clearly based on but abstracted from nature (see p. 352). Simple artistic and elemental natural forms echo one another: the round red orb of the declining sun finds its pictorial rhyme in the orb of an eye with a red teardrop. This abstraction transforms the emotive power of a Romantic cliché, akin to Caspar David Friedrich's viewers of moonrise a century earlier (cf. pp. 316–17). In 1930, the same year as this intellectualized outpouring of sentiment, Klee resigned his faculty position at the Bauhaus in an attempt to get away from the political controversies there, especially after the appointment of Mies van der Rohe as director. In much of his published work, Klee asserted that the wellsprings of creative art lay in the subconscious, though he firmly believed in the importance of conscious arrangement and technique rather than Dadaist spontaneity or chance. However, the lyrical order of Klee's latest art was produced while he was in exile in Switzerland, dismissed from his academic position at Düsseldorf Academy in 1933, one of the more celebrated victims of Nazi attacks on "degenerate" art.

REVOLUTIONARY RUSSIA, 1917

In contrast to the embittered politics of Berlin Dadaists after World War I and their frustration with revolution, the truly revolutionary situation of both society and art in postwar Russia offered an unparalleled opportunity for renewal. Russian artists, in close contact with developments in both Paris and Berlin, had already made their own radical contributions toward pure, geometrical abstraction before World War I. Artistic innovation after the revolution would be used for ambitious projects in the service of the new society.

In some ways, the pictorial reductions made by Kasimir Malevich (1878–1935) parallel and precede those of Mondrian. Malevich, who exhibited with the Blue Rider group in Munich in 1912, generated his "suprematist" forms out of a Kandinsky-like commitment to the spiritual, combined with a Delaunay-like affirmation of the technologically modern, including the airplane. His *White on White* (ca. 1918) marks the definitive detachment of painting from any depictive purpose outside itself as well as an attempt to achieve a "non-objective" image of pure sensation (Fig. **9.47**). By reducing visual expression to an opposition of geometrical essences – black/white, figure/ground – Malevich felt he had touched a mystical pictorial core: "the supremacy of pure feeling in creative art."

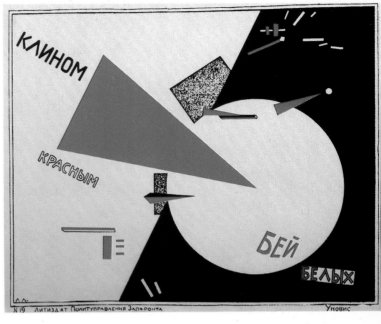

9.48 El Lissitzky, *Beat the Whites with the Red Wedge*, 1919. Poster. Van Abbemuseum, Eindhoven.

9.47 Kasimir Malevich, *Suprematist Composition: White on White*, ca. 1918. Oil on canvas, 31¼ × 31¼ ins (79.3 × 79.3 cm). Collection, The Museum of Modern Art, New York.

ART AS "AGITPROP"

The Russian Revolution in November 1917 linked such reconstitution of modern art to a new social enterprise. According to Lenin's minister of education and the arts, Anatoly Lunacharsky, art should be harnessed in the service of "*agitprop*," that is, agitation and propaganda for the spread and consolidation of the revolution. Yet that art could use the most "modern" forms available, pointing not to the past but to the future in the tradition of the artistic and political vanguard, or avant-garde. Kandinsky, back from Munich, was assigned in 1920 to restructure art education throughout Russia.

In the post-revolutionary economic crisis, much Russian art necessarily focused on inexpensive, temporary, and mass-produced design: posters, movies (by such film pioneers as Eisenstein and Vertov), and public decor, such as stage sets or pageants. Many ambitious designs never got off the drawing-board or stage of model building. Nonetheless, revolutionary Russian art often has the force of applied abstraction, inspired by the latest modern technology, such as airplanes and wireless communication.

EL LISSITZKY A good example is the 1919 civil war poster by El Lissitzky (1890–1941), *Beat the Whites with the Red Wedge* (Fig. **9.48**). Here the geometrical shapes

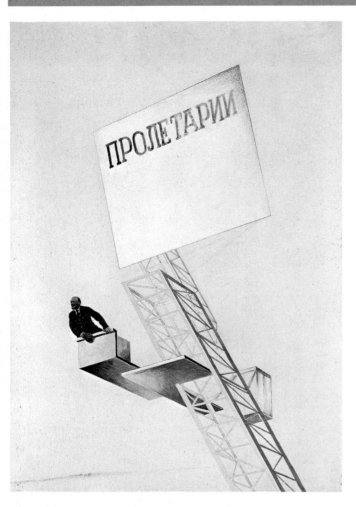

9.49 El Lissitzky, *Design for the Lenin Tribune*, 1920. Pen on paper. State Tretyakov Gallery, Moscow.

of Malevich take on the character of moral allegory, where the wedge of Lenin's Communists, the Reds, attacking from the side of light and moral superiority, triumphs over the powers of darkness, the white circle on dark ground, representing counterrevolutionary Whites. Lissitzky, who taught with both Marc Chagall and Malevich at a post-revolution art school in Vitebsk, also helped to design a new flag for the 1918 May Day ceremonies, and he designed a speaking platform (tribune) for Lenin in 1920 that was never built (Fig. **9.49**). This simple, industrial technology of construction aimed to eliminate decorative elements of "taste" or artistry in favor of utilitarian functioning in the new society. Lissitzky, however, also created constructions of complex geometrical networks in two and three dimensions that went on display with other modernist artworks in the West (Fig. **9.50**). Most of these creations he called "Prouns," based upon the Russian words for "affirmation of the new" (Fig. **9.51**). Extension of Malevich's principles into three dimensions implied that such geometry could also form the basis of architectural or sculptural design, like the Lenin Tribune (or related architectural designs and models made by Malevich). Lissitzky often gave his Proun designs

architectural titles, such as "Bridge" or "Town." He claimed that the artist no longer portrayed the world as it was but rather served as the creator of a new environmental reality, a "new world of objects." This utopian vision of the artist-engineer resembles the model architecture, based on pure geometry and mass-production, of Le Corbusier in France (p. 382). Le Corbusier actually designed a glass-tower Ministry of Central Economic Planning for Moscow (1928–32), but it was never built because Stalin disliked Modernist architecture.

LIUBOV POPOVA The new Soviet society also offered a more favorable setting for women artists. Liubov Popova (1889–1924) developed out of the Cubism of Paris a distinctive new techniqe, called *Constructivism*, combining radical abstraction and assembled planes, akin to the later Prouns of Lissitzky (Fig. **9.52**). Other artists explored Constructivist concepts of projecting space in sculptural media. However, Russian Constructivism also had a utilitarian, revolutionary agenda, and Popova became active in producing designs, including fabric patterns, rather than easel works for display. After 1921, many avant-garde artists in Russia abandoned the concept of "fine art" altogether, in favor of the design of practical objects (which had traditionally been marginalized

9.50 El Lissitzky, *Proun*, ca. 1923. Canvas, 22½ × 16¾ ins (57.1 × 42.5 cm). Busch-Reisinger Museum, Harvard University, Wertham Coll.

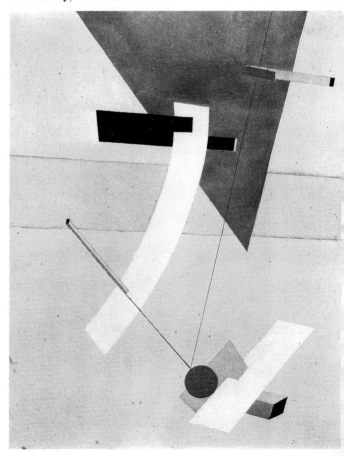

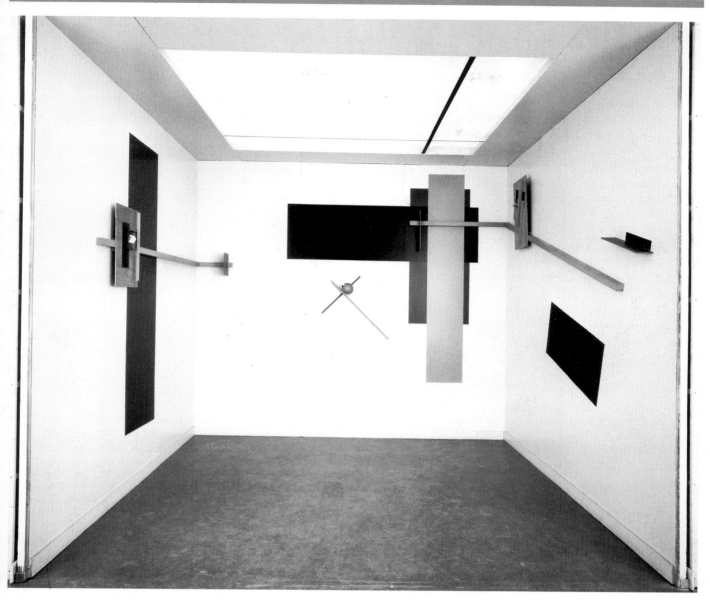

**9.51 (Above) El Lissitzky, Proun space, created for
Berlin Art Exhibition, 1923. Reconstruction, 1965. Van
Abbemuseum, Eindhoven.**

**9.52 (Right) Liubov Popova, *Architectonic Painting*, 1917.
Oil on canvas, 31½ × 38⅜ins (80 × 98cm). Collection, The
Museum of Modern Art, New York (Philip Johnson Fund).**

through terms such as "applied art"), such as Popova's fabrics,
plus furniture, photography, poster, and film. The victorious
side of the debate held that work in the new Marxist state
should be closely tied to engineering or craft rather than pure
creativity. Consequently, Lissitzky and Kandinsky, together
with a number of other artists who wanted to paint pictures,
left Russia for the West, usually Germany or Paris. Together
they helped to stimulate debates about the relationship be-
tween art and design in postwar Germany. There the merging
of art and design with more practical concerns, particularly
architecture, formed the basis for the Dessau Bauhaus.

PROBLEMS IN PARIS

If the predominant theme of twentieth-century Parisian art centered on Picasso and the formal absolutes whose ultimate expression was Cubism, there were nonetheless alternative movements based on imported themes. Instead of formal experimentation, some artists in Paris made direct use of their unconscious minds as an artistic source, in order to produce the psychic equivalent of dreams.

DE CHIRICO One such artist émigré in Paris was Giorgio de Chirico (1888–1978), an Italian of Greek ancestry. De Chirico used traditional techniques of representation, particularly heavy shadows, to convey a mood of mystery, melancholy, and isolation. *The Philosopher's Conquest* (1914) presents open yet depopulated public spaces, dominated by oversized inanimate objects, including an intrusive cannon, that take on a menacing quality (Fig. **9.53**). Distinctly modern and familiar urban elements – smokestacks, railroad stations, and clocks – fail to counter the unsettling emptiness (except for the visible shadows of two offstage cowled figures)

9.53 Giorgio de Chirico, *The Philosopher's Conquest*,1914. Oil on canvas, 49¼ × 39 ins (125.1 × 99.1 cm). Art Institute of Chicago. Joseph Winterbotham Collection.

9.54 Marcel Duchamp, *The Passage from the Virgin to the Bride*, 1912. Oil on canvas, 23⅜ × 21¼ ins (59.4 × 54 cm). Collection, The Museum of Modern Art, New York.

and spatial disorientation of this environment. De Chirico called the mysterious sense of displacement "metaphysical," in the sense of dream and enigma. What seems at first rational and unproblematic becomes upon further examination disturbing and inexplicable with unexpected juxtapositions of objects and variations on scale.

DUCHAMP

At the same time that de Chirico was using traditional visual means with unsettling combinations in order to disturb rational vision, a young French artist, Marcel Duchamp (1887–1968), was challenging the very premises of art-making and art-viewing in Paris. He began in the wake of Picasso with a pictorial elaboration of Analytical Cubist images of female figures, such as *Ma Jolie*. However, Duchamp's *Nude Descending a Staircase* (1912) animates the "still-life" premise of Picasso's figural conventions with the suggestion of motion. In the same year as *Nude Descending*, Duchamp turned to another modern icon, the machine, as the basis of his own "figural" painting. *The Passage from the Virgin to the Bride* also explicitly takes up the subject of sexuality through its

series of tubes, pipes, filters, and pumps (Fig. **9.54**). Here Duchamp offers the impersonal activity of machinery in place of the static immobility of de Chirico's "stilled lifes." For both artists, modernity produces a world filled with the non-human and alien. Yet Duchamp takes ironic delight in substituting moving machines, depersonalized but sexual in their repeated, thrusting movements, as the subject of his art. This dehumanization focuses on women, and it reduces female identity to the kineticism of robots. Such a strategy extends the sinister image of woman advanced by Picasso in his *Demoiselles* and underscores the centrality of depersonalized sexual initiation.

While carefully harmonizing brown color tones like Picasso, Duchamp also tests the limits of minimal artistry. Picasso had already begun to dissolve the boundaries between ordinary objects and art-making in his *Synthetic Cubist* collages and assemblages. But Duchamp's radical intellect used the same technique to test the theoretical limit to creativity itself. He reduced to absurdity the distinction between an artistic idea and its execution. In fact, in 1913 Duchamp exhibited objects

9.55 Marcel Duchamp, *Bicycle Wheel*, 1913 (reconstructed 1951). Assemblage. Collection, The Museum of Modern Art, New York.

that he had not "made" at all. For the earliest of these "*readymades*" he actually had disassembled two functional objects and combined them in an arbitrary fashion, in a sculptural ensemble called *Bicycle Wheel* (Fig. **9.55**). This unfunctional wheel, mounted upon a simple, industrially manufactured stool, steadfastly refuses to glorify the process of art-making, though it utilizes the gallery context to justify the identification of the non-functional object as "art". A succession of readymades followed this deconstructed combination, with utilitarian objects completely unmodified in appearance – except for the addition of a title and sometimes a signature as well: a snow shovel, a rack for drying bottles, and finally (in New York, where Duchamp spent the war years) a urinal (1917). Duchamp took pride in his personal indifference to the objects as such, claiming that they had been selected on the basis of chance ("complete anaesthesia") rather than through any deliberate aesthetic choice. In the process, he pointed out the status accorded to art objects on display in "artworld" contexts and to the artistic personalities who catered to an increasingly rarefied aesthetic delectation. Out of this Pandora's box, later artists could draw the conclusion that an artist's mere act of selection, or his/her personal "vision," could be an artistic act. Even an unrealized "conceptual art" could be substituted for visible objects, and Duchamp's reputation would enjoy a posthumous acclaim in the wake of the art of the 1960s (see p. 444).

Not surprisingly, the urinal caused a scandal – both because of its banality as a readymade and because of its provocative bathroom subject. Duchamp, however, was not above using the organs of the artworld to defend his object in an article, written under a pseudonym, that put him in the position of an art critic. Whereas *Bicycle Wheel* could be viewed as a poetic juxtaposition of shapes and functions (round versus rectilinear, mobile versus stabile), a urinal prosaically defied aesthetic appreciation. It steadfastly remained a form of provocative "anti-art." Duchamp's ideas enjoyed wide circulation in the artistic community, and his celebration of chance as well as his attack on craftsmanship served as fundamental postulates for the Dada group of Zürich in 1916.

Meanwhile, Duchamp himself continued to attack the Western artistic heritage by taking aim at some of its most venerated images. Instead of seeking out non-Western "primitive" traditions or non-canonical images, such as the German Gothic, Duchamp brought "barbarism" into the canon. In 1919 he made a work of "art" out of a reproduction, yet another modern, technological reduction of genius to the commonplace. He chose the most famous and revered of French images, the *Mona Lisa* of Leonardo da Vinci, one of the treasures of the Louvre, and drew a mustache and goatee on her celebrated features. In addition, he appended the letters "L.H.O.O.Q." underneath, a witty pun when they are pronounced in French. Translated, the phrase that results is: "She's got a hot ass." Like a schoolboy defacing a public wall, Duchamp's action thus provided the ultimate rejoinder to the cult of tradition and artistry, dating back to the era of Leonardo and the Renaissance celebration of artistic genius. In the

9.56 Marcel Duchamp, *Large Glass: The Bride Stripped Bare by her Bachelors, Even*, 1915–23. Oil and leadfoil on plate glass, 109¼ × 69⅛ ins. (277.5 × 175.6 cm). Philadelphia Museum of Art.

process, he also continued to focus on problems of modern sexuality, here blurring the boundaries between male and female, just as he had earlier confuted distinctions between women and machine.

DUCHAMP'S LARGE GLASS In 1923 Duchamp brought a decade of critical experimentation to a climax with the completion of his grandest, most bombastic, and most inscrutable work: the *Large Glass*, subtitled "The Bride Stripped Bare by Her Bachelors, Even" (Fig. **9.56**). Meticulously fabricated with oil paint and lead foil between panes of glass, this image interacts with its gallery environment; its transparency compromises artistic autonomy. Glass offers an enamel-like evenness as well as greater luminosity of color, and its machine aesthetic preempts any lively brushwork in the making of the images. Duchamp confirmed this intention in a later remark: "There was nothing spontaneous about it, which of course is a great objection on the part of aestheticians. They want the subconscious to speak by itself. I don't. I don't care. So the *Glass* is the opposite of all that."

The *Large Glass* is divided into two distinct sections, each of which recapitulates Duchamp's previous artistic experiments. Above, an image of the Bride extends his painted metaphors of humanoid machines from a decade earlier, including his bridal title of 1912. Below, the Bachelors section depends upon his readymades, although here, paradoxically, they are manufactured with exquisite precision by the artist himself instead of being industrial products. Duchamp had already made several of these objects, such as the *Chocolate Grinder* with its cyclical motion of turning wheels, as separate studies.

The theme of the *Large Glass* requires an elaborate explanatory program for decoding its complexities. In this respect, Duchamp's work suggests comparison with the "keys" used to accompany much modern literature or music. In 1934 he published *Green Box*, a compilation of documents, plans, notes, and sketches made in connection with the *Large Glass* to serve as a kind of "commentary" volume. These "documents" are not an explanation for the *Glass* but rather a verbal artifact alongside it, randomly arranged. Here again the possibility of a purely conceptual art arises out of notes and projects, reproduced in multiples and issued in a box by the artist-inventor. Duchamp makes this ongoing project explicit by saying, "The *Glass* is not to be looked at for itself but only as a function of the catalogue I never made."

Nonetheless, the *Large Glass* does present a "plot." As outlined in the *Green Box*, this mechanical universe is entirely about sex – in this case, sexual frustration. The rigid separation of the two parties prevents the consummation of the marriage. The Bride above is perpetually disrobing, while below the Bachelors are interlocked machines grinding on alone in unfulfilled desire. Once more the subject is masturbation and sexual isolation, as in Schiele. Yet here the machine metaphor serves to displace anxiety from the human realm. It also serves as a uniquely modern allegory, akin to Freud's symbolic realm of dreams, where repressed desire becomes the basis of art.

To the complex and calculated program of the *Large Glass*, chance provided an unexpected "completion." The glass matrix of the entire work shattered in transit in 1927. Random yet balanced surface-breaks now marked the surface of this enclosed, eternally regular machine. Impermanence and accident, like the changing background visible through the transparent glass, entered the fixed realm of the manufactured.

SURREALIST ART

From the experiments with chance by Duchamp and Dada to the deliberate liberation of the unconscious was a small step. Under yet another banner, *Surrealism*, a group of Parisian artists and writers in the 1920s sought to find the primal roots of creativity in the non-rational, chiefly in dreams and fantasy. Led by the writer, André Breton, they utilized automatic writing or drawing in their works, along with accidental effects, but they also discovered past artists (Bosch, Goya) whose free fantasy served as a touchstone for their imagery.

9.58 Joan Miró, *Catalan Landscape (The Hunter)*, 1923–24. Oil on canvas, 25½ × 39½ ins (64.8 × 100.3 cm). Collection, The Museum of Modern Art, New York.

Breton particularly admired de Chirico's work and published his writings as a counterpart of his own interest in psychology and expression, *Surrealism and Painting*.

The freedom and vividness of dream images underlie Surrealist art, much of which depends upon the unexpected, chance juxtaposition of otherwise lifelike images, using the techniques of Cubist collage to stimulate fantasy. However, hallucination, not illusion, became a goal. The art of children and the insane, as well as of "primitive" cultures or unschooled painters, became models. Surrealists also claimed the work of modern painters, such as de Chirico or Klee, whose imagery realized their goals.

JOAN MIRÓ Of all the "adopted" Surrealists, the most imaginative was Picasso's friend and fellow Spaniard in Paris, Joan Miró (1893–1983). His works have a childlike simplicity and playfulness like those of Klee. Like Klee, too, he sought essential pictorial vocabulary in "primitive" sources, particularly the schematic linear markings of the petroglyphs and prehistoric cave paintings of his native Spain. He uses signs and symbols, freely composed out of basic linear ingredients.

In Miró's earliest mature painting of 1923–24, *Catalan Landscape (The Hunter)*, a horizontal field contains an extraordinarily abstract pictorial sign language, indebted to the Synthetic Cubism of Picasso for its insistent flatness and legible conventions (Fig. **9.57**). On further scrutiny, however, this

magical world yields a coherent, if fantastic, set of interacting figures: a hunter and his quarry, the theme of the primal struggle for survival that underlies much primitive art. The lighted pipe, circular eye, and upturned mustache identify the hunter's triangular head at the upper left of the painting. From there a linear body is discovered, with bowed legs and surprising features, including a flaming heart and a sex organ that resembles an egg with hairs. At the end of one of his arms is a small, inverted (dead) animal – a rabbit. The tall cone at the end of his other arm is a smoking gun; the large ball beside it is the bullet. These shapes reappear throughout the landscape, just like the frequently repeated archetypal imagery on caves and petroglyphs. Such echoes point to underlying bonds between figure and setting, between hunter and quarry, and their basic shapes evoke other visual associations beyond representation.

At the top of the image an egglike, radiant sun gives life to the landscape; its shape is the same as the sexual organ of the hunter and a disembodied eye on the horizon underneath. Taken together, these elements symbolize the life-giving aspects of the sun and the sexual dimension of human perception in Surrealist psychology. The eye hovers at the edge of a large, egglike shape, recognizable as a plant only by

9.57 Joan Miró, *Harlequin's Carnival*, 1924–25. Oil on canvas, 26 × 36⅝ ins (66 × 93 cm). Albright-Knox Art Gallery, Buffalo.

its attached leaf. All primal nature is projected from the vision of this eye, the inward, depersonalized eye of the artist-seer.

Along with his evocation of the violent side of the primitive in *The Hunter*, Miró also produced pictures filled with exuberant happiness, exemplified by the subject and the lively forms of *Harlequin's Carnival* (1924–25; Fig. **9.58**). Here a schematic interior setting replaces the outdoor *Catalan Landscape*; once again, serpentine lines and circular forms fill the space with visual echoes. Here an entire menagerie of creatures dance gaily or float on wings; some are fantastic hybrids, while others, like the cat at the lower right are clearly identifiable behind the schematic abstraction. Miró shares the Cubist delight in music, showing both a guitar and a musical score in the hands of a female at the top center. He claimed that his working method arose from the spontaneous suggestion of shapes as signs, like *Harlequin's Carnival*. Recalling the combination of unconscious and conscious in Klee's creations Miró's method still conforms to the Surrealist prescription to utilize unconscious imagery as the basis of art.

ALEXANDER CALDER Such spontaneity cannot be achieved in sculpture. Nevertheless, the American artist Alexander Calder (1898–1976) achieved both animation and variability in his sculptures by creating moving constructions, or "*mobiles*." His visits to Paris in the 1920s made Calder aware of the cosmic themes of artists like Brancusi and Miró, while his engineering skills enabled him to produce transparent wire constructions that have been called "*space drawings*." Unlike Brancusi, Calder relied upon sheet metal rather than the virtuoso polish of bronze or marble; however, his deceptive simplicity rivals the formal reduction found in both Brancusi and Miró.

Calder's visit to the Paris studio of Mondrian in 1930 made him resolve to take basic shapes as the building blocks of his art. However, the balance of Mondrian's rectangles was not compatible with Calder's interest in chance and in motion. Nonetheless he persevered. The resulting new kind of sculpture, which hung from the ceiling, delicately balanced, became mobiles. The term "mobile" was coined by Duchamp, who, like most artists in Paris, was an early admirer of Calder's work (Miró was also one of his close friends).

In his 1939 *Lobster Trap and Fish Tail*, Calder uses echoing curves of suspended metal, akin to the linear shapes of Miró's

quarry, to represent the world beneath the sea (Fig. **9.59**). The delicate tension of the suspended sculpture suggests actual buoyancy, appropriate to the undersea theme; pinpoint balance permits constant motion and change in the relative positions of the parts. Calder's earlier wire sculpture has merged with the sheet metal to form diaphanous space, a three-dimensional drawing. Here chance is allowed a role in the moving artwork, light and open, as it interacts with its environment. As they did to Miró, or even Mondrian, basic geometrical shapes suggest equally basic organic forms to Calder: "the underlying sense of form in my work has been the system of the universe, or part thereof ... the idea of detached bodies floating in space ..."

Later, Calder also constructed more solid, earthbound forms, interpenetrated by open space, named *"stabiles"* by Hans Arp. Once more animal nature or powerful abstract forms in tension are given appropriate geometrical shapes, dynamically balanced in Calder's engineered composition. Here Duchamp's ironic modernity is reversed: heavy, large, metallic shapes acquire life (in contrast to images of human action taken

9.60 Alexander Calder, *Black Widow***, 1959. Standing stabile, painted sheet steel, 92 × 173 × 89 ins (233 × 434 × 226 cm). Collection, The Museum of Modern Art, New York, Mrs. Simon Guggenheim Fund.**

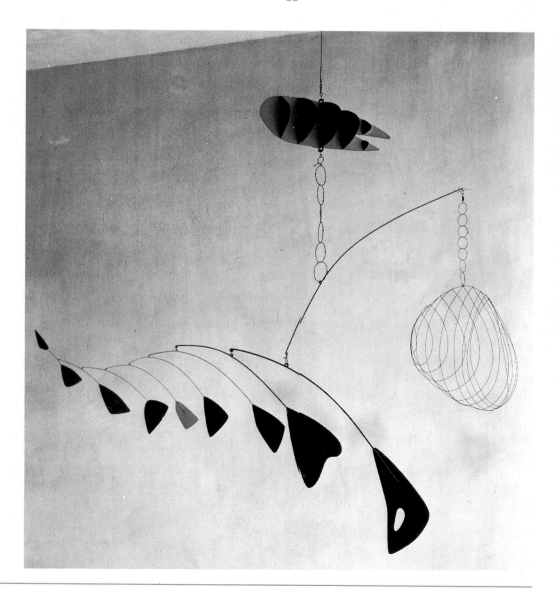

9.59 Alexander Calder, *Lobster Trap and Fish Tail***, 1939. Steel wire and sheet aluminum, 102 × 114 ins (259 × 289 cm). Collection, The Museum of Modern Art, New York.**

9.61 Pablo Picasso, *Three Dancers*, 1925. Oil on canvas, 84⅝ × 56¼ ins (215 × 142.8 cm). Tate Gallery, London.

over by machines). In fact, Calder's spontaneous working method with metal suggests Miró's painting process. A bold example of his organic stabiles is *Black Widow* (1959; Fig. **9.60**, p. 409). Powerful silhouettes of angular solids and extended curvilinear "arms" suggest the spider's body in movement across space at ground level. The large scale, spatial openness, and organic subject-matter of Calder's stabiles make such sculptures ideal and accessible public monuments for urban plazas. An example is his bright red Chicago *Flamingo* (1974), which brilliantly marks the site of a Federal Building complex by Mies van der Rohe.

The paintings of Miró and sculptures of Calder certainly adhere to the subjective, even subconscious, experience of a primal reality, but they also offer a positive, witty response to the morbid pessimism that pervades German Expressionism from Schiele through Beckmann. Theirs is an affirmation of life's vitality, including animal power and sexuality, that also rejects the mechanistic power and sexuality of Duchamp. Instead, their animated universes provide a subjective, energetic variation on the static idylls of their contemporaries Matisse and Brancusi. By the time Miró and Calder were working in the later 1920s, both painting and sculpture had begun to merge radical formal experimentation with themes concerning human nature and the subjective relation of people to the animal world.

PICASSO: VARIATIONS

Within this creative hothouse Picasso emerged again in a burst of creativity. He had been testing the limits of abstraction with a whole series of variations on one of his favorite perennial themes: the artist and the model in the studio (see p. 19). However, he soon turned to a more dynamic imagery arising from the subconscious. In 1925 the *Demoiselles d'Avignon* made its first public appearance, together with other works by Picasso, and was embraced by Breton for powerfully rendering an interior reality. Picasso pictures hung in the first Surrealist exhibition in 1925.

Spurred by his own retrospective viewing of the *Demoiselles*, Picasso created his first abstract figural painting in the new, restless and subjective idiom: *Three Dancers* (Fig. **9.61**). Like the *Three Musicians* of 1920, this lively painting retains the flat constructions of Analytical Cubism while reasserting the central importance of human figures. The three nude figures, however, are interlaced in a wild dance. Their stretched poses evoke comparison with the joyous abandon of Matisse's dancers, but their frenzy translates into extreme distortions of bodies and clashing colors, with shadows that become positive elements and extensions of the figures themselves. The figure at the left edge dissolves into a patchwork of patterns and body parts and offers a visual dissonance comparable only to the "primitives" in the *Demoiselles*. Her body torsion places her left side at the top of the picture; even there, her silhouetted breast and arm are lost behind a silhouetted face that emerges from the background as a red

outline without features. This same dancer has a hole at the center of her body, above which a large, Miró-like eye hovers. Her face is flung back to the left edge, and the extremity of her motion and emotion results in a frontal, masklike stare and savage, open mouth on half of her head, the rest lost in shadowy black. Out of her brow emerges a mysterious vertical alternative face: a thin profile crescent moon, like an alter ego. From this inventive, multiple face, Picasso originated his famous form of the modern persona – the residue of Cubist fragmentation – in the image of the composite face, seen at once as frontal and in profile. With the *Three Dancers* Picasso succeeded in integrating the aspirations outlined for his art by an admiring Breton, the synthesis of "Surrealist Cubism."

The double face of a woman, specifically Picasso's mistress of the early 1930s, formed the principal motif of his ultimate exploration of interiority, his 1932 *Girl before a Mirror*. With all the enthusiasm for Matisse's rhyming pattern, Picasso portrays a single figure as a composite of discreet colors and shapes. The face with its double aspect of Janus, combines a youthful profile in skin tones with a masklike frontal yellow crescent "far side" to constitute a frontal whole. At the same time, the girl contemplates her own image in a mirror, and her reflection offers yet another, answering profile in moody, darker colors (evocative of his earliest Blue Period) and more ambiguous interior shapes.

MINOTAUROMACHY In tapping myth and dream for his art during the 1930s, Picasso focused especially on the Minotaur, half-bull and half-man. His imagination had first been stimulated by the creature in his 1933 design for the cover of a new, Surrealist magazine, called *Minotaure*. This design places a threatening drawing of the Minotaur with a dagger at the center of a collage of everyday, bourgeois objects, including a doily and some corrugated cardboard – as if to suggest the passion and violence beneath the surface of everyday life. A creature of fantasy, the Minotaur symbolizes both irrational forces and vitality, akin to the subconscious. In place of the harlequins of his earliest paintings, the Minotaur now serves Picasso as his alter ego, the image of creative power.

Some of the most complex yet personal themes of Picasso's images of the 1930s revolve around the figure of the Minotaur. The most enigmatic of these images is his 1935 etching, *Minotauromachy* (Fig. **9.62**, p. 412). Here the Minotaur is shown near a young girl with a bouquet, as he approaches her with a toreador's cape. She counters by holding up a lighted candle, toward which he reaches with outstretched arm as if to shade his eyes from its glaring brightness. In this image, however, other figures lie between them: a disemboweled horse that staggers under the burden of his injury and a recumbent, topless female matador collapsed upon his back. Picasso has embodied here the primal violence of his native Spain, where the Minotaur incorporates aspects of both the bull and the matador. Two victims in his path are the usual innocents in a bullring – a horse (specifically female, a mare) and a woman-torera (she wears toreador pants and holds the

9.62 Pablo Picasso, *Minotauromachy*, 1935. Etching. Collection, The Museum of Modern Art, New York.

Picasso: *Guernica*

Picasso's sympathies were deeply stirred by the outbreak of conflict in the Spanish Civil War in 1937. Given the honorary title of Director of the Prado Museum in Madrid by the new Republican government in Spain, he agreed to produce a work that would serve as a show-piece for the Spanish pavilion at the 1937 World's Fair in Paris (Miró and Calder were also invited to make contributions). Shortly before Picasso began his painting, he received word of a tragic event in the Spanish Civil War: the bombing of the city of Guernica by the German air force under directions from Generalissimo Francisco Franco, leader of the Nationalists. The historic Basque capital city had no military significance and was unde-fended, yet incendiary bombs and machine-guns razed its buildings and killed most of its civilian population. This terrible event outraged world public opinion and concentrated opposition against the fascism in Nazi

9.63 Pablo Picasso, *Guernica*, 1937. Oil on canvas, 137½ × 305¾ ins (349.2 × 776 cm). Prado, Madrid.

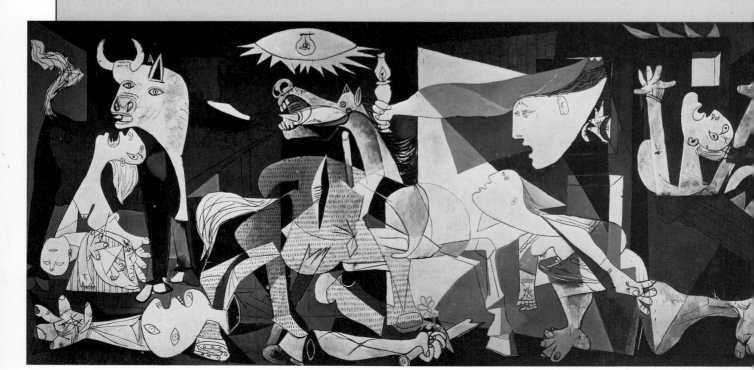

sword of a matador). Behind the fearless young girl confronting the Minotaur, a bearded, Christlike figure in a loincloth scurries up a ladder to safety. The setting for this frozen set of violent encounters is an open seacoast, redolent of the margins of life and the archetypal openness of the ocean. Picasso here stages an allegorical psychodrama of subconscious forces, akin to the program of Surrealism but still using the pictorial heritage of classical art and myth to express them (cf. the complex personal symbolism of Beckmann's *Departure Triptych*; Fig. 9.39).

EXPRESSIONIST IMAGERY exploded into modern art from the subconscious. Its diverse formal means and emotional effects range from anguish to exuberance. As the powerful, personal creations of modern individuals, these images have little in common except their inventive power and their reliance upon a distinctly private vision. The other thing they share is the hostility they provoked from conventional and conservative social forces. The Austrian judge who burned Schiele's drawing would be confirmed by a whole Nazi regime in Germany that branded Beckmann, Klee, and their entire generation "degenerate." That same fascism would unleash the universalizing anguish of Picasso's *Guernica*, as a last great history-painting as well as the monumentalized pain of a Spaniard-in-exile.

The rapid advent of World War II late in 1939 destroyed whatever stability European artists had maintained up to then. Many of them emigrated, at least briefly, to America: Beckmann (after his sojourn in Amsterdam), Mondrian, Gropius, Mies van der Rohe, and a host of artists generally adhering to or admired by Surrealism (Matta, André Masson, André Breton, Max Ernst, Yves Tanguy, Marc Chagall, and even Marcel Duchamp). European modern art was in disarray, with many of its leading practitioners in New York. The heritage of their interest in the mythic realm of the unconscious would be continued – and extended – by another group of younger, New World artists – the New York School.

Germany as well as under Franco in Spain. Six days after the bombing (May 1, 1937) Picasso began work on his mural canvas painting, entitled simply *Guernica* (Fig. **9.63**).

The protagonists of Picasso's great canvas are familiar from the *Minotauromachy*: a horse, a bull (rather than a half-bull), and a lamp in an outstretched arm. A small group of human figures distills the violence of the scene into the forms of an open-mouthed, dead soldier, a wailing mother holding her dead child, and an anguished woman consumed by flames. The muted color scheme of grays, black, and white adds a note of sobriety in keeping with the grim subject; this tonality originally served to harmonize the canvas with its simple World's Fair setting, a suitably austere pavilion for a fledgling nation at war – in stark contrast to the great, luxurious propaganda machines constructed by both Nazi Germany and the Soviet Union. Throughout *Guernica* the forms and the figures convey suffering, through their distended extremities, open-mouthed cries, and angular distortions or radically simplified features.

Picasso worked furiously on individual studies of the human figures and animal heads, each numbered and dated to its day of production in order to record the process of his invention; he also freely reworked the overall composition several times (documented in photographs) over the course of a month's labor. But even in the earliest conceptions the principals already appear in their essentials.

The power of Picasso's *Guernica* derives from his successful transfer of allegorical figures from his earlier psychic explorations into a narrative of personal anguish within a historically timeless setting. Careful composition and harmony of muted colors and shapes, such as the repeated lozenge shape of eyes or lights, achieve a universality that transcends the specific, topical historical event commemorated in the title of the painting. This wartime atrocity becomes assimilated into a tradition of agonies witnessed through Western Art, whether the Christian narrative of the Massacre of the Innocents or the more local Spanish heritage of Goya's horrific etchings (also in black and white), the *Disasters of War* (Fig. 7.22).

Yet the two animal antagonists of the bullfight also have their own specific meaning in *Guernica*. The wounded and shrieking horse, its side pierced by a spear, symbolizes the sufferings of the Spanish Republic itself. Just as in the *Minotauromachy*, women and a horse are the principal victims of an archetypal savagery. Above the weeping mother, the staring bull is once more the author or personification of that savagery. He can only refer to Franco and the Nationalists, hiding in the shadows, to be revealed by the light of truth above and behind the head of the horse. In speaking with an interviewer about another bull's head, Picasso later clarified this inevitable fusion of the bull with both fascism and darkness: "No, the bull is not fascism, but it is brutality and darkness." He also went on to say, "My work is not symbolic. Only the *Guernica* mural is symbolic. But in the case of the mural, that is allegoric."

In other contexts, of course, the Minotaur could symbolize the darker side of Picasso himself or of humankind in general, but in *Guernica* the unleashing of irrational violence has produced vicious and horrifying consequences, beyond the capacity of its makers to control or to comprehend. Even the bull in *Guernica* wears a look of astonished horror.

MODERN MEXICO

Although Mexico succeeded in throwing off the shackles of Spanish colonial rule early in the nineteenth century (1821), a series of dictatorships followed for a century until the Mexican Revolution in the second decade of the twentieth century. Coinciding with this political shift came a major new initiative in the visual arts, the phenomenon known as Mexican muralism. The artists who generated this visual revolution worked on the walls of the new civic buildings in the capital, Mexico City, directed (1921–24) by an inspired minister of education and fine arts, José Vasconcelos. The muralists took as their subject the entire history of their new nation, reaching back to pre-Columbian roots, as well as the continuing life of the people on the land. In contrast to revolutionary art in the Soviet Union with its emphasis on the utopian and the abstract, Mexican art chiefly employed traditional and easily grasped figural narratives. However, the Soviet example of using revolutionary heroes and workers as inspirational themes in public media (chiefly posters in Russia) served as a model for many Mexican artists. Mural painting is an ancient Mexican tradition, already found in the pre-Columbian classic Mayan cultures and at Teotihuacán. Its revival in Mexico during the 1920s led to widespread government commissions from the United States during the Great Depression as part of Franklin Delano Roosevelt's New Deal patronage of the arts (the Federal Artists' Project and its successor, the Public Works Artists' Project). Yet several murals in the US by leading Mexican painters, David Alfaro Siqueiros and Diego Rivera (see below), created scandals with their revolutionary subjects and were even whitewashed shortly after completion in 1933.

JOSÉ CLEMENTE OROZCO (1883–1949) brought the angular figures and brooding pessimism of Expressionism to the Americas. Like Max Beckmann, he often depicted religious themes, offering an apocalyptic atmosphere of death and destruction, painted in blood reds and dark earth tones. Orozco began his career as a caricaturist and illustrator, witnessing some of the bloody battles of the revolution in 1914–15. After beginning his mural works in 1923–26 at the National Preparatory School, Orozco spent seven years (1927–34) in the United States, where he produced important murals at Pomona College, the New School for Social Research, and Dartmouth College. The Dartmouth cycles make bitter political criticisms of the evils of capitalism (*Gods of the Modern World*, part of the *Epic of American Civilization*). Though quite controversial, it was never destroyed.

In addition to these murals, Orozco's easel paintings incorporated many of his favorite themes of revolution as conflict. Painted in 1930 during his exile in the United States, *Zapata* (Fig. **9.64**) presents as its protagonist, shown with his typical broad-rimmed sombrero, the peasant revolutionary hero of southern Mexico, Emilio Zapata (d. 1919). Zapata was noted for his leadership of a revolutionary Liberating Army of the South, which seized the large haciendas of landowners for redistribution. He is most often depicted as the leader of peasants or as a martyr of the revolution, but Orozco shows him in a new light, as the eye of a storm of destruction. The iconic, frontal figure of the leader serves as the vertical fixed point against counterpoised angular diagonals. At the bottom of the image peasants kneel and mourn with outstretched arms, imploring mercy from the anonymous, well-armed band of Zapata (compare this with the frightened victims and anonymous executioners of Goya's *Third of May*, Fig. 7.23). Orozco's Zapata, wearing a blood-red scarf, is presented as a ruthless cleanser of pre-revolutionary ills and an avenging angel whose fury tramples even those whom it presumes to liberate. A few years later in the Dartmouth mural (1934), a figure like Zapata presides over *Hispano-America*, wielding a rifle but standing immobile as, representing the Mexican Revolution, he is stabbed in the back by American generals and greedy financiers.

DIEGO RIVERA

For Diego Rivera (1886–1957), in contrast, the new Mexico was a vital and positive national force, to be celebrated in the public art of murals. Unlike Orozco, Rivera benefited from an extended apprenticeship in Europe (1907–21), chiefly in Cubist Paris, whence his early portraits and table scenes demonstrate his total engagement in Synthetic Cubist experimentation. After his return to Mexico in 1921, Rivera joined Siqueiros as early promoters of the new mural movement. Both artists, who had met in Paris, made study visits to Mayan ruins and incorporated Mexico's past into their work. Rivera also spent a year (1927–28) in the Soviet Union, and the heroes of the Russian Revolution, both Marx and Lenin, make cameo appearances in his subsequent murals, sparking controversy in the United States projects. Like many contemporary Soviet artists, Rivera had already celebrated the work, both rural and urban, and the leisure of the populace of Mexico in his extensive early murals projects, the Court of Labor and the Court of Festivals at the Secretariat of Public Education (1923–28).

9.64 Jose Clemente Orozco, *Zapata Entering a Peasant's Hut*, 1930. Oil on canvas, 78¼ × 48⅛ ins (198.8 × 122.3 cm). Art Institute of Chicago.

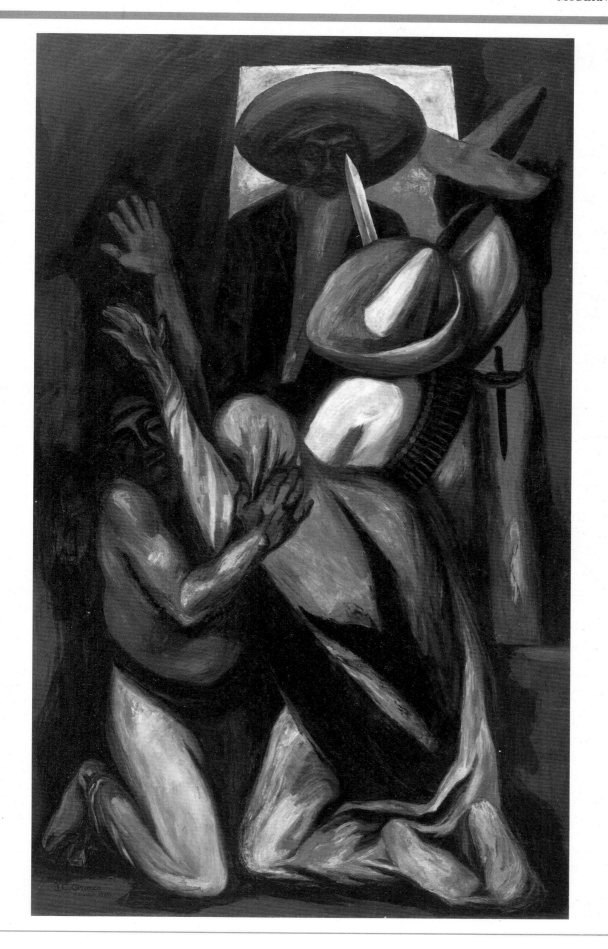

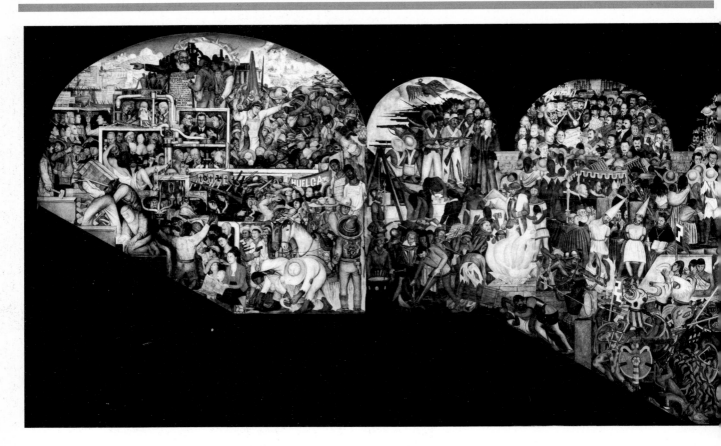

9.65 Diego Rivera, *History of Mexico*, Mexico City,
National Palace, 1929–35. Fresco murals. Below, detail.

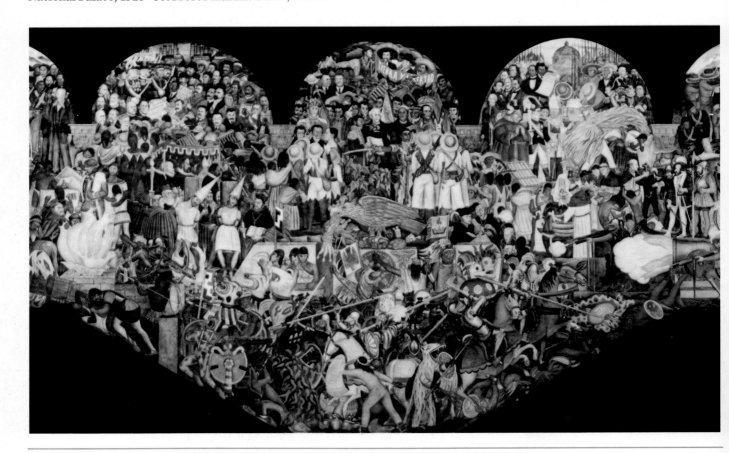

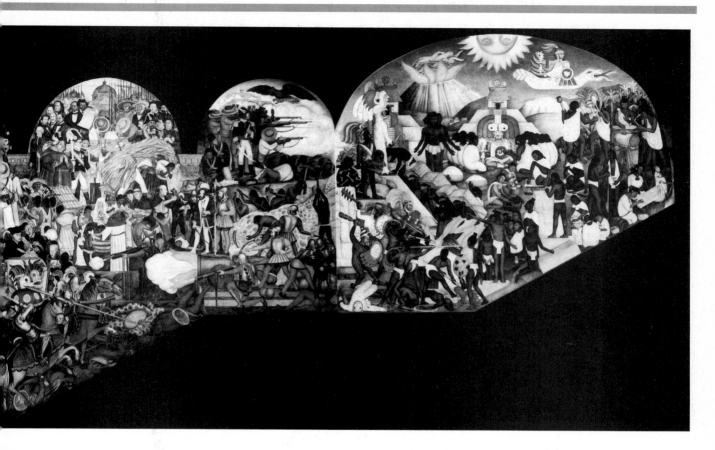

THE HISTORY AND FUTURE OF MEXICO

The full panoply of historical themes employed by Rivera appears in his mural, *History of Mexico* (Fig. **9.65**), for the National Palace, Mexico City (1929–30, 1935). In the tall, arched wall surface, the artist has arranged in chronological sequence both celebrated figures and anonymous followers to illustrate the history of Mexico up to the present time. At the base of the image, the pre-Columbian civilizations of brown-skinned warriors, some of them dressed in jaguar costumes, are assaulted by equestrian Spanish *conquistadores* in full armor with metal weapons. The conqueror Cortés and the last Aztec ruler, Montezuma, stand out from the crowd. In his mural cycle for the Palace of Cortés in suburban Cuernavaca (1930–31) Rivera expanded this theme into his *Battle of Aztecs and Spaniards*.

At the very center of the fresco stands the national symbol, commemorated on the national flag of Mexico, of the eagle grasping the serpent upon a cactus. To the ancient Indians, these animals symbolized Quetzalcoatl, at once celestial and terrestrial. Farther up are recognizable figures from the past two centuries of Mexican history, with Father Miguel Hidalgo (d. 1811), spiritual father of the independence movement from Spain, at the top center. Zapata appears at the very crest of the arch, carrying the banner with his rallying-cry "Land and Liberty" (*Tierra y Libertad*), as he meets an anonymous, denim-clad laborer. In contrast to Orozco's ambivalence, Rivera's unabashed fondness for Zapata as champion of land reform led him to paint him in his Court of Labor as well as the Court of Festivals and the Palace of Cortés – a white-clad

Zapata Leading the Agrarian Revolt, armed with only a machete and followed by peasants with hoes and arrows (the artist also painted a portable fresco version now in the Museum of Modern Art, New York, where he had a solo exhibition in 1931). In another mural in the National Palace dedicated to *Mexico's Future*, Rivera combines his favorite scenes of Mexican laborers with images of class conflict against the forces, including armed troops with gas masks, arrayed in defense of capital (Fig. **9.66**, p. 418). At the very top of this arch, the bearded icon of "Carlos" Marx instructs the workers in their potential communist future and points toward the projected workers' paradise at the distant horizon.

Like Orozco, Rivera spent a brief period in America (1930-33), where he produced celebrated murals for his capitalist opponents, the American industrialists Edsel Ford (a courtyard on the auto industry at the Detroit Institute of Arts) and John D. Rockefeller (for the newly completed complex of Rockefeller Center in New York City). The theme of the Rockefeller Center fresco was *Man at the Crossroads*, and preliminary pencil drawings were approved by the patron before the murals were begun in 1932. In the completed work, however, the central figure of an industrial worker was accompanied by a charismatic portrait of Lenin, amidst an admiring multiracial crowd of workers, a scene not visible in the sketches. Rockefeller, a major owner of oilfields in Mexico, took offense (surely intended by the artist) and prevented Rivera from completing the mural, which was then effaced. Upon his return to Mexico, however, Rivera completed in 1934 the composition for the wall of the Palace of Fine Arts (Fig. **9.67**, p. 418).

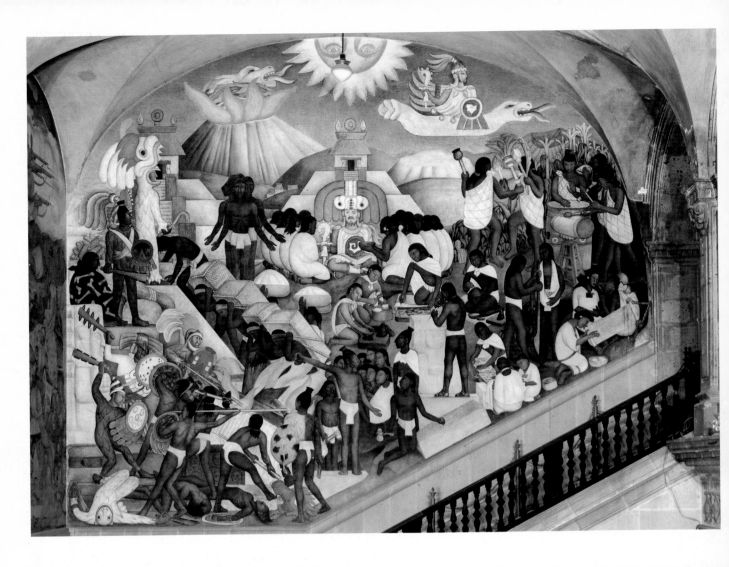

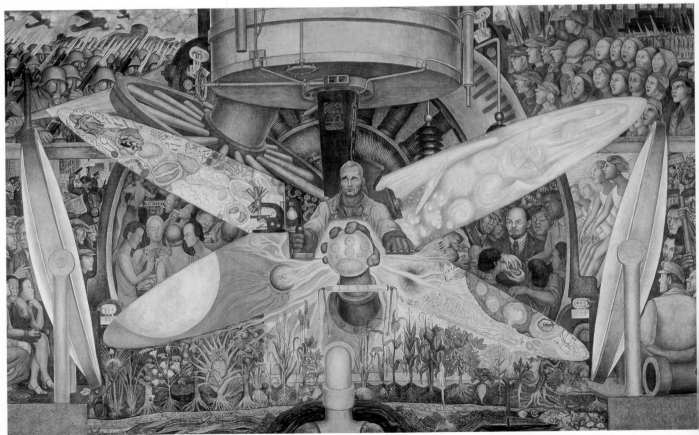

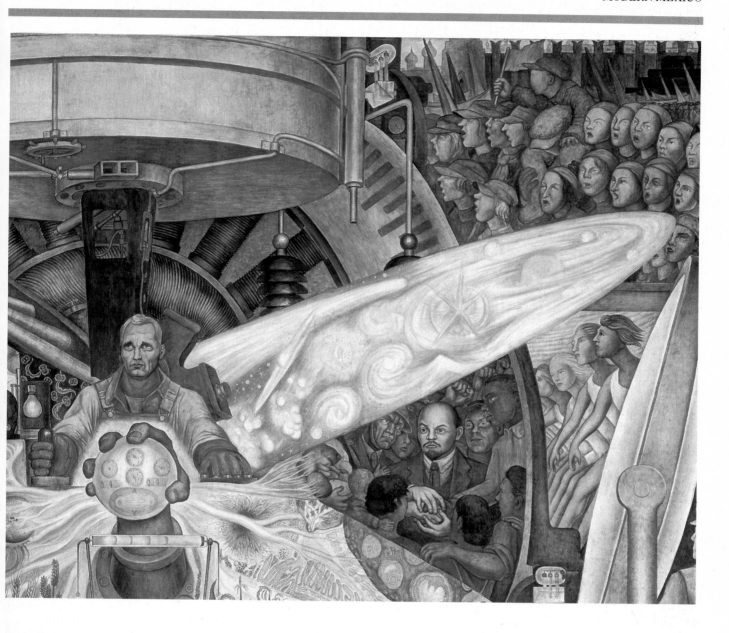

9.66 (Left, above) Diego Rivera, *The History of Mexico*, Mexico City, National Palace 1929–35. Fresco murals. Detail of *Ancient Mexico*.

9.67 (Left, below) Diego Rivera, *Man at the Crossroads*, Mexico City, Palace of Fine Arts, 1934. Fresco mural. (Above) Detail of Lenin leading the workers.

The composition represents most of Rivera's political views. The worker at the center of the composition finds himself within a pair of interlocking ellipses, one galactic in scale, the other microscopic. Out of a bedrock of productive soil grow a fertile tropical forest and temperate farm field. But the main elements of the composition are framed within the products of industrial technology: spoked wheel, dynamo, and a large holding tank. Rivera clearly sees the dilemma for the modern worker who is poised as the controller or the victim of this powerful technology. On the viewer's left side, the wealthy leisure class exercises its privilege and holds parties, while in the street mounted police officers put down a workers' demonstration; above, a massive army with gas masks and an air force overhead signify the use of technology in modern warfare. On the opposite side, where Lenin leads the workers, a white-clad troupe of youthful athletes runs in unison, while above them a chorus of uniformed youths amid a sea of red banners chants a Soviet anthem. These scenes of positive contrast derived from watercolor sketches made by the artist during his year in the Soviet Union. Rivera clearly meant to offer an unequal choice of capitalist repression or socialist equality in the troubled years of the Great Depression (with a disturbingly prophetic dark vision of the repression soon to emerge, especially in Hitler's Germany, but also in Stalin's Soviet Union).

FRIDA KAHLO The third wife of Diego Rivera was the artist, Frida Kahlo (1907–54); they were married from 1929 until her death in 1954. The presence of André

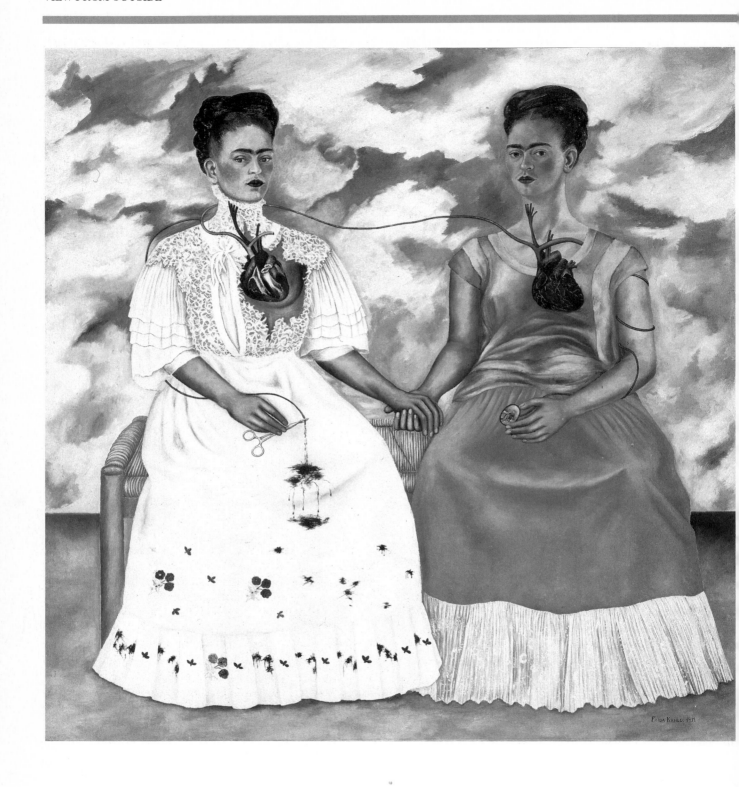

9.68 Frida Kahlo, *The Two Fridas*, 1939. Oil on canvas, 69 × 69 ins (175.2 × 175.2 cm). Museum of Modern Art, Mexico City.

Breton in Mexico in 1938 may well have reinforced Kahlo's visionary temperament, but she had a distinctive and personalized surrealist imagination. Kahlo became an invalid in a bus crash when she was still young; many of her images are confined to variations on her own likeness. Her own interests overlapped with the nationalism of Rivera but as a form of self-definition and personal expression. The current generation of feminism has rediscovered Kahlo's work in its lifelong public introspection on her identity as artist, wife, and Mexican after a career in the shadow of her more public artist-husband.

Kahlo's self-portraits take on different personas through the use of varied attributes, costumes, or fantasy distortions. In one of them she shows herself as a wounded deer, pierced by arrows, in flight from hunters. In another, *Broken Column* (1944), nails replace the arrows, and the nude artist in a body brace faces the viewer candidly and frontally; her invalid life is further underscored by a visionary open chest cavity with a shattered classical column exposed in place of her spine. Other portraits show her surrounded by lively monkeys, whose spirit of play and animal excess mocks yet complements her immobility.

Kahlo's double identity as Mexican traditionalist and modern woman emerges from a startlingly surreal double representation of *The Two Fridas* (1939; Fig **9.68**). On one side the artist shows herself in the high-necked, elegantly stitched, traditional bridal garment of her homeland; opposite she sits again in a contemporary sleeveless and neckless dress. The two Fridas, however, join hands, linked by a common artery that connects two exposed beating hearts. The traditional Frida snips another extension of the artery with a scissor, and two pools of blood drip on her lap, a possible reference to the Aztec ritual of cutting out the hearts of captives at the Templo Mayor as well as the colonial Spanish imagery of the Sacred Heart of Jesus. The background sky with expressive clouds recalls the mystical later religious paintings of El Greco of Toledo.

One of the most striking of all Kahlo's images is *Self-Portrait as a Tehuana (Diego on my Mind)* (1943; Fig **9.69**), where the thoughts of Rivera are made literal through a portrait of her husband on her brow. Her Mexican identity emerges once more from traditional costume, here the festive headdress of the women of Tehuantepec, a southern region whose folk dances had been observed in Rivera's 1922 travels and then rendered by him in his frescoes for the Court of Festivals, Secretariat of Public Education. Of course, the costume with the portrait of her husband also signals Kahlo's fundamental

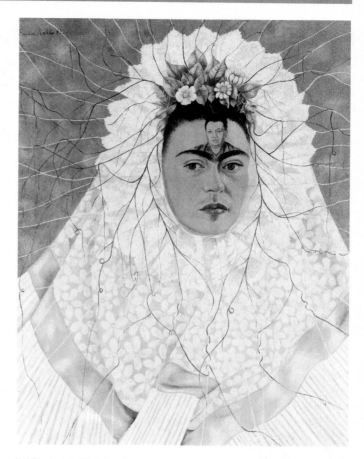

9.69 Frida Kahlo, *Self Portrait as a Tehuana*, 1943. Oil on canvas, 38 × 31.9 ins (96.5 × 81 cm). Kahlo Museum, Coyoacan.

identity as a bride and wife; biographers have underscored the tone of loneliness in much of her work. In this instance, however, the immobility of her body beneath this finery and the gold ground surface of the image point to another visual tradition: religious icons of the Virgin Mary and other venerated saints and martyrs (another Kahlo projection of suffering identity), from the colonial era. These were frequently rendered in meticulous carvings and painted in lifelike tones as well as dressed in actual costumes and jewelry. A final note of this image is contributed by tendrils of white and black that radiate out from the flower garland and headdress like jungle roots seeking for a nurturing connection in the tropics (and seeming to recall the arteries made visible in *The Two Fridas*).

MODERN NIGERIA (YORUBA), WEST AFRICA

Residing in the same territory as ancient Ife (see pp. 228–31), more than 10 million Yoruba people have continued the traditions of art-making under the central authority that characterized earlier traditions in southern Nigeria. The actual territory of the Yoruba spills over the current national boundaries to include portions of Nigeria, Benin (formerly Dahomey), and Togo. Succeeding that of Ife, their empire of Oyo coincided roughly with the era of the rise of the bronze-casting kingdom of Benin around 1400 and reached its political peak in the seventeenth and eighteenth centuries. In addition to the invasion of Islamic Fulani peoples to the north of Oyo, British colonial presence affected the Yoruba for over a hundred years, beginning with the official treaty to end the slave trade in 1851 and the establishment of the Colony of Lagos in 1861, and lasting until the official independence of Nigeria in 1960. (Benin was extirpated by the British Punitive Expedition of 1897.)

The role of centralized authority in Yoruba art emerges from examination of a majestic, tall, carved veranda post from the inner courtyard of the palace at Ikere (ca. 1910–14; Fig. **9.70**). The patron of this painted teak (*iroko*) image, the king (*oba*), Ogoga of Ikere, appears enthroned at its center, dominated by the tall figure of his consort, his senior wife, standing behind him. Both figures have elaborate markings. The queen, her face marked by three vertical scars on each cheek, has an intricate coiffure, matched by the king's conical beaded headdress (shaped like her pendulous conical breasts). His crown has mask faces on its sides and a long-beaked bird on top. Below, the king's authority is signaled by a kneeling woman at his feet, and a pair of palace servants attending him. One servant blows the flute announcing the king's presence; another servant, now lost, once tended him with a royal fan.

THE DOORPOST records an actual ritual ceremony for this king. He receives his crown from the senior queen, a symbolic act that invests him with the power of the office and links him to all previous *obas*, now divine, possibly represented by the faces. Yoruba beaded crowns stem, according to ancient legend, from Oduduwa himself, founder and first king of the Yoruba people. The bird on the crown, as well as the one on the staff of the king, symbolizes the power, specifically reproductive power, of female ances-

9.70 Olowe, veranda post from Palace at Ikere, Nigeria, ca. 1910–1914. Carved and painted wood, 61 ins (155 cm) high. Art Institute of Chicago.

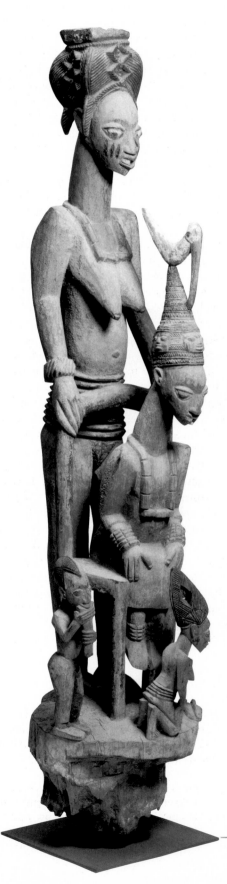

tors, female deities, and older women – a group analogous to the Western concept of witches and known collectively as "the mothers."

In Yoruba society this women's power is the source of royal sovereignty, and its importance and gender coding can be discerned in the adjacent doorpost of the Ikere palace, where a queen appears with her twins (Fig. **9.71**). Twins are a particular sign of reproductive power and are regarded as lucky in Yoruba society, though their survival rate in West Africa is low. When a twin dies, at whatever age, a Yoruba carver makes a small standing image (*ere ibeji*) of it in the appropriate sex. The surviving twin then cares for this image as if it were alive, feeding and clothing and washing it as a sign of family togetherness and as an affirmation of life. Despite her fertility, however, the powerful queen with twin daughters at Ikere is still a lesser figure than the senior queen on the center post, for she stands less tall, and her caryatid function of supporting the roof lintel is achieved by an additional impost block above her headdress.

Balancing the life-force of the queen with twins on the opposite side of the Ikere porch is the representation of male power incarnate, a figure of destruction: a mounted equestrian (Fig. **9.72**). His erect posture reaffirms his dignity, seated in the saddle as the king on the center post occupies his throne. Like all the other figures from the palace, his bulging eyes and exposed teeth suggest strength and power, here reinforced by a tall, ornamented spear and a sword, now lost, in his upraised right hand. Yoruba warriors from Oyo used horses for conquest, so the horse was the very emblem of their imperial power in the region; however, the mastery of the human is shown by the fact that his size is superior to that of the beast.

The carver of these veranda posts is known by name: Olowe of Ise (d. 1938). Like many Western artists, he lived at court, producing (with the aid of numerous assistants) doors, chairs, tables, drums, bowls, ceremonial masks, and other ritual objects for royal patrons. His pair of entry doors carved for the same Ikere palace show a full court ceremonial of 1897, at which the throned Ogoga received the British Captain Ambrose, traveling commissioner for the province (Fig. **9.73**, p. 424). Seated in his litter, the European is depicted as smaller than the Yoruba king. Each has his own retinue, but the crowned Ogoga appears before his senior queen, as in the veranda post, and his entourage includes a cluster of wives with children on their backs.

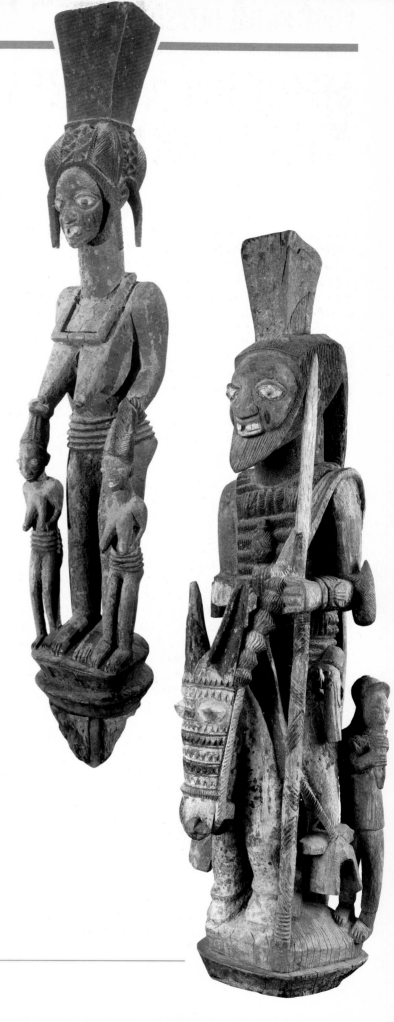

9.71 (Right, above) Olowe, *Queen with Twins*, from veranda, Palace of Ikere, Nigeria. Carved and painted wood, 56 ins (142 cm). Memorial Art Gallery, University of Rochester, Rochester.

9.72 (Right, below) Olowe, *Equestrian Warrior*, from veranda, Palace of Ikere, Nigeria. Carved and painted wood, 55½ ins (141 cm). New Orleans Museum of Art.

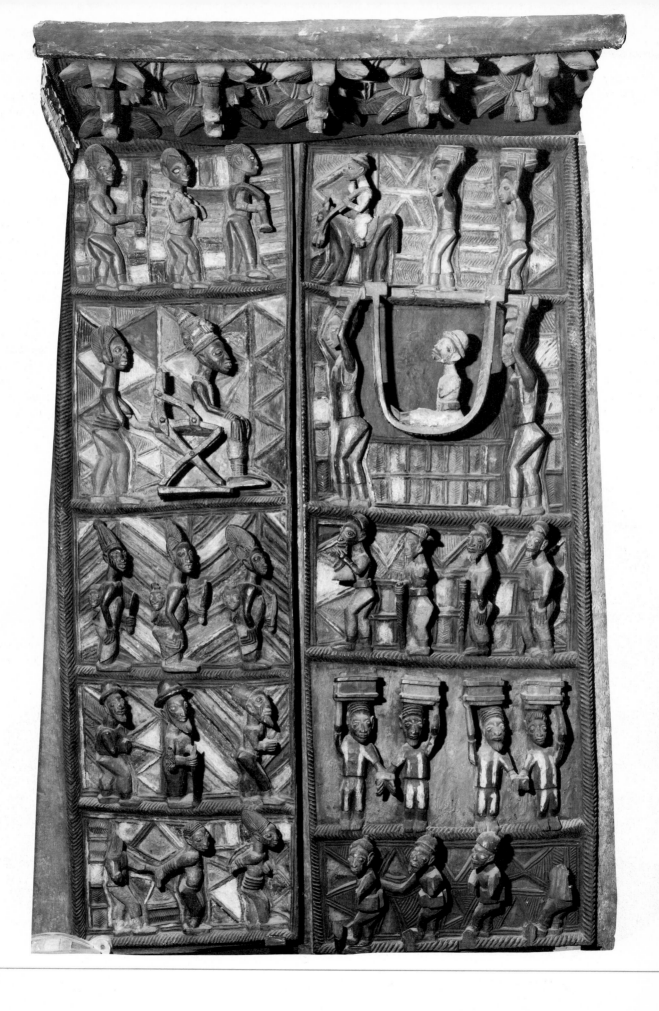

424

9.73 (Opposite) Olowe, entry doors, Palace of Ikere, Nigeria, ca. 1916. Wood. British Museum, London.

YORUBA COMMUNITY LIFE also consists of a number of animated public rituals, including dance and masquerade. In one such festival in northeast Yorubaland, the three days of Epa, massive headdresses, carved from a single block, promote both the fertility and the well-being of the community. Athletic boys and men perform the demanding dance, including jumps, with these heavy headdresses (Fig. **9.74**) as a test of their prowess. While the motif of a leopard attacking an antelope represents hunting on some of the masks and mounted warriors like the Ikere veranda figure represent conquest, others feature maternal fertility powers (*egungun*) as the main focus of the festival through the figure of a mother with her twins on her knee. In one headdress example, smaller women at the mother's feet make offerings to the benevolent goddess who sends twins. In the ensemble of Epa masks, the gender-coded world of male warrior conquest is paired and balanced by female generation, and the authority and power of Yoruba society, exemplified on the veranda post carvings, is replicated and celebrated for the community at large. Underneath, a grimacing grotesque face on the helmet of the mask represents the ancestral substructure on which the whole tradition is erected.

Another festival in southwest Yorubaland utilizes sculpture, dance, and costume for the Gelede Society, the means by which the magical nocturnal and female powers of the mothers, or witches, can be positively harnessed. The masqueraders are all male, wearing brightly colored cloths made by the women of the community; female elders are the honored guests at this propitiatory festival. Most of the mask faces depict flattened female features, graced with the peaked coiffure and facial scars already seen on the Ikere veranda posts, but often surmounted by additional items (Fig. **9.75**). The ceremony unfolds with an evening performance, Efe, in which social criticism and satire, as well as role definition, are employed in the interest of community reform. Next day the Gelede festival proper is staged: here the female faces are often paired with animal familiars, chiefly birds (alternatively crocodiles), or else modern technology, such as the airplane or motorcar, as emblems of social disorder. Gelede in particular choreographs energetic dancing to drums, designed to charm powerful witches into agreeable cooperation.

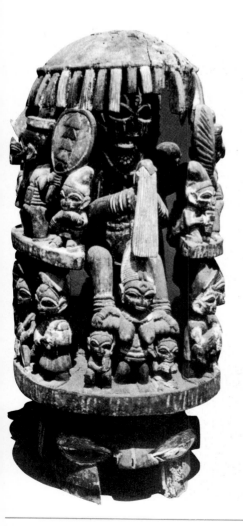

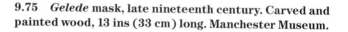

9.74 Bamgboye of Oda Owa, Epa headdress, ca. 1900. Carved and painted wood, 42½ ins (107.9 cm) high. Nigerian Museum, Lagos.

9.75 *Gelede* mask, late nineteenth century. Carved and painted wood, 13 ins (33 cm) long. Manchester Museum.

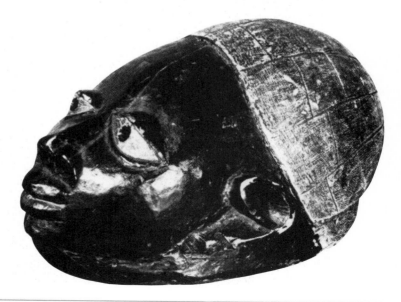

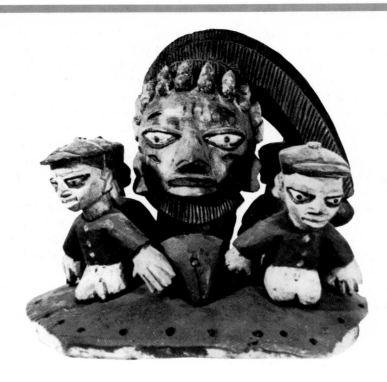

9.76 (Above) **Adugbologe of Abeoka, headpiece for** *egungun* **cult. Carved and painted wood, 15⅛ ins (38.5 cms) wide. British Museum.**

9.77 (Right) **Olowe,** *Bowl with Kneeling Figures,* **ca. 1925. Carved and painted wood, 25 ins (63.5 cm) high. Collection William J. Moore.**

The spirits of the dead, including dead rulers and twins, are celebrated in the other major Oyó Yoruba masquerade festival: Egungun (Fig. **9.76**). For this ceremony, the body and face of the whirling dancer are completely covered by multiple layers of brilliantly colored cloths and ornamented by beadwork, marks of the wealth and status of the sponsoring families. With its massed and shapeless fabric, the masquerade costume denies human shape and dress. The Egungun masquerade invokes the presence of a family ancestor among the living, though it can also give virtuoso displays of dance and costume as well as occasional comic effects. Together with the use of divination, the entire masquerade, like other Yoruba cults, becomes a collaborative achievement, in this case focused on a family or household.

Yoruba religion also evokes cult objects and rituals. For example, one ruthless early warrior-king of Oyo, Shango or Sango, became associated with the god of thunder and was given a cult of his own, which spread to the Americas through the slave trade of Oyo's kings. Shango is invoked for his power, allied to the king's power over life and death but also tied to the protection of twins. His devotees carry dance-wands from

altars, often made in a distinctive twin-headed thunderaxe shape above the depicted head of a devotee. Divination remains an important aspect of Yoruba religion. Ifa, god of divination, who is fed by the same kola nuts used in the ritual, is often the subject of attractive wooden divination cups or bowls, usually shown in the arms of a kneeling or seated woman. Often these women have elaborate scars or tattoos that attest to their ancestry and status; jewelry and hairstyle further suggest that they can be regarded as the equivalent of priestesses, honored "messengers of the spirits" and bearers of gifts to the gods. Other divinities, including Shango, are presented with such divination bowls for their cult altars, often created by master carvers, such as Olowe (Fig. **9.77**).

What the presence of altars as well as of costumed dance demands of the non-African viewer is a basic suspicion of museum display – no different from the caution one ought to bring to a Renaissance altarpiece or a classical sculpture when seeing it in a whitewashed gallery setting away from its original viewing site. In the case of African artworks, the multimedia context of music and movement provides a vital dimension to seeing, and even more to understanding, the culture-specific meaning of Yoruba (or any other African) artworks. The complexities of Yoruba politics and religion, or the specific role of art in mediating or inculcating community values, cannot be gleaned from a superficial enjoyment of works in museums, yet they remain essential to any serious understanding of Yoruba art, indeed the art of *any culture*. Despite the desire by American black artists to utilize African motifs, such as Shango dance-wands from the Yoruba tradition, for constituting their own African-American culture, despite the appropriation of African mask forms for innovative pictorial or sculptural values by Picasso and other experimental European artists in flight from Western traditions, African art, such as the masks, cloths, and carved figures of the Yoruba, deserves to be studied in the light of the ambitions and accomplishments of African cultures and people.

WORLD WAR II TO PRESENT

SUBLIME AND SECULAR: NEW YORK

The exhibition in 1942 at the Pierre Matisse Gallery in New York of "Art in Exile" witnessed the symbolic and effective transfer of tradition and energy from European artists, chiefly Surrealists, to younger artists in America. The adoptive homeland that sheltered these representatives of Western culture during World War II stood ready to challenge their oppressors – fascists who had branded them as "degenerates" and replaced their modern visions with "kitsch," mass-produced, formulaic, and industrial culture. American artists had the opportunity to pick up the mantle of Western civilization as well as the aegis of the avant-garde, or vanguard of cultural vision that had been the aspiration of all "modernists" during the previous century. Comparisons were made in print between America during the war and Florence during the Renaissance, welcoming the exiles from the fall of Constantinople: "The future of the arts is in America."

The support mechanisms were already in place in New York to foster a new art. The Museum of Modern Art, founded in the late 1920s, was energetically collecting European art from Post-Impressionism through Cubism and Surrealism. Led by its indefatigable director, Alfred Barr, the Museum of Modern Art was establishing a canon of avant-garde modernity for

Frank Lloyd Wright, Solomon R. Guggenheim Museum (see p. 473).

American collectors and artists. A landmark exhibition by Barr in 1936–37, "Fantastic Art, Dada, Surrealism," had introduced many American artists to recent developments in Paris. One of Barr's principal supporters was the wealthy collector, Peggy Guggenheim, who established her own private gallery/museum, Art of This Century, in 1942. She saw her mission as the salvaging of Western culture in exile and the provision of a politically neutral sanctuary, a "research lab for new ideas," where artists could work in peace on their "search for the extreme." Barr served as one of her artistic advisers for purchases in New York, assisted by André Breton, Max Ernst, and the prominent art critic, James Johnson Sweeney; in Europe Duchamp and the British art critic Herbert Read performed the same service.

THE NEW YORK SCHOOL

American artists strove to identify their proper subjects and forms. One important early manifesto, written by the painters Adolph Gottlieb and Mark Rothko (1903–70) as a letter in critical response to a newspaper review, reads like a "state of the union" of American aspirations in the light of European modernism, particularly under Surrealism: "To us art is an adventure into an unknown world ... of the imagination, violently opposed to common sense ... We assert that the subject is crucial and only that subject matter is valid which is tragic and timeless. That is why we profess spiritual kinship with primitives and archaic art."

BARNETT NEWMAN Another of the most articulate spokesmen for this emerging New York School, Barnett Newman (1905–70), spent much of his time during this formative period producing exhibition catalogues and essays on painting with portentous titles, such as "The New Sense of Fate." He gave voice to the "terror" evoked by the Surrealists but actualized in life by the recent nuclear bombing of Hiroshima. Newman, too, called for a new art that could create a modern image of the tragic.

Newman's pictures repeatedly took up primal themes, especially the theme of creation in Genesis. He produced works with a strong, mural, background color, in front of which lay a vertical stripe, an abstract, linear figure that divides artistic space. Both figure and ground are in almost identical colors of bright red. This minimal distinction has the elegance and abstraction of Mondrian's articulating stripes but with a new freedom of color and a new suggestion of the primal. Newman's play with basic pictorial elements on a grand scale – figure/ground, symmetry (or asymmetry), color – suggested both universality and the elegant simplicity of poetry. Newman called his breakthrough picture *Onement II* (1948; Fig. **10.1**), a title evocative of the several acts recorded in Genesis, whereby God created materials through separation (light from dark, land from water, man from earth). The vertical stripe thus serves as a gesture of creation, metaphorically for God's

10.1 Barnett Newman, *Onement II*, 1948. Oil on canvas, 60 × 35 ins (152.4 × 88.9 cm). Wadsworth Atheneum, Hartford. Gift of Mr Anthony Smith.

creation, literally for the creation by the painter, a creativity emphasized through the overtly brushed character of both the stripes and their ground, which stains the stripe in places. The generalization in the title harmonizes with the reductive essentials of this full-length vertical stripe. In a world of widespread calamity and destruction, defined by Newman as the modern tragic condition, such images could be affirmative, even heroic acts: "the defense of human dignity is the ultimate subject matter of art."

Newman's paintings suggest the direction that many other images of the later New York School would take in the gallery and museum environments for which they were intended: larger-than-life canvases, produced in series, whose grandiose titles have mythic or biblical associations. There is a distinct and recognizable, personal style in their forms, such as the

calculatedly geometrical stripe(s) by Newman, featuring reduced line, shape, or color, intended to communicate directly and immediately through pure form rather than representation. In the process, the formal experimentation of Cubism was wedded to the psychic truth, at once individual and universal, of Surrealism. Such an art, which could be at once abstract and expressive, came to be known as Abstract Expressionism.

MARK ROTHKO One of Newman's close friends, Mark Rothko, co-author of the important manifesto-letter of 1943, eventually found his own style in hovering veils of color, their edges vague as they float above (and in dialogue with) basic color grounds. An example of this is his 1956 work, *Orange and Yellow* (Fig. **10.2**). Like Newman's

canvases, Rothko's works are on a large scale, in order to envelop the viewer within the overall color field. He also stained his canvases directly, fusing the color with the ground, in addition to brushing color onto the surface of his painting. As a result his canvases seem to embody their colors, whose mysterious floating evokes moods powerfully and directly in each individual observer. They also seem to efface the active intervention and handiwork of the artist himself. Unlike Newman, Rothko abjured the suggestive use of titles once he settled upon his color-field paintings. Nonetheless, these colors have been compared to clouds for their indefinite yet suggestive qualities. Because of their luminosity and implied low "horizon," Rothko's canvases have even suggested comparison with the grandiose expanse of landscapes, confronting a human subject with an object of contemplation.

10.2 Mark Rothko, *Orange and Yellow*, 1956. Oil on canvas, 90½ × 70⅞ ins (230 × 180 cm). Albright-Knox Art Gallery, Buffalo. Gift of Seymour H. Knox, 1956.

10.3 Arshile Gorky, drawing study for *The Calendars*, ca. 1946. Charcoal and colored chalks on paper, 32⅞ × 40⁵⁄₁₆ ins (83.4 × 102.4 cm). Harvard Art Museums, Cambridge, Massachusetts. Gift of Louis Orswell.

ARSHILE GORKY While oversized canvases of pure color formed the basic building block of heroic painting for both Newman and Rothko, line or drawing remained the medium for other New York painters. Perhaps the closest adherent to the Surrealist traditions of automatic drawing and freely invented shapes was an Armenian immigrant who took the artistic name Arshile Gorky (1904–48). Characteristically, Gorky worked out his final painted composition through careful preparatory drawings, as in his 1946 study for *The Calendars* (Fig. **10.3**). Once again, the title suggests a basic human interaction, although the figural basis of Gorky's art is not immediately apparent. The artist has obscured the basic spaces and actors of his images within an inventive linear set of "biomorphic" shapes, redolent of botanical growths. Nonetheless, study of individual figures and comparison between drawings and paintings in Gorky's repeated cycles reveals that these heavily brushed canvases actually portray human activities. In the *Calendars* drawing, an older, balding man sits at the left edge of the painting. He attends a central, slender, tall "woman," whose downturned modest head resembles a sunflower in its garland or crown. Her limp-wristed arm gesture is clearly visible. Another, bearded "man" kneels beneath the rectangular form in the lower right corner in the preliminary drawing but is disguised in the final Gorky paintings.

Gorky's painted world, like Miró's, begins with essentially representational subjects. By developing novel forms and shapes that echo each other and provide compositional coher-ence, his final images become new organic wholes. Gorky practices a combination of abstraction followed by improvisation, like the working methods of Miró. His work is similar to that of several Europeans, in that his imagery is specific and personal and shares their dreamlike qualities. Significantly, Gorky was the last artist to be embraced as a Surrealist by the mercurial André Breton, then in America, although the young painter resisted Surrealism for what he considered its narrow ideas and its tendency to be "flippant."

For Gorky, like Newman and Rothko, forms themselves could directly induce reverie, but serious and lasting art was dependent on deliberation rather than spontaneity. His figurative world is nevertheless inhabited by lively forms, in which linear and coloristic elements mingle freely in suggested space, like the inhabited space of Miró's interiors. Gorky's paintings also frequently treat the theme of the battle of the sexes, whether in the idyllic vision of *The Betrothal* or else in the more problematic tenor of other titles, *Agony* or *The Liver is the Cock's Comb*.

JACKSON POLLOCK No painter more fully captured the public imagination as the heroic representative of the New York School than Jackson Pollock (1912–56). Even today both his life and his painting techniques have taken on the aura of a heroic, masculine myth in their own right. He was a hard-driving alcoholic, who spent a period of time in Jungian psychoanalysis, utilizing his drawings as part of the treatment. His wife, Lee Krasner, was a distinguished artist in her own right. Pollock's meteoric rise to fame also depended upon influential backers, notably Peggy Guggenheim, who gave the young artist his first one-man show at her influential Art of This Century Gallery in 1943. At the show an early canvas with a mythic subject, *She-Wolf*, was purchased by Barr for the Museum of Modern Art, and Pollock's career was underway.

Pollock began painting as a muralist. All of his large-scale canvases retain the scale and ambition of murals. However, he treated surfaces as empty spaces; he saw them through a *horror vacui* as needing to be filled full. One picture that broke new ground, *Guardians of the Secret* (1943 – shown at Art of This Century, with a catalogue essay by James Johnson Sweeney), reveals his methods of painting (Fig. **10.4**). Here he sets up a strong figure/ground base but restlessly and ceaselessly covers it with mysterious ciphers and dense layers of charged brushwork. The title, with its cryptic "guardian" figures, evokes the timeless myths then favored by Rothko and Newman, and the inscrutable surface of the painting suggests profound depths not immediately accessible to the viewer. The densest segment of the picture lies in its central rectangle, where the "secret" rests in an altar, shrine, or sarcophagus. Taken overall, this canvas shows an energy and formal invention, especially in its vitality of line and brushwork, that would rival any European abstraction by Picasso or Miró. At the same time it follows the dictates of New York's emerging canons. Like Gorky's work, it remains basically representational, taking the human form as its starting point; like Newman's (and Miró's), both its title and its seemingly uncontrolled spontaneity suggest the power and mystery of myth.

Pollock claimed that American-Indian culture was a source for his art, and he was credited in his biographies with "native" origins in Wyoming. Another archetype, the truly American primitivist, began to crystallize around him. Yet Pollock was scrupulous about defining his position as an artist relative to Europe. Like most emerging young American painters, he acknowledged France as the dominant art center of the past century and of recent art movements. He essentially grafted himself onto that heritage through association with art émigrés harbored by wartime America and honored in American collections. Pollock specifically cited Picasso and Miró, with their use of the unconscious, as a source for his own art.

10.4 Jackson Pollock, *Guardians of the Secret*, 1943. Oil on canvas, 48⅜ × 75⅜ ins (122.9 × 191.5 cm). San Francisco Museum of Art. Albert M. Bender collection.

10.5 Jackson Pollock, *Cathedral*, 1947. Enamel and aluminum paint on canvas, 71½ × 35¹/₁₆ ins (181.6 × 89.2 cm). Dallas Museum of Art. Gift of Mr and Mrs Bernard J. Reis.

DRIP PAINTINGS

Like Newman and Rothko, Pollock increasingly eliminated all mythic titles and visual representation from his art. Florid gestures with the brush and "allover" painting dominated the coverage he gave to his large canvas surfaces. Spontaneity had served as a criterion of value in art-making ever since the "automatic drawing" of Dada and Surrealist artists. Pollock's intense experimentation with art-as-process picked up this unconscious, spontaneous technique as a virtue. After 1947, he even developed a new technique to add an extra element of chance to his creations: drip painting. Using the thicker density of enamel paint, Pollock allowed the color to drip or run in long strings of pigment from a suspended brush above the canvas, also allowing drips and spatters. He claimed that by putting large, unstretched canvases on the floor of his studio rather than on the easel, he could walk around the image, working on it from all four sides to get *into* his paintings even more. For this method he claimed descent from "Indian

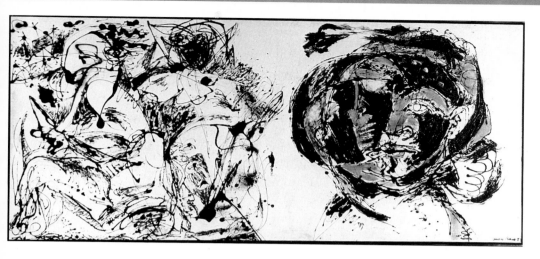

10.6 Jackson Pollock, *Portrait and a Dream*, 1953. Enamel on canvas, 58⅛ × 134¼ ins (147.7 × 341 cm). Dallas Museum of Art. Gift of Mr and Mrs Algur H. Meadows and the Meadows Foundation Inc.

sand painters of the West." Direct, spontaneous drawing from the unconscious was to be the result. In the process Pollock would promote mural painting over the easel tradition.

Pollock's drip paintings provoked outrage and notoriety when they were first displayed. One critic dubbed the artist "Jack the Dripper." Of course, others praised his obvious energy and improvisation on such a grand scale. The artist became a lonely, heroic individual once more, inventing a new vision in the tradition of the European avant-garde. The very attacks by the popular press on him only served to make his courage and individualism more appealing to his colleagues as a badge of honor.

Pollock gave a number of his drip paintings suggestive titles, such as the vertical *Cathedral* or the horizontal *Autumn Rhythm*. *Cathedral* (1947) evokes the soaring height of Gothic structures as well as the traditional spiritual concerns of art (Fig. **10.5**). Accenting its surface rhythms is the shiny, reflective surface of aluminum paint. Whether deliberate or not, such pigment connotes the luminous mystery of medieval church interiors as well as the precious materials used to create religious objects such as shrines. The swirling movements of interlaced paint on the surface of *Cathedral* have a life of their own quite apart from that conferred by the title, yet the layered density of motion confined within a frame echoes the rectangular "secret" of Pollock's earlier painting.

The poignancy of his isolation in this new kind of painting emerges from the testimony of the artist Lee Krasner, his wife, who revealed that Pollock once asked her "Is this a painting? Not is this a good painting or a bad one, but *a painting*!" Because he worked from all sides, the orientation of the picture remained uncertain until after it had been completed. In Pollock's art, arabesque calligraphy takes on its own identity, liberating drawing from any vestige of representation, even from the tracing of edges, thereby embodying the ultimate expression of "art for art's sake." More than any other artist, Pollock became the prototype of the movement later known as Abstract Expressionism. Where Newman's static art seeks to capture a single moment of initial creation or epic sublimity, Pollock's restless dynamism captures and elaborates a prior condition – primordial chaos, the polar opposite of

Mondrian's universal abstract landscapes of rectilinear balance. Like Rothko or Newman, Pollock respects the confines of his ample frames but creates a charged field within them.

Despite resorting primarily to neutral titles, especially numbers, for many of his later paintings, Pollock returned in his final works to representation and to a new austerity of black-and-white drawing. *Portrait and a Dream* (1953; Fig. **10.6**) once more engages Pollock with the faceted face invented by Picasso two decades earlier in works such as *Girl before a Mirror* (then on show at the Museum of Modern Art). Here the woman's face is shown in three-quarter view as its primary aspect but is complemented by an overpainted extension that culminates in a skull-like, solid full profile. Pollock's drawing is disciplined within the demands of basic depiction, but Pollock here has also successfully used bravura calligraphy in the manner of Gorky to suggest additional complexity. Even on the left, the side of improvisation and spontaneity, clusters of lines coalesce into a representation of two anthropomorphic figures, especially the schematic face at the upper right. In fact, these two figures resemble the two most "primitive" and unsettling figures at the right of the *Demoiselles d'Avignon* (Fig. 9.1; also on view at the Museum of Modern Art). These last works by Pollock also approach the bold, dark forests of shapes produced by his artist-wife, Lee Krasner. Poetic evocation returns in both the fleeting figurative imagery and suggestive titles, such as *Ocean Greyness* and *The Deep*.

As the title *Portrait and a Dream* suggests, Pollock was now moving beyond the purely reductive, lyrical drip paintings to rediscover with his new skills the original mythic, dream-based sources of his earlier paintings. According to Krasner, Pollock, like Gorky, had always begun his painted work with such images as "heads, parts of the body, fantastic creatures," and then went on to "veil the imagery," then left exposed. Like his early, mythic subjects, such as *Guardians of the Secret*, Pollock candidly drew inspiration from what Krasner called "the same subconscious, the same man's eroticism, joy, pain ..." She also records that Pollock described the face element in the "dream" segment of *Portrait and a Dream* in evocative terms as "the dark side of the moon."

The "Rothko Chapel"

From 1965 to 1967, Mark Rothko worked on a commission to produce a total contemplative environment for a non-denominational chapel in Houston (Fig. **10.7**). The pictures are supported by an austere architecture, an open space of whitewashed walls and a few stone benches to support contemplation, designed around the configuration of the pictures by Philip Johnson, a practicing architect who also served earlier as curator of architecture at the Museum of Modern Art. The patrons of this entire project were a wealthy pair of expatriate Frenchmen, the de Menils, longtime supporters of modern art, especially Surrealism. The de Menils also patronized Christian ensembles of modern art and architecture after World War II in France by such modern masters as Matisse –Vence Chapel (1951), and Le Corbusier – Ronchamp, Notre-Dame-du-Haut (1950–54).

Like Newman's biblical titles and universal forms, Rothko's chapel canvases attempt to suggest the spiritual in art through direct pictorial means, in this case a contemplation of shifting color tones, otherwise unmodified by either Newman's stripe or Rothko's hovering rectangle. Reduced to its ultimate essence, framed color, art strives to attain the sublime. The dark cycle of indigo, violet, and plum canvases, suggestive of a numbing void, envelops the visitor to what has become known as the "Rothko Chapel."

At the de Menil Chapel in Houston, Newman also installed his only site-specific monument, created in the

10.7 Mark Rothko, Rothko Chapel, St. Thomas University, Houston, 1965–67. Oil on canvas. Interior view. Chapel building designed by Philip Johnson, 1964–71.

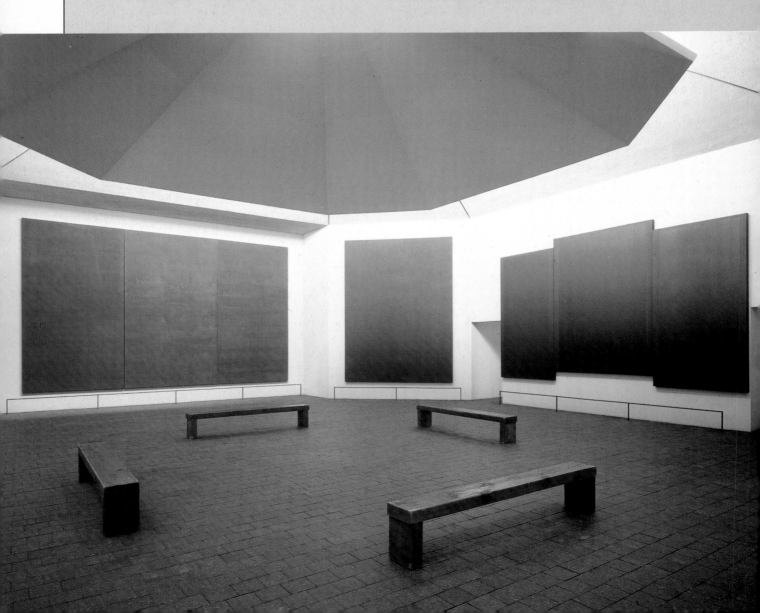

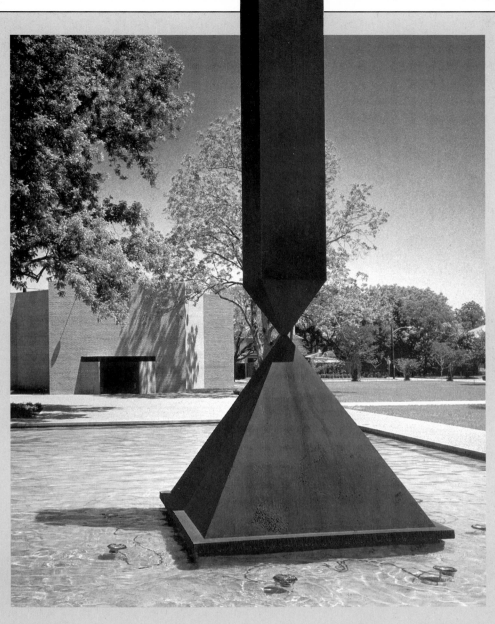

10.8 Barnett Newman, *Broken Obelisk*, 1963–67. Steel, 25 feet (7.65 meters) high. Rothko Chapel, St. Thomas University, Houston. Exterior view.

modern idiom of geometrical purity yet derived in essence from the oldest of monuments: the pyramid and obelisk of ancient Egypt. His *Broken Obelisk* (1963–67; Fig. **10.8**) presents a delicate balance of an inverted obelisk atop the perfection of a pyramid; the geometrical solids at the apex of both structures are congruent mirror images. Both kinds of works marked sites of spiritual focus, either at the tombs of pharaohs or at sacred places of solar energy, the divine sites of the sun-god Ra (see p. 35). The broken base of the obelisk utilizes architectural shorthand to suggest a much greater length that is not displayed; hence, the obelisk by implication extends indefinitely upward toward heaven. Their mutual concentration of spiritual energy climaxes at the intersection of pyramid and obelisk, a meeting of heaven and earth at a point, once again in analogy to the moment of creation in Genesis.

Although this sculpture was not originally designed to be an element of the Rothko Chapel in Houston, it was added to the ensemble shortly afterwards, dedicated to the memory of Dr. Martin Luther King, Jr. Its geometrical purity and spiritual content fully harmonize with the austere contemplative environment of the paintings in their architecture. Placed within a pool in front of the Rothko Chapel, *Broken Obelisk* serves as a monument, adding the voice of sculpture to that of painting and architecture at the Rothko Chapel. At the same time, this modern amalgam of the most ancient of structures serves as the overture to the unrelieved modernity and spiritual seriousness by Newman's friend, Rothko, within.

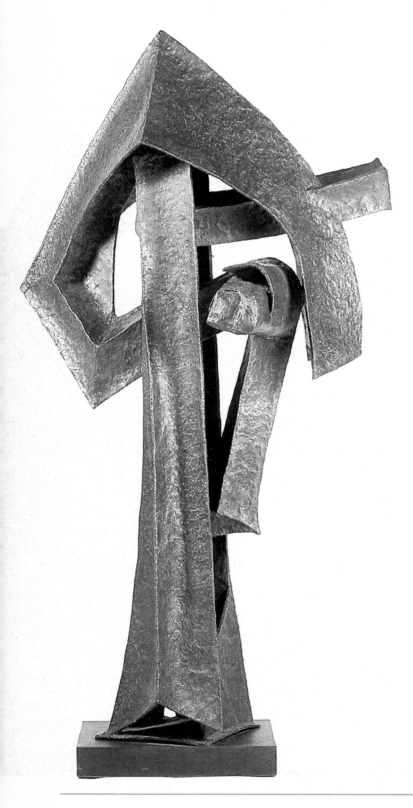

THE ABSTRACT IN SCULPTURE

Sculpture became as abstract as the liberated color and line of New York School painting but could not easily achieve its expressiveness. The one painter who took up the sculptor's tools with any success was Barnett Newman. After half a decade of painting experiments with his stripe pictures, he produced a ragged, powerful vertical presence, a standing stripe, 8 feet (2.4 meters) high, out of plaster (later cast in bronze): *Here I*, marking a place as surely as the initial stripe in *Onement II* marked a moment.

SEYMOUR LIPTON Full-time sculptors also struggled with the same ambitions and the fascination with mythic themes. One of the most independent and successful New York School sculptors, Seymour Lipton (1903–85), worked exclusively in metal but steadfastly maintained a biological matrix for his imagery. His fully-worked metal surfaces absorb light, to suggest a weight and density diametrically opposed to the weightlessness and kineticism of Calder's mobiles and stabiles (pp. 408–09). For Lipton archetypal imagery, abstracted from the natural toward the universal, serves as the motive power of art. He singled out "an interplay of tensions, of lines, planes, forms, spaces and suggested meanings to develop energy, and to evoke the mystery of reality." As a sculptor, however, Lipton had to be mindful of gravity and of material properties. His own working method departs from traditional sculpture in ways analogous to Pollock's liberation of painted drawing. Lipton neither molds nor carves his solids. Instead, he welds and "constructs" them out of sheet bronze and metal rods, reworking the surfaces for his distinctive textures and coloristic effects. Like Gorky, Lipton works from a series of preliminary, exploratory studies – first drawings and then metal maquettes in miniature to test the stability and the three-dimensional effects of his concepts. Deliberation, rather than improvisation, informs his works, adding to the power of their organic abstractions.

Lipton's *Sentinel* (1959) distills the anthropomorphic essence of a standing male figure yet works to balance that abstraction with the heroic properties of his metal medium (Fig. **10.9**). Solidity and weight focus on a vertical central shaft, which draws upon the traditional link between columns and the human figure. The crested metal figure suggests further analogies with knights in armor. Its bold silhouette assures this over-lifesize standing figure of a commanding, frontal presence, worthy of the guardianship of its title. Massive shapes and linear projections enhance the metaphor of power yet also cohere in a dense formal composition as true to its medium as Rothko's hovering pigments or Pollock's relentless brushwork.

10.9 Seymour Lipton, *Sentinel*, 1959. Monel metal, 102 ins (259 cm) high. New Haven, Yale University Art Gallery.

PURITY IN ARCHITECTURE: MIES VAN DER ROHE

American architecture also developed a particular aim of austerity and purity as the basis of personal style. Epitomized by his epigram, "Less is more," the leading practitioner of this exacting craft of architectural elegance was the German expatriate, Ludwig Mies van der Rohe (1886–1969; see p. 399). Employing all of the reduction and simplicity of Mondrian's compositions, Mies set out to produce essential, modern buildings out of the basic ingredients of a steel frame with a glass skin. As early as 1921 he had produced a skyscraper project for a competition that was nothing more than a tower of steel with a glass curtain-wall. Minimal in its technique, this soaring crystal structure was also a glass "cathedral" of modernity. Like Brunelleschi's essential, geometric structures in early Renaissance Florence, Mies aimed for a classical severity within geometrical regularity and clear construction using planar surfaces. His first important building in Europe was the luxurious, elegant model house built to represent Germany at the 1929 Barcelona international exhibition (see Fig. 9.45).

However, totalitarian architecture in Nazi Germany soon displaced the modern experiments of Mies van der Rohe, as surely as Nazi condemnation had exiled the Expressionism of Max Beckmann. Unlike Beckmann, who became a permanent exile, Mies found a second home when he came to America in 1940. By emigrating to Chicago, the original home of the glass-and-steel skyscraper in the late nineteenth century (see pp. 348–50), he grafted his ideas onto a local tradition begun by the generation of Louis Sullivan. In Chicago, Mies was able to continue the basic articulation of space through steel-framed boxes of glass that he had embodied in the Barcelona pavilion. The credo of such architecture is simplicity and purity, "truth" to materials and their actual function in the building. In this respect, Mies's aesthetic aligns nicely with the New York School aesthetic of painting and sculpture, scrupulous in its own use of materials and uncompromising about expressing the nature of its medium (the planar surfaces of painting; the metal materiality of sculpture).

Perfecting the essence of glass-and-steel construction, Mies created variations on the minimal skyscraper, almost realizing his initial project of 1921. Like the open spaces of his horizontal interiors, Miesian skyscrapers are equally adaptable as apartments or office spaces, and they were widely imitated in both America and Europe. His Lake Shore Drive apartments in Chicago (1948–51) were designed with a basic exoskeleton of steel I-beams revealing interior structure on the surface (Fig. **10.10**). Mies composed his two tower blocks with the same attention to geometrical ratios in their ground plans as he employed in the rectangular grid intersections of their window elements. The uniformity of the building is also expressed on its exterior, where each floor consists of identical apartments. With his characteristic love of detail, Mies creates a subtle, rhythmic system of bays by clustering four window elements into a single unit, articulated by the wider vertical structural beams. He also subdivides each window with a horizontal balustrade, proportionate to the overall ratios of his building. Like his statement, "God is in the details," the overall unity of Mies's calculations achieves integrity and balance. Technology merges with geometrical order to produce a distinctly modern harmony.

10.10 Ludwig Mies van der Rohe, Lake Shore Drive Apartments, Chicago, 1948–51.

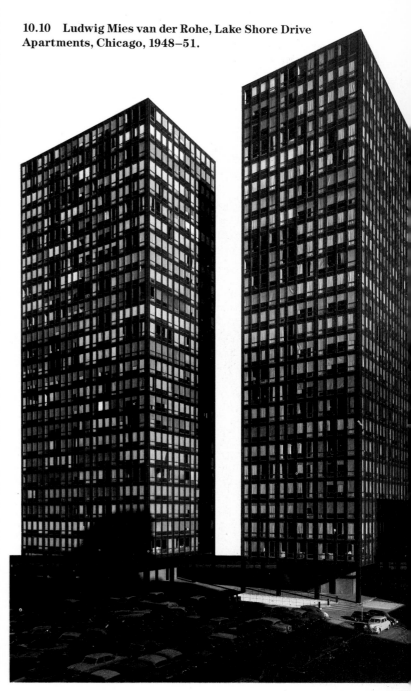

Mies perfected his skyscraper paradigm in New York with the Seagram Building (1954–58; Fig. **10.11**). Here he was free of the constraints of making a commerically viable building out of prefabricated parts, because he was commissioned by a major industrial corporation. From its inception, the project was intended to be a glass temple to modernity, associating its "clean" lines and crisp design with the image of efficiency and standardization of the modern corporation. Mies was chosen from a list of architects compiled by Philip Johnson, the former curator of architecture at the Museum of Modern Art, who eventually became his collaborator on this building. The lavish corporate budget of the Seagram Building allowed him to substitute bronze for steel in its external I-beams as well as other luxurious materials, akin to the provisions of the Barcelona pavilion. The Seagram Building presents a slender elegance, emphasized by narrower window openings than at the Lake Shore apartments and by the absence of supporting I-beam columns, now recessed behind the glass screen. The exposure of those supporting columns at ground level creates the severe classical dignity and open space of an entrance portal, visible across a wide plaza (Fig. **10.12**). Mies's building and its dark glass surface provide a statement of gravity and solidity across the plaza entrance. In all its dignity and uncompromising geometry, the Seagram Building offers an architectural counterpart to Newman's dramatic, grand stripe, standing tall and pure against a monochrome background.

10.11 (Right) Ludwig Mies van der Rohe and Philip Johnson, Seagram Building, New York, 1954–58. Elevation.

10.12 (Below) Ludwig Mies van der Rohe and Philip Johnson, Seagram Building, New York, 1954–58. View of lobby entrance.

"POST-PAINTERLY ABSTRACTION"

The formal austerity and geometrical perfection of Mies, Rothko, and Newman provided a stimulus to younger American artists. Claims to sublimity in the pioneering works of the New York School could not easily be sustained by subsequent artists, but the emphasis on purity of means in abstract art could be pushed to its logical and aesthetic extreme. Rothko's experiments in staining canvases and removing the artist's manual activity served as an instructive challenge for a number of younger artists. Philosophically minded critics hailed this work for its acceptance of the planarity or "utter flatness" of the canvas support and its use of pure, unmodulated color on that surface without any vestige of illusion or depth. While artistry and chance could still impinge upon these veils of pure color, the prevailing effect is the effacement of the active brushwork that marked much earlier Abstract Expressionism. This greater artistic reticence came to be called "Post-Painterly Abstraction" or "Color Field Painting," and it was quickly followed by more austere pictorial reductions.

FRANK STELLA Other painters, led by Frank Stella (b. 1936), emphasized the primacy of the picture plane through its shape rather than its colored content. Stella's career began with a statement of impersonality. His single-colored or black-and-white canvases begin with the irregular perimeter shape of the surface and trace its contours in strict, parallel rows of white lines in the interior (Fig. **10.13**). This kind of precise delineation of a surface from its edge to its center eliminates the celebration of the act of painting so carefully cultivated by Abstract Expressionism. Instead, it offers cerebral detachment, an inexorable logic of coherent creation that totally eliminates individual gesture or self-expression. Stella's minimal art quite literally paints picture-making into a corner, completely stripped of any particular aesthetic as well as moral or social values. Stella claims the radical reduction of his image to be nothing more than a visible object.

10.13 Frank Stella, *The Marriage of Reason and Squalor*, 1959. Black enamel, 90¾ × 132¾ ins (230.5 × 337.2 cm). Collection, The Museum of Modern Art, New York. Larry Aldrich Foundation Fund.

10.14 **Robert Morris, *Untitled*, 1965-6. Fiberglass and flourescent light, 23¼ × 13⅞ × 96¹⁄₁₆ins (60.3 × 35 × 244 cm). Dallas Museum of Art.**

Effacing the artist from the artwork became a goal of sculpture as well. Where Lipton had stressed his own, muscular style and his search for universal symbols, a sculptor like Robert Morris (b. 1931) strove instead for the opposite. Both illusion and the allusion of symbols were ruthlessly expunged in favor of a literalness that often depended on an undramatic repetition – redundancy – of basic shapes (Fig. **10.14**). Traditional sculptural interests in textures and in irregularly shaped surfaces or solids have been reduced to the actuality of substances in space and light. Morris refused to give his objects titles, using commonplace materials, such as steel mesh, plywood, and fiberglass in basic, replicable, geometric shapes and uniform colors. He worked against the prevailing vigor and solidity of traditional sculpture by choosing the limp, shifting shapelessness of felt to add a random element to every installation, utilizing the space around the material as part of its total effect. Viewer self-consciousness, not imaginative contemplation of artistic profundity, results from interaction with these minimal, though striking, objects.

Artworks now engage aesthetic problems as intellectual exercises or laboratory explorations, but their form of production and even their maker are irrelevant to the final effect. Indeed, Morris and other minimalist sculptors of the 1960s contented themselves with accurate descriptions or drawings of their conceptions, delegating the execution of the actual objects to others, usually "technicians" whose goal was precise replication. At every stage the personality of the artist should be eliminated from the work.

Such aesthetic experiences, however, are utterly dependent upon an established matrix of display: the insulated, white-washed world of gallery or museum walls, filtered through the perceptions of establishment critics. This institutional framework already existed in New York. Art journals offered fora for critics, who often doubled as curators or advisers to collectors. Both critics and collectors frequented "leading" galleries and contributed to temporary exhibitions and permanent collections of modern art in museums. Some artists also doubled as critics. Particularly in the wake of the postwar "art boom," the marketing and distribution of modern art in America prospered as never before. Within this institutional matrix, moreover, even the self-effacing artist of *Minimalism* participated in the commodification of the art object and the cult of its maker.

As a result, the public awareness and acceptance of artists altered immeasurably. Artists who had previously considered themselves spiritual seers, exploring the unknown realms of myth and the individual psyche, no longer found the masses hostile and only a discerning elite receptive to their work. Instead of maintaining the alienation of the avant-garde, they became media celebrities and overnight sensations. With such acclaim came enormous wealth and institutionalization at the broadest levels of culture.

ANALYTICAL PARADOXES: JASPER JOHNS

Some of the tenets of Minimalism underlie the works of another artist, often seen in opposition to both Minimalism and Abstract Expressionism: Jasper Johns (b. 1930). Characteristically, Johns selects a commonplace, even banal, image from the everyday world as the subject of his pictures. One of his favorite subjects is the American flag, on which he performs provocative variations: three superimposed flags (Fig. **10.15**), a white flag, and a flag above a blank white surface. According to the artist, such a subject attracts him precisely because of its availability and its familiarity to his viewers. This concept explicitly contradicts all the basic principles of Abstract Expressionism. In place of a subjectively psychic, universal yet personal "expression," Johns substitutes an objective, concrete, and commonplace image that seems to eliminate the need for a painter altogether. One cannot "express" a flag at all; it seems to be the very antithesis of abstraction and spontaneity. Moreover, its assertion of "nationality" further compromises the international or universal ambitions of the New York School.

Yet Johns's pictures subtly pose analytical paradoxes. After all, a flag *is* abstract: it uses the flatness of two dimensions and a mere three basic colors. Even white serves not as a blank background but rather as a positive color, itemizing each state against a blue background. Johns also uses the planarity of maps, like flags, to represent the United States in two dimensions, complete with labels for each of the states. Both the map and the flag keep fixed proportions, such that the full shape of the image is defined. Johns's commonplace images, therefore, accord well with the black-and-white shaped canvases of Stella, whose edges and interiors define each other. Johns does not eliminate color but rather reduces color choice to the primaries alone (red, blue, yellow) or else the complementary hybrids of the primaries (orange, green, purple). Such a limitation of palette further links Johns to the Minimalist painters and sculptors, despite his subjects.

Once more, however, Johns reverses his field. He utilizes short and assertive hatched paint strokes that reflexively call attention to themselves and irregularly "coat" the surface they seem to represent. His strokes create a tension between the depicted figure and its representation akin to Cézanne's visual play between his own hatched brushwork and the landscape or

10.15 Jasper Johns, *Three Flags*, 1958. Encaustic on canvas, 30⅞ × 45½ ins (78.4 × 115 cm). Whitney Museum of American Art, New York.

still-life subject. Yet for Johns, brushwork actually enlivens an otherwise flat and mechanical two-dimensional surface. At the same time that Stella was avoiding self-expression in his immense, immaculate geometries, Johns maintained a conspicuous link with the gestural brushwork of Abstract Expressionism. In addition, he employed meticulous gradations of tone (white under red, red under white) to forge a delicate balance of formal values and color saturations in his flag's colors. Despite his banal yet carefully chosen subjects, Johns's forms seem to synthesize the geometrical abstractions of Newman and Rothko with the gestural expressiveness of Gorky and Pollock. Indeed, his painstaking, wax-based painting technique of *encaustic* produces a textured relief surface fully at odds with the planar flatness of both his subjects and the minimalism of the picture plane.

Johns also played with the boundaries between painting and sculpture as media by including samples of each in his 1955 work: *Target with Four Faces* (Fig. **10.16**). As in the series of flags, commonplace and functional objects can be viewed anew as "abstractions" in terms of their circular shapes and colors. Here, too, encaustic surfaces ripple with relief, though newspaper collages visible beneath the paint surface also reassert

10.16 Jasper Johns, *Target with Four Faces*, 1955. Encaustic and newsprint collage on canvas with painted plaster casts, 30 × 26 ins (76.2 × 66 cm). Collection, The Museum of Modern Art, New York. Gift of Mr and Mrs Robert C. Scull.

planarity. In fact, Johns's mixture of plane with relief, of banal still-life subject with intense thought allies his work with Synthetic Cubism. "Stilled life" asserts itself in three dimensions above the "face" of the target, where four identical, unnaturally orange plaster casts of faces confront the viewer as frontally as does the target. These casts have been cut off arbitrarily at the eyes, so they differ from the targets or flags in being incomplete, made into objects rather than subjects with whom the viewer could identify. In a second version of the target, Johns carries this notion of stilled life still further with casts of separate body parts: an ear, a penis, a hand with missing fingers – all in arbitrary single colors. These human fragments turn Duchamp's readymades inside out. Whereas Duchamp's "found objects" were functional and intact, turned into art by virtue of their placement in a gallery setting, Johns's "objects" are fragments and are human rather than industrial in their origin. These reliefs have been manufactured by design in the studio, yet they have also been literally "depersonalized" or "abstracted" from their anonymous donors. The solidity of these body parts defies the flatness of the target plane. Their partial nature qualifies the wholeness of the target and reminds the viewer of the artist's selection process, if not his virtuosity as creator.

In similar fashion, Johns took a pair of actual ale cans – one open and one full – and had them bronzed at a foundry (an act of nostalgia normally accorded to baby shoes or diplomas). He also painted over their commercial labels, reasserting the mixture of painting with sculpture. This act of painting picks up the heritage of Duchamp's signed, readymade urinal as it adds artistry to a found object. Johns's ale cans lack the emotional and expressive side of art-making, yet their reworked surfaces and traditional bronze medium reassert the importance of a critical eye and mind in the process of art-making – and in perception itself.

ROBERT RAUSCHENBERG (b. 1925), Johns's colleague, also played with the boundaries between retrieved commonplace objects or televised images and personal artistry. While Johns was busy experimenting with his variations on the Flag, Rauschenberg smeared paint on the covers of his own bed (Fig. **10.17**; 1955) and placed it upright on a gallery wall, thereby removing it from its "function" as fully as Duchamp (see pp. 404–406) had refashioned his urinal *Fountain* with a signature and a title. Of course, Rauschenberg's bed brings a minimal biographical or personal element back into the artwork, even though an artist's selectivity and personal vision are fundamental in determining the value of such an object as an artwork. As if in counterpoint with Minimalism, Rauschenberg employs expressive abstract gestures of paint on the surface of a found object (rather than creating his own, purified geometrical objects for construction by others). Such artistic gestures and use of commonplace imagery are wholly dependent upon the precedent of Duchamp, whose own ideas acquired retroactive historical significance after the challenging exhibitions of both Johns and Rauschenberg.

POP ART

Abstract Expressionism and Minimalism depended upon the opposition between artist and society for their avant-garde status and aesthetic purity. By choosing commonplace objects, Johns and Rauschenberg defied this isolation and adopted elements of popular culture in their art, although they retained the obvious trappings of artistry. They threatened to undermine abstraction as the defining element of modernist art and to dissolve the carefully cultivated barriers between "high" and "mass" culture, between the avant-garde and "kitsch." Thus this new art, eventually called *Pop Art*, for its use of "popular culture," incurred hostile attacks from leading critics of the art establishment.

ROY LICHTENSTEIN Some of the leading Pop artists retaliated with satirical imagery of abstraction itself, such as Roy Lichtenstein's (b. 1923) *Brushstrokes* series (1965; Fig. **10.18**). Lichtenstein made large-scale gallery images out of subjects as diverse as comic strips, household objects, and paintings by Monet or Picasso, and all of his images simulated the dotted, mechanical half-tones of photographic reproduction. In this case, the gestural boldness that served as the signature of Pollock and other New York School artists forms the entire subject of the picture. Once more art derives from earlier art, but now the "authentic," individual, expressive stroke has been objectified, detached at second hand from its original action and emotion. Ironically, Lichtenstein has also inserted a "random" drip and has used commercial art techniques to suggest the physical shape of the stroke against its dotted ground.

10.18 Roy Lichtenstein, *Brushstrokes: Big Painting No.6*, 1965. Magna on canvas. Whitney Museum of American Art, New York.

10.17 Robert Rauschenberg, *Bed*, 1955. Construction with paint, 75¼ × 31½ × 8 ins (191.1 × 80 × 20.3 cm). The Museum of Modern Art, New York. Gift of Leo Castelli.

10.19 Claes Oldenburg, *Giant Hamburger*, 1962. Painted sailcloth, 52 × 84 ins (132.1 × 213.3 cm). Art Gallery of Ontario, Toronto.

10.20 Claes Oldenburg, *Batcolumn*, 1977. Welded steel. Chicago.

CLAES OLDENBURG Irony is also present in the ambitious Pop sculpture of Claes Oldenburg (b. 1929). In contrast to the hard, durable surfaces of traditional sculpture, Oldenburg routinely uses soft and industrially standard materials, either canvas or plastic. In place of the nature-based subjects of Brancusi, Calder, or Lipton, Oldenburg routinely selects commonplace objects, including fast foods, and then renders them on a grand, even colossal scale (Fig. **10.19**). As often as not, his oversized ice packs, typewriters, toilets, or light switches sag limply, contradicting their monumentality and technical reliability as well as the masculine tradition of rigidity, still so basic to the works of Lipton. Instead of the curious mixtures of found objects or images by Rauschenberg, Oldenburg fabricates his own sculptures and attends to the physical properties of his materials (plaster, plastic, or canvas). His stated aim echoes that of Johns: "I try to make the art look like it's part of the world around it. At the same time I take great pains to show that it doesn't *function* as part of the world around it." He makes art out of non-art and substitutes culture, the manmade, for nature as the wellspring of imagery.

Oldenburg also takes delight in the use of modern, commonplace imagery in place of the traditional sculptural monuments exemplified by Newman's *Broken Obelisk*. Rather than employing timeless abstractions like obelisks, Oldenburg has designed paper projects for urban monuments in the shape of everyday objects, such as a pair of scissors to replace the obelisk of the Washington Monument. For example, at the height of the Vietnam War he erected an oversized lipstick tube on a simulated tank on the campus of Yale University. As if to parody the abstract yet heroic standing figure of Lipton's *Sentinel*, Oldenburg created a 40-foot (12-meter)-high standing *Clothespin* for Philadelphia during the American bicentennial celebration. For Chicago, his 1977 *Batcolumn* soars ten storeys in a monument appropriate to the passion for sport in many American cities (Fig. **10.20**). Its airy lightness also extends the colossal, open steel construction traditions of Chicago skyscrapers into a new geometrical elegance worthy of Minimalist sculpture.

ANDY WARHOL The most famous of all the Pop artists, however, was Andy Warhol (1930–87), who most fully grasped the implications of the media revolution for art-making. Warhol began his career as a commercial artist, mastering the techniques of photomechanical reproduction of his designs as well as shiny, "slick" representation of objects. He was essentially a "packager," taking images of cultural figures or commercial products (including his celebrated soup cans) and transposing them through silkscreen into the gallery arena of high art. For Warhol the soup can label and the iconic image of an individual's face are virtually interchangeable currency, part of the explosion of imagery in the public domain. In using the face of Marilyn Monroe, a movie star and sex symbol made even more famous by her recent suicide, Warhol exploited her fame as his subject (1962; Fig. **10.21**). He used other media celebrities, such as Elvis Presley and

10.21 Andy Warhol, *Twenty-five Colored Marilyns*, 1962. Oil, acrylic, and silkscreen enamel on canvas, 81 × 57 ins (205.7 × 144.8 cm). Collection of the Modern Art Museum of Fort Worth.

Mao Tse-tung, indifferent to their distinct spheres of activity. Warhol presents images of images. The artist himself proudly drew analogies between his reproductive techniques and the photographic or industrially produced images that formed his subjects. He even came to name his studio "The Factory."

Warhol deliberately emphasized the distinction between his images and their originals. The faces appear in garish or unnatural colors, like the plaster faces above Johns's *Target*, often repeated in series of identical images side by side. While still claiming artistry in the production of his images, Warhol nonetheless rejected the artistry of Johns and strove for a standardized imagery at odds with the aspirations of the New York School. By following and reproducing time-bound subjects from the mass media, Warhol succeeded in reversing the pretensions and ambitions of the avant-garde, converting gallery art into the literal "rear guard" position of being derived from popular media. Rather than provoking rethinking or abstract sensibility toward familiar subjects in the manner of Johns or Oldenburg, Warhol eliminated any essential difference between his images and the omnipresent images of advertising or television.

Celebrity was the ultimate subject of Warhol's images, and he in turn became a celebrity through the mechanisms of the artworld. He delighted in acclaim and success, and lived a "jet-set" life worthy of the movie stars he took as his subjects. In contrast to Pollock, whose controversial art confirmed the gulf between the art establishment and the uncomprehending "public," Warhol became a public figure despite his claim to have no glamor of his own. The howls of protest from elitist critics only served to signal the conquest of high culture by mass culture, of artistic vision by artistic celebrity.

By the end of the 1960s artists and their works had achieved commercial success, yet paradoxically the personal and emotional element that informed all of the experiments of the New York School had been reduced to a cult of impersonality and "objecthood," whether Pop or Minimalist. Personal creativity no longer served as a measure of artistic success. Alienation from society, long taken to be the essential province of an artistic temperament, now became commodified and turned back onto mass culture through indifference and withdrawal, like a blank mirror. Warhol mechanically homogenized his subjects – whether commercial labels, celebrity faces, or violent newsphotos – in much the same way that television does.

No longer did the gallery system, the established critics, or the museum world serve as the arbiters of high culture and its ongoing tradition. America's heroic pioneering abstract artists had generated a polarized following, split between the hostile camps of Pop Art and Minimalism. Their very success undermined any resistance movement as the basis of art and any tightly knit consensus of a tradition-in-formation. They competed for careers openly in the art marketplace. In the course of a single generation, Modernism, the ambitious internationalism of the New York School, had become diffused and spent its energy. The resulting diversity, an aesthetic and institutional free-for-all, bears the non-label, *Postmodernism*.

AFTER MODERNISM

ART IN ACTION: BEUYS

On the evening of 26 November 1965 at a gallery in Düsseldorf, Joseph Beuys (1921–86), his head covered with honey and gold leaf, held a dead hare in his arms and carried it from picture to picture, holding up its paw to each one (Fig. **10.22**). At the end of his gallery tour, he sat in a chair with the hare and "explained" his pictures to the dead animal, "because I do not like to explain them to people." This staged event, called an "*Action*" by Beuys, exemplifies many of the process activities and alternatives to commodified, saleable objects offered by artists during and after the 1960s. In the art world of Europe, Beuys has assumed the character of a cult leader, and his international reputation signaled the full-fledged return of European participation in the "art world" after a postwar eclipse.

Annotating his Action, Beuys explained the hare as a symbol of birth and incarnation as well as a creature of the earth. The honey on his own head was a natural substance symbolizing productive, intuitive thought. Beuys emphasized the importance of thought and speech, and the obstacles to them, that is, the problems of communication, in many of his process activities. For example, his final installation, in a London gallery in 1985, put a soundless piano and an unused chalkboard in a densely insulated room, covered in felt, a favored natural material of Beuys (Fig. **10.23**). His avowed, ongoing theme is the desire to shock the public into an artistic consciousness of its own ("Everyone is an artist"), permitting the transformation of everyday, especially natural, items into media of expression and personal significance. Beuys's art rejects physical workmanship or the creation of lasting objects for possession. Instead, he uses events or temporary installations to heighten the consciousness of his viewers.

Many of Beuys's Actions emphasized primal experiences of birth or death, of pain and suffering. Quite a few of them referred autobiographically to his own plane crash during World War II and his subsequent rescue by Tartar tribesmen, who wrapped his frozen body in felt and fat. Beuys featured these two organic substances frequently in his sculpture, as in the silent (metaphorically frozen artistry) piano that was warmed symbolically (body thermometer) within nurturing felt walls. In that London installation the circumstances offered hope, akin to the artist's own recovery, for an awakened consciousness and eventual performance at the keyboard. By implication, Beuys's altered or juxtaposed natural objects are opposed to consumer culture; they resist being presented as commodities for sale. In contrast, they affirm a more creative, spontaneous, "natural" sensibility, though based on the vision of Beuys as a cultural seer.

Beuys thus assumed a leadership role in promoting a politically charged, atavistic return to nature and the preconscious basics of existence. In many respects, his provocative Actions recall the nihilistic street events of Dada during the height of World War I in Zürich, and the political protests, drug culture, and nascent environmental movements to be found in America in the 1960s. Beuys himself actively participated in the student uprisings in Germany during 1968 (later

10.22 Joseph Beuys, *How to Explain Pictures to a Dead Hare*. Performance at Galerie Schmela, Düsseldorf, 1965.

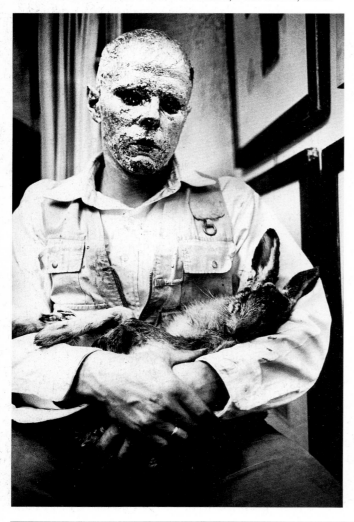

10.23 (Opposite, above) Joseph Beuys, *Plight*. Installation, Anthony d'Offay Gallery, London, 1985. Felt, grand piano, blackboard, and thermometer.

10.24 (Opposite, below) Joseph Beuys, *I Like America and America Likes Me*, Performance at Rene Block Gallery, New York, 1974.

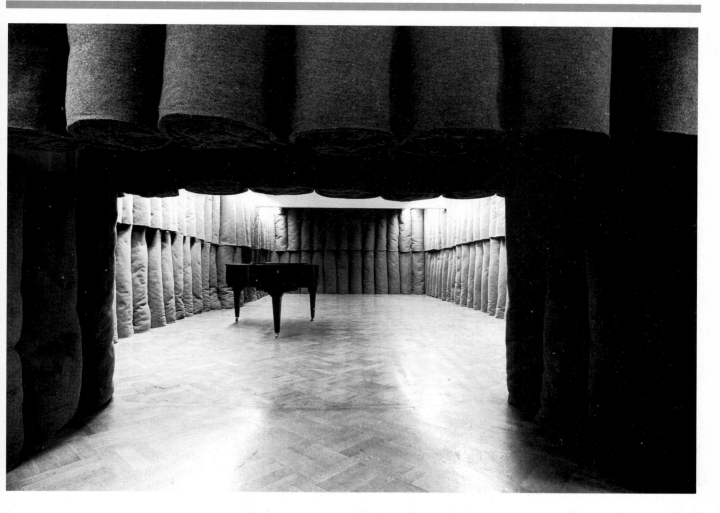

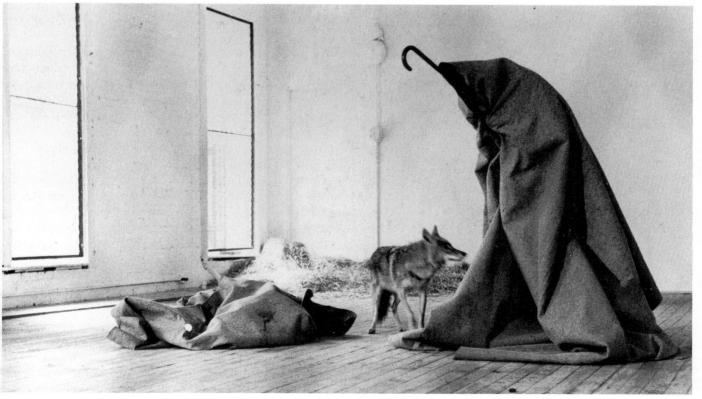

his own dismissal from a professorship in 1972 sparked a widespread protest). Yet more than politics, Beuys desired the role of a modern shaman, living in harmony with nature and opposing modern culture with his own mythic vision, enacted through natural substances and integrated with personal experiences. He even transferred his Actions to America. In a New York gallery in 1974, Beuys staged "I Like America and America Likes Me" by living for a week with a coyote (Fig. **10.24**, p. 449), the despised yet indigenous animal of the American West, in order to recover a primal version of the New World within the decadent world capital of art. Characteristically, the artist wore a large, felt bodybag, projecting his own rescue by tribesmen onto American Indian culture, as if to associate his own life with the coyote with totemic Indian identifications with the animals of their environment.

Of course, Beuys's entire career is a paradox. Despite his use of ordinary, even ephemeral, materials, his work has been underwritten – and collected – by every major institution in Europe and by private collectors. Moreover, he has been featured as a progressive artist in invited exhibitions, including the quadrennial "Documentas" of his native Germany. His every move and pronouncement has been documented, including a trademark "outdoorsman" outfit that he wore everywhere in public. If his message sounds like the polar opposite of Andy Warhol's embrace of celebrity and commercialism, Beuys's identity as a public icon and creature of publicity makes him Warhol's equal. His "alternative" spaces and Actions occupied center stage in the aesthetic arena of the European Community. Like Duchamp, he has also been acclaimed for his use of objects as critiques of art-making and gallery commercialization. Beuys's successes announce the importance of cultural critique – of both artistic and political institutions – as a fundamental ingredient of much contemporary art. Beuys was not alone in searching for new materials for sculptural display. One American artist who also emphasized randomness and the importance of process in arranging natural materials was Robert Morris, a noted Minimalist sculptor (see Fig. 10.14). Morris used heavy strips of cut fabric and even steam in order to undermine the solidity and clarity of his previous forms.

EVA HESSE The artist who most fully explored the implications of unconventional sculpted materials was a younger German, a Jewish émigrée from the Nazis, Eva Hesse (1936–70). Her tragically brief career was, like Morris's, based in New York. Using pliable, industrial, often impermanent materials, including latex, rubber, fiberglass, rope, and cloth, Hesse fashioned a variety of flexible and unsettling shapes, utilizing gravity and balancing created order with randomness of arrangement. She also kept extensive diaries and notes, including poignant reflections on her dual identity as woman and artist. Some of her constructions drew upon traditionally female occupations, such as stitching, wrapping, or bandaging, and she utilized the Minimalist preoccupation with repeated modules in series for her own unusual shapes.

10.25 Eva Hesse, *Hang Up*, 1966. Acrylic on cloth over wood and steel, 72 × 84 × 78 ins (182.9 × 213.4 × 198.1 cm). Art Institute of Chicago. Gift of Arthur Keating and Mr and Mrs Edward Morris by exchange.

Hesse's work is usually integrated with its spatial environment, providing another instance of an "installation" by means of the flexibility with which her modules are distributed and the spread of her hanging pieces across a floor. Critics have pointed to the erotic elements of her imagery, the phallic tubular forms, pliable rectangular membranes, and cylindrical receptacles, as well as to the use of spongy tactile materials in a cumulative ensemble.

In an early work, *Hang-Up* (1966; Fig. **10.25**), Hesse wittily breaks with the obsessive fascination that easel painters traditionally have with their frames as shapes, even as arenas for self-expression; variations on the theme of frames would often be explored later by painters themselves through elaborately shaped, irregular canvases (Frank Stella, Elizabeth Murray). Hesse's frame is "bandaged" and quite empty; its only expressive gesture is a metal rod that intrudes into the viewer's space only to return to the frame itself, like an artery. Of course, the firm rod also plays upon the essential yet spontaneous gestural line so important to Pollock's drip works. Hesse's concept enables her to explore – and parody – both two- and three-dimensional space as well as the hallowed relationship of viewer and object in a gallery situation.

ENVIRONMENTAL ART

American artists also opposed the limitations of established institutions and the commodification of artworks. A movement now known as *"Earthworks"* moved art completely out of the studios and galleries to distant, isolated, open spaces. A celebrated example is *Spiral Jetty* by Robert Smithson (1928–73), a construction built out of rocks and earth at the edge of the Great Salt Lake in Utah in 1970 (Fig. **10.26**). Its very dimensions are geological in scale: 15 feet (4.5 meters) wide but 1,500 feet (4572 meters) long. This work, fashioned out of natural, local materials and placed in a major, natural site, nonetheless used human labor to replicate in a novel context the helical curve already found elsewhere on a different scale in nature. Because this creation is part of nature, it is subject to the processes of dissolution and decay over time – in this case submersion. Such impermanence and physical distance from the art centers of New York occasioned a new form of artistic presentation in the gallery setting – documentation, usually in the form of photographs and film, and the preparatory drawings for large artworks to be displayed in open countryside.

Smithson established his reputation as a Minimalist sculptor, and, as part of his "non-site" or "off-site" documentation, he transported elements – rocks in bins – once more mixing the concepts of nature and culture, outdoors and indoors. In effect, this strategy reverses previous definitions of sculpture as a complex of solid shapes within a defined space. Now the sculptor marks an outdoor rather than an indoor site, and instead of simple or replicable geometrical solids, such as the Minimalist modules, he shapes a manmade version of nature itself out of the materials found at the site. From the marking of a site it was a short step to the related concept of constructing a site. Smithson, together with Morris, began work in 1970 on an observatory in Holland built out of sod and wood. Three hundred feet (91 meters) in diameter, this observatory drew on recent disclosures about the astronomical accuracy of the stone circles at Stonehenge. In an era of great social dislocation in America, provoked by the Vietnam War, such a celebration of the primitive, embodying the connection in ancient Stonehenge of earth and sky, offered a truly alternative artistic cosmos. Similar works by Morris's student, Alice Aycock (b. 1946), such as *Maze* (1972) explored the significance of the mythic symbols (such as the Labyrinth of the Minotour in Greek myth) as well as presenting a piece of sculpted architecture, forcing the visitor to move through the work in an exploratory way.

An even grander scale marks the ultimate expression of the earth itself as an artform, attuned to the cycles of the cosmos. Nancy Holt (b. 1938) has paid particular attention to the

10.26 Robert Smithson, *Spiral Jetty*, Great Salt Lake, Utah, 1970. Black rock, salt crystals, earth, water; diameter 160 feet (48.7 meters), coil length 1500 feet (457 meters), width 115 feet (4.6 meters). Destroyed.

integration of site and surroundings. In the Great Basin Desert, Utah, on an isolated site, named *Sun Tunnels* (1973–76), she has aligned four concrete tunnels in an X-shape to mark the extreme points of the sun's position on the horizon during the summer and winter. Within the tunnels, viewing portholes locate specific stars and serve, again like Stonehenge, to link the seasonal cycles of the earth and sun to the greater movements of the heavens. In similar fashion, James Turrell (b. 1943) has appropriated a volcanic site, Roden Crater, in northern Arizona as a viewing site. Turrell, trained in perceptual psychology, began his art experimentation with constructed rooms that offered the ultimate in minimal means: viewing either projected or ambient light through carefully controlled apertures. His choice of a volcano not only gives his work the historical dimension of geological time and the natural geometry of a cinder cone; its inherent circularity and openness also recalls the manmade structures of Stonehenge and its earthwork successors. Turrell plans to modify Roden Crater

with underground architectural enclosures (still at the stage of drawings, models, and plans), aligned with the sky like Holt's tunnels, which will simulate ancient astronomical sites and temples and provide viewing sites – extensions of Turrell's earlier apertures for viewing light – for celestial events, ranging from sunsets to solstices to eclipses calculated millennia into the future.

In recent years, Alice Aycock has produced large sculptures with a strong component of fantasy and imagery, reflected in their titles, which could be installed within a more conventional gallery or museum viewing context. Her ongoing interest in diagrams and unusual patterns, already signaled in *Maze*, is often complemented by a new fascination with both technology and cosmology (a series entitled *The Miraculating Machine*).

10.27 Alice Aycock, *Greased Lightning*, 1984. Steel, motors, theatrical lighting. The Jewish Museum, New York.

10.28 Edward Kienholz, *The State Hospital*, **1964–66. Mixed media. Moderna Museet, Stockholm.**

Greased Lightning (1984) returns to her interest in both natural forces and diagrams that represent them (Fig. **10.27**). It suggests the power and potential catastrophe of tornadoes in its conical spiral vortices; at the same time it also makes playful reference to a Jewish Chanukah game with a top, or *dreidel*, by marking the spinning forms with transliterated Hebrew letters.

EDWARD KIENHOLZ Gallery installations, like the larger, outdoor sculptures, at times take on the comprehensiveness of entire environments, in this case, of course, built environments. One artist has produced comprehensively specific, drab, man-made settings, such as *Night Clerk at the Young Hotel* (1982–83), in order to criticize the emptiness of urban life: Edward Kienholz (b. 1927), recently in collaboration with Nancy Reddin Kienholz. Kienholz's early career, based in Los Angeles rather than New York, offered images of explicit sexuality (including a Las Vegas bordello and a controversial 1964 *Back Seat Dodge*) as well as mordant attacks on oppressive social institutions, most notably in his 1966 work, *The State Hospital* (Fig. **10.28**). This tableau shows an antiseptically bare room under the glare of a single light bulb; only a two-tier metal hospital bed and a solitary bedpan punctuate the setting. In the bed lie two identical, sculpted, naked, male figures with fishbowls for heads. They are pinned to their bunks with arm restraints. These pathetic manikins, stripped of individuality, have been utterly subdued by their environment. There is a further irony, however: Kienholz uses the popular convention of a "cartoon balloon" around the figure on the upper bunk. Thus this companion figure is linked to the head – as the thought projection – of the man on the bottom bunk. This wretched man can only dream of his twin, or surrogate, who endures identical tortures in an endless present.

453

African-American Artworks

The roots of a self-consciously African-American creativity go back to early in the twentieth century. However, it was not until the Civil Rights movements for black Americans during the 1960s, that one painter, Jacob Lawrence (b. 1917) finally began to achieve recognition for work that he had been producing for a full three decades. Lawrence began his career in the wake of the "Harlem Renaissance," an African-American arts movement that included jazz and literature among its other accomplishments. Like many American artists of the 1930s, including Philip Guston (p. 464) as well as the Mexican muralists (pp. 414–21), his subjects were drawn from social issues of ethnic and class consciousness. These artists were seeking to employ politically committed painting to achieve social betterment (another example is Diego Rivera's recently censored murals at Rockefeller Center). Lawrence drew visual inspiration from such powerful models as Picasso's *Guernica* (Fig. 9.63), then on view locally in the Museum of Modern Art, and he affected a deliberate simplicity of reduced forms in emulation of both later Cubism and the socially-oriented art of North America. From his earliest works, Lawrence was committed to the principle of depicting African-American history in his art, including a series on the Haitian revolution led by Toussaint L'Ouverture (1800–03) as well as series on pioneer African-American abolitionists, Frederick Douglass (1938–39) and Harriet Tubman (1939–40). He even recapitulated his own family history in the larger framework of the series of sixty panels that first brought him national fame, *The Migration of the Negro* (1940–41), recounting the migration of black families from rural South to urban North in search of better opportunity.

Lawrence never abandoned these core social and historical themes of his work, and in the 1960s after visits to Nigeria he reprised his Harriet Tubman cycle. His 1967 painting *Forward* (Fig. **10.29**) recounts the heroic tale of

10.29 Jacob Lawrence, *Forward*, 1967. Tempera on wood, 24 × 35¾ ins (61 × 90.8 cm). **Courtesy of North Carolina Museum of Art, Raleigh.**

fugitive slaves in an almost allegorical mode of abstracted simplification of figures and landscape evocative of the sophistication employed by Picasso and Matisse in the first decade of the century. To enhance these effects, Lawrence employs tempera, an opaque yet durable surface, rather than transparent oil and glazes, in order to achieve powerful shapes and solidity akin to the paintings of the earliest Italian artists (cf. Duccio, Masaccio, or Mantegna). His narrative, too, conveys poignance in its evocation of the terror felt by the runaway slaves making their way northward. The cowering posture of the foremost figure, the watchful rear guard, and the gun in the hand of the Tubman figure at the center – all attest to the exposure and vulnerability felt by these refugees. Lawrence also is able to signal the courage and leadership of Tubman herself through her central position and the powerful gesture of her outstretched arm that seems to impel the forward motion of the title.

While following in this consciously African-American tradition, Martin Puryear's art (b. 1941) aspires to the universal in its craftsmanlike abstraction. Puryear, an African-American, has lived in Sierra. Leone, as well as Japan and Sweden. He takes a strong interest in natural materials, especially wood, but his refined reworking and shaping of objects is a return to the tradition of craftsmanship in sculpture. Organic forms, recalling the shapes of animals (and reminiscent of Brancusi's use of materials and shapes; see p. 379) or elegant functional shapes, akin to the streamlined architecture of boats, dominate Puryear's massive creations. In the case of the human-scaled work, *Lever no. I* (1988–89; Fig. **10.30**), basic intersecting shapes in cedar wood echo the universal, functional shape of the title object (like another work entitled *Ladle no. 2*) as well as shapes traditionally employed by basket weavers or coopers. Puryear has also assembled installations that make reference to nomadic

dwellings or tribal complexes. His imagery suggests a simpler human existence, adapting and distilling nature through craft and by juxtaposing basic, different shapes. His works combine simple materials with elegant forms to produce a powerful physical presence, usually on a monumental scale.

10.30 Martin Puryear, *Lever no. 1*, 1988–89.
Carved and shaped wood, 169 ins (429 cm)
high. Art Institute of Chicago.

POLITICAL ART

Like Oldenburg's anti-Vietnam War giant lipstick tube with a tank base, Kienholz also produced an anti-war statement: the *Portable War Memorial* of 1968 (Fig. **10.31**). It, too, juxtaposes bourgeois banality with famous propagandist war imagery. At the left Kienholz repeats the World War I recruitment poster with Uncle Sam ("I Want You") behind a sculpted recreation of the famous World War II propaganda photograph of marines raising the US flag on newly conquered Iwo Jima. In this instance, however, the marines are faceless, and they raise the flag into the umbrella hole of a cheap metal picnic table. At the far left the figure of the patriotic singer Kate Smith, a regular radio performer during World War II, has been constructed out of an inverted garbage can; her signature hymn, "God Bless America," plays continuously in the background of the installation with an insistent, multimedia irony (background live radios were also used in *Back Seat Dodge* and *Night Clerk at the Young Hotel*). The title of the *Portable War Memorial* appears at its center on an inverted cross with eagle, but its "victory day" and year are left blank; a chalk slate is provided for the addition of new memorial days and years, as history adds new wars to its annals. With the right half of the memorial, Kienholz completes the message of his picnic table, reminding the viewer that what is being defended and preserved through the sacrifice of warfare is tawdry consumerism: more picnic tables, a coke machine, and a walk-up snack bar. Through his inversion of familiar cultural icons and his ironic, fill-in-the-blank history, Kienholz undercuts the war effort of official propaganda machines, including the symbols of the previous two world wars. He also underscores the gulf that separates daily life at home from any combat at the front, cosmeticized (Vietnam was the first televised war) as heroism for contemporary consumers, like the lipstick above Oldenburg's tank.

ANSELM KIEFER Political comment on a seamy national past is at the root of much of the ambitious work of the German artist, Anselm Kiefer (b. 1945) who knew Beuys personally. Kiefer particularly examines the proud German history of philosophy and literature that was so often invoked by nationalists and eventually by Nazis, and he dares to investigate Jewish subjects as well, taken from Old Testament and from mystical writings. Kiefer's art, therefore, aspires to the heritage of history painting in both its large scale and its subjects, and even his explicit reference to Nazi monuments or to extermination camps takes up the nineteenth-century challenge "to be of one's own time" and address the major events of history – especially recent German history – in a forthright manner. Whether such works are interpreted as positive outgrowths of the healing process advocated by Beuys or as shameless exploitation of national guilt and ongoing prejudices depends upon the attitudes of the viewer, for these large works remain curiously ambiguous about their emotional subjects.

Some of Kiefer's images use actual Nazi monuments as the basis for some of his imaginary ones, such as a palette on a standing shaft, dedicated to "the unknown painter." In such a combination, the squared, classicizing columns of Hitler's favorite architect, Albert Speer, become an ironic, reconstituted setting for modern art, as if to reinstate the artists (such as Max Beckmann, see p. 395) who were branded as "degenerate" by the Nazis. Kiefer's *Interior* (1981) depicts

10.31 Edward Kienholz, *Portable War Memorial*, 1968. Oil, acrylic, woodcut on paper, and canvas. Ludwig Museum, Cologne.

**10.32 Anselm Kiefer, *Interior*, 1981. Straw, lacquer, and oil
on canvas, 111 × 120 ins (282 × 304.8 cm). Collection
Stedelijk Museum, Amsterdam.**

the main room of Speer's Reich Chancellery in Berlin as a
blackened ruin; in its center a black-and-white fire burns as a
memorial (Fig. **10.32**). Its flames pay tribute to German art
through their very medium, for the fire is a woodcut insert,
employing the forms first made famous by Dürer in the era of
Luther (see p. 150) and then revived again by German
Expressionists in the early twentieth century. Another painted
work, which uses his own studio as the background space,
features similar burning flame motifs to honor the memory of
famous cultural heroes, both writers and artists – presumably

the painter's own pantheon of Germanic celebrities, for it
includes composer Richard Wagner, landscape painter Casper
David Friedrich (see p. 316), and Joseph Beuys, all in a row.
Despite, or even because of, the fact that the Nazis also
celebrated their cultural heroes, such as Wagner, Kiefer
appeals to these ghosts of German culture "because power
has abused them." His use of fire as both memorial and
charring agent, like the cleansing immolation in Wagner's
Götterdämmerung, can be seen as a modern German exorc-
ism of Nazi ghosts.

10.33 Anselm Kiefer, *Departure from Egypt*, 1984. Straw, lacquer, and oil on canvas, 149½ × 221 ins (379.7 × 561.3 cm). Museum of Contemporary Art, Los Angeles.

Kiefer produces his art in conspicuous isolation from the city and its art institutions in a countryside studio, converted from a schoolhouse. His more recent canvases feature religious themes, often with a distinctly Jewish cast. In *Departure from Egypt* (1984), the viewer is set in a vast, blackened landscape expanse, a desert metaphor of wasteland or wilderness (Fig. **10.33**). Attached to the surface is the key to survival and recovery in the wilderness: the rod of Moses. This miracle-working staff of the Exodus account is here cast in lead, like the palette in the monument to the unknown painter. Kiefer suggests that this staff, with its creative magic, is the redemptive antidote to a barren, spiritual wasteland, and thus a metaphor for the power of art itself. In a similar fashion, he places a lead book before a vast open sea, reminiscent of Friedrich's landscapes. He seems to be claiming that art and learning can restore and civilize the German soul after the horrors of Nazi war crimes, including the banishment of artists and the burning of books. Kiefer's studio may lie at a literal distance from major art centers, yet he aims at reforming a national school of art, as Jackson Pollock and the New York School did a generation earlier (pp. 433–35).

HANS HAACKE As if in counterpoint to Kiefer, within the art world of New York, a German émigré, Hans Haacke (b. 1937) has staked out an outsider position as cultural critic, using appropriations of images in exhibitions within elite settings in order to effect a radical message attacking those very institutions and collectors. Born in Cologne, Haacke moved to New York in 1965. An example of his work, censored by the Wallraf-Richartz Museum in Cologne, is the 1974 *Manet Project*, a public display of a set of illustrated text panels, which reveal that a major donor to the museum, a banker who had donated a Manet still life to its collection, was formerly a minister of economics in the Hitler administration. This point emerged from a seemingly innocent history of the ownership of the Manet painting. The kind of documentation – maps, charts, and photographs – used for earthworks in galleries here served the purpose of public education and the exposure of the institutional corruption of the museum and its donor – in this case the same Nazi past evoked less personally by Kiefer. In similar fashion, Haacke produced an exhibition, canceled by the Guggenheim Museum in New York, dedicated to the exposure of prominent New York slum landlords (*Shapolsky et al., Manhattan Real Estate Holdings, a Real-Time Social System, as of May 1, 1971*).

Rather than bringing the "natural" into the gallery, Haacke instead uses his documentation to bring the political into the

10.34 Hans Haacke, *The Saatchi Collection (Simulations)*, 1987. Mixed media installation, 101 × 76 ins (256.5 × 193 cm). John Weber Gallery, New York.

consciousness of his viewers, removing liberal pretensions that are masking economic or political exploitations by corporations and individuals. Another Haacke exhibition focused on the connections between the advertising firm of the Saatchis, noted London collectors, and South African racism (1987; Fig. **10.34**). For his display, Haacke chiefly employed simulated

commercial packaging bearing the advertisements of the Saatchi company made to promote South African tourism. He also included a cluster of British flags in a sculpted head in order to show the Saatchi role in the election campaigns of Margaret Thatcher for Prime Minister of the United Kingdom, as well as the ironic use of an accompanying quote from Lenin that "everything is connected to everything else." The quote could be a motto of Haacke himself, who delves deeply into the political and social implications of the making, display, and collecting of artworks in the modern world. Haacke employs the precise reference of a Warhol, not to celebrate rich collectors and public figures, but rather to expose them to critical scrutiny. Haacke continually undermines and destroys the myth of aesthetic isolation and artistic autonomy by reasserting the commodification of art and its institutions.

FEMINIST ART

Similar institutional political critiques were made by female artists during the 1980s. Jenny Holzer (b. 1950) uses the concept of art as information in appropriating the styles of the street for her messages. Using short, pithy aphorisms, or "Truisms" (1982), some of them ironic and others straightforward, Holzer has blazoned her message on billboards, on park benches, and on computerized moving signs. An example of her seemingly bland "information" that is also loaded with political punch is the title of her 1983 collection, *Abuse of Power Comes as No Surprise*, displayed on the most famous and public spectacolor sign in Times Square, New York City (Fig. **10.35**). Unlike Haacke, Holzer succeeded in placing her messages, both benches and spectacolor signs, within the Guggenheim Museum in the fall of 1989.

10.35 Jenny Holzer, *Abuse of Power Comes as No Surprise*, 1983. Spectacolor board, Times Square, New York. Courtesy Barbara Gladstone Gallery.

10.36 Barbara Kruger, *You Invest in the Divinity of the Masterpiece*, 1982. Unique photostat, 71¾ × 45⅝ ins (182.2 × 115.8 cm). Collection, The Museum of Modern Art, New York.

BARBARA KRUGER (b. 1945), like Holzer, self-consciously utilizes both the graphics and the paste-up photographic style of contemporary magazine or billboard advertising. However, like the Constructivist photomontages with typography used for agit-prop (agitation and propaganda) in revolutionary Russia (see pp. 401–03), Kruger uses these popular design elements to raise critical consciousness and reverse conventional power relations as well as for artistic messages. She has worked as both a media critic and an art director for a women's magazine, so she uses the materials and techniques of popular photographic journalism or posters to convey her barbed and ironic messages. Often her verbal captions undermine the respectability or familiarity of her visual images. One image offers the ultimate "high art" cliché, a reproduction of Michelangelo's *Creation of Adam* from the Sistine ceiling, but this image of godlike creativity by the artist is completely subverted, with Haacke-like acerbity, by her superimposed message: "You Invest in the Divinity of the Masterpiece" (Fig. **10.36**). Ironically, this 1982 piece is now part of the collection of the Museum of Modern Art. Another montage features a close-up photograph of the

popular children's television puppet, Howdy Doody, with the ironic caption, "When I Hear the Word Culture, I Take Out My Checkbook" (as well as the fine print message: "We mouth your words," suggesting that a certain "we" is manipulated by the ventriloquism of a dominant and powerful "you").

Kruger exploits the ambiguity of the we/you oppositions of her captions to make her viewers uncomfortable and conscious of gender coding and other unequal power relationships in society. For example, her image of a marble Roman bust of a woman carries the message "Your Gaze Hits the Side of My Face." A 1983 exhibition of Kruger works bore the feminist title, "We Won't Play Nature to Your Culture."

AUDREY FLACK Feminist issues also became dominant subjects in more traditional forms. One of the first of a large number of artists who moved back to vivid versimilitude, or *Photorealism*, Audrey Flack (b. 1931) uses pictorial imagery for her meditation on both the history of art and its treatment of women. *Leonardo's Lady* (1974; Fig. **10.37**) takes its title and principal image from a Louvre portrait by the Italian master, shown in a book reproduction that draws attention to Flack's own use of existing images. However, the plethora of illusionistic objects on a table derives from the still-life tradition of seventeenth-century Holland (see p. 277; Fig. 6.64). The use of the Dutch heritage of the *vanitas* points to Flack's acute consciousness of the perishability of life and of organic materials, such as the large pink rose or dewy pear in the foreground; her use of an open watch also derives from the Dutch warnings about fleeting time.

10.37 Audrey Flack, *Leonardo's Lady*, 1974. Oil and acrylic on canvas, 74 × 80 ins (188 × 203 cm). Collection, The Museum of Modern Art, New York. Purchased with funds from the National Endowment for the Arts.

Moreover, items of cosmetic and personal ornamentation (jewel, cameo, sash) point to the vanity of womankind. Intended for personal adornment and for the male gaze, they offer a generalized social comment, yet the portrait by Leonardo gives the painting a specific reference in time and place. Flack, however, like all virtuosos of still-life painting, also delights in the artist's craftsmanship and the ability to render surfaces, reflections, and textures in the manner of the older masters. She presents herself in this rich image in the complex dual role of woman and artist, like Hesse and Kruger. In other Flack works, self-portraits appear amid the paraphernalia in the form of old photographs – of herself as a girl or her mother. Like an autobiographer, Flack becomes both participant and observer in her work in the tradition of old master painters, such as Rembrandt.

Mindful of the complex reality behind the public persona of glamorous women, she put an image of Marilyn Monroe among her still-life objects, as if in critique of the shameless use of the superficial images employed by Warhol, appropriately entitling the work *Marilyn (Vanitas*; 1977).

RETURN TO REPRESENTATION

Another artist who has explored the complexities of public personas in a media age is Chicagoan Ed Paschke (b. 1939), who has incorporated icons of Monroe, Elvis Presley, and the *Mona Lisa*, as well as political figures ranging from Washington and Lincoln to Hitler, in his recent works. Paschke distorts the clarity of their well-known faces by overlaying their features with the saturated, "hot" color patches and broken waves of video art, fragmenting them into a dazzling, masklike artifice, such as in the anonymous face of *Caliente* (1985; Fig. **10.38**). Noses and lips, reduced to triangular and oval shapes, suggest a fracturing of identity in the image transposition, despite the fame of the subject. Paschke's early works focused on figural abnormality and on the exaggerated and grotesque roles of sexual pinups at the margins of society, such as male wrestlers or drag queens and female strippers. Though *Caliente* is based on a photograph of an actor, Lord Olivier, likeness is subverted, rendered as frontal, masklike, eyeless opacity on a scale that is larger than life. Like Flack's veristic images with portrait photographs, Paschke's distorted faces remind us at once of the virtuoso technique of the painter as well as of the complex of concerns about perception itself that underlie his images. Like Kruger, his subjects recall mass media while calling attention to the imperfections and distortions – and stereotyping or gender coding – inherent in such imagery.

DAVID HOCKNEY Not all contemporary artists, however, use their images to criticize institutions or collectors. One artist whose work exemplifies the return to prominence of figurative art and traditional representation in

10.38 **Ed Paschke,** *Caliente***, 1985. Oil on canvas, 80 × 100 ins (203.2 × 254 cm). Art Institute of Chicago.**

10.39 David Hockney, *American Collectors*, 1968. Oil on canvas, 70 × 100 ins (178 × 254 cm). Art Institute of Chicago. Restricted gift of Mrs Frederick Pick.

recent years is David Hockney (b. 1937), and he has unapologetically embraced American ideals and the material possessions of the good life. Hockney is an expatriate Englishman, but with all of the coloristic joy of Matisse, he has affirmed the Mediterranean pleasures to be found in southern California: swimming pools, tasteful interiors, and the sensual individuals who enjoy those settings. Hockney's career neatly encapsulates the current phenomenon of the European (including English) return to prominence in the world art scene, while confirming the multiplicity of American art centers – Paschke's Chicago as well as Hockney's (and Kienholz's) Los Angeles – outside New York.

Hockney's subjects are often recognizable individuals, including his own friends and patrons, influential figures in the art world, such as Henry Geldzahler, curator of modern paintings at the Metropolitan Museum, or the southern California collectors and benefactors (and founders of the Los Angeles Museum of Contemporary Art), Fred and Marcia Weisman. The Weismans form the human subjects of Hockney's *American Collectors* (1968), a painting combining the compositional subtlety of Matisse with the starker representational idiom of Pop Art (Fig. **10.39**). Careful spacing of the two figures and their art collection presents them as sharing an emphatically modernist architectural space (itself a legacy of the Mies van der Rohe 1929 Barcelona pavilion, Fig. 9.45). The collection is quintessentially modern as well, combining primitivizing sculptures with actual tribal artifacts, such as a totem pole. This quiet assimilation of modern art and wealth serves as an uncritical antipode to the contemporary social investiga-

tions of collectors by Haacke. In contrast, Hockney delights in the same good life as his patrons. Paintings such as his 1967 *A Bigger Splash* show a house and pool like those of the Weismans, emphasizing the warmth and blue sky of California, where nude male bathers can swim outdoors in any season.

JENNIFER BARTLETT Some of the representational concerns for space and color that typify Hockney's work have been made the subject of more extended reflection by artists such as Jennifer Bartlett (b. 1941). Already in the 1970s feminist artists (led by Miriam Schapiro and Joyce Kozloff) had criticized the division between art and crafts that marginalized fabric arts and images based on surface patterns, such as on tiles or quilts. Bartlett and others took up this revisionist concept of art-making for investigation in its own terms as a framework for representation. Beginning with *Rhapsody* (1975–76), she built a systematic environmental work out of 988 square steel plates with variations on basic themes: four kinds of lines, three geometrical shapes (circle, triangle, square), four simple images (mountain, house, tree, ocean), and a limited palette of colors. After this exhaustive exercise, Bartlett continued to explore both the component grammar of visual representation, including broad brush strokes, and the poetry of the landscape world, often still within the grid structure derived from her separate panels of the

10.40 Jennifer Bartlett, *Fire/Nasturtium*, 1988–89. Enamel on wood. Walker Art Center, Minneapolis. Center, Minneapolis.

Rhapsody series. She has also exploded the confines of two-dimensional representation to combine three-dimensional versions of simplified depicted objects in the foreground of installation ensembles, juxtaposing usually discrete media and blurring the boundaries between images and objects. In recent years the pastoral simplicity of gardens and boats in her work has been invaded by the destructive element of fire, as in the 1988–89 *Fire/Nasturtium* (Fig. **10.40**). Here the interplay between two and three dimensions of the table makes the viewer doubly conscious of the rich color and vibrant van Gogh-like brushwork of both the green leaves and the orange flames. Recent works suggest that Bartlett has moved to her theme of fire as the one of the four traditional elements (earth, air, fire, water) which she had neglected to explore. Her choice of the nasturtiums may also be a reference to Matisse, who featured the flowers in some of his most daring experiments in the studio around 1910. This sophisticated, formerly conceptual or Minimalist, artist is now willing to make her work more accessible and to use natural references in the framework of a continuing consciousness of the artifice of art-making. Her recent works are filled with references and visual puzzles.

AMERICAN ARCHETYPE: GUSTON

The final set of images painted by Philip Guston (1913–80) during the 1970s also explored the ultimate issues of image creation within a conscious return to legible yet broadly brushed representation. Viewed in retrospect, Guston offers a cross-section of the prevailing issues in American art from the 1930s to the present. Although initially vilified by critics, Guston's late style, with cartoon-like simplifications, grand execution and scale, and simple subjects (often still-life objects), has achieved widespread recognition as a summation of issues in twentieth-century painting.

Guston's earliest paintings derived from the art and images of the Depression era, specifically the mural projects made in the 1930s by American artists, including Guston himself, under the Works Progress Administration, as well as related works by Mexican muralists (see pp. 414–21; in 1932 Guston had seen Siqueiros painting a mural in the Mexican section of Los Angeles). Such murals offered not only a grander scale but also a legacy of social commentary on poverty, industry, and urbanism through bold figural composition. Guston's imagery also partook of the specifically urban character of most easel

10.41 Philip Guston, *Martial Memory*, 1941. Oil on canvas and enamel on wood, 40⅛ × 32¼ ins (102 × 82 cm). The Saint Louis Art Museum. Purchase: The Eliza McMillan Fund.

art produced in New York during the 1930s (including Jacob Lawrence; Fig. 10.29), combined with the desire for archetypal figures and costumes featured in contemporary European art. These were gradually becoming familiar in America (through such artists as Picasso and Max Beckmann, whom Guston would later meet during Beckmann's final exile years in Saint Louis).

Martial Memory (1941) offers a legible yet simplified image of figures in a setting that is urban yet impoverished (Fig. **10.41**, p. 463). The dark- and light-skinned figures are

children playing, but they are play-soldiers, armed with shields made out of trashcan lids and with spears or swords of wood. Their battlefield is the back lot of a dreary tenement development, set against gray skies and the silhouettes of factory chimneys. *Martial Memory* criticizes the glorification of war even among the young, as if it were a premonition of America's entry later that year into World War II, already raging in Europe.

By the 1950s Guston had begun a decade of abstraction in works such as *Painting* (1954). A compromise between the gestural "action paintings" of Pollock and the tonal "field paintings" of Newman and Rothko, Guston's abstractions emphasize the construction of each painting through meticulous, coordinated brushwork and calculated harmonies of color within a narrow range of pigments, chiefly white, red, and pink (perhaps a reference to blood or skin). At the end of the decade, Guston introduced both a wider range of color, including darker tones, and a nascent reference to representation. His *Painter* (1958; Fig. **10.42**) not only reinserts a subject through its title but also shows its abstracted subject standing with a visible brush at work in the act of painting. Though the balance between abstraction and representation would shift toward the latter, this is the same tension or dialogue that would inform the final phase of Guston's career in such studio images as *Painting, Smoking, Eating*.

After this preoccupation with the means of painting as an affirmation of the activity of painting, Guston retreated into a decade of introspection and abandoned painting in favor of drawing. He renounced the willful autonomy of abstraction in order to recapture his "faith in the known image and symbol." As if in response to the materiality of Pop Art, his first painted

10.42 Philip Guston, *The Painter*, 1959. Oil on canvas, 70 × 68⁹/₁₀ ins (175 × 165 cm). High Museum of Art, Atlanta. Purchased with funds from the National Endowment for the Arts.

10.43 Philip Guston, *Painting, Smoking, Eating*, 1973. Oil on canvas, 77½ × 103½ ins (196.9 × 262.9 cm). Collection Stedelijk Museum, Amsterdam.

10.44 Philip Guston, *Pit*, 1976. Oil on canvas, 75 × 115⁹⁄₁₀ ins (190.5 × 294.5 cm). Australian National Gallery, Canberra.

representations were modest works in both subject and scale, using lively brushwork to depict homely, single objects, such as the hobnailed boot sole of his later works. Many of the large-scale canvases of the 1970s were restricted to accumulations of such everyday objects, particularly within the self-referential framework of the artist's own studio. However, Guston also found inspiration in a different form of self-reference: a reprise of his socially conscious forms and themes of the 1930s. He re-employed some of the shocking characters of his early work, particularly white-hooded Ku Klux Klansmen.

In *Painting, Smoking, Eating* (1973; Fig. **10.43**) Guston confronts the elemental basis of his own existence as a painter. He presents a messy studio space that evokes the self-reference to the artist in his studio by Matisse (*Red Studio*; Fig. 9.12) or Picasso (*Painter and Model*; Fig. 1.2). However, here a caricature of the artist in profile lies inert in his bed underneath a tray piled high with French-fries. He stares out of a lidless, cyclopean eye at cans with paint brushes and stacks of simple, hobnail boots, a staple subject in late Guston imagery. The entire picture is in a dusky pink, whose color and lively brushwork refer to familiar earlier Guston abstractions from the 1950s (such as *Painting*, 1954). Only after prolonged viewing does one notice that the recumbent artist is actually busy painting; his outstretched arm is applying a vertical rose stripe to a canvas in progress amidst the detritus.

Guston's pictorial construction self-consciously absorbs the lessons of the century concerning the independence of formal means – line, brushwork, and color – yet instead of using these techniques for abstraction, he redeploys them to represent things, including his artist persona, now reduced to outlines and essences. His artwork is grounded in the materiality of objects, simple yet recognizable, and painted surfaces, variations of brushstrokes and tonalities of pink. While this image may be a far cry from the grandeur and finish of Velázquez's *Ladies in Waiting* at the beginning of this book (Fig. 1.6), it is nonetheless a meditation on the same theme: the act of painting as an alchemical translation of material objects into

painted subjects and the artist as maker. In essence, Guston's art finally avers that all painting is a translation, an abstraction from nature or imagination into a set of pictorial conventions. At the end of a century of abstraction for its own sake, Guston reaffirms the heritage of painting as representation, even (or especially) of the unattractive or the commonplace.

Guston's final paintings move beyond an attention to accumulations of objects into explorations of vastness. Through the addition of a persistent horizon line, he returns to the preoccupations of most post-Renaissance artists: spatiality, particularly as the locus of serious ("historical") subjects of narrative or allegory. *Pit* (1976; Fig **10.44**) presents a vast, Dantesque landscape in reds and blacks akin to the desert wilderness of Kiefer's *Departure from Egypt* (see above, Fig. 10.33).

Guston also painted this subject in 1975 as part of a triptych narrating the floodtide destruction of the Egyptian army. Old Testament references to divine power fill this landscape, as symmetrical pillars of fire appear beside a fiery rain falling into a Red Sea. This firestorm, however, is itself a painting within a painting, solidly housed in its frame. Once more, Guston reminds the viewer of the artist's godlike role as creator (and destroyer), and he deploys the subjects and forms of Renaissance religious imagery. Below the desert opens the great pit, revealing Guston's characteristic hobnail boot, upright and still attached to downturned legs. This hellish dark cavern evokes the torments of Dante's Inferno, but it also suggests more modern perdition, such as the mass graves of Nazi concentration camps (presented in a more forthright fashion by Guston, a Jew, than by Kiefer, a German). Within the pit, a version of the artist-head casts its unblinking eye downward, as the painter refuses to avert his own gaze from these dark profundities of the horrific sublime. After all of the experimentation and reflexive meditation on the act of painting, Guston utilizes his own vision, steeped in pictorial tradition, to give back to painting at the century's end its primal significance.

NEW DIRECTIONS

By way of a coda to an unfinished narrative and as an indication that the careers of versatile artists continue well beyond the "signature" images that get selected and discussed in general books like this one, the recent work of an artist who was considered earlier in the chapter, Robert Morris, bears investigation. The protean Morris, already encountered as a founding Minimalist sculptor (Fig 10.14) as well as an earthworks innovator, rediscovered abstract painting and drawing in the 1980s, together with the ambitious scale and sublimely primal themes of the New York School of the 1940s in his series entitled *Firestorm paintings* (Fig. **10.45**). These imposing creations are actually mixed-media, combining vivid representation in their sculptural frames with a core abstraction on the painted field. Cast relief on the frames (recalling Johns's *Targets* but now taken to an apocalyptic extreme) features macabre imagery of bones, skulls, and random body parts (brains, entrails, phalluses) arranged decoratively, sometimes symmetrically, and occasionally intruding across the painted surface. No longer does the frame remain secondary to the basic subject of the work; instead, this horrific frame uses both its technique and its intrusive physicality to remain in dialogue with the central holocaust. The frame offers the detritus of nuclear destruction, while the center painting presents the firestorm itself, vivid color awash in the energy, swirl, and scale of a Turner cataclysm (see Fig. 7.27). If the abstraction of Newman evoked primal creation or that of Rothko landscapes of contemplation, then the Firestorm or Psychomachia series of Morris feature the landscape of ultimate annihilation, accompanied with full inscriptions to link this message to the conceptual practices of postmodern artists such as Holzer and Kruger. Even the term "Psychomachia" refers to the medieval opposition of virtue against vice, locked in a program of eternal conflict. While Morris had always grappled with basic issues of art theory and tested the limits of presentation in site or gallery, his recent work consolidates his lessons into colossal, even visceral meditations on the dialogue between visual creation and ultimate destruction of all humankind.

MONUMENTAL ART Another major shift of direction can be seen in a monument that is at once celebratory and personal: the towering quartet of female personifications, commissioned in 1990 from Audrey Flack by the city of Rock Hill, South Carolina. A double life-sized bronze allegory of city government, *Civitas* (Fig. **10.46**), harks back to the venerable Hellenistic and Roman tradition of female personifications, as well as to the late nineteenth-century public monuments in Europe and America (such as the Statue of Liberty in New York City). In keeping with the classicism of both the Greco-Roman tradition and the nineteenth-century monument, Flack's figures are crisply symmetrical, with both the facial features and flowing yet diaphanous drapery of a nymph or goddess. Her feminist commitments underpin her celebration of this imposing woman, brow crested with a rose and three stars, which echo the circle of gleaming stars she holds above her head.

Given the varieties of visual forms and subjects in contemporary painting and sculpture, not to mention media that have

10.45 Robert Morris, *Untitled,* **1984. Painted hydrocal, watercolor, pastel on paper, 76 × 92 ins (193 × 233.7 cm). Courtesy Leo Castelli Gallery, New York.**

**10.46 Audrey Flack,
Civitas, 1990. Cast
bronze, 12 feet (3.6
meters) high. Rock Hill,
South Carolina.**

**10.47 Maya Ying Lin,
Vietnam Veterans'
Memorial, Washington,
DC, 1982. Black granite,
500 feet (152.4 meters)
long.**

not been included here, such as video and fiber arts, it is
hardly surprising that public monuments present a disparate
appearance. One quite successful national monument, the
Vietnam Veterans' Memorial (1982; Fig. **10.47**), utilizes a
striking, simple abstract design to make its point. Near the
Lincoln Memorial a plot of ground was isolated for the
monument, selected from a design competition. The winning
design was produced by Maya Ying Lin, a young Chinese-
American. The basic monument consists of a wall of polished
black granite, using the color of mourning but sufficiently shiny
to reflect the visitor and inscribed with the names of all the
fallen soldiers of the Vietnam War. The wall has a subtle
change of shape as the visitor descends a ramp to the tallest
portion of the wall and then ascends to depart: it is angled, its
simple geometry echoing the angles of the nearby white
monuments, the Washington Monument and Lincoln Memorial,
while its chevron shape forms the initial "V" for Vietnam (as
well as an ironic non-victory to follow the "V for Victory" of
World War II). Some veterans complained about the declivity
and the need to descend, and they insisted on a conventional
bronze military figural triad akin to the Iwo Jima memorial
from World War II (parodied during the Vietnam War by
Kienholz; see Fig. 10.31). However, the emotional success of
the Vietnam Veterans' Memorial receives constant confirma-
tion through the wreaths, flags, and mementos placed daily at
its base by a stream of visitors.

MODERN TO POSTMODERN IN ARCHITECTURE: THE NEW MUSEUM

Such reaffirmation of traditions or assemblage of references to previous artworks and subjects in a new compositional play is not confined to the world of painting and sculpture. Indeed, such juxtapositions are inherent to the modern experience of artworks, indeed of almost all visual images. Whether in the framework of the modern museum, with its deliberate assemblage of works in all media from all cultures, or in the more arbitrary, expanded encounter of images reproduced in the "museum without walls" of modern mass media, the viewer encounters a bewildering number of collected artworks – just like the assortment within the covers of this book. To assess the current program for the presentation of art as well as the achievements of contemporary architecture, several recent museums in both America and – again the sign of renascence – postwar Europe can serve as a barometer.

After the ambitious utopianism or sublime aspirations of most of twentieth-century art, now labeled Modernism, had exhausted their self-conscious creative energies, a reaction set in, momentarily known simply as Postmodernism. Often playful and referential, freely utilizing either vernacular or historial citations, this new art and architecture lacks the consistency and program often ascribed to Modernism. Its common denominator is a rejection of previous functionalist

10.48 Mies van der Rohe, New National Gallery, Berlin, 1962–1969.

ideology and abstract formal clarity that preceded it, such as Mies van der Rohe's swan song, the New National Gallery in Berlin, completed in 1969 (Fig. **10.48**), a structure that continued and refined his steel-frame experiments of the 1929 Barcelona pavilion (Fig. 9.45). Elegant simplicity and clarity of structure designed in three basic elements – floor slab, columns, and roof slab – defines a totally open, flexible, grand pavilion intended to frame ambitious Modernist canvases and sculptures (like the large Calder stabile that adorns the plaza outside the pavilion).

THE POMPIDOU CENTER By contrast, Postmodern buildings have individual personalities, and the principles underlying their design cannot be easily discerned. When the Georges Pompidou National Center of Art and Culture (also known as "Beaubourg" after its market district location) opened in Paris in 1977, it generated enormous controversy (Fig. **10.49**). For one thing, its gargantuan scale before an open plaza dwarfs surrounding buildings. The building lies adjacent to the old open market area of Paris (Halles Centrales), and its high-tech glass and tube components continue the functional iron-and-glass sheds of the mid-nineteenth-century Halles sheds. The winners of an international architectural competition were truly an amalgam of the European Community: Renzo Piano of Italy, Richard Rogers of England, and a Danish engineering firm. Engineering made visible, in exaggerated parody of Miesian clarity, dominates the exterior of the building. The glass box core is suspended within outer columns and supported further by diagonal wind braces across the entire surface; glass-enclosed elevators and escalators also serve as external ornament. The interior space, by contrast, has much the same complete openness and flexibility as Mies's Berlin pavilion, but it is filled with ductwork

10.49 Renzo Piano and Richard Rogers, Centre National d'Art et de Culture Georges Pompidou, Paris, 1971–78.

and lattice beams. The true playfulness of the building lies in its articulation, especially the use of garish colors (red for elevators, blue for air conditioning, green for water, yellow for electricity) on its metal guts. Like Les Halles or the railway station of the previous century, Beaubourg is supposed to be popular and accessible, its open plaza a forum for gatherings and activities and its glass shed a machine for exhibiting artworks. Instead, the Pompidou Center imposes the central authority of the French government on the city with the vulgar brashness of American disregard for its historical fabric. While attempting to celebrate modernity and technology as well as appealing to popular taste, this ambitious building embodies a Pop art caricature of its model or an advertisement for the "futuristic."

THE KIMBELL MUSEUM in Fort Worth, Texas, completed at the same time (1972) for a private foundation, by Louis Kahn (1901–74), extends the shaped concrete spaces of Le Corbusier into an original vaulting invention of great dignity (Fig. **10.50**, p. 470). Using extended concrete barrel vaults, pierced by complex skylights, Kahn harnessed the brightness of the Texan skies to achieve a diffused and indirect natural lighting. The creamy wall tones of his concrete and the added travertine facing add another note of natural warmth to the open, monumental spaces, extended generously along a one-storey level like Mies's pavilion. Despite his use of Le Corbusier's technique of reinforced concrete and repetition of modular spaces, imaginatively developed, Kahn achieves a unique grace and brightness that complements the objects on display. The means of support ultimately derives from Roman architecture, which Kahn had avidly studied *in situ*, as a spatial and climatic analogue to Texas. At the same

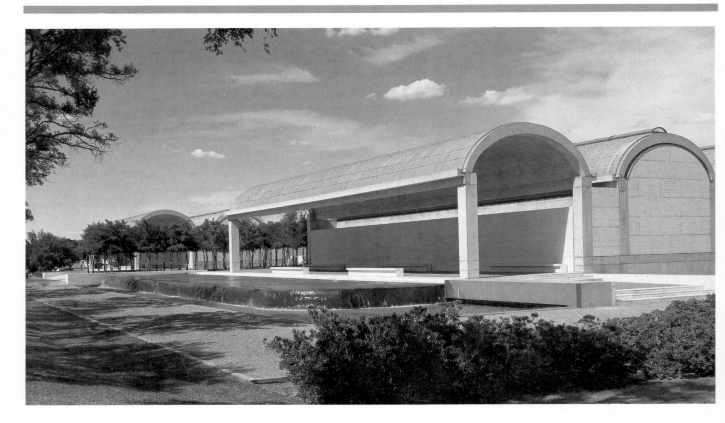

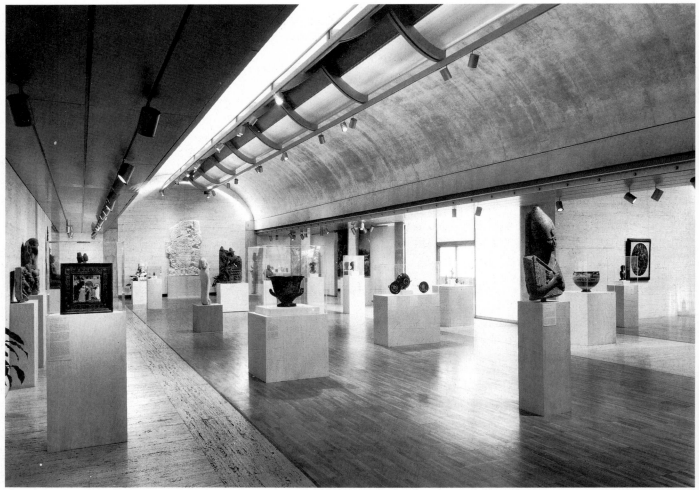

10.50 (Opposite, above) Louis Kahn, Kimbell Art Museum, Fort Worth, Texas, 1972. Exterior.

10.51 (Opposite, below) Louis Kahn, Kimbell Art Museum, Fort Worth, Texas. Interior.

time, the technology, never obtrusive, is emphatically modern: reinforced concrete, chiefly in the form of a continuous semicircular beam on minimal corner lintels. This technology permits the open spaces and the bright light, which normally would be reduced in a barrel-vaulted space to the gloom of a Romanesque cathedral nave (Fig. **10.51**). An overall structural order shapes the building in the form of a symmetrical, U-shaped court around a ceremonial entrance porch, in the manner of Italian villa architecture. The Kimbell Museum offers a rethinking of ancient forms and modern precedents with an inventive use of technology. The result is a wholly local solution to the particular problems of producing a welcoming yet practical environment for a very diverse collection of art objects.

STUTTGART STAATSGALERIE Of many contemporary museums, one other achievement stands out: the expansion of the Stuttgart Staatsgalerie in 1983 (Fig. **10.52**) by the English architect, James Stirling (1926–92). Here the structural forms make this building a self-conscious work of art in its own right. Built on a steep hillside site, the building responds with its own complexity, incorporating ramps and terraces and a bold banded masonry exterior. Like the Pompidou Center, the metal parts of the extension at Stuttgart are articulated with strong patches of color (red or blue railings, green window frames). Historical references abound, often quite explicitly. The ramps recall ancient Egyptian or Greek complexes, possibly spiritual centers, including the Acropolis of Athens. An open rotunda for sculpture at the summit recalls the original, domed classical museums of the nineteenth century. The space-shaping role of this rotunda in the entire complex also evokes comparison with the architectural gardens of Emperor Hadrian's villa at Tivoli near Rome. References to objects also emerge from Stirling's fantasy ensemble; at the entrance, the undulating curtain wall echoes the profile of a piano, in accord with the concert-hall function of the museum addition. Its glass-and-steel simplicity recalls Mies van der Rohe and Modernism, largely abandoned elsewhere in the building for the seemingly anti-Modernist solid walls of banded masonry. Stirling has called his building a "collage" of old and new elements. Such inventive, even whimsical juxtaposition of parts and of references to historical styles strives for drama and surprise far more than for clarity or apparent rationality. Its sensuous textures and variety of levels, colors, and shapes abandon all pretext of Modernist reductive formal abstraction. Complexity and contradiction provide a massive, Postmodern rejoinder to the Miesian Modernism.

10.52 James Stirling, Neue Staatsgalerie, Stuttgart, 1977–83.

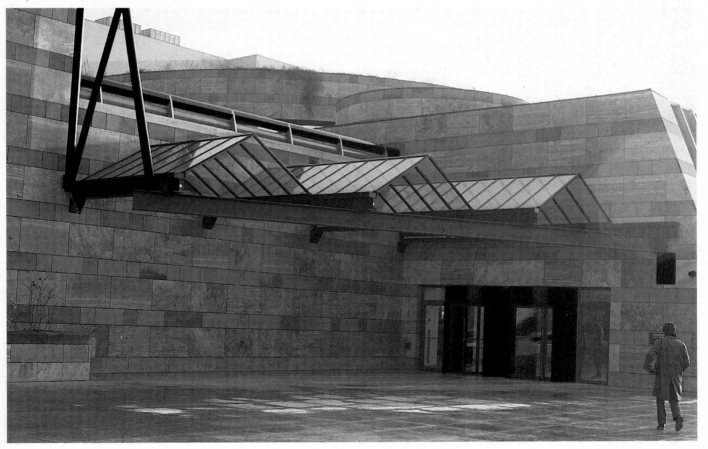

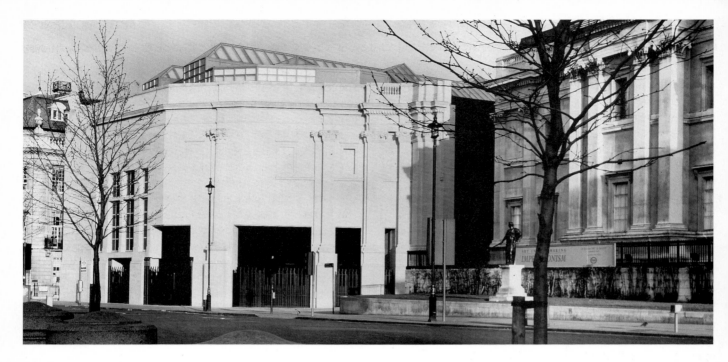

SAINSBURY WING, NATIONAL GALLERY A final example of sensitive, yet sophisticated and self-conscious design that strives to harmonize with its predecessor is Robert Venturi's addition to the National Gallery, London (Fig. **10.53**). Just as Bernini's additions to St. Peter's utilized the vocabulary of Michelangelo and ancient Rome to provide dynamic spatial cohesion, so have Venturi (b. 1925) and his wife and collaborator Denise Scott Brown (b. 1931) attempted to complement and complete a major London monument. Venturi is straightforward about employing clustered pilasters and the same stone facing as in the gallery itself, which was already a revival in the Neoclassical idiom of the nineteenth century (see pp. 328–29) remains invitingly decorative ironwork arches from the industrial architecture of the nineteenth century (see pp. 330–31) remains invitingly visible to people in the street through a glass curtain wall. Accented with the same darker *pietra serena* stone used by Brunelleschi in Renaissance Florence, the lofty galleries upstairs give priority to the pictures on display, varying the scale of the (controllably) light-filled spaces in accord with the size of the ojects, the oldest images in the permanent collection. Of course, the needs of the modern museum have not been neglected: temporary galleries for loan exhibitions, cinema space for slide/tape programs or video presentations related to exhibitions, interactive computer information rooms, conference rooms, a large lecture hall, and a restaurant.

POSTMODERNISM, like the analogous term Post-impressionism (see p 352), defines itself largely as the negation of a recent, more powerful epoch. Its own aspirations and techniques are inconsistent or obscure. Sometimes its conceptions, like Stirling's stewpot of references, smack of dandyism or end-of-the-century self-consciousness. Often appropriation of imagery from elsewhere dominates its creative energies, whether the source is the historical warehouse of previous art or else the smart, even cynical, representation of excerpts from the modern media. Certainly the

10.53 Robert Venturi and Denise Scott Brown, Sainsbury Wing, extension to National Gallery, London, 1991.

original optimism, energy, and faith dedicated to universal forms, such as the abstraction and simplicity of Mies or of the New York School, have been eroded or have disappeared through the continuous debasement of lesser imitators. And the clever, self-conscious Postmodernists vie with the critical opponents of traditional art institutions for domination in the contemporary art world.

A richness of choice in styles of painting and architecture has developed in centers all over the globe. Europe has regained its prewar vigor and artistic importance, as the examples of Beuys, Kiefer, Hockney, and Stirling indicate. Meanwhile, in America the hegemony of the New York art world has dispersed, as regional centers from Paschke's Chicago to Hockney's Los Angeles and a host of others compete for attention. Even within New York, alternative sites add complexity and "outsider" vision to the dominant institutions for modern art, such as the Museum of Modern Art, the Guggenheim Museum, and the Whitney Museum. The media explosion incorporates art as well, in the form of art journals and critics. A cacophony of galleries and art advocates, even within universities, speaks out where only a privileged few once dominated absolutely. In today's art market, a widely diverse set of programs contend: Abstraction jostles with Photorealism, Neo-Expressionism gestures against Pattern and Decoration, Conceptual Art may make compromises through appropriation in order to maintain its critical postures.

Ultimately, it is the museum building or the "museum without walls" that appropriates. As the ultimate repository of cultural creations, the modern museum collects the loot of lost civilizations, preserved for the edification of modern industrial empires, and also ratifies the first fruits of contemporary creativity. Museums define – and store – the objects designated "artworks." (Sometimes, these definitions shift over time, usually toward greater inclusivity, as in the removal of African

or Aztec monuments from ethnological collections and museums of natural history and their reinstallation within the canon of the art museum's aesthetic objects.) As they become more omnivorous and inclusive, however, museums tend to homogenize or make connections between all of the disparate cultures whose artifacts they shelter. The distinctness and the context of these objects for their original users get blurred against the uniform white walls of the modern museum. Today, even more than the wealthiest princely collectors of the past, each of us can be the audience for anything, as we stroll through the successive rooms of our municipal museums (just as television and publications have made us all members of a "global village").

The final great building by Frank Lloyd Wright (see p. 350) was a fantasy museum, completed posthumously in 1959: the Solomon Guggenheim Museum in New York (Fig. **10.54**). The architect organized the viewing space around a continuous, downward-flowing spiral ramp lit by a skylit dome over an open, central well. In effect, Wright was pulling together the notion of progress and succession with the act of viewing artworks. His open, domed space enshrines the art objects as

"treasures" within a modern Pantheon and establishes the suggestion of an unbroken tradition. Within this roomless temple of art, boundaries become effaced, images seem to be interchangeable.

However, the fact remains that art objects do have their own contexts of creation, each discrete and unique. This book is not a continuous narrative, not a step-by-step progress either from primitive to modern or simple to complex. Other objects could easily have been chosen. Each object deserves consideration in the terms of its makers and users, not just our current preferences and prejudices. Although ours is a consumer culture, and the museum is one of the great purveyors of objects for our consumption (especially in special exhibitions), the importance of "history" in the study of art history compels us to study each artwork on its own terms, recovering as much as possible of the place, time, and audience for which it was made. Otherwise we remain passive spectators passing along a descending spiral of accepted "tradition."

10.54 Frank Lloyd Wright, Solomon R. Guggenheim Museum, New York, 1957–59. Interior.

GLOSSARY

Abacus The flat slab between a rounded *echinus* and the *entablature* on a Doric capital.

Abbey A *monastery* ruled by an abbot; or the church building of an abbey.

Acanthus Architectural ornament based on a mediterranean plant with spiky leaves, particularly used in Corinthian *capitals*.

Acrylic Fast-drying synthetic paint developed around 1960; often used as a substitute for oil paint, permitting effective use of flat, even, color areas as well as heightened transparency.

Action Staged event by an artist. Term invented by Joseph Beuys (1921–86).

Aedicule A shrine formed by two *columns* supporting an *entablature* and *pediment*; usually designed to house a sculpture or sacred object; also called a *niche*.

Agit-prop Agitation and propaganda program developed in the Soviet Union after the Revolution.

Aisle Corridor portion of church space parallel to main central space, or *nave*, from which it is divided by supported *columns* or *piers*.

Altar Ritual center of the Christian church, a table where the holy Eucharist or mass is celebrated. Often marked with carved or painted devotional artworks, called *altarpieces* or *retables*.

Ambulatory Vaulted *aisle* passage surrounding the *choir* of a Christian church, for circulation of visitors.

Amphitheater Open-air circular or oval building with rising tiers of seats, for sports or entertainments. The most famous example is the Colosseum in Rome.

Amphora Ancient Greek vase used for storage of oil, wine, or other liquids; usually a tall vessel with two side handles, prominent foot, and spout.

Apocrypha Early Christian writings excluded from the New Testament; more generally, uncanonical writings of dubious authenticity.

Apse A half-circular or polygonal space at the rear of a Christian basilical church, often surmounted by half dome vaulting. May also appear at end of *transepts* or on western nave fronts where entry is at side.

Apsidioles Small *chapels* radiating off the *apse*.

Aquatint A printmaking process that is a variation on etching, in which the metal plate is covered with a powdered, resistant fine resin that creates irregular, tonal areas when dipped into acid.

Arcade A series of *arches* with their supporting *columns* or *piers*; an arched, covered passageway or avenue.

Arcadia Ideal rustic paradise (name of mountain district in Greece).

Arch A spatial span, usually constructed in a semicircular shape, although with variant shapes, such as a pointed arch, ogee, or horseshoe arch; composed out of wedged-shaped elements, or voissoirs, resting upon an impost and capped by a keystone.

round arch pointed arch

Architrave The lowest element of an *entablature*, beneath the *frieze* of a classic Greek temple.

Archivolt *Moldings* that frame the *tympanum* around the *arch* of a medieval Christian church.

Armature A structural framework underlying a construction in three dimensions, usually a sculpture.

Atrium The open entrance hall or central hall of an ancient Roman house; a forecourt before the principal portal of a church.

Attic The upper storey above an *entablature* or main *cornice* of a building.

Avant-garde An intelligentsia that develops new or experimental concepts in the arts, sometimes implying revolutionary politics.

Axis A straight line around which a figure or space is organized symmetrically or around which it rotates; alternatively, a main line of movement through a space.

Baldachin An ornamental structure resembling a canopy and used to mark a space, particularly the space of the *altar* or a throne.

Balustrade A barrier or rail, constructed upon supporting posts (balusters).

Baptistery A Christian space, either adjacent to a main church or built as a separate structure, where the sacrament of baptism was administered in a font; most often round or polygonal in shape.

Barrel vault A tunnel space shaped by a continuous profile of arches; also known as a tunnel vault; usually requires continuous buttressing at sides.

Basilica A large colonnaded hall for public use and the administration of justice, developed by ancient Rome and adapted as a building type by the Early Christian church. Usually subdivided into a *nave* with side *aisles* and an *apse*; elevation included *arcade*, *gallery*, and *clerestory*.

BAY A spatial subdivision of a building space, usually articulated through repeated supports, such as *piers* or *columns*, or windows.

BLACK-FIGURE VASE Ancient Greek figurated pottery, achieved through the production of silhouetted black areas of iron oxide "slip" against the red-orange ground tone of terracotta. Details of anatomy or costume were then incised into the black slip, exposing linear patterns of the ground. This is different from a later development (after 530 BC) known as *red-figure vases*, where the *ground* and linear accents were produced with slip upon silhouetted terracotta-colored figures.

BOOK OF HOURS A popular, late medieval Christian private prayerbook, organized according to the seven canonical hours of the church day. Also included prayers to assorted individual saints, psalms, and an office of the dead, as well as an ecclesiastical calendar.

BOSS Carved or sculptural projection at the instersecting point of the *ribs*.

BOZZETTO A sculptural model, usually built up out of a pliable medium, such as clay or terracotta before firing.

BRACKET An overhanging architectural member that projects from a wall in order to support a vertical load or to strengthen an angle. Often scroll-shaped.

BRASS A metallic compound or alloy, chiefly copper and zinc.

BREVIARY A popular medieval religious book, compiling daily prayers, psalms, and hymns; principally used by Christian clergy.

BRONZE A metallic compound or alloy, chiefly copper and tin. The Bronze Age is the period of human culture characterized by the use of bronze tools; in Europe the Bronze Age began in the fourth millennium BC.

BUTTRESS Any masonry support for an arch or wall that counteracts outward thrust; termed a *flying buttress* when surmounted by a springing arch support, as in Gothic cathedrals.

CALLIGRAPHY Fine writing or penmanship as an artform in its own right; a particular skill in Islamic traditions and in East Asia.

CAMPANILE Italian for a bell tower, usually built separate from but near a church.

CANTILEVER A projecting beam or canopy without direct support at one end.

CAPITAL The crowning section of a *column*, *pier*, or *pilaster*, which effects the transition between support and *entablature*.

CARTOON A full-size drawing preparation for a painting or tapestry; noted surviving examples by Leonardo da Vinci and Raphael.

CARYATID Structural supports or *columns* in a *post-and-lintel* system that have been carved into figures, usually female (male caryatids are usually termed atlantes).

CASTING A method of producing a three-dimensional object, often a sculpture, by pouring a hardening material, such as plaster or metal, into a mold. One principal technique of metal casting, is the *cire perdu*, or lost wax, process.

CATHEDRAL A Christian church that is the official seat of a bishop for a diocese.

CELLA The principal cult room of a Greek temple, preceded by a *portico*.

CHAPEL A small or subordinate religious structure, usually private; in many larger Christian churches, private chapels adjoin ambulatory spaces or fill side *aisles*.

CHIAROSCURO Italian for "clear-obscure." In painting, the use of contrasting tones to create an effect of modelling, that is highlights and shadows.

CHOIR In a Christian church, the enclosed area near the *altar* and behind the *transept* and *crossing*, named for the chanted services conducted there. Often separated from the surrounding spaces by a choir screen.

CIBORIUM A canopy structure supported on *columns*, specifically used to mark the consecrated space of a Christian *altar*. Also known as a *baldachin*.

CIRE PERDU French for "lost wax." A casting process for creating a metal sculpture from a wax model, encased in clay or plaster. When the wax is melted out, it is replaced by molten metal, usually *bronze*, which conforms to the shape of the mold.

CLERESTORY The window zone of an interior *elevation*, usually used to describe the portion of a *nave* in a Christian *basilica* that rises above the side *aisles*.

CLOISTER A covered walk or exterior *ambulatory* around an open courtyard, usually in the form of an *arcade* or *colonnade*. Specifically associated with the interior spaces of a religious *monastery*, hence a generic term for such a monastery.

CODEX A *manuscript* in book form, i.e. hinged with facing pages; different from a *scroll*, which it superseded in the West during the Christian era.

COFFER Recessed geometrical ceiling panels used to decorate *vault* interiors.

COLLAGE A composition of glued materials, including newsprint, papers, and cloth fabrics, on a paper or canvas surface.

COLONNADE A series or row of columns that supports a *lintel* or *entablature*.

COLUMN A freestanding cylindrical support, usually consisting of a base, a *shaft*, and a *capital*. Termed an engaged column when half or more of a column is attached to a wall; diminutive, *colonnette*, often clustered to form a compound *pier*, as in Gothic nave arcades.

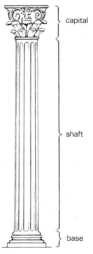

COMPOSITE ORDER A modified hybrid, combining aspects of both *Ionic* and *Corinthian* capitals, specifically the

angular *volutes* of Ionic with the acanthus-circled bell of Corinthian.

CONCRETE A fast-drying solid mortar, first developed by the ancient Romans to produce cast volumes for building structures. Revived in modern architecture, particularly in the form of *reinforced concrete*.

CONSOLE A projecting stone or wood section used to support a lintel; often composed of S-shaped scrolls. Also known as a *bracket*.

CONTRAPPOSTO A figural pose of sculpture in which the body weight is borne by only one leg while the other is relaxed; the counterpoise may be reversed in the upper body.

CORINTHIAN ORDER In Greek, or more commonly Roman, architecture, an ornate variation of *Ionic* Order, consisting of a column with base, a vegetal capital of stylized *acanthus* leaves, and an *entablature* or *architrave* with decorated *frieze*.

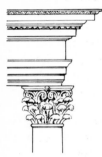

CORNICE In Greek architecture the upper part of the *entablature* or lintel slab; later a projecting *molding* atop a wall surface.

CROSS SECTION An architectural diagram that shows the parts of a structure as if intersected by a vertical plane across its width; perpendicular to a longitudinal section across its length and to a *ground plan*.

CROSSING In Christian churches, the intersection of *nave* with *transept*, sometimes marked by a dome or *crossing tower*.

CROSSING TOWER In Christian churches a tower placed on the exterior to mark the crossing of *nave* and *transept*.

CUPOLA A rounded *vault* on a circular base; also called a *dome*.

DÉCOUPAGE Decoration of surfaces with paper cut-outs.

DEËSIS Greek for "supplication." A Byzantine composition of holy figures as the object of prayers, consisting of a central Christ in Majesty flanked by the Virgin Mary and St. John the Baptist, who act together as intercessors for humankind.

DIPTYCH An image composed of two separate panels, usually hinged; may be wood, ivory, or metal, and either painted or carved.

DOME A rounded *vault* with a circular base; also called a *cupola*, may be hemispherical, bulbous, or pointed in vertical section.

DORIC ORDER In ancient Greek architecture, a building system consisting of a *column* without a base, a *capital* composed of both *echinus* and *abacus*, and an *entablature* divided into *architrave* and a zone of both *triglyphs* and *metopes*.

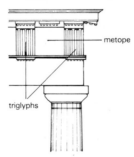

DRUM A cylindrical wall used to support a *dome*; also, one of the cylindrical *shafts* composing a *column*.

ECHINUS In *Doric order capitals*, the rounded, cushion-shaped *molding* beneath the *abacus*.

ELEVATION An architectural diagram or view that shows either the interior or exterior vertical surfaces of a building.

EMBLEM BOOK A publication containing a *woodcut* illustration and explanatory verses, usually expounding a truism or moral.

ENAMEL A powdered, colored-glass substance fused under heat to a metal ground. There are two principal techniques: (a) *cloissoné*, a method in which the surface is divided into segments with metal strips (*cloisons*); and (b) *champlève*, a method in which the areas to be filled are dug out of the ground and filled up without the use of any boundary strips.

ENCAUSTIC A painting technique using pigments mixed with a warm-wax binder.

ENGRAVING An *intaglio* printmaking process, in which the replicated images are produced from inked grooves in a metal plate. The grooves are produced manually through the use of a specialized tool, or burin.

ENTABLATURE The upper part of a Greek architectural *order*, subdivided into zones of *architrave*, *frieze*, and *cornice*.

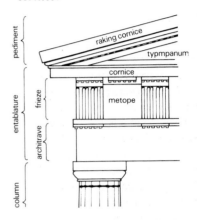

ENTASIS A subtle outward curvature or bulging of columns in Greek temples in order to compensate visually for their predominant verticality.

ETCHING A form of *intaglio* printmaking, where the inked metal plate produces replicated images from its inked grooves. Etching differs from *engraving*, the other major form of intaglio printmaking, by producing its grooves through the action of acid rather than manual gouging. In the etching process a waxy ground coating on top of the plate is scratched by a sharp needle; when the plate is then dipped into an acid bath, the resistance of the ground prevents any etching of the plate except where scratches have exposed its surface.

FAÇADE The front or principal entry of a building.

FLEUR-DE-LYS Heraldic lily, former royal arms of France.

FLUTING Shallow vertical grooves applied to *columns* in order to accent their vertical dimension.

FLYING BUTTRESS A structural element used to reinforce a wall by means of

both a masonry support, or *buttress*, and a connecting half-arch at its peak; particularly used in Gothic cathedrals to take the *vault* stresses outward and downward from the interior to the exterior above the side *aisles*.

FORESHORTENING A pictorial method of representing objects as if seen in sharp recession into depth; used in both painting and relief sculpture.

FORUM The official center of a Roman city or town, usually at the intersection of the two main directional roads. Used as a public gathering-place as well as the site of judicial decisions and often principal temples.

FRESCO Italian for "fresh." A technique of painting by means of colored plaster, which becomes part of the wall surface when dry. To be distinguished from *secco* (Italian for "dry"), which is applied to the surface of plaster that has already dried rather than mixing pigment integrally with the plaster medium.

FRIEZE In Greek architecture, the band of wall above the *architrave* on an *entablature*; also the decoration of that horizontal band with *relief* sculpture or decorative *moldings*, hence any extended decoration along a strip.

GABLE The vertical, triangular wall surface at the end of a pitched roof, called a *pediment* in ancient Greek architecture. Also the kind of roof created by two planes sloping downward from a central beam.

GALLERY An elevated floor suspended above an open space: in *basilica* churches, a gallery appears over side *aisles* atop the *columns* or *piers* of the *nave*. Alternatively, a long interior room, sometimes used for the display of pictures, most notably in the "Grand Gallery" of the Louvre in Paris.

GREEK CROSS A cross with four equal arms; hence a central plan structure, often roofed with a dome.

GROIN VAULT A *vault* formed by the right angle intersection of two identical barrel vaults; the resulting groin juncture forms a cross shape. Also called a cross vault.

GROUND The surface on which a painting is executed.

GROUND PLAN The arrangement of a building's structures as they would appear if the layout were drawn on a plane cut through the building at ground level.

HALL CHURCH A church plan where the side *aisles* are as high as the *nave*; especially popular in Gothic German churches through the fifteenth century.

HEMICYCLE A curved or semicircular structure, such as the rounded *ambulatory* space of a church *apse*.

HERM A rectangular stone *shaft*, carved at the top with a figural bust; also known as a term.

HIPPED ROOF Roof construction with sloped rather than vertical ends; contrasted with *pitched* or *gable* roofs.

HYPOSTYLE A large building space or hall in which the roof is supported by rows of *columns*; characteristic of ancient Egyptian temples.

ICON A religious image, usually a small, portable panel of Christ, the Virgin or saints, produced for the Byzantine or Orthodox Church.

ICONOCLASM Organized destruction of religious images, specifically the *icons* of the Byzantine or Orthodox Church.

IDEOGRAM Visual symbol of an idea (eg many Chinese characters).

IGNUDI Young male nude figures, often representing wingless angels.

ILLUMINATION Decoration of a *manuscript* with gold, silver and brilliant colors.

IMPASTO Pigment applied thickly to panel or canvas in the *oil* process.

IONIC ORDER An ancient Greek temple system, employing a plinth and decorated base, plus a *scroll capital* with *volute* supporting an unbroken *frieze* above an *architrave*.

IVAN In Near Eastern architecture, a large porch or shallow hall with a pointed *barrel-vaulted arch*, often serving as an entrance *portal*.

JAMBS Areas flanking an *arch*, doorway, or window opening; in medieval architecture, *portal* jambs support carved figures.

JAPONISME The enthusiasm of Western artists (eg Impressionists) for Japanese art (especially prints) after the opening up of that country to the West in the mid-nineteenth century.

KONDO The main hall in a Japanese Buddhist monastery complex.

KORE (pl. korai). Greek for "maiden." A standing statue of a clothed female.

KOUROS (pl. kouroi). Greek for "youth." A standing statue of a nude male.

KYLIX An ancient Greek drinking cup in the shape of a shallow bowl with two large handles at either side.

LANCET A high, narrow window with a pointed *arch*.

LANTERN A small circular or polygonal windowed structure atop a domed building or tower in order to admit light to the interior space below.

LAPIS LAZULI Bright blue pigment obtained from a gemstone.

LATIN CROSS A cross shape with a longer vertical member; often used to describe church *basilica* plans with longer *naves* than *transepts*.

LINTEL A horizontal beam or slab supported by posts above an opening.

LITHOGRAPHY A printmaking process employing a stone surface (sometimes a metal plate) and a greasy crayon that holds the ink, in contrast to the dampened unmarked stone.

LOGGIA (pl. loggie) A *gallery* or *arcade* open on at least one side.

"Lost-wax" process See *cire perdu*.

Manuscript A hand-written book; when illustrated, called an illuminated manuscript.

Martyrium A shrine or *chapel* erected over the grave of a holy martyr; usually a round or polygonal structure.

Mausoleum Any stately building used for burial, named after the tomb of Mausolus at Halicarnassus (mid-fourth century BC).

Medallion A large tablet or panel in a wall, resembling the round shape of a medal and adorned with *reliefs*, ornament, or other designs.

Metope Square area alternating with grooved *triglyphs* in the *entablature* section of a Doric Greek temple; usually adorned with sculpted *reliefs*.

Mihrab The *arch* or *niche* space in an Islamic *mosque* used to mark the *qibla*, or prayer direction toward Mecca.

Minaret A tower of an Islamic *mosque* complex, usually tall and slender; used by a muezzin to call the community to prayer at prescribed times.

Miniature Originally a painting with figures outlined in the red pigment of *minium*, hence an *illumination* in a *manuscript*.

Minimalism A movement of both painting and sculpture of the 1960s that aimed at the reduction of art to the basic elements of its medium and physical properties. Sometimes with an emphasis on mechanical precision or else with a suggestion of randomness without material intervention by the artist.

Mobiles Structure whose components are connected in such a way that it moves by force of wind or motor.

Modello A preliminary study for a later work, usually on a smaller scale but in the same materials, such as an oil sketch.

Molding A projecting ornamental band at the end of an architectural or other solid surface, such as furniture.

Monastery A religious community consecrated to prayer in withdrawal from the world, usually under the rule of a Christian order. Members are called monks or nuns.

Monochrome A painting in tones of one basic color, such as grey (*grisaille*).

Monstrance A container for the consecrated host in Christian ritual, often transparent and fashioned out of precious metal.

Montjoie A stone monument structure erected in medieval France.

Mosaic Pictorial or ornamental pattern constructed out of small pieces (*tesserae*) of glass, stone, or tiles; used on floors in ancient Rome and on walls and domes in Byzantine buildings.

Mosaic law In Christian theology, Jewish strictures according to the Torah, or Five Books of Moses; contrasted with subsequent era of "grace," after the mission of Christ.

Mosque Islamic place of communal worship, oriented toward Mecca (*quibla*).

Muqarnas Hanging volumetric ornament, "stalactites," in niche spaces and spandrels of Islamic architecture.

Mural Large wall decorations, often painted in *fresco* or *secco* technique.

Naos Inner part of a Greek temple.

Narthex An entrance hall or vestibule, esp. of Christian churches.

Nave The large, central, axial hall of a *basilica*, usually flanked by side *aisles* and crowned by a window zone, or *clerestory*; the chief congregational space of a Christian church.

Nef French for "ship." A table ornament in the form of a ship, popular at European courts in the fifteenth and sixteenth centuries. Made from precious metals.

Neo- A combination form to suggest a newer version or revival of some earlier movement, such as Neo-impressionism or Neo-classicism.

Niche A recess in a wall, often designed to contain a statue.

Obelisk An ancient Egyptian monument, consisting of a vertical stone *shaft* tapering to a pyramidal apex.

Oculus (pl. *oculi*) Latin for "eye." A circular opening in a wall or at the apex of a *dome*.

Oil A painting technique developed in the fifteenth century, which uses oil (usually linseed oil) as the binding medium with pigment; often enhanced with additional transparent oil film glazes in order to produce effects of luster and depth or volume.

Order (CLASSICAL). A system of building with columns, or *post and lintel* construction, which coordinates varying elements and proportions of *columns* (base, *shaft*, and *capital*) with elements of *entablature* (*architrave*, *frieze*, and *cornice*). Prominent classical orders include: *Doric*, *Ionic*, and *Corinthian*.

Order (MONASTIC). A religious community organized according to a particular rule under solemn vows. Prominent Christian orders include: Benedictine, Cluniac, Cistercian, Carthusian, Dominican, Franciscan, and Jesuit.

Papiers collées See *collage*.

Parchment A writing surface made of scraped animal skin, usually lamb or calf; also known as vellum.

Pastel A drawing medium of dry, ground pigment lightly bound with gum.

Pediment A triangular *gable* over a *portico*, door, or window; usually filled with sculpture on a Greek temple.

Pendentive A system of support for a dome, in which the transition from square to circle is made through spherical, curved triangles.

Peplos The woolen outer garment, also called the Doric chiton, worn by Ancient Greek women.

Peristyle A continuous row of columns, or *colonnade*, that completely surrounds the exterior of a building, esp. of an ancient Greek temple, or an interior space.

Perspective An illusion of depth on a plane surface. Two principles assist in the creation of perspective. The

principle of drawing parallel lines as if they converged at the horizon underlies linear perspective, perfected in fifteenth-century Italy. The principle of diminished color intensity over distance as well of a general whitening (higher value) at the horizon underlies aerial, or atmospheric, perspective.

PIAZZA A large, open public space; a plaza.

PIER A solid vertical masonry support within a wall surface, as distinct from a separate, cylindrical *column*.

PIETÀ Image of the Virgin Mary with the dead Christ on her lap.

PILASTER A shallow or flat vertical support, usually articulated with base and *capital* like a *column*; often a decorative element without structural function (if structural, and usually called a *pier*).

PLASTICITY Three-dimensional, sculptural properties.

PLEIN-AIR (PAINTING). Painting in the open air as opposed to in the artist's studio, a technique used by the Impressionists, rejecting the academic tradition.

PODIUM A continuous base or pedestal used to support *columns*.

POLYCHROMY Painting or decoration in several colors.

POLYPTYCH An *altarpiece* or *retable* consisting of more than three panels.

PORTAL An entrance composition of doorways and porches, esp. of a church.

PORTICO A roofed entrance space, usually open or partly enclosed on the façade of a building, a porch. Supported by *columns* and crowned with *pediment* and *entablature* in classical architecture.

POST AND LINTEL A construction system of horizontal members (lintels) set as slabs upon supporting vertical members (posts); also known as trabeation.

PRINT Any imagery printed in multiples on a plane surface, usually paper, from a basic template. Prints made from ridges on the template are known as relief prints (most common form: *woodcut*); prints made from grooves in template are known as intaglio prints

(most common forms: *engraving*, *etching*); prints made from a template surface are known as planographic prints (most common form: *lithograph*).

PSALTER Roll, *codex* or book of the *Psalms of David*, sometimes with a calendar indicating when each psalm was to be read, and incorporating also hymns, prayers, and a litany of saints. Manuscript examples of the eleventh through fourteenth centuries often had rich *illumination*.

PUTTI Small figures of naked male babies, usually winged and representing cupids or angels, popular in Italian art from the Renaissance onward.

PYLON Entrance gate to an Egyptian temple complex, usually consisting of a pair of broad mural towers, often truncated pyramids, flanking an opening.

QIBLA In Islam, the wall of a *mosque* oriented towards Mecca, the direction of prayer; often marked by a *niche*, or *mihrab*.

QUADRIGA Latin term for a chariot drawn by a team of four adjacent horses.

QUATREFOIL A four-lobed ornamental pattern.

READYMADES Ready-made objects exhibited by artists as works of art, introduced by Marcel Duchamp (1887–1968).

RED-FIGURE VASE Ancient Greek technique of decoration, developed around 530 BC, using the red-orange color of fired terracotta clay for figures silhouetted against an oxidized black ground of iron oxide.

REINFORCED CONCRETE Concrete made stronger through the insertion of wire or mesh steel supports; also called ferroconcrete.

RELIEF Sculpted forms emerging from a plane surface, or *ground*, called high relief when over half volumetric, or "in the round"; low relief or bas-relief when under half volumetric.

RELIQUARY Container for a sacred relic, often shaped like a small casket.

RETABLE A structure behind a

Christian *altar*, usually composed of carved or painted figures and scenes, or both. Also called a reredos or *altarpiece*. May be subdivided, as in the three-part triptych.

RIB A slender masonry *arch*, usually used to articulate and trace the intersection of two cross *vaults* or *groin vaults*, especially in Gothic vaults. Used both for additional support and as ornament.

ROSE WINDOW A circular window with stone tracery radiating outward from its center, invented for the Gothic façade.

ROTUNDA A circular building or interior space surmounted by a dome.

SACRISTY A room or building attached to a Christian church used to house sacred vestments and vessels; a vestry.

SARCOPHAGUS From the Greek for "flesh-eating." A coffin, usually of stone, often carved with relief sculpture.

SCROLL A long roll of either paper or parchment, used for writing or painting or both and either hung suspended (hanging scroll) or unrolled laterally (hand scroll); the favored form of painting in East Asia, and a major form of book production in the ancient world, prior to the development of hinged binding (*codex*).

SECTION A diagram of a building showing its appearance if cut either along a horizontal (*cross section*) or a vertical plane (longitudinal section).

SFUMATO A soft and hazy shadowy effect in oil painting, particularly associated with Leonardo da Vinci.

SHAFT That part of a *column* between the base and the *capital*; group of clustered columns.

SHAMSA Decorative central medallion (sun-disc) in Islamic art.

SIBYL A prophetic woman in Greek or Roman religion; later associated with specific prophecies of Christ in the ancient world, as employed by Michelangelo as a complement to the biblical male prophets of the Sistine Chapel.

SPANDREL The triangular two- or three-dimensional space between two arches

of an *arcade* or between the crest of an *arch* and its springing.

STAINED GLASS Windows composed out of pieces of colored glass, usually joined by lead strips; popular in Gothic churches and their later imitations.

STELE (pl. stelae). Greek for "standing block." An upright slab, usually carved in *relief* with inscriptions; often commemorative in purpose.

STOA A covered *colonnade* or *portico* in ancient Greek (later Roman) cities, often flanking an open market space, or agora, and used as a meeting-place.

STUCCO Plaster covering and coating for walls, usually mixed with lime as well as some sand and cement; finer stucco can be molded into sculptural or ornamental shapes adhering to either ceilings or walls as a form of interior decoration, especially popular between the sixteenth and eighteenth centuries.

SWAG An ornamental motif, derived from ancient sources, of a hanging or suspended element, usually a floral or evergreen strip or else a curtain; a festoon.

TABERNACLE A general sense for a place of worship, derived from the biblical description of the portable shrine carried by the Israelites in the Sinai and afterwards; more specifically in later Christian churches, a canopied recess for an image or a separate shrine for the consecrated host on an *altar* in the form of a miniature building.

TEMPERA A painting pigment mixed with a medium of egg yolk; popular in Italian panel painting before the sixteenth century.

TERRACOTTA In Italian, literally, "baked earth." A hard earthenware of rust color used for pottery, sculptural

figures, and even building materials; often glazed.

TESSERA (pl. tesserae) Individual pieces of tile, stone, or cut glass assembled into a composite to form a *mosaic*.

TRACERY Ornamental stonework, usually patterned in geometric shapes, most frequently encountered as both a support and a decoration in the windows of Gothic cathedrals but also applied "blind" to wall surfaces and screens. The two principal forms of tracery are: bar tracery, erected as curvilinear shapes within (window) openings; and plate tracery, giving the appearance of a cut-out silhouette shape.

TRANSEPT The arm extensions beyond of a cross-shaped *basilica*, usually used for a Christian church in the shape of a Latin cross.

TRIFORIUM An arcaded wall passage above the *nave arcade* in medieval church structures, especially Gothic, usually under a window section, or *clerestory*.

TRIGLYPH A decorated segment within the *Doric Order*, consisting of vertical grooves above the main columnar supports. Alternating rhythmically with carved relief sections, or *metopes*.

TRIPTYCH A three-part panelled *altarpiece*, consisting of a central panel and (usually) movable wing panels, which meet and close over the center. Movable wings are usually painted on both sides, often with the exteriors in muted or grey tones (*grisaille*).

TRUMEAU A central stone support post for a doorway, often carved with a standing figure on medieval church *portals*.

TRUSS An assemblage of iron beams forming a rigid framework.

TYMPANUM The area above a doorway lintel underneath a framing

arch, often carved on medieval church *portals*.

TYPOLOGY In Christian theology, the construction of relationships based upon perceived analogies between Old and New Testament events, such as the Sacrifice of Isaac and the Crucifixion of Christ.

VAULT A masonry roof, often constructed on the principle of the *arch*. The simplest vault is an unbroken, three-dimensional arch, called a barrel or tunnel vault. Intersecting barrel vaults are called cross vaults or *groin vaults*, and their intersection marks the groin. Along the groin diagonal ribs can be articulated in masonry to create rib vaults, a principal feature of Gothic cathedrals. A *dome* is a vault with a circular plan, rising from a variety of bases.

VILLA Latin for country house, usually at a remove from a city; an ancient building complex, revived in the Italian Renaissance and afterwards.

VOLUTE The spiral scroll of capitals, chiefly *Ionic*, but also *Corinthian* orders.

WASH An undifferentiated veil of color, either *watercolor* or dilute ink, brushed across a surface, usually paper.

WATERCOLOR A painting of water-soluble pigments, often with some gun arabic binder, usually brushed onto paper.

WESTWORK The west end of a Christian church, deriving from a pattern established during the Carolingian era under Charlemagne. Characteristically, this façade ensemble presents a large room enclosure, often a *chapel* or royal oratory, over the entrance to the *nave* plus a tower or pair of flanking towers above.

WOODCUT A print made from a carved block of wood. Lines of the woodcut print derive from the ridges left behind in carving, in the general process known as relief printing (that is, all blank areas have been carved away beneath the level of the remaining ridges).

CREDITS

The author, the publishers, and Calmann and King Ltd wish to thank the artists, museums, galleries, and other owners who have kindly allowed works to be reproduced in this book. In general, museums have supplied their own photographs; other sources, photographers, and copyright holders are listed here.

Peter Aaron/Esto: p. 467 (below)

© ADAGP, Paris and DACS, London 1993: pp. 379, 380, 393, 394, 404, 405, 406, 407, 408, 409, 432

Alinari: pp. 42 (above left), 48 (left), 59, 84, 86 (above), 196, 201, 202, 205, 235, 236, 237, 241, 247, 302

Amsterdam/Collection Museum Het Rembrandthuis: p. 266

Ancient Art and Architecture Collection: pp. 31, 135 (above left), 178 (below), 226 (above right), 228, 242 (below, left and right), 243, 279, 280

Architectural Association: pp. 351, 440, 469, 471

Archiv für Kunst und Geschichte: pp. 21 (above right), 142 (above), 146, 153, 154, 190 (above), 197, 213, 215, 218, 240 (above), 268, 278, 316, 317, 321, 326, 334, 336 (above), 338 (below), 346, 362, 391 (below), 392, 408, 468

Artothek: p. 318

Bildarchiv Foto Marburg: pp. 20, 45, 135 (below), 139, 140, 147, 163, 164, 170, 171 (below right), 172, 181, 256, 319, 355, 366, 367, 383 (below)

Bildarchiv Preussischer Kulturbesitz: pp. 101 (above left), 132, 248, 250

Michael Bodycomb: p. 470

Bridgeman Art Library: pp. 128, 129, 138, 141, 143, 167, 195, 215, 218, 251 (above), 265 (below right), 274, 295

Chicago Historical Society: p. 348

Colorphoto Hans Hinz: p. 380 (below)

© DACS 1993: pp. 16/17, 19, 28, 29, 370 (above), 371, 372, 373, 375, 381, 382, 383, 395, 396, 397, 398, 404, 410, 412, 448, 449

C.M. Dixon: pp. 94, 97

e.t. archive: pp. 219, 220

Werner Forman Archive: pp. 225 (below), 230 (below), 231 (below), 287

Fotomas Index: pp. 266 (above left), 271

Alison Frantz: p. 46 (below)

Hedrich Blessing: p. 446

Hirmer Fotoarchiv: pp. 46 (above), 47, 53 (above), 55 (above), 57 (above), 82, 92, 101 (above right and below), 103, 132, 165 (below right), 206

International Museum of Photography at George Eastman House: pp. 341, 344, 384

© Jasper Johns/DACS, London 1993: p. 443

Lisa Kahane, courtesy Barbara Gladstone Gallery: p. 459 (below)

© Roy Lichtenstein/DACS 1993: p. 445

A.F. Kersting: pp. 109, 320 (below), 329

Robert E. Mates/Solomon R. Guggenheim Museum: pp. 428, 473

© Succession H. Matisse/DACS 1993: pp. 376, 377, (above and below) 378

Louis K. Meissel Gallery: p. 467 (above)

Photoresources/N. Vincent: p. 284

© Robet Rauschenberg/DACS, London/VAGA, New York 1993: p. 445

© Photo RMN: pp. 2, 114, 340

Roger-Viollet: pp. 103, 106 (above left), 152, 304 (above)

Scala: pp. 16, 22, 23, 28, 44, 179, 180, 184, 188, 190 (below), 209, 210, 211, 249, 258, 270, 273, 391 (above), 402

Bob Schwalkwijk: pp. 418, 419, 420, 421

Phil Starling © National Gallery Publications Ltd.: p. 472

Nick Saunders: pp. 226 (centre right), 227

Caroline Tisdall: p. 449

Vincent van Gogh Foundation/Vincent van Gogh Museum, Amsterdam: p. 357

Visual Arts Library: pp. 134, 240 (below), 265, 277

John Weber Gallery: p. 459 (above)

BIBLIOGRAPHY

1. THE ROLES OF THE ARTIST

J. Alsop, *The Rare Art Traditions*, Princeton, 1982

M. Baxandall, *Patterns of Intention*, New Haven, 1985

P. Bonafoux, *Portraits of the Artist*, New York, 1985

N. Bryson, *Vision and Painting*, New Haven, 1983

R. Carpenter & J. Ackerman, *Art and Archaeology*, Englewood Cliffs, NJ, 1963

W. Chadwick, *Women, Art, and Society*, London/New York, 1990

H.P. Chapman, *Rembrandt's Self Portraits*, Princeton, 1989

V.W. Egbert, *The Medieval Art at Work*, Princeton, 1967

Z. Filipczack, *Picturing Art in Antwerp 1550–1700*, Princeton, 1987

D. Freedberg, *The Power of Images*, Chicago, 1989

M. Garrard, "Artemisia Gentileschi's Self-Portrait as the Allegory of Painting," *Art Bulletin* 62, 1980

E. Gombrich, *Art and Illusion*, 4th ed., London, 1972

F. Haskell, *Rediscoveries in Art*, Ithaca, 1976

A. Hauser, *The Social History of Art*, New York, 1951

E. Kris, E. & O. Kurz, *Legend, Myth, and Magic in the Image of the Artist*, New Haven, 1979

G. Kubler, *The Shape of Time*, New Haven, 1962

A. Martindale, *The Rise of the Artist in the Middle Ages and Early Renaissance*, New York, 1972

J. Pope-Hennessey, *The Portrait in the Renaissance*, New York, 1966

H. & C. White, *Canvases and Careers: Institutional Change in the French Painting World*, New York, 1965

R. & M. Wittkower, *Born under Saturn*, New York, 1963

R. Wollheim, *Painting as an Art*, Princeton, 1987

2. ANCIENT ANCESTORS

EGYPT AND ASSYRIA

C. Aldred, *The Development of Egyptian Art*, London, 1952

P. Amiet, *Art of the Ancient Near East*, New York, 1980

W. Davis, *The Canonical Tradition in Ancient Egyptian Art*, Cambridge, 1989

H. Frankfort, *The Art and Architecture of the Ancient Orient*, 4th ed., Harmondsworth, 1969

I.E.S. Edwards, *The Pyramids of Egypt*, London, 1961

S. Lloyd, *The Art of the Ancient Near East*, London, 1961, and *The Archaeology of Mesopotamia*, London, 1978

K. Michalowski, *Art of Ancient Egypt*, New York, 1968

A. Parrott, *The Arts of Assyria*, New York, 1961

W.S. Smith, *Ancient Egypt as Represented in the Museum of Fine Arts, Boston*, 6th ed., Boston, 1960, and *The Art and Architecture of Ancient Egypt*, Harmondsworth, 1958

E. Strommenger, *5000 Years of the Art of Mesopotamia*, New York, 1964

J. Wilson, *The Culture of Ancient Egypt*, Chicago, 1956

C. Woolley, *Mesopotamia and the Middle East*, London, 1961

GRECIAN GLORIES

B. Ashmole, *Architect and Sculptor in Classical Greece*, New York, 1972

B. Ashmole & N. Yalouris, *Olympia: The Sculptures of the Temple of Zeus*, London, 1967

J. Boardman, *Greek Art*, London, 1985, and *The Parthenon and Its Sculptures*, Austin, 1985

H.A. Groenewegen-Frankfort and B. Ashmole, *Art of the Ancient World*, Englewood Cliffs, NJ, 1972

L. Drees, *Olympia*, New York, 1968

A.W. Lawrence, *Greek Architecture*, Harmondsworth, 1967

J.J. Pollitt, *Art and Experience in Classical Greece*, Cambridge, 1972, and *The Art of Greece 1400–31 BC: Sources and Documents*, Englewood Cliffs, NJ, 1965

G. Richter, *Handbook of Greek Art*, 6th ed., New York, 1969

B.S. Ridgway, *The Archaic Style in Greek Sculpture*, Princeton, 1977, and *Fifth-Century Styles in Greek Sculpture*, Princeton, 1981, and *The Severe Style in Greek Sculpture*, Princeton, 1970

M. Robertson, *A Shorter History of Greek Art*, Cambridge, 1981

A. Stewart, *Greek Sculpture*, New Haven, 1990

S. Woodford, *The Parthenon*, Cambridge, 1981

HELLENISM

See previous section for general books.

M. Bieber, *Alexander the Great in Greek and Roman Art*, Chicago, 1964, and *The Sculpture of the Hellenistic Age*, rev. ed., New York, 1961

C. Havelock, *Hellenistic Art*, Greenwich, CT, 1971

A.W. Lawrence, *Later Greek Sculpture and its Influence on East and West*, New York, 1927

J. Onians, *Art and Thought in the Hellenistic Age*, London, 1979

J.J. Pollitt, *Art in the Hellenistic Age*, Cambridge, 1986

T.B.L. Webster, *The Art of Greece: The Age of Hellenism*, New York, 1966

ROME: FROM REPUBLIC TO EMPIRE

R.B. Bandinelli, *Rome: The Centre of Power*, London, 1970, and *Rome: The Late Empire*, London, 1971

J. Breckenridge, *Likeness*, Evanston, 1969

O. Brendel, *Etruscan Art*, New York, 1978, and *Prolegomena to the Study of Roman Art*, New Haven, 1978

R. Brilliant, *Roman Art from the Republic to Constantine*, London, 1974

P. Brown, *The World of Late Antiquity*, London, 1971

G. Hanfmann, *Roman Art*, Greenwich, CT, 1964

N. Hannestad, *Roman Art and Imperial Policy*, Aarhus, 1986

H.P. L'Orange, *Art Forms and Civic Life in the Later Roman Empire*, Princeton, 1965

S. MacCormack, *Art and Ceremony in Late Antiquity*, Berkeley, 1981

W. MacDonald, *The Architecture of the Roman Empire* (1965), New Haven, 1986, and *The Pantheon*, London, 1976

J.J. Pollitt, *The Art of Rome ca. 753 BC-AD 337: Sources and Documents*, Englewood Cliffs, NJ, 1966

Pompeii AD 79, exh. cat., Boston, 1978

D. Strong, *Roman Art*, Harmondsworth, 1976

J.B. Ward-Perkins, *Roman Imperial Architecture*, Harmondsworth, 1981

3. CHRISTIAN CULTURE

GENERAL REFERENCES

R. Calkins, *Illuminated Books of the Middle Ages*, Ithaca, 1983

O. Pächt, *Book Illumination in the Middle Ages*, Oxford, 1986

D. Robb, *The Art of the Illuminated Manuscript*, Cranbury, NJ, 1973

J. Snyder, *Medieval Art*, New York, 1989

M. Stokstad, *Medieval Art*, New York, 1975

CHRISTIAN EMPIRES: ROME AND CONSTANTINOPLE

J. Beckwith, *The Art of Constantinople: An Introduction to Byzantine Art (330–1453)*, 2nd ed., London, 1968, and *Early Christian and Byzantine Art*, 2nd ed., Harmondsworth, 1979

R. Cormack, *Writing in Gold: Byzantine Society and its Icons*, London, 1985

O. Demus, *Byzantine Art and the West*, New York, 1970, and *Byzantine Mosaic Decoration*, London, 1953

A. Grabar, *Byzantine Painting*, Geneva, 1953, and *Christian Iconography: A Study of its Origins*, Princeton, 1968, and *The Beginnings of Christian Art, 200–395*, London, 1967, and *The Golden Age of Justinian*, New York, 1967

E. Kitzinger, *Byzantine Art in the Making*, Cambridge, MA, 1977, and *The Art of Byzantium and the Medieval West: Selected Studies*, Bloomington, IN, 1976

R. Krautheimer, *Early Christian and Byzantine Architecture*, Harmondsworth, 1965

C. Mango, *The Art of the Byzantine Empire, 312–1453: Sources and Documents*, Englewood Cliffs, NJ, 1972

T. Mathews, *Byzantine Aesthetics*, New York, 1963

D.T. Rice, *Byzantine Art*, rev. ed., Harmondsworth, 1962

S. Runciman, *Byzantine Style and Civilization*, Harmondsworth, 1975

O.v. Simson, *The Sacred Fortress* (1948), Chicago, 1976

K. Weitzmann, *The Icon*, New York, 1982, and *The Age of Spirituality* (et. al.), exh. cat., New York, Metropolitan Museum, 1979

CHRISTIAN EMPIRES: CHARLEMAGNE AND THE CAROLINGIANS

J. Beckwith, *Early Medieval Art*, London, 1964

K. Conant, *Carolingian and Romanesque Architecture 800–1200*, 4th ed., Harmondsworth, 1978

C.R. Dodwell, *Painting in Europe 800–1200*, Harmondsworth, 1971

A. Grabar & C. Nordenfalk, *Early Medieval Painting*, New York, 1957

E. Kitzinger, *Early Christian Art*, Bloomington, IN, 1983

P. Lasko, *Ars Sacra 800–1200*, Harmondsworth, 1967

F. Mütherich & J. Gaehde, *Carolingian Painting*, New York, 1976

PILGRIMAGES AND POWER

F. Avril, *Manuscript Painting at the Court of France*, New York, 1978

J. Bony, *French Gothic Architecture of the 12th and 13th Centuries*, Berkeley, 1983

R. Branner, *Saint Louis and the Court Style in Gothic Architecture*, London, 1965, and *Chartres Cathedral*, New York, 1969

W. Braunfels, *Monasteries of Western Europe*, London, 1972

M. Camille, *The Gothic Idol*, Cambridge, 1989

F. Deuchler, *Gothic Art*, New York, 1973

G. Duby, *The Age of the Cathedrals: Art and Society 980–1420*, Chicago, 1981

A. Erlande-Brandenburg, *Gothic Art*, New York, 1989

H. Focillon, *Art of the West in the Middle Ages*, 2nd ed., London, 1969

P. Frankl, *Gothic Architecture*, Harmondsworth, 1963

J. Gimpel, *The Cathedral Builders*, New York, 1961

A. Grabar & C. Nordenfalk, *Romanesque Painting*, New York, 1958

L. Grodecki, *Gothic Architecture*, New York, 1977

J. Harvey, *The Gothic World*, London, 1950

G. Henderson, *Gothic*, Harmondsworth, 1967

H. Jantzen, *The High Gothic*, New York, 1962

A. Katzenellenbogen, *The Sculptural Program of Chartres Cathedral*, Baltimore, 1959

E. Mâle, *The Gothic Image: Religious Art in France of the Thirteenth Century*, New York, 1958

A. Martindale, *Gothic Art*, New York, 1967

E. Panofsky, *Abbot Suger on the Abbey Church of St.-Denis and its Art Treasures*, 2nd ed., Princeton, 1979, and *Gothic Architecture and Scholasticism*, New York, 1957

J. Porcher, *Medieval French Miniatures*, New York, 1960

W. Sauerländer, *Gothic Sculptures in France 1140–1270*, New York, 1973

M. Schapiro, *Romanesque Art*, New York, 1977

O.v. Simson, *The Gothic Cathedral*, Princeton, 1973

The Year 1200, exh. cat., New York, Metropolitan Museum, 1970

V. Turner, *Image and Pilgrimage in Christian Culture*, New York, 1978

W. Wixom, *Art Treasures from Medieval France*, exh. cat., Cleveland, 1967

G. Zarnecki, *Romanesque Art*, New York, 1977

JAPAN

The Great Eastern Temple, exh. cat., Chicago, 1986

J. Fontein & M. Hickman, *Zen Painting and Calligraphy*, exh. cat., Boston, 1970

Japanese Ink Paintings, exh. cat., Princeton, 1976

S. Lee, *History of Far Eastern Art*, 4th ed., New York, 1982

H. Mori, *Sculpture of the Kamakura Period*, New York, 1974

K. Nishikawa & E. Sano, *The Great Age of Japanese Buddhist Sculpture AD 600–1300*, exh. cat., Fort Worth, 1982

R.T. Paine & A. Soper, *The Art and Architecture of Japan*, rev. ed., Harmondsworth, 1975

P. Pal, *Light of Asia: Buddha Sakyamuni in Asian Art*, exh. cat., Los Angeles, 1984

Y. Shimizu, ed., *Japan: The Shaping of Daimyo Culture 1185–1868*, exh. cat., Washington, 1989

CHINA

S. Bush, *The Chinese Literati on Painting*, Cambridge, MA, 1971

J. Cahill, *Chinese Painting*, Geneva, 1960, and *The Art of Southern Sung China*, exh. cat., New York, Asia House, 1962, and *Hills Beyond a River: Chinese Painting of the Yüan Dynasty*, New York/Tokyo, 1976

W. Ho et al, *Eight Dynasties of Chinese Painting*, esp. pp.25–32, "Aspects of Chinese Painting from 1100 to 1350," cat., Cleveland Museum of Art, 1980

J. Fontein, "Chinese Art," *Encyclopedia of World Art*, vol. III, cols. 466–578, New York, 1960

J. Fontein & M. Hickman, *Zen Painting and Calligraphy*, exh. cat., Boston, Museum of Fine Arts, 1970

G. Loehr, *The Great Painters of China*, Oxford, 1980

L. Sickman & A. Soper, *The Art and Architecture of China*, 3rd ed., rev., Harmondsworth, 1968

M. Sullivan, *Symbols of Eternity: The Art of Landscape Painting in China*, Stanford, 1979, and *The Arts of China*, 2nd ed., rev., Berkeley/Los Angeles, 1978

4. EARLY RENAISSANCE

NORTHERN EUROPE

M. Baxandall, *The Limewood Sculptors of*

Renaissance Germany, New Haven, 1980

S.N. Blum, *Early Netherlandish Triptychs*, Berkeley, 1969

C. Christensen, *Art and the Reformation in Germany*, Athens, O. and Detroit, 1979

C. Cuttler, *Northern Painting*, (1968), rev. ed., New York, 1992

Flanders in the Fifteenth Century, exh. cat., Detroit, 1960

W. Gibson, *Hieronymus Bosch*, New York, 1973

E. Mâle, *Religious Art in France: The Late Middle Ages*, Princeton, 1986

K. Morand, *Claus Sluter*, Austin, 1991

E. Panofsky, *Early Netherlandish Painting*, Cambridge, MA, 1953, and *The Life and Art of Albrecht Dürer*, Princeton, 1955

J. Snyder, *Northern Renaissance Art*, New York, 1985

P. Strieder, *Albrecht Dürer*, New York, 1982

CENTRAL ITALY: SIENA AND FLORENCE

M. Baxandall, *Giotto and the Orators*, Oxford, 1971, and *Painting and Experience in Fifteenth Century Italy*, Oxford, 1974

B. Bennett & D. Wilkins, *Donatello*, London, 1984

A. Blunt, *Artistic Theory in Italy 1450–1600*, Oxford, 1962

E. Borsook, *The Mural Painters of Tuscany from Cimabue to Andrea del Sarto*, New York, 1981

P. Burke, *The Italian Renaissance: Culture and Society*, Princeton, 1987

B. Cole, *Italian Art 1250–1550*, New York, 1987, and *Sienese Painting*, New York, 1980

S. Edgerton, *The Renaissance Rediscovery of Linear Perspective*, New York, 1976

L.D. & H. Ettlinger, *Botticelli*, London, 1976

C. Gilbert, *Italian Art 1400–1500*, Evanston, 1991

E.H. Gombrich, *Norm and Form*, London, 1966

J.R. Hale, *Florence and the Medici: The Pattern of Control*, Plymouth, 1977

F. Hartt, *History of Italian Renaissance Art*, New York, 1979

L. Heydenreich & W. Lotz, *Architecture in Italy 1400 to 1600*, Harmondsworth, 1974

R. Krautheimer & T. Krautheimer-Hess, *Ghiberti*, Princeton, 1970

J. Larner, *Culture and Society in Italy 1290–1420*, London, 1971

J. Levenson, ed., *Circa 1492*, New Haven, 1991

E. Panofsky, *Renaissance and Renascences in Western Art*, New York, 1969

J. Pope-Hennessey, *Italian Gothic Sculpture*, London, 1955, and *Italian Renaissance Sculpture*, London, 1972

Splendours of the Gonzaga, exh. cat., London, Victoria and Albert Museum, 1981

H. van Os, *Sienese Altarpieces 1215–1460*, vol. I, Groningen, 1984

M. Wackernagel, *The World of the Florentine Renaissance Artist*, English ed., Princeton, 1981

R. Weiss, *The Renaissance Discovery of Classical Antiquity*, Oxford, 1969

J. White, *Art and Architecture in Italy 1250–1400*, Harmondsworth, 1966

R. Wittkower, *Architectural Principles in the Age of Humanism*, London, 1962

5. LATER RENAISSANCE IN ITALY

ROME REVIVED AND FLORENCE

J. Ackerman, *The Architecture of Michelangelo*, Harmondsworth, 1971

A. Chastel, *The Age of Humanism 1480–1530*, London, 1963

K. Clark, *Leonardo da Vinci*, rev. ed., Harmondsworth, 1988

H. Hibbard, *Michelangelo*, New York, 1971

R. Jones & N. Penny, *Raphael*, New Haven, 1983

M. Kemp, *Leonardo da Vinci*, Cambridge, MA, 1981

R. Klein & H. Zerner, *Italian Art 1500–1600*, Evanston, 1990

J. Levenson, ed., *Circa 1492*, New Haven, 1991

J. Pope-Hennessey, *Italian High Renaissance and Baroque Sculpture*, London, 1963, and *The Portrait in the Renaissance*, New York, 1966

J. Shearman, *Mannerism*, Harmondsworth, 1978

C. Stinger, *The Renaissance in Rome*, Bloomington, IN, 1985

VENETIAN VARIATIONS

J. Ackerman, *Palladio*, Harmondsworth, 1962

L. Barkan, *The Gods Made Flesh*, New Haven, 1986

P. Holberton, *Palladio's Villas*, London, 1990

M. Jenkins, *The State Portrait, Its Origin and Evolution*, New York, 1947

E. Panofsky, *Problems in Titian Mostly Iconographic*, New York, 1969

W.R. Rearick, *The Art of Paolo Veronese 1528–1588*, exh. cat., Washington, National Gallery of Art, 1988

D. Rosand, *Titian*, New York, 1978

Splendours of the Gonzagas, exh. cat., London, Victoria and Albert Museum, 1982

J. Steer, *Venetian Painting*, New York

R. Tavernor, *Palladio and Palladianism*, New York, 1991

Titian, exh. cat., Washington, National Gallery, 1990

R. Wittkower, *Architectural Principles in the Age of Humanism*, London, 1977

AZTECS, ANCIENT MEXICO

G. Kubler, *Art and Architecture of Ancient America*, 3rd ed., Harmondsworth/Baltimore, 1984

M. Miller, *The Art of Mesoamerica from Olmec to Aztec*, London, 1986

M.E. Miller & L. Schele, *The Blood of Kings*, Fort Worth, 1986

H.B. Nicholson & E.Q. Keber, *Art of Aztec Mexico: Treasures of Tenochtitlan*, exh. cat., Washington, National Gallery, 1983

E. Pasztory, *Aztec Art*, New York, 1983

R. Townsend, "State and Cosmos in the Art of Tenochtitlan," *Dumbarton Oaks Studies in Pre-Columbian Art and Archaeology* no. 20, Washington, 1979

IFE AND BENIN, ANCIENT WEST AFRICA

P. Ben-Amos, *The Art of Benin*, London, 1980

S.P. Blier, "Kings, Crowns, and Rights of Succession: Obalufon Arts at Ife and Other Yoruba Centers," *Art Bulletin* 67, 1985

H.J. Drewel & J. Pemberton III, *Yoruba. Nine Centuries of African Art and Thought*, New York, 1989

E. Eyo & F. Willett, *Treasures of Ancient Nigeria*, exh. cat., Detroit, 1980

S. Vogel, *Renaissance Art and African Ivories*, New York, 1989

F. Willett, *Ife in the History of West African Sculpture*, New York, 1967

6. AGE OF ABSOLUTISM

CATHOLIC EUROPE

Anthony van Dyck, exh. cat., Washington, National Gallery, 1990

A. Blunt, *Art and Architecture in France: 1500 to 1700*, 2nd ed., Harmondsworth, 1970, and *Nicolas Poussin*, New York, 1967

France in the Golden Age, exh. cat., New York, Metropolitan Museum, 1982

M. Garrard, *Artemisia Gentileschi*, Princeton, 1989

J. Held & D. Posner, *Seventeenth and Eighteenth Century Art*, New York, 1979

F. Haskell, *Patrons and Painters*, New York, 1963

H. Hibbard, *Bernini*, Harmondsworth, 1965, and *Caravaggio*, New York, 1983

M. Levey, *Giambattista Tiepolo*, New Haven, 1986

J. Montagu, *Roman Baroque Sculpture*, New Haven, 1989

R. Spear, *Caravaggio and his Followers*, exh. cat., Cleveland Museum of Art, 1972

G. Walton, *Louis XIV's Versailles*, Chicago, 1986

M. Warnke, *Peter Paul Rubens*, New York, 1980

C. White, *Peter Paul Rubens*, New Haven, 1987

R. Wittkower, *Art and Architecture in Italy 1600–1750*, 3rd ed., Harmondsworth, 1975, and *Studies in Italian Baroque*, London, 1975, and (& I. Jaffe, eds.) *Baroque Art: The Jesuit Contribution*, New York, 1972

CAPITALISM AND CALVINISM: HOLLAND

R.H. Fuchs, *Dutch Painting*, New York, 1978

W. Gibson, *Bruegel*, New York, 1977

Gods, Saints and Heroes, exh. cat., Washington, National Gallery, 1980

B. Haak, *Rembrandt: His Life, His Work, His Time*, New York, 1969, and *The Golden Age*, New York, 1984

F.F. Hofrichter, *Haarlem: The Seventeenth Century*, exh. cat., Zimmerli Art Museum, 1983

J. Rosenberg, S. Slive & E.H. ter Kuile, *Dutch Art and Architecture 1600–1800*, Harmondsworth, 1972

S. Schama, *The Embarrassment of Riches*, New York, 1987

Still Life in the Age of Rembrandt, exh. cat., Auckland City Art Gallery, 1982

P. Sutton, *Masters of Seventeenth-Century Dutch Genre Painting*, exh. cat., Philadelphia Museum of Art, 1984, and *Masters of Seventeenth-Century Dutch Landscape Painting*, exh. cat., Boston Museum of Fine Arts, 1987

A. Wheelock, *Vermeer*, New York, 1981

IMPERIAL ISLAM-ISFAHAN AND INDIA

W. Begley & Z.A. Desai, *Taj Mahal*, Cambridge, MA, 1989

L. Binyon, J.V.S. Wilkinson & B. Gray, *Persian Miniature Painting*, New York, 1971

M. Brand & G. Lowry, *Akbar's India*, New York, 1986

B. Brend, *Islamic Art*, Cambridge, MA, 1991

R. Ferrier, ed., *The Arts of Persia*, New Haven, 1989

J. Losty, *The Art of the Book in India*, exh. cat., London, 1982

G. Michell, ed., *Architecture of the Islamic World*, London, 1978

A.U. Pope, ed., *A Survey of Persian Art*, London, 1938–39

J.M. Rogers, *Islamic Art and Design 1500–1700*, London, 1983

N. Titley, *Persian Miniature Painting*, London, 1983

S.C. Welch, *Shah Abbas and the Arts of Isfahan*, New York, 1973, and *A King's Book of Kings*, New York, 1976, and *India*, New York, 1985

7. DAWN OF THE MODERN ERA

The Age of Neoclassicism, exh. cat., London, 1972

A. Bermingham, *Landscape and Ideology: The English Rustic Tradition 1740–1860*, Berkeley/Los Angeles, 1986

A. Boime, *A Social History of Modern Art*, Chicago, 1987

J. Burke, *English Art, 1744–1800*, Oxford, 1976

T. Crow, *Painters and Public Life in Eighteenth-Century Paris*, New Haven, 1985

F. Cummings & A. Staley, *Romantic Art in Britain: Paintings and Drawings 1760–1860*, exh. cat., Philadelphia, 1968

L. Eitner, *Neoclassicism and Romanticism 1750–1850: Sources and Documents*, Englewood Cliffs, NJ, 1970

The Eye of Jefferson, exh. cat., Washington, 1976

B. Ford, ed., *The Cambridge Guide to the Arts in Britain, vol. 5. The Augustan Age* and *vol. 6. Romantics to Early Victorians*, Cambridge, 1991

French Painting, 1774–1830: The Age of Revolution, exh. cat., Detroit, 1975

M. Fried, *Absorption and Theatricality: Painting and Beholder in the Age of Diderot*, Berkeley/Los Angeles, 1980

J. Gage, *J.M.W. Turner: 'A Wonderful Range of Mind'*, New Haven, 1987

G. Germann, *Gothic Revival in Europe and Britain*, London, 1972

Goya and the Spirit of Enlightenment, exh. cat., Boston, 1989

F. Haskell & N. Penny, *Taste and the Antique*, New Haven, 1981

J. Held & D. Posner, *17th and 18th Century Art*, New York, 1979

H. Honour, *Neo-Classicism*, Harmondsworth, 1968, and *Romanticism*, New York, 1979

J. Koerner, *Caspar David Friedrich and the Subject of the Landscape*, New Haven, 1990

M. Levey, *Rococo to Revolution*, London, 1966

F. Licht, *Goya*, New York, 1979

F. Novotny, *Painting and Sculpture in Europe 1780–1880*, Harmondsworth, 1971

R. Paulson, *Emblem and Expression: Meaning in English Art of the Eighteenth Century*, Cambridge, MA, 1975, and *Representations of Revolution*, New Haven, 1983, and *Breaking and Remaking: Aesthetic Practice in England, 1700–1820*, New Brunswick, 1989

N. Pevsner, *A History of Building Types*, Princeton, 1976

R. Rosenblum, *Transformations in Late Eighteenth-Century Art*, Princeton, 1969

R. Rosenblum & H.W. Janson, *19th Century Art*, New York, 1984

W. Vaughan, *German Romantic Painting*, New Haven, 1980

E. Waterhouse, *Painting in Britain 1530–1790*, 4th ed., Harmondsworth, 1979

E. Wind, *Hume and the Heroic Portrait*, Oxford, 1986

J. Wordsworth, M. Jaye & R. Woof, *William Wordsworth and the Age of English Romanticism*, New Brunswick, 1987

8. NATURE AND NOVELTY

A Day in the Country, exh. cat., Los Angeles, 1984

A New World: Masterpieces of American Painting 1760–1910, exh. cat., Boston, 1983

T.J. Clark, *Image of the People*, Princeton, 1982 and *The Painting of Modern Life*, Princeton, 1986

R. Goldwater, *Symbolism*, New York, 1979

R. Herbert, *Impressionism*, New Haven, 1988

H.R. Hitchcock, *Architecture: Nineteenth and Twentieth Centuries*, 3rd ed., Harmondsworth, 1969

P. Mainardi, *Art and Politics of the Second Empire*, New Haven, 1987

C. Moffitt, *The New Painting: Impressionism 1874–1886*, exh. cat., Washington, 1986

L. Nochlin, *Realism*, Harmondsworth, 1971

B. Novak, *American Painting of the Nineteenth Century*, New York, 1969

On the Art of Fixing a Shadow, exh. cat., Washington, 1989

N. Pevsner, *A History of Building Types*, Princeton, 1976

T. Reff, *Manet and Modern Paris*, exh. cat., Washington, 1982

J. Rewald, *Post-Impressionism: from Van Gogh to Gauguin*, New York, 1978

R. Rosenblum & H.W. Janson, *Nineteenth-Century Art*, New York, 1984

M. Roskill, *Van Gogh, Gauguin and the Impressionist Circle*, London, 1970

R. Shiff, *Cézanne and the End of Impressionism*, Chicago, 1984

D. Silverman, *Art Nouveau in Fin-de-Siècle France*, Berkeley, 1989

M. Weaver, *The Art of Photography 1839–1989*, New Haven, 1989

G. Weisberg et al., *Japonisme*, exh. cat., Cleveland, 1975

J. Wilmerding, *American Art*, Harmondsworth, 1976

9. IN SEARCH OF MODERNITY

Art into Life. Russian Constructivism 1914–1932, exh. cat., Seattle, Henry Art Gallery, Univ. of Washington, 1990

H. Chipp, *Theories of Modern Art*, Berkeley/Los Angeles, 1968

W. Curtis, *Modern Architecture Since 1900*, Englewood Cliffs, NJ, 1983

El Lissitzky, exh. cat., Cambridge, MA, 1987

J. Elderfield, *Matisse in the Collection of the Museum of Modern Art*, New York, 1968

J. Elderfield, *The Wild Beasts: Fauvism and its Affinities*, exh. cat., New York, Museum of Modern Art, 1976

J. Flam, Matisse: the Man and his Art, New York, 1986

M. Franciscono, *Paul Klee*, Chicago, 1990, and *Walter Gropius and the Creation of the Bauhaus in Weimar*, Chicago, 1971

J. Golding, *Cubism*, London, 1971, and *Marcel Duchamp: The Bride Stripped Bare by her Bachelors, Even*, London, 1973

J. Golding & R. Penrose, *Picasso in Retrospect*, New York, 1980

D. Gordon, *Expressionism: Art and Idea*, New Haven/London, 1987

C. Green, *Cubism and its Enemies*, New Haven/London, 1987

W. Haftmann, *Painting in the Twentieth Century*, London, 1968

G.H. Hamilton, *Painting and Sculpture in Europe 1880–1940*, Harmondsworth, 1981

R. Hughes, *The Shock of the New*, New York, 1980

H. Jaffé et al., *De Stijl, 1917–1931: Visions of Utopia*, New York, 1982

P. Paret, *The Berlin Secession*, Cambridge, MA, 1980

R. Rosenblum, *Cubism and Twentieth Century Art*, New York, 1960

W. Rubin, ed., *Pablo Picasso: A Retrospective*, exh. cat., New York, Museum of Modern Art, 1980, and *Picasso in the Collection of the Museum of Modern Art*, New York, 1972, and *Dada and Surrealist Art*, New York, 1968

A. Rudenstine, ed., *Russian Avant-Garde Art: The George Costakis Collection*, exh. cat., New York, Solomon Guggenheim Museum, 1981

P. Vergo, *Art in Vienna 1898–1918*, Ithaca, 1981

R. Washton-Long, *Kandinsky: The Development of an Abstract Style*, Oxford, 1980

P. Weiss, ed., *Kandinsky in Munich 1896–1916*, exh. cat., New York, Solomon Guggenheim Museum, 1982

MODERN MEXICO

J. Charlot, *The Mexican Mural Renaissance 1920–1925*, New Haven, 1967

H. Day & H. Sturges, *Art of the Fantastic: Latin America, 1920–1987*, exh. cat., Indianapolis Museum of Art, 1987

Diego Rivera: A Retrospective, exh. cat., Detroit Institute of Arts, 1986

J. Fernandez, *A Guide to Mexican Art*, trans. J. Taylor, Chicago, 1969

S. Goldman, *Contemporary Mexican Painting in a Time of Change*, Austin, 1981

L. Hurlburt, *The Mexican Muralists in the United States*, Albuquerque, 1989

The Latin American Spirit: Art and Artists in the United States 1920–1970, exh. cat., New York, Bronx Museum of the Arts, 1988, esp. J. Quirarte, "Mexican and Mexican American Artists: 1920–1970"

Mexico: Splendors of Thirty Centuries, exh. cat., New York: Metropolitan Museum of Art, 1990

A. Rodriguez, *A History of Mexican Mural Painting*, London, 1969

MODERN NIGERIA (YORUBA), WEST AFRICA

W. d'Azevedo, ed., *The Traditional Artist in African Societies*, Bloomington, 1973

W. Bascom, *African Art in Cultural Perspective*, New York, 1973, and *The Yoruba of Southwestern Nigeria*, New York, 1969

D. Biebuyck, ed., *Tradition and Creativity in Tribal Art*, Berkeley, 1969

H.J. Drewel & J. Pemberton III, *Yoruba*, New York, 1989

W. Fagg & J. Pemberton III, *Yoruba Sculpture of West Africa*, New York, 1982

R.F. Thompson, *Black Gods and Kings*, Bloomington, 1976, and *African Art in Motion*, Berkeley, 1974

F. Willett, *African Art*, New York, 1971

10. WORLD WAR II TO PRESENT

H.H. Arnason, History of Modern Art, 3rd ed., rev. D. Wheeler, Englewood Cliffs, NJ, 1986

D. Ashton, *American Art since 1945*, rev. ed., New York, 1982

B. Buchloh, S. Guilbaut & D. Solkin, eds., *Modernism and Modernity*, Halifax, 1983

L. Cathcart, *American Paintings of the 1970s*, Buffalo, 1978

J. Coolidge, *Patrons and Architects: Designing Art Museums in the Twentieth Century*, Fort Worth, 1989

J. Fineberg, *Strategies of Being: Art Since 1940*, Englewood Cliffs, NJ, 1993

H. Foster, ed., *The Anti-Aesthetic: Essays on Postmodern Culture*, Washington, 1983

H. Geldzahler, *New York Painting and Sculpture 1940–1970*, New York, 1969

S. Guilbaut, *How New York Stole the Idea of Modern Art*, Chicago, 1983, and (ed.) *Reconstructing Modernism*, Cambridge, MA, 1990

R. Hobbs & G. Levin, *Abstract Expressionism: The Formative Years*, exh. cat., New York, Whitney Museum, 1981

M. Leja, *Reframing Abstract Expressionism: Painting and Subjectivity in the 1940s*, New Haven, 1993

R. Marshall, *American Art since 1970*, New York, 1984, and *New Image Painting*, New York, 1979

S. Nairne, *State of the Art: Ideas and Images in the 1980s*, London, 1987

B. Rose, *American Painting, the Eighties: A Critical Interpretation*, San Rafael, CA, 1979

R. Rosen & C. Brawer, *Making their Mark: Women Artists Move into the Mainstream, 1980–85*, New York, 1989

I. Sandler, *The Triumph of American Painting: A History of Abstract Expressionism*, New York, 1970, and *The New York School: The Painters and Sculptors of the Fifties*, New York, 1978, and *American Art of the 1960s*, New York, 1988

S. Stich, *Made in USA*, Berkeley/Los Angeles, 1987

B. Wallis, ed., *Art after Modernism: Rethinking Representation*, New York, 1984

INDEX